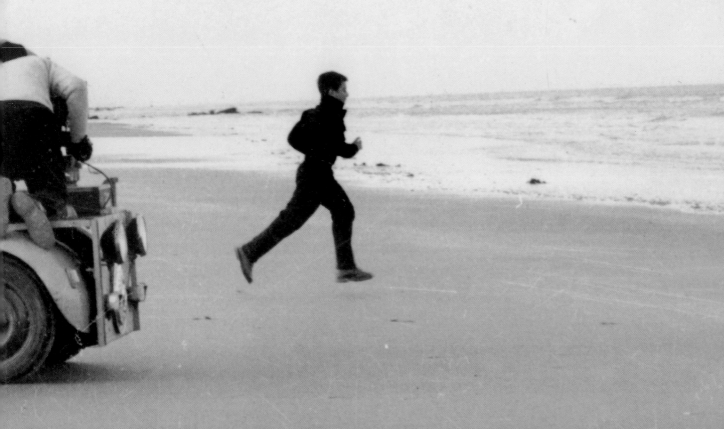

François Truffaut

at work

Phaidon Press Limited
Regent's Wharf
All Saints Street
London N1 9PA

Phaidon Press Inc.
180 Varick Street
New York, NY 10014

www.phaidon.com

English edition © 2005 Phaidon Press Limited
First published in French © 2004 Cahiers du
Cinéma

ISBN 0 7148 4546 X

A CIP catalogue record for this book is available
from the British Library.

Translated by Bill Krohn
Designed by Paul Raymond Cohen and adapted
by Jason Ribeiro
Printed in Italy

François Truffaut

at work

Carole Le Berre

Author's acknowledgements

My warmest thanks to all those without whom this book could not have come to life. First of all, Madeleine Morgenstern, Laura and Eva Truffaut, as well as Josephine Truffaut and all the filmmaker's collaborators who again agreed to answer my questions and to exchange conversation and opinions: Martine Barraqué, Marcel Berbert, Claudine Bouché, Yann Dedet, Claude de Givray, Jean Gruault, Roland Thénot. Thanks to Rosine Robiolle, second assistant on *Vivement Dimanche!*, and to Monique Holveck for her assistance with the photographs.

I also thank all those who encouraged me and accompanied me with their presence, and sometimes their logistical support, their complicity and their opinions: Jean Breschand, Emmanuelle Chamussy, Emmanuelle Demoris, Marie Guilmineau, Michelle Humbert, Eve Kirchner, Francoise and André Le Berre, Nadien Lamari, Alexis Lecaye, Jeanne Pannier-Chamussy and Vincent Chamussy, Isabelle Roux, Thomas Saez, Anne Santa Maria, and Daniel Sicard.

Also the staff of the BiFi archives and picture library for their constant availability and the quality of their research on documents, as well as the authors of the interviews with François Truffaut, extracts from which blazed the trail for this work. They are named in the Bibliography.

Thank you to Claude de Givray and Dominique Golfier, who read my successive dispatches with constant attention, and to Jean Gruault for his tonic proximity.

Thank you also to Fanny Ardant, Sylvie Zucca, Agnès Varda, Kika Markham, Isabelle Adjani, Michel Fermaud and Claude Chabrol for their kindness.

Sources

François Truffaut Archives at the Bibliothèque du film:
Documents: pp. 22–3, 37, 44, 68, 80, 81, 88, 90, 102, 114, 116 top, 117 top, 128, 130, 150, 156, 157, 168, 170, 182, 184, 185, 189 bottom, 198, 199, 214, 215, 238, 239, 262, 268, 269, 290, 304, 305, 308.
Photos: pp. 16, 20, 40–41, 42, 47, 49, 62 top right, 64–5, 67, 69 top and bottom left, 77, 82, 83, 86–7, 91, 94, 95, 98–9, 112–33, 115, 120, 121, 125, 151, 183, 184, 192–3, 194, 197 top, 224, 234–5, 259, 260–61, 264 bottom, 271, 273, 291 centre and bottom, 302, 307, 320.

Collection Cahiers du cinéma: jacket, flaps, pp. 14, 15 bottom left, 23 bottom, 28 top, 34, 35, 38, 46, 51, 53, 55, 59, 62 bottom, 66, 69 centre, 72 top, 74–5, 80 bottom right, 89, 107 top and bottom, 111, 139, 169, 171 top, 178–9, 206, 229, 263, 268, 276–7, 286–7, 301.
Collection Cahiers du cinéma/Dominique Rabourdin: pp. 13, 18–19, 85, 217, 288.
MK2: pp. 8, 10, 11, 15, 21, 22, 23 top, 27, 28 bottom, 31, 32, 33, 45, 61, 62 top left, 63, 69 top right, 73, 81, 100, 105, 107 centre, 108, 109, 116 bottom, 117 bottom, 119, 122–3, 131 top right, 136, 137, 141, 142, 144, 145, 146, 148–9, 152 top left, 152 top right, 152 centre-right, 152 bottom right, 153 bottom, 155, 162, 166–7, 176, 177, 179, 195, 197 bottom, 202, 203, 205, 208, 209, 211, 212, 214, 215, 216, 218–19, 220, 221, 222 (documents), 223 top, 225, 236, 237, 238, 239, 242, 243, 247, 249, 250–51, 256, 257, 258, 264, 269, 274, 275, 278, 279, 280, 281, 285, 289, 291 top, 292, 293, 296, 297, 303, 305, 306.
Collection Robert Lachenay: p. 17 bottom.
Collection Pierre Zucca: pp. 126–7, 129, 131, 133, 134, 143, 146, 152 centre and bottom left, 153 top, 163, 171, 174.
Collection Daniel Bouteiller: pp. 79, 189, 191.
Collection Raymond Cauchetier: p. 43.

Photo Credits

© MK2/Robert Lachenay: pp. 14, 15, 17, 34–5, 38–9.
© MK2/Pierre Zucca: pp. 8, 11, 13, 126–7, 129, 130, 131, 133, 134, 136, 137, 139, 141, 142, 143, 144, 145, 146, 148–9, 151, 152, 153, 155, 159, 162–3, 166, 167, 169, 171, 174, 176–7, 179, 320.
© Warner/Pierre Zucca: pp. 180–81, 183, 189, 191.
© MK2/André Dino: flaps, pp. 18–19, 21, 22–3, 27, 28, 31, 32, 33.
© Raymond Cauchetier: pp. 40, 41, 43, 45, 46–7, 49, 50–51, 53, 55, 59, 60, 61, 62 top, 63, 64–5, 66, 67, 69, 72, 73, 74–5, 77, 100–01, 105, 107, 108, 109, 111.
© MK2/Marilu Parolini: pp. 86–7, 89, 91, 94–5.
© MK2/Léonard de Raemy: pp. 10, 112–13, 115, 116–17, 119, 120–21, 122–3, 125.
© MK2/Bernard Prim: pp. 192–3, 195, 197, 199, 202–03, 205, 206, 208–09, 211.
© MK2/Hélène Jeanbreau: pp. 212–13, 214–15, 216–17.
© MK2/Dominique Le Rigoleur: pp. 218–19, 220–21, 223, 224–5, 229, 234–5, 236–7, 238–9, 242–3, 247, 249, 252–3, 256, 257, 258.
© MK2/Jean-Pierre Fizet: pp. 6–7, 260–61, 263, 264, 268–9, 271, 273, 274–5, 276–7, 278–9, 280–81, 285.
© MK2/Alain Venisse: pp. 286–7, 288–9, 291, 292–3, 296–7, 301, 302–03, 305, 306–07, 318–319.
© ADAGP: pp. 37 bottom right.
© MK2: pp. 25, 71, 98, 99, 103, 147, 157, 159, 199, 223, 231, 265.
© Warner: pp. 185, 187, 190.
© Sygma-Corbis: pp. 62 bottom, 171 top, 229.

Contents

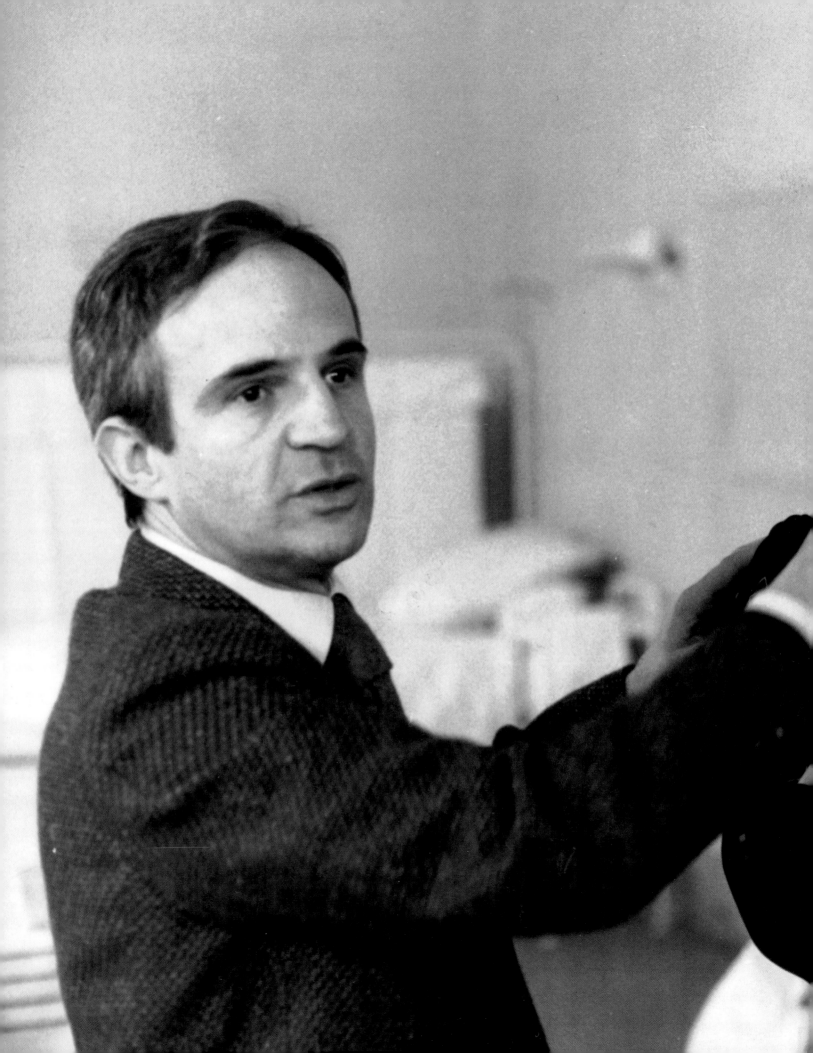

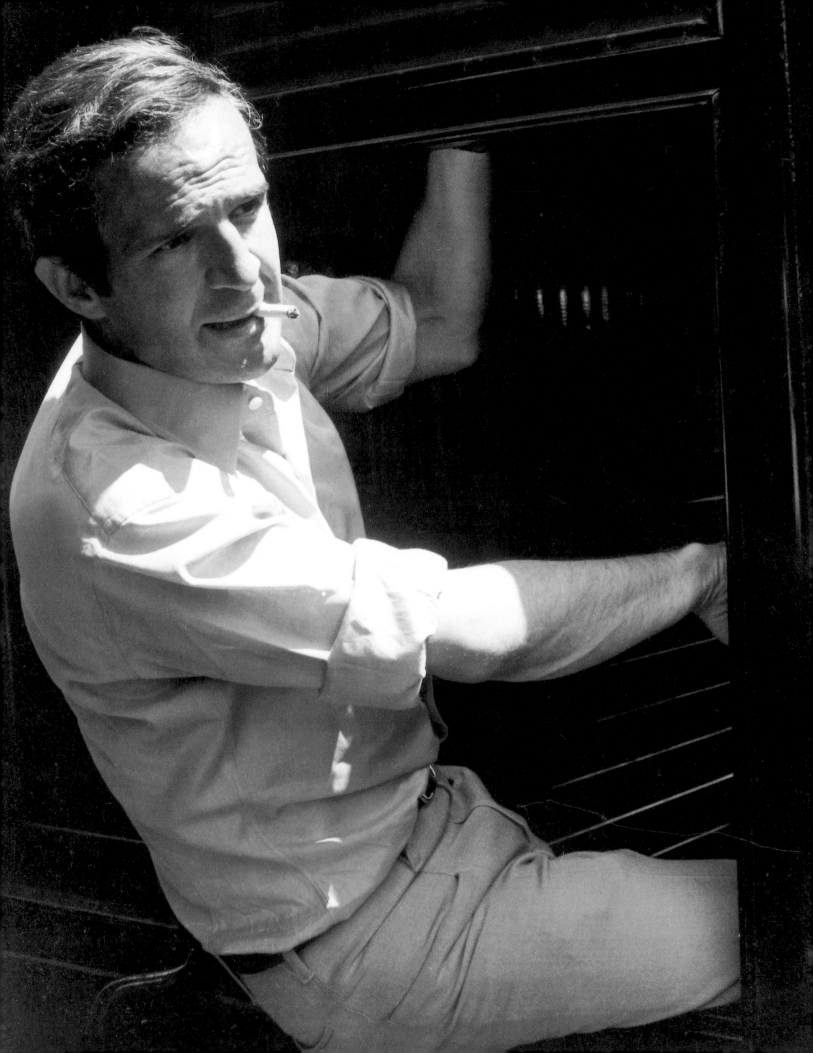

Introduction

The end of the 1980s: my heart was beating a little faster as I climbed the two flights of stairs at the end of the Robert Estienne cul-de-sac and knocked on the door of François Truffaut's production company, Les Films du Carrosse, which his wife Madeleine Morgenstern had kept going after his death. As a film student fascinated by the richness, intensity and secret violence of Truffaut's films, I had learned while leafing through a book about the film-maker (*Truffaut par Truffaut*, Dominique Rabourdin, La Chêne, 1985) that he had left archives containing work notes and annotated screenplays, and I wanted to know more. This rich oeuvre, so personal and at the same time so universal, composed of films 'round as an ivory egg' that are nonetheless shaken by heartrending situations, had never failed to astonish me, and I wanted to understand, to find out how it all worked, to raise the bonnet and examine the engine. After a few hours of conversation, Madeleine Morgenstern led me to a room at the back of the office. Indicating with discreet elegance the large cardboard boxes lining the wall, she said that I should feel free to come back whenever I wanted and consult them – an almost incredible opportunity that I would quickly seize, not realizing how much time I was going to spend exploring, with growing curiosity, the innumerable traces the film-maker had left of a creative mind at work.

Thanks to the confidence Madeleine Morgenstern had shown in me, and after investigating documentation I hadn't dreamed could exist, I was able to enter a film-maker's universe in a way that is rarely possible. Truffaut wrote a lot, noted everything, sent an incredible number of letters, of which he carefully kept copies, and covered his screenplays with handwritten comments, so when I opened the boxes labelled with film titles I had the impression that I was listening in on an uninterrupted conversation between the film-maker and his principal collaborators, between the film-maker and himself – the actual process by which the oeuvre had been developed. Because Truffaut had loved, indeed relished, preserving everything, it was possible to reconstruct that process now. When I picked the investigation up again ten years after writing my first book about Truffaut, I was not hoping to reveal the secrets of his life, as his biographers Antoine de Baecque and Serge Toubiana had already done to perfection; instead I wanted to grasp the secrets that transfer from film to film in the depths of the oeuvre. Above all, I wanted to understand by what paths, at what moment and by means of what system Truffaut, after much trial-and-error, had arrived at just the film he wanted and no other, how he freed its power and singularity, and how he constructed, film by film, an ensemble of exceptional, even radical, coherence.

Truffaut did indeed archive everything: scattered notes, drafts, first résumés, books filled with underlined passages and pencilled comments, character descriptions, multiple script versions, correspondence. Because he had not lost his youthful habit – and love – of keeping methodical dossiers on directors who interested him, he worked on projects that attracted him by opening files that he would gradually fill with press clippings, notes and fragments of dialogue jotted down on pages torn from notebooks or on sheets of onionskin paper, which he covered with his large

Previous pages:
François Truffaut
and Catherine
Deneuve in
Le Dernier Métro.

Opposite:
The filming of *Les Deux Anglaises et le continent.*

handwriting. 'The truth is, I have never chosen the subject of a film. I allowed an idea to enter my head, where it grew and developed, I took notes and more notes, and at the moment I felt myself thoroughly invaded by the film: Let's go.'

Truffaut often worked with co-writers. He had them deliver first drafts of stories he wanted to develop, which he annotated copiously, with energy and passion, sometimes with rage, in the margins or on facing pages – in every available space. Doubts, demands (frequently urgent), indignant outbursts, refusals, new proposals, maxims… Reading successive versions of these scripts covered with his handwriting, the still-living trace of a spirit always active and constantly on the move, means truly watching a film-maker at work, discovering his method and production secrets, following the first appearance of an idea or sometimes a sketch of the mise-en-scène: the birth of a film. This indispensable trove is now at the Bibliothèque du film (BiFi) in Paris. Did Truffaut, who had a passion for documents, for the unpublished writings of writers and film-makers, realize that he was assembling an unparalleled research archive of his own work? He rarely opened his files to those who wrote about his films while he was alive, except occasionally to give them access to shooting scripts, because he was bothered or intimidated by in-depth analyses and preferred not to learn too much about his own creative process, in order not to become too conscious of himself or the paths that led to his films. But he used all this scrupulously preserved documentation as a private hunting preserve where he went looking for ideas, and he was always taking dossiers out of their boxes to enrich some ongoing piece of writing. He would start over, sometimes years later, from a few notes jotted down on a piece of paper, shifting a scene from one film to another. He could start a new project from an idea he had abandoned years earlier, or more often from several that he suddenly felt the desire to combine – as he did when he made *Le Dernier Métro* by combining a project about the theatre with one about the Occupation, to obtain richer material that would give him the impulse he needed to begin a new film. A fragment of dialogue or a character trait jotted down at the time of *Les Quatre Cents Coups* might enrich a scene in *L'Argent de poche* or *L'Homme qui aimait les femmes*. A few phrases tried out on the corner of a page at the beginning of the 1970s suddenly made sense ten years later when he was writing *La Femme d'à côté*.

We think we know Truffaut's way of working because we've often heard it recounted: by Truffaut himself when his films were coming out, even though he often fudged things, if only to simplify the story and make it smoother; then, many times and often in scrupulous detail, by his collaborators after his death. Exploring his preparatory notes, the successive drafts of screenplays and his abundant professional correspondence will allow us to rediscover what these accounts have already told us and to carry them further by experiencing Truffaut's obstinacy and the coherence of his approach

With Suzanne Schiffman, filming *La Sirène du Mississippi*.

directly. It is hard to do justice to the stubborn insistence of his work on a film, which went from the development of the screenplay, constantly re-examined, to the film's release, which he always followed closely, not only in France but overseas. Truffaut wrote that Ernst Lubitsch took infinite pains (during the writing phase) and that he died of cinema twenty years too soon. It was no doubt the same for him.

Systems of freedom.

We also discover that Truffaut created a unique system, or a series of them, allowing him to work, to invent and to make his films with complete freedom. The first element, of course, was his production company, Les Films du Carrosse, which he started in 1957 in order to make *Les Mistons*, not realizing that his future father-in-law, Ignace Morgenstern, had helped him obtain bank financing through subtle pressure brought to bear by his financial director, Marcel Berbert, who would be the film-maker's right hand at Le Carrosse for 25 years. The existence of this company, which Truffaut managed to keep afloat through the years, guaranteed his artistic and financial independence and permitted him to produce or co-produce, in good years and bad, almost all his films, either with the participation of French producers and distributors or, for several films, with the French branches of US companies such as United Artists. On a day-to-day basis, nothing was as easy as it looks in retrospect. Many of Truffaut's projects were hard to set up financially, often being rejected as uncommercial the first or even the second time he presented them. This is true of, for example, *L'Enfant sauvage*, *L'Histoire d'Adèle H* and even *La Nuit américaine* and *Le Dernier Métro*. Often a film didn't recoup its money in France, but only gradually thanks to foreign sales. ('I feel I owe my creative freedom,' the film-maker said, 'to the fidelity of American, Japanese and Scandinavian audiences.') Although he was never obliged to carry out an assignment or make a film he didn't consider necessary (except perhaps for *L'Amour en fuite*), Truffaut did voluntarily limit himself to medium budgets to keep Le Carrosse in the black, which sometimes meant renouncing, as in the case of *Adèle H*, the temptation to make more expensive films.

A refuge from the snares and sirens of the industry, Le Carrosse was also a refuge plain and simple. For Truffaut it was a place to work, an office where he could come every day when he wasn't shooting, close the door, answer his mail, reflect on his upcoming films and store his archives, books and portraits of film-makers and writers he admired. It also gave him the security of a substitute family, a cinema family that surrounded him, protected him and accompanied him in his work. Beginning with Marcel Berbert, to whom he wrote in 1971 when he was recovering from a serious depression he had experienced during the filming of *Les Deux Anglaises*: 'At the beginning of the year Le Carrosse was teetering on the brink, and you helped me redress the situation, silently but very strongly; I hope all will go well now and that we won't

regret the adventure of *Les Deux Anglaises*.' Suzanne Schiffman was an essential collaborator whom Truffaut first met at the Cinémathèque française, then found again at the time of *Tirez sur le pianiste*, when he was able to hire her as script supervisor (something he couldn't do for *Les Quatre Cents Coups* because he didn't have his professional card at the time). Never a very conventional script supervisor, Suzanne was quite close to the film-maker, who rewrote scripts with her during the shooting of his first films. She officially became his assistant on *L'Enfant sauvage*, and he first gave her script credit on *La Nuit américaine*. Finally he gave her an office at Le Carrosse where, when subsequent films were underway, she could beard him in his den whenever she needed to. Co-writer, assistant and messenger on the set, to whom Truffaut often confided things he didn't want to say to people himself, she made the kind of constant contribution that is difficult to do justice to because it was often more oral than written, and she disliked talking about herself.

Truffaut surrounded himself with a faithful band to whom, combining in-jokes with economy, he often gave small roles in his films (Suzanne Schiffman being the only one who made only a very fleeting appearance in one film, *L'Homme qui aimait les femmes*): Claude Miller; Jean-François Stévenin; Roland Thénot (his production manager); Monique Dury (his costume designer); Claudine Bouché, then Yann Dedet and Martine Barraqué in the editing room; Christine Pellé (who became script supervisor after Suzanne Schiffman); Josiane Couëdel (production secretary)… He worked with screenwriters who were also his friends: Jean-Louis Richard, Claude de Givray, Jean Gruault… But he practised compartmentalization, keeping them from meeting at Le Carrosse and assigning them projects according to what he saw as their specialities. Similarly, when he started working with Nestor Almendros in the 1970s, he generally entrusted him with costume films where the photography would require considerable care, preferring to use Pierre-William Glenn for fast-moving films that would be shot quickly, like *Une belle fille comme moi* or *La Nuit américaine*.

Another figure was important in the protective network that Truffaut created around himself: his American friend Helen Scott, in charge of public relations for the French Film Office, who welcomed the young film-maker on his first trip to New York. (*Les Quatre Cents Coups* had just won the New York Critics Prize.) Assisted by a flight delayed in Chicago because of snow, it was the beginning of a long friendship. Truffaut developed the habit of confiding in Helen Scott, who became, as Claude de Givray put it, a sort of 'substitute Jewish mother', and fortunately for us the distance between Paris and New York (until Helen Scott moved to Paris at the end of the 1960s) inspired a correspondence in which the film-maker talked in detail, with the frankness that distance encourages, about his state of mind, his private problems and his professional concerns. The correspondence between

With Marcel Berbert, filming *Domicile conjugal*.

Truffaut and Helen Scott (with whom he undertook the project of a Hitchcock interview book between 1962 and 1966) is a precious barometer of his life and professional aspirations that makes an important contribution to our understanding of the process of production revealed by the archives.

Invention through reaction.

How did Truffaut invent? How did he move from a first draft of an idea to the finished film? Here again we see that the film-maker created a true system. The difficulties he encountered setting up *Fahrenheit 451* at the beginning of the 1960s frightened him. The fact that he was prevented from filming, with no next film in sight, put Les Films du Carrosse in danger, and he never wanted to find himself in that situation again. He therefore decided that he would always have several projects in development so that he would be free to substitute a different film for one that was not ready or had been rejected by his financial partners at any time: these simultaneous projects were started well in advance of production so that he could take as long as necessary to develop each one, distributing them among different co-writers with whom he worked separately, like a chess player playing several games at once. He also stayed on top of things so as not to miss out on a project that might interest him, subscribing to a professional library magazine that announced new books as they were about to appear, in order to spot them before they were published.

Above all, by discovering the notes written in response to his co-writers in the margins and blank spaces of the first drafts they submitted, by reading page after page of his notes on story and *mise-en-scène*, his quarrels, his interventions, his violent rejections – often funny, always sharp – we see that Truffaut invented by reacting, by becoming indignant, by refusing any vision that was not his, by acting out – often by over-acting – a drama of exasperation. It is as if he did everything possible to have before him, as if on a screen, a first film that would inevitably be shaky and, above all, not his; a film that he could rise up against before bringing forth bit by bit the film that would be his own, as personal as his fingerprints. This reactive style of working was essential for a film-maker who saw each film as part of a whole, because each film was also a response to the previous one, an attempt to do the opposite, to go against, to repair an omission, to resolve a dissatisfaction, to find a solution that would perhaps be – or perhaps not be – more satisfying than the one he had already implemented. The starting point for imagining almost every scene, every movement of the story, was a refusal: going further, not being satisfied with what one had, avoiding the commonplaces and evading the traps, concentrating and enriching a scene or a character by adding ideas taken from somewhere else, multiplying the layers... When we reconstruct his writing process, we discover one of the keys to the exceptional density of Truffaut's films, which he summed up himself by telling his writers not to construct a scene for one idea, but rather to collect many ideas in one scene.

A film-maker's self-criticism.

It is likely that this spirit of advancing by opposition, of inventing against, developed in Truffaut during the years he worked as a critic, when the violence of his reactions against the French films of the 1950s, his angry declarations, were a way of aspiring to another kind of cinema – one whose outlines were already visible in the film-makers he admired: Renoir, Ophuls, Guitry, Becker, Hitchcock... Nothing seems more false to me than the legend that Truffaut the hot-tempered critic, the gravedigger of the French Cinema of Quality, became a sober, reformed film-maker. To believe that, you would have to be blind to the subjects and the very nature of his films, to the violence that underlies them, to their way of always being both at the characters' side and in the very depths of their madness – indeed, to Truffaut's whole way of narrating and filming. When we investigate the process by which he put together his films and realize the fundamental role played by invention through rejection and opposition at every stage of the work – from writing the screenplay to choosing the settings to the way an actor is directed (Truffaut recalled that he made Jeanne Moreau laugh and be very animated in *Jules et Jim* to counteract the moroseness her other films had imposed on her) – everything confirms the continuity. The systems that Truffaut insisted on setting up, at the risk of being reproached for obsessive behaviour, permitted him to maintain a distance from his own work and to keep his critical sense alert – essentially, it was a way of carrying on an uninterrupted dialogue with himself, of being his own most severe critic in film after film.

In his personal life and his life as a film-maker, Truffaut never stopped trying to reconcile the contradiction between his desire to be recognized and accepted by society, to be part of the system, and his irreducibly antisocial nature. If you stop and think about it, he took on impossible subjects: *Jules et Jim* (two friends who love the same woman and agree to share her), *L'Enfant sauvage* (a child from the woods learning to walk and eat with a fork), *Adèle H* (a madwoman who wants to marry at any price), *L'Homme qui aimait les femmes* (a man obsessed with women walking), *La Chambre verte* (a man who thinks only of the dead), *La mariée était en noir* (a woman who thinks only of killing)... or even *Baisers volés* (a young man deciding between a woman of forty and a young girl, a subtle sentimental education), or *La Sirène du Mississippi* (a man who has been conned by a woman and continues to love her)... When he chose these paradoxical subjects, Truffaut was gambling that he would manage to interest us in them – not necessarily all of us at once, but each of us, everywhere, in France and in Japan or Scandinavia as well. Then the work on the screenplay began, the filling in of the tapestry, where the solution to the problem often lay in adding something: a young woman's monomaniacal passion for a man without qualities becomes possible if she turns out to be Victor Hugo's daughter, whose own identity has been erased by the crushing power of her father, especially if the viewer is forced to wait for the moment of revelation; the

passion of a man who follows his wife through France under a false name becomes interesting if we follow each stage of the emotional and sexual evolution of the couple, etc. The solution may also be found by working out a good scene, or a succession of good scenes, because Truffaut never stopped going back, and obliging his co-writers to go back, to make them richer and more entertaining, to reverse the cliché so that something happens and the violence of feelings unfolds and reveals itself.

The art of contraband.

What is it that Truffaut's films have that those by others don't? These deceptively smooth, easy films are certainly worked on more than others, revised again and again, rewritten again during shooting, then all over again in the editing room. Each film conceals a portion of the violence and savagery that inhabits and distinguishes all of them, even the most seemingly reassuring ones. As Claude de Givray pointed out to me, *César et Rosalie* (by Claude Sautet) could be a kind of *Jules et Jim*, but without the recollection of World War I at the heart of the film, without the gravity that enables it to achieve universality over and above its charm. It was when he rewrote and again when he was shooting that Truffaut tightened his scripts, eliminated the picturesque moments and permitted himself to invent the most crude, excessive scenes in his films, which never stop playing on the disjunction between their anodyne appearance, the amiable mask of entertainment, and the ball of savagery that rolls through them and breaks out in spurts. Certainly part of this strange savagery is rooted in the film-maker's childhood – the situations he put on paper but hesitated to put in his films, to avoid reopening family wounds, or ended up exploiting much later and in a more indirect manner. It is only in the flashbacks of *L'Homme qui aimait les femmes*, protected by the speed and intricacy of the narrative, that he exposed a fundamental scene written for the first time in his notes for *Les Quatre Cents Coups*: the one where the mother walks around half-naked in front of the child, who remains immobile, 'the better to confirm that he didn't exist'. Truffaut constructed his cinema starting from the contradiction between the power of the fantasies he set loose in his films and his desire to be accepted, his attempt to oblige audiences to accept the strong or excessive situations recounted in them, to tell them about the violence and strangeness of his fantasies while rendering them sufficiently presentable that the characters and the films won't be rejected. For prosaic reasons first of all, because as his own producer he needed a public and needed for films to work as well as possible commercially, since that was the only way he could keep making them with the same freedom, but also because he needed to be understood and loved. The rejections, the public failures, such as *Tirez sur le pianiste*, *La Peau douce* and *Les Deux Anglaises*, were particularly difficult for him, especially when the attacks were aimed at what he had attempted that was most personal to him: the naughtiness, the shifts of tone and the intensity of feelings. This need

to be recognized and accepted, like Antoine Doinel's desire to enter into families, is the origin of the misunderstanding that would have us believe in the sweetness, the good manners and the smallness of Truffaut's cinema. One can always choose to believe in appearances and refuse to look further, but for Truffaut, who often wrote in praise of subterfuge – not as a flight from the essential, but as a way of attaining the essential – cinema was 'an indirect art, one that hides as much as it shows.' A way of civilizing his portion of madness so that it could finally be accepted by everyone. Protected by his image as a classical film-maker, he never renounced the radical nature of his subjects, going so far as to expose his own body as if like 'a letter written by hand' (*La Chambre verte*). Always on the edge, he relied on unfailing intelligence to keep all his bets covered.

This book, dedicated to the work of a great film-maker, was written in spite of two great absences: Truffaut's of course, and also that of Suzanne Schiffman, who died just over three years ago, in May 2002. Whereas I often met with Suzanne Schiffman when I was writing a first book on Truffaut ten years ago, while writing this one I often missed being able to telephone her to obtain (and sometimes not to obtain, because she was, like Truffaut, rather secretive) answers to questions I was asking myself – especially the decisions about *mise-en-scène* made on the set, for which she was the first interlocutor, which are harder to decipher from work notes. It was indispensable to combine the reading of the documents, the numerous versions of scripts, the correspondence, the interviews or testimony left by those who are no longer here (Nestor Almendros left a book – *Un homme à la Caméra*, Hatier, 1980) with the memories and the views of those who accompanied the life and work of Truffaut: Madeleine Morgenstern, Jean Gruault, Claude de Givray, Marcel Berbert, Martine Barraqué, Yann Dedet, Claudine Bouché, Roland Thénot, all privileged witnesses whom I regularly saw or pursued by telephone about this or that detail. It was also necessary to sift and choose from a profusion of facts in order to reconstruct as cleanly as possible the trajectory of each film, so that I was regretfully obliged to sacrifice this beautiful note on a screenplay, that good detail, this idea passionately developed in an interview or a letter... Because, as Jaques Rivette reminded Truffaut before advising him to cut several scenes of his films, 'in the words of Renoir, we live only by constant small sacrifices'.

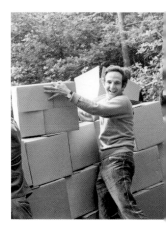

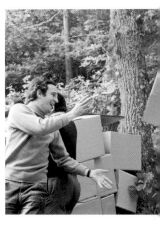

Une visite (1954)
A Visit

Histoire d'eau (1958)
A Story Of Water

Les Mistons (1958)
The Brats

Winter 1954: thanks to Jacques Rivette, who served as cameraman and also knew where to borrow a camera and find inexpensive film, Truffaut started out by making a 10-minute short, *Une visite*. The film, which has no real story, was improvised in Jacques and Lydie Doniol-Valcroze's apartment around the premise of an encounter among three people: a young woman (Laura Maurie, Truffaut's girlfriend at the time), a young man who comes to rent a room (Francis Cognany, a friend of Laura's) and the young woman's brother-in-law (Jean-José Richer, a critic for *Cahiers du cinéma*), who has come to drop off his daughter for the weekend (because Lydie Doniol-Valcroze had asked the tiny crew to baby-sit her two-year-old daughter). Disappointed and unhappy with his own amateurishness, Truffaut refused to show the film even to friends, judging it to be the work of a beginner who had no sense of what to leave out: 'What did I learn? To distrust useless shots. I had never realized that to show someone going from a phone booth to an apartment you needed so many shots of the entrance to the building, the stairs, the guy knocking on the door, which is then shown from the other side...' He never lost his fear of boring the audience, 'the obsession with the empty moment': 'I suffer physically when people get bored in a cinema, even if the film isn't mine.' Truffaut quickly managed to misplace the film for a number of years. But in this first one-reeler he already had Jean-José Richer showing the young woman the steam locomotive trick, which the girl played by Marie Dubois later performed in *Jules et Jim*. Twenty-five years later, Jean-José Richer was Marion Steiner's 'Saint Aubain' in *Le Dernier Métro* – the man she spends the night with to make Bernard Granger jealous, then refuses to see again.

In 1958, after he had already shot *Les Mistons*, Truffaut set out with a few hundred metres of film supplied by the producer, Pierre Braunberger, who was trying to get various projects off the ground with him, to film a few shots of a flood in the Montereau region. 'I had a passion for floods – just as I did for fire: Every year the newsreels of the period showed people leaving their homes in boats.' Claude Chabrol lent him a car and Jean-Claude Brialy, then still an unknown, agreed to go along, together with an actress who was also just starting out, Caroline Dim. Truffaut improvised with them on the banks of the Loing, where the water had already started to recede, but he was ashamed to be filming frivolous images in the midst of the very real problems the victims of the flood are having. ('I took along 600 metres of film and I brought back 600 metres of exposed film that didn't impress anyone, not even us.') Jean-Luc Godard asked to see the rushes and said it would be fun to try to edit them and add a commentary. That is how the 18 rather jokey minutes he was able to use ended up being signed by two film-makers, even though it was neither 'Godard's best film nor Truffaut's'.

With *Les Mistons*, the young director signed his first real film. In the spring of 1957 he found a story by Maurice Pons, whom he had met at the weekly magazine *Arts*, where they both were contributors. He liked the story's style, the situation (a group of boys just entering adolescence harass a pair of lovers) and Pons's evocative, sensual images. The film was also easy to shoot. 'Everything happened in sunlight, and there was no need for a producer,' he told *Cinéastes de notre temps* in 1965. 'I just needed film, and I knew someone at Montpellier who had the equipment.' He went on to make the film with the equipment and help of Jean Malige, a cameraman who had set up a mini-studio in the South of France, near Montpellier. But the absence of a producer is a fiction, because in order to shoot *Les Mistons* Truffaut set up his own production company – helped, unbeknown to him, by his future father-in-law Ignace Morgenstern, who sent his second in command, Marcel Berbert, to talk to the lending institution.

In April 1957, after Truffaut wrote a favourable review in *Arts* of an actor he had seen in Julien Duvivier's *Le Temps des Assassins*, he became friends with Gérard Blain and his young wife, Bernardette Lafont. A month later, during the Cannes film festival, he suggested that they play the couple. Blain refused at first, reluctant to let his wife become an actress, then accepted. Truffaut decided to shoot in Nîmes,

Jean-José Richer does the 'steam locomotive trick' in *Une visite*.

'Bernadette playing tennis': Bernadette Lafont in *Les Mistons*, her sensuality captured in motion, filmed by Truffaut as Ingmar Bergman had filmed Harriett Andersson in some shots of *Monika*.

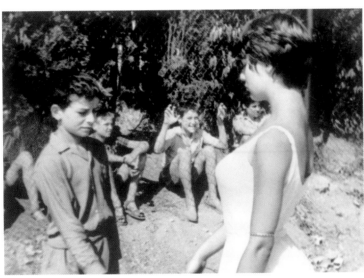

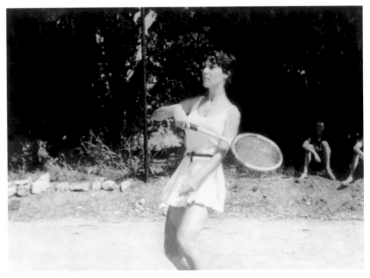

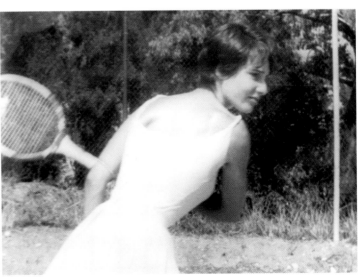

A page of notes for *Les Mistons*, which includes ideas that will be used in *Les Quatre Cents Coups* and *L'Argent de poche*. The names of the actors for another film which was never made can be seen at the top: a peasant visiting Paris who goes looking for the Eiffel Tower.

Bernadette's home town. His friends joined in. Robert Lachenay, whose inheritance from his grandmother went toward the financing, was to be the production manager, and Claude de Givray, who could drive and had a car, was to be the assistant director. All that remained was to find the brats (*les mistons*), whom Truffaut recruited through an ad in *Midi-Libre* – 'film director seeks five boys aged 11 to 14 to play *Les Mistons*' – picking five boys from those who showed up. He began filming with them on 2 August 1957, and quickly realized that the outline he was trying to follow interested him less than certain images. Later he said that he wanted to adapt the story because of a line about the heroine, Yvette (who became Bernadette), playing tennis, or the simple pleasure of filming freely with the children. 'When I was shooting *Les Mistons* I realized that there are certain things I like and others I don't, that choosing the subject of a film is more important than I had realized, and that one mustn't commit lightly. Every time I had to film something that was really part of the subject, the five children pestering the couple, I was uneasy. Whereas every time I filmed quasi-documentary things with the

children, I was happy.' In all respects, from the way the film shifted during shooting to the rapid literary commentary that drove the images, *Les Mistons* was an advance résumé of Truffaut's cinema. When he adapted Pons's story he cut and moved things around freely, as he would later do with *Jules et Jim* or *Les Deux Anglaises*. A beautiful line – 'We were as proud of all the kisses we interrupted as if we had received or given them ourselves' – was moved from the beginning of the story to the end of the film, and Truffaut created collages that reproduced Pons's style. For the commentary after the death of Bernadette's fiancé, he combined Pons's text – 'When we returned from holiday, life gave us a cruel answer, leaving feelings of abominable sadness in our hearts for a long time after' – with a line Julien Green had used as the epigraph for a collection of his plays, which Truffaut must have underlined because he found it seductive: 'We have to fearlessly take responsibility for the harm we inflict on ourselves and on others, but the result of all that is an abominable sadness.' To make the text fit the images, Truffaut pastiched Pons, just as he would pastiche Roché years later, inventing lines that were not in the story but seemed to come from it because they adopted its rhythms and fit the subject: 'For these moments of grace we would have paid an eternity of solitude' (when Bernadette takes back from one of the *mistons* a tennis ball that has been hit too far) or 'Who would kiss the child we no longer were, or the adolescent we had not yet become?'

Initially planning a longer film, Truffaut asked Maurice Pons to write additional text to accompany shots showing the awakening of the boys' desire. 'I filmed a dozen shots of girls in the street (walking), in the country (dancing), a kiss before a front door with a *miston* looking on, a poster of a pin-up with a sign: "Children under 16 not admitted", an obscene gesture, etc.' – shots that disappeared from the final version of the film along with the additional text, which was closer to Truffaut's universe than that of Pons and already looked forward to *Les Quatre Cents Coups*, *Tirez sur le pianiste* and *L'Homme qui aimait les femmes*: 'Too many legs, too many breasts, too many flying skirts that followed us in our dreams. What did it mean, this parade of desire that we preferred to make fun of? Who are they, these ridiculous vamps, these incredible *femmes fatales*? These naturally provocative young women before whom we were obliged to step back and hug the walls of life, what were we to them? These too-red lips, these heavy bosoms? Each of us carried in his heart the madness of love and images more precious than the life that authorized them.' As he would do for other films, Truffaut asked a voice actor, Michel François, who dubbed James Dean for French versions of his films, to read the commentary rapidly, with no emoting.

In *Les Mistons* we also see Truffaut's way of making a borrowed universe his own by inserting jokes and homages – sudden, playful shifts of tone, like the man

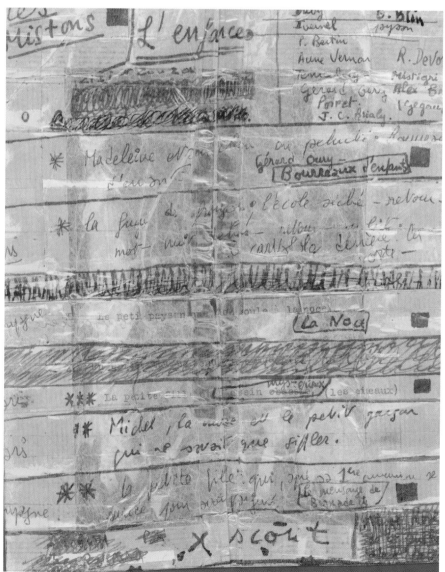

(played by *Cahiers* critic Jean Domarchi) who refuses to give Gérard Blain a light in the street just before another passer-by (Claude de Givray) agrees to give him one, or the little remake of the Lumières' *The Sprinkler Sprinkled* that opens the tennis sequence.

'I was happy when I was filming useless scenes, but when I had to tell the story, it slipped through my fingers. The film is made of little things placed side by side'. There are images of children shooting each other with invisible machine guns, or slightly slowed-down images of their faces leaning over the seat of Bernadette's abandoned bicycle to inhale the still-warm odour. Above all, images of Bernadette, whom the camera loved as it would Fanny Ardant later in *Vivement dimanche!* – laughing or sulking, spinning around on the tennis court, her short skirt flying up when she hits the ball, riding her bicycle through Nîmes. Truffaut's fantasy is already on screen: the passion and happiness of filming a female body in motion, which, for him, was not to be distinguished from the pleasure of cinema itself. 'Images of a bicycle in motion are always pleasant. When you film them, you know that all is well: it's a perfect harmony between cinema and a means of locomotion. From the moment you focus on something that is going forward, a car, a locomotive, a bike, you know that you are in the movement of the film.'

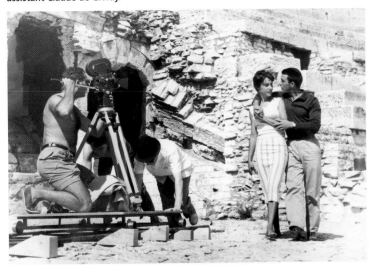

Filming *Les Mistons*: Bernadette Lafont, Gérard Blain and, behind Truffaut, his assistant Claude de Givray.

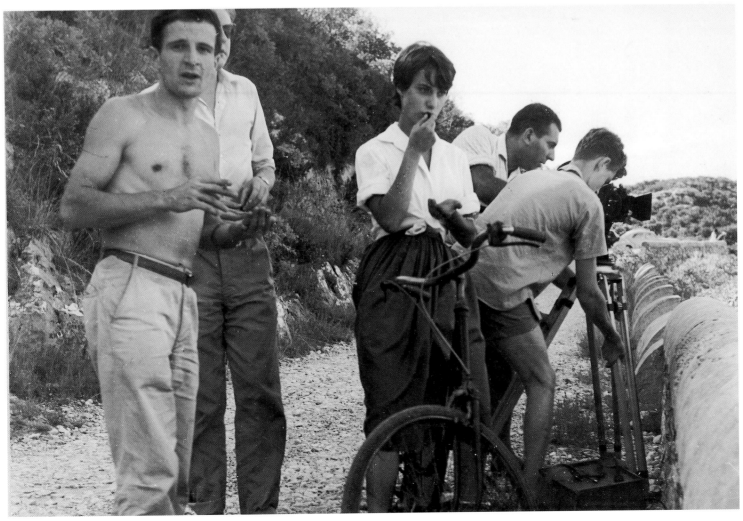

Les Quatre Cents Coups

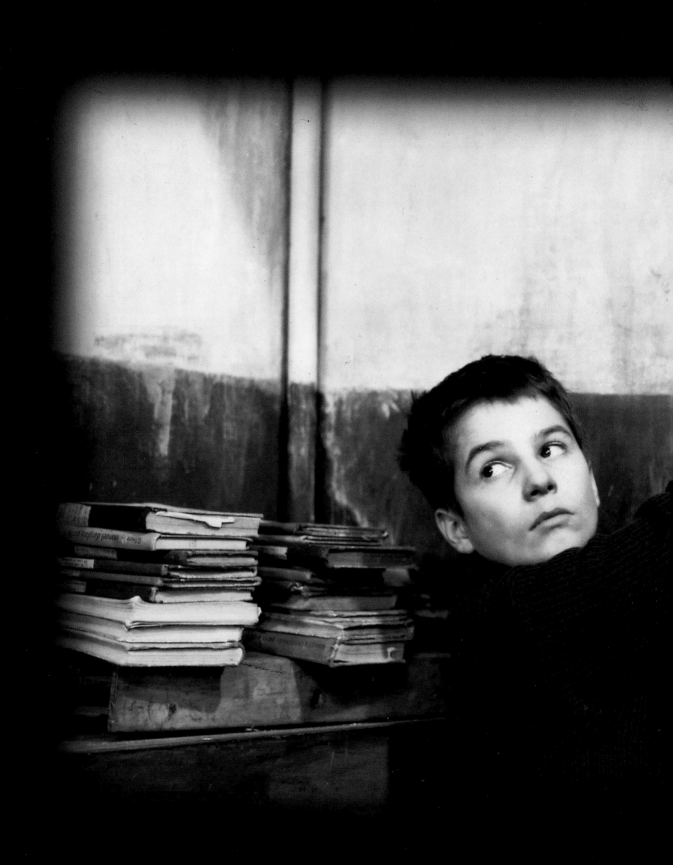

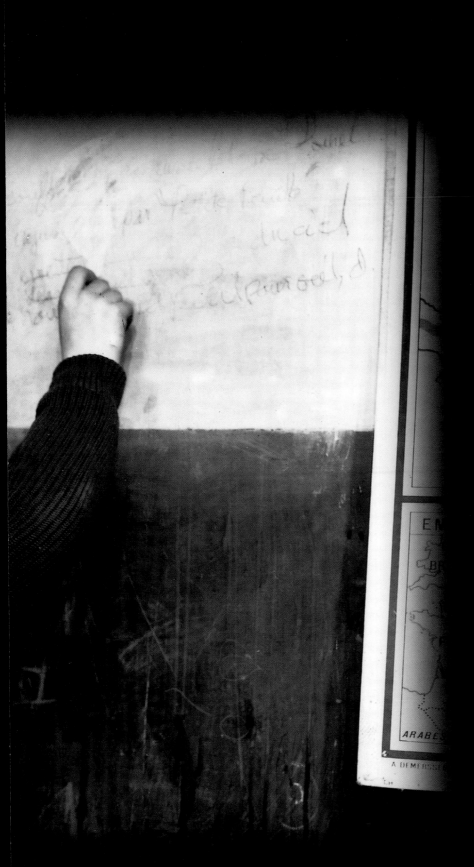

Les Quatre Cents Coups (1959)
The 400 Blows

'It was Bazin who got me out of a mess ten years ago by more or less becoming my guardian, and you have so much in common with Bazin that when we talked, I felt guilty and at the same time rescued. Just as he helped me "correct my aim" in my life, you are going to help me make a film that will be more than just a whining, self-satisfied confession – a real film.'

After their first meetings, the young Truffaut made this lovely declaration of trust to Marcel Moussy, who he wanted to work with on a scenario that was still called *La Fugue d'Antoine* (Antoine's Flight) at the time, or sometimes *Les petits Copains* (The Little Pals). Initially *La Fugue d'Antoine* was planned as a 20-minute sketch that would complement *Les Mistons*, filmed the previous summer: part of a feature film about childhood composed of brief episodes. During the spring of 1958 Truffaut decided to make it his first feature instead of an unrealized project that Pierre Braunberger was supposed to produce: *Temps chaud*, adapted from a novel by Jacques Cousseau that was a little like Erskine Caldwell. Truffaut originally planned to set the story of a boy who doesn't dare go home after telling a lie at school, and the infernal machine he is subsequently caught up in, against the background of the Occupation. But he did not have the budget for a period picture, and abandoned this idea: 'I dropped an aspect of the subject that was dear to me: Paris under the Occupation, scams on the black market, etc.' Truffaut went on to recreate this ambience almost 20 years later in *Le Dernier Métro*. At the beginning of June 1958 Truffaut decided to collaborate on the script with Marcel Moussy. Eight years older than the film-maker (Truffaut was 26 in 1958), Moussy was a novelist whose book *Sang Chaud* told the story of his childhood in Algeria, and a television writer whose broadcast about conflicts between children and parents, *Si c'était vous*, produced by Marcel Bluwal, Truffaut had liked very much. While he refused to work with a screenwriter who already had the industry's stamp of approval, preferring someone who had not learned the conventional way of doing things, Truffaut knew that he needed someone to help him shape a mass of elements that were still fairly undramatized, without sacrificing their authenticity. 'Moussy was a big help to me in constructing the script,' he said when the film opened. 'I had pages and pages of notes, but it was all so close to me that I wasn't able to give it a structure.' Truffaut's first writing accomplice, Moussy had several characteristics in common with the writers he worked with afterwards, however different their personalities: he brought Truffaut perspective, competence – he was a former English teacher and had just participated in the broadcast about childhood – and the flexibility that came from not being a professional screenwriter with a career behind him, so that he was not constrained by formulas (Truffaut never worked with an 'established' screenwriter, except perhaps for Jean-Loup Dabadie). He was also someone who could contain and deflect the violence Truffaut was afraid he was going to project into a story that was too close to his own: 'If I had been alone, I would have been inclined to portray my parents in a very caricatured manner, to create a violent, subjective satire, and Moussy helped me make these people more human, closer to the norm.'

Previous pages: Jean-Pierre Léaud.

Truffaut searches for a title for his first feature film.

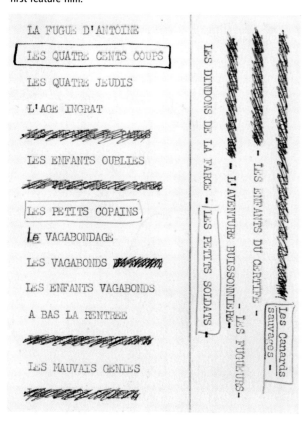

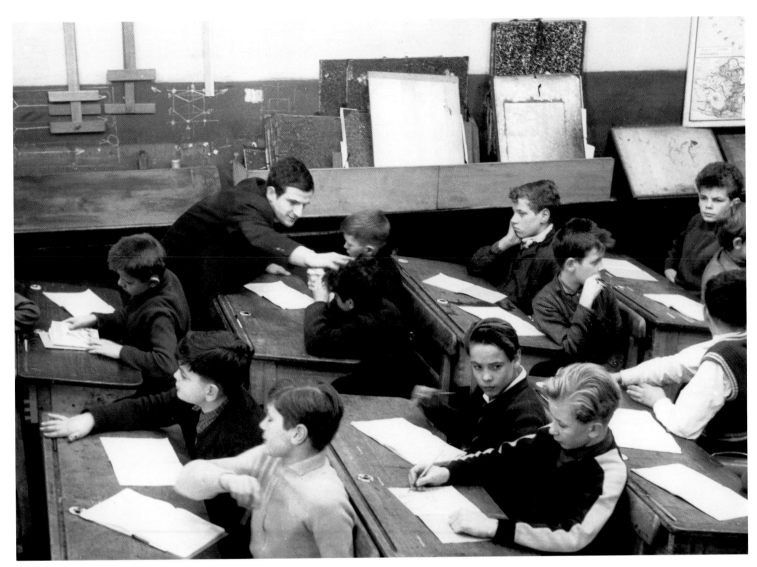

In fact, Truffaut did not trust himself. While he denied it later in order to protect those close to him and kept asking that the autobiographical dimension of the film be played down, he was starting from material that was very directly autobiographical. 'If the young Antoine Doinel sometimes resembles the turbulent adolescent I was, his parents absolutely do not resemble mine, who were excellent,' he lied in an article for *Arts* at the time of the film's release (3 June 1959) called 'I Did Not Write My Autobiography in *Les Quatre Cents Coups*'. 'They are much more like the people who confronted one another in the television broadcasts that Marcel Moussy wrote for Marcel Bluwal, "If It Were You".' Aiming for universality, Truffaut refused to reduce the film to a settling of scores, to the 'whining, self-satisfied confession' he had told his co-writer he wanted to avoid. When he handed Moussy a first outline of Antoine's itinerary, constructed as a series of catastrophes in which a first error leads to another, greater one, which has consequences, and so on, he prefaced it with a number of remarks. In them he stressed his wish to distance the material: 'The behaviour of Antoine's parents, and more generally of all the adults portrayed in the film, will be shaded, clarified, humanized.' Years later Truffaut continued to be evasive about the autobiographical element in *Les Quatre Cents Coups*. At the end of May 1981 he wrote to Charles Tchernia, who planned to bring the film up in

a television broadcast, asking him to 'set aside the film's autobiographical reputation' because even though his mother had died in 1968, he wished to spare his father, who had just turned 70: 'At the time this film caused a real family drama, and today, 20 years later, I'm still fearful of the repercussions.'

A mother.

Even though the film is not kind to adults – something Jean-Pierre Léaud's charm brings out all the more by contrast – the film-maker wanted to strike a balance between the boy and his parents. Still, passages from the pages Truffaut wrote for Moussy in June 1958 describing the characters show him preparing for more direct attacks than he ultimately let himself make in his first film. Not surprisingly, the portrait of the mother, whom Truffaut both admired and detested, was particularly severe: 'Extremely nervous and intolerant, she terrifies Antoine, never letting him get away with anything. If he says nothing, does nothing and remains in his corner reading, all is well – she just pretends to ignore him; what she cannot forgive is when he occasionally behaves like a child: loud laughter, asking a question, making noise, etc.' This description is very close to what Truffaut confided to Aline Desjardins in a candid 1971 interview for Radio-Canada: 'My mother couldn't stand noise, or rather I should say,

In the classroom Truffaut directs young Richard Kanayan, whom he noticed during screen tests for *Les Quatre Cents Coups* and to whom he later gave the role of Fido in *Tirez sur le pianiste*.

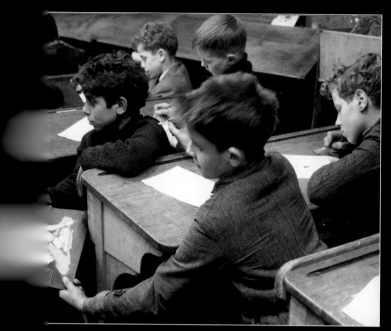

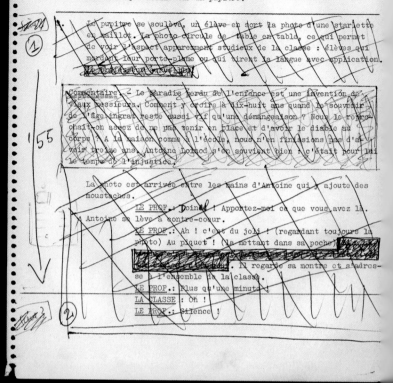

1. INTERIEUR SALLE DE CLASSE - JOUR
 Le Générique défile sur un pupitre.

Below and right: Truffaut's description of Antoine in these notes is very close to what he himself was like as a child: 'At home he almost never opens his mouth because he is terrorized by his mother, whom he admires in a confused way and of whom he is rather proud. [...] He's humble with his parents; insolent and mocking outside [...] Already something of a pedant, he provokes paradoxical comments, such as: "He acts like a man of thirty" etc. [...] If his parents argue, he sides with his mother, who is not at all appreciative [...] All that he has inherited from his father is his habit of cracking up laughing.' After two screen tests, Truffaut chose Jean-Pierre Léaud to play Antoine: 'Very handsome, a bit feminine [...] His letter is well-written, simple, neat [...] Intelligent.'

Right: The first page of the shooting script. Truffaut crossed out a scene after filming it: here, the scene about the 'pin-up that fell from the sky', for which Antoine receives his first punishment.

Nº 3 LÉAUD Jean-Pierre

12, avenue George V - Paris 8º

Tél. BAL 77-16

x trés beau, un peu féminin

x fils de Jacqueline Pierreux et P.Léaud

x il connait Domarchi ?

x sa lettre est bien écrite, simple, nette.

x né où ?

x intelligent

x AuNoire Reyé

Fric Antoine
 ========

Douze ans et demi, parisien. Il a hérité de sa mère un sens critique trop développé; il a tendance à se moquer des copains plus frustes, des concierges; ... trop méprisant.

Chez lui, il ne " l'ouvre pas " ou presque, terrorisé par sa mère qu'il admire confusément et dont il est assez fier. Il se rattrape dehors et devient vite saoulant; comme il a un avis sur tout et un esprit de contradiction insensé, ses copains de classe le redoutent un peu et ne l'aiment guère; il est humble chez ses parents, insolent et persifleur dehors.

Précocement pédant, il suscite des compliments paradoxaux genre : " Quand il parle, on croirait un homme de trente ans" etc..

La peur de sa mère l'a rendu un peu lâche avec elle, maladroitement flatteur et servile, ce qui ne fait que l'indisposer davantage contre lui. Si son père et sa mère se disputent, il se range du côté de sa mère qui ne lui en est absolument pas reconnaissante : " toi, le petit, tais-toi s'il te plait ! " Mais lorsque le père met en boite la mère, il ne peut s'empêcher de rire ce qui provoque les drames.

De son père il a hérité le fou-rire facile, c'est tout.

Il est à l'aube de la révolte, déjà cynique, sans scrupules et glissant vers la sournoiserie.

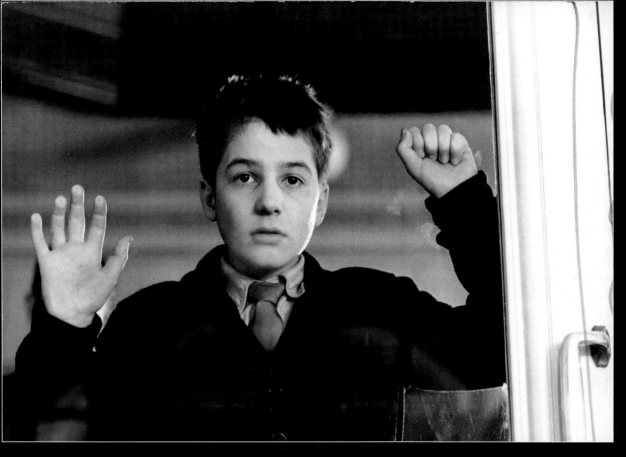

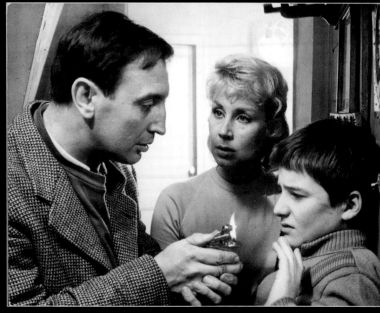

Above: Antoine the firebug (Jean-Pierre Léaud),
with his parents (Albert Rémy and Claire Maurier).

Left: Notes given back to Marcel Moussy for
writing the screenplay.

she couldn't stand me. In any case, I was supposed to make myself invisible and stay in my chair; I didn't have the right to play; I had to make her forget I existed.' Later, in describing the character, Truffaut didn't pull any punches, adding a certain misogyny to his hatred: 'She is not intelligent, just a little better educated than the average woman. She has an opinion on every subject and is preemptory to the point of unconsciousness.' 'She has great contempt for the whole universe: "all idiots".' (In his portrait of Antoine – and of himself – Truffaut said that the child 'inherits from his mother an over-developed critical sense; he has a tendency to make fun of his coarser pals, of concierges; he's too contemptuous'.) Or again, speaking of the mother: 'She suffers from a formidable lack of simplicity. She is one of life's Bovarys. Her husband sometimes calls her "the savage", and she takes it as a compliment.' Truffaut would portray the full scope of his mother's bitterness and indifference, which *Les Quatre Cents Coups* only hints at, in *L'Homme qui aimait les femmes*, a film where the autobiographical element is less directly visible, being hidden in the flux and variety of the story. When Truffaut decided to describe the childhood of Bertrand Morane in flashback during the summer before the preparation of *Les Quatre Cents Coups*, he outlined scenes that he only filmed 18 years later: 'Antoine exists so little for his mother that she could easily walk around the little apartment in front of him wearing bra and panties; she's wearing this costume when she gives him money to go shopping.' Or these notes accompanying the first résumé of the story of Antoine's flight: 'Show that Antoine has never had the right to play; at home his mother can only tolerate him sitting in a chair reading; she has a horror of noise, and therefore of toys; the neighbourhood children play in the street, out in the square, but Antoine isn't permitted to; one night his mother finds him in the square chatting with someone: "Go home, little man – fast."' This would become the scene in *L'Homme qui aimait les femmes* where Bernard's mother finds him in the street, with a girl of course: 'Who's the little turkey with the flat arse?' In 1958 Truffaut specified in his notes for Moussy: 'Always "my little one", "the kid", "the little one" or sometimes "my poor friend".' Even on the sheet he devoted to Antoine's father he could not stop himself from adding this astonishing, ambivalent portrait of the mother: 'Unlike the mother, who is almost an anarchist, a domestic terrorist, "outside of society" (one senses that it wouldn't have taken much for her to become an adventuress, a bit of a thief, or above all a prostitute), he is rather well integrated socially.' Here we see the first version, set down years in advance, of the radical and surprising link established in *L'Homme qui aimait les femmes* between the mother and a prostitute walking in the street. We can also see that several heroines of films to come will have something of what the mother could almost have become, according to Truffaut: Marion in *La Sirène du Mississippi*, who is an adventuress, a bit of a thief and a bit of a prostitute, or Camille in *Une belle fille comme moi*, as well as *La Petite Voleuse* (a film finally made by Claude Miller in 1987). Those characters were also inspired in part by one of the first women Truffaut lived with, whom he happened to run into again some time before writing *La Sirène du Mississippi* and ended up interviewing, hoping she would help him write Marion's

dialogue. It is as if the 'savage', albeit not fully developed, aspect of the mother might contain something more positive than negative, even though he accompanies it by the vengeful description 'a domestic terrorist'. As for the father, he was criticized less severely: 'He isn't very interested in women; he cheats on his wife 12 times less than she cheats on him; he'll say "a beautiful babe with huge knockers"… but he prefers indulging in that kind of talk about women to putting it into practice.' Or again: 'If he were an artist he'd be a third-rate singer; he only sees what won't upset him; he hates "fusses"; his leitmotif is "above all, no dramas".' Everything is a pretext for a joke. He may gripe in the morning because he doesn't have a clean shirt, or because his jacket still has some spots on it, but since his wife is better than he is at raising her voice, he prefers as a rule to adopt an ironic tone: 'Say, there are bits of sock in my pair of holes' – a line Moussy will use in the dialogue. 'It's really the film of a period in my life,' Truffaut said in 1962. 'Made three years earlier, it would have been more angry. Now, on the contrary, I find that it is too much of an infernal machine. During shooting I allowed myself to be influenced; I was afraid the boy was too unsympathetic and I decided not to film scenes of pilfering, thefts from shop windows and general effrontery. Today, on the contrary, I would attempt to include those scenes in order to strike a fairer balance between the adults' responsibility and that of the adolescents.'

She's dead.

The teacher shakes the child, who doesn't have an excuse for his absence: 'It's my mother, Monsieur' / 'What's wrong with your mother?' / 'She's dead.' In the first draft version of this famous scene, it is the father and not the mother that Truffaut's hero pretends has died: 'Haggard, pale at the enormity of the lie he is about to tell, he takes the plunge: "Well, my father..." The teacher, skeptical: "Now what's wrong with your father?" – "He's dead".' Replying in 1979 to an American correspondent who has just named him an honorary member of the Society of Friends of Mark Twain, Truffaut added this postscript: 'Can you tell me if Mark Twain is the author of this quotation? – Any Frenchman is lucky who knows who his father is.' In the first draft of *Les Quatre Cents Coups*, what sends Antoine into a tail-spin is the chance discovery in the family record book that he is a bastard. 'The word "bastard" is distinctly pronounced twice in a row by the father and the mother', we read in this first summary, a sentence that Truffaut crossed out, eliminating the autobiographical reference, when he prepared the text for publication with the other screenplays in the *Aventures d'Antoine Doinel* in 1970. Seeking to distance this overly autobiographical detail, Truffaut proposed another point of departure in a text accompanied by a few notes for Marcel Moussy: 'The initial idea of revealing the "illegitimacy" will be abandoned for one that is stronger dramatically: Playing truant, Antoine encounters his mother in the arms of a man. Since she says nothing about it that night, Antoine imagines that there now exists a total complicity between them, and therefore systematic impunity for him, which is quickly shown to be false. (His mother is present at the school when his father slaps him.) This disappointment is a sufficiently powerful motive to bring about his first flight.' Truffaut was now

dramatizing a different kind of encounter than he had planned in his first draft, where Antoine has the fright of his life when he runs into his mother in the street, but she doesn't see him because she is absorbed looking at a shop window full of lingerie. He completed the idea of the encounter and the double *flagrante delicto* (the mother with her lover, the child playing truant) in a remark written on a separate page headed 'For Moussy':

'Two dramatic ideas support the first third of the film:

1) A child, having surprised his mother in the arms of a man, believes himself bound to her by a complicity that assures him impunity;

2) Not having a written excuse for missing school when he returns after two days of vagabondage, a child tells his professor that his father is dead. The discovery of his lie will lead to his first flight.'

This changed again in the structural résumé based on Moussy's first draft, where for the first time it is his mother that Antoine 'kills':

'At school he justifies his absence by saying that his mother is dead. The shame provoked by the discovery of this lie incites his partial flight (not going home).'

'There are also attempts at reconciling with the mother, the promise of a good grade in French composition and the imitation of Balzac, which leads to a double disaster: the fire at home and the accusation of copying.'

The first draft of *La Fugue d'Antoine* does not contain the idea of a pact with the mother, the alliance she proposes, or rather imposes ('We can have our little secrets too'), but it does describe Antoine's exaltation at reading a novel by Balzac and the fire he starts by lighting a candle in front of the portrait of the writer he reveres. Then during production, to temper the unremitting harshness of the adults' behaviour, Truffaut decided to prolong the sequence where Antoine's furious father puts out the fire by having the mother suggest going to the movies. What follows is a kind of truce, the only brief scene of *détente* and reconciliation with the parents, where Antoine's laughter is heard and the film-maker inserted a private joke: the film they go to see is *Paris nous appartient*, which Jacques Rivette had not yet finished. (Its post-production would be made possible by, among other things, the success of *Les Quatre Cents Coups*.)

Structure.

During the summer of 1958 Truffaut was looking for a structure, going so far as to over-dramatize his story, as if he still lacked confidence in its emotional power. 'We need to find a third idea strong enough to trigger the second flight. And a fourth idea to bring about the theft of the typewriter that is stronger than the desire to go to the country – either that or we have to make that desire more imperious. We don't have anything that can trigger his running away.' Truffaut vacillated between a tighter dramatic line focusing on the lapses and misfortunes of his main character and the original project of a sketch film about children modelled on *Les Mistons*. 'Certain little gags and sketches have nothing to do with the story, but we'll try to conserve them and integrate them better with the action so that they aren't just anecdotes, painting as complete a picture as possible of childhood in general: joyful, sad, persecuted, spoiled. Little boys and girls of

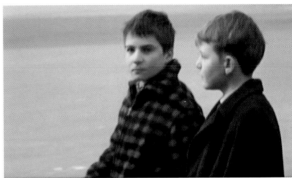

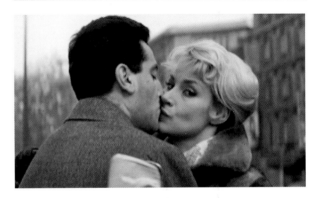

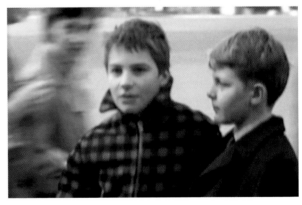

In Place Clichy, Antoine Doinel, who is playing truant with his pal René (Jean-Pierre Léaud and Patrick Aufay), catches his mother in her lover's arms (Claire Maurier and Jean Douchet).

various ages will appear episodically.' Planning to combine stories he had heard with his own memories, he kept until the shooting script the story of little Mado and her stuffed dog, a childish caprice Madeleine Morgenstern had told him about that he planned at one point to make one of the shorts that would be combined with *Les Mistons*. (In 1959 he gave the Cinémathèque française six typed pages of a sketch with dialogue called 'Torturers of Children' which was supposed to accompany *Les Mistons*.) In the second résumé this anecdote is told at length: little Mado's caprice of refusing to go to the restaurant without her stuffed dog Totor (black, dusty and repulsive), preferring to stay home alone. No sooner have her parents gone out than she opens the window and cries: 'I'm hungry!' Hearing this, Antoine and René, who see her from the apartment across the way (the story is inserted at the point of Antoine's stay in René's big, empty apartment), send her a basket of fruit and cakes using a system 'inherited from the cable car'. Later, a little boy clowns around to amuse Mado from the balcony facing hers – he is scolded when his mother comes home. Madeleine's parents return, and in the days following the incident they cannot understand why their neighbours are looking at them disapprovingly. The sequence is repeated in the shooting script, when Antoine and René are at the window playing with their pea-shooters, and was finally not filmed. Truffaut would resurrect it for *L'Argent de poche* (where little Mado becomes little Sylvie, the name of the actress), along with several other scenes he had in mind during the writing of *Les Mistons*, then *Les Quatre Cents Coups*, such as the 'first kiss in summer camp', which he noted would be 'the only flashback in the film', or a lengthy scene at a fair, where Antoine and René were going to wander for a long time before trying the *rotor*, a spinning fairground ride. Finally Truffaut chose not to put any of these scenes in the film so as not to slow it down. All that remains of the idea of painting a picture of childhood in general is the Punch and Judy show, a long, self-contained sequence that stands apart from the rest of the film, in which Antoine and René – who we have seen walking around the paths of the garden with an anonymous little girl – watch Punch and Judy with a group of younger children screaming with fear and delight: the ideal spectators for a film-maker who once said that he wanted people to watch his films 'open-mouthed'. Truffaut later confided that he could have edited this scene to run 30 minutes but was constrained, in spite of the temptation, to leave in only the strict minimum. After a lot of back and forth between Truffaut and Moussy, the film gradually found its structure and its point of departure. At first the story of the pin-up drawn on a piece of paper that circulates from desk to desk before being intercepted by the teacher was one anecdote among many, one schoolboy prank among others that are told in no particular order (the submarine glasses stolen from the best student in the class; the child who has a friend cut his hair so he can keep the money for the barber – a scene that later appeared in *L'Argent de poche*; the unpopular gym teacher abandoned, in small groups, by his students). 'Another time an almost naked pin-up cut out of a magazine like *Paris-Hollywood* passes from desk to desk; one boy adds glasses drawn with a pencil, another adds a moustache; the teacher confiscates it: "And for that you stay an hour after school –

if you don't like it, two hours. And you, what are you laughing at like an imbecile? An hour for you too. Ah, my fine young men, you're going to get it, I can tell you."' Truffaut, who had planned to start the film with the parents' alarm clock, rebounded off a new opening proposed by Moussy: the studious class bending over a task as we pan to discover Antoine in a corner, punished. 'Instead of starting with Antoine being punished,' Truffaut wrote in the margins of the first script with dialogue, 'we can go back to the cause of this first unjust punishment, to have a more Kafkaesque series of misfortunes! For example: Credits over a desk; the lid of the desk is raised and the camera pulls back; a student takes out a photo of a girl in a bathing suit; the photo circulates from desk to desk, coming to Antoine, who draws a moustache on it: "Bring me what you have there... To the corner!" That way we can begin with innocence and a laugh from the audience in the first minute.' Antoine's first crime, then, will be a pencil mark on a photo of a pretty girl. This is an early example of the often ominous power of photography in Truffaut's films. Antoine's crime is linked to femininity, to transgression and to writing, and the punishment is not long in coming: the few verses he writes on the wall earn him a double punishment and expulsion for eight hours. As has often been noted, all of Antoine's attempts at writing result in disasters: the written excuse supplied by René that he does not succeed in copying, or rather copies too well, since he does not write in his own name, but copies René's; the grandiloquent letter he sends his parents to justify his departure, which is greeted with irony and incomprehension; the composition borrowed from Balzac and the accusation of plagiarism; even the theft of a typewriter that leads to his arrest, a night spent at the police station and imprisonment in a Centre for Delinquent Children. The day it was filmed, the occasional verse written by Antoine ('Here suffers poor Antoine Loinod / Unjustly punished by Little Page / When he hadn't said a word') was rewritten (the last line becomes 'For a photo that fell from the sky', then 'For a pin-up that fell from the sky'). Truffaut changed his hero's family name during production (the film being almost entirely post-synchronized). He later said that he thought he had invented 'Doinel' (instead of 'Loinod', an anagram of 'Doniol-Valcroze', the editor-in-chief of *Cahiers du cinéma* when Truffaut started writing for it), only to realize that it was the name of Jean Renoir's secretary.

Antoine and René.

In the first screenplay with dialogue, it is René who rides in the *rotor* at the carnival while Antoine watches. Truffaut then inverted their respective places and gradually swapped around characteristics between the two friends. Initially he had imagined that Antoine would be submissive and anxious, as Truffaut was himself, in contrast to a version of René who is more enterprising, like Truffaut's childhood friend Robert Lachenay. (Antoine's friend is named Robert in the first outlines and his mother is named Bigey, like Lachenay's grandmother.) Defining the characters for Moussy, Truffaut wrote that Antoine 'is perpetually anxious, because no sooner does he escape from one complicated situation than he tumbles into another from which it is impossible to extricate himself'. He envies

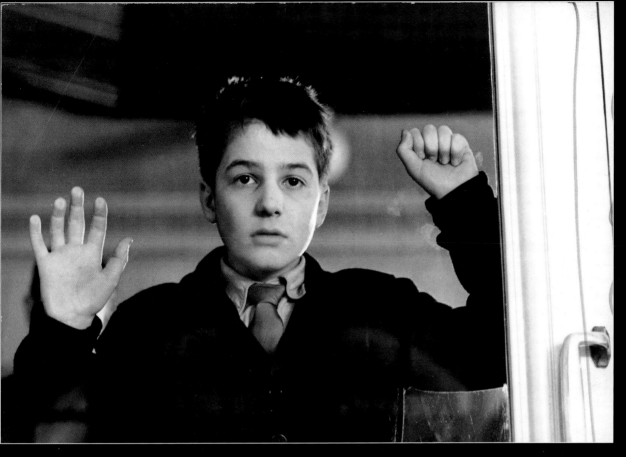

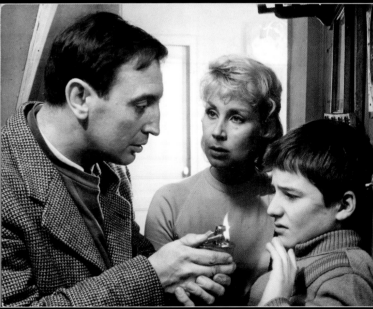

Above: Antoine the firebug (Jean-Pierre Léaud),
with his parents (Albert Rémy and Claire Maurier).

Left: Notes given back to Marcel Moussy for
writing the screenplay.

she couldn't stand me. In any case, I was supposed to make myself invisible and stay in my chair; I didn't have the right to play; I had to make her forget I existed.' Later, in describing the character, Truffaut didn't pull any punches, adding a certain misogyny to his hatred: 'She is not intelligent, just a little better educated than the average woman. She has an opinion on every subject and is preemptory to the point of unconsciousness.' 'She has great contempt for the whole universe: "all idiots".' (In his portrait of Antoine – and of himself – Truffaut said that the child 'inherits from his mother an over-developed critical sense; he has a tendency to make fun of his coarser pals, of concierges; he's too contemptuous'.) Or again, speaking of the mother: 'She suffers from a formidable lack of simplicity. She is one of life's Bovarys. Her husband sometimes calls her "the savage", and she takes it as a compliment.' Truffaut would portray the full scope of his mother's bitterness and indifference, which *Les Quatre Cents Coups* only hints at, in *L'Homme qui aimait les femmes*, a film where the autobiographical element is less directly visible, being hidden in the flux and variety of the story. When Truffaut decided to describe the childhood of Bertrand Morane in flashback during the summer before the preparation of *Les Quatre Cents Coups*, he outlined scenes that he only filmed 18 years later: 'Antoine exists so little for his mother that she could easily walk around the little apartment in front of him wearing bra and panties; she's wearing this costume when she gives him money to go shopping.' Or these notes accompanying the first résumé of the story of Antoine's flight: 'Show that Antoine has never had the right to play; at home his mother can only tolerate him sitting in a chair reading; she has a horror of noise, and therefore of toys; the neighbourhood children play in the street, out in the square, but Antoine isn't permitted to; one night his mother finds him in the square chatting with someone: "Go home, little man – fast."' This would become the scene in *L'Homme qui aimait les femmes* where Bernard's mother finds him in the street, with a girl of course: 'Who's the little turkey with the flat arse?' In 1958 Truffaut specified in his notes for Moussy: 'Always "my little one", "the kid", "the little one" or sometimes "my poor friend".' Even on the sheet he devoted to Antoine's father he could not stop himself from adding this astonishing, ambivalent portrait of the mother: 'Unlike the mother, who is almost an anarchist, a domestic terrorist, "outside of society" (one senses that it wouldn't have taken much for her to become an adventuress, a bit of a thief, or above all a prostitute), he is rather well integrated socially.' Here we see the first version, set down years in advance, of the radical and surprising link established in *L'Homme qui aimait les femmes* between the mother and a prostitute walking in the street. We can also see that several heroines of films to come will have something of what the mother could almost have become, according to Truffaut: Marion in *La Sirène du Mississippi*, who is an adventuress, a bit of a thief and a bit of a prostitute, or Camille in *Une belle fille comme moi*, as well as *La Petite Voleuse* (a film finally made by Claude Miller in 1987). Those characters were also inspired in part by one of the first women Truffaut lived with, whom he happened to run into again some time before writing *La Sirène du Mississippi* and ended up interviewing, hoping she would help him write Marion's

dialogue. It is as if the 'savage', albeit not fully developed, aspect of the mother might contain something more positive than negative, even though he accompanies it by the vengeful description 'a domestic terrorist'. As for the father, he was criticized less severely: 'He isn't very interested in women; he cheats on his wife 12 times less than she cheats on him; he'll say "a beautiful babe with huge knockers"… but he prefers indulging in that kind of talk about women to putting it into practice.' Or again: 'If he were an artist he'd be a third-rate singer; he only sees what won't upset him; he hates "fusses"; his leitmotif is "above all, no dramas".' Everything is a pretext for a joke. He may gripe in the morning because he doesn't have a clean shirt, or because his jacket still has some spots on it, but since his wife is better than he is at raising her voice, he prefers as a rule to adopt an ironic tone: 'Say, there are bits of sock in my pair of holes' – a line Moussy will use in the dialogue. 'It's really the film of a period in my life,' Truffaut said in 1962. 'Made three years earlier, it would have been more angry. Now, on the contrary, I find that it is too much of an infernal machine. During shooting I allowed myself to be influenced; I was afraid the boy was too unsympathetic and I decided not to film scenes of pilfering, thefts from shop windows and general effrontery. Today, on the contrary, I would attempt to include those scenes in order to strike a fairer balance between the adults' responsibility and that of the adolescents.'

She's dead.

The teacher shakes the child, who doesn't have an excuse for his absence: 'It's my mother, Monsieur' / 'What's wrong with your mother?' / 'She's dead.' In the first draft version of this famous scene, it is the father and not the mother that Truffaut's hero pretends has died: 'Haggard, pale at the enormity of the lie he is about to tell, he takes the plunge: "Well, my father…" The teacher, skeptical: "Now what's wrong with your father?" – "He's dead".' Replying in 1979 to an American correspondent who has just named him an honorary member of the Society of Friends of Mark Twain, Truffaut added this postscript: 'Can you tell me if Mark Twain is the author of this quotation? – Any Frenchman is lucky who knows who his father is.' In the first draft of *Les Quatre Cents Coups*, what sends Antoine into a tail-spin is the chance discovery in the family record book that he is a bastard. 'The word "bastard" is distinctly pronounced twice in a row by the father and the mother', we read in this first summary, a sentence that Truffaut crossed out, eliminating the autobiographical reference, when he prepared the text for publication with the other screenplays in the *Aventures d'Antoine Doinel* in 1970. Seeking to distance this overly autobiographical detail, Truffaut proposed another point of departure in a text accompanied by a few notes for Marcel Moussy: 'The initial idea of revealing the "illegitimacy" will be abandoned for one that is stronger dramatically: Playing truant, Antoine encounters his mother in the arms of a man. Since she says nothing about it that night, Antoine imagines that there now exists a total complicity between them, and therefore systematic impunity for him, which is quickly shown to be false. (His mother is present at the school when his father slaps him.) This disappointment is a sufficiently powerful motive to bring about his first flight.' Truffaut was now

dramatizing a different kind of encounter than he had planned in his first draft, where Antoine has the fright of his life when he runs into his mother in the street, but she doesn't see him because she is absorbed looking at a shop window full of lingerie. He completed the idea of the encounter and the double *flagrante delicto* (the mother with her lover, the child playing truant) in a remark written on a separate page headed 'For Moussy':

'Two dramatic ideas support the first third of the film:

1) A child, having surprised his mother in the arms of a man, believes himself bound to her by a complicity that assures him impunity;

2) Not having a written excuse for missing school when he returns after two days of vagabondage, a child tells his professor that his father is dead. The discovery of his lie will lead to his first flight.'

This changed again in the structural résumé based on Moussy's first draft, where for the first time it is his mother that Antoine 'kills':

'At school he justifies his absence by saying that his mother is dead. The shame provoked by the discovery of this lie incites his partial flight (not going home).'

'There are also attempts at reconciling with the mother, the promise of a good grade in French composition and the imitation of Balzac, which leads to a double disaster: the fire at home and the accusation of copying.'

The first draft of *La Fugue d'Antoine* does not contain the idea of a pact with the mother, the alliance she proposes, or rather imposes ('We can have our little secrets too'), but it does describe Antoine's exaltation at reading a novel by Balzac and the fire he starts by lighting a candle in front of the portrait of the writer he reveres. Then during production, to temper the unremitting harshness of the adults' behaviour, Truffaut decided to prolong the sequence where Antoine's furious father puts out the fire by having the mother suggest going to the movies. What follows is a kind of truce, the only brief scene of *détente* and reconciliation with the parents, where Antoine's laughter is heard and the film-maker inserted a private joke: the film they go to see is *Paris nous appartient*, which Jacques Rivette had not yet finished. (Its post-production would be made possible by, among other things, the success of *Les Quatre Cents Coups*.)

Structure.

During the summer of 1958 Truffaut was looking for a structure, going so far as to over-dramatize his story, as if he still lacked confidence in its emotional power. 'We need to find a third idea strong enough to trigger the second flight. And a fourth idea to bring about the theft of the typewriter that is stronger than the desire to go to the country – either that or we have to make that desire more imperious. We don't have anything that can trigger his running away.' Truffaut vacillated between a tighter dramatic line focusing on the lapses and misfortunes of his main character and the original project of a sketch film about children modelled on *Les Mistons*. 'Certain little gags and sketches have nothing to do with the story, but we'll try to conserve them and integrate them better with the action so that they aren't just anecdotes, painting as complete a picture as possible of childhood in general: joyful, sad, persecuted, spoiled. Little boys and girls of

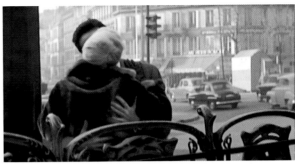

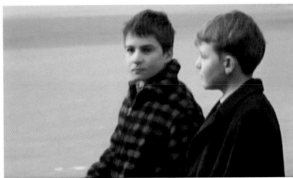

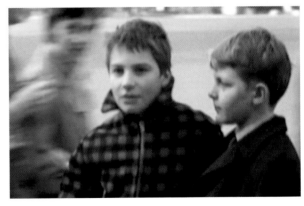

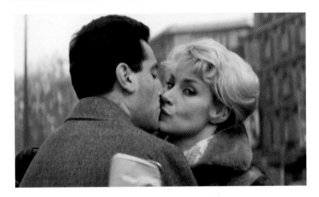

In Place Clichy, Antoine Doinel, who is playing truant with his pal René (Jean-Pierre Léaud and Patrick Aufay), catches his mother in her lover's arms (Claire Maurier and Jean Douchet).

various ages will appear episodically.' Planning to combine stories he had heard with his own memories, he kept until the shooting script the story of little Mado and her stuffed dog, a childish caprice Madeleine Morgenstern had told him about that he planned at one point to make one of the shorts that would be combined with *Les Mistons*. (In 1959 he gave the Cinémathèque française six typed pages of a sketch with dialogue called 'Torturers of Children' which was supposed to accompany *Les Mistons*.) In the second résumé this anecdote is told at length: little Mado's caprice of refusing to go to the restaurant without her stuffed dog Totor (black, dusty and repulsive), preferring to stay home alone. No sooner have her parents gone out than she opens the window and cries: 'I'm hungry!' Hearing this, Antoine and René, who see her from the apartment across the way (the story is inserted at the point of Antoine's stay in René's big, empty apartment), send her a basket of fruit and cakes using a system 'inherited from the cable car'. Later, a little boy clowns around to amuse Mado from the balcony facing hers – he is scolded when his mother comes home. Madeleine's parents return, and in the days following the incident they cannot understand why their neighbours are looking at them disapprovingly. The sequence is repeated in the shooting script, when Antoine and René are at the window playing with their pea-shooters, and was finally not filmed. Truffaut would resurrect it for *L'Argent de poche* (where little Mado becomes little Sylvie, the name of the actress), along with several other scenes he had in mind during the writing of *Les Mistons*, then *Les Quatre Cents Coups*, such as the 'first kiss in summer camp', which he noted would be 'the only flashback in the film', or a lengthy scene at a fair, where Antoine and René were going to wander for a long time before trying the *rotor*, a spinning fairground ride. Finally Truffaut chose not to put any of these scenes in the film so as not to slow it down. All that remains of the idea of painting a picture of childhood in general is the Punch and Judy show, a long, self-contained sequence that stands apart from the rest of the film, in which Antoine and René – who we have seen walking around the paths of the garden with an anonymous little girl – watch Punch and Judy with a group of younger children screaming with fear and delight: the ideal spectators for a film-maker who once said that he wanted people to watch his films 'open-mouthed'. Truffaut later confided that he could have edited this scene to run 30 minutes but was constrained, in spite of the temptation, to leave in only the strict minimum. After a lot of back and forth between Truffaut and Moussy, the film gradually found its structure and its point of departure. At first the story of the pin-up drawn on a piece of paper that circulates from desk to desk before being intercepted by the teacher was one anecdote among many, one schoolboy prank among others that are told in no particular order (the submarine glasses stolen from the best student in the class; the child who has a friend cut his hair so he can keep the money for the barber – a scene that later appeared in *L'Argent de poche*; the unpopular gym teacher abandoned, in small groups, by his students). 'Another time an almost naked pin-up cut out of a magazine like *Paris-Hollywood* passes from desk to desk; one boy adds glasses drawn with a pencil, another adds a moustache; the teacher confiscates it: "And for that you stay an hour after school –

if you don't like it, two hours. And you, what are you laughing at like an imbecile? An hour for you too. Ah, my fine young men, you're going to get it, I can tell you."' Truffaut, who had planned to start the film with the parents' alarm clock, rebounded off a new opening proposed by Moussy: the studious class bending over a task as we pan to discover Antoine in a corner, punished. 'Instead of starting with Antoine being punished,' Truffaut wrote in the margins of the first script with dialogue, 'we can go back to the cause of this first unjust punishment, to have a more Kafkaesque series of misfortunes! For example: Credits over a desk; the lid of the desk is raised and the camera pulls back; a student takes out a photo of a girl in a bathing suit; the photo circulates from desk to desk, coming to Antoine, who draws a moustache on it: "Bring me what you have there… To the corner!" That way we can begin with innocence and a laugh from the audience in the first minute.' Antoine's first crime, then, will be a pencil mark on a photo of a pretty girl. This is an early example of the often ominous power of photography in Truffaut's films. Antoine's crime is linked to femininity, to transgression and to writing, and the punishment is not long in coming: the few verses he writes on the wall earn him a double punishment and expulsion for eight hours. As has often been noted, all of Antoine's attempts at writing result in disasters: the written excuse supplied by René that he does not succeed in copying, or rather copies too well, since he does not write in his own name, but copies René's; the grandiloquent letter he sends his parents to justify his departure, which is greeted with irony and incomprehension; the composition borrowed from Balzac and the accusation of plagiarism; even the theft of a typewriter that leads to his arrest, a night spent at the police station and imprisonment in a Centre for Delinquent Children. The day it was filmed, the occasional verse written by Antoine ('Here suffers poor Antoine Loinod / Unjustly punished by Little Page / When he hadn't said a word') was rewritten (the last line becomes 'For a photo that fell from the sky', then 'For a pin-up that fell from the sky'). Truffaut changed his hero's family name during production (the film being almost entirely post-synchronized). He later said that he thought he had invented 'Doinel' (instead of 'Loinod', an anagram of 'Doniol-Valcroze', the editor-in-chief of *Cahiers du cinéma* when Truffaut started writing for it), only to realize that it was the name of Jean Renoir's secretary.

Antoine and René.

In the first screenplay with dialogue, it is René who rides in the *rotor* at the carnival while Antoine watches. Truffaut then inverted their respective places and gradually swapped around characteristics between the two friends. Initially he had imagined that Antoine would be submissive and anxious, as Truffaut was himself, in contrast to a version of René who is more enterprising, like Truffaut's childhood friend Robert Lachenay. (Antoine's friend is named Robert in the first outlines and his mother is named Bigey, like Lachenay's grandmother.) Defining the characters for Moussy, Truffaut wrote that Antoine 'is perpetually anxious, because no sooner does he escape from one complicated situation than he tumbles into another from which it is impossible to extricate himself'. He envies

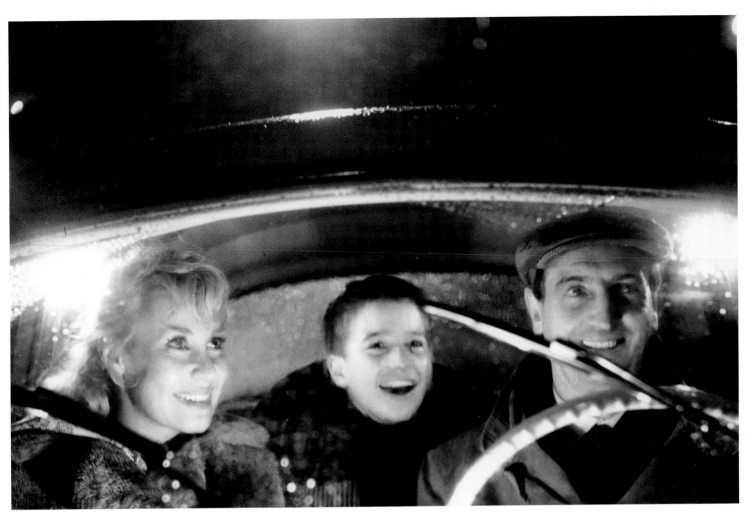

Coming back from the movies: Truffaut developed this scene during shooting to compensate for the harsh relations between his hero and his parents.

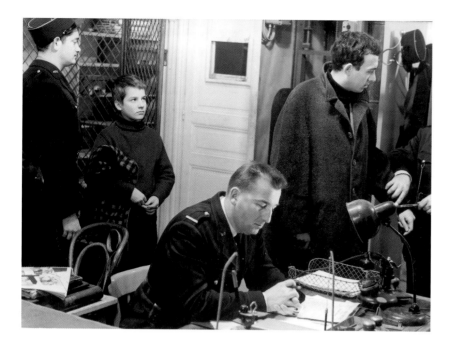

An unconventional police station: Jacques Demy plays a cop who puts Antoine Doinel in his cell and spends the night playing a children's board game.

Truffaut in conversation with cameraman Henri Decae. In the background is Jean-Luc Godard, visiting the set.

Robert because he has practically no accounts to render to his parents, who do not treat him like a child the way Antoine's parents do. Robert is described as stronger: 'He is much freer than Antoine, whose subservience he continually makes fun of. He is cleverer, more relaxed, more Machiavellian and more audacious ... Robert dominates Antoine, takes all the initiatives. It's thanks to him and his mockery, which can be cruel, that Antoine becomes conscious of the strangeness of his relations with his mother ... He takes more risks than Antoine because everything is simple for him: his mother is somewhat mad and his father is indifferent. Robert loves dangerous situations, the emotion of stealing and everything that provokes twitches, anxiety and sometimes stomach-aches in Antoine, which he often makes fun of.' During filming, Jean-Pierre Léaud's personality supplanted that of Patrick Auffay, who played René, and transformed the more servile, sneaky Antoine that Truffaut had planned.

In response to an ad in *France-Soir* in September 1958 ('Seeking a boy 12 to 14 years for a role in a cinema film'), Jean-Pierre Léaud, 14 years old, who had been recommended by *Cahiers du cinéma* critic Jean Domarchi, wrote the film-maker a short letter asking for a meeting and a screen test. After the first tests Truffaut, favourably impressed by the child's humour – he had already played a small role a year before – was uncertain whether to have him play Antoine or René, then resolutely decided to give him the leading role. 'I saw Antoine as being more fragile, more unpolished, less aggressive; Jean-Pierre gave him his health, his aggressiveness, his courage. He was a precious collaborator.' Among the tests filmed in 16 mm during October 1958 is a brief, spontaneous conversation between Jean-Pierre Léaud and Patrick Auffay where Léaud, energetic and determined, walks away with the scene while his colleague keeps his arms crossed and is more evasive. In the transcribed text of this improvised dialogue, Léaud is already called Antoine: 'Antoine–Patrick Dialogue.' 'Antoine expresses his desire to succeed in cinema to a less resolute, more indifferent Patrick. He asks Patrick if he takes drama classes at school (the answer is no), then tells him: "We get together for rehearsals in the evening without telling anyone, and then when the time comes: Here we go!" (he claps his hands and whistles). "We put up a little stage and perform something... Everyone is amazed; it always has a great effect."' Truffaut would remember this story when he showed, in a brief scene in *L'Enfant sauvage*, a little show secretly improvised by the deaf-mute children in the dormitory of the institute.

When production started, Truffaut eliminated René from several scenes that he had shared with Antoine at the beginning of the film. In the script René goes home with Antoine after school. (It is clearly the first time: 'Say, it's not very big at your place.') He also accompanies him during the torture of shopping. (Since Antoine has lost the list prepared by his mother, the script includes the following dialogue between the two boys: 'Antoine: Oh God, I lost the list / René: You know what a telling-off is? / Antoine: What can I buy? René: You know salad, you know sardines? / Antoine: I know my mother.') He offers moral support when Antoine begins writing out his punishment, measuring his occiput in the mirror while voicing reflections

on the respective sizes of skulls and brains. (Self-taught, René has read that great men have heavier brains: Napoleon, Galileo…) Truffaut sacrificed all these scenes and decided to give more prominence at the beginning of the film to the solitude of his hero, whose only friend will therefore be the viewer. Alone, without a confidant, Antoine becomes at once more sympathetic, more audacious, more clumsy and more vulnerable. He indulges in all sorts of little fraudulent acts that were not in the script (wiping his hands on the curtain like Chaplin in *Modern Times*, stealing money), although Truffaut already had them in mind when he wrote his notes on the character in summer 1958: 'His behaviour when he's alone is a mixture of good and bad actions. He wipes the dishes and burns a towel trying to dry it too fast; after bringing up coal, he wipes his hands on the bottom of the curtain, etc.' Less funny than the script, the film became more direct and more poetic. Truffaut also added a beautiful scene during production, which he did not hesitate to draw out, where Antoine, sitting at his mother's dressing table trying her perfume and beauty implements, is puzzled by her eyelash curler.

In production.

Certain scenes that seem improvised were written: the gag, in class, of the child with all the hair (Richard Kanayan, who did some astonishing screen tests for this film and appeared again in *Tirez sur le pianiste*) using up a whole notebook that he covers with ink blots before realizing that there is no page left to write on; or the encounter during Antoine's nocturnal flight with a young woman looking for her dog (planned from the very first draft). Others that seem written were improvised or sketched in at the last minute, like the scene of Antoine at his mother's dressing table, the family outing at the movies, or a classroom scene written in the margin of the script where Robert is questioned by the English teacher: 'Where is the father?' As would be his custom, Truffaut wrote notes in the margins of the shooting script, reworked dialogue, reinforced openings or moments within scenes. Next to a breakfast with the parents he noted a mannerism he would give to Charles Denner in *L'Homme qui aimait les femmes*: 'We stay on Julie, who removes his sweater without taking the cigarette out of his mouth.' 'If you ask me for a thousand francs, you must be hoping for 500, so you need 300. Here are 100 francs,' he had him say, reintroducing a certain cruelty into the film, in place of a weaker line in the script: 'How many times a day do you eat lunch?' He made the scene where the parents discuss what to do with the boy during the holidays tougher by adding an opening where the mother talks in front of her son about a cousin whose wife is expecting their fourth child ('They're like rabbits'), and by switching around the characters' lines. It is no longer the father who says 'OK, we'll send him to summer camp,' but the mother who breaks off the discussion with 'Summer camp isn't for dogs.' Truffaut radicalized another family scene by imagining an alarm clock that fails to go off, permitting him to show Antoine getting dressed at top speed in his room, putting on yesterday's clothes, wiping the condensation off the mirror in the kitchen and panicking because he hasn't finished his punishment ('I won't deface the walls of the classroom'), while the mother answers the father, when he asks what

happened to the money for the boy's sheets, that he likes sleeping in his sleeping bag. (The new scene was taped over the old one in the shooting script.)

While filming, Truffaut realized that the tone of his film was becoming sadder than he had intended. Accordingly, he didn't shoot the scene where Antoine and René, during one of their escapades in the streets, ask a passer-by where the Eiffel Tower is. They were supposed to meet 'a befuddled, beaten-down peasant who explains that he also wanted to go to the Eiffel Tower but never got there' – a scene of which there are many versions, left over from a project for a short film for Raymond Devos and Jean-Claude Brialy that the film-maker sold to Pierre Braunberger in 1957. The script of *Les Quatre Cents Coups* even mentions Raymond Devos: 'Tirade to be written with Raymond Devos, who will play the part.' Truffaut ended up dropping the scene, which no longer corresponded to the mood of the film, and decided to use the shots he had already filmed of the approach to the Eiffel Tower for the credits, accompanied by the music of Jean Constantine. Because the film was too long, he also shortened the section where Antoine and René take refuge in the Cocteau-like apartment of René's father, by eliminating a scene where they make caramel on the marble fireplace and break one of the father's horse trophies. Often the scenes that disappeared are partly cruel and partly comical, but with a kind of comedy that would be a distraction. In another cut scene the boys try to get René's mother's cat drunk, and later in the script Truffaut deleted a scene where Gilberte, Antoine's mother, sees a psychic, as much to find out how to behave with her son as to learn about her lover's feelings.

Doing away with the commentary.

At the same time Truffaut discovered that he could do without certain explanations. In the script, when Antoine encounters his mother with her lover on the Place Clichy, the parallelism of their double misdeed was explained heavy-handedly in the dialogue. ('All the better if he was doing something he shouldn't – he won't say anything to your husband,' says the lover, played by Jean Douchet.) In the end all that is left is Antoine's answer to René – 'I don't think she's going to mention it to my father' – and a brief question asked by the lover: 'Which one is your son?' Once the film was finished, the director decided he could also do without the narration in the screenplay, a rather literary text that tells the story, to be spoken by René: 'Meanwhile I was at a loss confronted by the empty page, even though History was my favourite subject – but not Ancient History. My teacher also detested this uninteresting material. Obliged, moreover, to teach French, he avenged himself by giving us innumerable written tests. This earned him his nickname: "Little Pages".' Truffaut first asked Moussy to rewrite the narration, noting next to the encounter with the mother in her lover's arms, for instance, in the first version of the script with dialogue: 'More commentary so as not to dissipate the emotion Antoine feels, to give gravity and distance to this scene and avoid a banal dialogue exchange. Something like: "We didn't say a word as we returned to the porch to recover our satchels; Antoine seemed overcome and I couldn't find

the words to comfort him; sadly he explained that he had decided to return to school the next day after finishing his punishment; I pointed out that he didn't have a written excuse for being absent", followed by franker, documentary-style dialogue, the letter with the top cut off, etc.' Finally Truffaut realized that unlike *Les Mistons* the film he had made needed no commentary. Contrary to the more complex way he would use the device in later films, the redundant commentary in the script appears to be a kind of shield or charm against the fear of not pulling it off, of not being able to make himself understood through cinema alone. After the shots of Antoine against the wall of his cell, sweater pulled up to his chin, after his tears behind the bars of a police wagon passing through Paris at night, after the Centre for Delinquent Children, Truffaut could not end the film the way he had planned, with a comforting voice-over giving rather silly news of the characters: 'The last image of this shot, Antoine beside the sea, freezes and fades to another, in motion: Antoine and René walking in the streets of Paris (an image we've already seen during the truancy sequence). This image in turn freezes, reminding us that it was taken by a street photographer, as we hear the last words of the voice-over: "Then I received a card from Fourcroy-sur-mer where I finally managed to rejoin Antoine… How are we doing? Very well, thanks… and you? We're free and far from the torments of adolescence, but when we walk in the street we can't help casting knowing looks at our successors in the sixth grade as they begin their own four hundred blows."' The temptation to have an upbeat ending sums up the film-maker's vacillation between freedom of tone and style, sometimes at the risk of cruelty, and the desire for conciliation. Truffaut chose to end his film with a suspended élan, the famous frozen image of Antoine coming to a stop, undecided, at the sea. And when the film was released in certain countries – for example in the USSR – that last shot would be once again be diminished by the addition of an optimistic commentary.

This film is dedicated to André Bazin.

Truffaut began shooting on 10 November 1958, with the scenes in the Loinod apartment, in Montmartre, not far from the neighbourhood where he grew up. He settled on Albert Rémy to play the father. ('Antoine's father should be played by an actor whose looks seem rather tough [like Gérard Oury or other anti-actors], but he should still be able to assume a humorous air when he makes his jokes. Perhaps Albert Rémy. Or William Sabatier, who seems younger and a bit sensual,' he indicated in his notes to Moussy.) And for the mother, Claire Maurier, whose hair he had dyed blonde. During filming the actress had trouble with her character's harsh treatment of her child – the fact of never calling him by his first name, for example. The character was far removed from the actress, the film-maker later admitted; in his notes of summer 1958 he had specified 'Antoine's mother should look rather mean (someone like Michèle Courdoue), sensual, good figure, pretty legs, etc.' He insisted on waiting for cameraman Henri Decae (who was shooting *Les Amants* for Louis Malle and then *Les Cousins* for Claude Chabrol during the summer and the beginning of autumn), and Decae, who knew how to give the film the grey tonality of a Paris

winter, achieved miracles within the constricted set – his acrobatics included hanging in midair outside a window to film certain scenes in the miniscule spaces. Truffaut also insisted on using a scope format, which permitted him to stylize reality. 'Dyaliscope transfigures reality, imparting to a dirty, realistic setting the stylization without which it would be impossible to obtain a certain poetry,' he wrote in the publicity brochure. The evening of the first day of shooting, during the night of 10–11 November, André Bazin died, and Truffaut dedicated the film to him.

The first day of shooting exteriors was 19 November. Antoine and René play truant, and Truffaut filmed the encounter in the street with the mother in her lover's arms. Then he tackled the scenes where the boys take refuge at René's in a big apartment lent by a friend of Bazin and Doniol-Valcroze, where the director decided to use a life-sized statue of a horse he found in one of the rooms. ('Wow, a horse,' Antoine exclaims. The dialogue that follows was added. René's father, entering his son's room and smelling the 'tobacco stink', spots the clothes René has draped over the horse: 'Bucephalus isn't a rubbish dump,' he says. 'He's worth at least a million. He's an artwork, and I wouldn't part with him except in the direst necessity.') On 20 November Simone Jollivet, the actress who was supposed to play Toute Belle, René's mother, didn't turn up. ('An older Mistinguett [Simone Jollivet, the former girlfriend of Charles Dullin]; four layers of make-up; alcoholic; faint, weary voice; good-hearted and balmy [like the artistic mother in *Strangers on a Train*],' say the summer 1958 notes.) Some scenes were filmed instead with Georges Flamant, who played René's distant father, and on 24 November Yvonne Claudie replaced Simone Jollivet in the role of Toute Belle. Truffaut cut a scene where Antoine's father comes looking for his son and runs into Toute Belle's alcoholic incoherence. On 27 November he filmed the Punch and Judy scene. (The extras planned for on the call sheet were four mothers and five children; reality surprised Truffaut with a roomful of children, which he gratefully took advantage of.) On 29 November it was the police station, the cell and the three fairy-tale prostitutes who were added to avoid a cliché scene, as were the gendarmes (Jacques Demy and Charles Bitsch) playing a game of 'petits chevaux', a French version of snakes and ladders played with 'little horses'. On 9 December, Jeanne Moreau and Jean-Claude Brialy played the scene of the 'hunt' pursued by a small dog in the darkened streets of Pigalle. On 10 December, the added scene of the family coming home from the movies in a car was filmed ('using Charles Bitsch's Dauphine'). The last street scenes, the police wagon carrying off Antoine, were also supposed to be filmed, but at 3.50 in the morning 'the police ask for a shooting permit, then take Philippe and the wagon to the station'. Truffaut had hired Philippe de Broca as a technical advisor and was filming without a shooting permit because he himself had not gone through the necessary steps that gave the right to become a director (these steps included working as a second assistant director and then a first assistant director three times). On 13 December the shots leading up to the Eiffel Tower were filmed, and on 16 December, the final shot of Antoine by the sea in Trouville. The scenes in the school were filmed during the holidays.

Antoine and René (Jean-Pierre Léaud and Patrick Auffay) hiding in the printing plant where Antoine spends his first night after running away from home.

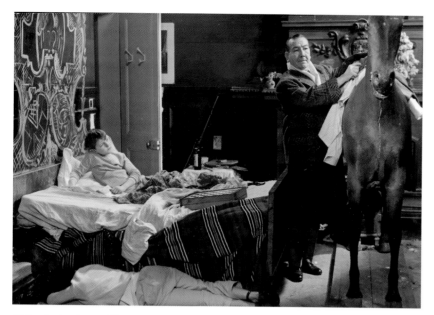

Hiding in the Cocteau-like atmosphere of the large apartment belonging to René's father (Georges Flamant).

On 24 December the sequence where the gym teacher loses his students was held up because of Jean-Pierre Léaud's insolence: '11.15. Incident with the owner of a café. Arrival of the police car. 11.30. The two boys are taken to the station.' On 29 December the scene where Antoine's lie is discovered was filmed, for which Truffaut, still unsure of certain choices, said he thought of Hitchcock when he had the mother on the other side of the glass look at the class in an unrealistic way: 'Here's where you see Hitchcock's talent: finding the moment when he no longer needs to be realistic. Logically a mother arriving at school wouldn't know where her son is, so she would look around the classroom. But if her look had hesitated, it wouldn't be effective, so I had her look straight at the child as if she knew where his seat was. That way her look chills us, because she's looking at us, straight at the camera.' Similarly, just before we see the parents behind the glass, Truffaut cut to Antoine raising his hand to his mouth, already seeing disaster coming and panicking. The slap Albert Rémy gave his 'son' wasn't faked, as we learn from the production report: '4.10 p.m., Jean-Pierre's cheek has to recover.' In the script it was the mother who comes alone looking for Antoine, feigning tenderness for him in the principal's office; she and her husband would then have come looking for him together after his flight and the night spent in the printing plant. But Truffaut decided to switch the two scenes while filming, to make the consequences of the lie more immediately serious and irredeemable in the boy's mind. In the courtyard during playtime, Robert Lachenay played a teacher talking learnedly with Guy Decomble, who played Little Pages, the gym teacher.

The psychologist.

On the morning of 3 January, the penultimate day of shooting, Truffaut filmed the scene of the *rotor*, the great moment when his protagonist discovers the joys of being carefree, of movement and speed, which he prolonged, multiplying shots. He inserted himself among the spectators and left the shot just behind Antoine when he emerges from the rotor, delighted and staggering. That same afternoon Truffaut filmed, in an office at the school of photo-cinema in rue Vaugirad, the famous interview with the psychologist – the only scene of the film shot with direct sound, where he dropped the standard tests and questions in the script to recapture the naturalness of Léaud's screen tests: 'I changed my mind, I had a sound camera brought in, I placed the microphone, and I sat in front of Jean-Pierre Léaud and asked the crew to leave. I asked him questions he didn't know in advance, leaving him free to answer as he liked, which was relatively easy for him because it was the end of shooting and he knew his character well. Sometimes the answers were from his own life. That's why a grandmother appears in one of them who is never mentioned in the film. Then I replaced my questions with questions asked by the voice of a woman I didn't feel I needed to show.' One of the more prosaic reasons for the change was that the actress Truffaut wanted to play the psychologist, Annette Wademant, was pregnant; for some reason he no longer wanted to see her, which led to the idea of filming nothing but Jean-Pierre Léaud's unrehearsed answers, thus creating by reaction a scene that would be widely admired for its truth and formal audacity.

A portrait of childhood and adolescence as 'a bad period to be got through,' the film is still as engaging as ever, no matter how many times one has seen it, because of its flights of freedom and irreverence (the *rotor* scene at the fair, the two boys escaping in the streets, running in the Place du Tertre, joyously shouting 'Bonjour Madame' to a priest who has no idea what is going on...), but it carries the day thanks to its cruelty and its gravity. A gravity that wells up sometimes despite the author (Truffaut didn't want the scenes with the parents to be so harsh and tried to compensate by adding, for example, the outing to the movies), sometimes deliberately: 'During shooting I constantly fought with Jean-Pierre Léaud. He was wonderful, but he was scared that he'd be unsympathetic, so he always wanted to smile. For three months I kept him from smiling.' Without formulating it or making it into a system, this was the beginning of the rule of invention by opposition that came from Truffaut's past as a critic and his keen sense of what he did not want to do, which remained one of the vital sources of his creativity in film after film.

Between takes: François Truffaut and Claire Maurier, who had trouble accepting her character's severity.

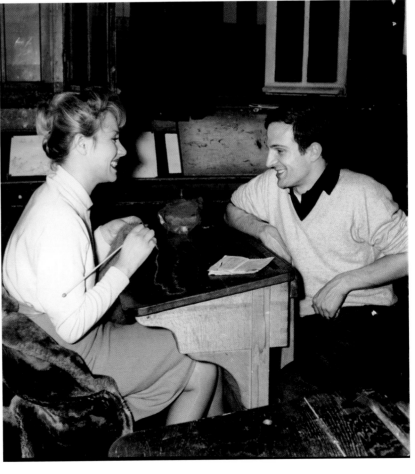

Tirez sur le pianiste (1960)
Shoot The Pianist

**Filming Léna's death in the snow
(Charles Aznavour and Marie Dubois).**

'This time I wanted to please the real film buffs and only them, even if it meant confusing most of the people who liked *Les Quatre Cents Coups*. In the end *Tirez sur le pianiste* may confuse everyone, but so what.' At the end of 1959 Truffaut filmed *Tirez sur le pianiste* in reaction to the success of *Les Quatre Cents Coups*, which he feared could restrict him. Produced by Pierre Braunberger, who had produced one of his first films, it replaced two projects that Truffaut dropped with no regrets. The first was *Temps chaud*, a kind of *Et Dieu créa la femme*; the second, *Le Bleu d'Outre Tombe*, a novel by René-Jean Clot, was the story of a woman teacher who becomes a social outcast, which would have meant shooting in a classroom with children again. Truffaut again considered making it before *Jules et Jim*. Risking the public's displeasure was not an obvious choice, but Truffaut's refusal to be trapped by a fashion or a specialty won out, and by making *Tirez sur le pianiste*, he expressed his need for freedom. He also chose *Tirez sur le pianiste* for Charles Aznavour, whose small stature, reserve, fragility and power seduced him the first time they met at Cannes in May 1959 during the triumphal reception of *Les Quatre Cents Coups*. 'I turned my back on what was expected of me and took my own pleasure as my only rule of conduct,' said the film-maker, who carried further the fantasy already present in David Goodis's novel.

Tirez sur le pianiste consists almost entirely of digressions and shifts of tone, beginning with the surprising sidestep that opens the film: a man running at night smashes into a streetlamp and is helped up by a stranger carrying a huge bouquet of flowers, who tells him how he fell in love with his wife after two years of marriage. Truffaut skipped the more conventional opening in the script, where the scene opens on Place Pigalle to reveal a little crowd in front of an employment agency for musicians. One person detaches himself from the crowd: 'Here is Charlie, the man we are interested in.' He also didn't film the scene introducing Chico, Charlie's tough little brother, whom we end up meeting as he is being pursued by a car. He was supposed to be introduced in a boutique where he swipes a coat, outwitting a salesman by pretending to take him at his word: the salesman tells him that if he doesn't take the article he'll regret it the rest of his life; Chico replies that in that case he'll take it and runs off with it. Instead Truffaut opens his film in pitch blackness (he told his cameraman Raoul Coutard to make do with the light of the streetlamps rather than waste time replacing the lights he had brought, which had burned out). He plunges us into a thriller atmosphere that he immediately contradicts with the sentimental monologue he entrusts to the film-maker Alex Joffé; then he follows it with another shift of tone as we enter the bistro where Boby Lapointe is singing his first song: 'Marcelle, when you come down from that dustbin…'

Some of the flights of fancy in *Tirez sur le pianiste* were in the script; others were invented during shooting. Truffaut knew that he did not want to film ordinary gangsters, so in the script he had already subverted the sequence where Charlie and Léna are kidnapped, which was filmed quickly on the outskirts of Paris. 'In the midst of the fights, the settling of scores, the kidnappings and chases, all we hear about is love: sexual, emotional, physical, moral,

marital, extra-marital, etc.' During the kidnapping the exchanges between the crooks who quarrel about driving and philosophize about women ('They all want it, and if they want it, they'll get it') were written out almost word for word in the script, along with direct borrowings from Jacques Audiberti, who discovered Boby Lapointe with Truffaut during one of his first appearances at the Cheval d'or. It was also an homage to Audiberti when the director gave the young actress Claudine Huzé her stage name after hiring her to play the waitress who is in love with Charlie: Marie Dubois. 'I love 'em all for what they are,' says Daniel Boulanger, who plays Ernest, and the script continues in a pastiche of Audiberti that Truffaut would pick up again in *L'Homme qui aimait les femmes*: 'the hunchbacks for their humps, the redheads for their smell, the whores for their knees, the bourgeoises, the little ones, the big ones, the medium-sized ones…' While Momo (Claude Mansard) raves about girls who wear knee-socks and recalls what he felt trying on his little sister's panties one day, Ernest recounts how his father was struck by a car crossing the street while following a pair of legs, then died in the hospital trying to grab the legs of his nurse. Truffaut cut the second part of the monologue, but would film it 15 years later for *L'Homme qui aimait les femmes*.

The nocturnal visits of Clarisse, Charlie's hooker neighbour, who lives with him in a kind of clandestine conjugality, are described in detail in the script, including the way Truffaut flirted with a screen taboo by showing her breasts, which caused him problems with the censor once Clarisse was incarnated by Michèle Mercier. ('In movies it has to be like this,' says Charlie, holding the sheet up to her chin.) In August 1959 Truffaut wrote to Aznavour that he was finishing the script after a first draft by Marcel Moussy: 'It will definitely be a documentary on timidity.' And indeed the script includes the disturbing dialogue about fear between Charlie and Plyne (Serge Davri) at the end of the first night in the dive: 'I bet I know your problem. You're timid; you're afraid. / Charlie: Afraid? / That's it. / Charlie (abstracted): Afraid. I'm afraid. Shit! I'm afraid!… / Come on, buddy, what's wrong?' But Truffaut only carried the idea through to its conclusion during production by inventing little skits about timidity, like the sequence where Charlie stops in front of a bookseller and picks out all the books he can find on the subject.

During production Truffaut also transformed the audition scene and created one of the film's most famous digressions. After several inserts of Charlie's finger approaching the doorbell, the camera decides not to enter the impresario's office with him, choosing instead to follow a beautiful young violinist as she leaves silently, walking down the corridor and into the courtyard, while the first chords of Charlie's audition resound. Not wanting to film the audition, Truffaut planned a Lubitsch solution: leaving the camera in the corridor where one listener, then several, stop and gather. The idea of following the violinist, a shot that would be seen as an expression of the *Nouvelle Vague*'s free-wheeling spirit, came from Truffaut's wish to film a young woman he had noticed who turned out to be incapable of saying a single word of dialogue. He went on to introduce her brief second appearance in *Jules et Jim* with a slightly cruel

private joke, when a friend presents her to Jim explaining that she's 'pure sex'. The editor, Claudine Bouché, recalls that at first she had no idea what to do with the audition scene. (A very young editor who met Truffaut for the first time when she started work on *Tirez sur le pianiste*, Claudine Bouché was a last-minute replacement for Cécile Decugis, who had been incarcerated for supporting Algeria's National Liberation Front.) After an interminable screening of everything that had been shot, during which Truffaut never unclenched his teeth, he left Claudine Bouché alone with a mountain of rushes that he was not even sure were going to add up to a film – he needed to see a first very rough cut to recover a minimum of critical distance. She therefore ended the audition scene with Aznavour going into the impresario's office, and it was Truffaut who told her to include the young girl's departure in its entirety and in all its strangeness.

During production Truffaut pushed the shifts of tone further. When filming Fido's kidnapping he come up with the idea of the car breaking down and the scene where Fido is enthroned behind the wheel ('Go on, push') while the crooks try to push the car. Here Truffaut permitted himself the pleasure of exploiting the singular energy of Richard Kanayan (Fido) – a hoarse, almost adult voice in a child's body – whom he had noticed during auditions for *Les Quatre Cents Coups*. Fido gesticulates and dances in the street as he did briefly in *Les Quatre Cents Coups* (during the episode with the gym teacher), drops a carton full of milk on the gangsters' windscreen with a friend's help (giving Truffaut a chance to film a close-up of the milk being spread by the windscreen wipers: a director's delight). Fido is carried off by the crooks who trap him in his coat as if it were a straitjacket, like the hunters who capture *L'Enfant sauvage* years later.

Truffaut developed a kind of syncopated intensity, alternating between melancholy or cruelty (Charlie's past) and comedy, or rather farce, in the midst of scenes that should be full of menace (the child who refuses to believe the gangsters' tall tales: 'No, it's not metal, not even Japanese,' referring to the scarf the crook pretends is woven from a special kind of metal). Until the menace becomes real, the gangsters are ridiculous. But their bullets are real, and Léna's body slides through the snow.

Truffaut constantly rejected conventional scenes. When Plyne comes to talk to Charlie as the bar is closing the first night, Truffaut cut the beginning of the scene, where Plyne questions Charlie about his brother and the two guys who are looking for him. All the more conventional dialogue was cut ('You must be taking night classes in police work. You probably lend a hand for interrogations') in favour of Plyne's poetic strangeness, modelled on Audiberti's prose ('women are magic'). Even though he dreams of her, Plyne throws Léna into Charlie's arms and calls himself a big lout. All Truffaut kept of the dialogue between Charlie and Plyne was the sentimental, poetic discussions ('She's giving you the eye'), cutting any facile lines ('I'd have as much of a chance with that doll as an Eskimo would have with a Berber'). He delighted in playing with what Orson Welles called the train set of cinema:

(Suite 32)

MOMO - Les bossues pour leur bosse ...

ERNEST - Les rousses à cause de l'odeur, les pu-
 tains, les bourgeoises, les petites, les
 grandes ...

MOMO - ... les moyennes ...

ERNEST - L'ennui, c'est qu'il faut leur parler,
 avant et surtout après, alors que, juste-
 ment, on a envie de partir tout seul se
 promener ...

MOMO - ... à la recherche d'une autre !

CHARLIE (timidement)- Si je peux me permettre, hum !
 (Silence)(Il avale sa salive) Mon père à
 moi, il disait, à propos des femmes:
 quand on en a vu une, on les a toutes
 vues. Je livre cette pensée à votre médi-
 tation.

Rires de Momo, Ernest et aussi Léna.

ERNEST - Quand j'en vois une pour la première fois
 c'est le coup de foudre, je la regarde,
 je l'aime, ma parole, je voudrais l'épou-
 ser, lui faire des gosses, passer ma vie
 avec elle. Dès qu'elle a ouvert la bouche,
 c'est fini, j'ai seulement envie de me
 l'envoyer et de ne plus jamais la revoir.

Left: The gangsters' wacky dialogue, taken from Jacques Audiberti.

Right: The sound was so bad when Boby Lapointe was singing in the bistro that both the editor and the producer said, as a joke, that the song should be subtitled. Truffaut went ahead and did it.

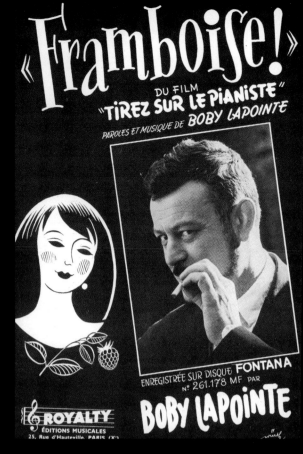

(Suite 38 bis) 60.

CHARLIE - Tu comprends, s'il n'y avait pas eu Zélé-
 ny, je ne serais jamais devenu un pianiste,
 c'est le seul type qui m'ait jamais aidé;
 il a été un père pour moi; il m'a pas seu-
 lement appris le piano, il m'a appris à de-
 venir un homme. C'était un type extraordi-
 naire; je lui dois tout ce qui est arrivé
 d'heureux dans ma vie; parler avec lui c'é-
 tait comme pour un hindou se baigner dans
 le Gange ! Il était mal portant, mais sa
 santé morale était formidable. Il emprun-
 tait de l'argent à voix haute et en prê-
 tait discrètement. Avec lui tout devenait
 simple, clair et franc. Quand il s'absen-
 tait de chez lui pour plusieurs jours, il
 cherchait toujours un ami à qui prêter sa
 maison, un autre ami à qui prêter sa voitu-
 re ...

THERESA - Il t'aimait beaucoup, certainement ...

CHARLIE - Il aimait tout le monde, sans exception; on
 se demande toujours si le monde est juste
 ou injuste, mais je suis certain que ce
 sont des types comme Zélény qui le font
 meilleur car à force de croire la vie
 bonne et en agissant comme si elle l'était,

 .../

Left: A cut scene – talking about his piano teacher, Charlie paints a beautiful portrait of André Bazin, 'He was an extraordinary guy; everything good that ever happened to me I owe to him. [..] When you were with him, everything became simple, clear and real.' Truffaut described Bazin in the same terms to the Canadian journalist Aline Desjardins in 1971.

Right: A note signed by Jean Cocteau. Les Films du Carosse had co-produced Le Testament d'Orphée the year before.

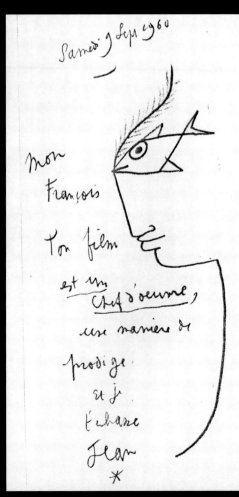

Thérésa's confession: a change of tone
for a long flashback at the heart of the
film (Nicole Berger with Charles Aznavour).

Ernest the gangster (Daniel Boulanger)
carries off Fido (Richard Kanayan).

combining three shots of Plyne embedded in circles while
the gangsters tell how easy it was to get Charlie and Léna's
addresses from him, or using an iris to reveal Momo's
mother dropping dead when he swears on her life. ('May
she die right now').

Truffaut hoped a nod to American films would help him
to pull off the fight over the knife, which he filmed without
much conviction: 'Go home, it's just an accident' – a B-
movie commonplace – the owner of the bar (Catherine
Lutz, whom Truffaut used again in *Baisers volés*) yells at
the neighbours peering out of their windows after Plyne is
killed. As Claude de Givray recalls, Truffaut wanted his
film to have the charm of 'an American film dubbed in
French'. Rather than having Aznavour read Charlie's
intermittent first person narrative, where he comments on
some of his actions and non-actions, Truffaut preferred to
have the voice-over read by an actor specializing in
dubbing, Yves Furet, because he wanted it spoken with no
inflection. At certain moments he trimmed the voice-over,
substituting visual effects. When Charlie accompanies Léna
at night, Truffaut delayed the moment when the voice-over
begins, replacing it with a real moment of silence between
the two future lovers, shooting and editing in scenes that
were not in the script – where Charlie takes Léna's hand,
then withdraws, puts his hands together behind his back
and opens his fingers one by one, counting down to the
moment when he will dare to make another pass... the
'documentary on timidity' that Truffaut fleshed out in
scene after scene.

After deciding to adapt this novel for Aznavour, Truffaut
realized it had been written for a much larger man. So he
reversed the roles and cast Aznavour opposite a girl who
would be stronger than he was and able to carry him on
her back. That is what he was filming when Marie
Dubois/Léna drags Charlie out of the basement and into
the light – the same bright sunlight that assails them the
next morning when they arrive at the mountain cabin,
while it wipes viewer's eyes clean after being submerged
in nocturnal ambience or grey winter light from the
beginning of the film. (Like *Les Quatre Cents Coups* the
previous year, this film was shot from November to
January.) Truffaut later reproached himself for making a
film with no single, identifiable subject, even if he had
managed to include, under the pretext of a thriller,
everything he had to say about glory, success, being down
and out, failure, women and love. He took chances with
structure by putting a long flashback ('the first in my
oeuvre, which is still slender,' he noted in the script) in the
middle of the film. It is difficult not to interpret the conjugal
scenes that make up the flashback as a documentary on
himself, on his anxieties as a film-maker and his way of
dealing with the success of *Les Quatre Cents Coup*s. The
reproaches Thérésa (Nicole Berger) makes sound like
self-criticism: 'Your conversation for the last year is lovely. I
ask you what you think of Hemingway. "It seems he collects
all my records." And so and so didn't like my recital. And
such-and-such said to whoozit that in his opinion I'm the
world's greatest pianist. "Should I agree to do this or that?
What does Dupont think of me? Did the concierge see me
on television?"' Truffaut had her add: 'I'd rather you were

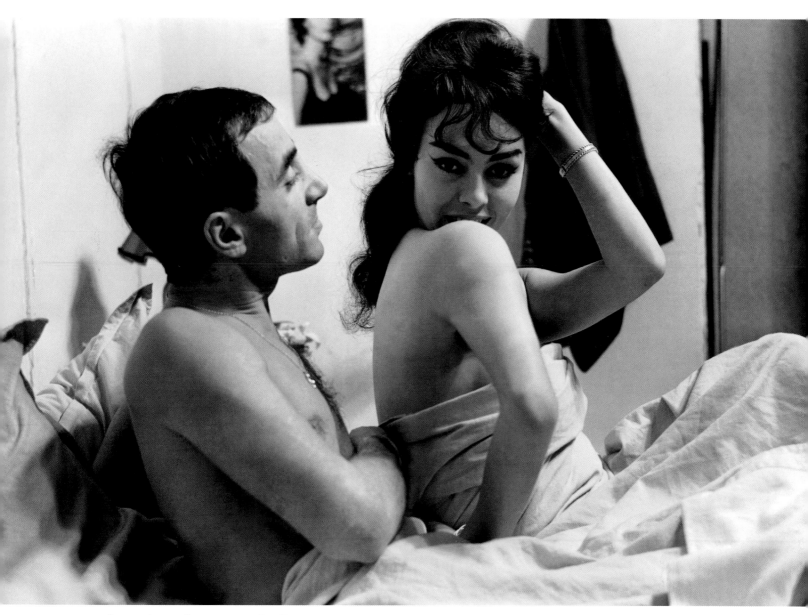

more pretentious and sure of your own genius. The slightest criticism makes you ill.' To avoid making the autobiographical aspect too obvious, he cut these lines: 'What do you care – as if you ever hesitated to ruin others before. Charlie: Precisely – I regret that now. / Thérésa: Ah, regrets. Too late, my good man!' Truffaut said that in writing these scenes he thought of Atherto Moravia's *Ghost at Noon* [later filmed by Jean-Luc Godard as *Le Mépris*]. 'I think you have contempt for me since I'm a success,' he had Aznavour say. In a different style to the rest of the film, these scenes are like a prelude to *La Peau douce*. He even filmed them in long, moving shots as he did certain scenes in *La Peau douce*. When she enters the hotel room where her husband's success has transported them, Truffaut started with Nicole Berger's hand on the switch as she turns on the light.

Tirez sur le pianiste was also the film where Truffaut began to assemble the team that was to accompany him in years to come, after meeting Marcel Berbert at the time of *Les Mistons* and the creation of Les Films du Carrosse: Raoul Coutard, who was to be the lighting cameraman on all the films up to and including *La mariée était en noir*, after

which he left to spend a few years in the United States, and Georges Delerue, the composer Pierre Braunberger recommended to Truffaut. Delerue understood the film-maker's intentions after seeing the first rough cut. He immediately recognized it as 'a film noir treated in the manner of Raymond Queneau'.

The film opened in Paris on 25 November 1960, after a summer release in seaside towns where it was badly received. The shifts of tone in *Tirez sur le pianiste* did no better with Parisian audiences, who were were confused and not very appreciative of the film's mischief and charm. Truffaut thought that he had not done all he should have: '*Tirez sur le pianiste* needed one more month of work. By mixing two or three reels of films you love, you won't come up with something that interests people, even if what's there is good.' Although he had partly expected it ('I know there's nothing the public hates more than shifts of tone, but I have always had a passion for shifts of tone'), the failure disappointed him. He would no longer dare to continue in this vein, assuming the risks of an art of digression and mixed genres – at least not in such a radical, way. Instead, in the future, he deployed an art of contraband.

Michèle Mercier's breasts (with Charles Aznavour), or games with the censor. 'He's timid, OK,' Truffaut said about his character, 'but women love timid men and throw themselves on him.'

Jules et Jim

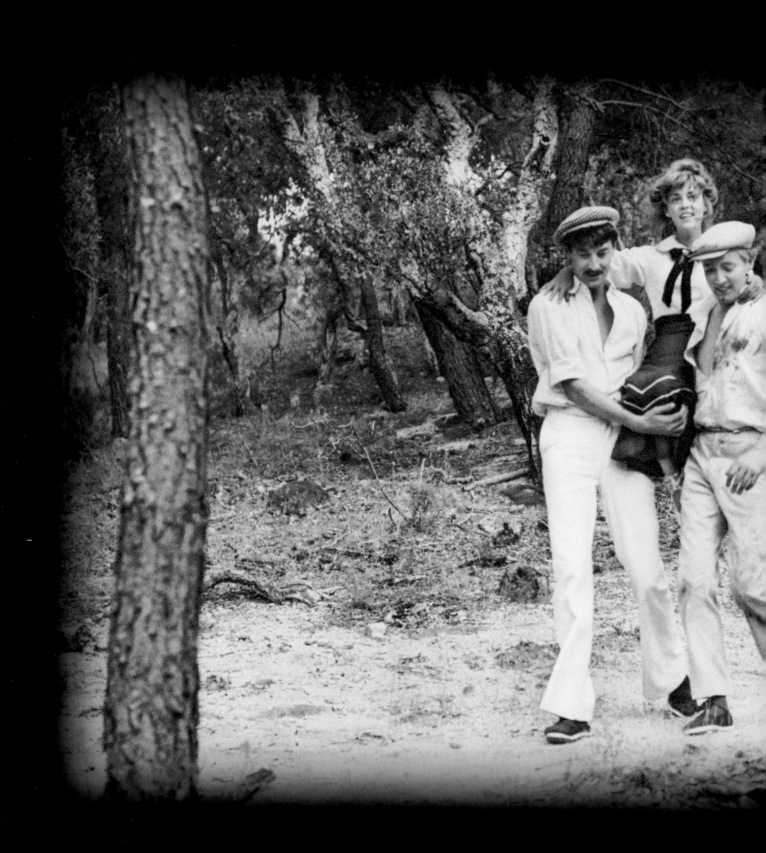

Jules et Jim (1962)
Jules and Jim

Re-seeing *Jules et Jim*, despite the rather crushing myth that surrounds the film, one has the impression of seeing and re-seeing time suspended, an eternal present. As if Truffaut, more than for any of his other films, had succeeded in capturing and imprinting on celluloid the present moment: laughing with joy, Jeanne Moreau disguised as a boy and running on the bridge, bicycles spinning along winding roads, Jeanne Moreau again, hanging bathing costumes out to dry near the big house in the South, or her expression suddenly changing on the beach while she is watching her two men sparring at the water's edge. Jim (Henri Serre) rolling in the grass with little Sabine Haudepin in his arms, Jules (Oskar Werner) stopping Jim on the stairs and saying, 'Not this one, Jim.' Or later, from a cabin lost in the German countryside, calling his best friend to tell him he is free to approach Catherine: 'Jim, if you love her, don't think that I'm an obstacle. Love her, marry her and let me see her.'

This sensation of an eternal present, caught in the spaciousness of Scope and the lyrical flights of Raoul Coutard's camera, undoubtedly has something to do with the joyous family atmosphere of the shoot, especially for the scenes in the Alsatian chalet. Although those weeks have perhaps been idealized a little in retrospect, they were still described by everyone involved as having been like being on holiday. ('Life was truly a vacation,' says the text of the commentary attributed to Henri-Pierre Roché.) 'The crew was so small that Jeanne Moreau sometimes had to cook for everyone. She had no stand-in, and no Sundays off, either... I remember that Oskar Werner, who had just been in *Lola Montes*, seemed to consider our enterprise a holiday film,' Truffaut recalled in 1980. This was also a moment when the film-maker hid his anxiety beneath a relaxed appearance as he never stopped reinventing a screenplay that had been left fluid and open. Without really improvising, he was as open to the inspiration of the moment as he was to one borne out of long immersion in his subject.

'I wanted to make a subversive film of total sweetness,' Truffaut said of his work on *Jules et Jim*. Writing and shooting the film, he asked himself how he was going to make the 'pure love *à trois*' described in the novel acceptable to the spectator. How do you force the public to accept on the screen things it would condemn in real life? 'What amused me was that we were going to have a terribly original, daring situation that we would render plausible and acceptable to everyone within a framework like a pre-war MGM film, where people grow old peacefully in their homes in the company of their grandchildren. Except that in this case there isn't one husband, but two. That doesn't seem like much, but it's an enormous difference, and that's what pleased me.'

Truffaut liked to tell the story of how he discovered Henri-Pierre Roché's novel in 1955 among the used books on a stall in front of a bookshop near the Palais Royale, his curiosity aroused by the double 'J' in the title, and even more by the paradox of a first novel written by a man who was 74 years old. From the first pages the young critic was seduced by the writing of this 'love story told in a

Previous pages: Henri Serre, Jeanne Moreau and Oskar Werner.

A sentence from Henri-Pierre Roché's novel *Jules et Jim*, rewritten by Truffaut for his film.

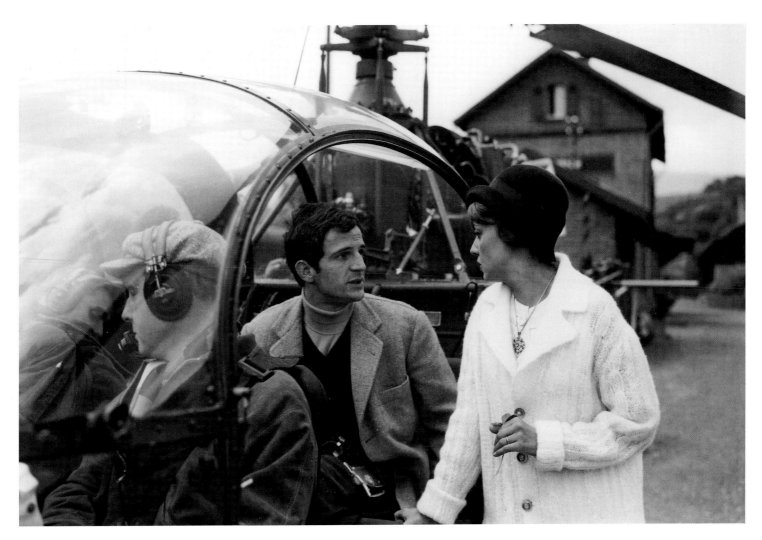

telegraphic style', by the short sentences, at once poetic and concrete, of a 'peasant Jean Cocteau' who almost seemed to surpass Truffaut's favourite author with his ability to achieve 'the same kind of poetic prose with a smaller vocabulary, by writing ultra-short sentences using everyday words'. Truffaut was overwhelmed by the novel, which seemed to him an example of what he dreamed of doing someday in a film – showing two men who love the same woman, without obliging the public to side with any of the three characters – and he never missed an opportunity to mention it. His review of *The Naked Dawn*, a B-Western by Edgar G Ulmer, in *Arts* a few months later became famous because, taking advantage of the 15 minutes in which the film's two male protagonists are in love with the same woman, he managed to insert a vibrant homage to *Jules et Jim*. 'What matters is the three characters' relationships, which are portrayed with novelistic finesse and precision. One of the most beautiful novels I know is *Jules et Jim* by Henri-Pierre Roché, which shows us two friends and their common girlfriend loving one another throughout a whole lifetime and almost without conflicts, thanks to a new, aesthetic morality that is constantly being reconsidered. *The Naked Dawn* is the first film that gives me the impression that a cinematic *Jules et Jim* is possible.' Touched by this truthful recognition, all the more so because his novel had not had the impact he had hoped for, Henri-Pierre Roché answered Truffaut, and a correspondence and a friendship began. It was quickly

understood that Truffaut would adapt *Jules et Jim* if he became a film-maker, but he did not feel able to tackle it until he had made his first couple of films. At the beginning of April 1959, when he had finished editing *Les Quatre Cents Coups*, Truffaut sent Roché some photos of Jeanne Moreau. Roché died a few days later (9 April 1959) having had the satisfaction, not of writing the dialogue for the film as he had thought he would do, but at least of having seen the face of his 'Kathe', now Catherine. To keep the film from being a contest between stars, Truffaut insisted on casting two faces unknown to the public to play opposite Jeanne Moreau: Henri Serre, whose resemblance to Henri-Pierre Roché he was struck by, and Oskar Werner, an Austrian actor whom he had noticed in the role of a young student in *Lola Montes*. The heritage of Max Ophuls was fundamental for the young film-maker, who would remember for all his films something he observed when he spent a day watching *Lola Montes* being made: 'Ophuls had noticed that an actor is necessarily good, necessarily un-theatrical, when he has to make a physical effort: walking up stairs, running in the countryside, dancing during the whole of a single long take.'

A collector.

'I write, like Stendahl, for the future, for the day when sexual matters will be out in the open and a sex against another sex will be spoken of the way we talk about a cheek against another cheek, with all the nuances involved in

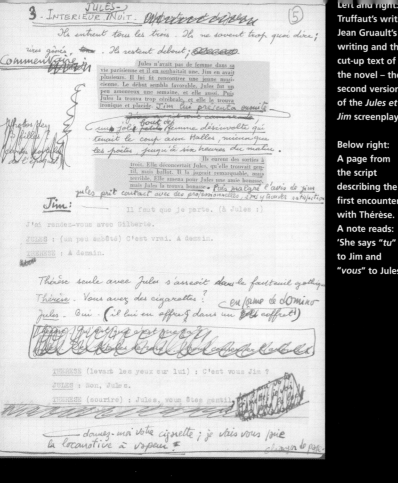

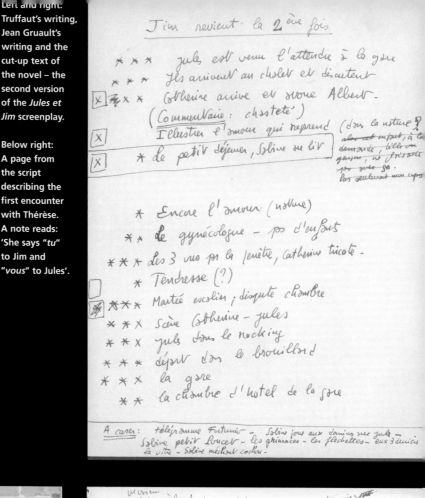

Left and right: Truffaut's writing, Jean Gruault's writing and the cut-up text of the novel – the second version of the *Jules et Jim* screenplay.

Below right: A page from the script describing the first encounter with Thérèse. A note reads: 'She says *"tu"* to Jim and *"vous"* to Jules'.

Above: As a reminder on the shooting script, short additional scenes that must not be forgotten: 'Brief flashes showing Jules taking care of Sabine during Jim and Catherine's honeymoon: he feeds her on the terrace; he plays darts with her; he walks around the chalet with her; he puts her to bed in the hammock.'

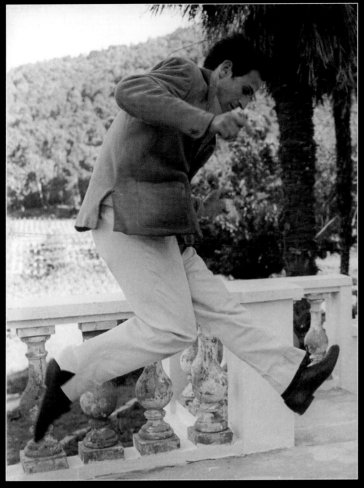

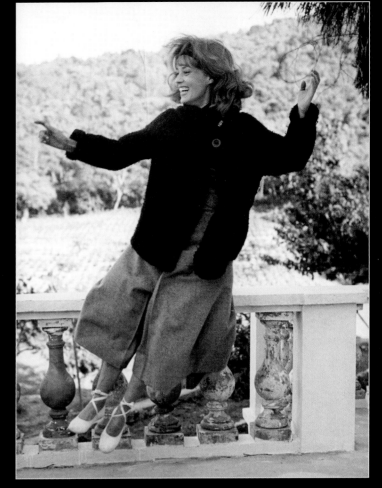

Above and below: 'Life was truly a vacation'. With Jeanne Moreau on the terrace of the house in the South, 'white inside and out'. With Raoul Coutard in the Alsatian mist. In Paris, Suzanne Schiffman with Jeanne Moreau disguised as 'Thomas the Imposter'.

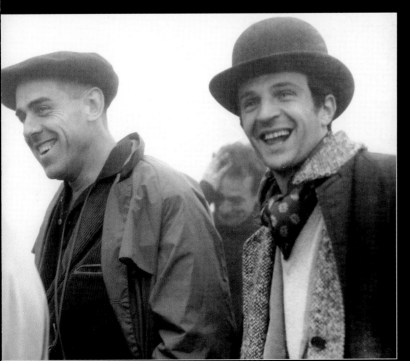

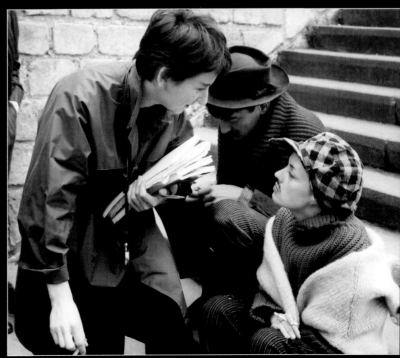

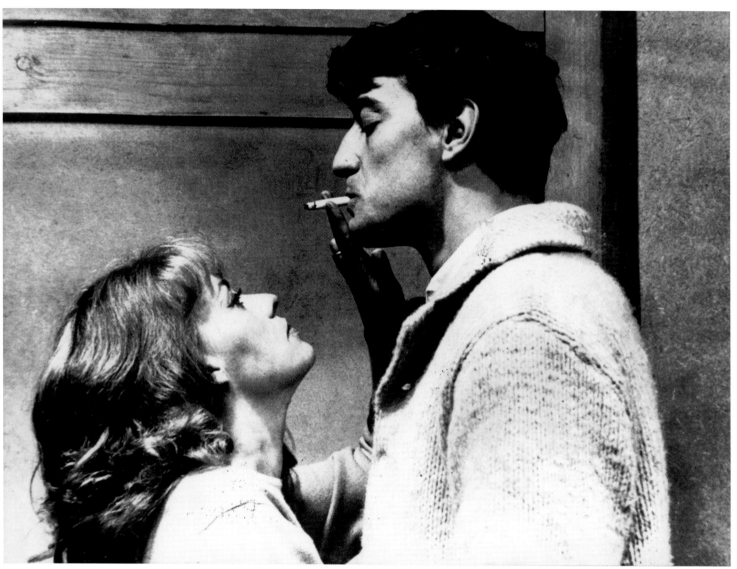

With Jim (Henri Serre).

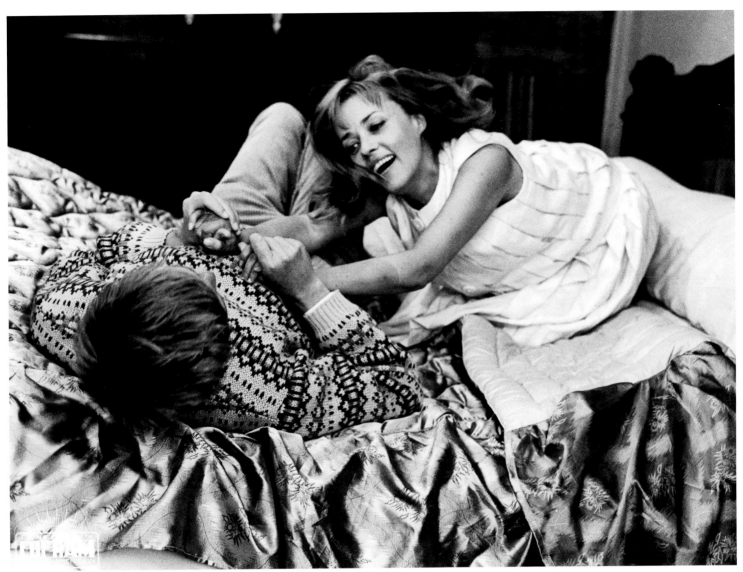

With Jules (Oskar Werner).

these matters, every situation being emotionally and sexually unique,' Roché noted in one of his notebooks in 1922, a logbook where he recorded his worldly encounters and his many adventures with women. Truffaut had these notebooks typed up years later to keep them from being lost and tried in vain to have them published. (Only the notebooks for 1920–1, the '*Jules et Jim* years', were published later, in 1990.) He would draw on them for part of his inspiration, explicitly in *Les Deux Anglaises* and less directly in *L'Homme qui aimait les femmes*. Henri-Pierre Roché was a modest figure in cultural Paris during the post-war years, a lover of modern art, a translator (of Schnitzler and Keyserling), 'friend of painters and sculptors' (this definition is applied in the film to Albert, Catherine's third lover), whom he discovered and championed. A friend of Picasso, Brancusi, Satie, Auric and many others, including Marcel Duchamp (to whom he devoted his third, unpublished novel, *Victor*), after the war Roché became an advisor and buyer for an American art collector, whom he made a character in the last quarter of his novel, which is not included in the film. A collector of art as well as conquests, Roché fascinated Truffaut because of his way of putting his life before his work, his insatiable curiosity about women, feelings and the senses, his ability 'to always keep in his heart and within reach of his body' two or three regular mistresses, to whom he would add other adventures. The novel *Jules et Jim* is a transposition of Roché's friendship with the German writer Franz Hessel, whom Roché met in 1906, of their habit of sharing women, and of their encounter in 1912 with Helen Grund, a young German who had come to Paris to study painting at the studio of Maurice Denis, quickly attracting attention at the Dome café, a cosmopolitan gathering place for post-war artists. ('I remember,' Roché wrote with his wonderful gravity in one of his notebooks, 'Pierre, not Helen, please – not this one.') Only the ending of the novel was completely invented by the writer to dramatize the adventure he had lived. The tragic twist of having Jim and Kathe die, leaving Jules alone, was perhaps an expression of Roché's remorse. For while Helen Hessel lived to be an old lady who was amazed at Truffaut's ability to reproduce the truth of their old story à trois when she saw the film, Franz Hessel, a Jew and an émigré in France after 1938, was put in the Camp of the Thousand in 1940, and Roché made no effort to help him, their friendship having ended with the end of his love affair with Helen. Hessel died a few months after the Liberation in 1940.

An accomplice.

To help him adapt *Jules et Jim*, Truffaut sought out Jean Gruault at the theatre where he was acting in a play by Jacques Audiberti. Gruault was an actor Truffaut had often seen during the 1950s at the Cinémathèque or the Studio-Parnasse ciné-club, where they admired the same films and sometimes loved the same girls, notably Liliane, the model for the young girl pursued by Antoine Doinel in *Antoine et Colette* and then in *Baisers volés*, whose indifference had driven Truffaut to a suicide attempt, then to the foolhardy decision to sign up for three years in Indo-China. Gruault had written *Paris nous appartient* with Jacques Rivette, so Truffaut chose Rivette to be his go-between and brought a copy of the novel to the theatre, before going there in

person to speak to his future co-writer. Initiating a method of collaboration that they would always use from then on, Truffaut gave Gruault an annotated copy where he had underlined the passages he liked or marked them with an X. Gruault produced a first try at an adaptation, which Truffaut used as a point of departure that he reduced and reworked, in the process inventing visual shortcuts and discovering where he wanted to go. Massacring several copies of the novel, of which Truffaut had ordered a large supply from Gallimard, they reworked the adaptation 'with scissors and glue' in order to edit, dismantle and move the things they wanted to use from one episode to another, organizing them differently. Some versions of the script (written between summer 1960 and spring 1961, the start of production) combined fragments of typed text, passages cut out of the novel and handwritten additions.

A puzzle.

'After filming I was afraid of cars and drove carefully because I said to myself: "No one else would ever be able to figure out this mass of film; there are commentaries to write, things to move around and dub in…"' From the first attempts at adaptation to the editing, what characterized Truffaut's work on *Jules et Jim* is the freedom with which he manipulated the ingredients of the novel, displacing them and reinserting them in another context or putting them in the mouth of another character, to such an extent that he probably was the only one who could make sense of it. Because they could not make a film several hours long, the constraints of adaptation obliged Truffaut and Gruault to gradually give up several characters and whole sections of the novel. They decided to forget about the last part of the novel altogether, where Kathe and Jim, meeting in Paris after their separation, then breaking up again, become lovers once more for real and for a long time. In the novel, reconciliations, journeys, great happiness and small injuries, holidays, then new storms and new encounters precede the final break-up, which this time is for good. But Truffaut got several ideas for scenes or bits of commentary from this last section that he put earlier, during the trio's vacation at the seaside or at the cabin where Jim and Catherine's love is born: the book she is reading at the beach, whose author describes the sky as an empty bowl embedded in a solid crust; Jim's worries about how Jules will react ('Jules? He loves us both. He won't be surprised. This way he'll suffer less'), which are placed earlier than in the novel, during Catherine and Jim's honeymoon; a comment about the end of a holiday in the Manche where Kathe, unhappy with Jim, sends him away ('The rest of the hive, which didn't know, sensed confusedly that Jim had fallen out with their queen: his departure was therefore to be expected'. These lines were inserted at the moment Jim leaves the chalet in the fog); Jim's thought, during the last part of the novel, when Kathe holds receptions where he feels out of place, which is used during Albert's visit to the chalet ('He could only admire Kathe without reservations when they were alone. In company, she became relative for him'); or again, the famous line about happiness that precedes the final storms between the lovers: 'Happiness is hard to recount. It's used up before one has perceived it…') When Jim returns to the chalet after taking too long to leave Paris and discovers that

Catherine has spent the night with Albert to even the score, Truffaut used Roché's lyrical description of some nth reconciliation in the last pages of the book: 'Once again they were starting over, and once again they soared very high like great birds of prey.' Truffaut would recall this image of great birds of prey when he was writing the last scenes of *La Sirène du Mississippi*, and again in the big love scene in the play being performed in *Le Dernier Métro*: 'Yes, love hurts: like great birds of prey, it flies over our heads, immobilizes us and threatens us…'

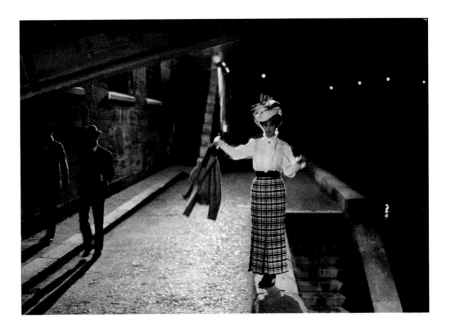

Truffaut tried out these displacements, tested them and then began all over again during the first stages of editing. In the novel, Kathe's appearance is preceded by Jules and Jim's adventures with several other young women. Jean Gruault had the women appear in an early version of the script, but Truffaut, who was afraid that the viewer who had come to see Jeanne Moreau would start tearing up the seats if she didn't appear on screen within the first 20 minutes, asked him to reduce the preliminary scenes. Several scenes with women who are so many preludes to Catherine are deleted from the screenplay, and the film-maker continued to eliminate them in the editing room. 'I remember a lot of scenes with girls at the beginning, which were rather gloomy and sad,' recalls Claudine Bouché, Truffaut's editor. 'That's when he said to me: "People will go along with us for five minutes; after that we have to interest them."' Some of the scenes removed in the editing – with Lucie and Birgitta, old loves of Jules whom he introduces to Jim during a trip to Germany before they meet Catherine – were actually shot during the first days of filming. The streets of a German village were faked at Ermenonville, and a few anonymous shots from this material were used in the rapid montage at the beginning of the film. Gruault and Truffaut gave Catherine characteristics of all the women loved by the two men: 'Since we didn't want to lose certain pleasant characteristics of the other girls,' recalls Jean Gruault, 'we attributed them to Catherine, who thus became the sum of all those who had preceded her.'

Sums.

Apart from the main model, Kathe, the Catherine of the film is a composite of Odile, an eccentric young Scandanavian whose favours Jules and Jim share, of Magda, a young German with whom Jim spends the night under the influence of ether, of Gertrude, an athletic girl who once consoled Jules and gives herself to Jim, and above all of Lucie, a very beautiful woman who hides her suffering behind an apparent serenity, with whom Jules is very much in love: despite her first refusal, he proposes to her again and prefers, when it doesn't work, to see her get together with Jim. Henri-Pierre Roché describes Odile as 'aristocratic by her father and of the people by her mother'. It is also Odile who, after drenching a stuffed lamb with petrol (a detail that appears in the first drafts of the script), burns a letter in front of Jim, starts a fire and wants to buy a bottle of vitriol 'for the eyes of a lying man'. And it is Odile who goes to the seashore with Jules and Jim and finds the little house of her dreams, 'white inside and out, with no furniture'. It is Magda of whom Roché wrote that she

'took root again in life and become more beautiful'; she is also the one who informs the two friends when Jules throws a tantrum, 'You're both idiots', then seeks Jim's support: 'Protest, then,' says Magda. 'I protest,' says Jim. (In the film this dialogue precedes Catherine's leap into the Seine.) Gertrude is the one who tells Jim how she 'was in love with Napoleon and dreamed that she met him in a lift; he gave her a child and she never saw him again', a story Catherine tells the two men to get their attention when they are playing dominoes without her. And finally it is Lucie who is described in these words, which apply so well to Jeanne Moreau: 'Her nose, her mouth, her forehead were the pride of the province she incarnated as a child in a religious festival.' Jim describes Lucie to Jules as 'an apparition for all men, perhaps not a woman one can have for oneself'. And it is Lucie who, sensing that Jim is attracted to her, quotes a few lines of Goethe that she orders him to translate ('All the inclinations that go from heart to heart, ah! My God! My God! What pain they cause'). Finally, it is also with Lucie that Jules steps aside for Jim: 'Jim, Lucie doesn't want me any more, and she's going out of my life. Jim, love her, marry her and let me see her. Stop thinking that I'm an obstacle...'

There is only one woman in the film whose encounter with Jules and Jim precedes Catherine: Thérèse, played by Marie Dubois, who flees from her anarchist lover with whom she has been painting an unfinished insult on the walls of Paris. She throws herself into Jules and Jim's arms, then disappears just as quickly after leaving Jules at a café to follow another man – a rehearsal for the joyful, casual way Catherine arrives in the two friends' lives. Truffaut filmed certain sequences with Thérèse and Catherine in exactly the same way, but reversed: Thérèse is carried off in a carriage by the two friends who teach her to say, not Jim and Jules, but Jules and Jim (Jim at this point is frame left and Jules, frame right); Catherine, after her swim in the Seine, soaked, proud and silent 'like a young general who is being modest after his successful Italian campaign', is transported in turn in a carriage between the two men in almost the same shot, except that the two friends' positions are reversed (Jules on the left and Jim on the right). Paradoxically, Thérèse comes from Roché's second novel, *Les Deux Anglaises et le continent*, in which Truffaut had marked certain passages for Gruault to use in adapting *Jules et Jim*, just as he used some passages of the novel *Jules et Jim* years later when he adapted *Deux Anglaises...* All the elements of the encounter with Thérèse in *Jules et Jim* – the way she dumps them at the café concert, the details of her life story that she tells Jim when she returns to Paris, even her dialogue and tediously lengthy language – are taken directly from *Deux Anglaises et le continent*, where she is a character in a story Claude tells his two English cousins, who want to know more about prostitutes.

Other strong moments in the film are nourished by the novel of *Deux Anglaises et le continent*, in particular the whole sequence of crossed letters between Jim and Catherine when they separate, letters that always arrive after enough time has passed that the lovers are constantly writing at cross-purposes. The text for the letters was borrowed from letters written by Muriel, the most puritanical and

passionate of the two sisters: 'I will stop thinking of you so that you will think more of me'; 'Sometimes you disgust me, but I'm wrong, because nothing should be disgusting'; 'This morning he is going to come. Let's quickly gather up all our hard words of yesterday'; or for the important letter from Catherine who, like Muriel, believes herself to be pregnant with the child she and Jim had so desired: 'There are so many things on earth that we don't understand and so many incredible things that are true.' More rarely Truffaut used one of Anne's letters to Claude for Catherine's appeals, which he rewrote during production: 'Come when you are able, but be able soon. Even if you arrive late at night,' and this declaration: 'This paper is your skin, this ink is my blood, I'll press down hard so that it enters.' When Truffaut invented a scene where Catherine and Jim break up that is not in the script, he again turned to the novel of *Deux Anglaises et le continent*, which is more violent, and the journal Muriel writes while she is separated from the one she loves – lines that are so universal they seem perpetually modern, in 1900 as well as in 1962, or more than 40 years later: 'I have no heart: that's why I'll never love you or anyone'; 'When you're 40 and want a woman, I'll be 42, and you'll take one who is 25.' Truffaut also borrowed the theme of Catherine's eye problems from *Deux Anglaises et le continent* (when Catherine is tired and disappointed in Jim, she can only read big letters, like Muriel), along with the words he has Jeanne Moreau say in her voice-over at the beginning of the film:

> 'You said to me: I love you.
> I told you: Wait.
> I was going to say: Take me.
> You said: Go away.'

The Chinese Emperor.

From one novel to another, from one character, episode or piece of dialogue to another, the journeys and displacements of elements are innumerable. All the way through shooting and editing, too, the script of *Jules et Jim* was like a huge, mobile puzzle whose pieces keep changing places. The line linking the rocking chair and the pleasures of the flesh (*la chair*) was attributed to Jules for a long time. But when it was time to film the song, Truffaut gave the line to Albert (Cyrus Bassiak, alias Serge Rezvani, the author of *Tourbillion*). Albert has just spent time with Catherine with Jules and Jim looking on, but a brief gap concealed what was happening between them. In one of the first drafts of the script, it is Jules who says to Catherine, during a collective bicycle ride: 'When Jim wants to do something, as long as he doesn't think it will hurt someone else (he can be mistaken about that), he does it, for pleasure and to see what he learns from it. Someday he hopes to achieve wisdom.' Truffaut ended up using this dialogue when Jim explains to Gilberte that he is leaving Catherine, so that the line about seeking wisdom through curiosity becomes a definition of her: 'She was usually sweet and generous, but if she thought we didn't appreciate her enough, she'd become terrible and pass to the other extreme with sudden attacks'. In the script this was part of the commentary, when the danger that Catherine will leave with Albert hangs over the house. But during filming Truffaut gave the lines

to Jules for the scene where he furiously explains to Jim how Catherine functions when she has not come to meet him at the train station because she is off on her escapade.

While filming, Truffaut manipulated and twisted a script that was rich enough for him to always find what he needed in it to nourish scenes he was reinventing. The story that ended up being told by Jules about the Chinese Emperor caught between his two wives ('I am the unhappiest of men, because I have two wives: the first wife and the second wife') was at first, in the script, a memory of Jim's, when he feels caught between Gilberte and Catherine. Realizing during shooting that he was missing a scene (Catherine wants to drive Jim away, not understanding her own feelings), Truffaut remembered the story and used it at the last minute to write Jules's dialogue when he consoles Catherine. 'In the novel, it's Jim who recalls having seen the play,' explains Jean Gruault. 'François had underlined the passage in one of the copies he gave me. He wanted me to work it into my collages somehow. A prisoner of my damned logical mind, I couldn't find a way to do it. No doubt because I was too intimidated by Roché's text, I kept trying to give it to Jim. Freer than I was with respect to the novel – and this is just one example out of a hundred – François gave it to Jules.'

They're burning books.

At the end of the first script he gave Truffaut, Gruault proposed an ending that was quite different from the novel and rather surprising. After escaping from Catherine's revolver, Jim takes refuge in a cinema where he sees newsreels of the Reichstag Fire. Jules, summoned back from Germany by Catherine, arrives by train. Before his eyes, Catherine drives into the Seine with Jim. Jules helps Gilberte with the cremation, then returns to Germany, where he finds his village preparing for a Nazi ceremony. He passes a group of girls singing the *Horst Wessel Song* before going home, where he is greeted by the daughter he had with Catherine. Truffaut did not yield to the temptation of an openly political ending that would have been too close to the love story, inspired by the last years of Franz Hessel, who had to work for his publisher clandestinely beginning in 1935. Instead he preferred to end the film with Jules's wish to mingle Jim and Catherine's ashes, and the line from the book: 'But it wasn't permitted.' He nevertheless re-appropriated Gruault's idea. In the next draft, no doubt influenced by his interest in Ray Bradbury's novel *Fahrenheit 451*, the rights to which he was in the process of buying, Truffaut replaced the images Jim sees of the Reichstag Fire with images of book-burning. The cinema where they are shown becomes the place where Jules, Jim and Catherine meet again by chance, and Jules says as they leave the theatre, 'So now they're burning books…'

In the second draft, reworked with glue and scissors, Truffaut began to appropriate the film. Little by little, in the margin of things taken from Roché, he added jokes of his own that contributed greatly to the film's charm. The steam locomotive trick, for example, which Thérèse does for Jules, putting the lit end of a cigarette in her mouth and chugging around the room (a triumphal procession that the camera accompanies with a 360-degree pan), is a

'Her eyes could no longer read anything but big letters.' The theme of poor eyesight was borrowed from Henri-Pierre Roché's second novel, *Les Deux Anglaises et le continent*.

trick that Truffaut, the eternal schoolboy, had already had one of his friends do in the short he made in 1954 (*Une visite*). He also began imagining situations that were personal to him: Jules's 'not this one, Jim' is said on the stairs leading up to Catherine's apartment, not in a café where they are playing dominoes. He added the little local train when Jim arrives in Germany, where Catherine is waiting at the station, and the idea that the painters' friend, Albert, introduced by Jules to Jim at the beginning of the film, projects the blown-up photo of a statue on the wall using an old slide projector instead of showing them a reproduction on paper. (Truffaut used this same slide projector in *La Chambre verte* when Julien Davenne shows the child who lives with him images of World War I.) Projecting the smile, which Jules and Jim say that they will follow if they ever find it, creates an image of the fantasy-as-projection at the moment their amorous obsession crystallizes.

At the same time Truffaut introduced a few personal references: the quotation from Raymond Radiguet ('The rocking of the rocking chair invites us to pleasures of the flesh'); a nod to Cocteau (which he finally does not film): 'Let's break the ice [*glace*],' says Jules, breaking a little pocket mirror [*glace*] when the three of them are suddenly intimidated at finding themselves together at the chalet after the war; or a first evocation of Guillaume Apollinaire: during Jim's second visit to the cabin, when Catherine remains hostile and silent, he makes conversation by telling the story of 'a poet who was discharged from an artillery unit. Wounded in the head, the man was evacuated to the rear. Here is his photo (a photo of Apollinaire with his head bandaged, or 26 photos that move when flipped: G A taking off his hat and putting it back on). From his hospital bed, writing to his mistress: "Your breasts are the only shells I love."' This addition in Truffaut's hand was an idea found during shooting that he gave more weight to later, when it became one of the most beautiful scenes in the film: Jim telling Jules and Albert about meeting a gunner in the hospital who lived an astonishing love story by correspondence with a girl he met on leave.

The war.
It was also while working on this draft that Truffaut had the idea of having Jules sing *La Marseillaise* and following it with images of the war. He proposed having the song continue over these images, not sung but 'recited' by Jules with a piano accompaniment. When the scene was filmed, Oskar Werner read the lyrics from big cue-cards held up for him off-camera so he could speak them at the speed the film-maker wanted, and the impromptu beauty of his head movements as he looks from card to card owes much to this improvised device.

To develop the cutaway about the war, the film-maker sketched a commentary indicating that Jim receives packages from Gilberte in the trenches and asks her to marry him while he is on leave, only to give up the idea of marriage after seeing a gynaecologist who tells them that they would not have very strong children. (During production Truffaut removed this direct allusion to Roché's eugenic preoccupations – the fear of transmitting

his parents' fragile constitution to his children, which kept coming up in his writings.) Truffaut planned a scene where Jim says to Gilberte that he is afraid of killing Jules, as well as the scene in the German foxhole when Jules writes to Catherine that his transfer to the Russian Front will permit him to stop living in fear of killing Jim. Truffaut thereby gave the interruption by the war an importance it did not have in the novel. Declared unfit and rejected during the mobilization of 1914, Roché was in fact one of the few writers of his generation who escaped trench warfare. After being jailed for two weeks on suspicion of passing intelligence to the enemy because of his voluminous correspondence with his German friends (Roché got a first novel out of the experience, *Deux semaines à la Conciergerie pendant la bataille de la Marne*, described by Truffaut as 'a little volume of around 50 pages that already has his lively, joyful style'), he was sent on a mission with the French High Commission in Washington and remained in the United States until 1918. The novel disposed of the war in five lines: 'Three days before the journey Jim was planning to Germany, war broke out and separated them for five years. All they could do was let each other know they were still alive via neutral countries. Jules was on the Russian Front. It was unlikely that they would meet.' Truffaut substituted four minutes of newsreel footage from the period for this laconic account – perhaps a memory of the play being rehearsed in *La Grande Illusion*, and an after-effect of Abel Gance's *Paradis Perdu*, one of Truffaut's first cinema memories, a film he saw secretly in 1940. He later told how he was struck by the way the emotional atmosphere of this film coincided with that of the theatre where he saw it, which was full of men on leave accompanied by their girlfriends or their 'war godmothers'. When Catherine disguises herself as a man, Truffaut slipped in another reference to the war that was also a nod to Cocteau: 'Thomas is an imposter.' Truffaut accomplished this 'expiration', as Cocteau would have called it, of what was near and intimate to him, in small successive touches, and always in reaction to proposals that had been made to him, amalgamating these added ingredients to the adapted work as if they had always belonged to it (just as the lines of commentary not written by Roché but 'in his style' become Roché's). Thinking *mise-en-scène*, visual ideas (the slide projector, for example), he was always looking for the heart of his subject. When he rewrote the night scene where Jim begins his declaration to Catherine, who has been questioning him about his love life, Truffaut had the idea of having Jules appear on the balcony above them to close the windows: it is Jules, and not Catherine, who recites the Goethe verses and asks Catherine to translate them. When Truffaut wrote this sovereign appearance of Jules at the moment Jim is on the verge of giving in to his attraction to Catherine, Truffaut summed up the way he had dealt the film, where he always wanted the game to be played three-handed.

Discoveries during filming.
'If Catherine smokes, a guy can ask her for a light and call her Monsieur', Truffaut noted on his copy of the shooting script next to the scene where Catherine, disguised as Thomas, says she is ready for 'the test of the street', accompanied by Jules and Jim. He added on the left page:

'Possibility for a commentary here. Catherine was happy with the success of her ruse. Jules and Jim were moved as if by a symbol they did not understand.' *Jules et Jim* was one of the films that Truffaut changed the most during production, adding a thousand details, moving or replacing scenes, cutting, reinserting a bit of the cut scene further on, filling the margins with fragments of ideas or sketches of texts for the commentary, filling in the holes and blank spaces. 'On the set François was completely concentrated, closed in on himself and on the film. You sensed that only the film counted,' Jeanne Moreau recalls. 'So there's a gravity, a depth, and at the same time there were these perpetual bursts of laughter, an openness to seize whatever happened during filming, to use it and incorporate it in the film.' Truffaut invented all Jules and Jim's activities during the opening credits at the moment when he was filming them, as well as the opening commentary (the script simply indicated that the two friends walk while 'devising' – a phrase the film-maker annotated with a laconic 'activities'): the dominoes, the blind man and the paralytic, the mock battle with brooms, etc. During filming, he modified the way Thérèse dumps Jules at the café. As written, she would have told the two friends to wait while she proposed her services to a plate-breaker who was doing his act, but Truffaut preferred a gag based on repetition (he also saved a little money by changing the scene) and had her do the locomotive trick again: 'Bored, Thérèse does the locomotive trick for another guy and leaves with him: one lost, ten gained.' He also invented the famous images of the trio's bicycles gliding along the roads during shooting. Inspired by a sentence from the novel, Gruault had proposed that they share 'a bicycle built for three' during their escapade in the South, which Truffaut annotated at the last moment: 'Three bicycles.' In the South, around the house that was 'white inside and out', he wrote more new scenes. He cut out a scene where Catherine was supposed to cause a scandal in the little seaside town by walking around in her bathing costume (left over from a scene with Odile in the novel) and wrote this exchange for the conversation between Jules and Jim as they are returning from the beach: Jules – 'Would you approve of my marrying Catherine?' and Jim's response – 'She is an apparition for all men, but perhaps not a women one can have for oneself.' Appropriating again from the novel (in the Lucie episode), he then added Jules's proposal to Catherine, sketching the *mise-en-scène* in the margin: 'Jim isolated (to permit Jules to ask his question). Jules: Jim, I asked Catherine to marry me. She almost said yes.' He borrowed Catherine's response from Joshua Logan's *Bus Stop* – and from Marilyn Monroe: 'You haven't known a lot of women, and I've known a lot of men. That averages out. Maybe we can be an honest couple.' Starting from another scene in the novel, he imagined and freely filmed with his three actors the scene of the long promenade around the house when they go in search of 'the last trace of civilization', from which Jules and Jim return carrying their weary queen on their linked arms, forming a portable chair. Truffaut thought of accompanying the sequence with a picnic, as a note in the margin attests: 'Wood fire. cutlets grilled on a stick. primitive meal. filthy. followed by the last trace of civilization' – a scene that was either never filmed or deleted in the editing. Changing his approach, Truffaut

Jules (Oskar Werner) plays dominoes with Sabine (Sabine Haudepin).

simplified the scene where Catherine slaps Jules: he eliminated the idea that the trio begins by singing a song and acting it out, worked in Catherine's fantasy about Napoleon (who would have given her a child in the lift), imagined the indifference of the two men, absorbed in their dominoes, to this story and added Jules's 'Scratch yourself, and Heaven will scratch you', which brings on their queen's change of mood. Using a technique that he avoided later as being too ostentatious (preferring to do less perceptible freeze-frames), Truffaut included in his *mise-en-scène* his desire to have Jeanne Moreau play against her previous films, where he found her rather grim. In a formula that could characterize all his work, Truffaut summed up what he hoped to obtain from his lead actress as 'a list of things to be avoided'. Not too intellectual, or too glamorous, or too much like the exquisite pest of American comedies. 'We could say that this character is made up of commonplaces and anti-commonplaces. So when she becomes Scarlett O'Hara, I give her glasses, I try to make her more human, more realistic.'

During filming, dialogue and commentary exchanged places. When it rains and Catherine demands to be taken back to Paris from the South, Truffaut crossed out the commentary he had planned ('The trio were known in the countryside as the three loonies'), sketched another ('Life was really a vacation'), and ended up inserting both lines during the birth of Jim and Catherine's love at the cabin. When Catherine burns 'letters from lying men' in front of Jim at the beginning of the film, Truffaut first planned to have the narrator say, 'Jim thought of her so much as belonging to Jules that he didn't form a clear idea of her,' then noted, 'Move to later in the South', and ended up putting it a bit earlier, at the end of the race, when Catherine says they must go to the seaside. Truffaut looked longer before finding the place for a line he especially liked: 'Never before had Jules and Jim used such big dominoes.' Truffaut added new details everywhere that made the film lighter and livelier: the bathing costumes drying near the house ('The bathing costumes dry on a line, they get them and leave on their bicycles'), the French boxing move Jules and Jim try out on the beach, the games with Sabine ('Jules dances with Sabine in his arms; later they throw themselves into each other's arms', or 'Catherine makes her repeat the word "prune" so that she'll have a pretty mouth', which was finally not cut in), Catherine's dialogue about the portrait of Jules as Mozart lent by Oskar Werner, or the hat Jim gives Jules when they meet again in Paris, the game where the hats are exchanged and must not be laid on the bed being one of the film's many rhymes. During filming Truffaut continued to slip little personal jokes into the film, such as the encounter at the café with the friend and the superb but stupid girl the friend calls, with tranquil misogyny, 'the Thing'. The girl was played by the same actress who played the beautiful musician in *Tirez sur le pianiste*, the one who leaves so that Charlie can audition for the impresario, while the camera follows her down the corridor and into the courtyard of the building. And the film-maker also pursued his personal obsessions: Jim returning to the places where the most violent battles of the war were fought ('Visit to the trenches after the fact [Vieil Armand, etc.]').

In the course of the rewriting process the film gained in both gaiety and violence – the gags and the harshness went together. During filming, when he immersed himself in the heart of his subject and, day after day, had the impression that the film was becoming better than the script thanks to the actors, Truffaut invented or reworked scenes that are among those that everyone remembers, like the one when Jules angrily explains to Jim that he doesn't know how to love Catherine. ('You have to give her all your attention, like a queen.') He crossed out her presence at the train station, where the script had her coming with Jules to meet Jim but remaining distant and silent, imagining instead that she has gone off to avenge Jim's delays. ('In case of doubt, Catherine will always do more than someone else would have.') This permitted him to have a scene where the men talk about her in her absence, only to have her reappear in the nick of time, looking fresh and insolently innocent, just as Jim is about to leave. Borrowing dialogue from *Deux Anglaises et le continent*, he wrote the scene of Catherine and Jim's break-up, interpreted dryly by Jeanne Moreau: 'Are you suffering? Well I'm not, because we shouldn't both suffer at the same time.' Truffaut telephoned Jean Gruault because he felt he had not found the right emotional climate for this part of the film, then reworked on his own the scene where Jules tries to console Catherine by telling her the story of the Chinese Emperor and his two wives. Always happy to work with whatever material was at hand, Truffaut added to this dialogue a couple of things Jeanne Moreau had confided in him a few days before. Even playing just a few centimetres away from the huge Cameflex that was filming them in close-up, the two actors made him the gift of a scene carried to a paroxysm of emotion, weeping in each other's arms. 'Everything you like in my films, Antoine's interview, Nicole Berger's confession, Jeanne Moreau weeping with Oskar, all that was done with just Coutard and me, throwing everyone else out,' Truffaut wrote to Helen Scott to explain why he did not want too many people coming to visit his sets. In the editing room he realized that he would prefer to loop the scene because of the noise of the Cameflex. 'They'll never be able to do it,' Claudine Bouché told him, but Jeanne Moreau managed to put herself into the same state and sobbed just as she did when the scene was being filmed.

Deflowering by correspondence.

'There was never improvised dialogue, but a certain freedom for the actors, yes,' says Suzanne Schiffman. 'For example, the first scene where they eat dinner after Jim returns from the war was one that François considered rather serious. He had the actors rehearse once, and when they started to laugh he found that wonderful. He thought Jeanne's laughter was much better for the scene than if he had filmed it seriously, so we filmed it that way.' Because it was an easy answer, Truffaut let it be said and said himself that part of his work was improvised. But instead of improvisation in the strict sense of the word (with the very partial exception of children, he never let his actors invent dialogue in front of the camera), Truffaut's process was one of continual rewriting and reworking, combined with an ability to incorporate during production both his oldest obsessions and events happening on the spot. It was because Jeanne Moreau, Serge Rezvani and the others were singing

Tourbillon on the set that the film-maker decided to make it a scene in the film (one of the few filmed with direct sound), and when Jeanne Moreau mixed up two verses and mimed prettily with her hands that they should be reversed, he kept the liveliest take. The scene when Albert visits the cabin seemed to him too flat as written. The four characters finish dinner, the commentary describes the situation, then Jules goes off with Jim and criticizes Catherine. Instead, taking advantage of the pretty weather, Truffaut substituted a long dialogue with Jules, Jim and Albert filmed outside, returning to the idea of using Apollinaire's letters and modifying it further. Apollinaire, whose collected love letters Truffaut re-read during the shoot, is no longer named. Now the story is about an anonymous soldier Jim says he met, which confirms one of the ideas most frequently defended by the film-maker: that passions belong to everyone and not just to artists and poets. Above all Truffaut condensed the adventure of Apollinaire and Madeleine Pagès, a young girl from Oran whom the poet met on a train in January 1915 when he was returning from his leave in Marseille, to whom he began writing more and more passionate letters from the front. Recounting this extraordinary 'deflowering by correspondence' enabled Truffaut to weave together several preoccupations: his fascination with the destructive violence of World War I, his fondness for letters and his curiosity about a passion that develops at a distance, in pure imagination and pure fantasy. He changed the end of the story somewhat by imagining that the soldier wrote in his last letter: 'Your breasts are the only shells I love.' For when Apollinaire died just before the Armistice (from an infectious flu, instead of the head-wound caused by the shell that exploded in 1916), he had long since stopped writing to his distant fiancée, whom he had seen again, breaking the charm, during his leave in 1916. To this tale of masculine imagination getting carried away Truffaut responded with Catherine's very concrete irony. ('When he was at war Jules also wrote me very beautiful letters,' he had Catherine, who has been listening, say.) The scene's leisurely atmosphere, like that which must have existed during the shoot (time for conversation, the bucolic atmosphere, three nonchalant men sitting on the grass), almost makes us forget the violence being evoked. ('The violence of trench warfare, that collective madness, and the presence of death at every instant.') Truffaut also used this long story to deflect the indecency of the situation: Albert who has come to carry off Catherine, the three men at the mercy of their queen bee. The triviality of the possible adultery is masked by romanticism. It is one of the poetic facilities that Truffaut reproached himself for later, when he made *La Peau douce* in opposition to this film because he felt that 'intellectuals liked *Jules et Jim* too much.' He wrote differently to Helen Scott after a private screening in 1961: 'Certain intellectuals are enthusiastic (Queneau, Audiberti, Jules Roy and my film-maker pals!). Women cry, many men are a bit bored. It's my first deliberately trying film (1 hour 50 minutes). Frankly, thanks to the three actors, it works better than my previous ones...'

Balancing.

There were also scenes Truffaut decided not to film when they were at the cabin. 'Catherine sends off Mathilde [the baby-sitter] so she can be alone with Jim. Daytime lovemaking; Catherine undressed by Jim (Hat?). He takes off her shoes. Outside, the laughter and play of Sabine, Oskar sawing wood, etc.,' he planned on his copy of the script, before finally rewriting the scene so that Catherine is content simply to offer Jim the nape of her neck, the only part of her that he can see without being seen, ending with a shot of Jules and Sabine outside: 'Oskar saws the wood and piles it in the arms of Sabine, who carries it into the house.' To avoid alienating viewers who might not be ready to accept the friendly sexual freedom described by Roché, Truffaut and Gruault had already decided to give up some of the most daring scenes in the novel, like the story about the evening Jules and Jim used ether with their shared girlfriend, or the baths the trio take together, or the sudden violence that sometimes leads to blows between Kathe and Jim. Truffaut hesitated a long time before cutting out the scenes where Fortunio, a young friend of Jules and Jim, and Catherine's former lover, visits them at the chalet and shares a bed with Jim and Catherine. ('Catherine's right hand held Jim. Jim was sure the left held Fortunio. Catherine's silent intrigues were continuing. Jim no longer wanted a child with her.') Truffaut initially planned to film these risqué scenes. 'End with Jules's announcement of Fortunio's telegram,' he noted in the margin of the sequence just before, and he wrote the text of the telegram on his copy of the script: 'Father Jules and Father Jim. Stop. 24 hours with you. Stop. Dismemberments and brainectomies are the twin mammaries of our friendship. Stop. Pataphysically yours. Fortunio.' He finally (alas!) gave up the idea so as not to lose the public's sympathy for his characters. Truffaut later said that he could not have filmed these sequences unless he had given the role to Jacques Demy, whose air of purity and innocence would have succeeded in contradicting the indecency of the situation. While editing Truffaut resigned himself to cutting a scene where little Sabine comes to say hello to Jim and Catherine in bed one morning. Everyone who saw the early cuts told him that the scene would never be passed by the censors. 'If I'd had a half an hour more, I could have made the public accept my characters' life even to that extent,' he said. But even without the scene, the film was forbidden to anyone under 18 by the board of censors, and some family associations want it banned altogether. Truffaut was seeing how far he could go. 'While he was filming *Jules et Jim*,' Suzanne Schiffman recalls, 'François' greatest fear was: "The viewer must not laugh at the trio; he has to be in harmony with them." So we saw each other every night after shooting and talked about it. We'd say: "What scenes do we have in the continuity, when is Catherine with Jules, when is she with Jim, what happens between Jules and Jim? Are there lots of sad scenes? Do we need a happy scene, or do we already have too many of those?", etc., and that's how he came to write additional scenes – for example, the scene where Jules plays horsey with Sabine...'

How to risk losing the public at one moment of the film, only to win them back at another? How to present the situations the viewer might reject by balancing them with outdoor sequences or family scenes? During Jim and Catherine's first night of love (chastely filmed in silhouette by a film-maker who detested showing scenes of love-

making), Truffaut's camera leaves the lovers and films the trees around the cabin through the window. Then we cut to the next morning when Jules is playing dominoes with Sabine, and Catherine, very simply, imposes Jim's presence at the family breakfast table. The scene where Catherine kisses Jules at the bottom of the stairs, then Jim more amorously at the top of the stairs, is followed immediately by a shot where we see Sabine sleeping outside in a hammock while Catherine looks at her maternally from a window. When she decides to seduce Jules in her room while Jim, below, suddenly jealous, goes for a walk, the film-maker shows just afterwards the family on a walk beside the lake, with Jim carrying Sabine on his shoulders. 'In a film,' Truffaut noted, 'as soon as you talk about physical love, the public becomes very infantile, like a child at the awkward age, and you have to take that into account. You know very well that a certain line will provoke laughter, so the next line has to come very fast. By the same token certain things make people laugh if the character says them in bed, for example; and if the commentary becomes a bit delicate, I pass rapidly to an exterior shot: the chalet filmed by a moving camera, from a helicopter, so that the beauty of the landscape strangles the laughter in the spectators' throats.'

Voice-over and music.

The editing of *Jules et Jim* was particularly long and complex, taking almost nine months, with moments of time off when Truffaut took his editor out of the editing room to see a film or acted as her witness the day she bought a new car. 'We drew curves,' she recalls. 'We put pieces of cardboard on the wall with a brief summary of the scene, first of all to see what we had, and also to be able to switch scenes around. Then we drew arrows saying: "Here it goes up; here it descends." We could easily see when we screened it where the film went up and where it descended.' Truffaut asked for certain scenes to be shortened. He also artificially extended the scene of Catherine's first leap into the Seine, which was too rapid: the body in free-fall is put a little higher in the image each time the shot changes. (It was Jeanne Moreau who jumped that day instead of a double as planned.) He preferred 'cheating' other scenes. For example, he reversed a shot of Catherine and Sabine knitting together behind Jules and Jim, who are playing dominoes, so that the scene ends on a close-up of Catherine chewing on her knitting needle while the voice-over underlines that 'all was not well'. More difficulties arose when the commentary to be inserted had to match the tempo of the images. Truffaut tried recording some tests, and Claudine Bouché tried it as well, desperately forcing herself not to give it any intonation because she knew he wanted the commentary read with as little expression as possible. 'When we were fairly satisfied, he crossed out, he rewrote. We moved phrases; I would say: "Here we need a little more, here a little less", and we would move something.' According to Claude de Givray, Truffaut threw out a reading of the text done by Michel Bouquet that was too theatrical. Finally he asked Michel Subor, who had just done *Le Petit Soldat*, to read the commentary in a rapid, neutral style, like a sports announcer, without putting any emotion into it. But Georges Delerue's magnificent score, particularly for the scenes at the chalet, which

was delivered just a few days before it was time to mix, changed everything. His lyrical flights for the post-war scenes modified the speed of the image and covered up the commentary, which had to be rerecorded and re-synchronized so as not to overwhelm or reduce the music. 'We had to rewrite the long passages of commentary to let the music breathe,' recalls the editor. 'We had to redo all that meticulous work.' This was the price to be paid for the lyrical flights of *Jules et Jim*, which would make the risqué subject matter acceptable. 'Delerue had seen the film without the commentary, and every time he saw the camera flying over valleys, fields, forests, he said: "Now I can let myself go".'

'The sky is a hollow bowl.' Catherine tells Jim and Jules about a book she likes.

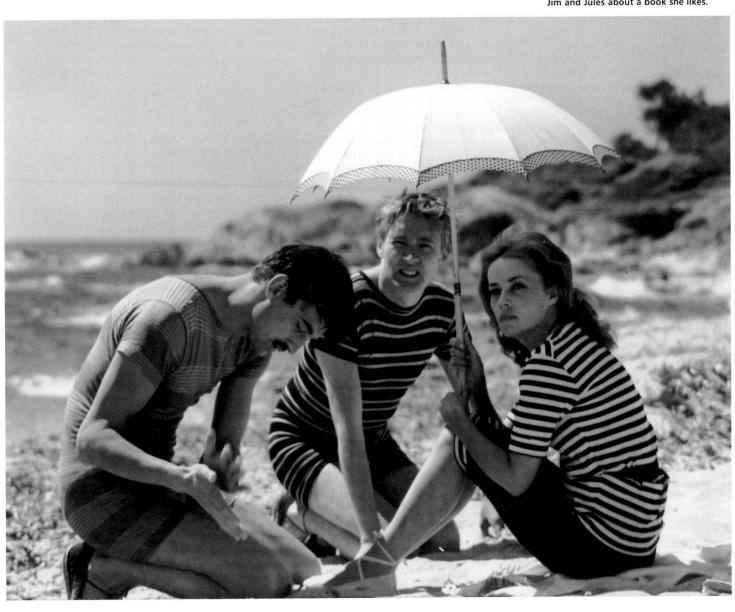

Antoine et Colette (1962)
Antoine and Colette

At the beginning of 1962, for as long as it took to make a half-hour short, Truffaut filmed the only assignment of his career. He accepted it because it coincided with a project he already had in mind: bringing back Jean-Pierre Léaud and showing the beginnings of Antoine Doinel's professional life and his first loves. In June 1961, after Truffaut finished shooting *Jules et Jim*, the producer Pierre Roustang approached him with a project to bring young film-makers together from around the world for a film composed of sketches about love at twenty. While Roustang was convincing Andrzej Wajda and the Japanese director Shintaro Ishihara, Truffaut recommended his colleagues Marcel Ophuls and Renzo Rossellini (the son of Max Ophuls and the nephew of Roberto Rossellini) to make the other sketches. For himself he saw it as an opportunity to make a first sequel to *Les Quatre Cents Coups*, an idea he had had for a few years. In July 1959, while writing *Tirez sur le pianiste* with Marcel Moussy in Saint Paul de Vence, Truffaut told a journalist from Nîce that he was waiting for

Jean-Pierre Léaud to turn 17 before working with him again: 'I'll film an adolescent's first love story. I want to do this film. I'm already working on it. Like *Les Quatre Cents Coups*, it will come out of myself.' Actually, Truffaut had forbidden himself to make a sequel too quickly because, out of pride or modesty, he did not want to appear to be profiting from the success of his first film: 'But since then I have realized that you should never give up an idea because of something as secondary and external as appearances. You have to do exactly what you want to do.' He would even regret not making a feature about Antoine Doinel's first great setback in love, an omission he corrected a few years later when he made *Baisers volés*.

'Antoine Doinel, predictably, will fall violently in love at the first opportunity.' The three-page outline was provisionally called *La Fougue d'Antoine* (Antoine's Passion) in memory of *La Fugue d'Antoine* (Antoine's Flight), the first title of *Les Quatre Cents Coups*. When he wrote it, Truffaut transposed the painful story of his passion (in 1950, when he was 18) for Liliane Litvin, a girl he met at the Cinémathèque who played a cat-and-mouse game with several habitués of the institution, as Jean Gruault recalls in his memoirs. Her suitors included Jean-Luc Godard and Jean Gruault himself, who appreciated the sanctuary and the meals offered by the girl's hospitable family – like Antoine Doinel and like Truffaut, the poorest member of the Cinémathèque group. Also like Antoine, Truffaut took a room across the street from the family. But his passion ended badly in reality – much worse than Truffaut would want to tell in a sketch he was deliberately making lightweight: after a party where she played the field without even looking at him, the young man attempted suicide by cutting his right arm 25 times with a razor. 'The rest of the story was like *La Règle du Jeu*: intrigues, street scenes, doors slamming,' Truffaut wrote years later to his friend Robert Lachenay, immediately seeking shelter in cinema. 'L played Nora Gregor, changing from "Saint Aubain" four or five times, and I was Jurieu – there had to be a victim. The next day, returning home at seven in the morning, I lay down on the bed and slit my arm.' Three months later, before he could be drafted, Truffaut enlisted in the Army for three years and then deserted during one of his first leaves.

When Truffaut wrote *L'Amour à vingt ans* Liliane became Colette (the name Liliane was crossed out and replaced with Colette in the first treatment), and the Cinémathèque was replaced by an organization that put on concerts for young people. Truffaut staged Antoine's love-at-first-sight for Colette at the Pleyel auditorium, filmed in the manner of Hitchcock, to whom he sent a long letter a few months later (in June 1962) proposing that they do a book of interviews. 'I'm going through a Hitchcock period,' he wrote in October 1962 to Father Jean Mambrino, a friend of Bazin and an occasional contributor to *Cahiers du cinéma*. 'Each week I go to see two or three of his films that are being re-released. There's no doubt about it – he is the greatest of them all, the strongest, the most beautiful, the most experimental and the luckiest. He is touched by grace.' Marie-France Pisier has often talked about how precise Truffaut's direction of her was in this scene,

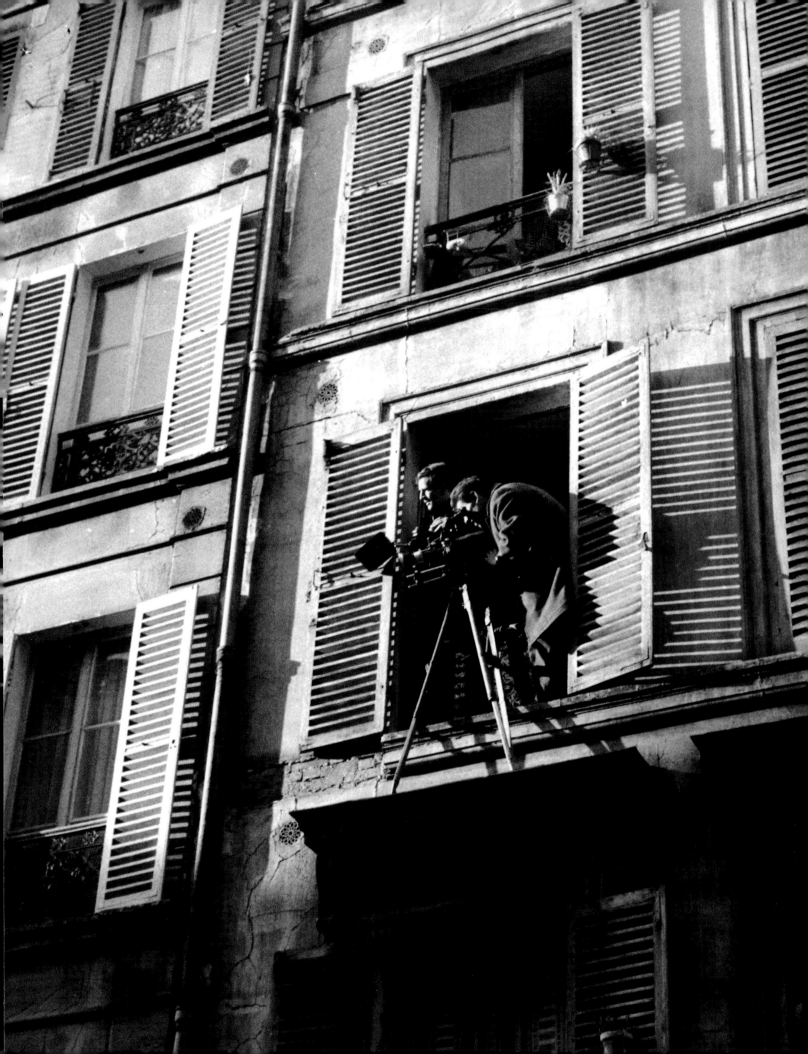

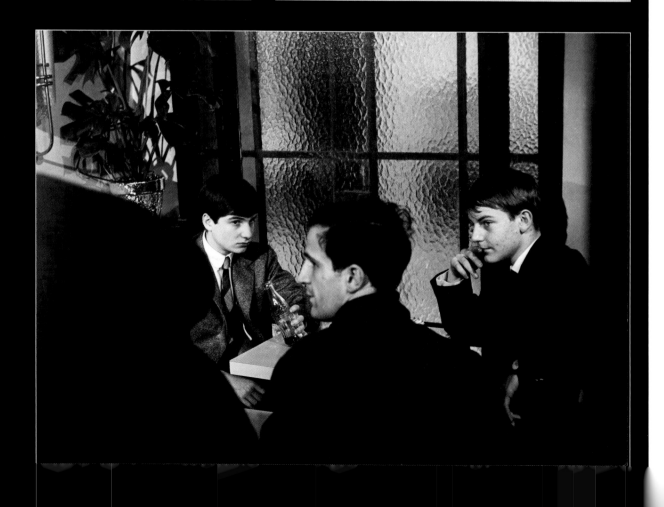

LA FOUGUE d'ANTOINE (court-métrage)

Antoine DOINEL, cela était prévisible, serait violemment amoureux à la première occasion.

Il a maintenant seize ans et demi. Ses ~~frasques~~ d'adolescent l'ont conduit jusque devant le juge pour enfants. Évadé d'un Centre d'Observation des Mineurs Délinquants, il a été repris cinq jours après sa fuite et transféré dans un Centre plus surveillé. La "psychologue"/~~attachée~~ s'étant intéressée à lui, il a finalement été remis en liberté surveillée. Ses parents ont été déchus de leur autorité.

Antoine a une chambre en ville ~~près qui paye~~. Il travaille comme magasinier dans une maison de disques et il s'est passionné pour la musique. Il s'est inscrit aux Jeunesses Musicales de France et ne rate pas un concert d'initiation à la musique classique. Il sort souvent avec son labadens René BIGEY. Lorsqu'ils ne parlent pas haute fidélité et stéréophonie, ils parlent des filles qu'ils ont connues, connaissent ou connaîtront.

C'est en ~~écoutant~~ (un Récital Berlioz qu'Antoine devient fou d'amour pour une jeune fille, Colette qui se trouve là, ce dimanche matin dans le Théâtre du Chatelet. Il la suit des yeux à la sortie, elle dit bonjour à ses amies.

A d'autres concerts, Antoine la remarque et ~~fait~~ ~~vient~~ s'asseoir à côté d'elle; ils ~~font~~ connaissance.

Une autre ~~fois~~, il réussit à la raccompagner chez elle. Par ses employeurs, Antoine obtient des places pour des grands concerts (non réservés aux Jeunesses Musicales) grâce à quoi Antoine réussit à sortir seul avec Colette.

[handwritten marginal annotations: attachée à l'établissement — clichy — quelques rangées devant lui — un jour à — Quatre cents coups — rue des Martyrs; près de la place — assisbant à — plusieurs fois — qui à rien S2 — Au vieux]

Above and right:
Winter 1962.
Filming *Antoine et Colette* (with Jean-Pierre Léaud and Patrick Aufay).

Above right: Truffaut had written a first résumé three months before called *La Fougue d'Antoine* (*Antoine's Passion*) after the original title of *Les Quatre Cents Coups: La Fugue d'Antoine* (*Antoine's Flight*).

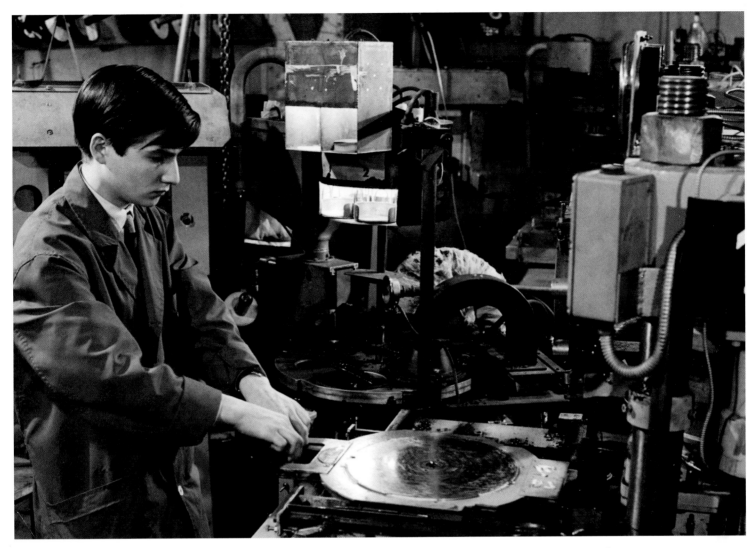

whereas he left her much more freedom and latitude for improvisation in the scenes of daily life, and how he had her make certain gestures: turning her head, crossing her legs, tugging on her skirt, chewing her lip. Truffaut told Jean-Pierre Léaud to maintain a steady gaze and gave him very precise directions about were to look, experimenting with a way of showing the beginning of an erotic obsession that would be developed in *La Peau douce*.

Truffaut also experimented intuitively with the system of flashbacks that he later developed more extensively in *L'Amour en fuite*. Jean-Pierre Léaud was reunited with Patrick Auffay, the young actor who played Antoine's pal René, and Truffaut decided to exploit the living material he had at his disposal by flashing back to one scene, the one where Antoine hides at the foot of the bed when René's father appears. And when Antoine takes a room that faces Colette's apartment, Truffaut filmed – almost 20 years before *La Femme d'à côté*, but in a less tragic vein – a character who watches the comings and goings of the woman he loves until the moment the lights in the apartment across the street are turned off.

Dining gaily with Colette's parents, Antoine says he no longer see his own parents very much. In his first treatment Truffaut crossed out a paragraph about Antoine visiting his parents. His father recalls his pranks and how much trouble they had raising him; his mother says, 'That's over – all that is forgotten. Let's talk about something else,' after which Antoine's father makes him blush by talking about girls, teenage acne, etc. Truffaut preferred to dispense with this autobiographical allusion because he did not want to aggravate the schism in his own family, even though this time he was planning to give the mother a more flattering role. 'The way I've compensated for *Les Quatre Cents Coups* is by having very sympathetic adults. This time I've shown a different family, one that works well. That's probably why I like this film better, because it's lighter, simpler and, I think, closer to life.'

Truffaut planned to make a comedy, beginning with Antoine's home-made alarm going off – a Chaplinesque alarm – or having fun with wacky effects like the appearance of Georges Brassens' bust in the aisle of the record factory, where the words of songs escape from records as Antoine handles them. He realized afterwards, however, that the film he had made was sadder than he had planned. Even though the ending was more ironic than the ending of the story he lived in real life, the humour was mixed with bitterness. In the last shot Antoine, supplanted by a rival, finds himself with Colette's parents in front of the TV. 'It's the third time this has happened to me,' Truffaut wrote after finishing *Jules et Jim*, 'starting a film I think will be amusing and realizing along the way that only sadness will save it.'

La Peau douce

La Peau douce (1964)
Soft Skin

'It has been much less pleasant making this film than my others. It's painful, too hard, demoralizing,' Truffaut wrote to Helen Scott at the end of 1963. 'Jean Desailly, who will be on screen from start to finish, doesn't like the film, the character, the subject or me, so our relationship is furtively hostile. Françoise Dorléac is charming, excellent and conducts herself as well as Jeanne. Nelly Benedetti, the other woman, begins tomorrow, and since no display of bad taste is too appalling for me, the Lachenay marital quarrels will be filmed in my apartment, rue du Conseiller Collignon.' He was halfway through shooting a film he first planned to call *L'Amour, le jour* before changing the title, as Jean-Louis Richard recalls, to *La Peau douce* because, he joked: 'It's by her soft skin that one recognizes Ginette.'

For the first time Truffaut experienced an unhappy shoot, one that was tiring and, apart from his relationship with Françoise Dorléac, devoid of harmony, as if the severity with which he had decided to treat the subject had affected him and the atmosphere on the set. His personal life was in crisis while he made this film partly composed of autobiographical ingredients, and even though reactions to *Jules et Jim* were favourable, Truffaut's morale had been poor since its release – all the more since he had had no luck in the meantime setting up his project of adapting *Fahrenheit 451*. ('I emerge from *Jules et Jim* as if from a humiliating failure, and I can't understand why,' he wrote to Helen Scott a few months before.) Certainly, he would have preferred to give the role of Pierre Lachenay to François Périer. He had little appreciation for his leading man, with whom he could not manage to get along as he would have liked. Unlike Françoise Dorléac, whose gestures and line delivery Truffaut was obliged to slow down, from the very beginning Jean Desailly did not give the film-maker the speed he wanted. 'Truffaut was preoccupied with the rhythm people spoke at and didn't like clumsiness,' recalls the editor, Claudine Bouché. 'He couldn't stand an actor who needed two tries to open a door. Desailly, who is a very good actor, irritated him constantly because he couldn't get the timing right – it started when he couldn't open his briefcase in one try. Truffaut said: "I made a stupid mistake – I took a guy who's bigger than me". Sometimes violently unfair – with others and with himself – Truffaut would none the less create in *La Peau douce* one of his most remarkable, carefully crafted films.

A transitional film.

Actually, *La Peau douce* was initially a small replacement film. Since the end of 1962 Truffaut had been looking for a way to make *Fahrenheit 451*, the financing of which, running aground again and again, had turned out to be impossible. At the end of the spring of 1963, frustrated by new delays and not having filmed for almost two years (apart from the few days of filming on *Antoine et Colette*), he decided that rather than risk losing his production company, he would prepare a 'transitional' film as quickly as possible, which he went to Cannes to write with Jean-Louis Richard during summer 1963. 'I'm leaving this afternoon to write the new script with Jean-Louis Richard,' Truffaut informed Helen Scott in July 1963. 'It will be easy to write because it's very close to life. The film will be indecent, completely shameless and rather sad, but very

Françoise Dorléac behind the camera.

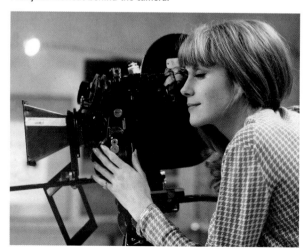

simple. It will be written fast, filmed fast, distributed fast
and, I hope, will make back its money fast.' Truffaut got
along very well with Jean-Louis Richard, Jeanne Moreau's
former husband, an actor turned screenwriter with whom
he had just had a lot of fun writing the script for the
Moreau vehicle *Mata-Hari*, to be filmed by Richard the
following year. Truffaut gave his co-writer the role of the
boorish pick-up artist who approaches Franca at the wrong
moment at the end of the film and is insulted in the middle
of the street, and Richard also supplied various voices
we hear off-screen, such as the TV sports announcer.
Working for hours at a time behind closed shutters,
drawing on newspaper items and exchanging anecdotes
and personal experiences at top speed, the two accomplices
wrote the first draft in barely 20 days, a version that
contained the essence of the film and ended with Franca's
murderous act. 'In close-up, Franca fills her lungs with air
and exhales as if she were emerging from underwater.
A great relief. Off-screen we hear the owner giving the
number of the police over the telephone at the bar.'
This ending that Truffaut wrote by hand on a few sheets
of flimsy paper shows how much he already had the film in
his head. For although the film was written in a few weeks,
the idea was not new to the film-maker, who recalled that
he had started developing it a few years earlier from the

image of an adulterous couple kissing in a taxi at 7.30
in the evening before each went home for dinner – a
very carnal kiss, accompanied by the sound of their teeth
clashing. Ultimately the image did not appear in the film,
but it influenced its tone. 'I've had all these notes on
adultery in my head for so long that the haste with which
the script was written may not be apparent' (still writing
to Helen Scott, in September 1963). From the moment
Truffaut read the news item in *Détective* that gave him the
ending of the film – a woman who shot her husband on rue
de la Huchette with the hunting rifle he had given her as a
present – Truffaut was ready to take the plunge.

The Hitchcock touch.

In a way that is rather exceptional for Truffaut, this first
draft was written with extreme, almost clinical precision
– it is almost a shooting script already, particularly in the
scenes without dialogue, where the description of shots,
gestures, looks and significant objects is often very detailed.
This no doubt was the influence of Truffaut's assiduous,
almost daily viewing of Hitchcock films a few months
earlier with two collaborators at the Brussels Cinémathèque
for the 'Hitchbook' he had been preparing since 1962 and
published in France in October 1966, some months after
he finished shooting *Fahrenheit 451*. He added, for instance,

LA PEAU DOUCE.

N° 0 - LE QUAI D'UNE STATION DE METRO.

- Gros plan d'un homme inquiet qui allume une cigarette *et regarde droit devant lui*
- *Ce qu'il voit : un peu de monde sur le quai et ~~la rame du quai d'en face~~*
- ~~On repasse sur la station~~ *Gros plan de l'homme qui regarde partir le métro qui se met en mouvement. On le suit en panoramique de droite à gauche. le métro*

- L'autre rame apparaît en sens inverse au fond du tunnel.

- On repasse sur l'homme, la tête tournée vers la rame qui arrive. Il *ôte la cigarette de sa bouche.* tourne la tête, ~~appuie~~
 - *l'Homme* ~~Kla~~ la main contre le mur.
- ...~~s~~'écrase ~~avec~~ ~~rapide~~ (Plan rapproché) ~~sxx~~~~bxxdxxxxdxxquaixdxnxx~~

 ~~inxxxdxxix~~

- L'homme ~~nxxxxxxxx~~ se lève et s'avance vers les rails, au-delà des autres voyageurs qui se tiennent immobiles *sur le quai.*

- Il regarde vers le tunnel

- Le métro arrive

- L'homme en pied en bordure de cadre ~~Le métro entre dans cadre~~
- ~~le métro entre dans le cadre.~~
 ~~Travelling à la vitesse du métro sur l'homme~~

- Plan de l'homme qui baisse la tête

- Plan fixe sur les rails (avec bruits et ombre du train *qui avance*)

- Les jambes de l'homme, coupées au genoux. Il saute.

- Plan de l'homme, coupé à la ceinture *Il tombe hors cadre.*

- Le plan le plus général de la station. Cri et grincements de freins.

- Les gens se précipitent à l'avant du métro, stoppé au premier tiers du quai

- Plan rapproché du chef de gare qui avance vers le métro.

- Un employé court vers la queue du train immobilisé dans le tunnel.

- A l'intérieur du dernier wagon, Pierre, regarde sa montre. *le billet de métro ~~est~~ plié en deux est coincé dans son alliance.*

- Un voyageur ouvre la porte pour regarder ce qui se passe. ~~métro est plié dans son alliance.~~

- L'employé qui courrait arrive et demande aux voyageurs de descendre par le tunnel *du wagon et de gagner le quai en marchant un peu dans le tunnel.*

Left: First version of the screenplay: opening with a suicide on the metro, a memory of Audiberti's novel *Marie Dubois*.

Right: A note from Claude Chabrol and Stephane Audran: '*La Peau douce* is in our prayers. Father Claude and Mother Stephane.'

Below and right: A telegram sent by François Truffaut to Jacques Demy after *Les Parapluies de Cherbourg* and Jacques Demy's reply.

JACQUES DEMY

Ton télégramme est une pure merveille

et je veux te dire encore combien j'ai aimé La Peau douce
Ami
Demy

1/ on enlève le dessert
2/ Jean qui se tache
3/ réaction tache Nic. regards corsages =
4/ Pierre corsages - livre d'or
5/ Corsages → réaction corsages -
6/ livre d'or arrive - sortie Nicole

Lui = Elles ont le même corsage
Elle = Oui, c'est ça
Lui = C'est pas de très bon goût
Elle = C'est même de très mauvais goût mais les femmes qui portent ça et bien (plus près à l'oreille) elles ~~font~~ l'amour

110.

130. INTERIEUR SALLE A MANGER . HOTEL COLINIERE

Pierre et Nicole se dirigent droit à leurs places habituelles, font un signe de tête aux serveuses. On doit, tout à coup, avoir l'impression qu'ils vivent là depuis longtemps.

On enlève le dessert

Du point de vue de Nicole ou de Pierre, à tour de rôle ou ensemble, nous examinons un peu les autres pensionnaires. Ils ont tous un air de clandestinité : femmes trop sensuelles, trop maquillées, robes ou ceintures faux-léopard; les types moustachus, en général assez costauds. Drôles de couples, patron-secrétaire ou plutôt fils-de-patron avec secrétaire, etc... Prévoir un couple à la ressemblance de Pierre et Nicole.

Chaque fois que l'on regarde un couple, il doit y avoir une action : une main vers l'autre, "à ta santé, je tire sur ta cigarette, goûte mon saumon...".

Il faut aussi que Pierre et Nicole se parlent de temps en temps sans qu'on entende ce qu'ils disent, mais tout en devinant qu'il s'agit de commentaires sur les clients, ou que l'on comprenne par mimiques : regards, sourcils, froncements, petits gestes, etc... Et, pendant ce temps-là, on perçoit des bribes de conversations des autres tables qui révèlent que la plupart des partenaires se connaissent mal : "Ah, tu n'aimes pas le saumon... tu ne manges jamais de poisson... avant, j'étais brune et ça m'allait très bien... où passes-tu tes vacances d'habitude ? - En Bretagne, c'est mieux pour les gosses...".

A un certain moment, la montre-réveil de Pierre se met à sonner et tous les regards convergent vers lui, Pierre, très gêné, bloque rapidement la sonnerie. Nicole s'amuse de cet incident.

7 - EXTERIEUR RUE.

Pierre se promène avec Nicole,ils s'acheminent vers le cours de
gymnastique.Donc ~~comme~~ ils ne peuvent pas se voir ce soir,elle part
à Milan,ah,mon Dieu,prendra t'elle la chambre 8I3 ?

*Nicole: Pourquoi 813 ? Ce chiffre ne lui
dit plus rien. Pierre lui rappelle que c'était
celui de la chambre d'hôtel de Nicole à
Milan. Non, il n'a pas spécialement
la mémoire des chiffres mais 813 est
un beau roman de Maurice Leblanc
dont les aventures d'Arsène Lupin ont
enchanté son enfance. Nicole ne
connaît pas. Pierre lui fera connaître.
[Ensuite, ils*

Above left and right: A scene cut
from the film where Pierre Lachenay
(Jean Desailly) buys Nicole (Françoise
Dorléac) a novel by the creator
of Arsène Lupin, Maurice Leblanc.
Because Truffaut admired the novel
813, he played with the number
in almost all his films.

Left: Franca's fury (Nelly Benedetti).

Opposite: Re-writing and blocking
of a scene about 'women who love
making love' during filming

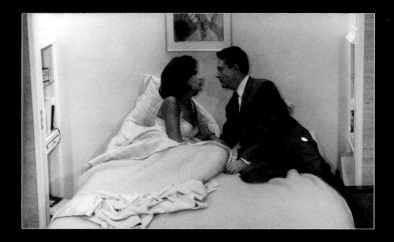

this detail to the opening scene that was to take place in the metro (which does not appear in the actual film): 'The metro ticket, folded in half, is caught in his wedding ring' – an image he would replace with the images in the opening credits of a woman's hand caressing the hand of a man wearing a wedding ring. Or this description of meeting the stewardess on the airliner, from which he did not deviate, except to substitute Lisbon's Airport for Milan's: 'The stewardess has sat down in a row ahead of Pierre on the other side. She catches him looking at her and notices that he is smoking. She looks at the No Smoking sign. Following her gaze, Pierre puts out his cigarette in the ashtray on the armrest of his seat. The stewardess's look. Shot of Pierre's hand putting out the cigarette. His wedding ring. Pierre looks out of the window. Arrival at the Milan Airport… Pierre leans out into the aisle and sees the stewardess near the pilot's cabin taking off her flat-soled shoes and putting on her high heels.'

Truffaut, who avoided any self-indulgence in most of his films, perhaps did so a little more in *La Peau douce* – even though he later said that he would have gladly accepted a punishment of 20 years hard labour to be spent remaking the film if he could make it with a different actor each year, starting with Michel Bouquet or Charles Denner. While filming and editing, and afterwards, he kept asking himself: Would it have been better if…? He sometimes regretted not starting the film with the killing of Lachenay, making the whole story a flashback that would have been more interesting because the spectator would already know the tragic outcome. In a way, the script was more explicit about this. The film was supposed to open with a suicide in the metro (described shot by shot in the first pages: a man waits, puts out his cigarette, then throws himself under the train that is pulling in. Pierre Lachenay, who is held up by this, finds himself stuck in the last car, which has stopped in the tunnel.) Finally Truffaut decided not to shoot the scene, which would have begun the film with the image of a tragic death, indirectly announcing Pierre's at the end. (Although the film starts with Lachenay running out of the metro, all that is left of the suicide is a reference when he talks to his wife.) He blamed himself because the ending surprised some viewers. Truffaut felt he had not found a way to make it seem inevitable and therefore less off-putting, and spoke about this whenever he presented the film in a festival. In fact, a film buff told me he heard Truffaut express this regret during a presentation in 1981, not long before the start of production on *La Femme d'à côté*, a film that he had not conceived as a flashback proceeding from the death of the lovers until after seeing a first cut that he had found unsatisfying.

The rifle.
To justify or not to justify: these doubts continued during the passage from script to film. Truffaut and Jean-Louis Richard asked themselves whether they should not prepare the audience for the last scene where Franca, pushing aside some hatboxes, takes the hunting rifle out of the closet. To make the incongruous presence of this object in a Paris apartment less unexpected, they first thought of showing it to the viewer in an early scene. In their first draft and in the shooting script, Franca, looking for ties to pack for Pierre,

knocks down a rifle that has been badly attached to the door. Pierre puts it back and they both race to the plane he has to catch. Later in the script the writers planned to recall the rifle's existence to subtly prepare the viewer for the moment when it would be used at the end. During the escapade at la Colinière, Pierre and Nicole go for a walk in the woods. To amuse her, Pierre pretends to put a rifle to his shoulder to shoot a duck. When Nicole launches into a diatribe against hunters, he gets out of it with a gag and adds that for three years he hasn't gone out hunting at all. Truffaut decided to do away with these rather heavy-handed justifications, so that all that remains in the film is a photo showing the couple hunting, sitting on a table in the entrance to the apartment, which we fleetingly glimpse behind Pierre or Franca (most clearly when Franca is looking for the newspaper Pierre wants: Truffaut inserted the photo in a scene when Pierre lies to make a pretext for escaping from the apartment). Caught as he frequently was between the desire to emphasise, to make himself understood, and the desire to go fast, Truffaut ended up regretting not having prepared the spectator better for the fatal outcome.

A part of himself.
Truffaut enriched the screenplay of *La Peau douce* with a hundred personal details that were either things he had noticed or things that were directly autobiographical: gestures that belonged to him. (In a scene that was planned for the middle of the film we would have seen Pierre put all his cigarettes in the same pack, an orderly gesture that would be saved for the end, just before Franca appears with the rifle. We also find it being reproduced by Charles Denner at the beginning of *L'Homme qui aimait les femmes*.) Details were worked into the *mise-en-scène* that were drawn from the film-maker's experiences participating in festivals or presentations of his films, where we can recognize his well-known repulsion for sight-seeing and visiting museums, his refusal of the picturesque. Shots of a restaurant, for example, would generally be filmed against a wall with as few extras as possible, and Lisbon exteriors were reduced to the bare minimum. 'Pierre didn't sight-see in Milan because he had work to do in his room,' we read in the first draft of the script. 'The person he's speaking to frowns slightly: "I hope that next time you'll have time to visit such-and-such"' – an idea that would finally be concentrated in the Reims episode (where the priest reproaches Lachenay for not visiting the famous smile). The director's pet peeves also turn up, like this description of a dinner with friends: 'Conversation. The important thing to show, without descending into satire, is that people always talk about love in a banal way, in a tone that is completely false, conventional and superficial: women in the Israeli Army, I want to marry Papa, etc. Pierre has a secret and wonders if he is the only one who does.' In the film Truffaut shows, in a series of close-ups, Pierre's discovery of Nicole's phone number written inside a pack of matches while the others are talking about a car breaking down in rue St-Denis. The conjugal scenes when a crisis is brewing also have a rightness that can only be based on observation. ('Show that Franca always thinks ahead,' the script indicated. 'Their next holiday, decorating the apartment, etc.') No doubt this accounts for the precision of the scenes where they quarrel, their

night-time reconciliation in bed after the scene of the lost
newspaper and Pierre's crisis of bad faith, and the little
scene in the morning when Franca raises the possibility of
spending a couple of days in the country and he responds
with an unfocused look: 'We'll see.' (He ends up spending
two days in the country, but with Nicole…) In keeping with
the obsessive personality he wanted his character to have,
Truffaut went so far as to use him to communicate his
own directorial demands in the scene in the forest, where
Pierre's fussiness is spelled out in the script: '"I don't like
your legs like that. No, not crossed…" Pierre goes over
and arranges her legs himself: uncrossed, one a little higher
than the other with her hand cupping the knee… "There,
that's good."' While the character's obsession, his fixation
on the young woman, is absorbed by the *mise-en-scène*
and reinforced by it, the script planned to make more
of Pierre's intellectual superiority over Nicole. He was
supposed to catalogue the new books in her library and
discovers that she does not know what he is talking about
when he mentions a friend who wrote a book about Dien
Bien Phu – sour notes that Truffaut removed from his film,
preferring to establish an equality between the characters
by giving the young woman an emotional lucidity of
which Lachenay is incapable, to the point of punishing
the character who is closest to himself.

After seeing a rough-cut that was too long, Truffaut had
to make numerous cuts and sacrificed quite a few scenes
that he had shot. In February 1964 he told Helen Scott
he had seen a 90-minute version of the film where 'at the
end of the screening the characters still hadn't got to
Reims for the conference! It was too long, full of muddles
and redundancies – in short, an abominably disappointing
screening'. Before adding: 'You can't write a script in 22
days without it showing, even if it comes easily… There's
nothing more stupid than filming scenes you have to throw
away later: days of work thrown away and millions of
francs with them.' Truffaut did away with redundancies
and focussed the stay in Lisbon on the meeting with the
stewardess, the scenes in the lift, the corridors of the hotel
and Lachenay's exultation at getting a date, when he turns
on all the lights in his suite, while saving for Reims the
situations of secrecy and getting caught *in flagrante delicto*.
Some scenes like that had already been written for Lisbon:
when he is going to meet Nicole, Pierre is plagued by a
cultural attaché and has to pretend he is not meeting her.
Truffaut shortened the scene in the Lisbon restaurant,
keeping for later differences that would only be brought out
when the affair is ending. ('Nicole asks for explanations of
the dishes, while Pierre rapidly chooses fairly simple things,'
said the screenplay.) He also cut a scene that duplicated
the episode in Reims: Pierre has Nicole wait in the car in
front of a Paris restaurant, then gives up having dinner with
her because he has seen a guy he knows accompanied by
his wife – a scene inspired by the Jacoud Affair, the second
news item that Truffaut incorporated in his story: 'Going to
a restaurant with Linda Baud, Jacoud leaves her in the
car, goes to a second restaurant where he chooses a table
in the back of the room and seats her facing the door. Each
time the door opens he wonders who it is. This character
pleases me as an emotional person and as a man who, each
time a problem appears, chooses the worst solution.'

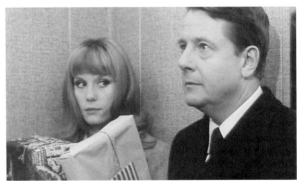

With Françoise Dorléac while filming the scenes in the forest.

With Jean-Louis Richard and Nelly Benedetti, during the rehearsal of the scene where Franca is accosted by the pick-up artist.

Cuts.

Most important, Truffaut decided to sacrifice all the scenes in which the adulterous couple experiences, even fleetingly, a moment of *détente*, leisure or amorous happiness, scenes that were written in the script and for the most part filmed (notably those where Pierre Lachenay visits Nicole's studio apartment, filmed in the apartment of Florence Malraux). He cut the scenes of '*marivaudages*' (playful flirtation), as Truffaut called them in the script, where Pierre bunks off work, finds Nicole's apartment and buys her flowers that he leaves at her door, pretending to know nothing about them when they arrive. The script makes Pierre a child, playing truant and rediscovering the pleasures of love. When Nicole tells him she has lost his phone number, he amuses himself by writing it everywhere in her apartment, 'on the flyleaf of a book, on the edge of a board, on the heater in the bathroom, on a porcelain spice box and an object near the telephone…' Nicole plays a song that she loves for him on a defective record player; later he buys her a new one. In the first version of the script, when Nicole draws Pierre into her room to spend the night, Truffaut added: 'They move forward in the shadows, and Pierre is like a child.' At the airport, before Nicole leaves on a flight, the lovers have time to spend at a bar, in a bookshop, at a cinema (where they see a film about Paris in 1900 in which a man jumps off the Eiffel Tower for the camera wearing a parachute and is killed, 'one of the first victims of cinema'). The script also included an explanation of one of the most recurrent private jokes in Truffaut's cinema, the number 813 (which we find drawn in pencil by the architect on a wall of the Lyon apartment in *La Sirène du Mississippi*, along with other notes). Because Nicole's room in Lisbon is number 813, Pierre explains to her that it is the title of a novel by Maurice Leblanc, the author of the adventures of Arsène Lupin, which he loved as a boy. ('Nicole doesn't know them. Pierre will introduce her to them.' He then buys her an Arsène Lupin book at the airport bookshop.) Truffaut pruned away these scenes and once again cut the scene about stockings that was already cut from *Tirez sur le pianiste* (a man awkwardly buying stockings for a woman in a lingerie shop). He also cut the scene where Nicole strips in the car, which he filmed again with Catherine Deneuve in *La Sirène du Mississippi* but left in. While Pierre drives, Nicole changes her sweater for a blouse (which goes better with the skirt she has put on in place of the jeans her lover has rejected). Pierre pretends to close his eyes; the car zigzags. A car coming from the other direction starts zigzagging too. The lovers laugh. In the script, in a brief, rather silly digression, Pierre and Nicole were supposed to see a woman in a slip standing in the street and calling to someone named Adonis. The Adonis in question turns out to be a moustached cop who has mounted his bike while blowing kisses to his Dulcinea – the theme of the cop in love that turns up again in *La mariée était en noir*, in a story Charles Denner tells to his Diana the Huntress.

As written, the character of Pierre Lachenay is gayer and more whimsical (closer, obviously, to one facet of Truffaut himself) than he is in the finished film. In a scene between father and son (just before the start of shooting Truffaut replaced the little boy he had originally cast with Sabine Haudepin, the girl he had already worked with in *Jules et*

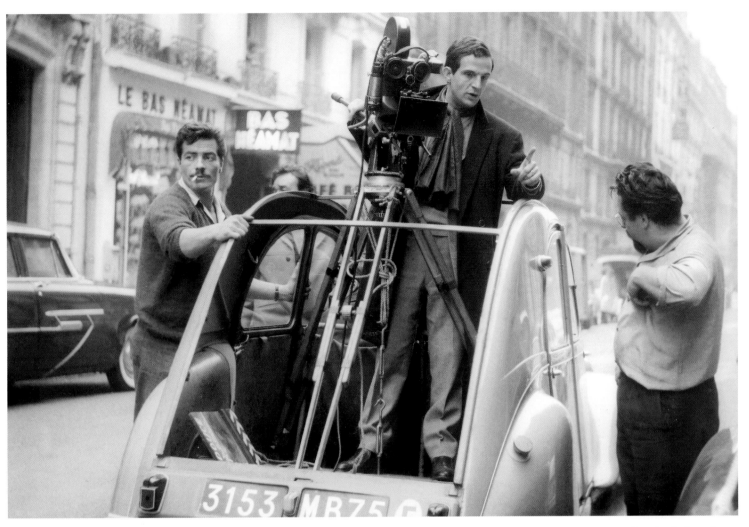

Shooting *La Peau douce*.

Jim), Pierre brings the boy a record and makes a game of not giving it to him right away: 'Pierre puts the record on his head and runs his fingers along the grooves while singing; a father-son rumpus ensues, until a vase is broken by accident. Complicity between father and son, the mother being in the kitchen…' On his copy of the shooting script Truffaut crossed out the character's monkey tricks (which it is easy to imagine being autobiographical), as if he had given up any thought of having them played by such a serious actor. Truffaut also explained – giving reasons that sound like excuses – that he cut some of the scenes of good times at the outset of the affair because he felt they had been done badly: 'In *La Peau douce* I filmed scenes for the first time knowing that this wasn't how they should be done. That happened in the stewardess's little apartment. There I was in this little setting, which had pleased me when I examined it quickly. But when it was time to shoot, I realized that it wasn't right at all.' The truth is that Truffaut had decided during shooting to sacrifice everything to unity of tone, making a tough film, so depressive that it runs the risk of being repellent, a film like a scalpel where there is no place for scenes of relaxation and recreation. 'The subject sets the tone,' he would say whenever he was asked about the film's severity. 'It's about terrible things. It's absolutely impossible to have digressions. The character played by Jean Desailly is hemmed in; the trap closes on him. No smiles possible.' *La Peau douce* became a tense film, shot through with guilt, a film of constant anxiety. In Reims, when Lachenay is trapped into dining with the cultural leading lights of the city, a young girl asks to speak to him. Even though she is not Nicole, come to make a scandal, but just a young girl who wants his autograph, Truffaut still took care to film the anguish in his character's face and body, making the spectator feel it. Hemmed in, constantly racing the clock, obsessed to the point of compulsiveness, Lachenay is caught in his own trap. He can no longer escape from his own fearful, cowardly character. 'It had to be cold. And when you start something, you have to stay with it,' Truffaut would say, recalling how he suffered during filming and editing from the need to be dry and the impossibility of letting any warmth into the film. Truffaut kept only one scene at the airport, a terrible scene of an amorous impulse stifled, when Lachenay, who has fled to Orly after an argument with his wife, writes a very beautiful telegram from a man carried away by love to Nicole, who he thinks has taken off ('Since knowing you I'm another man, and that man can't imagine living without you') – a telegram he crumples in his pocket like a coward when Nicole appears because her flight has been delayed, finally throwing it away. On the route to Reims, Truffaut cut the naughty striptease scene but kept the scene in the petrol station where Pierre looks disgustedly at Nicole's jeans and asks her if she has any dresses in her luggage, until she, wishing to please him, goes and puts on a skirt. What Truffaut concentrated on was the fixity of Pierre's drawn-out looks, with close-ups of the petrol pump and the numbers spinning, a fixity that makes Pierre an obsessive character and a man hounded by anxiety, even when he is standing on the side of the road with lorries driving past, as soon as Nicole disappears for even a few minutes. Likewise, for the scene in the lift, Truffaut

would later recall that he asked his actors to show no feeling – just neutral, precise looks, which were prolonged occasionally by brief freeze-frames.

Apparent insignificance.

Throughout a film that is less a romance than a story of desire, lyricism is paradoxically borne from apparently thankless choices (stares that are violently fixated or turned on the grey walls of the lift), even as the thread of anxiety that begins in the first shots of the film is being spun. Truffaut made *La Peau douce* in reaction against his previous films: abandoning Scope, eliminating any flights with the camera or use of landscape, abstaining from charm and fantasy, editing excessively and giving priority to the most common objects, from speedometers to telephone dials. *La Peau douce* was booed at Cannes and treated with contempt by most critics, who saw it as just another comedy of manners without seeing how the comedy had been appropriated by a depressive, pessimistic style. Truffaut suffered from these reactions. Nevertheless, feeling and involuntary poetry appear in this film in a new way: through the inserted shots of light switches, which a man's hand turns on and a woman's hand turns off again when they enter a hotel room, or when a couple, accompanied by Delerue's music, turn off the lights as they pass through their apartment on the way to the bedroom in one of the film's long moving shots. Through the ballet of keys being exchanged before the door of a hotel room, or the lights that Lachenay, suddenly freed, turns on in all the rooms of his suite when he speaks to Nicole on the phone and she agrees to see him. Through this apparent insignificance, which led to new misunderstandings of his cinema, Truffaut achieved, in the driest manner imaginable (for the lovers' story is not even sustained by the alibi of passion as it will be in *La Femme d'à côté*), a quasi-mathematical precision in the representation of desire and its impossibility, and one of his most intense films.

'Something happens to him that has happened to many others but never to him. From then on, everything he does is for the worst,' Truffaut said of his character, regretting not having chosen between telling the story of a madman and a normal man. 'I portrayed him as hyper-nervous, almost to the point of madness, to avoid a) dullness and b) bourgeois drama,' he wrote to Helen Scott. Adding, correctly: 'This presents a great risk *vis-à-vis* the public, because I don't think they're going to find him very sympathetic.' He regretted not having Pierre faint when, trapped at the restaurant with the nuisance from Reims, he does not dare go to help Nicole, whom he sees, through the window, being accosted by a creep. Lachenay is a normal man and a madman whose look, caught in the door of a lift, betrays the crudeness of his desire.

Two years later, while filming *Fahrenheit 451*, Truffaut defined the cinema as the art of creating beauty without seeming to: 'What is nicest about the *métier* of film-maker is that you can seem to be really up to nothing at all; you can look like an idiot or just a guy who has filmed beauty without knowing it.'

Previous pages and below: Jean Desailly and Françoise Dorléac.

Fahrenheit 451 (1966)
Fahrenheit 451

Opposite: François Truffaut with Julie Christie as Linda, fireman Montag's wife.

Truffaut's shooting script.

'Fortunately, in one of the essential scenes, when he [Oskar Werner] was supposed to faint in front of the Captain, he agreed to do it. This fainting fit was very important to me, almost the key to the film.'
'Why?'
'Because fainting was the best way to escape… The ideal ruse. In a way, *Fahrenheit 451* is a film in praise of ruses. The ideal means of resistance.'

This is how Truffaut presented his film for the 1965 Venice Film Festival in an interview with *Arts*. A turning point in his career, *Fahrenheit 451* was nonetheless a partial failure. For one thing, Truffaut had trouble communicating with his main actor, Oskar Werner, whose needs and expectations had changed since they made *Jules et Jim*. This misunderstanding, which Truffaut, increasingly unhappy and irritated, wrote about in the diary of the shoot he kept for *Cahiers du cinéma*, was not without consequences for the film. Also, *Fahrenheit 451* was a cumbersome project, one that had been put off for too long because the young film-maker, despite the good reputation he enjoyed thanks to his first three films, had considerable difficulty setting it up. These delays and difficulties frightened Truffaut, as they put his production company in danger. He went more than two years without making a feature, and would have gone longer than that if he had not thrown himself into writing and filming *La Peau douce* as a 'small replacement film'. Even before he was sure of making *Fahrenheit 451*, Truffaut put in place a system that would allow him never to be without a next project, because he would always be able to substitute another film for one that could not be made as planned.

Filmed in January 1966 at Pinewood Studios near London, Fahrenheit 451 was a project Truffaut planned to make in France and in French, after briefly thinking of doing it as a Franco–American coproduction in 1962. The producer Raoul Levy brought Ray Bradbury's book to his attention in 1960. Perhaps Levy could have co-produced the film, but he was probably scared off by the Manifesto of the 121. ('Declaration of the right of civil disobedience during the Algerian War', so called because of the 121 writers, academics and artists who had already signed it, a list to which Truffaut added his name on 13 September 1960.) In any case, that is what the film-maker believed when he acquired the rights to the book in spring 1962. Since the film-maker insisted on making it in colour and with an adequate budget, it promised to cost more than his previous films, and the theme put off possible financiers. In France and then in America, prudence repeatedly forced potential backers to pull out. 'Why did I take three years to start making it?' Truffaut wrote in his Fahrenheit Journal. 'Simply for money reasons. In the euphoria of Jules et Jim, I had thrown myself into a project that was too big for me.'

Truffaut contacted Ray Bradbury about the project, but the author refused to work on the screenplay. Having already adapted his novel for the theatre, Bradbury was tired of it and thought he would do a bad job. Truffaut discussed his desire to adapt the novel with Jean Gruault in 1961, when they were writing *Jules et Jim*. Gruault wrote a first attempt at a screenplay a few months later, which the film-maker completely rejected, except for one clever idea proposed

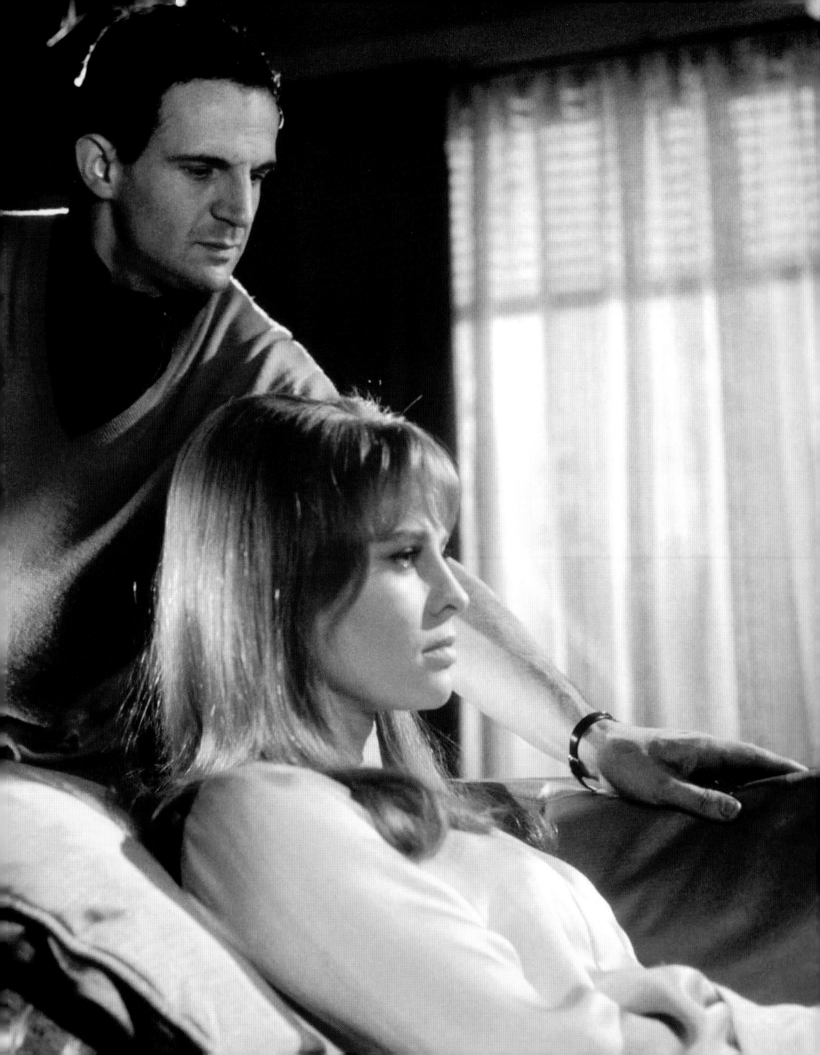

RELIRE LE SCENARIO POUR:

1) condenser le dialogue au maximum:le remplacer par du visuel

2) pour inventer et caser des détails de Science-Fiction.

3) pour étudier l'évolution des personnages,un par un.

4) pour vérifier le principe:scène quotidienne dans un contexte inhabituel et
 scène extraordinaire dans un cadre réaliste.

5) suspense et dosage de pur visuel. Tenter de les nourrir et dilater.

7) attitude du public devant ou après chaque scène:les sentiments,émotions,
 les réponses à l'éternelle question:"Et après ? "

8) les questions de "point de vue".

9) pour caser les généralités et les détails abandonnés en cours de rédaction.

10) l'idée de livre en tant qu'objet.

11) voir attentivement (et avec Coutard) tout ce qui peut-être tourné
 a) en accéléré b) au ralenti c) à l'envers d) à l'envers joué à l'envers

12) pour répartir tout ce qui est vu et dit à la T.V. ou seulement dit.

13) pour caser quelques détails drôles pour soulager après tension

14) pour relier les scènes entre elles intimement (crochet,maillons)

15) du point de vue Montag, Azusve (est-ce qu'il agit ?
 est-ce qu'il aime Clarisse)

FAHRENHEIT 451

NOTE CONCERNANT LA POST-SYNCHRONIZATION DU ROLE DE MONTAG

Indépendamment des questions de la qualité du synchronisme, de la prononciation
anglaise pour ce rôle, et des variantes possibles dans le vocabulaire, toutes
questions pour lesquelles je ne suis pas competent, et m'en remets définitivement
a Norman Wanstall et Helen Scott, je souhaite qu'Oscar Werner puisse rapporter
des ameliorations dans sept scenes du film:

Nos. 21 a 27: Première scene de Montag rentrant chez lui et retrouvant Linda.
Dans cette scene, Montag parle trop fort. Bien qu'il soit a une certaine distance
de Linda, il ne doit pas donner l'impression d'hostilité, mais de vie normale.

No. 70 : Au lendemain de l'évanouissement de Linda. Même reproche, mais
cette fois, plus serieux, car Montag doit chercher a obliger Linda a se rappeler
ce qui s'est passe la veille, mais sans animosite -- plutot sur un ton fatigue,
sans quoi, nous sommes dans le contre-sens absolu.

No. 79 : Pour la première fois, Montag lit un livre, la nuit devant la television.
Effectivement, il doit lire comme un enfant qui commence a apprendre, puisque c'est
l'intention de la scene, mais il devrait avoir la voix claire.

No. 84 : Scene du bar avec Clarisse. Dans toute cette scene, Montag parle
fort alors qu'il s'adresse a Clarisse, et qu'il est tout pres d'elle. De la facon
dont la scene est jouee actuellement, il est incroyable que les autres clients du
bar ne se retournent pas sur Montag qui a l'air d'engueuler une femme. Cela devient
encore plus sensible a partir de l'arrivee de l'informant.

No. 95 : Dans la salle de bains, entre Linda et Montag. Cette scene est jouee
trop brutalement par Montag, presque criee, en particulier, ses deux phrases: "And that's
what interests me now" et "You've got your pills, haven't you?". Touce ce dialogue a
ete ecrit dans un autre esprit: un homme normal s'adresse a une femme qui ne l'est pas.

No. 110 : Montag invective les trois amies de Linda. La encore, il s'agit de ne
pas confondre la vehemence et les hurlements. Cette scene se placant immediatement
apres le suicide de la vieille femme que Montag a laisse s'accomplir, toute exageration
peut donner une impression penible. On pensera que Montag,qui n'ose pas affronter son
Capitaine, ni ses collegues, a peu de merite en insultant quatre femmes sans defense.

A propos de ce *source-flamme* manié (dangereusement)
dans sa (scène) du 1er April Cusack, Oscar
Werner devient nerveux et une violente
dispute nous oppose pendant cinq
minutes (que nous nous accrochions). C'est la deuxième fois depuis le
début du tournage et je m'aperçois
qu'il est impossible de tout
raconter dans ce journal destiné à paraître sous
la terminaison du film.—
Je viens justement de lire
ces derniers soirs les souvenirs de Sternberg
et je dois convenir qu'Oscar
Werner est plus facile à travailler que
Emile Jannings ou Charles Laughton !

Julie Christie sera épatante, aussi facile
à travailler que Jeanne Moreau ou Françoise
Dorleac, comme elles faisant confiance, ne
chipotant jamais et ne posant jamais de
questions abstraites du genre : "Que ressent-elle
quand elle dit plati ptata ..."
Dans ce rôle de Linda je vais la filmer généra-
lement de profil en réservant la face pour le
rôle de Clarisse. Son profil est justement
très beau à la manière d'un dessin de
Cocteau ; le nez droit fantastique et la lèvre
supérieure très ourlée. Immense bouche, large, un
peu vampire.

Above left: Preliminary notes, including instructions to 'condense
the dialogue as much as possible, replacing it with visual ideas'.

Above: Each night, Truffaut wrote a journal for *Cahiers du cinéma*.
Everything was going well with Julie Christie, who played Linda
and Clarisse, but Oskar Werner (seen below on the right) resisted
the film-maker's directions for playing Montag.

Left and below: Truffaut looped scenes that Werner had acted in a
way that contradicted his direction. According to his dubbing notes,
the first scene with Linda should give an impression not of hostility,
but of normality. After her suicide attempt, her husband should ask
what happened, with no animosity – 'a weary tone instead, or else
the meaning of the scene will be completely opposite'.

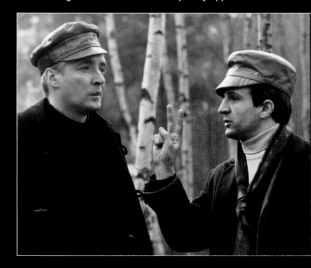

by his co-writer: the replacement of the robot dog-spy in the novel with the idea of the firemen's pole that betrays Montag, who can no longer use it once he has read a book. Put off by Gruault's enthusiasm, Truffaut, who wished to be sole master of his project, engaged Marcel Moussy, with whom he wrote a new draft at the end of the summer of 1962. He hoped to make the film at the end of the year and offered the role to Jean-Paul Belmondo. If Truffaut was thinking of making a film in America and in English at this point, it would not have been *Fahrenheit 451*, which seemed too big a project, but a rather light comedy. He had received a screenplay, *Love in Connecticut*, which he saw as offering a possible role for Jean-Pierre Léaud. 'What would be amusing would be to have Jean-Pierre Léaud speaking a form of English not much better than mine, having to fall back all the time on the titles of American movies,' he wrote to Helen Scott on 2 June 1962. But he pulled back: 'What bothers me in the script is that the boy is too sure of himself; he is certain in advance that he is going to seduce the woman; I'd make him more crafty and more timid. He would move his pawn with subterfuge and naivety; he would gradually immerse himself in her bed rather than pushing her…'

In July 1962 Truffaut knew that he would not be making *Fahrenheit 451* until next spring. In December 1962, having given up on Belmondo (the actor was too expensive and rarely available), he sent the novel to Charles Aznavour: 'Although the science-fiction aspect worries you a bit, I will explain the way it's going to be adapted, which simplifies all that considerably: the film will show today's reality slightly exaggerated in a disquieting way.' Truffaut informed Bradbury of his plans: 'If Montag turns out to be Charles Aznavour, the other firemen will be short and slight like him. They will be little men.' In January 1963 Aznavour accepted the role, and Truffaut prepared to shoot in the spring; at the same time, he was finishing the book of Hitchcock interviews, also planned for the spring. (Like *Fahrenheit 451*, the book would not be ready until 1966.) Dissatisfied with Moussy's first version, Truffaut started to work on the screenplay again with Jean-Louis Richard, with whom he had just written the screenplay for *Mata-Hari*, starring Jeanne Moreau. 'I'm working quite a lot,' he wrote to Helen Scott, 'because I'm afraid of the year 1963. I'm going to shoot *Fahrenheit* in June and want to finish the "Hitchbook" before that if I can.' He was planning to co-produce the film with Henry Deutschmeister of Franco

A gift from the skies: on 14 April, snow falls on London and Pinewood Studios, permitting Truffaut to film a beautiful final sequence.

Firemen burning books.

London Films. At the end of March 1963 Truffaut sent Charles Aznavour, who was touring the United States, a telegram to encourage him: 'My Dear Charles, All is well between Deutsch and me. We are starting to look for a distributor. I'll be ready to shoot beginning 10 June in Paris, in colour. Have a big success in New York.'

But the negotiations led nowhere, and in June the film was put off indefinitely. 'I would have been happy and proud to help you prepare *Fahrenheit 451*,' Maurice Pialat, who was supposed to work on the film, wrote to Truffaut. 'I have heard that you've had to abandon the project, and I deeply regret it. You would have made a beautiful film.' Truffaut was beginning to envision a transatlantic solution. He said he was ready to have the script translated into English so that it could be set up with independent producers in New York. Later he would judge the version written with Jean-Louis Richard with affectionate severity. 'I should add the adaptation Jean-Louis Richard and I wrote never aroused much enthusiasm, except from three or four friends,' he wrote in the journal he kept during filming.

At the beginning of the summer Truffaut gave *Fahrenheit*, which had become *Phoenix* in the English-language version, to Lewis Allen, a New York producer who had approached him to adapt Nathanael West's *The Day of the Locust*. Paul Newman, whose name had come up even before the rights were purchased, was mentioned; the film could be set

up using his name. But Truffaut wasn't wild about the idea, all the more so since Newman demanded a major rewrite, and the film-maker would have lost his independence. 'I find him very handsome, especially when he's filmed in colour, and I prefer him to all the actors in Hollywood who are big at the box office: Rock Hudson, Gregory Peck, Charlton Heston, Marlon Brando, Burt Lancaster, etc.', Truffaut wrote to Lewis Allen, fully aware that Newman's fame would have permitted him to have a large budget. ('I will admit I'd rather have six helicopters for the finale than one.') But he distrusted Newman's Actors Studio methods: 'It is out of the question for him to hold the wheel with one hand and scratch his nose with the other. I want both hands on the wheel, a certain stiffness and total neutrality.' Truffaut suggested other actors: Montgomery Clift, 'the American actor closest to Aznavour and therefore to the present script', Sterling Hayden, 'a gentle, sentimental giant, on the condition that he doesn't look as old as Robert Ryan', and Terence Stamp, whom he described as 'a kind of English Oskar Werner' – a rather amusing comparison in retrospect. Truffaut again insisted on shooting in colour and at the beginning of 1964. Changing course, he wrote and filmed *La Peau douce* from summer to autumn of 1963. In August of 1963 Lewis Allen bought the rights of the screenplay while agreeing to keep Truffaut as director. A series of contracts were signed between Allen-Hodgson Productions and Les Films du Carrosse. (Some of these, concerning the writing of

The monorail scenes were filmed in France near Châteauneuf-sur-Loire, where this experimental line had been built.

Fahrenheit, named Jean Gruault, who briefly worked on the screenplay, Marcel Moussy, Jean-Louis Richard; Claude de Givray in turn would write up a comparison of the various versions.) Several locations were considered: New York, Philadelphia, Toronto. Jean Seberg was mentioned to play Montag's wife in a production planned for spring 1964.

But new delays arose. Distributors refused to come on board without knowing who the star would be. Paul Newman, who wanted a more dramatic Montag, had a more political and sociological vision of the film than Truffaut. Other actors were approached during the course of 1964: Kirk Douglas, who might have been interested, then Terence Stamp, who would very much have liked to play the part. Peter O'Toole was also a possibility, and... Paul Newman, who expressed renewed interest. Discouraged many times, Truffaut was ready to get involved again. 'I'm waiting for *Fahrenheit* without becoming impatient,' he wrote to Helen Scott in July 1964. 'All it will take is a favourable sign from Peter O'Toole and my enthusiasm will rebound – I'll jump at the chance. It's a great and beautiful subject that must not be spoiled.' Lewis Allen tried to set up a French–Canadian production that would have had to be filmed in Toronto. By the end of the year Truffaut was hesitating between the coproduction possibility with Canada and a possible offer of a Swedish coproduction, which might have begun

shooting in May–June of 1965. At the same time as Sterling Hayden for Montag, Oskar Werner was pencilled in, but for the role of the Captain. Even though Truffaut often said he was prepared to rework the screenplay in order to get something he could modify during production, he was becoming a little nervous: 'Like *La Peau douce*, but for different reasons, *Fahrenheit* is one of those films everyone sees in his own way. Everyone wants to modify and manipulate it: not enough science fiction, too much science fiction, too strange, not unusual enough, not enough of a love story, too much love... Finally the only way to have peace is to tell everyone to go to hell' (Letter to Helen Scott, 16 December 1964). He refused to let Lewis Allen's wife, who translated and slightly rewrote the script, be credited as a writer. There were several points about which Truffaut was not inclined to make concessions, notably the idea of having a love story between Montag and Clarisse, which he felt would be falling back into convention. After more delays, he was afraid he would lose Terence Stamp. He wanted him enough not to give in when Sam Spiegel, who was involved in discussions about a co-production, rejected Stamp's name because Stamp had refused to appear in one of his other films. Breaking off discussions with Spiegel was ultimately just fine with Truffaut, who had worried about the way the budget was swelling during this process. But to the film-maker's great regret, it was Stamp who finally pulled out of the project.

At the end of summer 1965 Lewis Allen succeeded in setting up the project with an offshoot of Universal as an English production starring Terence Stamp and Julie Christie. In autumn of the same year Allen had the idea of having Julie Christie play both Linda (Montag's wife) and Clarisse (the young neighbour who introduces Montag to books): he had noticed that her face changed – very round when her hair was short or pulled back, much thinner and more delicate when she wore it long. He timidly suggested this idea to Truffaut, who reacted enthusiastically and sent him a telegram: 'Dear Lewis: Your idea of Linda–Clarisse is excellent. We should think through the technical problems that might eventually arise. All the best. Truffaut.' To Helen Scott he admitted that he had sometimes been too quick to react against his producer: 'Lewis Allen has had the wonderful idea of having Linda and Clarisse played by the same actress with different hair-dos. This solves all the problems that have been driving me crazy for so long concerning height, age, look, etc. I have agreed to the idea, and my God, all the better if it's Julie Christie.' But in September 1965, Terence Stamp backed out, although the film was set for January. He seemed bothered by the idea of the actress playing two roles and worried about sharing star billing with Julie Christie. In vain, Truffaut wrote Stamp two long letters on 21 September. He used all his best arguments, stubbornly defending his decision: 'Having Julie Christie play both Clarisse and Linda finally gives me a chance to resolve the eternal problem of the thankless role and the glamorous role, to show two sides of the same woman, and at the same time to show that for most men their wife and their mistress are the same.' He flattered Stamp by telling him he was 'the poetic actor cinema needs at a time when Hollywood has become incapable of recruiting anything but playboys or G-men.' He identified him with the character: 'The role of Montag, because it unites innocence and revolt, tenderness and violence, the idea of primitive man and civilized man, because the character is poetic and believable, fairy-tale and human, is a superb role that should go to a superb actor. You are already this character in *Billy Budd* when you look at a book over Melvyn Douglas's shoulder. You are Bradbury's hero; you are Montag. I await news of you impatiently. I'm out of arguments and no longer know what to say, my dear Montag.'

But Truffaut wanted freedom to manoeuvre more than anything, as he had already written to Ray Bradbury in spring 1963: 'The essential things – that is, fidelity to your book and after that freedom for me in my work – will absolutely be preserved, whoever the actors or producers of the film may be.' And to keep his freedom, he let go of Terence Stamp despite everything, braving past and future difficulties with an élan that was no doubt more rhetorical than realistic: 'If you judge this idea to be unacceptable and our collaboration is over because of this, I will regret it very much, but I will wait as long as necessary, six months, a year, three years, to film *Fahrenheit* the way I want and without any external constraint.' Truffaut expected trust in his decisions from an actor. If Stamp stayed with him, he demanded from him '"total" trust, even if you see me giving up scenes you like or adding others, even if I hire the Beatles to play the other firemen,

I ask you to give me "carte blanche", as Charles Aznavour, Jeanne Moreau, Oskar Werner and Françoise Dorléac have done in the past'.

The story of the setting up of *Fahrenheit 451* is a series of failed rendezvous: with Charles Aznavour, with Paul Newman, with Terence Stamp and finally with Oskar Werner, who was really a replacement solution, and from whom Truffaut would not have the trust his predecessor had refused. Now that fame had arrived, Truffaut no longer found Werner the warm, modest actor of *Jules et Jim*, and after the first euphoric days of filming, many conflicts arose between them about how to handle dangerous scenes or even how to interpret the role. 'The character in *Phoenix* [the provisional English title of the screenplay] is a weak, closed-off, timid man whose violence is completely internalized, introverted', Truffaut wrote to Lewis Allen in July 1963, when the role was still going to be played by Paul Newman. The misunderstanding between him and Oskar Werner was profound. By way of avoiding all clichés, Truffaut had been ingenious in purging the screenplay of any implied love story between Montag and Clarisse, the argumentative young neighbour who leads him back to books, and for four years he had firmly refused all attempts to take the script in this direction. ('The script we have isn't perfect, but I believe it has a rather pure through-line and that it would be an error, for example, to develop a love story,' he wrote to Lewis Allen in September 1963. And to Terence Stamp, two years later: 'The role of Clarisse may seem flashier, but it is quite brief, and I have no wish to develop it by having a romance between her and Montag.' So he had no tolerance for Werner's temptation to systematically seek a romantic relationship with Julie Christie when she was playing Clarisse. ('New headaches with Oskar Werner, who wants to touch Clarisse's arms and shoulders, whereas I want no romance between them,' he noted on 22 February, after a little more than a month of filming.) Or Werner's insistence on adopting a brutal style with his wife and being sweet and seductive with the young girl next door, whereas in Truffaut's mind having the two roles played by the same actress would permit him to fight convention and finally give equal stature to the two women: 'After playing the violent husband with Linda, he wants to play the suitor with Clarisse, not realizing the harm he is doing to his character: odious at home with his books, a sweetheart outside with his teacher' (the *Journal* for 11 March). Truffaut tolerated even less what he saw as Werner's way of trying to hog the spotlight and shine at his partners' expense, and did not mince words about it: 'The greatest proof of amateurishness and stupidity an actor can give is the fierce desire to seem more intelligent than his partner. My favourite actors are those who love to look like fools: Michel Simon, Belmondo, Albert Rémy, Jean-Pierre Léaud, Michel Piccoli, Jean Yanne, almost all the Italians: Mastroianni, Gassman, Sordi, Tognazzi…' Visibly sad and furious, and expressing his feelings with less and less restraint in his journal of the shoot, Truffaut rapidly devised ways to compensate that reassured him but nevertheless had the disadvantage of being only that: filming with Oskar Werner's stand-in whenever possible, who graciously agreed to do shots refused by the actor, or cutting out the shots or lines that had been sabotaged.

These artifices permitted the film-maker to obtain some very beautiful scenes, like the one where Montag reads a book for the first time. During filming Truffaut had the idea of having him read the first page of *David Copperfield*, opening the book as if it were an unknown object, and having him read earnestly, following each line with his finger, the indications on the flyleaf as if they were part of the text of the novel: the date, the name of the publisher... But Truffaut gave up the idea of showing Montag trying to figure out a book whose pages haven't been cut, with this direction for the actor: 'Imagine you're a monkey who has found a wallet.' 'I'm giving up this kind of improvisation to spare myself having to hear stupid questions like: What does that mean? Where will it go? Why should I act like a monkey? I want it to be a book of poetry, etc.'

Things soon passed the point of no return. On 1 February 1966, the night of the fourteenth day of shooting, when he had butted heads with his actor for the second time – 'a violent argument for five minutes' over a flamethrower that was supposed to be handled behind his back by Cyril Cusack, the Irish actor playing the captain of the firemen – Truffaut sent a note to Marcel Berbert confiding some of his anxieties: 'My dear Marcel, excuse me for not writing at greater length. I'm overwhelmed by this film, which has not been sufficiently prepared. Every weekend I have to write notes about the sets, the costumes, the props, etc., to avoid unhappy surprises. The quality of the work is improving, but so slowly! One piece of good news for you – I've changed my style: three shots maximum, print one, instant editing except for the scenes of action with three cameras...' At the end of this short letter there was already,

from the heart, this cutting sentence: 'In any event, I'll never make another film with Oskar!' After *Fahrenheit 451* Truffaut would no longer wish to make a film in English, because his inability to achieve the music of the dialogue had contributed to his discomfort during production. Most important, the fear of not being able to go on making films and the real difficulties into which the incessant delays had plunged Les Films du Carrosse led him to find another system of organization that would permit him never to be caught short again – a veritable plethora of projects and a programme, to be reviewed and corrected every year according to the circumstances and priorities of the moment, which he described to Helen Scott on 27 November 1964, shortly before the cameras rolled on *Fahrenheit 451*: 'For 1965 I am making great resolutions to improve my professional life [...] Like Resnais and the Americans, I'm going to have three or four writers (such as Moussy, Gruault, De Givray) working on film subjects that I have in reserve. I'll pay them a kill fee if the project doesn't go anywhere, double or triple that if the film is made, and I'll see each of them separately once a week to work on the construction. Here are my projects: 1) *L'Enfant sauvage* (the story of the wolf boy I told you about); 2) *La Petite Voleuse* (like Ingmar Bergman's Monika, the birth of femininity and coquetry in a little delinquent, a female *Quatre Cents Coups*); 3) a story like *Tirez sur le pianiste* or *Bande à part* for Jean-Pierre Léaud, maybe an old Goodis novel; 4) a dramatic comedy about a young couple who break up and reconcile, which might eventually be for Romy Schneider and Belmondo; 5) and last, the film I've been talking about for a long time, where all the action takes place in a school.'

La mariée était en noir

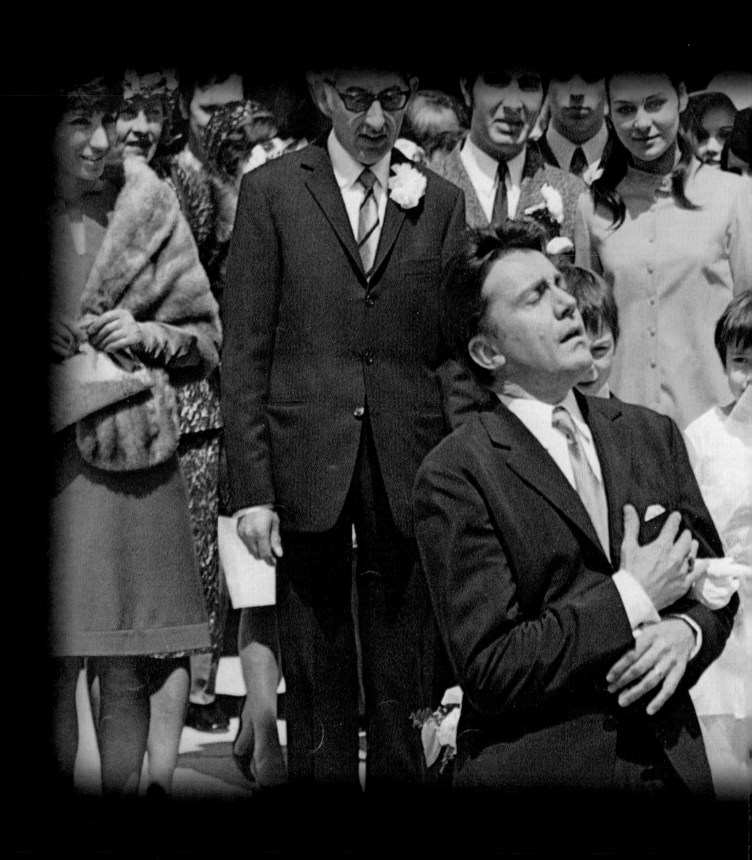

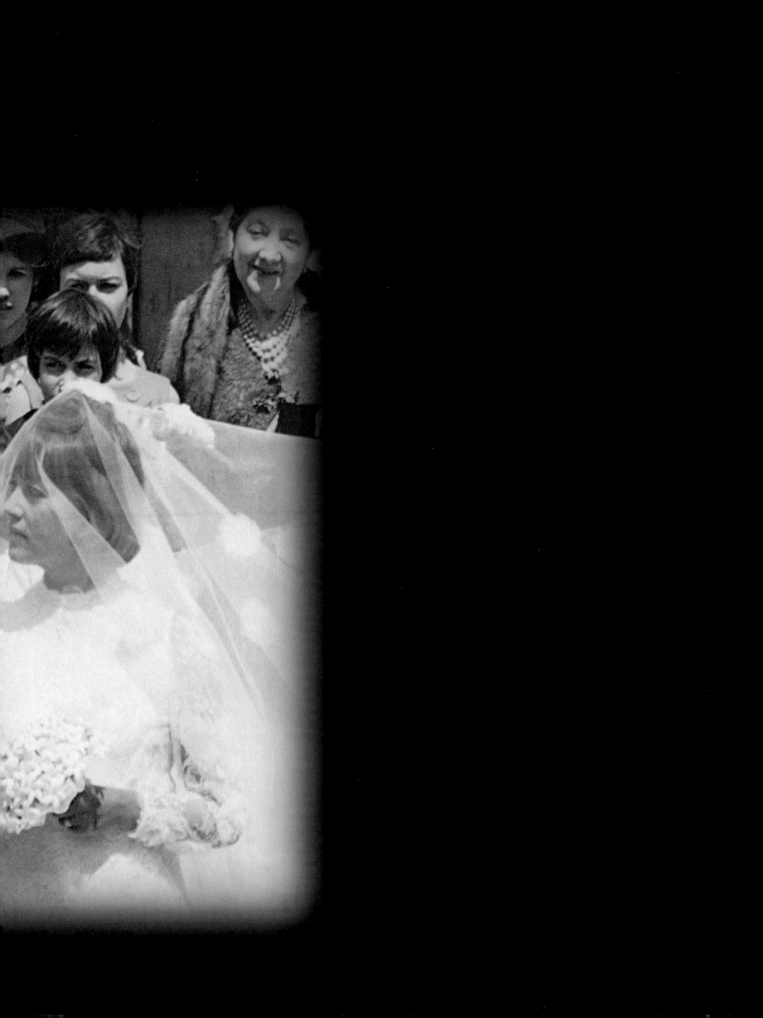

La mariée était en noir (1967)
The Bride Wore Black

A woman who kills five men to avenge the death of her husband: 'When a film is based on such an exciting premise, even if the screenplay is badly constructed, the *mise-en-scène* terrible and the acting poor, even if the reviews are bad, the production faulty and the distribution inadequate, the film can't help but attract a large audience.' That was how Truffaut presented the project to Oscar Lewenstein (whom he described as 'Tony Richardson's Berbert'), his contact at United Artists, in September 1966, attempting to reassure him and to obtain, through humour, the green light that had still not come.

The film's financing was compromised when the financial backers were disappointed by *Fahrenheit 451*, which had just opened in Paris. Even though *La mariée était en noir* was initiated as a project that would be filmed in London and in English (with Jeanne Moreau surrounded by four English actors), Truffaut was now reluctant to repeat the painful experience of *Fahrenheit* and argued for making it in France and in French. Because he wanted to start filming at the beginning of the year and needed to begin casting the male roles (he would end up filming in 1967, but only in mid-May), he did not hesitate to remind United Artists that every distributor rejected the script of *Jules et Jim*, and threatened to take *La mariée était en noir* to Universal if they didn't want it.

In 1964 Truffaut, who was looking for a subject for Jeanne Moreau after spending a few days in the South with her, thought of this *série noire* by William Irish, which was 'one of the books I've always known', one that he 'borrowed' from his mother and read in secret not long after the Liberation. He wrote to Helen Scott about it, confiding in her that his feelings for Jeanne Moreau had returned: 'Everything is not rosy, and I have moments of solitude; nonetheless I'm experiencing the same intense feelings you witnessed at the time of the Chicago–New York trip, only more real this time, more reciprocated, less "fabricated" by me. Naturally, for Jeanne and me, that takes the form of a great desire to work together again as soon as possible. Hence my interest in the book *The Bride Wore Black*.' The same day, 19 August 1964, he wrote to the American literary agent Don Cogdon, who handled all questions relating to progress on the 'Hitchbook' for him, and asked him to negotiate the purchase of the rights from William Irish (whose real name was Cornell Woolrich), hoping that he would be able to obtain a contract that would be 'simpler and more advantageous' than the one for *Fahrenheit 451*. With his habitual mania for secrecy and compartmentalization, Truffaut asked Helen Scott not to talk about the project, 'even to Cogdon'… In case nothing happened with *Fahrenheit*, whose start date had again been pushed back to the beginning of the year, he wanted to be ready to film *La mariée était en noir* quickly. But the rights were too expensive for Les Films du Carrosse and would finally be bought for him by United Artists a year later, in the autumn of 1965. He started writing the script with Jean-Louis Richard at the beginning of the summer, as soon as the rights negotiations were concluded. For nearly two years before the start of production they wrote, together and separately, several versions during the course of which the mystery aspect

Previous pages: Serge Rousseau and Jeanne Moreau.

First US edition of *The Bride Wore Black*

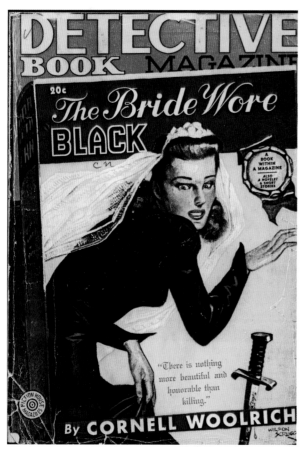

A subject for
Jeanne Moreau.

that predominated in the original story was gradually eliminated. The last draft was finished in March 1967 after two months of hard work with Richard. At the same time Truffaut, careful to accumulate projects, worked on the first treatments of *L'Enfant sauvage* with Jean Gruault, began an adaptation of *La Sirène du Mississippi* as soon as he was done shooting and editing *Fahrenheit 451*, at the end of 1966, and started writing *Baisers volés*. He assembled a cast of his favourite actors around Jeanne Moreau – Claude Rich, Michel Bouquet, Michel Lonsdale, Charles Denner and, for his look, identifiable at a single glance, Daniel Boulanger (the script described the character as 'a completely bald man with an eagle eye'). He began shooting on 16 May 1967, in the order of the episodes: the murders of Bliss, Coral, Morane, then Fergus the painter, whom the heroine kills with the arrow of Diana the Huntress, the subject of the painting for which she has been posing. The film-maker relied on Jeanne Moreau to welcome each actor and explain his character when he arrived.

From novel to film.

As he set out to adapt William Irish's novel, Truffaut was aware of the risk he was running by portraying a murderess, hard and locked up inside herself, who eliminates several men and allows nothing to deter her from her goal. It was also a risk to expect the viewer to stay interested in a repetitive story that can only lead to one fatal outcome, with each murder coming too predictably after the last. He enumerated all these risks when he pleaded the film's cause with producer and artistic director Oscar Lowenstein in his letter of September 1966. He knew that he would have to make Jeanne Moreau sympathetic to the audience without blackening the masculine characters around her, and without falling back on the idea that she is mad in order to justify her actions. Truffaut would also have to persuade the audience to accept the fact that she continues avenging her husband's murder even after learning that it was really an accident. To that end, Truffaut made several modifications that change the novel's structure. He began by getting rid of a misunderstanding that Irish had used to conclude his story. In the last chapter the cop who is pursuing the heroine explains to her that she has been running after a chimera, that none of the men she has killed is responsible for her husband's death on the day of their marriage – it was another murderer, hidden in the house facing the church, who fired the fatal shot. At the precise moment the shooter

des voix et des rires. Une voix, plus forte que les autres, s'exclamait ça :

— C'est ça! Vous y êtes; continuez!

Comme la femme revenait vers le salon, elle rencontra Marjorie.

— Je cherche mon fiancé...

Elle prononça le mot avec une sorte d'orgueil, en même temps qu'elle effleurait sa bague du bout des doigts.

— Vous ne l'avez pas vu? insista-t-elle.

La femme en noir sourit, poliment.

— Il était là tout à l'heure, dit-elle.

Elle se dirigea vers le salon, sans hâte.

La femme de chambre et le valet n'étaient pas au vestiaire installé près de la porte d'entrée. On les appela pour donner son manteau à la jeune femme. La porte du palier se refermait lorsque la sonnerie du téléphone relié avec le rez-de-chaussée se mit à sonner. Le valet ne décrocha pas tout de suite.

Marjorie revenait de la terrasse. Elle dit, à haute voix :

— C'est étrange, il n'y est pas.

Sa mère, à qui le valet venait de passer l'appareil, poussa un cri perçant. La fête était terminée.

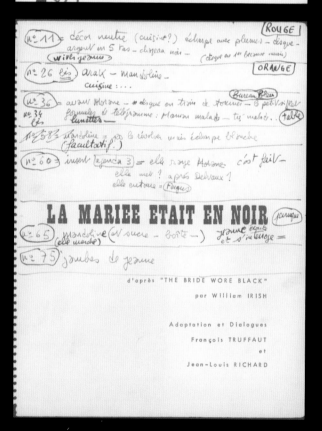

Far left: William Irish's novel, with Truffaut's notes. On the page describing Julie's departure after the first murder are his first ideas about the scarf she leaves behind: 'For the ending of the scene, should we show
a) the body on the ground
b) the scarf floating down to the body (or perhaps he has grabbed it)
c) Her flight. Camera ground-level: body, scarf and her disappearing round a corner
d) the [word illegible] calling the mother
e) end on Marjorie screaming or fainting?'

Left: Recapping the character's journeys and destinations.

Far left: The flyleaf of the shooting script with Truffaut's notes describing the scenes where Julie's record of mandolin music will be heard. For the scene with the white scarf, the direction is 'Optional'. (In the film the music is heard as the camera follows the drifting scarf.)

Left: A modification Truffaut made before filming the scene where Fergus' friends invade his studio: 'Diana the huntress, so she's a virgin!' Truffaut thus lets the spectator in on the secret he said he had only shared with Alfred Hitchcock and Jeanne Moreau: his murderess is a virgin.

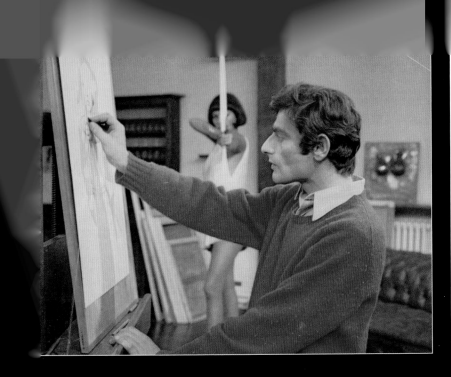

« Cette fille rousse me plaît à cause
de sa vulgarité; j'aime beaucoup la
vulgarité chez une femme, c'est
vivant; enfin, maintenant elle a
rejoint la réserve des « possibles »…
Oh, il faut absolument que je vous
raconte un cauchemar épouvantable que
je fais quelquefois; c'est le matin…
je suis habillé… je sors dans la rue,
il n'y a que des hommes… je continue…
j'avance… que des hommes… rien que des
hommes… plus une seule femme…
(Un temps)
Alors je me réveille en sueur, soulagé
quand même puisque ce n'était qu'un
rêve. Vous savez, il m'arrive le soir
de me balader et de regarder les
filles aux terrasses de café à la
façon d'une bonne sœur qui quête dans
un restaurant : celle-là c'est fait,
celle-là pas encore, tiens, il faudra
que je demande à celle-là…
(Il regarde plus attentivement Julie)
Le nez est formidable et votre bouche…
si j'étais écrivain j'en ferais un
roman.
C'est pareil si je prends le métro, le
train ou l'autobus; dès que je suis
monté, je regarde si je trouve une ou
plusieurs femmes " possibles "; dès
que j'en ai repéré une je suis
soulagé; s'il y en a plusieurs, je les
examine et je fais un classement.
Évidemment, je ne leur fais rien, je
leur fais même pas de l'œil mais je
sais qu'elles sont là, je suis
rassuré… Si nous avons un accident, si
le métro reste bloqué toute une nuit
entre deux stations, eh bien tout sera
possible… Est-ce que je vous choque? »

**Left: Fergus'
monologue, a
prelude to the book
that 'the man
who loved women'
(also played by
Charles Denner)
will someday write.
Like the dialogue
of *Tirez sur le
pianiste*, it was
inspired by
Jacques Audiberti.**

pulled the trigger, four men happened to be passing in a car that backfired several times. Because the police understood that the shots really came from the house across the street, they never looked for the occupants of the car, so Julie has just killed four innocent men. Not very fond of the kind of final twist that informs the character and the spectator that they have been fooled, Truffaut reacted with a 'very ingenious, but too complicated' when he annotated the book before discussing it with Richard. To make it easier for the audience to become involved and to avoid piling up coincidences, he preferred to imagine that the heroine attacks the real killers of her husband, even for a ridiculous murder committed accidentally and almost out of stupidity. He also gave up an idea revealed in the last pages. In Irish's book, the real murderer is Corey (played in the film by Jean-Claude Brialy), who is friends with both Bliss and the painter. He and Julie's fiancé were minor crooks who had been accomplices in some kind of racket. Julie had told her husband to choose between her and his gang, not realizing that by doing this she was signing his death warrant. Truffaut began by separating himself from this B-movie ambience in order to reinforce the emotional aspect, which is equally present in Irish's novel. The dead husband is idealized, and Truffaut put this woman's unconditional love for a man she barely had time to marry at the heart of his film, certain that he was thereby centring the story on its strongest idea, which he had pointed out to his coproducer: a woman carrying out a mission she has undertaken for love. While he set aside the thriller elements and the series of surprise endings, he underlined and kept one sentence which expresses the intensity of the love that has been taken from the young woman when she makes her final confession: 'I stayed awake at night counting the minutes and seconds that separated me from the moment when I would see him again.' In the novel Julie falls into a trap set by the police that she does not see coming; Truffaut imagined instead that she deliberately arranges her own capture to get to her last victim in prison. She is master of her own destiny, ready to do whatever it takes to carry out her plan and satisfy her *idée fixe*. In the first synopsis he included the scene where Corey, the friend of two of the victims, recognizes a mysterious woman at the funeral and 'tears off the black veil, revealing to everyone present the naked face of Julie Killeen'. (Killeen, from 'kill', is the character's original name, which Truffaut finally changed to Kohler.) Writing to his American co-producer, Truffaut could pride himself on having 'a logical, satisfying ending that cannot be predicted in advance' because he knew that he and Richard had been clever in concocting this twist that would permit him to film the last murder behind the walls of a prison.

Placing the motive.
In this very detailed synopsis established with Jean-Louis Richard, Truffaut also decided to put the revelation of the murderess's motive long before the end, thereby ensuring that the spectator would be on her side. The novel saves the flashback to the marriage and the revelation of the murderess's motive for the next-to-last chapter, but in this early treatment Truffaut inserted a first partial flashback after the second murder (the episode of Mitchell, who

would be called Coral, played by Michel Bouquet), then a longer, more detailed one at the time of the third murder (the episode with Morane, alias Michel Lonsdale). Here is where Julie tells her love story – it would come out later that it was a love that began in childhood. A Hitchcockian solution, the origin of which Truffaut would happily acknowledge when questioned about Hitchcock's influence on the film after it was released: 'Certainly he influenced the construction of the story, since we give the solution to the enigma well before the end. That way the public doesn't have to wait too long for an explanation that, however ingenious it may be, rarely deserves to be the ending of a film' (*Le Monde*, 18 April 1968). The question was no longer: Why is she killing them? It became: How will she kill the next one? And above all – as a result of how the screenplay had evolved – what will happen between them? Will she go all the way? Will she really kill him?

When he annotated the novel, Truffaut also did not hesitate to transform Irish's characters and make them his own. The most spectacular transformation, and the funniest, concerns Holmes, the man Julie doesn't succeed in killing. The idea that the murderess sees one of her targets get away because he is arrested in front of her was Truffaut and Richard's invention (in their first synopsis). In the novel the murders follow one another in a linear fashion, but the two collaborators imagined this subterfuge to spice up the story and break the monotony of the repetition, to recreate suspense and awaken the interest of the spectator, who will share the heroine's frustration. Holmes is a successful writer in the novel, with all the attendant clichés: financial ease, a beautiful home, servants, fame. Irish uses this to complicate the last part of the story and entrap the heroine. Two young women arrive in the famous writer's beautiful house: a student who has bet her girlfriends that she can seduce him (but is she really a student?) and a new secretary, replacing the one who was just fired. Irish plays on the uncertainty: which of them is there to kill Holmes? Then he pulls a switch. It turns out that Holmes is a policeman who has taken the writer's place, and Julie is caught in the act. Truffaut crossed out this whole chapter. He inserted certain elements of Julie's confession in the Morane episode and imagined that she misses Holmes after her third murder. Unconsciously, no doubt, he gave his story the structure of a fairy-tale: Papa Bear's oatmeal is too hot, Mama Bear's is too cold and Baby Bear's is just right (as Truffaut wrote in an article on Lubitsch). After the climax of the Morane episode, which is also the moment of the big flashback and the revelation of Julie's motive, the idea of a series of trials that often shapes such tales dictated that the quest should start afresh, this time with a failure. In a departure from the novel, Holmes (who is named Delvaux in the finished film) is no longer a successful novelist; instead he is a second-rate gangster, a crooked garage owner trafficking in stolen cars who is arrested by the cops as Julie looks on. (In effect, Truffaut displaced on to this character the little scams attributed in the novel to the husband and the real murderer, revealed at the very end.) This gave him a chance to indulge his own fantasies by dressing Jeanne Moreau in a leopard-skin outfit, since she presented herself to Delvaux not as a secretary, but as a whore.

Characters.

Truffaut extended and reworked the characters in his own style. He radicalized the solitude of Mitchell (the future Coral, Michel Bouquet) by making him a pathetic confirmed bachelor, crossing out all references in the pages of the novel to a waitress girlfriend Truffaut preferred to remove. 'Establish that he never receives letters' was a marginal note he made in this character's chapter – the height of solitude for Truffaut. In the margins of the book he sometimes jotted down fragments of scenes or dialogue, images he was beginning to see, gestures and lines that were signatures of his universe: 'He drinks from his glass. She speaks to him dryly; he simpers and wants her to drink from his; she puts him in his place and excuses herself. He says: I will know your thoughts… You will. Your thoughts don't interest me; mine, you wouldn't understand' (the Mitchell episode). Or an occasional critical remark on sloppiness Truffaut noticed in the novel when he was thinking about how he would film a scene. For example, when Mitchell drinks the alcohol Julie has brought without hesitation: 'A difficulty is glossed over: Why is he the only one who drinks?…etc.' For the character of Corey, the friend of Bliss (the first to be killed) and Fergus (the painter), Truffaut planned to reinforce his character as a misogynistic skirt-chaser, at once sympathetic and carefree, by attributing aphorisms to him like these, written in the margins of the book: 'You, if you were walking down the street with Ava Gardner, you'd turn to look at Marilyn Monroe', or 'We run after them till they catch us', 'Me, I run after no one, but I don't pass up anything'. The romance between the murderess and the painter in the film, the closeness that develops between them to the point of creating suspense about a possible love story (Will she kill him? Could she fall in love with him and renounce her goal?) is absent in Irish, or barely indicated: the painter doesn't say a word while he is working. Truffaut was the one who gave Denner a long monologue about his passion for women – inspired by Jacques Audiberti, a precursor of the unceasing flow of Denner's commentary in *L'Homme qui aimait les femmes*. The film-maker developed this character particularly in his second draft, where the idea that the painter never stops talking appears, and where Truffaut planned to have him tell the story of the cop in love who tried to commit suicide by firing a bullet – the bullet-hole can still be seen in the painter's kitchen. 'You see, this story fascinates me because in most people's mind a cop can't be in love,' says the screenplay. 'You hear stupid songs on the radio all the time that oppose lovers and the bourgeoisie, poets and cops, whereas when the bourgeoisie or cops fall in love, they feel much stronger, more violent passions than the poets, the free thinkers of the right or left, etc.' (Truffaut would attenuate the comment while filming to avoid falling into reverse racism.) In the same way he attributed to Morane, who he would say was inspired partly by Jean Dutourd, a desire for local political power that the character does not have in the novel.

New murders.

'Expand the last scene. Dialogue on either side of the door; flashback. Death of Morane.' Truffaut wrote this on his copy of the novel at the point where Julie has shut Morane in the cupboard where he will die of suffocation. The novel completely skips over the moment of the murder, which is only recounted and described afterwards during the police investigation, but here at the heart of his film the film-maker decided to unveil the murderess's motives. Planned from the first draft of the script, the double flashback (the five men playing with the gun in their bachelor pad; the marriage and the exit from the church) became the film's centre. This note is also an example of a movement that Truffaut would follow from start to finish. In version after version, he distanced himself from the structure of the novel, which follows each murder with one or two chapters about the police investigation. Conversely, as the investigation becomes less and less important and the murder mystery moves into the background, Truffaut expanded the murder scenes, often described briefly or elided in the novel, into showpieces, almost romantic encounters. The progressive elimination of the police investigation goes together with the distancing from conventional and overly familiar representations of violent crime. (The only time a traditional crime scene, with the police standing around the body, is seen is at the end of the Morane episode, where Truffaut filmed not the body, but the door of the cupboard, open at last.) The murders woud be filmed without a drop of blood – clean murders, so to speak, but no less atrocious for that. Bliss falls off the balcony; the murderess watches Coral, poisoned, beg and twist around on the floor ('Julie sits down in front of Coral as if watching a show', the second script specified); Morane is shut in the black nightmare of the cupboard (the idea of the duct tape that keeps the air out appeared in the first synopsis in place of the putty used in the novel); Fergus is pierced by the arrow of Diana the Huntress… A more conventional-seeming attempt at murder with a revolver was quickly diverted. (No sooner does the murderess take her revolver out of her bag than she sees the victim escape, arrested by the police as she looks on.) The final murder with the knife is kept off-screen; when Julie picks up a knife during the Morane episode, she uses it to cut the telephone wire… The painter Charles Matton, who lent his brushwork to Charles Denner, recalls that he 'got into a bit of an argument' with Truffaut during filming: 'I explained to him that a painter today, no matter how reactionary he might be, would never buy a short skirt, a bow and a quiver of arrows for a model posing as Artemis. But he absolutely wanted Jeanne Moreau to kill Denner with an arrow. The rest he didn't care about. "What's important is the idea people have of it," he told me. Truffaut wasn't really in life; he was a pure film-maker.'

Rivette's opinion.

We are no longer following an ordinary criminal, pursued by the forces of law and order, but the mystery of a woman who kills and lets nothing stand in her way. While Truffaut had already started reducing the police procedural aspects of the script, he was encouraged to go further in that direction by Jacques Rivette, to whom he showed the second draft of the screenplay. Rivette 'straightens out [his] ideas' by giving him back, as he would later also do for *L'Enfant sauvage*, which was being written at the same time, a carefully argued report.

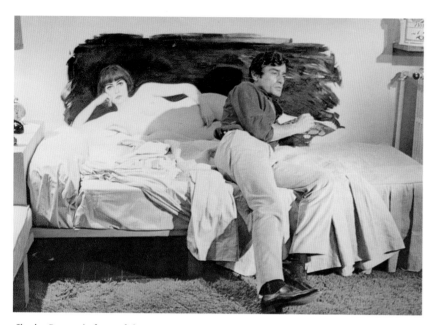

Charles Denner in front of the portrait
of Jeanne Moreau painted, in reality, by
Charles Matton.

Wanting to inject the film with a sense of urgency, Rivette advised Truffaut to get rid of the remaining scenes with the police. 'If we adopt throughout the postulate of urgency and the acceleration of the story,' he noted, 'we can, I think, remove without problems the few transitional scenes with the police that remain.' In the film the interrogations of the teacher had disappeared. Truffaut, playing on what the viewer knows, retained the beginning of the investigation (the cop who tries to question little Cookie, although we know that he only says he saw Mademoiselle Becker because Julie passed herself off as her), but the scene ends as soon as Cookie pretends to recognize her. Cut to an insert of a newspaper informing us that she has been arrested.

It was also Rivette who pushed Truffaut to rework the Morane episode, which he found weak. 'The only problem, in my opinion, is the middle of the film,' he slipped in at the end. 'Especially the famous point two-thirds of the way through, the danger zone where one either wins or loses: that is to say, in this case, the end of the Morane episode.' Rivette urged his colleague to sacrifice the character of Madame Morane, whose bus trip to see her sick mother was shown in the first versions of the script, closely following the construction of the book: her anxiety, her surprise and alarm when she finds her mother in good health, her vain attempts to reach her husband, when the murderess has just cut the line on the other end. Rivette reacted against these scenes because they risked dividing the sympathies of the audience, who would find themselves as much on the future widow's side as they were on Julie's. The Morane episode was the only one he felt was less successful than the book, whereas the other four seemed to him much improved – something he attributed to the fact that Irish was able to take his time, whereas it was impossible to devote an hour to the Morane episode in the film. 'This episode is built around the parallel montage of two big sequences: a) Morane and Julie; b) Madame Morane. After the murder: c) Cookie and the teacher. As Jean Renoir says, we live only by constant small sacrifices; it seems that to me that here we must on the one hand sacrifice multiplicity for duration (that is, develop one element thoroughly and eliminate the others) and on the other, sacrifice b) and c) for a), which is the subject of the film.' Rivette proposed the following: 'Cut out all of Madame Morane's journey. I'm not interested in this woman, I don't see enough of her to share her feelings, and I don't care what happens to her...' He encouraged Truffaut to stick to his subject and avoid dispersion of feelings and sentiments by focusing on the relentless line his heroine was following. If the fiancées or wives of the men she kills were sacrificed, if the film-maker ended up making them transparent characters, contrary to the desire he often expressed to strike a balance between glamorous and unglamorous characters, wife and mistress, he did it for the sake of the central character and her *idée fixe*. The film's tour de force, accomplished all the more lucidly by Truffaut because he was fully aware of the risk of having an unsympathetic heroine, is to put us constantly on the side of the unstoppable, avenging murderess and to make us care more about the success of her enterprise than we do about her victims' unhappiness. Truffaut could not give Morane's wife or Bliss's fiancée an importance that

would remind the spectator that their fate (brutal loss of a husband or fiancé) would be exactly the same as Julie's. It is the heroine's sadness, and not theirs, that he decided to show. Accordingly, he wrote the scene where her suffering breaks through and she bursts into tears listening to Morane shouting his version of what happened from inside the cupboard (the only moment in the film when she cries): 'I want to see David; I want to see his eyes.' His heroine's one-way trajectory is traced over the abyss of an aching loss that nothing can replace: 'You have taken something away from me that you can't give back.'

Persistence.

Truffaut's reactions to Rivette's recommendations are interesting for what he accepted and for what he rejected. When Rivette encouraged his colleague to cross the two themes of the film, Julie and her victims, by stylizing the murderess and getting to know the men she kills, he was pushing Truffaut in the direction he had chosen from the beginning: opposing Jeanne Moreau's inflexible obstinacy to the weakness of the men, who reveal themselves to her as they probably never have to anyone before, naively showing her their feminine ideal. 'All this, I can see, is already contained in your screenplay, and should in my opinion be the principal line of force of the *mise-en-scène*. Putting it schematically, it is she who is "virile" and they who are feminine. (The only one this is not true of is Holmes, who is a stylized character like her.)' Rivette also proposed two visual ideas that Truffaut would adopt. On the one hand, the idea that the scarf that slips from Julie's neck after she pushes Bliss off the balcony is then filmed as the wind carries it over the city. 'Suggestion,' said Rivette. 'Go from the faint [of Bliss's fiancée] to a closer shot of the white scarf, still hanging from the outside rail, which a gust of wind carries off; follow it eventually with a pan as it flies over the night lights of the city, then cut to a (night) flight crossing the sky and flying over the sea.' This visual and musical transition offers a respite after the first murder; the film turns suddenly from a thriller into a fairy-tale. In the early versions the scarf, which would be found clutched in the dead man's hand, was going to be nothing but a clue in the police investigation, before the film transforms it into a light, poetic, useless object. In the second draft Truffaut introduced the principle of linking and transitioning between murders by a means of transportation (aeroplane, train) that propels the murderess from one part of France to the next, from one man to the next, while she crosses out the victims' names in her little notebook. He also introduced in that version the idea that she listens to a little mandolin melody before each murder.

Further on, Rivette proposed a way of filming the shadowing of little Cookie Morane when he leaves school that Truffaut adopted almost to the letter: 'Perhaps you can replace the cliché of "shadowing" by another that is as trite but more elliptical: showing Cookie and his mother going away, then cutting to their arrival at the pavilion and Cookie's reappearance with the ball without ever showing Julie, only rediscovering her when the ball rolls up to her feet (advantage: preserving the appearance-disappearance aspect of the character).' This game of appearance-disappearance was important to Truffaut, who stressed

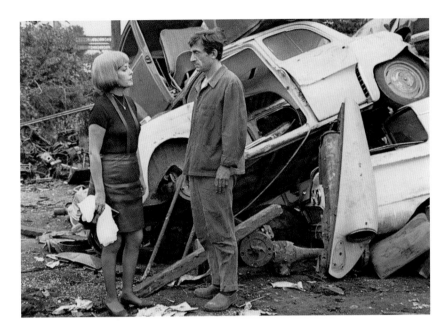

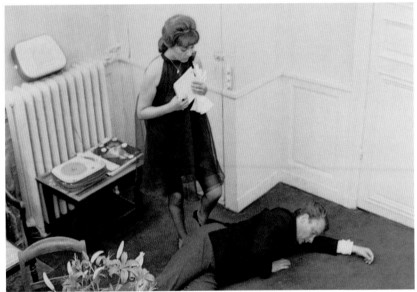

Metamorphoses of a murderess (with Paul Pavel and Michel Bouquet). Truffaut invented a postponed murder to re-start his film.

in the margin of one of the early chapters of the book: 'Appearance-disappearance: we never see her arrive or leave.' On the other hand, he didn't follow Rivette's suggestion that he spell out the chronology of events by using some visual marker to indicate that everything happens in eight days, always showing the spectator what day it is. 'Show that a certain thing isn't possible because it's Saturday night or Sunday or Thursday, etc.; try to end one episode in the morning and begin the next on the evening of the same day (or the reverse).' This recommendation contradicted the way in which Truffaut handled chronology in film after film, precisely by avoiding any exact temporal reference point and linking strong scenes while passing over uninteresting ones without giving clear indications of how much time has passed. (The exceptions occur in films where the commentary reports not ordinary chronology, but big leaps in time, as in *Les Deux Anglaises* – 'Four years was yesterday' – or *Le Dernier Métro*: 'After 813 days spent in the cellar...') In *La mariée était en noir*, as in all his films, the time between episodes or scenes could just as well be a few minutes or hours as a few days or months; the question of time is simply never raised. More precisely, Truffaut managed to keep the viewer from ever thinking of it. He therefore rejected Rivette's proposal of an 'external time framework' such as the Tour de France bicycle race or any other public event – realistic reference points that he rejected because he preferred to situate his film in a universe floating between reality recomposed and a fairy-tale.

Mechanics and familiarity.

When he directed *La mariée était en noir*, Truffaut alternated between stylization and familiarity. He chose total stylization for certain moments, such as the flashback showing the five men separating after the gunshot that has killed the husband, filmed in a single high-angle shot of them going off in different directions after descending a stairway. He also more or less succeeded in doing this for the scenes where his heroine appears and disappears. Elsewhere he attempted to inject the quotidian and the familiar with Jeanne Moreau's help, when she uses with little Cookie Morane, for example, the expressions she used with little Sabine in *Jules et Jim*. 'Sleep tight, don't let the bedbugs bite,' she says to him, as Catherine did to her child. 'This is all too fast, too schematic. We lose the relaxed, happy family atmosphere that makes Morane and little Cookie completely forget Madame Morane's absence,' Rivette noted on the script. 'The viewer should also forget for ten minutes how the scene is going to end, or only see it foreshadowed fleetingly by the occasional clue.' If Truffaut gave Jeanne Moreau the hard, hieratic façade that he needed for the character on other occasions, he would succeed perfectly – and these are among the best moments of the film – in suspending the audience's awareness of the direction in which the Morane episode is moving thanks to the everydayness of Jeanne Moreau's acting and to ideas she contributed, like the trick she uses to get little Cookie to eat: 'You say you don't like your yogurt, but maybe it's your yogurt that doesn't like you.' ('Yes it does like me,' answers the child, gobbling it up.) With the yogurts and the instant soups made by Morane,

Truffaut forgot about the rigour of his subject for a moment and, as a diversion, introduced into the film his tics and even his own ways of eating, so as to achieve the proximity he needed. In the first script Morane tries to make dinner for his son by disgustedly dipping two fish in flour; the flour spills, etc. (a scene already written for *Les Quatre Cent Coups*, based perhaps on an autobiographical recollection, and never finally filmed as such). Cookie's bedtime is written like that of Lachenay's little girl in *La Peau douce*: 'He doesn't want Julie to go – just a few more kisses, another object that needs moving, the light not completely off, the glass of water near him, etc.' When filming ended, Truffaut wrote to Hitchcock about Jeanne Moreau in case the Master might consider her for a role: 'The danger for her in *La mariée* is that the role she's playing is just too marvellous: the character, a woman who manipulates men and then kills them, is too "glamorous". To balance that I asked Jeanne, as I did in *Jules et Jim*, to play the role simply and in a familiar manner that would render her action unexpected, believable and human. As I imagine her, Julie Killeen is a virgin, since her husband was killed at the church on the day of their wedding. But this revelation doesn't appear in the film and should remain a secret between Jeanne Moreau, me and you!' The secret is no secret for the viewer who understands indirect allusions, since Truffaut decided when he was filming the 'weekly cyclone' at the painter Fergus's place (the band of pals who leave as she begins posing) that one of the guys should call out, while she's taking refuge in the bathroom: 'Diana the Huntress... So she's a virgin.'

Emotional suspense.

Until he had finished editing Truffaut kept asking himself about the issue of sympathy. Is his heroine too distant, too enclosed in her obstinacy? He deleted in the editing room Julie's attempt to poison the painter. She has brought a box of poisoned sugar to Fergus's that she tries to put in the tea she makes for him, but her attempt fails because Fergus says he never takes sugar. After cutting out this incident, Truffaut replaced this external obstacle to murder with an internal obstacle that substitutes emotional suspense for thriller suspense. When the first murder attempt fails because Diana's arrow misses by a few centimetres, is Julie vacillating? Is she falling in love with the painter? If she almost breaks down after missing, is it because she's unhappy or happy about it? 'The whole time, you're anticipating the public's reasoning and having fun with it. You say: "We'll make them think that..." That she's going to fall in love with Charles Denner, for example.' Once she has killed him, Julie's hesitation when she finds herself painted on the wall next to his bed is justified in the screenplay by an external element: 'She hurriedly starts to paint over her face on the bricks of the wall, but the noise of the front door incites her to look at the silent telephone again and change her mind.' In the film, the moment when Julie doesn't paint over the face at first remains unexplained, a pure moment of hesitation, as if she can no longer efface this expression of Fergus's fascination. We only understand later that she has had another idea: to arrange to be recognized and caught by the police in order to gain access to the prison where her last victim is sheltered. After seeing a rough cut, Truffaut felt something was missing that

was needed to restart things after Morane's murder and the return of the teacher to the school when her name is cleared. How could he make the viewer understand what was happening with his heroine? How could he escape from the mechanical series of murders? Bernard Revon proposed that he insert a scene taken in a confessional. 'This isn't a mission – it's a job, a job I have to finish,' she says with childish stubbornness when the priest tries to dissuade her. (We don't see him because Truffaut only filmed a close-up of Jeanne Moreau, in shadow behind the grill of the confessional.) Her explanation is a transcription of the film-maker's own intentions, because he had asked his actress to act without coquetry, with the competence of a specialist doing a job. ('You will act like Coutard, the cameraman, whose face is generally expressionless, calm and competent.') Filmed two months after the end of principal photography, this brief confession, like the flashback in the Morane episode, clarifies an inner state that is hard for us to grasp. ('I died with David.') And does it without an ounce of sentimentality, because Truffaut used the confession to refuse the priest's counsel of resignation, putting him in the position of the viewer. Paradoxically, the scene ends with his heroine recovering her courage: 'I came looking for the strength to continue, and you've given it to me. Despite yourself, you've given it to me.'

La mariée était en noir is, of all his films, the one Truffaut liked least and judged most harshly in retrospect. The film he ended up with was simply too far from the film he had dreamed. (A sign of this distance is the fact that the film-maker asked his editors to include a scene he was sure he had filmed but hadn't, a scene with Coral/Michel Bouquet at the theatre.) He was unhappy with the colour treatment (this being his second colour film after *Fahrenheit 451*), which he felt took away the film's mystery – he got on badly with Raoul Coutard during shooting because he disliked the way he was lighting Jeanne Moreau, and they would never work together again. He was also unhappy, after the fact, that he chose for Jeanne Moreau, in reaction against *Jules et Jim*, a subject and a character that imprisoned her too much and did not take advantage of her possibilities: 'I wanted to give Jeanne Moreau something that wasn't like any of her other films, but it was not well thought out. It was a bad idea to give a part like that to Jeanne Moreau, who's at her best when she's animated, when she speaks, when she moves, when she lives.' And finally he was unhappy to have made, in the final analysis, an apology of vengeance. He couldn't stand re-seeing the episode with Charles Denner. A few years later he thought of reuniting Moreau and Denner for a film about a relationship that hadn't worked out (which would be developed in *La Femme d'à côté*). He would also go on to turn those 20 minutes from *La mariée était en noir* into a whole film by making *L'Homme qui aimait les femmes*. 'This is what should have been done, this is what should have been said, this is what should have been filmed,' he wrote, describing himself during the editing of *L'Histoire d'Adèle H*, 'and thanks to this renewed dissatisfaction, thanks to this major frustration, I become impatient to begin a new film.'

Baisers volés

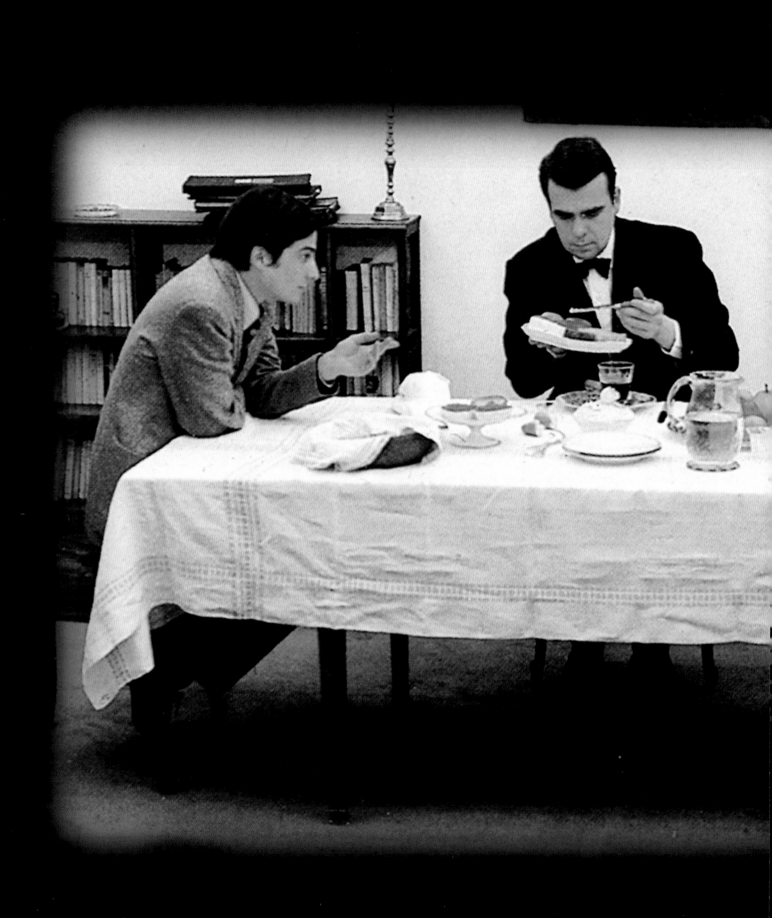

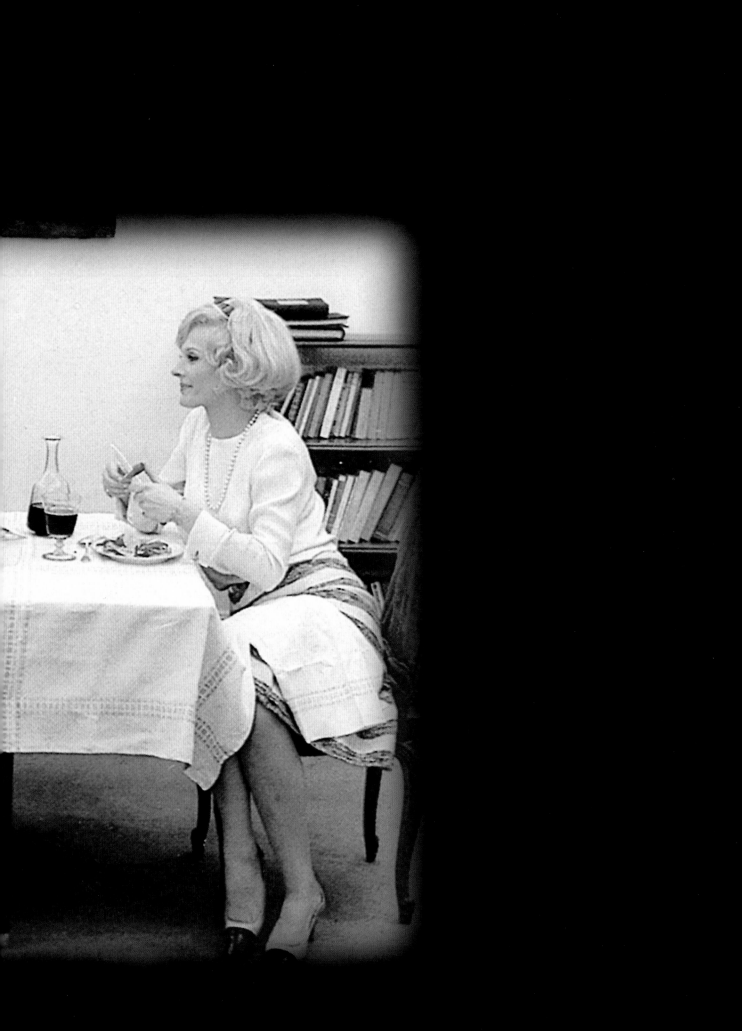

Baisers volés (1968)
Stolen Kisses

Shooting one of the first scenes of the film: the pan from the Eiffel Tower to the Dupleix barracks where Antoine Doinel is imprisoned.

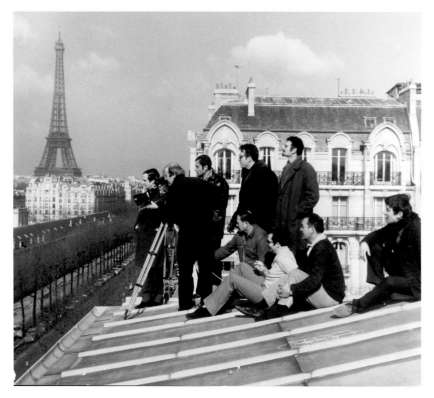

Fabienne Tabard: 'Do you like music, Antoine?' Antoine Doinel: 'Oui, Monsieur.' 'Ridiculous! She would never say that in front of him. Be logical,' Truffaut erupted in the margin of the first draft of the screenplay of *Baisers volés*, which Claude de Givray and Bernard Revon, his two co-writers, had just delivered, and bit further on: 'Idem. Wrong. She would definitely talk about something else, except by letter.'

The beautiful 40-year-old woman who captivates Antoine Doinel and to whom he has replied 'Oui, Monsieur', visits him, and the text indicates that she speaks about his slip: 'You ran away because you said, "Oui, Monsieur".' This dialogue provoked Truffaut's anger and a scathing response to his collaborators. The 'except by letter' is appropriate for a film full of letters – from the 19 letters a week Antoine wrote to his girlfriend Christine, to the letter about politeness and tact that Madame Tabard (Delphine Seyrig) leaves outside Antoine's door and the bravura scene of the pneumatic system running through Paris's underground. It is also important in the world of a film-maker and a man for whom what was important could only be said at a distance and by correspondence. ('I want to write to you today about things I have never dared say to you, because you are unpredictable and sometimes your actions frighten me,' Cecilia writes to Davenne in *La Chambre verte*.)

This response is also characteristic of a method and a way of working. When he wrote with Claude de Givray and Bernard Revon, Truffaut alternated face-to-face meetings with his co-writers where preliminary ideas were exchanged and a kind of collaboration 'by correspondence', where the notes he gave them served as the basis for developing a new version that he would criticize in turn. It is almost as if Truffaut deliberately had first drafts of films delivered to him that were unlike his own vision, so that he could become indignant, react and define precisely, by rejection, what he was aiming for. Even though he was at times exasperated when he received material he thought was a mess, and even though he sometimes evoked the fantasy of the ideal screenplay, ready to shoot, that he would not have to correct, he usually came up with the film he wanted to make by rejection and reaction: as if he could only see his vision clearly in opposition to something else. 'He pretended he had no imagination,' Bernard Revon told me. 'He wanted to react. He would read something we had done, and when he became indignant about our work, that's when he found things – in a state of indignation. He'd say "no" and then propose something. He opposed us, he'd say, "No, that doesn't work, for such-and-such a reason," and then he would find the solution. At that point he became extraordinarily animated, passing from one scene to the next: "If we do this at Scene 3, we'll have that at Scene 17, etc."'

After sketching the outline for *L'Amour à vingt ans* in 1962, Truffaut looked for 'a new subject for a film with Jean-Pierre Léaud before he grows up'. He was interested at one point in an American play, *Love in Connecticut*. Then, in a series of projects he described to Helen Scott in November 1964, he planned 'a story like *Pianiste* or *Bande à part* for

Jean-Pierre Léaud, maybe from an old Goodis novel'. In August 1965 he started writing an original screenplay with Jean-Louis Richard, a kind of sequel to *L'Amour à vingt ans*, recounting the beginning of Antoine Doinel's career as a journalist, with rather Balzacian preliminary titles: *Un jeune homme à Paris*, then *Un début dans la vie*. This was the first version of *Baisers volés*, but much closer to the actual life of the young Truffaut... A few months later, wanting to distance himself from this autobiographical material, he changed collaborators and entrusted the project to his friend Claude de Givray and his co-writer Bernard Revon, whom he first contacted to write an adaptation of René-Victor Pighles's novel *La Rhubarbe*, a story about the quest for identity that he had to give up because of rights problems. Accustomed to hunting for 'the little true detail' with a tape recorder and compiling extensive documentation (they worked together on a film about prostitution directed by de Givray, *L'Amour à la chaine*), they begin writing using a fresh premise for this 'new adventure' (the early days as a journalist are forgotten; Antoine is hired by a detective agency), which Truffaut would rework considerably.

Starting points.

To write the film, Truffaut gave his screenwriters three or four starting points: leaving military service, the title *Baisers volés* and the 'Oui, Monsieur' episode, taken from Anatole France's *Mémoires de jeunesse*. Truffaut also gave them the

idea of the character at the end, to which he was fervently attached, a man who has an *idée fixe* about the young woman and says he is very happy... Since Truffaut wanted to get away from journalism, Revon suggested having Antoine join a private detective agency, but only convinced the director of it after having him listen to more than 12 hours of interviews with the detective Duchêne, who loved to repeat, as Claude de Givray happily recalled: 'I'm at the heart of the human heart'. He turned out to be a mine of information: the record of adultery, shadowing people, the idea of the periscope, and the character of Tabard who comes and asks for an investigation of himself... When they were looking for casual jobs for Antoine, the idea of the night watchman, according to de Givray, came from Eric Rohmer, who had worked as a night watchman at a hotel, where he was able to write his articles. They also worked a good friend of Antoine's (as close to him as Robert Lachenay was to Truffaut) into the story, a friend who shares his departure from the Army and also the maid's room he is living in, one of them sleeping there during the day and the other at night, at least as long as Antoine is a night watchman. Truffaut removed the friend character just before the start of filming – in the interest of unity and to strengthen the role of Christine.

Filling the margins with suggestions and more or less angry remarks, Truffaut rejected out of hand the first draft of the screenplay. He didn't want to see Antoine leave the Val de

Antoine (Jean-Pierre Léaud) has finally managed to spend the night with Christine (Claude Jade). On a first version of the script Truffaut noted for his co-writers: 'We've lost sight along the way of the initial idea: for a boy of 20, it is much easier with women of 40.'

Previous pages: Jean-Pierre Léaud, Michel Lonsdale and Delphine Seyrig.

DUBLY
DÉTECTIVE
48e ANNÉE
"LOYAUTÉ"

ENQUÊTES PRIVÉES, COMMERCIALES, INDUSTRIELLES — FILATURES MOTORISÉES — SURVEILLANCES
D'ENTREPRISES — ENQUÊTES AVANT MARIAGES, ASSOCIATIONS, PROCÉDURES — RECHERCHES
SUR DISPARITIONS ET VOLS — GÉNÉALOGIE — SERVICES DE PROTECTION — TOUTES MISSIONS
PARIS PROVINCE ÉTRANGER

121, RUE SAINT-LAZARE
PARIS (8e) FACE GARE
MÉTRO : SAINT-LAZARE
TÉL. 387.37-36, 46-53
52-39, 43-89
CHÈQUES POSTAUX PARIS 691-32

PARIS, LE 7 SEPTEMBRE 1968

Monsieur François TRUFFAUT

5, Rue Robert - Estienne,

PARIS (VIII°)

Cher Monsieur,

Je vous remercie d'avoir bien voulu
me faire parvenir les deux fauteuils valables pour
la représentation d'hier, en soirée, de Baisers Volés.

Je n'avais pas oublié la séance de tourna-
ge à laquelle j'avais assisté au mois de Février
dernier Avenue de Villiers. Il me plaît de rappeler
la compréhension avec laquelle vous aviez parlé de ma
profession, celle-ci souvent difficile à exercer et
la plupart du temps méconnue. Nous nous étions séparés
ce soir là, vous me disant," vous ne serez pas déçu."
J'en avais la conviction. J'en ai aujourd'hui la certi-
tude.

" Baisers Volés " me semble être une re-
cherche constante de l'amour et de l'amitié par une
jeunesse en mal d'apprendre le dur métier d'homme : ce
qui lui amène joies et déceptions du coeur, complexités
diverses dans les rapports humains. J'y ai trouvé une
observation minutieuse du comportement des gens, une ap-
proche de la réalité, celle-ci dut-elle offusquer cer-
tains esprits rétrogrades.

Permettez-moi d'apprécier avec toute la
considération qu'elle mérite notre participation au gé-
nérique. Soyez-en remercié très sincèrement.

Je souhaite une carrière brillante à
" Baisers Volés " et vous prie d'agréer , Cher Monsieur,
l'expression de mes meilleurs et distingués sentiments

4. - Les conséquences pathologiques des pratiques

sexuelles anormales.

5. - Les copulations déviées.

6. - La frigidité.

7. - La continence périodique.

etc... etc...

Antoine feuillette le contenu du livre et ses yeux tombent

sur de très belles planches anatomiques qui présentent, vus en cou-

pe, les appareils génitaux de l'homme et de la femme. Il les contem-

ple perplexe ...

Je déteste les stades...

Le lendemain, dimanche, au stade de Coubertin, Antoine

et Martine, assis dans les gradins, assistent à l'ultime phase d'un

match de tennis qui opposent deux championnes.

Juché sur sa chaise haute, l'arbitre, au micro, annonce

le score.

L'ARBITRE

40 - 0, balle de match.

Martine, excitée, bouscule un peu Antoine et lui attrape

le bras.

Tabard cherche encore parmi
ses livres de comptabilité.

Tabard : Ah qu'est ce que je
trimballe, celui que je cherche
partout, il est dans le coffre
de la voiture... je descends...
Antoine, attendez moi ici...
je reviens.

Antoine reste seul avec Fabienne.
On s'installe pour le café.
Fabienne au valet de chambre :
laissez, je servirai moi même.
Antoine tousse un peu.
Fabienne se lève pour mettre

un disque. Antoine rêve.
Fabienne : Antoine, aimez-vous
la musique ?
Antoine : Oui Monsieur
Deux ou trois échanges entre
Fabienne, simplement étonnée,
et Antoine, catastrophié.
Il s'enfuit.

Left: First
page of the
screenplay:
notes for the
beginning
of the film.

Bottom left:
During filming,
Truffaut
finishes the
scene with
the message
sent via
the pneumatic
system.

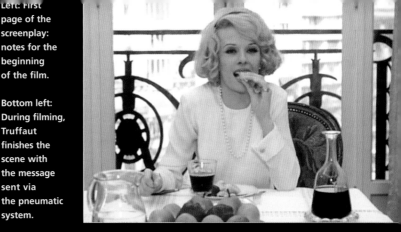

1/ cellule militaire —

2/ situation — ~~serment~~ l'adj dans un
cours sur le séminage — ~~Ben~~
Refus du livret de bonne conduite —
habits civil perdus — prime
dépensée — signe papier pour
rendre costumes et prime etc...

3) Vie civile recherche d'habits

4) son copain doit lui rendre sa chambre;
il s'emmerde — il lui fait des
frigues ~~Doy~~ layers —

BAISERS VOLÉS

5) Antoine trouve une place de
veilleur de nuit le copain peut
garder la chambre because (la
femme la journée et le veilleur de
nuit — vous comprenez).

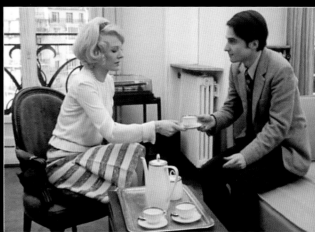

56 Bis : Documentaire - Pneumatique.

Ici viendra un montage de plans
~~qui~~ illustrant le trajet d'un pneumatique
: une main place le pneu dans un rouleau
transparent
: le rouleau ds un tuyau qui l'aspire vers
le haut
: suite des égouts portant les noms des rues
parcourues
: le tuyau d'arrivée etc...
~~Event~~ Eventuellement (à filmer ds appartement
Tabard) main, avec ongles rouges, ~~₃~~ de Fabienne
déroulant ~~₃~~ et ouvrant le pneu

57 Ter - le Cauchemar d'Antoine.
a) Dans son lit il se tortille et ~~il~~ revit ~~des~~
la scène pénible. (Une demi douzaine de plans)
b) Appartement Tabard. On voit Fabienne
~~des~~ devant son électrophe : Aimez-vous la
musique ?
- Coupe sur Antoine : Oui Madame.

Grace psychiatric hospital after a doctor obligingly tells him he is forced to let him go. Instead he proposed the military prison and the idea of the class on mine clearance given by an adjutant, and planned to enrich these scenes with a few of his own memories: 'Refusing the good conduct book. Civilian clothes lost. Bonus spent. Signing a paper promising to give back the uniform and the bonus etc.' 'Interior cell. Gags about guys trying to get sick: tapping their elbows against the wall. Smoking cotton…' In reaction, and because he was already reading the script with the eyes of a director, he imagined his first shot: 'Eiffel Tower. Pan to the Dupleix barracks. Zoom in on the prison.'

Disgust and refusal.

Revon and de Givray's first draft was radically removed from the Truffaut manner and his whole world, to an astonishing extent. It was their first real collaboration, even though de Givray had known Truffaut for a long time, and there was a misunderstanding about the subject and spirit of the film, 'starting out in life'. The screenwriters fell into an attempt at Parisian satire and an account of young people in the 1960s, whereas Truffaut really wanted to feature his own youth in a disguised form. He even crossed out the idea that Antoine reads a Livre de Poche of Rosseau's *Les Confessions* in prison (and later meets a young girl he falls in love with because she's reading the same book), preferring to risk the anachronism that he has 'a Larousse Classic tucked in his sock'.

The margins of this first draft were therefore filled with a long series of violent and often funny rejections and ferocious tongue-lashings. Truffaut rejected, obviously, swimming pools (where Antoine and the future Christine were to meet, a few steps from the juke-box and the life-guard) and stadiums: 'I hate stadiums.' 'No table football. Nothing collective.' He refused to permit the characters to use '*tu*', the casual form of the second person: '*Vous, vous,* always *vous.*' 'The whole pals-and-girlfriends aspect is unfilmable.' 'No brothers or sisters,' he noted at the end of the screenplay. Diatribes against fashion, against what seemed to him bogus and fake: 'People who call their daughter Martine or Caroline are arseholes who became intoxicated with Martine Carol between 1950 and 1955. Like Brigitte later and now Sylvie. So, no Martine.' Refusal of the authorial tone, of everything that suggested superiority to the characters: 'I detest the name Captain Baratin (even if it's authentic). It's like Hergé, Roger Nicolas, Louis Daquin, Enrico – it's stupid.' 'I detest the name Cyprienne [the future Fabienne Tabard]. It smacks of farce.' Truffaut gave his writers lectures where all his principles can be found: 'You have to fix this, work out the chronology in detail, create a narrative that will be analytical, plausible and filmable'; 'Lazy opening: we have no idea where he is or what he's doing. You have to fix that'; 'This shadowing scene is badly told, badly established, foggy and confused' (Antoine tails the future Madame Tabard in a large store, and while he is following her she tries perfume, make up, wigs); 'To film this correctly would take 10 to 12 minutes, and the idea of growing familiarity still wouldn't come across. So?'; 'Murky because no one understands'; 'Terrible lack of inventiveness'; 'All this is banal, not one good detail'; 'This lacks finesse'; 'Be logical' – which meant, according to Suzanne Schiffman, adopting the film-maker's own logic. And a series of adjectives that were really, in his eyes, swear words: 'murky', 'not serious', 'too easy', 'false', 'too elliptical', 'bad, facile, conventional, false', 'not realistic, tricky, too rapid' and the famous 'a waste', which Truffaut reserved for ideas he liked, even if he thought they had been poorly used, such as the 'Oui, Monsieur' scene, which he would completely rewrite, or the joke about the girl who is too big, with whom you have to 'appear professional'. (In the script, Antoine just complains to the old detective that his girlfriend is larger than he.) Truffaut would write a double scene during filming in order to exploit the joke's visual aspect: a conversation with one of the detectives that sets up the punch-line – What do you do when you go out with a very tall girl? Then cut to a shot of Antoine walking in the street with a girl who is indeed much taller than he.

Sometimes Truffaut asked to be convinced: 'This isn't good, or else you have to convince me by writing the whole scene.' (The old detective shows Antoine some of his tricks.) He even changed his mind: 'This could be interesting' (about the same scene). Even though compliments were more rare (in keeping with the principle of working by opposition), he conceded a few 'very goods' or 'interestings' before returning to the attack with 'make it more beautiful!', running the risk of unfairness or even personal attack when dialogue, a scene or a sequence pushed him to heights of exasperation: 'Very bad 1937 dialogue for Renée Saint Cyr' (the future Christine explaining to Antoine that her father knows she is a grown-up and lets her go out with whomever she likes). 'Ridiculous. When a scene ends on the hero in an apartment, the following scene can't begin in the same apartment except in a film by Grimblat.' And still on the sequence where Antoine shadows Cyprienne, the future Fabienne Tabard, through Paris: 'All this is really not serious. I told you: do it for yourselves, not for Chabrol…'

'Oui, Monsieur'.

Faced with the 'Oui, Monsieur' episode, Truffaut showed his disappointment violently, even calling on Jean Renoir and Jacques Becker to motivate his writers: 'This whole scene is to *Édouard et Caroline* what *L'Eau à la bouche* is to *La Règle du Jeu*.' Revon and de Givray's first draft was in fact very far from what the film-maker would do. Antoine and the old detective are assigned to shadow the wife of a jealous husband, a military man. Antoine is the only witness to a minor accident involving Cyprienne, the wife he is following, and a fire-engine. She invites him to a party to meet her insurance agent. Arriving in the midst of a cocktail party, Antoine is introduced as 'the little witness' to about 15 people who listen to a record on Europe 1 about the Arab–Israeli War, then play a game where you have to put a cushion in front of a woman to embrace her. Antoine talks to the insurance man, then to a colonel, who asks him about his discharge; when everyone goes into the next room to dance, leaving Antoine alone looking out of the window, Cyprienne comes back and asks him if he likes music, and he answers, 'Oui, Monsieur.' He flees but remains on the stairway to

watch the people coming out and to report to his boss. Truffaut was enraged: 'All this is like Georges Conchon, meaning Parisian satire.' Then he added: 'What film are we in?'

It was while putting together his notes for his two co-writers and making them a list of suggestions that Truffaut drew a picture of a completely different set-up: 'They will be drinking coffee together. For whatever reason, Antoine is moved. The woman asks him: "Do you like music?" and he replies "Oui, Monsieur." After the "Oui, Monsieur", all I can imagine for the moment is flight and violent music. "Oui, Monsieur" is such a dramatic high-point that the action following it can't be calm.' The way he revised the episode exemplifies his approach: categorical refusal of satire, exit the banally jealous military husband, exit the cocktail party; enter the apparent triviality of the shoe shop, where the banality of the husband and the airy beauty of Fabienne Tabard will re-introduce a poetic, incongruous note. It was also no accident that Truffaut chose Michael Lonsdale and Delphine Seyrig to play the couple. Truffaut wanted to start from the seemingly banal in order to surprise and move the audience. He said to his writers: 'Let's give the everyday a feeling of exoticism as strong as a James Bond movie.'

No one likes me.

Truffaut invented through opposition. Because he disliked the idea of the jealous husband paying to have his wife investigated, or found it unsatisfying, he took up another element suggested by the detective Duchêne: a story about people who pay to have their own little businesses investigated. He commented in the margin of the script: 'I prefer to see the husband (Michel Lonsdale) explaining his case at the Dubly Agency: "Nobody likes me."'
Then he sketched out, already knowing for which actor he was writing, one of the most astonishing, delicious scenes of the film. The dialogue (or rather the monologue) in this scene, where Truffaut clearly enjoyed letting himself go, was first summarized in the shooting script in indirect style. Then Truffaut wrote it in its entirety just a few days before he filmed it, on separate sheets that he filled with his large handwriting:
'Monsieur Tabard explains his case. Actually, he has come for no special reason, just to see, because he has no particular problem.
Yes, he's married to a 'superior' woman, no problem there. No, she doesn't work. Business is very good. The shop is prospering.
What shop? His, obviously: his shoe shop. Naturally he has many enemies, but he doesn't give a damn. Since college and the regiment he has got used to being hated, envied; that has never kept him from sleeping.
Monsieur Vidal interrupts to ask him the reason for his visit, and, coming down a bit from his high-horse, Monsieur Tabard says he'd like to pay to have himself investigated in order to find out why no one likes him.
Shouldn't he consult a psychiatrist instead? He's thought of it, but the idea repels him. Not because of the money it would cost, but because of the time spent lying on the couch. He's not a weakling. He prefers another approach that will interrupt his work less.

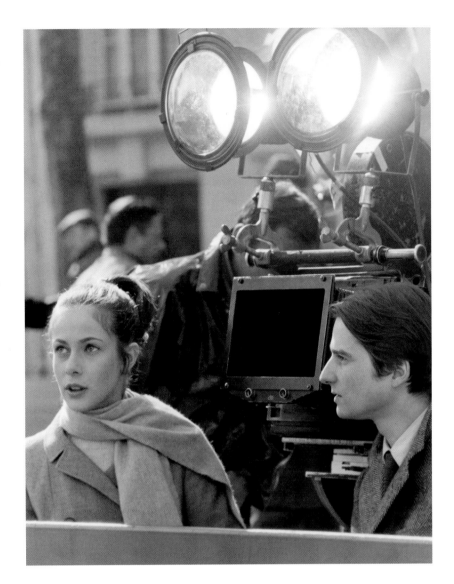

He, Tabard, doesn't dislike anyone. He sells shoes to Jewish women, to Arab women, if he has to he'll sell shoes to Chinese women, as long as they learn to walk on high heels. It will serve them right...'

Propositions.

Reaction after reaction, Truffaut took back his script, changing it for his own benefit and for the pleasure he hoped to give the viewer. He brought everything back to his own world. In Revon and de Givray's version, after leaving gaol Antoine goes to see a friend who is a tattoo artist in Pigalle; Truffaut proposed instead a visit to ladies of the night. 'You'll screw for us at five o'clock,' Antoine's fellow prisoners call after him when he is freed from the Dupleix barracks. In a scene where the detectives in the agency hold a meeting, Truffaut preferred that a woman detective refer to the Hilton Hotel in London, where he stayed while he was making *Fahrenheit 451*, instead of telling a story about shadowing someone in the Pyrenees. De Givray and Revon made the 'Definitive Man' a lawyer living with his mother, Christine's neighbor, but Truffaut crossed that out because for him this man could only be unknown, strange, a voyeur, with no social marks or ties. Truffaut preferred not to have Antoine meet the girl he will be in love with during the film, so that they can become engaged at the end. Instead, he wanted him to meet her again, because as far as the film-maker was concerned, 'he was in love with her before he joined the Army'. This idea of meeting again rather than meeting for the first time was fundamental for Truffaut, from *Jules et Jim* (where seeing the smile on the statue is the prelude to meeting the woman who has the smile) to *La Femme d'à côté*. We even find this preference for meeting again played in a minor key at times, like the scene in *La Peau douce* where Nicole refers to a dinner she attended given by Louise de Vilmorin where Pierre Lachenay was expected and didn't show up – dialogue turns up again in *Le Dernier Métro*, when Nadine tells Bernard that they almost met at a dinner given by a certain Massoulier (the name given in several films to characters we hear about but never see), a dinner Bernard didn't go to...

With the young girl, whom he preferred to name Christine (instead of Martine), Truffaut planned to re-enact his own fondness for his girlfriends' parents when he was an isolated young man, as he did in *Antoine et Colette*, while trying to make it more dramatically effective this time. Always happy to kill two birds with one stone, he proposed that Antoine visit them: 'She isn't home, which permits us to have a scene with the girl's parents while putting off seeing her a bit longer.' He asked his co-writers to find more ways of playing with the viewer. Because he thought it was too easy to have the old detective Antoine meets simply offer him a job, Truffaut asked that the scene be conceived differently: 'I'd like it to be more indirect and unexpected than it is now. The old detective mustn't propose the job to Antoine; we have to avoid dialogue and make the audience work to figure out the idea.' He would do this by filming the whole scene from afar through the windows of the café. Page after page, we see how his refusals allowed him to begin imagining the film he wanted to make. After 'Oui, Monsieur', Antoine follows 'Cyprienne',

who takes a taxi, buys a tie in a drugstore, then takes another taxi and is driven... to Antoine's. While she is talking to the concierge, Antoine slips ahead of her and pretends to be in bed when she knocks on the door. 'I wonder if it wouldn't be better to stop the scene after she buys the tie,' Truffaut noted. 'She goes home. Antoine goes home. The next day he receives a package: the tie (which we recognize) and a little note, the text of which I have in my head. Then he sees her again, etc. We save the scene in his room for later. We've lost sight of the original idea: For a boy of 20, it's easier with women of 40, because [mixing French and English] desertion Martine is dramatic motif woolly-minded and not clear.' In the accompanying notes Truffaut sent to his co-writers, he asked: 'Is there another variation possible? After "Oui, Monsieur", Antoine, disgusted and humiliated, gives up the assignment by pretending to Monsieur Dubly that he has been "spotted". He eventually hands the case over to a replacement, the older woman at the agency, and the replacement, following the married woman, ends up at Antoine's place. That's a possibility. There are surely others.' Truffaut used both. After finding the package containing the tie and the little note from Fabienne Tabard on his doorstep ('I understood your flight, Antoine. Until tomorrow'), Antoine sends her a poetic note via the pneumatic system, with the result that Delphine Seyrig appears in his room in the flesh. Just before, the detective from the agency, played by Catherine Lutz (who was the owner of the bar in *Tirez sur le pianiste*), has told Antoine she is on the lover's trail, because she followed the beautiful Madame Tabard and saw her buying ties, when her husband doesn't wear them...

Using a structure that is not all that far from Lubitsch, Truffaut saw to it that the audience enjoyed having all the facts while he multiplied ingredients, bombarding them with micro-events designed to continually distract them and divert the course of the action. Antoine's first attempt at resigning, when he asks to speak to the boss, is defeated by the drama of the homosexual client who discovers that his friend is married. 'This resignation scene doesn't work very well,' Truffaut noted in the script's margin. 'Here we can place the scene with the queer. 1) The director alone with the queer explains that his friend was married, divorced, and has two children that he has been going to see precisely when his absences have aroused suspicion. 2) The queer throws a fit. 3) The director takes him to the next room and tells Madame What's-it to take him to his home etc. Antoine is there and... I don't know what happens next...' In keeping with the principle of diversion and accumulation, scenes are never one-note, never limited to one idea or one event; instead they compress several layers and several levels, the criss-crossing of different lives that a single setting ('at the heart of the human heart') brings together in one place at the same time.

The death of the old detective.

Truffaut was saving for a few scenes later the death of the old detective while talking on the telephone, an anecdote he had heard and hoped to use one day. After Monsieur Henri's heart attack, Truffaut continued to create the uniqueness of his film by refusing scenes that were proposed

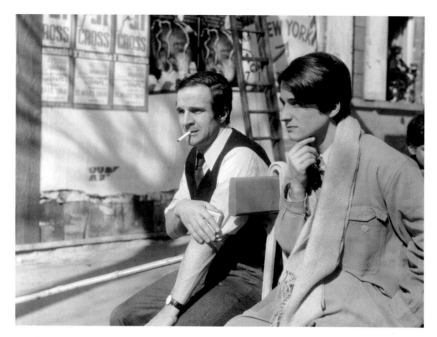

Family resemblance: François Truffaut
and Jean-Pierre Léaud during the filming
of *Baisers volés*.

to him, which no doubt struck him as too ordinary.
Antoine was supposed to wait in the hall and overhear a
discussion of the problems caused by the death; the boss
was to have given him back his letter of resignation,
and Antoine was to have asked to follow the body to
the morgue. 'I want to do something else,' Truffaut said.
'We see the end of Baratin's funeral. We leave the
Caulaincourt Cemetery. Everyone separates: Antoine goes
to the Place Blanche and goes upstairs with a prostitute.
That night he tells his friend: I'm awful. I loved this guy
and I went to get laid… The friend says: I did the
same thing three months ago after my grandmother died.
After death, you have to create life. Making love is a way of
re-establishing the balance etc. What do you think of that?'
In the editing room Truffaut split this scene into two parts:
a first scene, placed at the beginning of the film, where
Antoine talks with one of the detectives one night in
the street (replacing the friend who was removed from
the screenplay at the last minute) and hears how he made
love to his cousin after the death of his grandfather; and a
second scene, much later, where Antoine leaves the
cemetery after his mentor's death to spend some time with
a prostitute. Another way of making the viewer work, all
the while finding a path between lucidity and poetic prose,
rebellion and melancholy, towards the exoticism of
the everyday that Truffaut had evoked for his writers.

Show or tell.

Truffaut always asked himself how to transform, stylize,
re-appropriate and find or place the material that was
brought to him. Finding the best spot for a quote Claude
de Givray brought him about men of genius that Truffaut
liked very much ('It's 10% inspiration and 90%
perspiration'), which he managed to insert into the boss's
explanations to Antoine of the *métier* of the detective.
Or placing the joke 'Y-a-bon Banania', which he adored –
an old detective's trick for getting the address of someone
when you have their telephone number. (You call and
let them win a pretend competition, so that they believe
they've won several packages of Banania: 'If I say, "Y-a-
bon" [It's good], what would you answer?') 'We have to
give this to Antoine, but not at work,' Truffaut told the
writers, adding a remark that tells us a lot in passing about
his morality as a man and a film-maker. 'He does it to help
Christine's parents and prove his competence. In general,
Antoine will never be ashamed of his job. He will be a
mediocre but valiant private eye, not sullen like Belmondo
in *Le Voleur*.'

Truffaut had to decide if it was better to tell certain stories
or show them. The story of the stripper nurse, for example,
was written out at length in the first draft: Antoine follows
the nurse, who takes two little girls to the park and leaves
them alone with a man in a car; he finds himself taking care
of the two little girls, and even has to wipe one of them
with a letter he is writing to Christine. Truffaut crossed out
all these pages, tried to rework the story by adding the idea
that the nurse entrusts the children to a concierge who
keeps them in her miserable lodge, then preferred to have
Antoine recount the scene and act it out for Christine and
her parents, certain that this would make it funnier and

confident about what Léaud could do with it: 'So now she
did her nurse's strip-tease! She did two or three things with
the bottle…'

'Work on this, please'.

In a story that contained no big surprises, Truffaut, never
satisfied, was preoccupied with making each scene
interesting, enriching it with little dramas and introducing
off-beat elements. He refused the first version of the
record of adultery that gets Antoine fired from his night-
watchman job, no doubt because he found it banal or
poorly developed. Yelling, the husband throws himself on
the adulterous couple, the detective closes the door and
tells Antoine to call the police because they're going to
break everything. 'Please detail the chronology of events
in the room' was Truffaut's reaction. 'Work on this, please.
What he breaks, etc. We have to show that Baratin has
pulled off a coup, so he coldly hands the husband a vase
for him to break, you see?' In the next version the scene
was rewritten according to his instructions: the husband
insults the wife; the detective hands him a vase, which the
husband throws out of the window. When he was ready to
shoot it Truffaut, still not committed to a scene he found
too brisk and too simple, introduced new complications:
the idea of the wife's undergarments being shredded (an
idea he had found in an article in *Détective*), and the idea
of the flowers the husband throws at his wife's body;
in despair, he misunderstands when the detective hands
him the vase ('Ah no… No, not the flowers, Monsieur.
The vase!') This transformation of the scene is another
hijacking carried out by poetic prose, via three objects and
at three moments, the layout for which Truffaut hurriedly
sketched in the margins of his shooting script:
'1) The couple in shadow. Light; they straighten up
(the husband in the frame)
2) Jean-Pierre turns away. Harry Max fatalistic
3) The husband: flowers in the face [then Truffaut
crosses this out in order to keep the flowers for later].
The underwear
4) The husband. The flowers
5) Harry Max the vase.
6) H. Max; Jean-Pierre.'

As usual, just before shooting, stage fright made Truffaut
morose and pessimistic. Despite his efforts, he felt that
he had a bad screenplay, too lightweight and unsatisfying.
He was starting off, however, with an excellent cast, and he
went to check out at a theatre, without being seen, Claude
Jade, to whom he would give the role of Christine and with
whom he quickly fell in love when shooting started. Was it
to give her more scenes that he made some modifications
that tightened the script just before shooting? Getting rid
of the best friend, Didier, and his girlfriend Juliette enabled
Truffaut to show Antoine alone at times (so that his
best friend is the viewer) or to re-assign certain scenes to
Christine. At the hotel where Antoine is the night watchman,
the visit from Didier and Juliette is replaced by a visit
from Christine (it was planned that the friend would give
Antoine the box of vitamins), permitting Truffaut to write
a real reunion scene, evoking their past and their eventual
break-up. He also imagined a lovely visual device: we see
Christine arriving at the front door of the hotel, which she

Rehearsing with Jean-Pierre Léaud and
Claude Jade.

has difficulty opening at first, not knowing that you have to push – just like her relationship with Antoine. Antoine was going to ask Didier and Juliette to guess his new job at the detective agency, but the scene was re-assigned to the Darbons and was intended to include Christine's mother. Because the actress, Claire Duhamel, was absent on the day the scene was filmed, Truffaut filmed it with just Léaud, Daniel Ceccaldi and Claude Jade and had them partially improvise it. (The excuse for the mother's absence, 'the trains are on strike', could be an allusion to the demonstrations against Henri Langlois's expulsion from the Cinémathèque française, which happened during the production.) Another scene written for Juliette (whom Antoine would have met in the street) and given to Christine was the origin of a brief episode that is rather mysterious. Truffaut crossed out the street and noted: 'Actually, it happens in front of the Darbon house. We see Christine arriving carrying a violin.' Truffaut reinforced the mystery while filming it, since Christine's mother swears to Antoine that she is not there; then we see Christine emerging from the cellar after Antoine's departure – a little episode about a secret between mother and daughter that is never elucidated.

In these modifications made before shooting began, we also see Truffaut concerned to have the 'Definitive Man' appear throughout the film, whereas the scenario only introduced him at the end with a monologue the director wrote in one spurt on some sheets of onionskin paper. He only decided to work on these appearances at the last minute, which also enabled him to add an enigmatic element to the film. 'First appearance of the final guy' when Antoine pays his first visit to Christine's parents. 'Second appearance of the guy' when we see Christine with her violin in front of her house. At the moment of the argument between Antoine and Christine at the shoe shop where she has come looking for him, a lovely moment of bad faith for Antoine added just before the shoot, when he hits Christine with the statement that for him, love and admiration go hand in hand: 'At the end of the scene, just before Antoine and Christine separate, we see the third "appearance of the guy".' Then, 'fourth appearance of the guy' when Antoine stops in front of the Darbon residence in the SOS car. If Truffaut redressed the balance between Fabienne Tabard and Christine by adding this scene where Christine comes to 'harass' Antoine at the shoe shop, he also added a scene, accompanied by melancholy music, where Claude Jade comes and knocks on his door, even trying to open it, when he is with Madame Tabard.

The Langlois affair.

Paradoxically, the business with the Cinémathèque and the hyper-activity into which Truffaut was thrown by the resulting meetings and demonstrations rescued him from his anxieties. On 9 February 1968, four days before the start of filming on *Baisers volés*, an administrative council ratified Henri Langlois's eviction from the Cinémathèque française, which he had founded. Film-makers and friends of Langlois quickly mobilized. A 'defense committee' for Langlois was set up, in which Truffaut participated quite actively, never hesitating to occasionally arrive late on the set or for the screening of rushes. On 14 March,

two months before May 1968, a demonstration that led to a clash with the forces of order turned public opinion in favour of Langlois, but another month of combat would be needed before he was allowed to resume his office. Truffaut was swept along by the excess of activity this militant fever provoked, and the filming was happy and inventive. He gladly accepted certain ideas from his actors when they brought him elements that interested him, such as the scene of Fabienne Tabard in Antoine's room, where Delphine Seyrig, remarking that she has just come up the stairs, suggested that she play the scene out of breath. His *mise-en-scène* was particularly fluid and rather complex, but invisible and limpid, married to the movements of the characters. There are many scenes where two simultaneous actions were filmed in single sequence shots or almost, without ever being ostentatious. Thus the scene in the garage where Antoine tells Christine's mother the story of the nurse, while the father keeps entering and leaving, was filmed in one take until Christine's arrival, cutting only when Antoine steps into the phone booth to demonstrate the effectiveness of 'Y-a-bon, Banania'. Then a new single shot accompanies the departure of everyone to the street, where a little argument between Antoine and Christine takes place in front of her parents. (Because they aren't going to the cinema, Antoine will not be able to throw himself on her in the dark.) These long takes are loaded with information, variations of mood, sensations – such as the big scene at the agency where Truffaut got the maximum out of the set, a big room with a double door parallel to the director's office, from which it was separated by the entrance hall. This set allowed him to follow the criss-crossing characters and their actions, the proliferation of crossed destinies, with long, barely perceptible single sequence shots, creating an uninterrupted flux where something was always going on... until the death of the old detective, a sudden pause that interrupted a long take.

Other scenes were filmed more simply in shot-reverse shot, especially when the text had been given to the actors at the last minute – something that happened even more often than usual because of the Cinémathèque affair. For the scene where Fabienne Tabard comes to see Antoine and proposes spending two hours in bed with him, Truffaut had the idea of having her in constant motion, sitting only an instant on a chair she gets up from immediately before approaching Antoine, who is imprisoned in the reverse shot where he remains immobile, as if paralysed. The effect is funny and the *mise-en-scène* portrayed the situation precisely.

In the editing room Truffaut became anxious and strict again. Yann Dedet, who was the assistant editor, recalls that the editing process was rather tense, because Truffaut had the impression they were verging on a banal French comedy, was mad at himself about it, and was tempted to speed everything up. A certain number of scenes he found uninteresting were therefore cut, notably those where Antoine learns the *métier* from the old detective. This was the moment when the film-maker became at least provisionally invulnerable to the charm of the film, of which he would prefer to say, as he told Claude de Givray: 'This film deserves no more than one hour twenty-five.'

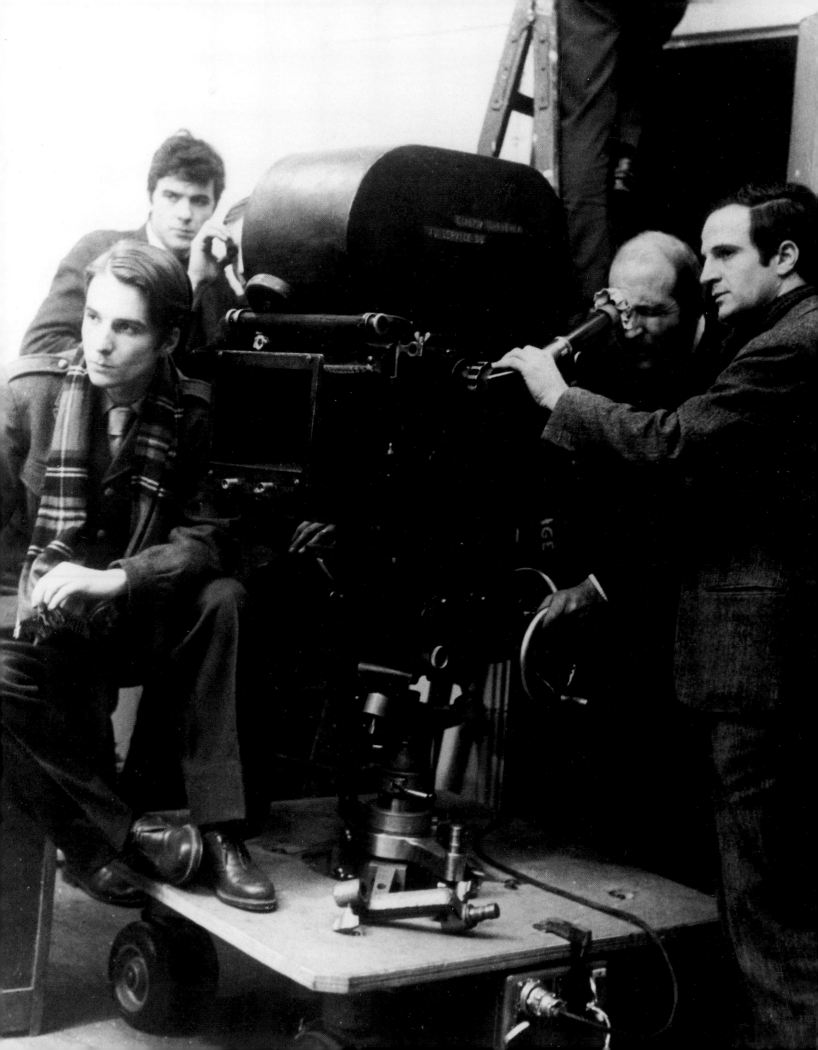

La Sirène du Mississippi

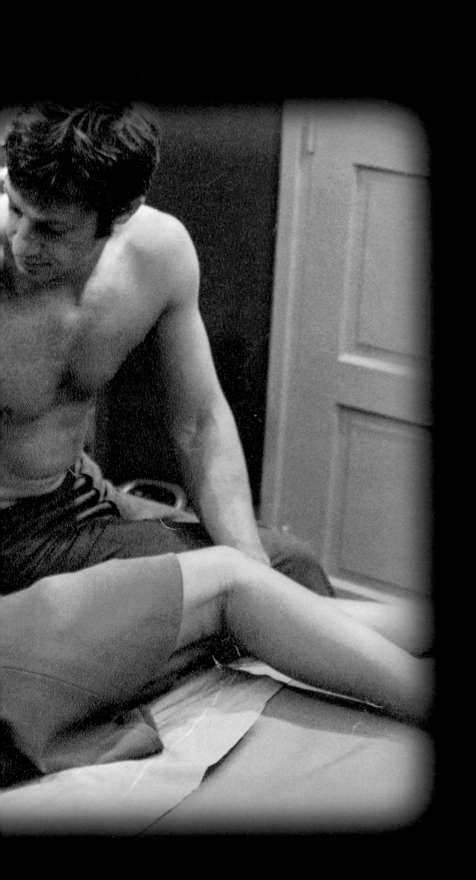

La Sirène du Mississippi (1969)
Mississippi Mermaid

La Sirène du Mississippi and *La Peau douce* can be seen as companion films: the two heroines are played by sisters, Françoise Dorléac and Catherine Deneuve, and the masculine characters are almost the same person, a virgin (or the equivalent) who discovers the joys and suffering of adultery and love for the first time.

'I don't like it when actors arrive on the set knowing their lines by heart. I want them to learn them in the heat of the moment. I think that when you're feverish, in the medical sense, you are much more vibrant, and I'd like my films to give the impression of having been filmed with a temperature of 112.' Applied to William Irish, those 112 degrees send the timid Louis Mahé (Jean-Paul Belmondo) in pursuit of blonde Catherine Deneuve, who got off the boat in place of the brunette Julie Roussel. Truffaut would indeed achieve that temperature at certain moments in this film: when Louis Mahé is driving at top speed to the bank, where he will make them open up in the middle of the night, only to discover that his account has been emptied by a usurper whom he told just that morning that she was worthy of being adored; when he collapses, in a fog, on the aeroplane taking him to the Continent before a sleeping cure at a clinic called Heurtebise, a name taken from Cocteau; when Julie alias Marion throws herself on him and demands that he make love to her after the detective's death; when Louis realizes that he has been poisoned after his hand brushes a newspaper comic strip in which Snow White is starting to eat the apple the witch has offered her... 'If we play the game of free association, the name Irish leads to the words amnesia, cotton, all-nighter, bandage, sleep-walking, wedding ring, veil, pain, slow motion, anxiety, forgetfulness,' Truffaut wrote on the subject of the author in 1980.

To create the poster for the film, Truffaut reversed the layout of the US magazine where the novel first appeared.

At the end of 1966, the project seemed ready to take off: when the Hakim brothers proposed that he make *La Sirène du Mississippi*, Truffaut, who knew the novel well (particularly since he had re-read it while working on *La mariée était en noir*), quickly adopted the idea and planned to start production very rapidly. He was even planning to substitute one film for the other, because the start date for *La mariée* had just been put off. He quickly got a 'yes' from Jean-Paul Belmondo and was happy to report that the actor did not 'show any wish to put off agreeing until he'd read the script, which in any case would be physically impossible because pre-production has to start in two weeks and I'm planning to write most of the dialogue during shooting, as I've always done for my French films' (Letter to Robert Hakim, 16 November 1966). But disagreements with the producers forced him to put off the project, after which he filmed *La mariée était en noir* and *Baisers volés* as planned. According to Truffaut, his disagreements with the Hakims had less to do with the choice of a female lead (Truffaut wanted Catherine Deneuve, whom he said he thought of as soon as he read the book; the producers at first would have preferred Brigitte Bardot), than with the male lead. ('They wanted Alan Bates or Delon; I held firm for Jean-Paul,' he wrote to Gilles Jacob at the end of October 1969.) Above all, the Hakims insisted on approving the final cut and did not really have the rights to the book, which were held

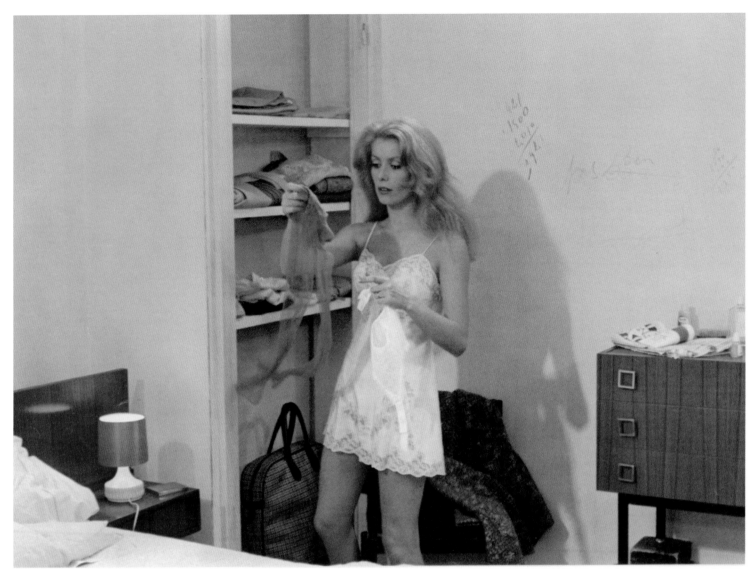

by Twentieth-Century Fox. When Le Carrosse finally succeeded in buying the rights at the beginning of 1968, Truffaut took up the adaptation he had written at the end of 1966 again and reworked it, for once not with a co-writer but with the help of Suzanne Schiffman. Location scouting started at the beginning of the summer, after completion of *Baisers volés*. Until October he had been planning to shoot the film in Corsica; then he suddenly changed his mind, deciding to set it on the island of Réunion in order, he said, 'to improve the screenplay and get closer to the spirit of the novel'. More prosaically, Truffaut was furious when the locations found in Corsica did not correspond to what he had imagined. Roland Thénot, his production manager, recalls that Truffaut left two hours after he got off the plane, having rejected two or three locations that he did not find exotic enough. Marcel Berbert says he got a phone-call from Truffaut that weekend, when the crew was ready to leave for Corsica on Monday to start organizing the shoot: having decided to cancel everything, Truffaut was very excited about New Caledonia (in the film, this would be the original destination of Julie Sorel and her sister Berthe). Horrified by the distance (40,000 miles) Berbert, consulting a map, proposed Réunion as a compromise solution – Berbert, to whom Truffaut gave the role of Louis Mahé's faithful

associate Jardine, who became 'the man with the statistics…' Co-produced by United Artists, who accepted the film at the same time as *L'Enfant sauvage*, thinking that the commercial success of the big film with two stars would make up for the off-beat subject and likely failure of the smaller second film, *La Sirène du Mississippi* was a big-budget project that Truffaut threw himself into without a safety net. ('I give myself until 1972 to learn English, because *La Sirène* will be one of the last big-budget films that won't be made simultaneously in English. It is madness not to when a production costs eight million francs.') By a happy irony, the profits from *L'Enfant sauvage* helped to make up for the commercial failure of *La Sirène du Mississippi*, a failure Truffaut would later explain (in 1975) as being a result of the difficulty he had persuading the public to accept an actor like Jean-Paul Belmondo in the role of a defeated, desperate man: 'It's not hard to understand what shocked the Western world. *La Sirène du Mississippi* shows a man who is weak (despite his looks) captivated by a woman who is strong (despite her appearance). A secret notion inspired me while I was making that film: for me, Catherine was a boy, a hoodlum who'd been through hard times, and Jean-Paul was a young girl who expects everything from her marriage. […] He doesn't say so, but for me Belmondo is a virgin!'

For *La Sirène du Mississippi* Truffaut wrote, filmed and once again cut a scene where a man is sent to a lingerie shop by his lover to buy a pair of stockings.

Previous pages: Catherine Deneuve and Jean-Paul Belmondo.

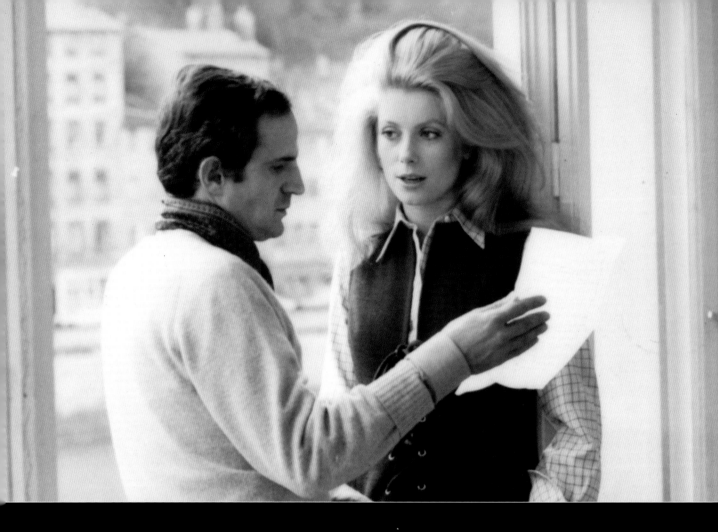

Right: The novel by William Irish as annotated by Truffaut, who already seemed to have in mind the idea of showing at any given moment exactly where the characters are in their romantic and sexual lives. On the left page Durand is asked by the colonel whether he wants a blonde or a brunette companion for dinner: 'Blonde or brunette? Brunette! Very important, this "brunette or blonde" business, even if it is placed elsewhere in the film.' (It wasn't used.) And on the right page describing Durand trying to make love to his wife, fully clothed, while the colonel is waiting at the door, Truffaut noted: 'A small obscenity: she checks whether he has an erection!'

blonde ou brunee? Brune !

174 LA SIRÈNE DU MISSISSIPI

Le colonel se frotta jovialement les mains.

« Nous dînerons en petit cabinet, ajouta-t-il. Je retiendrai une de leurs alcôves, où on est à l'abri des regards indiscrets, derrière un rideau. Vous n'aurez qu'à nous chercher. » De l'index, il tapota la poitrine de Durand. « Et n'oubliez pas : c'est moi qui invite.

— J'entends vous disputer cet honneur, dit Durand.

— Nous débattrons cela, le moment venu. A demain soir, donc. Conclu ?

— A demain soir. Entendu. »

Worth se hâta de rejoindre le groom qui attendait sur le seuil, ayant évidemment reçu l'ordre de ramener le colonel.

Brusquement, Worth fit demi-tour, revint précipitamment, se haussa sur la pointe des pieds et chuchota d'une voix rauque à l'oreille de Durand :

« J'oubliais... Blonde ou brunette? »

Un instant, une image traversa l'esprit de Durand. Il dit précipitamment :

« Brune », et une lueur de souffrance vacilla une seconde dans ses yeux.

Le colonel lui donna un coup de coude dans les côtes en signe de camaraderie libertine.

très important ce truc de : "brune ou blonde" même si ailleurs dans le film.

le colonel sur le pas de la porte

186 LA SIRÈNE DU MISSISSIPI

Pas un mouvement. Rien qu'un frémissement de vêtements froissés.

Puis le rire éclata, une fois de plus; mais assourdi, furtif maintenant.

Il reconnut la voix du colonel — sorte d'épais chuchotement :

« J'ai attendu cet instant toute la soirée. Ma p'tite... ma toute p'tite... »

Le froissement d'étoffe s'accentua : elle résistait.

« Cela suffit, Harry. J'ai encore l'intention de porter cette robe. Ne la mettez pas en lambeaux.

— J'vous en paierai une autre... dix autres... »

Elle se dégagea enfin; mais les bras de l'homme l'enserraient toujours. Elle les repoussait, en s'appuyant de tout son poids. Enfin, elle brisa leur étreinte.

« Mais c'est que j'aime cette robe! Ne soyez pas si brutal. Laissez-moi. Je vais allumer. Nous ne pouvons pas rester ici de la sorte.

— Moi, je préférerais.

— Je n'en doute pas! répliqua-t-elle insolemment. Mais tant pis! Je fais de la lumière! »

Elle s'avança dans la pièce, s'approcha de la veilleuse qui s'illumina sous sa main. Elle se tenait là, baignée de lumière et il la vit renaître, une fois de plus, après un an, un mois, un jour. Elle était là, bien réelle, dans toute sa splendeur et dans toute son ignominie, avec toute sa beauté et toute sa perfidie.

Et la vieille blessure se rouvrit dans le cœur de Durand et se remit à saigner.

Elle jeta par terre son éventail, jeta l'écharpe

() petite obscenité; elle vérifie qu'il bande.*

MARION
Mais j'attends.

LOUIS
Parlons un peu de ton sourire maintenant,
non, (elle sourit) ~~celui-ci~~, non ~~celui~~
~~celui~~, pas celui-là. Ça c'est celui que
tu fais dans la rue ou pour les commerçants.
Non, donne-moi l'autre ... le vrai, celui du
bonheur. Voilà, c'est ça ... Formidable !
~~maintenant~~ Non, c'est trop ... ça me fait
mal aux yeux. Je ne veux plus te regarder.
Attends. (*Il ferme les yeux*)

MARION
Je t'attends.

LOUIS
J'ai les yeux fermés et pourtant je te vois,
je vérifie. Si j'étais aveugle ...

Louis, les yeux fermés, caresse très doucement le visage
~~Louis~~ *de Marion.*
~~caresse que sa~~

LOUIS
... Je passerais mon temps à caresser ton
visage, ton corps aussi ... Et si j'étais
sourd, j'apprendrais à lire sur tes lèvres
avec mes doigts ... comme ça.

Louis lui passe le doigt sur les lèvres. Marion se blottit dans
ses bras. ~~xxxxxxxxxx~~

A un moment, Marion tente de cacher un journal : Louis l'a vue
et le prend. Sur ce journal on parle de Richard qui vient de se
faire arrêter en Belgique. Marion, joyeuse, fait remarquer que
Richard ayant tiré sur les policiers au cours de sa capture, il sera
sûrement condamné à une lourde peine. A cette première réaction
cynique succède chez Marion une forte mélancolie. Richard est
l'homme qu'elle hait le plus au monde, cela ne fait aucun doute.

1er étage

53 . CHAMBRE A COUCHER . INTERIEUR . SOIR

Le même soir, Marion se refuse à Louis et lui explique que l'idée
même de faire l'amour lui est devenue insupportable; elle a déjà
traversé des périodes comme celle-ci, elle demande à Louis de se
montrer patient. Louis sera patient. Leurs nouveaux rapports n'ex-
cluent pas la tendresse, bien au contraire.

réflechir enchainement

Scène d'amour

54 . VILLA AIX . INTERIEUR . JOUR

Scène à définir ultérieurement, au cours de laquelle Louis insiste
pour que Marion ne renonce pas à son projet de se faire faire de
nouvelles robes.

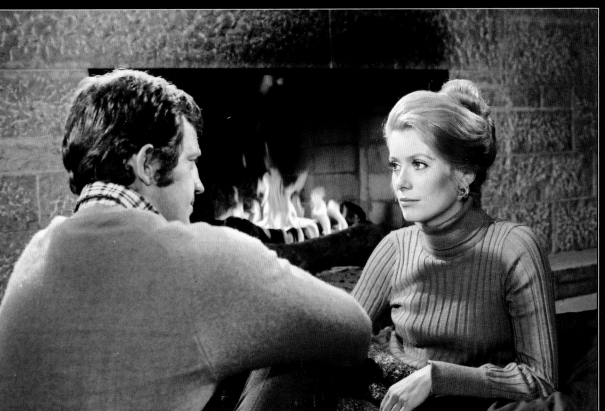

Above and left: 'To create heroic characters, write long scenes.' The long conversation by the fireside was written during filming. In the screenplay it is described simply as 'scene to be determined'. It is preceded by a scene, described but not written out, where Marion, upset that her former lover and accomplice has been caught and will probably be condemned to death, becomes incapable of making love. Truffaut noted, with an arrow to the 'love scene' that follows in the script: 'Rethink sequence of scenes'. In the film, Marion's frigidity is not linked directly to the news of her ex-partner's capture.

A couple.

Part thriller, part fairy-tale, part soap opera, part marital comedy and also a big romance, *La Sirène du Mississippi* is above all a film about a couple and about couples. That is what is most successful about it today, most true and most alive. The thriller scenes and the uneven allusions to Hitchcock (a car starting up and mysteriously driving along a corniche) are less accomplished than the often serious, often naughty intimate scenes, which are about the difficulties Louis and Marion have coming together. The same is true of the beginning of the film, where one feels that Truffaut was ill at ease filming the arrival of a steamer, the waiting crowd, the surprising discovery of a young blonde woman standing on an immense esplanade and holding a birdcage. As was often the case, it was only when he returned to his first attempts at adaptation after the project had been interrupted that Truffaut more or less consciously steered his film in the direction that would make it unique.

Of course we can already see a certain number of scenes that belong more to the film-maker's world than to William Irish's in the first synopsis written in Truffaut's hand (still very close to the direction of the novel, except for editing down the story a bit and switching from New Orleans in 1830 to Corsica in 1967). Truffaut had already come up with the scene where Mahé throws the fake Julie's lingerie in the fire after he discovers the deceit – a ridiculous substitute vengeance that Truffout used differently a few months later in *Baisers volés*, before filming it for *La Sirène du Mississippi* as he had intended. He also used the same words that described Fabienne Tabard in *Baisers volés* to describe the appearance of Louis' fiancée, taking nothing from Irish's novel: 'No relation to the Mademoiselle Julie of the photograph… This is a real apparition. She is certainly younger, and she has the éclat, the blondness, the quality of being "lit up from within" that one finds more often in dreams than in real life.' Also in the first synopsis, needing a visual idea that could take the place of long scenes of pursuit when Louis is looking for his wife on the Continent and living in hotels (without as yet falling into a depression and checking into a clinic), Truffaut had him recognize her being filmed as a bunny girl in a regional news broadcast about the opening of a club in Juan les Pins (which would later become Antibes, home of writer Jacques Audiberti). Another visual shortcut imagined very early on: the drawings of Snow White that enable the hero to realize he is dying. ('In a newspaper lying on the night table he sees a comic strip for children: Snow White. He sees the witch give Snow White an apple. The four images dance before his eyes. He has understood!') At the end of William Irish's novel, Louis dies just as the police arrive in the rented room near the train station that the couple were planning to leave from after she confesses to him that she loves him at last. Truffaut rejected this grim ending in favour of one he preferred to be happy: 'They must flee, not through the front door; through the back door. Yes, through the garden, then over the tennis courts, until they come to the railway bridge and start following the tracks. He has to get well… but flee first, flee and then get well. It's not important, since love is there between them, settled, stronger than ever, indestructible:

definitive love!' It is amusing to see how he reduced this lyrical flight a little, making it more ambiguous, when he had the synopsis typed: 'Love is there between them, a love that's all the more intense for being threatened.' In the next phase, reworking the adaptation almost two years later, Truffaut envisioned the ending, like that of *Tirez sur le pianiste*, taking place in the mountains and the snow: 'Last image: Louis' car runs out of petrol a couple of miles from the frontier; in any case, they're out of money… Louis and Marion continue on foot and disappear in the snow.' This final indirect homage to Renoir (the departure for the frontier in the snow, like the ending of *La Grande Illusion*, except that the fleeing characters in *La Sirène du Mississippi* go in the opposite direction) came before Truffaut decided to open his film with shots taken from *La Marseillaise*, since he didn't yet know at this point that he would be shooting the film on Réunion.

Marital comedy.

When *La Sirène du Mississippi* was about to start up again and he returned to the process of adaptation, Truffaut resolutely began to take more liberties, trying things and amusing himself a little, while constantly examining the couple's relationship. Some of these scenes would not make it into in the final film; others would give the interludes of marital comedy the mix of naturalness and audacity in the portrayal of sex – audacity that was often disguised by speed and an apparent casualness – which characterizes *La Sirène du Mississippi*. As he was writing this treatment, Truffaut was obviously trying to inject life, not hesitating to push his characters and situations further (this being the version where Louis Mahé leaves the island after the catastrophe to take a 'sleep cure in a clinic on the Riviera'), and at the same time giving freer rein to the spirit of childhood. We now discover a Louis Mahé who is a brother of Antoine Doinel and a future brother of Bertrand Morane and Bernard Granger (in *L'Homme qui aimait les femmes* and *Le Dernier Métro*), playing with a model plane on his day off. It is the scene where the couple put off opening the trunk that the fake Julie pretends to have lost the key to. 'In the garden Louis flies a scale model of an plane on the end of a cable – it whistles as it cuts through the air', with this addition: 'If the plane is impossible, it can be replaced with something else, an English dart game.' This childlike, recreational part of the relationship was supposed to return in the cities where they stop to rest, but Truffaut finally forgot that idea, concentrating and merging the moments of recreation with Louis and Marion's sexual games. Truffaut was infusing the new treatment with his own personality. In a letter to Charles Bitsch, a cameraman and friend from the *Cahiers du cinéma* days, he reported that he wrote it 'alone with a viewfinder in my right hand and the book in my left; happily for me, it was Jacques Doniol-Valcroze's viewfinder and a book by William Irish. (I wonder what the reverse would have produced!).' Jokes appeared (while looking at the house to rent in Aix en Provence, Marion begins calling the real estate agent, Mme Travers, 'Mother Traviole' or 'Madame de Traviole'), plays on words (Louis tells Marion, coming out of the bank where he just gave her the right to make withdrawals from his accounts, that she is 'adorable, that is worthy of being adored'), and pranks that are more or less autobiographical

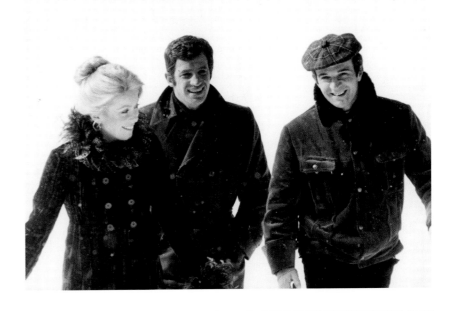

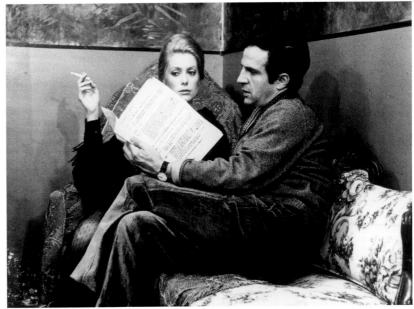

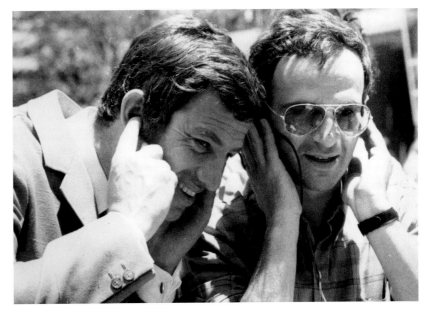

Respect for money: Marion (Catherine Deneuve) carefully smooths the notes that Louis Mahé (Jean-Paul Belmondo) just brought back from Réunion.

in origin. Truffaut reintroduces in the screenplay the idea of the strip-tease that was edited out of *La Peau douce*: Marion changes sweaters, revealing herself in her bra; Louis pretends to cover his eyes and makes the car zigzag; the driver of a Peugot 404 that passes them, thrilled, starts zigzagging too... When he filmed the scene Truffaut went a bit further, just for fun: Marion isn't wearing a bra under her sweater, and the oncoming car ends up in a tree.

Sex and money.

Truffaut started augmenting the sexual dimension of Louis and Marion's relationship considerably when he found the direction in which he wanted to take his film (or which the scenes he had written, one after the other, had found for him). He would later say this explicitly: 'My whole aim was that the public should know at each moment where the characters were in their romantic relationship, in their sexual relationship and also with respect to their money problems!' After the canary's death, Julie openly uses her sexual power on Louis. Truffaut reinforced her little game with the dress she unhooks so that she can invite her new husband to hook it up for her. ('Louis goes up the stairs, and we cut when he enters the room,' he wrote, giving the scene a Lubitsch ending. But during filming he prolonged the scene, using the stairway as a ramp from which Julie leans in a position that one can imagine Truffaut indicated with great precision in order to film the end of the scene – when she makes Louis sit down nearby and takes his head on her knees – through the railing, which blocks our view at the same time that it lets us see.) 'We should sense that their sexual complicity has grown enormously since they have got back together,' Truffaut wrote in the script after the scene where Louis takes Marion back despite everything she has done. For the section set in the house in Aix en Provence, he outlined the scene when Louis hides her panties under his pullover, challenging Marion to find them: 'Marion starts looking for her panties like a child playing Hide the Thimble: "You're warm, you're getting colder, you're burning up." The end of the scene will be improvised.' Marion's attack of frigidity also appears here ('The very idea of making love has become unbearable to her'), linked by Truffaut to the news that her old accomplice has been arrested, which Marion is first happy about, then melancholy. ('She has been through periods like this before; she asks Louis to be patient, and Louis says he will. Their new relations don't exclude tenderness, quite the contrary.') Truffaut slightly displaced the attack of frigidity during editing, so that it is linked less directly to a visible cause. He put it just after the scene, invented during shooting, about the personal ads (of which Marion makes fun and Louis, who has used them, defends). We often find this gradual break with explicit causality in Truffaut's work. By affecting us on a less conscious level, his films take on the force of free association. In editing, Truffaut also worked on the alternation between the scenes of the couple's carefree sexual games and the menace that pursues them. After the scene where Louis hides Marion's panties under his pullover comes the brutal arrival of the detective at the Aix train station. And after the strip-tease in the car, shots of the detective walking around the city. It is as if the film were built around two kinds of time: on the one hand, time suspended by love, and by a clandestine

situation that is experienced at first as a holiday, where the scenes of the couple are like islands separated by indeterminate periods of time. (Even when Truffaut filmed a married couple, he made it a clandestine couple.) On the other hand, the thriller plot, which re-establishes the external menace and little by little turns their play feelings into real love.

La Sirène du Mississippi is a fairy-tale where imagination is mingled with reality, often rather raw reality. In making his film less a thriller than a study of a couple that he enriched with elements from his own world, Truffaut was spelling out what was left unsaid in the novel. After the murder of the detective and his burial in the cellar, Truffaut added a very risqué scene of a rise of sexual passion – a bold, unmistakable indication that the murder and hiding the body have cured Marion's frigidity. 'Marion looks at Louis without saying a word. She gives herself to him for the first time in a long time, with renewed ardour. He starts to undress, but she doesn't want him to. She says, in a very low voice: "Take me like that… right now…"' (So much for the myth of Truffaut's sweetness and modesty.) Truffaut tried to follow this sequence with recreational scenes (Louis pretending to be the postman who is delivering some calendars) that he removed later, including the recurrent scene of shopping for stockings, a remake of the scene cut from *Tirez sur le pianiste* and *La Peau douce*, which he again ended up cutting from this film. Above all he reworked his treatment to establish the link between sex and money which the film gives such prominence. Truffaut enhanced the sexual game-playing in the scene when Louis, who has gone to Réunion to sell his shares in the factory to his associate Jardine, returns with the money. ('Marion pretends to be asleep. Louis pretends to believe that she's asleep.') After re-reading it, Truffaut added this note: 'He's relieved when he sees that Marion has respected their *mise-en-scène*, which moves both of them… They both seem to love his game, slow and precise as a ritual, leading to the moment when Marion shows that she's wide awake and ready for love.' During filming, Truffaut made the scene a little more sophisticated: hearing on the intercom that Louis is back, Marion changes her clothes before pretending to be asleep, putting on sexy underwear and a dress with lots of buttons for him to undo slowly… In the next shot we see the stack of notes that she is smoothing as she counts. This is also a scene Truffaut invented during production, writing notes in the margin of his script: 'She smooths the notes…With money… Consideration… legion of honour… republican guard…' Catherine Deneuve alias Marion affirms, as if it were very important, that if they are sent to prison but decorated, they have the right to demand a member of the Republican Guard stationed at the door – a residual respect for public honours at the heart of her insolence that makes her like Camille in *Une belle fille comme moi*. This is probably an anecdote Truffaut picked up with the intention of using it in dialogue on the first occasion that presented itself.

Stage fright.

The shooting script for *La Sirène du Mississippi* – without dialogue, except for a few scenes or fragments of scenes, because Truffaut preferred to write the dialogue a few

The feather collar of the coat Yves Saint Laurent designed for Catherine Deneuve, an eccentric coat that could cause Marion to be spotted by the police.

Previous pages: Jean-Paul Belmondo and Catherine Deneuve.

days before filming it – is very close to the film-maker's final treatment. As was almost always the case, a few days before the start of principal photography (he started shooting on Réunion on 2 December 1968), or even the night before, Truffaut was suffering from stage fright. 'I strut around self-confidently, but as you might suspect, three days before shooting, the nerves are there, and I'm plagued with the usual escapist fantasies: "What if Catherine Deneuve were to break a leg… or Jean-Paul were to come down with tonsillitis…"', he wrote to Helen Scott. 'In other words, once again they'll literally have to drag me to work, la Shife [Suzanne Schiffman] will kick me up the arse to keep me going.' Nevertheless, Truffaut was about to realize one of his dreams by shooting a film almost entirely in sequence, which would enable him to follow the development of the couple from one day to the next. Shooting began on Réunion, then moved on to Nice, Aix, Lyon and the Grenoble region. *La Sirène du Mississippi* was Truffaut's first road movie, one where the route is less important than the couple's stopovers along the way in places that are more or less protected from the world: the house in Aix before the detective intrudes; the apartment in Lyon, which is quickly invaded by the police; the chalet in the mountains. So furious at the way the inside of the house on Réunion had been arranged that he refused to shoot there (several scenes were played on the veranda to avoid filming inside), Truffaut gave up shooting in sequence for certain scenes that would have to be filmed in Aix or Paris, notably those in the bedroom. (The fake Julie's nightmare when she wakes up suffocating and says she can't sleep without the light on, which is also the first conjugal scene, casting a shadow on the marriage that has just taken place.)

'Curiously, after three days I realized that it would be impossible for me to keep a journal about shooting *La Sirène*, probably for a reason that Henri-Pierre Roché sums up in a sentence: "Happiness is hard to recount, but it gets used up even if we don't see it happening"', the film-maker wrote on 14 January 1969 to Jean Narboni, then editor-in-chief of *Cahiers du cinéma*. 'This is my best shoot since *Jules et Jim*. I'm talking about the ambience, not the result: that we'll see in June.'

The big scenes.

As he got to know Catherine Deneuve, Truffaut wrote new scenes for her during filming, such as the big love scene by the fireplace, the most intimate scene in the film and the only one the film-maker shot almost exclusively in tight shot-reverse shots, which in the script was as yet undefined: '54. House in Aix. Interior. Day. Scene to be defined later, in which Louis insists that Julie not give up her plan to have new dresses made for herself.' This was supplemented by a laconic note in the margin: 'love scene'. Truffaut added little vignettes, always contributing to the central theme, that verged on private jokes. 'You have something against making love in the afternoon?' we hear as we see the shutters of the house being closed. Or the sentimental gag about the double coffees [*serrés*], which of course become 'two coffees hugging [*serrés contre*] each other'. Above all, as he plunged into his film while inventing supplementary scenes during shooting, and as the need to portray the couple more and more precisely became uppermost in his mind, Truffaut did not hesitate to write whole scenes that were quite long, where the characters ended up exposing themselves with no holding back. ('To create heroic characters, Pagnol, Fellini, Bergman are not afraid of long scenes,' he wrote years later to his co-writers de Givray and Revon.) The scene by the fireside, which follows the moment Marion realizes she is unable to make love, starts off, before Louis declares his love, with an allusion to the abortions she has had. In the scene where they talk about the personal ads, filmed in the evening on the balcony of the house in Aix, Louis tries to explain that he wanted to establish something definitive in his correspondence with Julie Roussel but instead has found the provisional in Marion. There is also a scene of a violent quarrel, filmed in the bare apartment in Lyon, where Louis calls Marion a parasite and a 'chick'. And finally the scene where Marion makes a record while Louis is away looking for money on Réunion. This is a retake done in Paris at the very end of filming, when the editing had already begun, as if something were missing that was needed in order to make the final reversal possible when Marion, a prisoner, money all gone, tries to kill Louis before discovering her love for him. Marion records her voice while he is away, consulting, as Truffaut himself might have done, notes she has made in a matchbook (recalling the matchbook where Françoise Dorléac writes her number for Jean Desailly in *La Peau douce*). She tells Louis she misses him, that she is dressed the way he likes, and then cannot keep from talking crudely about the money he is bringing back and what it means to her. This ambiguous declaration is lost when the record breaks in the street as she is leaving the studio, and Marion, with no sign of regret, pushes the pieces into the gutter – a beautiful way Truffaut had found for her to address the viewer while preserving his hero's ignorance.

It is this constant mixture of almost childish naughtiness and lyricism, of crudeness and runaway feelings, that makes *La Sirène du Mississippi* not the star vehicle that was originally announced, but every bit as much a first-person film as other Truffaut films that are more openly personal. It is touching to see today how inspiration linked to the birth of love and the encounter with Catherine Deneuve's crisp, matter-of-fact acting allowed Truffaut to re-introduce marriage at the heart of thriller scenes, carrying out, even at the risk of being misunderstood, the goal he had set himself when he reworked the script. When the apartment in Lyon is invaded by the cops and the couple have to try to recover the money they have left upstairs, Louis stops Marion, who wants to slip up the fire escape to the apartment, because her pretty, eccentric coat will give her away. The only answer she can think of is, 'Are you crazy? What's wrong with this coat?' Everyday married life takes precedence over the danger. At this point they are as much a couple trying to manoeuvre their car without scratching it as they are two criminal lovers on the run, and it is this everyday quality in the face of danger that gives the film its flavour.

While he was rewriting the script, Truffaut imagined the couple driving to Aix 'in a superb red American convertible'. Starting from this simple desire, he had the idea during

filming for a funnier, more elaborate scene about a couple and a marriage that demonstrates how Marion has gained the upper hand: Louis picks a grey car, she wants a red one, he refuses, and we next see them rolling down the road in the beautiful red car. Truffaut discussed the idea with Suzanne Schiffman, as he always did when he had written a new scene, before retracting it because he was afraid to tell Belmondo. As so often, Suzanne Schiffman played the messenger: 'We talked about it and Truffaut said, "Let's forget it. I can't see myself talking to Belmondo about that. He won't want to do it – he'll say: What will I look like?"' I said, "I'll go talk to him.' So I went to see Belmondo: "François has an idea for a scene where you're going to pick a car, and Catherine wants a red car, but you say: No, the grey one. Then we see you on the road in the red car..." He says, "And what am I going to look like?" I say, "You'll look like an ass." We both broke out laughing, and that was that. There were no problems, and we did the scene.'

Truffaut directs Jean-Paul Belmondo and Catherine Deneuve.

L'Enfant sauvage

L'Enfant sauvage (1970)
The Wild Child

Previous pages: Jean-Pierre Cargol and François Truffaut.

The raw material.

'Whatever happens to a child between the ages of three and fourteen can help him or ruin him for life. The wounds received at this age can't be healed. People are sentimental about their childhood memories, but most of the time childhood is a nightmare that you want to go away as soon as possible. A nightmare of no affection, a nightmare of solitude.'

That is how Truffaut explained his interest in the story of the Wild Boy of Aveyron not long after the film was released, in terms close to those he had used for *Les Quatre Cents Coups*. With respect to his first feature, *L'Enfant sauvage* could be seen as a variation on the same theme, the absence of care and emotional deprivation, to which is added cultural deprivation. When he realized after completing the editing that by playing Dr Itard himself, he was no longer identifying with the child but with the adult, the father, Truffaut dedicated the film to Jean-Pierre Léaud. Firmly convinced of the astonishing progress represented by the education given to the young boy who was discovered in the woods in 1797, even if it was only partial, incomplete and punctuated with errors and failures (Victor never did really learn to speak), Truffaut vociferously denied the reactions of those for whom it would have been preferable to let the child live a free, happy life in the forest. He was convinced that in reality the child had had a miserable existence for which he was no better adapted than he was for civilization. Indeed, he did not hesitate to show in the film the numerous scars on the body of the boy, who had never stopped fighting for his life, and insisted on placing at the film's beginning a violent clash between the young savage and some dogs. Nonetheless, as he embarked on his attempt to make this story into a film that would also be entertaining, he knew it was a gamble: 'Will we be able to get people interested in a little boy found in the forest, who is taught to stand erect and eat at a table?'

'The passage from Scene 19 to Scene 20 is absolutely ridiculous and unworthy of the screenwriter of *Paris nous appartient*, *Jules et Jim* and *Vanina Vanini*.' Truffaut responded to his collaborator Jean Gruault's first thoroughly researched attempt at adapting the report written by Dr Itard on the Wild Boy of Aveyron in the last years of the eighteenth century with his customary severity and a touch of provocation. Gruault had made a mistake of sorts: in Scene 19 of his script, doctors meeting at the Institut des sourds-muets (deaf-mutes) in Paris decide that the young savage will be entrusted to Dr Itard's care; in Scene 20 we see Itard take him to the home of some friends. Truffaut, always meticulous about transitions, protested: 'How dare you show the wild child accompanying Itard to a "friend's house" when you haven't even shown him moving into Itard's house?' Then he proceeded in a rather dictatorial way to outline a new structure. ('At this point in the screenplay, the logical order is the following: a) Victor moves into Itard's house and Madame Guérin is introduced...') This exchange at the outset of their second collaboration (if we except Jean Gruault's brief contribution to a draft of *Fahrenheit 451*), exemplifies a particular way of working that they would continue until the beginning of the 1980s, defined by both of them as 'collaboration by

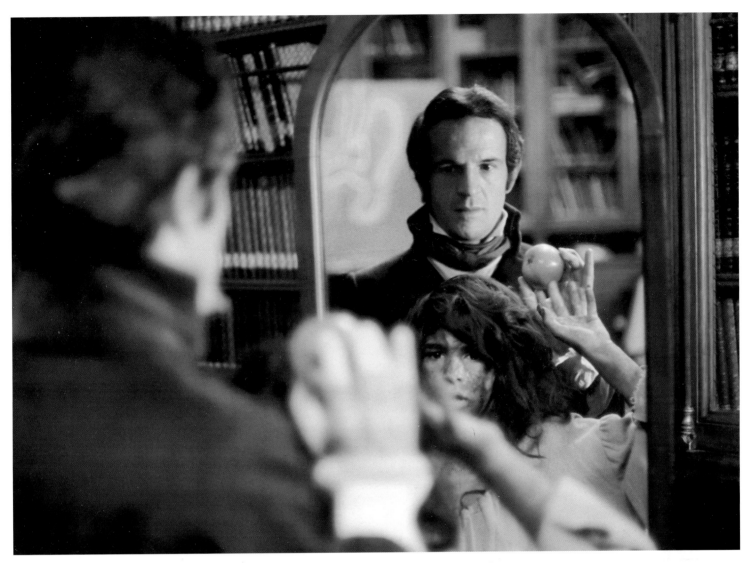

First experiments: The child tries to grab the reflection of the apple held by Dr Itard.

correspondence' or 'ping-pong style'. After months spent ruminating on the subject the film-maker had assigned him, Gruault, who was generally rather wordy, gave Truffaut a first draft with dialogue, often quite long and hand-written in big spiral-bound notebooks, which was then typed up. Truffaut made notes, generally detailed, often imperious, on this draft which he sent to Gruault, in his small office full of books in the 19th arrondissement, so that he could start on a new version – a draft that would be annotated in turn, and so on, until the moment the film-maker took possession of his film. Only after Gruault had had experience with other, more direct and conversational, working methods in his collaborations with Alain Resnais (*Mon Oncle d'Amérique*, then *La Vie est un roman* and *L'Amour à mort*) did Truffaut, stung by jealousy, in part give up the written back-and-forth method to work with Gruault face to face for days and weeks at a time on developing their project *00-14*.

The lost secret.

When Truffaut discovered Dr Jean Itard's *Mémoire et rapport sur Victor de l'Aveyron*, published in 1964 as an appendix to a study of wild children by Lucien Malson, he naturally decided to entrust the job to Jean Gruault. For one thing, because he knew Gruault had a capacity for absorbing a plethora of historical and literary documentation, and

handling tricky material that was not *a priori* very cinematic. Gruault would have to combine two actual reports by Jean Itard, one written in 1801 after a year of education, the other in 1806. The two men also shared a passion for the 'lost secret' of silent cinema, which Truffaut was thinking about more than ever at the time he attempted a film about a character deprived of the power of speech. He had first announced to Helen Scott, among other projects, a film already titled *L'Enfant sauvage* at the end of 1964. In January 1965 he asked Gruault to write a first trial draft, which he took back and annotated during August. 'Jean Gruault has written a first treatment of *L'Enfant sauvage* that is pretty good and easy to improve, which will make a superb film,' he wrote to Helen Scott. Always concerned to have the approval of 'specialists', he wrote to Lucien Malson in 1966 to get his opinion of the screenplay. As he did for *La mariée était en noir*, Truffaut also solicited the advice of Jacques Rivette, who commented on the screenplay in depth and recommended several decisive reductions.

In spring 1966 Truffaut planned to make the film the next year, just after *La mariée*. In reality, two films would come before that – *Baisers volés* and *La Sirène du Mississippi* – leaving another two years for work on *L'Enfant sauvage*: time for Truffaut to compose a third condensed version of the script with Gruault. It took that long to overcome the

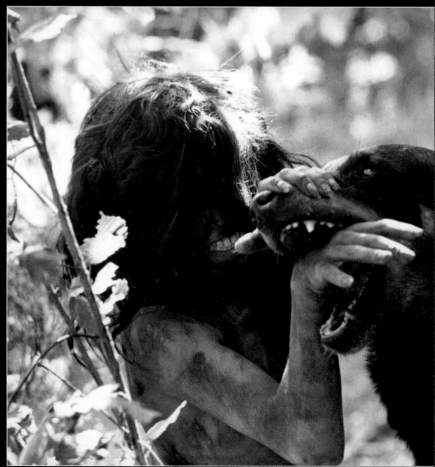

Top-left handwritten manuscript:

— L'enfant a l'air égaré mais il ne réagit plus avec violence.

— La maîtresse de maison le prend par la main et le fait asseoir sur un divan, à côté d'elle. Quelqu'un dit

> Un invité. — C'est Madame de Saint-Yves à côté de l'Eugène !

— La maîtresse de maison embrasse l'enfant au milieu des applaudissements. L'enfant semble prendre à ce baiser un certain plaisir.

> Un invité. — Que ne suis-je à sa place !
> Maîtresse de maison. — Allez donc vivre une dizaine d'années tout nu parmi les loups, et revenez me voir !

— Bien. L'enfant pince doucement la main de la maîtresse de maison, son bras, ses genoux, comme sollicitant un nouveau baiser. Au lieu de baiser, la dame lui offre des bonbons qu'il repousse violemment. Il s'en va vers une autre femme et recommence le même manège. L'assistance s'esclaffe. Itard, en retrait, suit la scène avec une gêne croissante. On offre des rafraîchissements au vieux paysan qui prend maladroitement un verre et le renverse. Un jeune homme facétieux souffle à sa voisine :

> Jeune homme. — Lequel est le sauvage ? Le jeune ou le vieux ?

— L'enfant prend une dame par la main et l'entraîne dans un coin de la pièce. Tous les invités le regardent faire avec une curiosité amusée et un peu méprisante.

Top-right typed report:

"L'ENFANT SAUVAGE"

(rapport Rivette)

1 - Première observation : le scénario se divise en deux parties très distinctes (de 1 à 37 / de 38 à 117), ayant chacune sa propre logique, son propre système : dans un film italien, on lirait au milieu de la page 80 "Fine del primo tempo". De ces deux parties, la seconde est, évidemment, le "vrai" film. Première question : tout ce qui précède doit-il être considéré (et traité) comme un énorme prologue, ou au contraire doit-il affirmer son autonomie en "balançant" et équilibrant suivant ses lois propres le deuxième volet du film; faut-il donc essayer d' "unifier" l'une et l'autre parties, en imposant, sans doute artificiellement, à la première les critères de la seconde, jouer au contraire sur leur opposition (stylistique, plastique, etc ...) ou, enfin, "passer", soit progressivement, insidieusement, soit par "sauts" successifs, d'un film (celui que doit imposer la première séquence, l'ouverture même du récit) à l'autre (celui, cohérent, quasi-homogène, qui constitue toute la seconde partie) ?

2 - On aura déjà compris que mes réserves, ou mes réticences, portent toutes sur ces 80 premières pages. La seconde partie (mis à part quelques points de détail sur lesquels je reviendrai, et le "mécanisme" de la dernière séquence) impose sa logique et sa cohérence. Et c'est légitimement qu'elle est tout au long non seulement commentée, mais commandée par le Cahier d'Itard (donc, contrairement à la note de la page 80, je ne pense pas que celui-ci doive être progressivement "gommé" : il faut au contraire insister sur lui comme principe structurel

Right-margin captions:

Left: The second version of the 'Visconti sequence' proposed by Jean Gruault, when the savage is exhibited in Madame de Recamier's salon.

Right: In a detailed report Rivette gave Truffaut, a crucial opinion on the screenplay as it was being written.

Bottom left: Truffaut rewrote a scene he was particularly attached to (where the dogs catch up with the child) by hand.

Bottom-left handwritten manuscript:

— L'enfant sauvage cherche à présent à s'élever dans l'arbre. Il s'accroche à une branche supérieure.

— Le chien saute le long du tronc de l'arbre.

— la branche à laquelle l'enfant est suspendu cède et c'est la chute.

— L'enfant et le chien se trouvant brièvement

— le chien saute sur l'enfant à terre et une lutte commence. Tous deux roulent sur le sol, étroitement enlacés. L'enfant se redresse mais au lieu de se tenir debout il se tient à quatre pattes et lutte comme on croirait voir la lutte de deux loups entre eux.

— l'enfant protège son visage avec le bras mais il ne se contente pas de se défendre. Par instants, il relève le bras au dessus de la tête et attaque le chien.

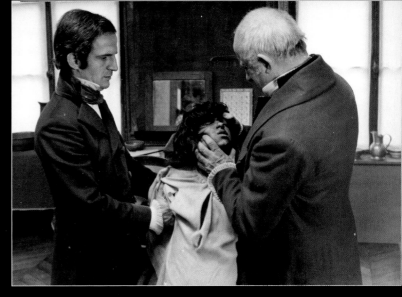

Truffaut covered the flyleaf of Gruault's first screenplay with notes such as 'It is *perverse* not to have shown the first meeting between Itard and the child' and 'We're missing a scene showing the dismemberment of a bird – with feathers around the mouth'.

'Our drinker takes his place in front of the window, erect, eyes turned toward the countryside, as if in this moment of delectation this child of nature sought to reunite the only two good things that had survived his loss of liberty, a drink of clear water and the sight of the sun and the landscape' (second report of Jean Itard, 1806).

doubts of his financial backers, who were not inclined to commit to a small film with such a marginal subject and no important actors, which the film-maker insisted on shooting in black and white. Finally Truffaut obtained a kind of 'package deal' from United Artists with *La Sirène du Mississippi*, and contrary to everyone's expectations, the surprise success of the little film ended up absorbing the big film's commercial failure. ('Something comical happened which definitely shows that you can never predict these things,' Truffaut said to *Cahiers du cinéma* in 1982. 'With a budget of 7.5 million francs, *La Sirène* lost 3.5, but *L'Enfant sauvage*, which cost a little less than 2 million, made 4.') The shoot took place at Aubiat in Auvergne during the summer of 1969, and except for some scenes at the Institut des sourds-muets on rue Saint-Jacques, filming was confined to the home region of Truffaut's production manager Roland Thénot. Thénot's house became the house of Dr Itard, which was supposed to be a middle-class home in the nearby suburbs of Paris of the period, in the countryside around Batignolles.

Visconti sequences.

'We have to show the outside of Madame Recamier's mansion, the arrival of carriages, the beautiful, elegant ladies with their outfits, etc., etc. In other words, this will be *L'Enfant sauvage*'s Visconti sequence.' When he sent Jean Gruault a first series of notes in 1965, Truffaut yielded to the temptation of a rather florid, corpulent film, his imagination visibly excited by the idea of showing not only the relationship of Dr Itard and the child, but the manner in which the child was welcomed, fêted and then rejected by the high society of the period: a little example of the human race's frivolous curiosity and stupidity. (These satiric scenes somewhat recall the cultural dinner in Reims filmed for *La Peau douce*.) Gruault thus wrote at Truffaut's request a long crowd scene during which the child is presented in the worldly salon of Madame Recamier, one of the foremost salons of the period, when he first arrives in Paris, long before he is entrusted to his mentor: political and literary conversations between characters in costume, followed by the exhibition of the child before a gathering that is thrilled at the idea of entertaining the Noble Savage described by Voltaire or Rousseau. 'He's Voltaire's Huron,' exclaims an extra. Another asks: 'Has he not marvelled at all the beautiful things in the capital?' But the child does not speak, has nothing to tell about the mysteries of his life in the woods, and jumps on the beautiful ladies in the group with embarrassing ardour. (To keep things simple, Truffaut decided to remove these allusions to the savage's sexuality from the film.) The assembly quickly loses interest in the child, and the conversation turns to the Italian Revolution. Far from rejecting this elaborate historical sequence, Truffaut initially built it up, only asking that it be refocused: 'We shouldn't lose sight of the child once we're inside the Recamier mansion. All the lovely dialogue inventions will remain, but will mostly be heard off-camera. Now we have to invent new developments concerning the child and his behaviour during this reception. We also need to show how the feelings of all these worldly people change towards him: enormous curiosity at first, then a kind of worldly tenderness, then disappointment, which should be more clearly conveyed.' He even imagined additional fantasies: 'We can presume that the servants are initially irritated by the child's success with the snobs, and I could easily imagine a sneaky valet giving the boy's bottom a boot in the corridor! But the valet hasn't seen the old party who intervenes and attacks him, etc., etc. We have to plan on having a little orchestra, harpists, etc.'

Jean Gruault followed this scheme in the second draft, writing a long sequence that was even more crowded with horse-drawn carriages arriving in the park, the entrance of the 'Fops' and 'Women of Style', a little orchestra playing Cimarosa, snatches of worldly conversation… All this Viscontian debauchery would be radically suppressed, for financial as well as artistic reasons. Truffaut forgot all about the Recamier mansion and filmed the Paris crowd, that is attracted to the child as if he were a side-show exhibit, in a single compact mass, mostly seen from behind, gathered around his carriage when he arrives in front of the Institut des sourds-muets, where Itard is waiting to examine him. He kept one ironic allusion to the Parisians' curiosity in the conversation between Itard and his friend Pinel, where he inserted the naive remark about the savage marvelling at the beauties of the capital. Itard is astonished when he reads it in the newspaper (and Truffaut managed, as he did whenever he particularly liked something, to have the viewer hear it twice, when Professor Pinel, basically speaking for Truffaut, asks Itard to repeat it: 'Certainly the savage cannot fail to marvel at the beauties of the capital').

Multiple characters.

The severe editing was not yet on the agenda during the early stages. Truffaut clearly planned to make a rather long film, with events unfolding progressively in something like their real chronology: in 1798, in Aveyron, the child was seen and caught a first time; then he fled, was seen again on a number of occasions (Gruault also wrote a scene where children catch sight of him while playing at being savages) and did not return openly to the area near the village until the arrival of a very cold winter. That is when he is taken to the insane asylum at Rodez, then driven to Paris. 'We can show snow falling on the village,' Truffaut noted, seeing an opportunity to film his favourite element. 'The snow will be the reason the child has returned to the village.' Further on he asks for developments to be put back: 'We can permit ourselves almost no shortcuts during the first part of the film. We have to show the boy's arrival at the Rodez asylum. What is this asylum? What do we see there? Probably a few idiots, some mad people, some mongols. Who is waiting for the wild child? How do the doctors treat Old Rémy, etc., etc.' In the third draft, however, the asylum was removed and replaced by a short stay at the Rodez police station, where a few shots would suffice to show the child's distress at being deprived of his freedom, huddling behind the bars.

In Gruault's first drafts the child's actions and gestures were commented on at length by the villagers, a schoolmaster and various doctors through whose hands he passes. The educated characters generally bring up other cases they know of, cases Truffaut and Gruault had decided to use for inspiration in creating their savage. 'It's simply

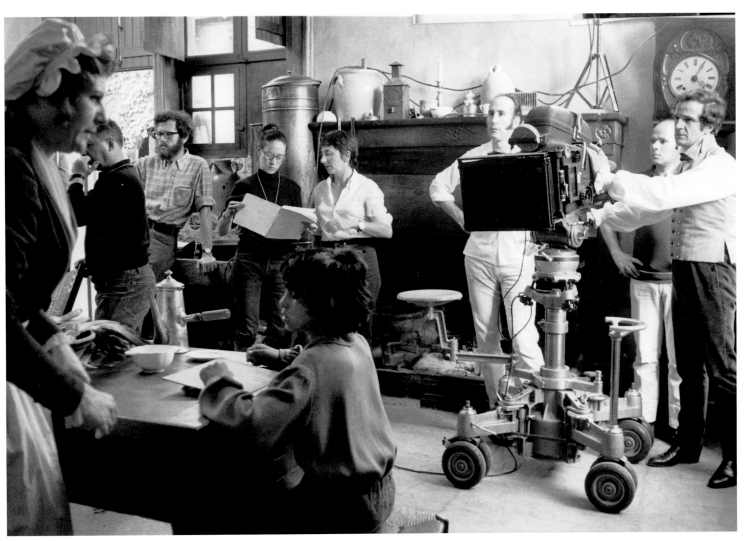

François Seigner (Madame Guérin) and Jean-Pierre Cargol (Victor), and on the other side of the camera (left to right) Jean-Claude Rivière, assistant cameraman, Christine Pellé, the script supervisor, Suzanne Schiffman and Nestor Almendros, the cinematographer.

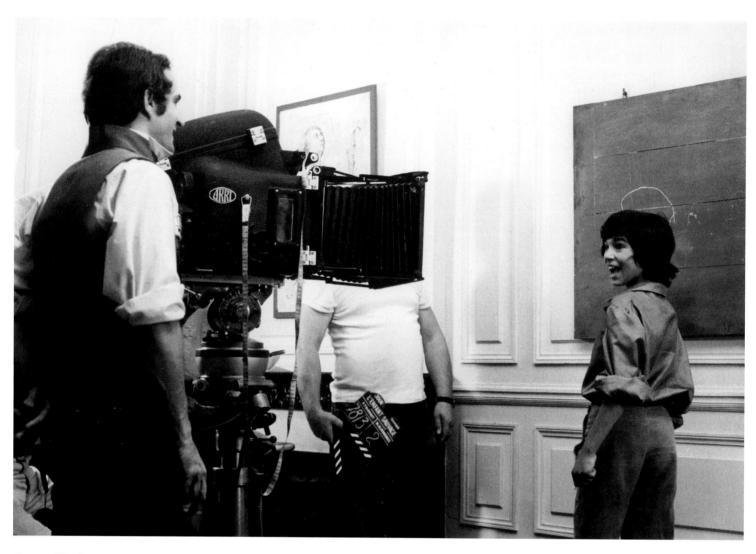

perverse not to have written the first meeting between
Itard and the child,' wrote Truffaut and rejected this scene
encumbered by historical references, all the more so since
their abundance distracts from Itard's first appearance.

In the next draft Gruault moved the conversation about
earlier cases to the coach carrying the child to Paris, writing
a long general discussion involving 11 passengers. The way
this discussion in the coach is contracted in the next draft,
and then by the *mise-en-scène*, is spectacular. In an almost
wordless scene, the coach pauses for a minute before
fording a river. The occupants, including the child, held
by a rope around his ankle, get out and walk over a
little stone bridge while the coach is crossing. In the same
shot Truffaut shows us the child who, having escaped
from his handler for a few seconds, surprises the spectator
by reappearing on the other side of the river and drinking
greedily before being caught again. The savage cocking a
snook at civilization while he indulges an elemental desire –
all that signified purely by *mise-en-scène*, with no recourse
to dialogue.

Previous cases.

As often happened in their collaboration, Jean Gruault
could not help citing his sources whereas Truffaut was
freer and more casual in the way he manipulated them
and appropriated from them. He had had a list of 'previous

interesting cases' drawn up with an eye to collecting 'details
not reported by Malson, Rousseau or Condillac'. But he
was not interested in enriching interminable conversations
between various more or less secondary characters; he
was looking for any interesting characteristic that could
be given to his main character. Thus his savage became a
composite of Victor of Aveyron, the Wolf-Child of Hesse
(discovered in 1344 at around seven years of age), the
Bramberg Boy (discovered in Bavaria in 1680) or the Girl
of Champagne (captured in 1731 in a forest in France at
approximately ten years of age and placed in a convent,
she succeeded, exceptionally, in learning to talk.) He also
borrowed a characteristic from the Boy of Shajahampur,
discovered in India: 'He stays in the corner with his chin
pressed against his knees.' From the Girl of Champagne he
took the idea that she could not sleep in a bed: 'Instead of
sleeping in her bed, makes a kind of nest in a corner of the
room with bedcovers and blankets around her.' From the
Bramberg Boy he took the story of the fight with the dogs:
'On all fours, fights with the dogs with his teeth and chases
them off' – an idea Truffaut liked and wanted to use at
the beginning of his film to immediately characterize the
harshness of the life the boy must have led in the forest.
He rewrote and elaborated the most violent scene of pursuit
by dogs himself, going so far as to show that the young
savage is capable of killing one of them. While Truffaut did
look at a certain number of documentaries showing the

behaviour of autistic children and gave certain autistic characteristics to Victor (rocking, trembling, instinctive and repetitive facial contractions), he was also inspired by the story of Caspar Hauser, the young man without a past who was found one morning in a German village. On the flyleaf of a book about him (*Gaspard Hauser ou la paresse du cœur*, by Jacob Wasserman), Truffaut assembled several traits that he thought he might give to Victor: 'Let's imagine that a hunting horn terrifies Victor', 'He can be given a Soviet wooden toy' (a nurse brags to the Parisians about how the savage found a wooden doll brought by a visitor), 'In one scene Itard goes walking with the boy and describes the countryside to him as if he could understand', 'He shows unwelcome visitors the door' (an idea that Truffaut found in Malson's descriptions of Victor and used at the end of the film during a visit from a doctor)... On the last page of his shooting script Truffaut had copied the verses Verlaine wrote for Gaspard: 'I came calm, orphaned / Rich only in my tranquil eyes / Towards the men of the great cities / They did not think me clever.'

Teacher and student.

Truffaut wondered how to show the growing bond between Itard and the child. Just as he freely gave Victor traits that belonged to other wild children, he did not hesitate to transfer to Itard several scenes originally given to other characters, according to the principle of enrichment by concentration and transference of elements that he applied, without ever planning to, in film after film. The first screenplay presented a whole gallery of characters who took turns interacting with the child. But Truffaut preferred to delegate the care of the child entirely to Old Rémy in the early scenes of the film, until the character became an encumbrance in turn: 'I think that Old Rémy should disappear from the film before this scene (the one where Itard decides to take the child into his home); if not, the public will get the impression that the child is surrounded with affection, since it would seem that he has two stepfathers: Rémy and Itard, who almost get into an argument about who will raise him.' At first the film-maker wanted to give Rémy a last scene that he asked Gruault to write: a scene where he says goodbye to the savage and gives him an apple through the bars of the institute. ('We hear about the old man who isn't allowed to visit the boy. Why not film it?') But the child doesn't recognize him and loses interest in him. This scene disappeared in the third draft of the screenplay, either as a result of the process of concentration and simplification going on at that time, or as a result of a rather stinging remark made by Rivette to his colleague: 'Rémy is indeed "noble", but his last appearance (bars, basket refused) is pretty close to De Sica (or at least runs that risk...')

Truffaut also transferred to Itard certain scenes or attitudes of the governess, Madame Guérin, whose relationship with the child was much more prominent in the early drafts. In the first draft it is Madame Guérin who goes out for walks with the boy, takes him regularly to visit the friend's house and even does a few exercises with him, including the first attempts with the alphabet – all scenes that were given to Itard, whose relationship with the child Truffaut made the primary one, even if affection and material care remain largely the domain of Madame Guerin, while stubbornness and intellect are on the side of Itard. 'The public cannot fail to notice that Itard's behaviour in scenes that take place in his office is very different from what it is in Victor's room. In his office Itard is a professor, a doctor, an experimenter who is often impatient. In Victor's room he's an adoptive father, affectionate and jovial.' But even though he added this handwritten note in the margin of the second treatment, Truffaut would only partly put it into practice, adopting instead a certain reserve and a certain stiffness when he played Itard and saving his most affectionate gestures for the last part of the film.

Six ideas in one scene.

Truffaut summed up the work of transference and concentration that he demanded from his co-writer in a final maxim at the end of his notes: 'In the next phase of work on the screenplay, we won't be increasing the number of scenes or profoundly modifying the structure, but rather enriching the existing scenes and adding to them in order to give them greater density. A one-minute scene should never be created for a 15-second idea; instead, group four 15-second ideas in a single one-minute scene.' This general principle was a kind of leitmotif with him. Some years later he would demand a similar effort from Claude de Givray and Bernard Revon in the margins of the first draft of *L'Agence Magic*, and in almost the same terms: 'A scene should not be a 'mini-scene' [*scénette*: a made-up word that puns on *saynète*, sketch]. The public has to be held in their seats with their mouths open. One shouldn't insert a scene to have a place for one idea, but rather make a place for six ideas in one (long) scene.'

Two days after he sent Gruault his remarks on the first screenplay, Truffaut sent him a second series of a more general nature ('General remarks and important details', dated 1 September 1965), where he went back over things they may have overlooked or neglected. Distancing himself a bit from the screenplay, he returned to his sources, Itard's journal and Malson's book. 'An important idea from the book has disappeared: Victor showing unwelcome visitors to the door and giving them their hats and canes.' Or: 'I'm very attached to an idea in the book, where we see the child eat a bird he has killed with his fingernails. We wouldn't show the whole scene, which would perhaps be unbearable, but only the end of it: the remains of a bird on the ground, and feathers and a bit of blood around Victor's mouth.' Truffaut was clearly fond of this idea (in his first remarks the film-maker had already inserted: 'We don't have the slaughter of a bird with feathers around the mouth at the beginning') but none the less gave it up. Perhaps because it was not all that easy to show, and also because he had put the fight with the dogs at the beginning, showing the child's ability to fight with animals as an equal, and one scene excluded the other. He also dropped the idea of showing all the effects of the neglect from which the savage has suffered: 'Without falling into a scatological film, it's important to show at the beginning that he relieves himself anywhere and that this gets him a punishment (probably at the asylum). The scene would take place in the garret and would be seen from pretty far off by some nurse, which would permit it to be filmed with

In the end, the crowd scenes were
reduced to a minimum.

decency.' If Truffaut decided not to burden himself with
lessons in cleanliness, it was no doubt to avoid scenes that
would ultimately be rather boring.

Truffaut was obsessed with not passing up any possibility
for a good scene or a good ingredient, and some elements
recovered in this way became important developments in
a story where the child's progress and relapses articulate
the dramatic high-points. 'Don't forget his euphoria in
the carriage when he sticks his head out of one window,
then the other'; 'Let's not give up Victor's only invention:
the chalk-holder'; 'Let's not give up the idea of Victor's
penchant for arranging things. One night when Itard
is sitting at his bed-side, Victor, who was in bed, gets up
to put an object or piece of clothing in its proper place.'
During filming Truffaut wrote to Gruault that he was re-
reading Itard's reports 'to recover certain details', like the
invention of the chalk-holder.

How to dramatize.

When they were selecting the learning exercises they would
put in the film from among those described by Itard in
his report, Truffaut and Gruault had a tendency to choose
the ones they would be able to show fairly simply, whose
unfolding, eventually interrupted by the child's anger, would
be entertaining. They therefore discarded more abstract
exercises aimed at recognizing figures based on colour
patterns. In order to avoid complications, Truffaut and
Gruault were also forced to give up an idea that interested
them, which they tried to write: showing that the child
knew how to make the connection between a particular
book and the drawing of a book on the blackboard, but
was unable to perceive the general concept of 'book'.
The scene was still in the shooting script, but it was
crossed out and not filmed.

Truffaut and Gruault were looking for ways to dramatize a
story where a dry documentary quality or an overly linear,
repetitive development would have been disastrous. As
usual, Truffaut tried to create strong moments. After
finishing the film he stressed how much he appreciated
filming a character who seems to be doing everything for
the first time. Although Truffaut did not formulate this
explicitly and probably was not even conscious of it when
he reacted to the first screenplay, several remarks
underlined the importance of these firsts: 'Something
interesting can be done with the first pair of shoes'; 'It's
very important that we show him tearing the first clothes
they try to make him wear'; 'We have to show his refusal
to sleep in a bed the first time. Then his getting used to
it.' Some of these firsts became little dramatic climaxes,
carefully prepared in several steps, with opportunities
for suspense and emotion: the scene of the first shoes
where the child seems to accept walking unaided before
falling down and biting; the first word he pronounces,
which is actually a failure, because Victor only moans the
word 'milk' after getting his reward and not before (he
therefore has not understood one of the main purposes of
language); the first time he writes a word (the word 'milk'
again) using wooden letters that he first places upside down
and then, displaying a certain cunning, solves the problem
by simply reversing them.

The need to dramatize also led Truffaut and Gruault to invent Victor's flight at the end, or rather to make it an event. (Itard briefly recalled that Victor ran away because his governess was sick and couldn't take him for a walk, but it was an incident of no importance.) In the first screenplay Gruault tried to use the experiment with unjust punishment to create an ending. Placed by Itard in the dark closet even though he had just done an exercise properly, Victor rebels and shows that he has acquired a sense of justice and injustice, that he has become a moral person. Truffaut first thought this would make a good ending ('Victor's indignation and tears give us a sufficiently exalting and dramatic finale'), but he finally put it before the last third of the film, then imbued the last third with a more emotional drama: the threat to the equilibrium that has been achieved should an order from the Minister deprive Victor of his apprenticeship and the affection he has found (a way of dramatizing that was not fundamentally very different from that used at the end of *Le Dernier Métro*: threats to the Montmartre theatre). In the second treatment, because Madame Guérin, who is ill, can't take him for his walk, Victor runs away but can't survive alone in nature and is found by the gendarmes. (Madame Guérin goes to the police station to collect him, as Davenne and Julie go to get the young deaf-mute in *La Chambre verte*.) Truffaut crossed out the scene with the gendarmes and wrote a final scene where the child comes back by himself. A dramatic irony: Itard is writing in his journal 'I don't think we will ever see Victor again' when a silhouette appears in the window. The film-maker would nonetheless later regret having created an open ending ('Soon we'll start your exercises again,' followed by a last iris-out), without giving the public any information about his character's future. That reaction impelled him some years later to add a summary to the epilogue of the story of Adèle H.

Working on the image.

'I'm quite taken with an idea for entertaining Victor: Itard uses a mirror to move the reflection of a sunbeam on the walls of the room. Then he gives the mirror to Victor, who does the same.' While he was summing up for his co-writer ideas that it was important not to forget, Truffaut mentioned the notion of recreational pauses and visual pauses. In a way that was not at all typical of his work, this film would at times have a contemplative aspect that was inherent in the nature of the subject and the main character. 'We have to go on the assumption that anything is possible in cinema and film a scene where Victor contemplates the moonlight (which will eventually be faked in the studio). It should be seen by Itard from his window, with the child in the garden, perhaps crouched in a tree. Even though it's a visual scene, like a reproduction of an engraving, we will none the less have to find one or two details to animate the tableau.' He simply added, besides the tension of Itard watching at the window, the child rocking joyfully and gradually becoming calm in the moonlight. *L'Enfant sauvage*, which was Truffaut's first collaboration with cinematographer Nestor Almendros, is one of his films where the visual style is particularly polished: black and white photography, lighting effects indoors and out, precision of disposition and scenes filmed in a single shot, where frames within the frame appear

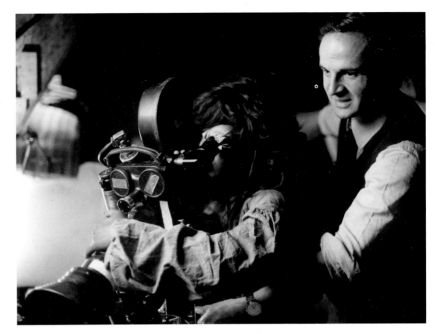

Jean-Pierre Cargol behind the camera.

regularly (mirrors, windows, interior and exterior backgrounds and foregrounds), care with the beginnings and endings of scenes (as in the first appearance of Itard, very stylized: he enters the shot in left profile, staying that way until the end of the shot, which now shows him in right profile looking out of the window, lost in his thoughts about the savage who has been found). The precision of certain combinations of movements can be quite beautiful. At the beginning of the film, when the child sits at the top of a large tree, the camera slowly pulls back, revealing the surrounding space, ending with a very wide, contemplative shot. Almost at the same time, in a reverse movement, an iris gently encircles the child and closes, refocusing the viewer's vision on him. This discreetly mobile camera is a way of captivating the viewer. (An image of an empty set is rarely stationary; the Institut des sourds-muets is discovered in a zoom-back that starts from a basin and finally includes the whole park.) Almendros, who had just worked with Eric Rohmer on *Ma nuit chez Maud*, had to adapt himself to filming shots that were constantly moving in a way that was almost invisible: 'It was very difficult for me, because I'd never done tracking shots, and in a film by François the framing is a little like playing pinball: you lose one character and pick up another while the camera itself is moving.' He seconded Truffaut's desire to rediscover certain effects of silent cinema and dug up at an old apparatus for irising out at a hire shop, 'an antediluvian relic' which, by avoiding the use of an optical printer, gives the irises a rounder, softer look. Taking the place of the 'Visconti sequence', the iris, which closes or opens many scenes, gives the same sensation of going back in time while avoiding decorative scenes with costumes. It gives a rhythm to the breaks in the narrative and focuses our gaze on the child, around whom it frequently closes.

The Rivette report.

It is perhaps on the subject of *mise-en-scène* that Truffaut listened least to Rivette, whose advice he solicited and who gave him a highly circumstantial report on the long version of his screenplay that helped him make several rather radical choices. If the ping-pong method permitted Truffaut to maintain a certain distance and to rediscover the screenplay with fresh eyes each time he received a new draft, an intelligent outside eye could be just as valuable. Rivette first pointed out to him that the script seemed to consist of two parts: everything before Itard takes the child home with him; then the child's apprenticeship under Itard's guidance. 'First observation: the script is divided into two quite distinct parts, each of which has its own logic, its own system. In an Italian film you'd find in the middle of page 80 "*Fine del primo tempo*". Of the two parts, the second is obviously the real film.' This second part, he said, imposed 'its own logic and coherence', whereas his doubts all concerned the first 84 pages. Should the first part, he asked, be considered an enormous prologue or should it affirm its autonomy? Should one pass insidiously from one film to the other or reinforce the opposition between the two parts? Truffaut settled this question by reducing and considerably concentrating the beginning of the film, throwing out with no regrets the 'Visconti sequence' that he had asked for. He also heeded another remark of Rivette's, recommending that he concentrate the

story around the child: 'It's the child who is "interesting", and nothing else is, except in relation to him – including Itard. Everything that doesn't directly concern the child is distracting or boring.' In the final version of the screenplay Truffaut eliminated the last remaining intermediaries, doing away with the conversations between peasants, the opinion of a schoolmaster or a pastor, or the examination by Bonnaterre, a doctor ('In fact, all these are "doubles" of Itard and only serve to lead to him,' noted Rivette at the end of his report), introducing Itard, who is interested in the case of young savage of Aveyron, less than ten minutes into the film. According to Rivette, the question raised by the child (is he animal or human?) was 'the only interest that we can expect a future viewer to have – a viewer who is confronted with the child in almost in exactly the same way as Rémy, the pastor, etc., and finally Itard (who is really the "first spectator", or if not, his delegate, like Jimmy Stewart in *Rear Window*, with some differences of course).' How much, we might ask, did this remark influence Truffaut's decision to play Itard himself, rather than giving the role to an intermediary?

Rivette's opinion was also decisive for the importance Truffaut would give to Itard's journal as a structural element that moved the story forward, giving it depth and élan. Even though this use of the journal, the flow of Itard's writing as well as his speech, was not so different from the use he already made of commentary in *Jules et Jim* or would use again in *Les Deux Anglaises*, Truffaut asked himself in a curious moment of hesitation if he should perhaps reduce its importance. But this question, asked at the bottom of a page of the screenplay, may simply have been a ruse designed to avoid worrying backers who might read the script. (Truffaut planned to insert the following note at the bottom of a page where Itard is writing in his journal: 'From now on we will frequently find this notation: "On Itard's journal". The reader shouldn't worry about this form of narration, which will be abridged later and made more supple. These frequent but very brief uses of commentary will impart a rhythm to the story, and their final effect on-screen will be as neutral as the fades that frequently punctuate films stretching out over a long period of time.') Whatever the reasons for this note, Rivette firmly advised against reducing the use of the journal, recommending on the contrary that Truffaut should make it 'a structural principle': 'It's quite legitimate that it [the second part] should be not only commented on but commanded by Itard's journal. So, contrary to the note on page 80, I don't think it should be progressively "erased": Instead, you have to insist on it as a structural principle… The (suspended) acquisition of speech/writing is the motor that drives the story: I believe it is also its formal principle. Therefore the entrance of speech, then of writing, should be turning points in the film.' Rivette advised delaying as long as possible the first spoken words heard in the film: 'Most of the hunters' lines are unnecessary: gestures will suffice, or some grumblings in an indistinct dialect, even an invented one, like Audiberti or Dubillard' – advice that Truffaut followed, without going so far as to invent a dialect. But he did render the interjections of the hunters sufficiently indistinct so that the first distinct, intelligible speech, coming just after the child is captured, coincides

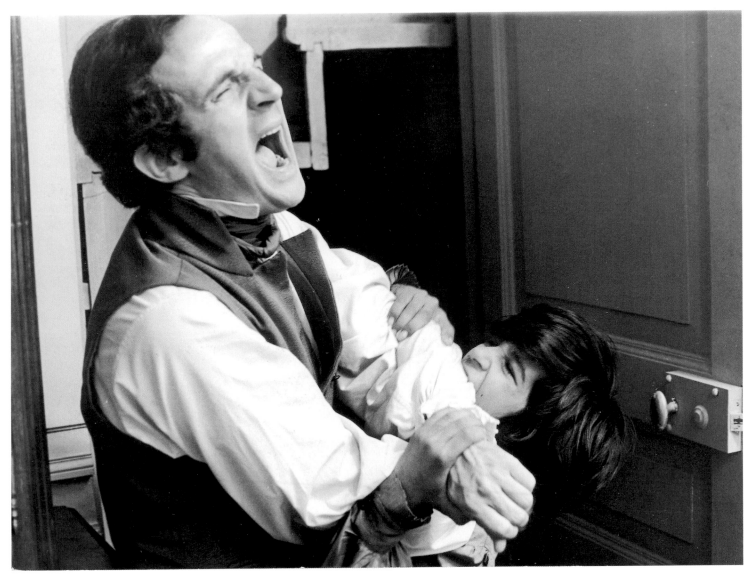

Filming the scene of the 'unfair punishment'.

with the first appearance of Itard. He filmed that first appearance in the calm interior of a house which contrasts with the natural world where the young child had been fighting for his survival, associating Itard with an image of intelligence and reason, since the shot begins on an anatomical chart on the wall representing a cutaway view of a brain. Intellectual élan is fused with movement: the scientist is seen walking around the room reading the article that he has just cut out about the discovery of the savage. And for Itard's second appearance Truffaut followed an orderly image (Itard writing while the camera pulls back to show the room empty and peaceful around him) with a swarming one (the child at the village struggling in the midst of a curious crowd).

Truffaut will be Itard.

On the other hand Truffaut did not follow Rivette's suggestions about the *mise-en-scène*. Rejecting in advance any fake documentary approach or shooting principle founded on images 'captured from life' or wishing to give that illusion, Rivette imagined 'a very apparent, explicit *mise-en-scène* (blocking, framing, montage of fixed shots rather than long takes with a moving camera; stylized rather than natural acting style), closer to Hitchcock, even to Murnau, than to Renoir or Rossellini.' Truffaut, however, without ever wanting to give the illusion of a documentary, chose a mobile camera that accompanied as often as possible the characters' movements, whose spatial disposition is discreetly stylized. He explained one of his reasons for his going before the camera in this film as follows: 'I'm often amazed at how rarely actors take advantage of the opportunities we give them. Particularly in the way they occupy space. That has always struck me. You tell the actor: "It's a long scene, you can talk while going from the window to the door", and he'll leave the window, but he won't go all the way to the door. I always found that bizarre, because visually, it would be more stimulating. You cover more space; everything is truer. So I finally took advantage of this opportunity to go into action myself.' The decision to play Itard also did away with the intermediaries between Truffaut and the child, with whom Itard is already in the position of director. And of course we must not overlook, as Gruault underlined, 'cash reasons', given the film's small budget. Truffaut waited almost until the last moment, when it was already a *fait accompli*, before talking to his collaborator, to whom he had vaguely suggested the names of Charles Denner or Serge Rousseau, about his decision to play Itard himself. 'Pardon me for being secretive about my playing the role of Itard. I wanted to keep it a secret until the last moment, and I hope you aren't disappointed by my amateurism,' he wrote to Gruault on 1 August 1969, after he was halfway through shooting. As a rule Truffaut did not use very expressive actors, and he himself played as simply and as neutrally as possible. The intensity, the enthusiasm that animates the character is in his voice, which he often used as a bridge from one scene to the next, wedding speech to movement. When he was setting up, he decided on the framing and movements of the camera while Suzanne Schiffman acted as his stand-in. 'Actually, he was less anxious when he acted,' she recalled. '*L'Enfant sauvage* was a lovely shoot, without great tension, without great anxiety. *La Chambre*

verte was a very happy shoot. He was nervous before filming, when he went to the hairdresser or tried on his costume… He had actor's nerves as well as director's nerves; it was as if one replaced the other.' 'It's true that playing the rather austere Dr Itard made me very happy and gave me the impression that I was dominating the filming,' Truffaut wrote to Jean-Loup Dabadie in 1971. Jean-Pierre Cargol, who played the child, was a young gipsy spotted in the street by Suzanne Schiffman, whom Truffaut, giving up the idea of having the savage played by a young dancer ('a child Nureyev'), had sent to the South to spy on kids leaving school. Truffaut later explained that he directed him very simply, using comparisons: 'For his looks I said, "like a horse". I mimicked Harpo Marx for him when he had to express wonder with round eyes.' The settings except for the house (the forest, the stone bridge over the river, the friend's house) were all within a narrow perimeter, and the shoot was both concentrated and relaxed. Suzanne Schiffman's children were among the little peasants who heckle the savage during the family scenes at the beginning. Catherine Deneuve visited the film-maker during shooting, and Claude de Givray and Bernard Revon also spent a few days, during which Truffaut switched hats at night, going from being an actor-director to being a screenwriter as he revised the text of *Domicile conjugal*, which he was going to shoot that winter, in just a few months' time. When the scenes at the Institut des sourds-muets were filmed in Paris, Jean Gruault came and played an unhappy visitor who is astonished by the child's apathy and exclaims: 'If I'd known, I'd have brought the children.'

When the film opened at the end of February 1970, Truffaut, who was shooting *Domicile conjugal* until March, paid particular attention to its promotion. He reacted to publicity materials (Truffaut was the co-producer, and his film's success was important to him for that reason as well) with the same demanding style that he applied to all phases of his work. The same caustic rage that he sometimes expressed with his co-writers appeared when he was presented with a poster that he thought didn't work: 'I have indeed received your poster and I think it's disastrous. In my opinion we needed a very popular, figurative poster in the style of the cover of *Black River*, showing a kind of young Tarzan. Jean-Pierre hanging from a branch in a real forest is what is appropriate to the audience for in-depth marketing. The decision to go and see a particular film is a function of the advertising materials and not of the film's reputation. But instead of that we have a falsely artistic poster that doesn't "speak", with a character who is neither a girl nor a boy, and above all not a savage…' As soon as he sensed that the film could do very well, Truffaut didn't hesitate to go overboard. After the first weeks of release he insisted to his contact at United Artists that the film be given a shot in the arm through the appearance of newspaper ads, feeling that the cost was well worth it, especially since he had noticed that the film was performing even better during the holidays. '*L'Enfant sauvage* is especially successful on Thursdays or Sundays, and the next week, which will be the 9th week of exclusivity, we have from Thurday 30 April to Sunday 3 May four consecutive holidays for the children and also, why not mention it now, the hope of an 11th week of exclusivity with several holidays.

In my opinion it is essential to remind people in the main Parisian newspapers on Thursday, Friday, Saturday and Sunday of the existence of this "adult film that you can take your children to'". Ready to make numerous trips during spring and summer 1970, he proposed that his distributors prepare for the opening of the film by stimulating word of mouth among certain categories of viewers who would be receptive to it. 'Experience shows that the types of audience most directly interested have been: a) teachers – b) doctors – c) Catholics,' he wrote to the United Artists representative in Marseille. And for the Japanese release: 'Our experience with the release of this film in France has shown that it can be very commercial if we take care to do a lot of promotional work before the film opens by having screenings for a) the directors and editors of magazines for children, b) school principals and teachers, c) the medical profession.'
Even at the risk of a certain didactic insistence, Truffaut's stubbornness was the stubbornness of a film-maker who wanted his films to be seen, for whom work on a film did not end with its production.

The child's unexpected return is seen through the window in a single sequence shot.

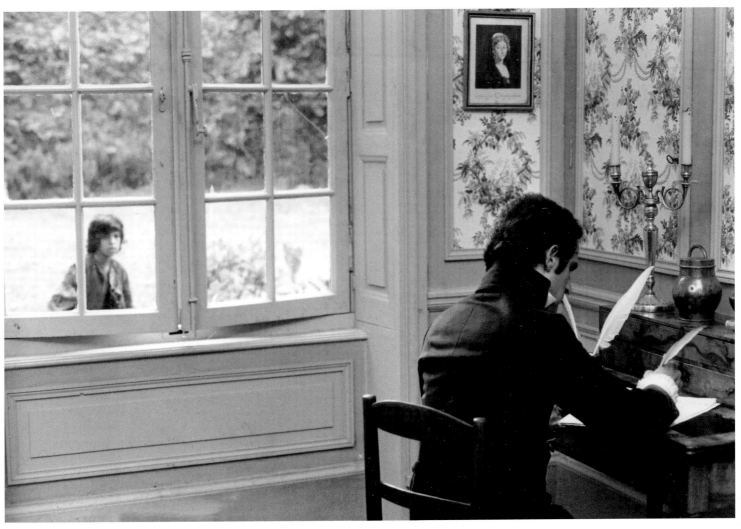

Domicile conjugal (1970)
Bed and Board

Opposite page: François Truffaut,
Suzanne Schiffman, Claude Jade and
Nestor Almendros in the apartment on
the fourth floor, above the offices of
Les Films du Carrosse, where the scenes
of married life were filmed.

The mattress changes rooms. Rehearsal
of the big fight.

'When I worked on screenplays with him, he said:
"You have to learn to hate direct information." The director
he's closest to, finally, may be Lubitsch.' That is how Claude
de Givray remembered it. *Domicile conjugal* presents itself
first of all as a series of attempted responses to this quest
for the indirect story: how do we show that they're married?
How do we show that they're expecting a child? How do
we have Antoine Doinel learn that he is the father of
a little boy? How will Christine let her husband know
that she knows he's cheating on her with a Japanese girl?

Truffaut threw himself into *Domicile conjugal* on the advice
of Henri Langlois who, after a screening of *Baisers volés*,
expressed his desire to see the couple married, and the
beginnings of their married life. On 1 September 1968, a
week before *Baisers volés* opened, Truffaut wrote to Lucette
de Givray, his secretary and the wife of his co-writer:
'The private screenings of *Baisers volés* are going very well,
an unexpected success. If the public goes along and the
film makes its money back, I'll ask Claude [de Givray]
and Bernard [Revon] to help me continue the series one
of these days: the married life of Antoine Doinel (hmm,
harder and harder), Antoine a father, etc.' He worked
with his collaborators in the spring and summer of 1969,
asking them to undertake a preliminary investigation,
collecting 'little true facts' about florists, US enterprises
based in France, etc. Several scenes were developed directly
from this research. Some may seem less essential, but are
gorgeous, like the the young alcoholic looking for a fight in
the courtyard of the building, played by Philippe Léotard,
whom Truffaut gave his first role. This scene came from
an anecdote the writers heard from the owner of a bistro.

Truffaut had considered starting his film with the return
of the 'Definitive Man' (Serge Rousseau) who declared
his love to Claude Jade at the end of *Baisers volés*. He was
interested in the story of a man who had committed suicide
in his village by getting up on a roof, then discarded all
the signs of his social success (glasses, watch, shoes) before
throwing himself off the roof naked. He had thought about
opening the film with the suicide of the 'Definitive Man'
before giving up this rather harsh idea and starting off in
a more openly comic vein. Truffaut would have liked to
find a way of presenting the marriage of Claude Jade and
Jean-Pierre Léaud to the public – or rather of Christine
and Antoine – and spoke admiringly to his co-writers of
a Lubitsch film (*One Hour With You*) where, after a police
raid on Hyde Park to round up all the couples who are
making love there, we discover that two of them are in
fact husband and wife. He found screenwriter Samson
Raphaelson's invention of these two characters who act
like they aren't married when they are, very amusing.
'We'll avoid exposition in the traditional sense, which is
documentary and anti-dramatic,' he advised his co-writers.
'We'll look for an amusing way to let the public know a)
that Antoine is married; b) that his job is painting flowers.'
Truffaut reinforced his opening scene during production:
he preferred that Christine, with just her legs and the violin
case she's carrying shown in the frame, should respond
immediately and triumphantly: 'Not Mademoiselle,
Madame' to the salesman who addresses her as if she
were a young girl. The screenplay delayed this information

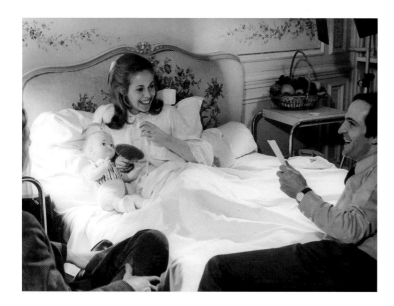

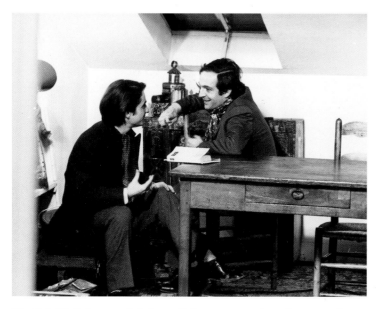

Claude Jade's first day of filming. She was getting over a bout of jaundice and started, in bed, with the maternity scenes.

Rehearsals with Jean-Pierre Léaud.

slightly, until the moment when she enters the courtyard, where we would have heard the concierge call her Madame.

Truffaut regretted not getting more use out of his character's violin case. He solicited his co-writers' help: 'I'd really like to find one or two jokes with the violin case. (At a certain point in the film Christine uses her case as a suitcase by packing night clothes in it – a scene on the theme of "I'm going home to mother" – but we still have to find the reason she does this and how we show it.)' During the quarrel, Antoine takes some fancy underwear out of the case, thereby discovering that Christine, who is pretending to be going out to give a violin lesson, intends to spend the night at a hotel. But the film-maker would have liked to find more variations on this theme: 'I wanted to find something funny with the violin case and I haven't found it. The girl uses it at night to pack her bags, and that's all. I was constantly telling myself that Lubitsch would have worked wonders with that violin case.' Years later, in *Le Dernier Métro*, Truffaut finally found a way of perverting the explicit purpose of a cello case, when the stage manager at the theatre puts the ham he has bought for Catherine Deneuve inside one.

As far as script devices are concerned, Truffaut was only happy with the scene where Christine reveals to Antoine that she has understood, by boldly disguising herself as a Japanese girl. While filming, he decided to actually show the tears flowing down her cheeks further. ('She is crying,' he noted in the margin of the shooting script.) In the process he took the game he was playing with the audience all the way: having them share Antoine's surprise, letting them enjoy the gag, then putting them on Christine's side as her emotion rises up. 'I knew people would laugh, but then I had him come forwards into the room and moved the camera in on her, and when we get to a close-up, you see that there's a tear on her cheek, the laughter is blocked and people are ashamed to have laughed. I thought this tear would be the high point of the scene, because it functions a bit like a cold shower.' Once disguised as a geisha (she was the one who had the idea of inserting two knitting needles in her chignon), Claude Jade couldn't manage to cry in the jokey atmosphere that prevailed on the set. Suzanne Schiffman blew cigarette smoke in her eyes until just one tear appeared, a real one. Truffaut was also happy, finally, with the gag of the tulips that open, letting the love notes written to Antoine by his Japanese mistress fall out. But he hesitated a long time, because he didn't find the idea credible. Bernard Revon recalls that Truffaut resisted him a lot on this point. 'Ah, Bernard, I really don't buy that.' But as soon as he adopted it, Truffaut took the artifice further by speeding up the image, then stopping it when the little notes were falling, freezing the frame at the instant Christine turns, mouth open with stupefaction. Just as he did not hesitate to introduce into this film, which he saw as somewhat experimental, a shot representing a Japanese garden agitated by the wind (an effect fabricated on the soundtrack) just after Antoine's mistress makes a declaration: if she commits suicide someday, she'd like it to be with him. A mnemonic device scarcely a hundred pages long (that is how Claude de Givray characterizes certain Truffaut scripts, saying that he wrote into them things he didn't want to forget), the *Domicile conjugal* screenplay left the dialogue in a certain number of scenes to the inspiration of the shoot, notably the marital scenes, whose content and direction were often outlined and left to be filled in. Truffaut left open what would happen when Antoine and Christine come home after a first dinner with her parents: 'The couple has entered the apartment and Christine has locked the door… Here we will have a scene that is at once useless and essential describing marital happiness.' He invented, while Christine is in bed reading beneath a photo of Nureyev, a conversation where Antoine joins her and announces that he has just discovered that one of her breasts is smaller than the other, baptizing them Don Quixote and Sancho Panza. Truffaut shared his heroine's fascination with the famous dancer, spelling out his intentions in the preface to a book about Nureyev that he wrote in 1973: 'Since Antoine Doinel deceives his wife with a very beautiful Japanese girl whom he idealizes, I felt that the only way to strike a balance was with Nureyev – which is to say a man that you don't have to idealize to have everyone accept him as exceptional.' Seeing in Nureyev the ideal actor to have played Caspar Hauser, 'a creature from the night of Time, the only person who could plausibly

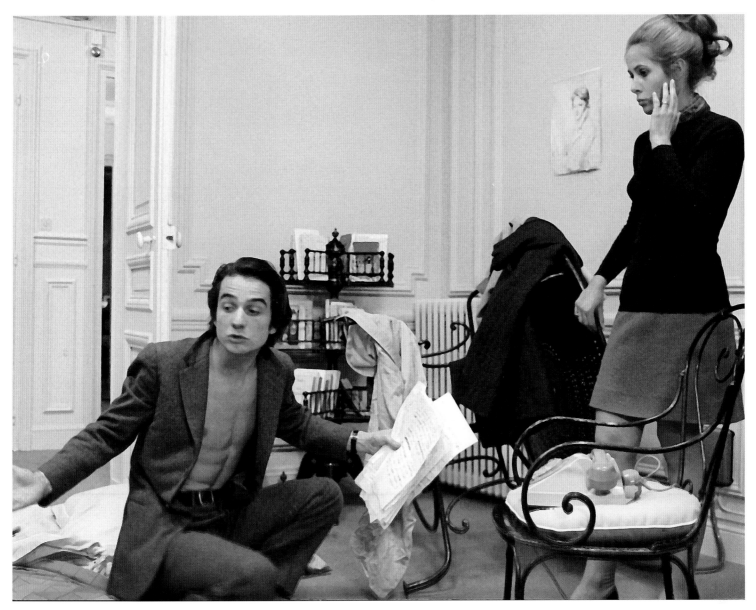

play a prehistoric man', and 'a man who doesn't need other men to exist', he added that he 'also thought of him while filming *L'Enfant sauvage* and while I was directing Stacey Tendeter in *Les Deux Anglaises et le continent*, or while I was directing the musical scenes of the film being made in *La Nuit américaine*.'

The dialogue for other scenes with the couple was developed and rewritten during shooting – such as the scene where Christine empties her purse and draws up an account of their separation, a gift of a scene that Truffaut made to Claude Jade, who executed it flawlessly. In effect Truffaut ended up giving the actress the job of expressing a rather severe self-criticism with respect to *Les Quatre Cents Coups*: 'You know, I don't much like this idea of recounting one's youth and criticizing one's parents, of dirtying them. I'm pretty ignorant, but I know one thing: a work of art can't be a settling of accounts, or it's not a work of art.' According to the writers, Truffaut never hesitated to try out scenes from his personal life: 'He would test the break-up scenes, he was sometimes capable of creating a conflict out of anything, of creating an incident just to have a good scene.' The film-maker undoubtedly took a lot

from the people who had counted in his life. For the last scene, before the couple's provisional reconciliation, when Antoine calls Christine from the restaurant where he is being bored to distraction by his mistress, the content of the dialogue was just summarized in the screenplay: 'He expresses the intention of letting the dinner go this evening if Kyoko, as usual, settles for smiling at him in a way he once thought enigmatic but judges more severely now.' Truffaut wrote the dialogue entirely in the margins of his shooting script. 'Every minute is tripled, I feel like I've been in this restaurant since this morning... we finished the meat course, she wanted cheese... I have to go back now... If she orders dessert, I'm going to commit suicide. So long.' Truffaut said he wanted to remake *La Peau douce*, whose failure had left him unhappy, unsure of what he had been trying to do: 'I said to myself: "I'm going to remake the same film and show that one can say all that while laughing instead of being gloomy." Which explains why we find similar scenes and enormous resemblances between these two films, because the second is the 'happy' remake of the first. But then when *Domicile conjugal* was finished, I perceived that it was sad too...' The filming of *Domicile conjugal* from the end of January to mid-March

Antoine is writing a novel whose title will be given in *L'Amour en fuite* – the book is called *Les Salades de l'amour*.

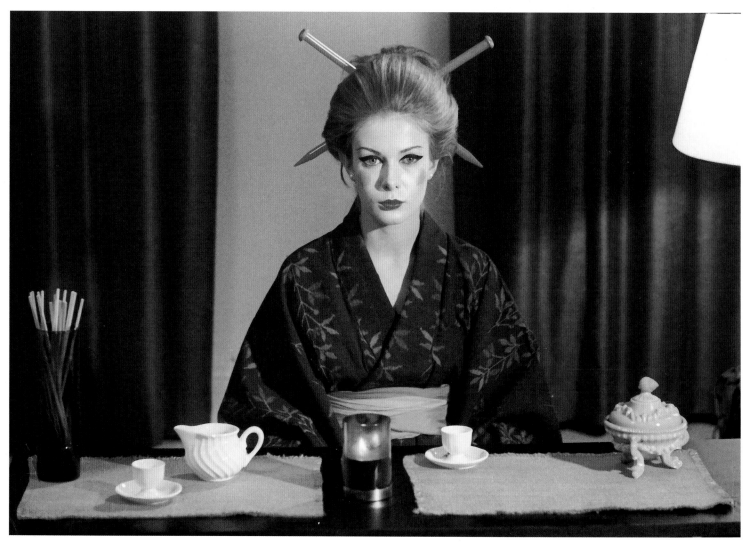

Christine dresses up as a geisha to show Antoine that she knows why he is reading a book about Japanese women.

Opposite: Japanese variations.

1970, which followed very rapidly upon completion of *L'Enfant sauvage*, was not, unlike the preceding shoot, all that happy for the film-maker, who would remember it as having had a bad atmosphere. Nestor Almendros, who was starting his second film with Truffaut and considered this one the most visually thankless of all those they made together, is of the same opinion. 'Shooting a comedy in winter is particularly difficult. The days are short and you have to shoot fast so as not to lose the hours with good light. In the courtyard where a lot of the film takes place, the temperature was below zero. The actors were supposed to be wearing spring clothes. Jean-Pierre Léaud and Claude Jade were freezing, while the crew members were bundled up in sweaters and coats! Shooting in a real apartment reduces your space. The camera and crew were always confined to a corner. All this affected Truffaut, who was more nervous than for his other films.' Nonetheless, Truffaut was careful about his camera movements, again using the principle of long shots discreetly accompanying the movements of the characters as much as possible. 'The camera was always on wheels,' recalls Almendros, 'and we kept reframing slightly, generally keeping the actors in a medium shot, a bit like classical American comedies.' The scene where Antoine and Christine separate and Christine says she wants to give back the little Balthus he gave her while she is walking around talking about the apartment, was filmed in a very natural, invisible single-

sequence shot of three minutes, from the first moment we see Antoine playing with his son until they exit towards the stairs. In the courtyard the camera pans up to flowers treated by Antoine in the window of the old man who will not come down until Marshal Pétain's ashes are transferred to Douaumont, then descends again to discover that the flowers have turned red. This movement is then followed without a cut by a pull-back shot that picks up the owner of the café coming out of the building, catches up with Antoine accosted by Ginette, the waitress who dreams of getting him in bed, then discovers, following Ginette's departure, a new character (the little screeching man, played by Ernest Menzer, whom Truffaut would use again in *La Nuit américaine*) and returns to Antoine at his stand. The criss-crossings of life are recreated and captured by encompassing and barely perceptible camera movements.

Because of the difficult atmosphere of the shoot, Truffaut decided that he definitely had to escape Paris, a city he considered to be 'not a favourable place, creatively', when making his next films. Certain that the price of obtaining everyone's emotional involvement was to separate them from their families and routines, Truffaut henceforth made his films in the provinces, with the sole exceptions of *L'Amour en fuite* and *Le Dernier Métro*.

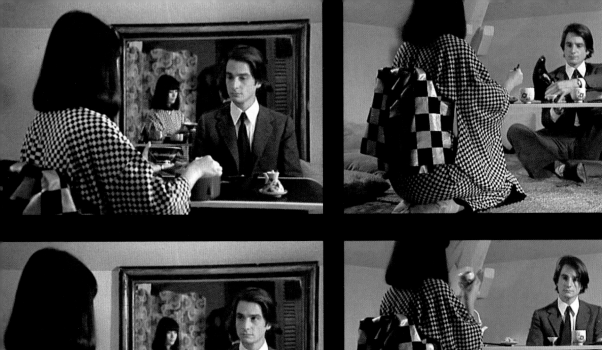

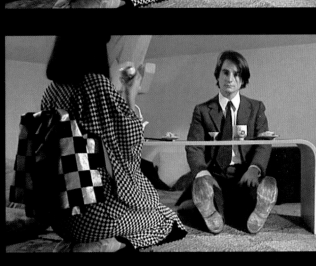

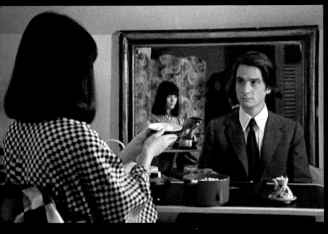

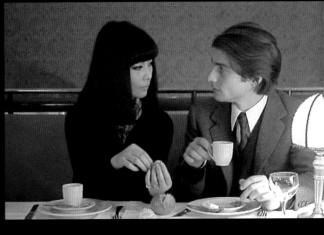

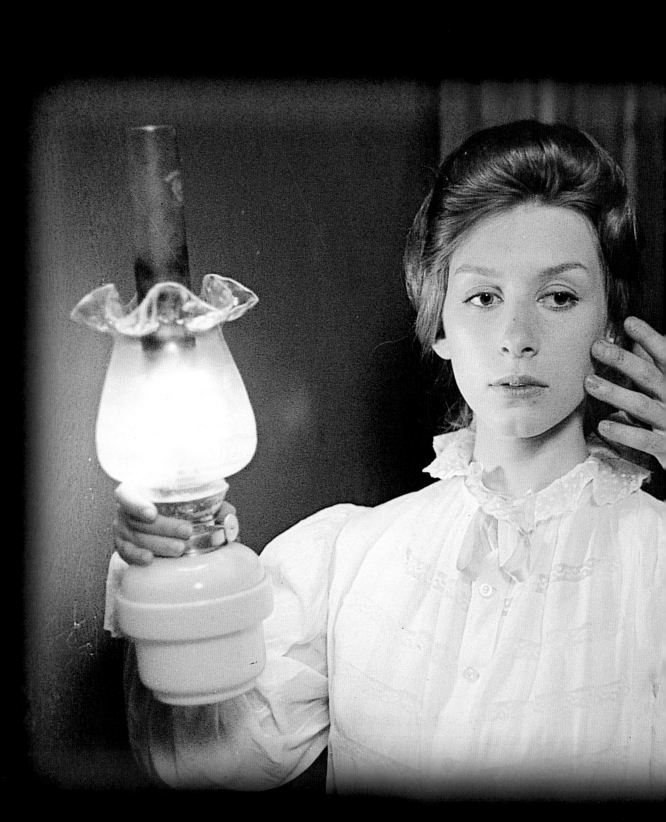

Les Deux Anglaises et le continent (1971)
Two English Girls

'Love, love. The dogs are loose. They gallop in Claude's heart.' At the beginning of 1971, after a break-up followed by sudden violent depression, Truffaut threw himself feverishly and precipitously into a film he had not planned to shoot – at any rate, not so soon – in which he exorcised his suffering.

In *Les Deux Anglaises et le continent* Truffaut created a film that is at once lyrical and cruel, infused with the fits and pains of passion, of which he would later say he realized he 'wanted to squeeze love dry like a lemon'. The whole film is about feelings that are out of sync, as *La Femme d'à côté* would be later. 'We've changed places, like in a game of musical chairs,' Muriel writes to Claude. On the flyleaf of his shooting script, Truffaut copied out again the few lines he had Jeanne Moreau read over the blackness in the opening credits before the images of *Jules et Jim* burst forth, lines that come from the novel *Deux Anglaises et le continent*:

> 'You said to me: I love you
> I told you: wait
> I was going to say: take me
> You said to me: go away.'

At the beginning of 1968, Truffaut decided to entrust to Jean Gruault the adaptation of the novel, which he had frequently re-read since Henri-Pierre Roché had sent it to him ten years earlier. It was Roché's second novel, published in 1956. After *Jules et Jim* the author had again plunged into the years of his youth and his encounter with two passionate and puritanical English girls, inserting the letters and intimate journals the three of them had exchanged at the beginning of the century with almost no changes. Beginning in 1967, Truffaut tried to get the rights to the novel from Gallimard. (He finally succeeded in 1969.) At the end of February 1968, while he was filming *Baisers volés* and was caught up in the affair of the Cinématheque, he sent Gruault Henri-Pierre Roché's journals, large sections of which he had had typed up with the agreement of Roché's widow, asking that his co-writer use them and draw inspiration from them for his adaptation. He accompanied them with this letter dated 27 Februrary 1968:

'My dear Jean,
Lucette will give you Henri-Pierre Roché's notebooks. I hope you find them as fascinating as I do. I ask you, however, to keep your reading of them an absolute secret. This has to remain absolutely confidential.
For your convenience, I'll note that Muriel is generally described using the name "Nuk", while Anne appears under the first name "Mauve".'
Nevertheless, if you read attentively, you will realize that sometimes the names change in mid-adventure. On the copy that Lucette is going to give you, you can check off in pencil what seems interesting to you or whatever you want us to discuss. I'll be at your disposal for a few days at the start of April to discuss.
Amitiés.

Previous pages: Stacey Tendeter and Jean-Pierre Léaud.

The actresses playing the two sisters, drawn for Truffaut during the filming of *Les Deux Anglaises et le continent*.

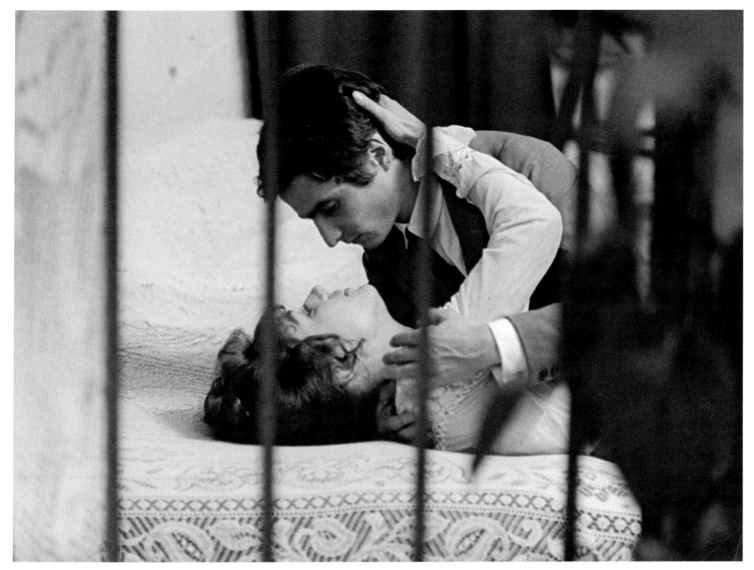

The encounter between H-P Roché and the two sisters happened before he kept a daily journal, but you will find what followed, the adventure with Mauve, who marries Mouf, and Nuk, who comes several times to Paris...'

A monster of screenplay.

Truffaut added to the notebooks a copy of the novel that he had annotated by underlining lines he wanted to use. They might also be using excerpts from the novel of *Jules et Jim*. Jean Gruault got to work on this enormous mass of material. 'I'm having a lot of trouble with *Les Deux Anglaises* (as much as H-P. R must have had Nuk),' he wrote to Truffaut in January 1969. Then he delivered an overly abundant first version of the screenplay, whose length frightened the film-maker: 552 typed pages and 222 scenes, almost six hours of film. He put the project in a drawer for the time being.

After shooting his tenth film, *Domicile conjugal*, which was finished in March 1970, Truffaut was emerging from a period of hyper-activity and felt the need to take a break. He had just made six films in four years, the last three – *La Sirène*, *L'Enfant sauvage* and *Domicile conjugal* – in the space of a single year, from the beginning of 1969 to the beginning of 1970. He said that he had no film projects

before 1972 and hoped to spend the time on several joint editorial projects in France and the United States: publishing the Doinel screenplays, collecting his articles for *Arts* and *Cahiers du cinéma*, finishing *Jean Renoir*, which was left unfinished by André Bazin, and preparing it for publication. He spent a lot of time and energy promoting *L'Enfant sauvage* overseas (the film opened in Paris in February 1970), agreeing to make a number of trips in the summer and autumn of 1970 (New York, Montreal, Scandinavia...). He was starting to get interested in the story of Adèle Hugo and asked Gruault to work on a first sketch of it in September 1970, knowing that it was *a priori* a long-term project. In November he declared that he had no film projects planned for several months.

But in January 1971 it was time to clear the decks at Les films du Carrosse: the filming of *Les Deux Anglaises* was set for the end of April. At the clinic where Truffaut had gone for a sleep cure, he had re-read Roché's novel, then attacked the screenplay again: 'At the beginning of the year I went to work again with scissors and scotch tape (on a roller, not out of a bottle) and got the script down to two hundred pages, asking Jean Gruault to work on it behind me. We more or less collaborated at a distance, by correspondence, as we had previously done for *L'Enfant*

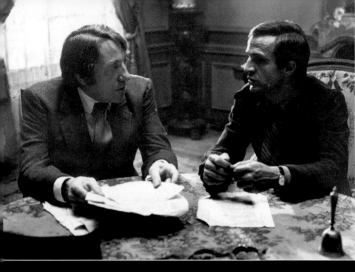
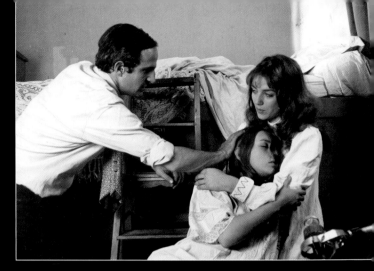

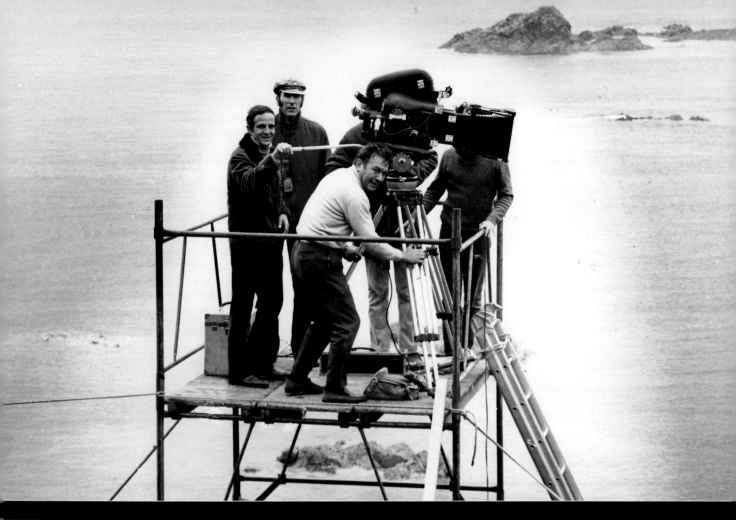

Opposite page, clock-wise from left: Filming *Les Deux Anglaises*. François Truffaut with Georges Delerue.

With Stacey Tendeter and Kika Markham, his two English girls.

With Oscar Lowenstein (the neighbour, Mr Flint).

Setting up the 'squeezing the lemon' scene and the arrival of the train at the little station.

With Stacey Tendeter and Jean-Pierre Léaud.

With Nestor Almendros.

sauvage.' Starting from the first screenplay, copiously crossed out and annotated by Truffaut, Gruault fabricated by further editing a new version, which Truffaut again re-oriented and condensed, going off to work a few days with Suzanne Schiffman in Nîce, before having it typed up for filming. (At 101 scenes and 192 pages, it was still a long script.) Right before the start of shooting and even while he was shooting, Truffaut continued to rework the text and made large cuts, removing whole sections of the story, such as Claude's period of military service, during which he wrote letters to the two sisters.

The search for the main location, the Brown family home, was carried out urgently at the beginning of the year. Finding an old, isolated house of relatively modest appearance turned out to be complicated. Roland Thénot, Truffaut's production manager, hoped to find one south of Nantes, while the production designer explored the North Atlantic coast. They finally found what they were looking for near Cherbourg: a house isolated on an estuary, belonging to a woman who flatly refused to allow any filming at first. Truffaut had the too-white chimney blackened, and he and Nestor Almendros, for their first period film in colour, had the curtains, linen and blouses dyed off-white and decided to work with intermediate colours: mauve, orange and ochre. During production, while his production manager was absent, Truffaut did not hesitate to have a row of fine hydrangeas cut down because it was keeping him from seeing the young women walking in the garden in their period dresses. (When Roland Thénot returned, a grip ran up to his car saying: 'I had nothing to do with it. François had all the hydrangeas cut down.' Thénot had no choice but to replace them afterward with the most beautiful hydrangeas in Cherbourg.) The scenes in Normandy exteriors were often filmed towards nightfall to give them a somber tone more suggestive of England, and as often as possible from high angles, so as not to show the sky. The scenes in the little train station were filmed in the Jura region, where this little old train still existed, which resulted in a slight error in the scene where Claude's mother arrives, noticed later by Jean Gruault: a train conductor wearing a beret, although we are supposed to be in the English countryside at the beginning of the century…

Proust in love with the Brontës.
They were starting from a novel that was particularly wordy and stilted, one that Truffaut feared would prove to be 'unadaptable': a chronicle of feelings filled with innumerable repetitions that combined the story with letters and passages from private journals. Jean Gruault tried, beginning with his first draft of 550 pages, to contract certain events taking place over several years during the course of Claude's encounters with the two sisters in various places. Although he had already removed several episodes and some characters (the two brothers of the two English girls, whose description, 'solid British reserve', was later transferred to the mother), he preserved several of Claude's journeys that he felt were important to the character's development: a visit to Spain where he meets a young woman in church who introduces him to the pleasures of sex; a trip to Rome after his *rapprochement* with Anne; and the Swiss holiday he takes with his mother after being

forcibly separated from Muriel. Truffaut pruned this orgy of settings and journeys, as well as the over-abundance of walks and excursions the trio take in the first version. They settle under a tree whose twisted branches serve as their salon and discuss the prisoner of Poitiers at length. Muriel and Claude jump over a rotted railing that gives way under their weight (a scene taken from *Jules et Jim*). They visit a pigsty and have a contest, the goal of which is to transport piglets from one pen to another as quickly as possible. They attend a fair, where Claude's interest in Muriel grows when he sees her surrounded by children (this scene is also taken from the novel of *Jules et Jim*). Unfilmable scenes that Truffaut slashed as he sought to undo the extremely relaxed construction of the novel, gradually building instead a continuous dramatic movement that would quickly and inevitably bring Claude and Muriel together.

This over-abundance of material was also a result of multiple sources. In the authors' minds the Proust reference was added to what they were taking from Henri-Pierre Roché. Like Proust's mother, Claude's mother lays on his bed the copy of *Figaro* where his first article has appeared. Later, in the train carrying them to Switzerland, Claire reads to her son 'like Proust's mother reading to him on the train to Venice'. Jean Gruault recalls that during this period Truffaut would often buy two copies of particular volumes of Proust's correspondence, one for him and one for his collaborator. In the press book when the film opens in 1971, Truffaut presented his characters this way: 'The hero of *Les Deux Anglaises* is a bit like a young Proust who has fallen in love with the Brontë sisters.'

Not to be thrown out.
If he rejected an enormous number of scenes from the first version, for obvious considerations of running time and dramatic success, Truffaut also tried to extract elements from them, or lines of commentary or dialogue, that he hoped to use elsewhere. From a commentary on a walk along the cliff ('I see the white nape [*nuque*] of her neck under the massive golden chignon. Just for myself, I'll call her Nuk'): 'in reserve'. From a passage in Claude's journal ('You lie more easily in France,' she says, 'but once one knows the percentage, it's not at all bothersome'): 'to be kept, but as dialogue between Anne and Claude'. From a walk with Anne accompanied by a chaperone ('I can't choose between vice and virtue, because it happens that I only know virtue'): 'Put in Scene 39'. At the end of the scene where the trio discusses the prisoner of Poitiers: 'I'm talking about physical love,' says Claude. 'A good continental visitor,' Muriel says to him, 'should notice when his insular audience is tired.' Truffaut indicated: 'To be held in reserve, maybe for the boat.' (The scenes in the boat became walks on the quay with each of the two sisters.) The problem then was to find a place where the selected element would be stronger and more effective. From a scene about a trip, where the trio jumps from the train before it comes to a stop, Truffaut took this line: 'Muriel jumps from the moving train and, with no effort, stops cold. I'd like to get to know her muscles' and notes: 'We should be able to work this superb comment into

'We have to make the viewer wait', Truffaut noted next to this scene on his copy of the screenplay. The film-maker delayed the moment when Anne lets Claude look at and touch her and says 'Tonight, no curtain.'

Right: Flyleaves of the second draft of *Jules et Jim* and the shooting script of *Les Deux Anglaises*. The four lines that Jeanne Moreau spoke at the beginning of *Jules et Jim* are carried over to the title page of the later film, becoming its unspoken epigraph.

Below: Anne and Claude's first night of love. Piling up obstacles, Truffaut rewrote the long sequence of the stay on the island during filming.

Les Fils du Carrosse et Sédif
présentent

Jeanne Moreau
dans
Jules et Jim
(un peu amour à trois)
d'après le roman de Henri-Pierre Roché
Adaptation et dialogue François Truffaut et Jean Gruault
Mise en scène François Truffaut

"Tu m'as dit : je t'aime."
"Je t'ai dit : attend"
"J'allais dire : prends-moi"
"Tu m'as dit : va t'en"

— Tu m'as dit : je t'aime
— Je t'ai dit : attends
— J'allais dire : prends moi
— Tu m'as dit : vas t'en

LES DEUX ANGLAISES ET LE CONTINENT

d'après le roman de HENRI-PIERRE ROCHÉ
"DEUX ANGLAISES ET LE CONTINENT"

Adaptation : François TRUFFAUT
et Jean GRUAULT

Mise en scène : François TRUFFAUT

Jour d'amour

(F) Extérieur - intérieur - Jour -
Derrière la maison : le Pontou -
un poisson = jour sur la
maison : de l'autre côté. le fers.
(commentaire) "Que de merveilles...
sans nous compter..."

(G) : Nuit d'amour :
Elle décide : pas de rideaux
lui : Qu'est-ce que tu fais ?
Elle : ce soir pas de rideaux
lui : Ah bon
Elle : pas de robe etc...
puis : les leçons impossibles.
puis l'amour

(H) une scène après l'amour

(I) : le départ

131

Anne répète en écho, avec une voix changée :

ANNE
...fera de nous... | Viens, Claude, maintenant,
tout de suite !

Et elle attire Claude sur elle. Elle est "rouge et grave".

Claude essaye "doucement".

ANNE
Va, va !

Claude semble encore hésiter.

ANNE
Mais viens donc !

VOIX CLAUDE (off)
Une légère barrière résiste encore. Je la force.
Elle cède...

Anne fait une grimace douloureuse vite réprimée.

VOIX (off)
Claude était en elle.
Elle le regardait avec des yeux de copain, sans plus.
Mais ce jeu abolissait tous les autres. Ils l'apprenaient.

Commentaire insuffisant... On peut le développer à l'aide du dialogue n° 75 (indiquer qu'elle n'a pas joué)

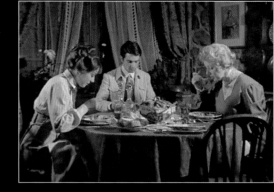

The first 552-page screenplay of *Les Deux Anglaises*, taken up again by Truffaut at the beginning of 1971. His rewrite was already a *mise-en-scène*: how to make the young man who is going to fall in love and the viewer desire a character's appearance.

Right: The 'sequence of the empty chair' (Kika Markham, Jean-Pierre Léaud and Sylvia Marriot).

Below left: Returning from the walk. The comparison to the river is taken from the novel *Jules et Jim*: 'They followed the river, which was torrential in places with waterfalls. They decided that the mass of water when it fell was like Anne; the furious eddies, like Claude; and the calm spots where the river broadened afterwards, like Muriel.'

37

Salle à manger

13 - MÊME LIEU, PLUS TARD . INTERIEUR . NUIT

Claude assis à une petite table devant sa fenêtre ouverte.
Bruit assourdi de la mer.

Claude a pris son cahier et rédige son "Journal".

" .. J'ai senti en Mrs. Brown une solide réserve britannique. Anne lui a parlé de moi. Soit ! Mais *elle attendra de* juger par elle-même. ~~Ne pas s'emballer.~~ Muriel a ~~mal aux yeux et n'est pas parue pour le dîner. Demain j'irai avec Anne peindre en haut de la falaise.~~ "

"La surprise du dîner c'est l'absence de Muriel. Elle a mal aux yeux, ne veut pas quitter sa chambre; nous dînons sous presque parler et je regarde en face de moi cette chaise vide, celle de Muriel.

(handwritten margin notes): *Ils seuls à table sans parler. La conversation roule Claude: "Commentaire littéraire" La conversation s'enserre de l'importance à la chaise vide (absence de Muriel)*

93 - 14 - ABORDS D'UN TORRENT . EXTERIEUR . JOUR

Le jour a baissé. Les trois jeunes gens ont pris la route du retour. *Ils passent devant un torrent.*

VOIX ~~~~ (off)
Ils revinrent
~~Nous revenons~~ en longeant une rivière, torrentueuse par endroits, avec une
Ils décidèrent
chute. ~~Nous pouvons~~ que la masse
il
d'eau qui tombe ressembl~~e~~ à Anne, les
claude
remous furieux à ~~moi-même~~ et l'élar-
suivait
gissement calme qui ~~suit~~ à Muriel.

L'été passa comme un rêve, tout ~~en~~ était
claude écrivait
si naturel avec elles deux. ~~Je pris~~
sur elle chaque jour quelque chose dans son journal
~~mais il aimait encore~~
~~Même~~ mieux les regarder.

Scene 40', a scene in the garden that he rewrote so that Muriel jumps over a little wall, 'or anywhere else that's physical, gymnastic'. He finally put it at the beginning of a rising dramatic curve, just before the two girls' mother asks to speak to Claude and sends him away, thus precipitating without intending to Claude and Muriel's discovery that they are in love. (Muriel leaps over a bench, but the commentary is absent from the final film.) It also happened that Truffaut couldn't find a new place for something: 'To be used because of the beauty of the text, but I don't know where. It could be turned into dialogue or a letter (not to be thrown out).' He made this remark, then crossed it out, about a long declaration by Muriel to Anne that she doesn't love Claude. ('I played at imagining that I might love him. But I have no love for him').

Transfers.

Truffaut permitted himself every liberty with the material Roché's text offered him, in which he was thoroughly immersed: transferring dialogue and commentary from one situation to another, putting into one character's mouth something said by another. And of course, slipping a text that he liked into another film. In the novel and the first screenplay, after Claude gives her to understand that he has had his first sexual experience, Muriel rejects the news violently, then sends him her journal: 'You have helped me see life differently... Now I can inform myself on my own. But for love I have only you.' These lines, which Truffaut first thought to use for the sequences of Muriel's unhappiness ('do not throw away: number 65'), he finally gave to Anne after she has experienced sex during her stay on the island with Claude. Then in another film he would give them to Adèle, who writes them in vain to the lieutenant she wants to marry. Truffaut spelled out this scheme of freely circulating material when he noted in the margin of the final love scene between Muriel and Claude: 'For Muriel's departure. She wants to leave. Claude doesn't understand. Eventually, we'll have to give Claude (in the scene) Muriel's arguments (in the book) and use Claude's arguments for Muriel (in the scene).'

Truffaut increased the intensity by collecting and condensing his material in longer, denser scenes. He wanted to make one letter from Anne to Claude out of several written over a period of days: 'For the letter, which can be long, see also script page 333 ("At four o'clock I felt your lips ..."), page 334 ("our secret, hard to keep"), page 337 ("write to Muriel about her eyes"), page 348 ("unmarried couples"). End with this line: "I know there are other women in your life, but I'm not jealous."' For Truffaut, this process of concentration through an art of the telling detail – his ability to select what was brief and memorable, to be put in the right place at the right time – was completed by his constant questioning of the purpose of scenes, which he took great care with in writing and then in editing. When Claude's mother, alerted to her son's marriage plans, rushes to Wales to put a stop to them, he placed at the very end of the scene her rather terrifying statement: 'When your father died, I called you my monument, and I built you stone by stone.' Anne's promise to Claude, 'You will see Muriel tonight', ends a scene like an organ chord, whereas before it was buried in dialogue. Truffaut finally decided to end the scene

of the Nun's Kiss – a chaste kiss Claude has to give Anne through the bars of a chair – on Muriel's look, a long look full of suppressed jealousy, whereas the screenplay planned an intervention by Mrs Brown ending the game and reminding the young people that it is time to go to bed.

Muriel's empty chair.

When he began reworking Gruault's mammoth first version, Truffaut reacted as a film-maker. He refused situations that would be impossible to show and began constructing a film, composing scenes that he imagined as if he saw them projected on a screen. When Claude arrives in Wales, a scene in the first screenplay shows him writing in his room: 'Muriel's eyes hurt, and she wasn't able to come to dinner.' Rewriting the scene in the margin, Truffaut imagined an actual scene to defer the first meeting and invented the device of Muriel's empty chair: 'They sit at the table without talking. The camera isolates Claude: commentary spoken by him. The camera will give importance to the empty chair (Muriel's absence).' The waiting and mystery magnetize Claude's desire and the viewer's as well: dramatization and *mise-en-scène*. In the margins of his shooting script, next to the scenes where Claude slowly approaches Anne's body during their stay on the island, torn between desire and fear of discovering the pleasures of sex, Truffaut would make the same recommendation: 'We have to make the viewer wait; we have to delay the event, make the viewer desire it. At the end of each scene we have to have an attempt by Claude stopped by Anne: "Wait... wait a bit... Be patient... Wait a bit more... Help me..."'

In the first version, a few pages after Claude's first dinner with the Brown family, the film-maker reworked the second dinner, where Claude sees Muriel for the first time. On the left-hand page he dramatized and plotted out the whole scene (a dinner where Muriel appears wearing a blindfold), breaking it down into three acts in order to have a strong moment framed by a prologue and an epilogue: '16. Claude's room: Anne comes to get Claude. Anne: Muriel will dine with us tonight. Come meet her, but don't look at her yet.
17. Dining room. Anne presents Claude to Muriel, already seated, who lifts her blindfold a little: banal dialogue. Claude sits down, but his look returns often to Muriel, who lifts her blindfold again to see her plate...
18. Claude's room. He writes to his mother. We hear the text of the letter, which is about Muriel. While he writes, a pebble strikes his window. He opens it. Anne is outside. "I wanted to talk to you..." He agrees. He goes out.'
In three movements, Truffaut creates intensity by making the series of scenes a ceremony: a short preparatory scene to create and develop tension, a repetition of the first dinner where the blindfold hiding the eyes plays the role of the empty chair, and finally the passage to writing to prolong the scene and give it importance. His rewrite is already *mise-en-scène*.

'You come from the earth.'

Reworking the screenplay in the margins, Truffaut was clearly trying to alternate moments that concentrate and that accelerate the story, making it advance along an

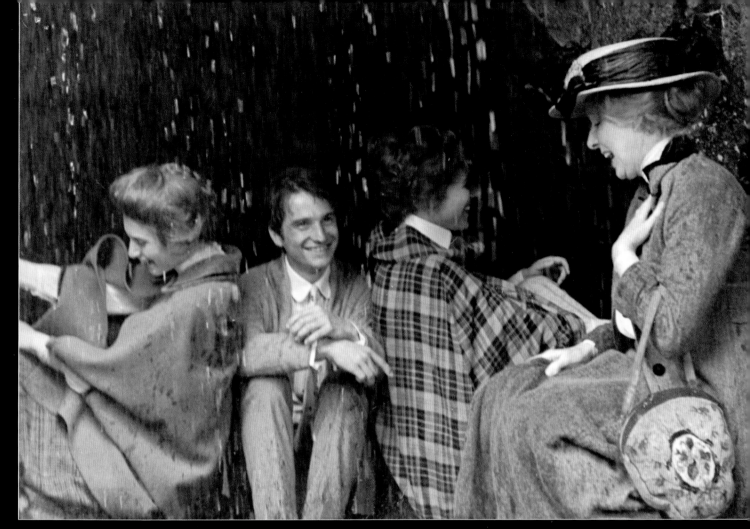

Squeezing the lemon: Claude (Jean-Pierre Léaud) between Muriel (Stacey Tendeter) and Anne (Kika Markham) as their mother (Sylvia Marriott) looks on. 'Suddenly Claude was moved as if by a game he didn't understand. [...] He felt their bodies as an indiscretion.'

ascending dramatic line that brings Claude and Muriel together, and those that slow it down and suspend it. When Claude declares his love to Muriel, Truffaut reduced the number of letters he writes ('All I've done for five days is write to her. I've written five letters that I haven't sent') to one scene that he transformed into a 'real proposal: I want you. I love you and want you to be my wife', then cut numerous intermediary scenes to get as quickly as possible to Muriel's negative response, which shatters Claude, followed by a hopeful one ('I still say no, but I no longer say "never"'). The story is accelerated, keeping pace with the rhythm of the growing erotic excitement that the arrival of Claude's mother will cut short.

Conversely, Truffaut took the time to develop some scenes to which he wanted to give importance. He rewrote the scene where Claude, at night, finds a furious Muriel in the garden and has to pacify her so as to make the growth of Claude's attraction to the more puritanical sister more apparent. (In the first versions Claude had returned to Wales from his military service; Muriel received him coldly until they found out that their letters had been confiscated.) 'First floor. He goes into the living-room and then the kitchen. He drinks a glass of water. Muriel appears. He approaches her with emotion.' In the left margin he completed the dialogue, giving Claude a line he saved from a scene he had cut, which he had annotated 'set aside': 'You come from the earth, and I think that's what I like.' (In the novel, it appears in one of Muriel's letters to Claude: 'I come from the earth, and I think that's what you like'.) Note that Truffaut refused the conventional romanticism of the moonlit garden, transporting the scene into the more anodyne setting of the kitchen. (The clandestine lovers of *La Nuit américaine* also meet in the kitchen before fleeing 'like thieves'.)

Once again, rewriting is already *mise-en-scène*. Perhaps Truffaut was so precise because he was reading this saga of a screenplay with pen in hand, knowing that he would start filming very soon. For the arbitration scene, where a neighbour has the idea of imposing a year's separation on the two young lovers who are in too much of a hurry to marry, Truffaut proposed an opening that is more incisive, more dramatic and more visual: 'When the scene begins, we see Claude and Muriel leave the table and go into the garden. Everyone follows them with their eyes, and when the door shuts Mr Flint begins speaking.' Always careful with his scene endings, Truffaut imagined a form of closure that also marks the end of a chapter in the film: 'Brown Garden. Ext. Night. We're on Claude in a close shot. At the end of the scene, Claude looks toward Muriel; she cries, her mother dries her eye and takes her in her arms like a baby.' On his shooting script Truffaut added Anne to the tableau: 'End on Anne who lowers her head and slow fade.'

A trio.

Reworking and contracting the story, Truffaut was careful to re-establish the trio whenever one or the other of the two sisters was forgotten in the lax movement of the first screenplay, which was more like that of the novel. Using a commentary that, in the book, accompanied Claude's two visits to a maze with the two sisters ('Moved by the similarities and differences between Anne and Muriel, I marvel that they treat me like a brother'), he removed a boat trip taken by Muriel and Claude because he wanted their scene to be identical to a previous walk with Anne. Truffaut sketched out the whole exchange in which Anne, the go-between, refuses to join them so as to leave them alone: 'Brown house, ext. night. Identical to Scene XIX. In front of the house, all three on the doorstep. Muriel: Let's go. / Anne: You go. / Muriel: Come with us, Anne. / Anne: I'll stay here / Muriel: I insist / Anne: And I insist on staying. Anne closes the door. Muriel and Claude start walking, following exactly the same path that Anne and Claude took in Scene XIX. Muriel: Your English won't improve; you should speak with other English people besides us...' When he shortened the film at the request of the distributors, brutally cutting up the prints after the first week of release, Truffaut slashed out the first of the two parallel walks, upsetting the balance he had created so carefully.

Anne has promised her sister Muriel to Claude – a love story she wants to bring about from her very first scene with him, when she shows him a photo of Muriel as an adolescent. When Claude and Muriel do not seem to her to be getting together fast enough, she admonishes Claude: 'The lightning I was waiting for hasn't struck.' Truffaut gave Anne back her function as go-between: when Muriel, after Claude's proposal, gives him hope, Truffaut rewrote the scene to re-introduce Anne, the accomplice, at the beginning. The three come out of the Brown house and Anne retires 'as if to let them talk'. When Claude and Muriel separate for a year, Truffaut planned to have Anne visible in the background and substituted for the Brown house the setting of the little station, more appropriate for farewells: 'Muriel and Claude stand beside the car. Anne is much further away, in the background.' He pursued this idea visually, sometimes isolating Anne by a camera movement or an iris closing at the end of a scene between Muriel and Claude.

Rather surprisingly, we discover in the long version of the screenplay and in the novel that Anne was not present for the symbolic scene of 'squeezing the lemon'. Gruault combined two scenes from the novel: a walk where Muriel and Claude are caught in the rain and seek refuge under a rock where they play at being in 'a prehistoric cavern', and the return from an excursion in a cold train car where Claude simply finds himself being warmed between Muriel and her mother, and thinks only of Muriel: 'As for Muriel, I feel her firmness as an indiscretion. I've lived months at her side, avoiding brushing her fingertips or looking too much at her hands, and now she presses the flesh of her back against me and pushes with all her might... Her temples are beaded. I don't dare breathe her odour.' (This is the text of the novel.) Diving into the heart of his subject as he rewrote the scene, Truffaut was not about to miss this opportunity to materialize the physical and emotional oscillation of Claude between the two sisters. It is between the warm bodies of Anne and Muriel that he literally squeezes him, making him lean now towards the one, now towards the other, in front of the mother who

soon stops the game. Truffaut filmed a scene carried by a commentary where he concentrated the double movement of desire and taboo, approach and withdrawal, the burning contradiction that runs through the whole film: 'Suddenly, Claude was moved as if by a game he didn't understand. [The first sentence of the commentary comes from the novel of *Jules et Jim*.] Caught between Muriel and Anne, whose brows were beaded, he didn't dare breathe their odour. He felt their bodies as an indiscretion.'

The sorrows of Muriel.

Rewriting from January to April 1971, Truffaut gradually directed his film toward a greater crudeness and violence of feelings. He filmed the letter Claude sends Muriel breaking with her by imagining that Claude shows it to his mother: 'Claire reads the very explicit letter Claude plans to send telling Muriel that he will not marry her, that he has women friends and has to work, etc.' And Truffaut decided to concentrate in one episode and one place 'the sorrows of Muriel': '65 – Brown house. Muriel's Room. Here we group everything in a kind of monologue by Muriel. Anne and Mrs Brown take turns at her bedside. The long paragraphs are separated by dissolves. Compresses, tablets, sleep, waking, crises. Maintain the visual unity.' A unity Truffaut put together, collecting the elements he saved from many suppressed scenes where they had been distributed by Gruault in different settings: walks in the rain, dreams, letters written to Claude and never sent. Truffaut extracted from these sources the lines that he would have Muriel say, imprisoned in her suffering – sometimes in English, as if her moral and physical rout were sending her back to her first language: 'I want all of Claude or not at all, and if it's no, then let it be like death'; 'Women friends... I don't understand those morals... What are you looking for in these women? You are too curious'; 'I thought it was over. I was wrong. I've succumbed again. Claude will never return. I will never see him, never love him.' In the screenplay, waking up from a dream where Claude touches her thigh and licks his finger as if it were honey (an account of a dream taken from the novel), Muriel writes in her journal: 'I will no longer write this journal for Claude. I will never marry', a line Truffaut had annotated with 'don't throw out, Number 65' before specifying: 'She is at her window; it's snowing outside [the snow will be replaced by rain]. It's the last flash of pain for Muriel.' Confinement and crudeness, space contracting around a suffering body, obsessive repetition, scenes that go on until they become suffocating – Truffaut had never carried the portrayal of heart-rending love and suffering so far. Never again would he go this far except, much more briefly, in *La Femme d'à côté*, when Mathilde, being fed through an intravenous drip in a hospital bed, says: 'I'm thin, I'm ugly, I'm not loveable.' Perhaps when he constructed this segment he was thinking of Bergman's *The Silence*, a film he admired. During production Truffaut amplified his effects: tears and cries, brutal falls, jerky movements, slow camera moves in on the ravaged face of the young woman framed by her long hanging hair, slowed-down camera moves inside the room, between the bed and the prayer stool, contrasts between the very black backgrounds and the white night-dresses that Muriel no longer takes off... The film-maker never hesitated to drive the nail in during what seems an interminable sequence (almost ten minutes), not shrinking for once from the risk of causing oppression, discomfort and displeasure in the viewer. He then resigned himself to cutting out half of Muriel's sorrows after the first week in cinemas, putting them back in their entirety in the complete version of the film that he re-edited in 1984.

During filming Truffaut exaggerated even more the ravages inflicted on the body by the pain of love. Taking advantage of the sloping garden he had at his disposal, he imagined that Muriel faints when she reads Claude's letter. ('Letter-box at the Browns: a letter is dropped in. Muriel in the garden, she reads, faints. Anne and her mother (or the gardener) carry her...') It was also during filming that he imagined Muriel running to vomit in the sink when Anne confesses having loved and been loved by Claude and decides to film in all its cruelty this distress of a body struck by the inconceivable.

Inventing death.

In the last part of the film, filled with suffering, Truffaut invented the deaths of Anne and Claude's mother, which do not occur in the novel. It is actually Claude's mother who says to him: 'What is it? You look old this evening' at the end of the novel and the first draft of the screenplay. When he started cutting down that epic version, Truffaut invented, after the episode of the liaison with Anne and the appearance of a rival, the death of the mother, already describing very precisely the scene he had in mind: '80. Claire's home. Interior. Day. We see Claude seated with a businessman who advises him to sell one of his buildings that is costing more than it brings in and rent the other two. Claude says: "I should ask my mother's advice." The businessman leaves. Claude goes to Claire's room. She is very sick, she says to Claude: "Whatever you do will be right." We know she's going to die. 81. Façade Arago. Ext day. The curtains of mourning are lowered. Double exposure of Claude crying.'

In the second treatment Truffaut imagined Anne's death from tuberculosis, which was taken from Emily Brontë. (Is this, in this film of exorcism, a memory of Françoise Dorléac, run down on a road in 1965?) The last line which the editor Diurka tells Claude was spoken by Anne, also comes from Charlotte Brontë: 'My mouth is filled with earth.' Truffaut, reworking this sentence in the first screenplay, initially planned to give it to Muriel at the moment she sends him her confession after learning about Claude's affair with Anne: 'My Claude, when Anne spoke to me about the two of you, I suffocated and my mouth was filled with earth. I could no longer remain with you or even try.'

The palm-reader who predicted a happy marriage for Anne in the first version now refuses to tell her her future and foresees a great danger. With these deaths that mark the passage of time, Truffaut infused his film with the power of melancholy. He introduced the irreparable. Still, even as he engaged his film on this shadowy slope, he did it with an energy and a freedom that were no doubt linked to the personal emotional state that had made him throw himself into the film, rushing ahead and never

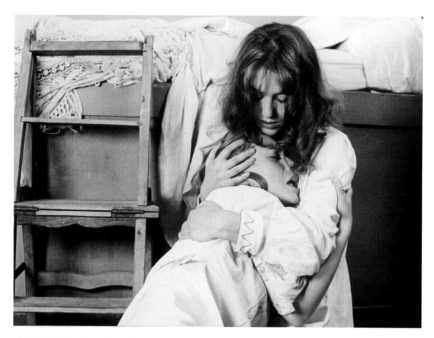

The two sisters, Muriel and Anne.

pulling back, because the exorcism it effected permitted him, as Claude tells his editor, to make his characters suffer in his place. Muriel's sorrows, Claude's depression when he locks himself in darkness and repeats that he no longer understands anything about life, the deaths of Anne and Claire, the evocation of all the deaths in the war of 1914 – the film is bit by bit taken over by blackness, the blackness of the mourning curtains that fill the screen behind Claude, the blackness of the fades and irises that seem more numerous in the last part of the film (the iris encircling the dying Anne's chalk-coloured face, or just after, Claude's face when he hears the news). By killing Anne, Truffaut also caused the death of the most liberated of the two English sisters, and after her disappearance all that remains for Claude to do is to arm Muriel as a woman against himself. Truffaut would have said he had Anne die in the spirit of contradiction, deliberately striking the less romantic of the two sisters. Anne's death feels like an injustice, a punishment. But it is also as if it opened the way for the double epilogue: the single night of love with Muriel and the fleeting encounter with a young English girl who might be her daughter. (She is her daughter in reality in Roché's novel, but only virtually in Truffaut, whose vision is more cruel.)

Muriel's confession.

Before turning to the last page of his story, Truffaut wanted to insert an episode from the book where Muriel sends Claude, in the form of a long journal, a confession where she says that she has masturbated since childhood and has discovered that it is 'a bad habit'. At first he had trouble finding the right place for this episode, and he modified Claude's reaction to it from one version to the next. In the first screenplay, after Muriel returns to England (when she learns of Claude's liaison with Anne), Gruault planned that after several letters have been exchanged Claude will receive Muriel's journal, at the end of which is her confession. After reading it Claude writes to Muriel to come and see him in Paris. ('I have to liberate Muriel. There's only one way. I have to do to her what I did to Anne.') Truffaut lightened up the episode and proposed another chronology: Claude reads a letter from Muriel, who is returning to England again. He sees his editor at the press; the editor gives him the proofs of his book on art and asks him what he feels. (This is the first modest reference to the idea that the character frees himself by writing.) When he returns from the press, his concierge gives him a package: part of Muriel's journal, 'the most astonishing confession by a woman that I've ever read.'

In the following treatment, Gruault put the sending of the confession before Muriel's visit to Paris, just after the death of Claude's mother and at the moment of Anne's affair with Diurka. Then Truffaut added: 'A brief commentary will indicate that Claude is overwhelmed by this confession, which is more moving than shocking for him as it is for us. The conclusion of the scene still has to be found.'

In his shooting script Truffaut again moved the confession earlier, after the 'sorrows of Muriel', thinking that it could be the material he needed for an 'undefined supplementary scene: here we will have a scene showing the passage of

time. We will show that Anne and Mrs Brown are helping Muriel heal while in Paris; Claude, who has become a fine connoisseur of painting, multiplies his conquests with his mother's approval, since she prefers this scattered approach to a true love that would endanger her. In short, Claude seems to forget his two English sisters.' At the same time, and rather amusingly, Truffaut began to modify Claude's reaction, making it less sentimental: '67 – Claude receives Muriel's confession. Claude's reaction: literary and aesthetic; he is more moved than shocked, and he responds to Muriel with a casual letter. (To create a 'heroic misunderstanding', Muriel has made him believe that she isn't suffering.) In Paris Claude says to his mother, "You were right, Muriel didn't really love me."'

Finally, Truffaut wrote another scene about the 'heroic misunderstanding': it is Muriel who answers Claude's letter breaking off their relationship with a casual letter (one that we know is a lie) to Claude, who is a little disappointed. And Truffaut finally put the confession scene later, during the Anne–Claude liaison and before the death of Claude's mother, when Anne, after returning from Persia, is in Wales again with Muriel, who is convalescing. Muriel sends the confession as a way of bringing the story to an end, in order to re-establish the balance between her and Claude by destroying the legend of her purity. And Truffaut, exploiting the dramatic irony of the situation, rewrote the scene again during filming to take the idea of a 'literary and aesthetic reaction' further, eliminating any sentimentality in his character: Claude dictates the journal to a secretary whom he watches closely, and asks Muriel's permission to publish it. ('Muriel's confession provoked more curiosity than emotion in Claude. He thought above all of the literary profit he would be able to derive from it.') The search for the right ending to a singular episode, the most astonishing part of which is that Truffaut (the supposedly well-behaved Truffaut) represented it with no beating around the bush: zooms-in that enclose the face and eyes of Muriel severely making her declaration; flashbacks to Muriel as a child with the little girl who helped her discover her body, stiff, speeded-up delivery, zoom-in on the letter sent to Muriel by the League of Virtue. As with 'the sorrows of Muriel', he chose an excessive, radical and unsentimental approach adapted to a singular subject, even if it shocked the viewer. Furious nonetheless to have put himself in this situation and ill at ease when the time came to film the scene in bed with the two little girls, Truffaut panicked at first ('We can't shoot this scene – what am I going to say to these kids? I can't explain it to them'), and Suzanne Schiffman went to talk to the two little girls, passing the scene off as a game that consists of disappearing under the covers: 'Suddenly François felt so guilty for having thought of this scene that he was blocked. Normally, he would have found the solution himself.' But he didn't deviate from the aesthetic line he had fixed for himself: during the editing he created dollies-in on the optical printer to get even closer to Stacey Tendeter's eyes.

The last piece of the puzzle.

Because he was filming it barely three months after having restarted the whole process, the shooting script was even more fluid than usual. It still contained two visits by Claude

Truffaut's English actresses, Kika Markham and Stacey Tendeter.

to Wales, which Truffaut contracted at the last minute into one, and the scenes of the regiment were removed altogether. To replace them and to justify a moment of bad humour on Muriel's part (who originally was going to be sullen with Claude at the moment of his second arrival), Truffaut invented a scene where mother and daughters iron while singing, as Claude comes and goes on the terrace in front of the house reading a book that obviously doesn't interest him much: 'Living room. Ironing; the game of islands. Anne fears that Claude is getting bored, proposes walk; Muriel, bizarrely irritated, leaves; astonishment of others.')

While he was annotating the novel, Truffaut wrote 'From now on, we have to go very fast' at the end of the chapter where Muriel discovers Anne's liaison with Claude, but at this point the film-maker still did not know how to handle the epilogue. He therefore left a kind of hole in the screenplay before the last part and the final reunion of Claude and Muriel, which he planned to fill with commentary:
'*Various*.
Here, a scene to be defined. The commentary will indicate that Claude's book was noticed by some, but did not have a popular success.
In Wales, Muriel seems resigned to Sunday School.
Anne marries an alpinist.
Claude lives partly from his pen, partly from the buildings he rents, but above all from the sale of paintings; he doesn't buy them for himself, but he advises rich connoisseurs who want to collect. Time passes again. One day, Claude learns that Anne is dead, tubercular. For three months she refused to let herself be treated. One day she felt so weak that she said to Muriel: "If you called the doctor, today I'd agree to see him." She is dead soon after. It's Muriel who writes all this to Claude; she ends her letter by saying, "My mouth is filled with earth, adieu Claude."
Life continues. Claude travels a lot. Around 1910 it is he who carries the first Picassos to the United States. Back in Europe, one day in the railway station, he meets Muriel.'

During the shoot Truffaut was very happy with the scenes filmed with Philippe Léotard, to whom he had given a miniscule role in *Domicile conjugal* (a drunk who passes through the Doinels' courtyard). Truffaut used his own love at first sight for the actor, which was shared by the crew, to imagine that Diurka, Anne's lover, goes to Wales. He thereby finds, with the arrival of an antique car on the road, the missing piece of his puzzle. Diurka (so named by Truffaut after Bernadette Lafont's sculptor husband, instead of Mouf as in the novel) becomes Claude's editor, and this function permits him to restart the story. 'If we reintroduce Diurka, it can only be here,' Truffaut noted in the margin of the scene at the press. 'Surprise, he's the proofreader! The commentary will say that they didn't get along before, but that today… etc. In this case it is Diurka who gives Claude news of Wales; he knows that Anne has broken off her engagement; he could say that he's decided to go there, etc. (It is Claude who finally convinces Diurka to make the trip.)' The re-introduction of Diurka sends ripples in various directions: it makes it possible to show that time has passed and to show Anne's death. It is Diurka who announces that Anne is dead, saying: 'My mouth is full

of earth.' Truffaut sketched out the scene at the bottom of the page, under the scene at the press:
'94b: Brown House (the house changed). Diurka arrives with Muriel / Muriel Sunday school (she teaches it) / Attention! Not too much Mother ['Mother' in English]… Anne tubercular, she doesn't want doctor / Mother overcome / Garden: Mother prostrate / Anne dying / Muriel cries / Anne accepts doctor.'

This also permitted Truffaut to move on to the scenes where Claude sees Muriel again and frees her from him, since it is Diurka who tells him about her trip to Calais. Diurka also enabled Truffaut to evoke the exorcism of suffering accomplished by the film: at the same time that he added the sequence of Claude's depression ('I'm nothing, I'm no one, I no longer understand anything of life') and his cure, he jotted down this rough dialogue in the margin of the scene at the press. 'What do you feel? – a great relief. Now I'm no longer unhappy, the characters in the book suffer in my place.'

Red on her gold.

Not interested in shoring up his film with casting coups, Truffaut chose two unknown English actresses in London to play the two sisters, knowing that he was going to give them trying scenes that would be difficult to play: two young women who were no more important than Jean-Pierre Léaud, who were part of 'real life' and were physically credible as characters from the beginning of the twentieth century. He also knew that he was asking Léaud, as the young Roché, to play a character much further from himself than Antoine Doinel. 'I said to him at the beginning: "This will be the hardest role for you because you will have to act as if you were rich and important." I asked him not to try to soften the viewer's heart with *gaucheries* as he had in his previous films, and to be a well-bred young man with these two girls.' Truffaut recalled that he asked the two young English girls to speak their dialogue with a sustained rhythm even when they might not understand the meaning. 'I had to work very hard with the actors and even use a few ruses, because finally ruses are important in this *métier*. For example, sometimes you give actors directions the others don't know about. I might find one of the girls and say: "You have to act as if Jean-Pierre were a child and you were five years older." After that I'd go see Jean-Pierre Léaud and tell him: "Act as if she were a little girl and you're five years older," and afterward I'd watch them confront each other after secretly giving both of them that instruction.' Shot in two and a half months, the film was edited in Nîce at the beginning of summer 1971 at the Victorine Studios. As always, Yann Dedet recalls, Truffaut was sincerely crushed by the first very rough cut. ('What are we going to do with all this crap?') Then he got down to the delicate task of rewriting the commentary to fit the images: 'He came to the screening room, asked Martine [Barraqué] for two aspirin, sat down in a corner and wrote.'

We know that when the film was released it was greeted with incomprehension and rejection on the part of the public and a good number of critics (the famous murderous review by Jean-Louis Bory, who said on the radio that he

was 'bored from the first to the last image'). Jean Gruault recalls that the sequence between Anne and Claude on the island, which the film-maker had worked on precisely to 'make the viewer wait', was the one that got the most laughs when he saw the film in a cinema. ('So go on and fuck her!' shouted his neighbour.) It is none the less hard to imagine the kind of pressure Truffaut was under from anxious distributors. Even though he probably accepted without much difficulty reducing the film's length so as to allow an extra screening per day, brutally cutting into his film, he obstinately refused to cut the shot showing the spot of Muriel's blood or to soften the scene. (Even Suzanne Schiffman, and other friends, reproached him for that spot of blood, because it was too abundant and artificial.) After the third week of release Truffaut received from his distributor, Hercule Macchielli of Valoria Films, a severe but polite letter demanding even shorter copies for the provinces:

'... Based on all the impressions I've heard, the most criticized scene is the one in Calais reuniting Claude and Muriel in a hotel room, and particularly the length of this scene, where Muriel's sighs go on much too long, and above all the sight of the blood that consummates the loss of Muriel's virginity.
I duly told you how much I love the film, but I must remind you that in the first screening of the married print I called your attention to the problem of length, the often useless commentaries and above all the bloodstain.
Even though the length was reduced after the first week of release, you have always refused to deal with the bloodstain, on the pretext that you'd be going against your own judgement to do so.
The film will open in the provinces in January, and it is to be feared that we are headed for a more serious failure than that recorded in Paris.
I don't deny that your position as an author and a director gives you privileges that I actually do respect.
But I think you also have to take into consideration our position as co-producer and distributor. [...]'

Ten years later, in *La Femme d'à côté*, Truffaut slipped a small private joke into a scene where Mathilde, who has drawn a large pool of blood under a little boy who fell down, obstinately refuses a variant that 'doesn't betray it' proposed by her publisher, a rather sympathetic character: the same drawing without the spot of red.

Une belle fille comme moi

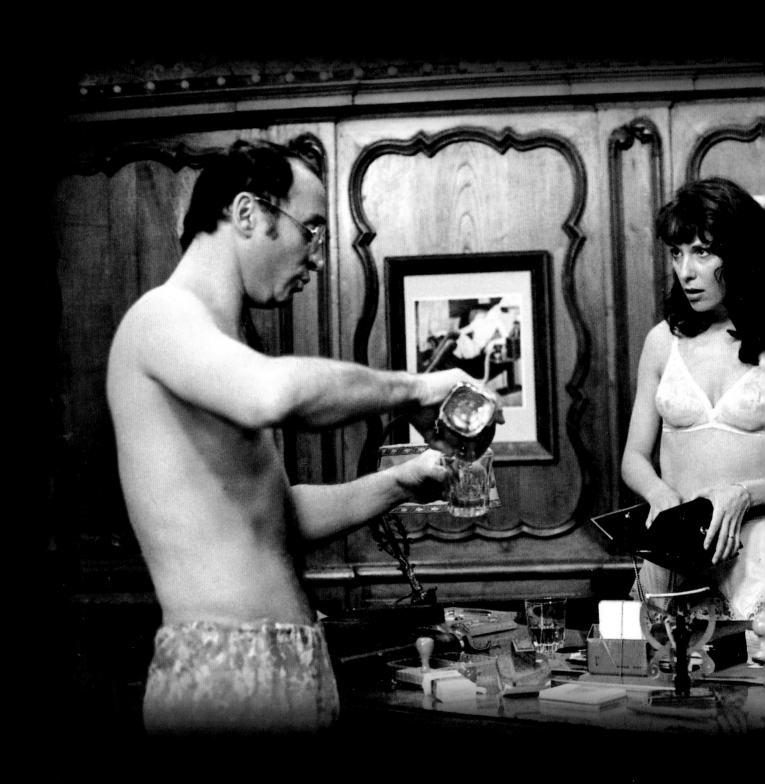

Une belle fille comme moi (1972)
Such a Gorgeous Kid like Me

A young sociologist writing a thesis on female criminals decides to research his subject more directly by interviewing some in prison. He happens on an astonishing specimen (played by Bernadette Lafont), who toys with him while giving him a revised version of her adventures. Even before starting to film *Les Deux Anglaises* (beginning at the end of April 1971), Truffaut was already thinking that his next film would break with the tone of the one he was about to shoot. When he was on the verge of plunging into 'the sorrows of Muriel', Truffaut already felt the need to contradict the gravity with which he was about to represent the extremities and contradictions of love, to 'make fun of himself', as he would say when *Une belle fille comme moi* opened.

This would not just be a film of self-mockery, but rather one that expressed a facet of himself that he had shown less often – childish and jokey, full of insolence, vulgarity and joyous crudeness matched with a taste for cheap gags that Truffaut told Claude de Givray he thought he inherited from his stepfather. ('Everything was an excuse for a joke', Truffaut wrote while describing him in his preparatory notes for *Les Quatre Cents Coups*.) Although his friends and others close to him knew this side of his personality, Truffaut was more prepared to give it free rein in his letters, which were sprinkled with puns, or in the sex-fiend articles he occasionally wrote for *Cahiers du cinéma* and generally signed Robert Lachenay. He rarely showed it in his films, except intermittently – in a few scenes of *La Sirène du Mississippi* and most notably in *Tirez sur le pianiste*. Perhaps he would have allowed himself to continue in this vein if that film had been better received. When he adapted *Une belle fille comme moi*, however, Truffaut decided to go all out and indulge his taste for this kind of humour to his heart's content, surrounding himself with excellent actors he knew would play farce with conviction (Bernadette Lafont, Charles Denner, Claude Brasseur or Philippe Léotard…). But the public was taken by surprise and the film was, in its own way, as badly understood in 1972 as *Les Deux Anglaises* was the previous year.

As early as March 1971 when he was deep in pre-production for *Les Deux Anglaises*, Truffaut inquired about getting the rights to a *série noire* novel he read on a plane by one Henry Farrell, *Le Chant de la Sirène*, whose original English title, *Such a Gorgeous Kid Like Me*, he would use word for word. In an article published at the start of production, he told the story of how he had laughed so hard reading the novel that the stewardess thought he'd lost his mind and warned the pilot. Truffaut learned that the rights belonged to Columbia and would cost more than Les Films du Carrosse could pay. A few bargaining sessions later he got the rights to make the film, but for Columbia. Truffaut then contacted Jean-Loup Dabadie and sent him *Le Chant de la Sirène* at the end of March. He had been having books on prostitution sent to the screenwriter since the end of February 1971: preparatory work or preliminary research on a common topic?

'I needed a collaborator for the adaptation and dialogue of *Une belle fille comme moi*. I recruited Jean-Loup Dabadie because he was the one who said the most nice things about

Previous pages: Claude Brasseur and Bernadette Lafont.

The first version of Camille's song, which Truffaut asked Dabadie to rewrite using the phrase 'Une belle fille comme moi.'

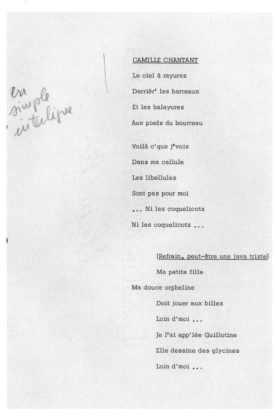

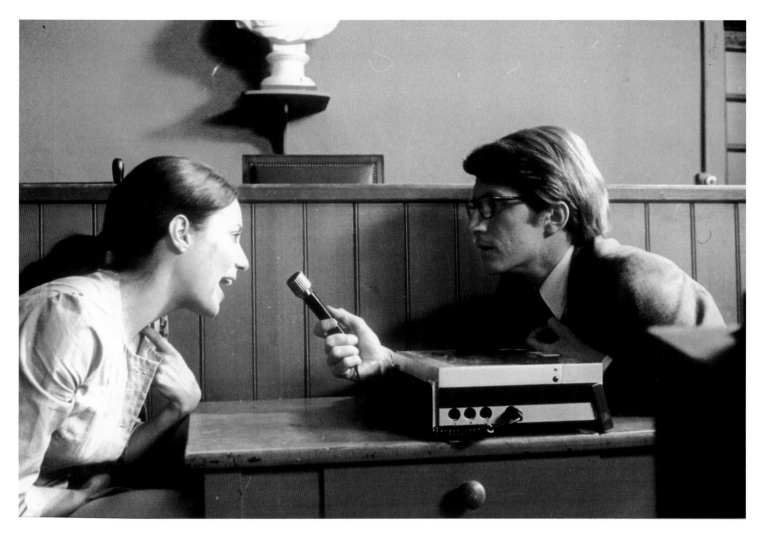

Camille Bliss
(Bernadette Lafont)
tells her life
story to sociologist
Stanislas Previne
(André Dussollier).

my films, even those that played for only three days. We started working together while on holiday in Antibes, and I quickly realized that we were a team like Noël-Noël and Fernandel in *Adémaï-Aviateur* when they go up in a plane, each thinking the other knows how to pilot it.' Truffaut's first collaboration with this young screenwriter who was beginning to make a name for himself (after *Les Choses de la Vie* and *Max et les Ferrailleurs*) and who was not one of his regular sidekicks, was the result of a small misunderstanding. Truffaut, who had recently read and liked very much the script of *Chère Louise*, written by Dabadie for Philippe de Broca, cherished the dream of one day receiving a kind of ideal screenplay, one that would be all done, finished, impeccable, which he would only have to film, with no effort, without having to rework it or get angry before making it his. A screenplay he would not have to tinker with again during the shoot, as he was in the process of doing on *Les Deux Anglaises* – as he had always done, as he would always do. For even if it required a kind of gymnastics that seemed exhausting after a while, this was how Truffaut continued to invent, taking advantage of the concentration and focus that a shoot offered him for getting to the bottom of his subject. 'The script for *Louise* made me want to work with you, for I had the impression that for the first time I was reading a French script that could be filmed just as it was,' he wrote to Dabadie at the beginning of May 1971, during the shooting of *Les Deux Anglaises*. 'If we construct a well-balanced structure

together (15 days – 3 weeks), which I will then let you dress up while taking a look once a week or only at the end (whichever you prefer), we'll end up with something I can shoot without having to patch it up endlessly and plug the holes. I want that and I need that.' It was a paradoxical dream, or rather an impossible one for a film-maker who needed to react against the material that was brought to him in order to find his own path. When Dabadie delivered a screenplay a few months later, Truffaut of course did not find it to be what he had imagined and was obliged, in order to turn it into a film that would be his, to annotate, criticize and rework as he would have done with a first draft from de Givray, Revon or Gruault...

The tribe of Bliss.
Truffaut was less free with Dabadie than with his usual collaborators, whom he didn't hesitate to take by the throat and chew out ferociously in the margins of certain scripts. He moderated his style, modifying and toning down some of the irritable remarks he had made on his copy of the script when he had them typed up for his co-writer. At the point when the sociologist and his secretary are looking for a home movie that may contain proof of the beautiful girl's innocence, his remark 'All these intrusions in the homes of 8 mm people go in the toilet' became, more civilly: 'We'll wait until we've had a chance to time the script before deciding, but I think we'll have to get rid of all these sketches in the homes of amateur

pour jean-loup.

Page 72 = les scènes entre Stanislas — Marchal ont un coté utilitaire. je préfère soit un rapport — style monologue de Stan dans sa voiture (style universitaire sociologue) soit monologue intérieur pendant qu'il conduit.

Page 75 = le tiroir fracturé ; on ne devrait pas se priver de le montrer.

77 = le retour en ascenceur me gêne

78 = "le Vas de ferraille en nitoen": Meilleur à montrer qu'à raconter

79 = je ne suis pas emballé par les scènes de trio = Stan — Helene — Marchal

84 = Helen est une secrétaire, elle doit rester une secrétaire

90 = les menottes. Pour Sam ou pour Camille quand elle sortira de prison ?

91 = Mamy, attention à cause de Mamy Bleu

Une belle fille comme moi

NOTES POUR GEORGES DELERUE

pour la musique d' "une belle fille comme moi"

Music 1

Le prologue dans la librairie. Il s'agit d'une musique d'attente, une musique pour intriguer : note tenue ou corde pincée ; quelque chose d'étrange.

Music 2

La cour de la ferme : idéalement, la musique ne devrait être ni comique ni dramatique, mais scrupuleuse sur les synchronismes : les coups de pieds, manœuvres de l'échelle, chute du père , réaction de la petite fille, etc...

Je ne sais pas si c'est la plus difficile à faire mais c'est pour moi la plus difficile à décrire.

Music 3

Evasion de Camille . Cette fois le film démarre vraiment . La musique peut adopter le style du train qui roule sur ses rails, et qui sera le sien, je l'espère, jusqu'à la fin du film . Dans cette musique, le synchronisme important est sur le baluchon intriguant , dont on découvre en fin de scène qu'il contient les chaussures de Camille .

Music 4

Encore les chaussures mais celles de Clovis. Départ en voiture, et si on compare le film à un livre, fin du premier chapitre lorsque la voiture disparait dans l'image. (L'image a été rallongée après dernière projection).

Music 5

Très discrète.

./.

124

ARTHUR
Ne dites pas non, surtout ne dites pas non...

94. PARLOIR PRISON. INT. JOUR

CAMILLE
Alors, comme l'avocat y m'avait pris mes sous, Arthur y m'en redonnait, cinquante sacs par cinquante sacs, et je sentais qu'y fallait pas refuser parce que ça lui aurait fait trop de peine.

STANISLAS
Parmi ces hommes que vous fréquentiez à cette époque, n'aviez-vous pas une préférence ?

CAMILLE
Je sais pas. Je les aimais tous bien pour des qualités personnelles différentes qu'ils avaient chacun. Par exemple Murène l'avocat, c'était le mieux sapé, et puis je croyais qu'il allait rendre Clovis riche en justice...
Sam Golden, il allait devenir une idole

assez sombre

par un peu chuchoté...
ambiance
(confessional)

43

Elle court sur la route et arrête une voiture en agitant frénétiquement ses bras. Une tête d'homme sort par la portière. Nous restons sur Clovis, qui panique.

CLOVIS
Camille !! Reviens, minou !!

Camille se retourne.

Une seconde d'hésitation entre eux.

Clovis a un air misérable.

Camille revient en se dandinant vers lui.

Derrière elle, la voiture repart.

Camille est en face de Clovis.

CLOVIS (d'une pauvre voix)
Abandonne-moi pas.

Camille, belle, le corsage ouvert, regarde son mari.

Finir sur 2 belles images bien nettes illustrant la chose : "Par dessus son épaule

il colle vu de loin

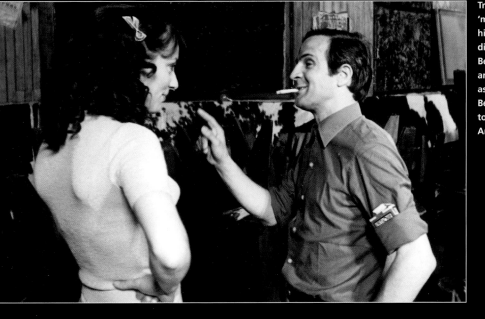

Truffaut has fun 'making fun of himself' and directing Bernadette Lafont and Charles Denner as well as Bernadette Lafont together with André Dussollier.

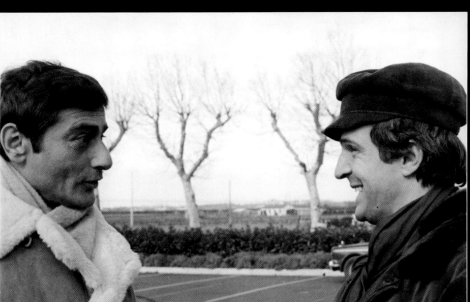

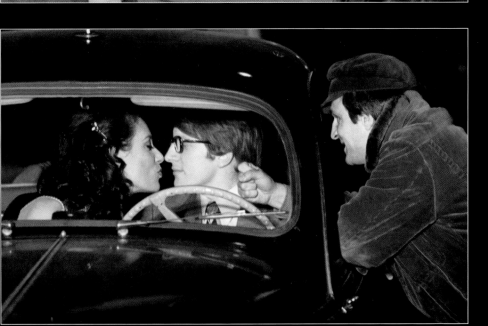

film-makers.' (Dabadie ended up playing, for one brief shot, one of the photographers the investigators go to for information.) An 'almost incomprehensible. No one's going to listen to Camille's charges against the lawyer' became 'Danger: because the image will be too active at this point, the audience won't listen to Camille's complaint against Maître Murène.' Or this somewhat aggressive reaction: 'Get rid of Arthur's monologue. (Denner will refuse the role)', which became 'Arthur's long monologue: We need to discuss.' Part of the slight misunderstanding had to do with the fact that Dabadie had offered Truffaut a story that was less rapid and concentrated than he had expected. Asked to supply comic effects, Dabadie had sometimes used methods that the film-maker would not have chosen himself. Dabadie suggested, for example, a scene where the young sociologist is crying as he listens to recorded statements by Camille Bliss, the object of his study, only to show us afterward that he is peeling onions for his supper. Truffaut would rather have concentrated on the repetitive comedy of his heroine's impertinent verve, the creativity of her lies and the gap between what she says and what we see. The film-maker simply had a different vision of the story that he could only communicate by implementing it himself. 'The force of the book: it's a *série noire* story narrated by a sociologist – let's not lose sight of that,' he added at the end of his notes for Dabadie. 'He's actually an ethnologist, one who is studying the Tribe of Bliss. If we have to choose between Audiard (at best) and Rouch (all audiences), let's do Jean Rouch.'

Curiously enough, when in years to come he thought of working with Dabadie again, Truffaut never gave up this idea of a script that would come to him almost finished and that he would be able to shoot without having to think about it. The two men talked about a new collaboration several times. Truffaut had briefly thought of Dabadie to write what would become *La Nuit américaine* before working on it with Jean-Louis Richard ('I think that *Le Chant de la Sirène* would be good material for us, or just as much, the film about making a film,' he wrote to him in 1971). He considered him for his film about children (the future *L'Argent de poche*), but decided that the fee he was able to propose did not correspond to Dabadie's growing fame and preferred to give him back his freedom. Truffaut asked him to think about a subject for Isabelle Adjani, which he combined with his long-standing desire to make a film about a young girl who was a thief. ('We have said, I have said, that for our next film, the initiative has to come from you: Isabelle as a thief'), but gave up the idea after shooting *Adèle H* and 'seeing and re-seeing the face of Isabelle A on the Moritone'. He summed up the schism that separated him from the actress: 'She has succeeded in ageing so well that she'll have to go in reverse for her next roles, and I can't be the right man at the right time until her real age has caught up with what she appears to be in *Adèle*. I am also convinced that she needs to experiment with other styles of direction.' In reality, Truffaut would have loved for Dabadie to bring him a screenplay: 'My desire to work with you is as strong as ever, but it takes a paradoxical form. I don't want to give you a subject and discuss it and explore it as I do with Gruault, Aurel, Suzanne Shiffman; I would like the idea to

come from you, its development too, so that you would offer it to me like *Chère Louise*.' (This was in March 1981, when he was about to film *La Femme d'à côté* and had just seen *Clara et les chics types*, which Dabadie wrote.) But would Truffaut, who had always refused such proposals, film a script and an idea that had not come from him? When Dabadie sent him a project two years later, Truffaut just didn't feel at ease: 'Your project about two men living together is certainly very interesting, but not my kind of thing. But the desire to work together is reciprocal, as you know.' He suggested that Dabadie write something for Fanny Ardant, if he was inspired by her different possibilities: romantic like with Resnais, or a Katharine Hepburn heroine as in *Vivement dimanche!*. The film-maker's death would decide differently.

The sociologist's report.

'If we use the construction (or rather the concept) of the book, we'll get something no one has ever seen, a much more original film and one that is no less funny,' Truffaut wrote to Dabadie after reading the first screenplay of *Une belle fille*. The book alternates sessions where Camille tells her life story to the sociologist, who is rapidly captivated; scenes where he questions different people in her group, often coming up with the opposite of what he hoped to find; and chapters devoted to the report, loaded with intellectual and technical terms, that he writes of his meetings with Camille. Truffaut wanted to make this report the key structural element of the film, as Rivette had convinced him to do with Itard's journal in *L'Enfant sauvage*. The sessions with the tape recorder send the story into flashback, and the narrative is then regularly picked up or prolonged by the scenes with Hélène, the sociologist's discreet secretary, by his dictated comments, or by new recordings. It is precisely the tone and vocabulary of the sociologist's report, constantly contrasted with Camille's crudeness, that amused Truffaut. In his first screenplay Dabadie used the sociologist's commentaries less systematically, planning to divide opinions about Camille into scenes between two people (Stanislas, the sociologist, with his lawyer) or three (Stanislas, his lawyer and the secretary). That earned him this request from Truffaut, who felt that he would not have a real comedy unless his two principal characters (and this also applied to those around them) totally believed in what they are saying and doing at every moment: 'We only have to rework the "report" side of the story to make a film that won't present itself as a comedy, but as 100% deadpan.'

The truth of life.

As usual, Truffaut gave Dabadie a copy of the book where he had underlined and circled things that amused and interested him, notably in Camille's stories, the language of which he intended to work with. 'The film also has a linguistic aspect,' he noted, and he would keep insisting on this. '"Be cool", that is perhaps the key to Sam's language, an Americanism in every sentence,' he remarked at the bottom of one page. Throughout the book he was enthusiastic about the idea of the fateful bet and he underlined Camille's statements: 'So it was like, you know, he and I, we had made a bet and Fate would have to say who'd won.' As well as the heroine's frank sexuality and

pretended innocence ('I had a personality, you understand, that boys liked') he pounced on the idea that Camille feels real admiration for those who have succeeded in having their name emblazoned in large letters for all to see: 'Royal [the singer at the Blue Corral, renamed Sam Golden by Truffaut] was the first person I'd known who had his name printed in big letters'. And later, this statement by Camille, which he underlined heavily: 'I have to say I've always had this kind of respect for those who can treat themselves to their name up on a sign. Like, you know, they really know the truth, that kind of thing, right?' A statement lightly reworked ('I've always had a lot of fucking respect for those who can treat themselves to having their name printed on walls: I say to myself, they must know the truth about life... Something like that, right?') which Truffaut would accompany with a close-up prolonged by a light zoom forwards on the face of his actress, underlining this moment when the character says not what she believes or pretends to sincerely believe to be her truth (a truth often heavily refurbished), but what she truly is. Truffaut got some of the film's most priceless lines, the vulgarity of which is cross-bred with involuntarily frankness, from the book. The description of the lawyer: 'He relaxed so much that I was starting to wonder if he'd have the energy to get home.' (In the film we hear it twice: said first by Camille, the line is replayed on the tape-recording that the secretary, Hélène, is listening to, before stopping the recorder in a rage.) Or Camille's self-justifications when she finds herself with four men on her hands: 'I loved them all, I think, for the different qualities each one had.' And these professions of faith: 'I wouldn't have slept with them for no reason. I'm not like that.' Or: 'Me, I tried to be nice to everyone, and that's what turned the thing into a true tragedy.' When he asked Bernadette Lafont to play his heroine, Truffaut knew that he would be able to count on her to go all the way when she said and acted these lines, with sincerity and energy, without any winks or irony – to *become* the character. 'Unconscious tramp,' he defined Camille, 'absolute naturalness and cynicism.' Before deciding definitely on Bernadette Lafont, whom he had thought of immediately on reading the book, he hesitated and briefly considered Claude Jade: 'I'm observing little Jade, but I haven't talked to her about anything, because I think after all that she's a little too young,' he wrote to Dabadie in the course of 1971. Truffaut would have ended up with a different film.

Truffaut planned to add two ideas of his own for the film's ending, which he began by annotating the last pages of the book when the sociologist finds himself in prison: 'Camille, when she visits Stan: "There are two kinds of people, the ones who've known this and the others... Now you're like me." We have to show a) Stan in his cell b) a bit of the corridor and c) a grilled speaking barrier.' Marion says this line about prison to Louis in *La Sirène du Mississippi*, and in *L'Homme qui aimait les femmes* it is the great love, the queen of bad faith played by Nelly Borgeaud, who says it to Bertrand Morane. When Truffaut re-read the book, he began to imagine the final twist of the secretary who faithfully waits for Stanislas, sketched on one of the last pages: '"Thanks to Hélène, I've gotten preferential treatment": TSF Radio plays: "I'll wait for you..."'

Sublimated penis envy.

'This episode is much funnier told than shown... watch out,' Truffaut remarked in the margin of the scene where the pest control officer jumps on Camille after taking her into a house he is about to 'operate on'. Using Camille's tape-recorded story to drive the flashbacks allowed Truffaut to have it both ways: the scene as told with exponential hilarity by Camille ('So he fell on me as if he had two dozen hands... So then and there I said to myself that Fate had sent me a hell of an opportunity, and it was my turn to be full of initiatives') and the scene as shown (Charles Denner as a repressed virgin throwing himself on Camille, his body stiff and frenetic, spasmodically tossing his head). Whether a given scene was funnier told than seen was a question the film-maker often asked. 'The junk-heap croaking: better to show than tell,' he noted in the margin of the screenplay he had got from Dabadie when Camille describes the car breaking down right next to the Colt Saloon. Again, the structure of the film gave him the pleasure of having it both ways: the pleasure of serving, so to speak, a double portion, since he could have both Camille's voice recounting ('We were on the road when all of a sudden it's curtains for the heap of junk') and the image of the car which hiccups, then stops, and out comes Clovis suddenly cast adrift and thinking only of telephoning his mother.

To recover a few additional ideas, Truffaut had passages that were cut from the novel when it was published in France translated. This is where he fished a line out of the sociologist's report – since it was about Camille's banjo ('"possible equation between music and sexuality": funny if put back in the form of dictation by Stan to Hélène') – that would allow him to set off a quarrel between Stanislas and his secretary: 'The suggestive form of the instrument possibly indicates sublimated penis envy.' ('Sublimated penis!' says Hélène, who represents not only the bluestocking secretary with neatly combed hair, but also the voice of common sense. 'You haven't thought that she might just be a tramp?') In these pages recovered from the original novel Truffaut also found the idea of a scene where Stanislas questions Camille's old teacher to learn more about the unhappy youth of his protégée and uncovers a snag: in the teacher's eyes, Camille is an evil demon, beyond saving, with no excuse, and she doesn't have words harsh enough for her. 'I believe in the interest of "fishing out" this formidable scene. Teacher,' enthused Truffaut, who would transpose the scene in the screenplay but finally sacrificed it during editing to preserve the unity of the film. However, he would keep, because they didn't impede the movement of the story, the scenes between Stanislas and an old guard at the prison who comes from the same village as Camille, who salivates at the mention of the young woman ('Little Camille, yum yum yum'). His joyful libidinous appetites put off the sociologist, who never seems to get the answers he expects. Truffaut had the idea for this character when he found a scene between the sociologist and a former schoolmate of Camille's in the cut pages: 'To place these remarks about Camille's infantile sexuality, we can modify the character: both schoolmate and guard at the prison.' As to the process of tightening, Truffaut was always looking for ways to kill two birds with

The pest control officer (Charles Denner) becomes furious when he discovers pornographic magazines displayed on the news-stand.

one stone, which focused the film and permitted him to repeat effects. Here the character who would allow him to create a funny scene where the sociologist hero is confronted by something he doesn't want to hear is at the same time the one we regularly encounter at the entrance to the prison. As usual, Truffaut didn't hesitate to combine characters: 'In my opinion the ten following pages should be deleted despite the quality of the dialogue. Camille's mother performs the same function as Isobel. We have to keep the best lines and give them to Isobel.' Truffaut was perfectly aware that his film depended on the energy and truculence of his main character. After reading the first draft he warned Dabadie: 'All the scenes we keep have to be about Camille: a) as she is; b) as others see her; c) as Stanislas sees her.' Dabadie had in fact written 315 pages and 175 scenes, a script that was much too long and spun out, from which Truffaut would take numerous scenes in order to fuse them. Dabadie started off with the story of Camille's miserable childhood until the moment she escapes from the house of correction. Only then did he show two men arriving at the prison, a lawyer and a sociologist who has already begun, we gather, his research on female criminals. Truffaut restructured all this, starting again from the beginning. Because of his obsession with clarity and his love for grabbing the viewer, he preferred to start the story with a little flashback, even if the procedure seemed dated. (A young woman looks in a library for a thesis on female criminals that has never appeared. What happened a year ago?) He also refused to give up the first meeting between Stanislas and Camille: 'Marchal [the lawyer] explains Camille and introduces Stan.' Recounted instead by Camille and commented on by Stanislas, the future criminal's unhappy childhood takes on its full comic dimension. Truffaut pulled out all the stops, deploying the 'fateful bet' in the first minutes of the film. (She takes away the ladder that leads up to the attic. If the old man notices, she loses and gets a whipping; if the old man falls and breaks his neck, it is Fate that wanted it that way.) And he did not shrink from self-mockery: 'The relationship between papa's accident and what I'm accused of today: no hesitation. If I'd had a happy childhood in a happy home, parents who hugged and all, I wouldn't be here today. And that's what society should be ashamed of, like my lawyer never stops yapping about.'

The tears of Hélène.

The most instructive and amusing part of the process still rested on the suggestions made by his co-writer that Truffaut dismissed out of hand. He flatly refused any buddying up between Stanislas and his secretary. Dabadie had made Hélène a modern young woman of the 1970s with no complexes, who, even if she refuses an invitation to dinner at her employer's (instead of, as Truffaut prefers, timidly proposing one, which Stanislas will refuse), instead asks permission to take a bath! In the draft by Dabadie, who had forgotten about Truffaut's total lack of interest in dinner scenes both in life and in films, Stanislas turns out to be a serious, competent cordon-bleu chef at home. ('He cooks pigeon flambé using a glass of cognac.') Hélène improvises dinners with friends on a bridge table at her place, with sweet corn and chianti, paper plates and coloured candles, to which she invites the sociologist and

the lawyer. Up to a certain point this could have been Claude Sautet's world (although the relationships between the characters, who are too schematic, lack the necessary complexity), but it was not Truffaut's. 'Hélène is a secretary; she should remain a secretary,' the latter dryly noted. He would make Hélène a self-effacing, somewhat old-fashioned character, secretly in love with Stanislas, but her expressions of indignation are without euphemism and stand out all the more for that. ('This girl is a nymphomaniac. She has to have all of them.') Truffaut also rejected scenes where Hélène makes overly direct declarations to Stanislas. He crossed out a scene where she talks to the sociologist about her mother and turns it into a discussion between Hélène and Stanislas where, following the old rule of litotes and inversion, which is as true for Corneille as it is for US comedies, he only indicated Hélène's feelings, classically, through acerbic remarks about the incident of the gloves. Hélène finds the yellow gloves that Camille offers Stanislas at the prison ridiculous – we'll learn later that they're stolen – checking and mating Stanislas when he tries to get away with saying his godmother gave them to him: 'Your godmother is a whore.' Truffaut turned down a scene where Hélène waits in vain for Stanislas at a restaurant and breaks down in tears, proposing something else: 'Hélène (at home) listens six times to a line on the cassette that wounds her, like: "You're cute all dressed up with your tie (or something about the gloves)."' He removed another scene where Hélène waits for Stanislas at the restaurant again, cries when he arrives, tells him she loves him and hands in her notice. Trauffaut's reaction: 'I find Hélène too direct. We (the public) know that she's in love. Stan doesn't realize it.' His Hélène, played by Anne Kreis, a reserved, young unknown 'who had the good idea of sending her photo to Les Films du Carrosse', would finally be more proactive and would have more confidence than the liberated but weepy young woman in the first screenplay. Truffaut clearly wished to use her to re-establish, with respect to Camille's stories and Stanislas's fascination, an external viewpoint that could relay that of the viewer. His intentions were visible in the laconic notes by which he re-built an outline of the structure of the beginning of the film, punctuated by scenes with Hélène: 'story Camille, first flashback, end of flashback, we're at Hélène's'; '11: at Hélène's: first commentary by Hélène on Camille; 2nd flashback: Clovis'; then, further on: '36-37-38: end of flashback… photo shown to Hélène? Back to Hélène, scepticism… After flashback No. 2… citronella, Hélène… until the car break-down…' (The 'citronella' gag – Stanislas wears a new perfume that everyone comments on – would eventually be abandoned.) In defense of the film, Truffaut said that he felt he was as much the exuberant Camille as the awkward sociologist. He was surely all three of the main characters. He thought briefly of playing the sociologist himself and wrote to Jean-Loup Dabadie: 'I am thinking – sit down before you read this – of playing the role myself… I haven't absolutely decided; perhaps another idea will present itself, or I will realize that the screenplay contains many scenes that will be difficult for a non-actor like me to play. I would again be able to call the shots in the role of the investigator; I'm sure of my own impassivity and the contrast that would be created between Bernadette and me, the danger being an eventual attack of realism, or rather of

reality.' Eventually he decided to place in opposition to the well-known faces that people the film, from Guy Marchand to Denner, a face the public didn't know in the role of the sociologist: young André Dussollier, who was just graduating from the conservatory.

Indianapolis and the pest control officer.

The film-maker made short work of another suggestion from Dabadie that they give Sam Golden, the mediocre crooner impeccably played by Guy Marchand, bizarre sexual manias tending to sadomasochism. He puts on black gloves before making love and equips himself with the complete collection (whip, ropes, red scarf, etc. Camille says in comic counterpoint that she was looking for 'warmth and tenderness' from him). This comes back in another scene, where Sam's wife appears suspended from the chandelier by handcuffs, in boots and army shorts… 'On my copy I've removed the whole sadomasochistic sexual aspect of the singer because I feel incapable of making jokes about sexual oddities,' Truffaut responded. 'Hey, all that is disquieting…' He preferred to invent other off-beat elements: the presence among the technicians at the 'saloon' of a deaf-mute electrician in the style of Harpo Marx, who would be the catalyst for the (tragicomic) drama when he explains to Clovis, with gestures, that he has been cuckolded. And the gag of the record with the car races in Indianapolis that Sam Golden plays every time he lays a girl. A repeated gag, used when Sam lays Camille, then re-used as dramatic irony when, conversely, he is sleeping with his wife while Camille shows up on the other side of the door. The gag of the vroom-vrooming record yields one of the most beautiful, hilarious comic twists in the film when Camille comes to pay a quick visit to her singer lover, while Arthur, the pest control officer (Charles Denner), whose little truck she's using as a taxi, is outside waiting for her: Camille disappears into Sam's pad (Truffaut also got rid of the idea that she sometimes joins him at a luxury hotel, concentrating everything in the crummy setting of the roadside bar-nightclub-cabaret), we hear the vroom-vroom of the racetrack starting up, and Denner, on the side of the road, turns his head, looking for where the car sounds are coming from. 'Do you believe in the science of the paranormal?' he asks Camille when she rejoins him, ready to go across town and spend a few minutes in the sofa bed with the lawyer (Claude Brasseur). 'There's a curious acoustic phenomenon here: you hear cars long before they arrive… and long after?'…

'Careful with Arthur,' Truffaut wrote to Dabadie. 'a) not to treat him like an idiot b) not to put him at too much of a disadvantage with respect to Camille c) no slang or familiarity in his language 4) he is pompous, puritanical, moralistic, mystical, passionate, full of "noble feelings."' The film-maker knew that the character of the almost mad virgin pest contol officer – the most excessive of all the gallery of not exactly tragic characters in the film – risked becoming a caricature that could turn against him. That is the tour de force in *Une belle fille comme moi*: it constantly flirts with caricature without ever displaying an ounce of superiority to the characters. With his passion of the job well done, his obsession with exterminating insects ('if the termite lives, the building dies'), Arthur is the culmination,

Happy nights with the Bliss family:
Camille (Bernadette Lafont), Clovis
(Philippe Léotard) and his mother
(Gilberte Géniat).

at once pathetic and comic, of the characters possessed by an *idée fixe*, a brother to *La mariée* who prefigures, in a style taken to extremes, *L'Homme qui aimait les femmes* (where we find Charles Denner again) or Davenne of *La Chambre verte*. (Truffaut thought Denner would have been able to play the role he eventually chose to play himself in that film.)

Truth and lies.

When Dabadie tried offering Truffaut 'a bit of Truffaut', it didn't necessarily work any better. During a visit from Stanislas, Camille asks him to buy her stockings, size three, dusky brown – a private joke Dabadie was making because he knew that Truffaut had given up a scene of a man buying stockings in a lingerie store more than once. But the idea was not picked up in the screenplay reworked by Truffaut and Suzanne Schiffman, the version where he speeded up the story (the screenplay was reduced to 140 scenes) and solidified the principle of the flashbacks from the tape-recorder and the interviews recorded by Stanislas. Truffaut reconstructed the whole ending where Dabadie had combined two suspense curves in alternating montage that start to get mixed up and finally annihilate one another: on the one hand, Camille's attempt to murder two of the men she has on her hands (her husband Clovis and the crooked lawyer), and on the other hand, Stanislas and Hélène's search for the proof of Camille's innocence, which might be contained in a home movie shot the day of the pest control officer's death. 'Disordered chronology: danger,' noted Truffaut, who preferred to separate the two series of events. He decided not to start Stanislas's attempt to clear Camille until after the end of the story she is telling: how Arthur was waiting for her outside the hotel where he had deposited the revived bodies of Clovis and Maître Murène, how he took her to the top of the cathedral to jump off with her, how she succeeded in not jumping off with him. He also wanted the viewer to share Camille's shock when she finds on the hotel bed the two bodies she had left in a far-off house that was about to be fumigated. Dabadie's version gave the surprise away, because we would have seen Arthur coming back to his workplace, finding and reviving the victims well before Camille returned to her hotel. Truffaut went for surprise instead. 'In the novel, very good interruption (because of the woman guard),' he noted on the first screenplay. 'Camille returns home and finds the two guys. (We shouldn't see Arthur revive the two guys.)' He stayed with his heroine, then cut in the image of Arthur finding the bodies in the fumigated house as a flashback when he explains to Camille how he saved the two men while he heads for the cathedral as fast as his old truck can carry them. 'When you write a screenplay, you constantly ask what people believe' was one of the film-maker's leitmotifs. Despite its heavy-handed appearance, which permitted Truffaut to fool his public, the construction of *Une belle fille comme moi*, reworked again in the editing, is very finely developed in its effects on the audience, in Camille's play of lies and truth, and the split between what is said and what we see. Truffaut sometimes changed his mind on how he wanted to play with the viewer. In the screenplay, the final manipulation that sends Stanislas to prison (Camille puts the blame for the murder of her husband on him) is told entirely in flashback,

including all the scenes of the fatal evening. Stanislas, who comes to pick up Camille after her show and takes her home, is finally about to touch her when the husband pops up, etc. While he was editing, Truffaut moved Stanislas's visit to Camille after the show to the narrative present, inflicting a last little bit of suspense – romantic, or rather, sexual – on the viewer: anything could happen. Will Stanislas finally possess Camille? It is when the showgirls descend for the cancan (a fleeting homage to Renoir) that he cuts to a newspaper seller who announces a 'drama of jealousy' and starts another flashback.

While filming from mid-February to mid-April in the Béziers region (Suzanne Schiffman had found an almost perfect location near Lunel for the 'Colt Saloon', and the tourist site mentioned in the screenplay for the pest control officer's suicide became the cathedral of Béziers), Truffaut pushed his effects and never hesitated to radicalize certain details. For the flashback to Camille's youth, he added the idea of the banjo crushed by her alcoholic father. (In the screenplay he smashed the radio). To make the reasons for little Camille's resentment clearer, Truffaut added the kick in the little girl's behind that propels her to the top of a haystack, a trajectory he filmed by accelerating the image in editing for maximum comic effect. ('Camille as a comic martyr,' he had noted on Dabadie's screenplay.) In other scenes, other details reinforce the situations portrayed: Camille, who escapes by climbing over the wall of a Centre for Delinquent Minors, is carrying a pair of high heels in a knotted handkerchief that she puts on at the side of the road. Bernadette Lafont/Camille makes obscene gestures at the first cars that don't pick her up, setting the tone for her character. Excusing herself during the first interview to go to pee, she asks Stanislas to hold her cigarette, and the young sociologist holds it pointing up, sitting there like an idiot and straight as a judge, until Camille returns, all the while recording his first commentary. Truffaut developed Stanislas's conversation with the old guard, to whom he gave rather funny extra dialogue about having affection for Camille 'like you have affection for the gas company or the electric company – you wouldn't want to do without.' And he gave these additional lines, as chilling as they are funny, to the pest control officer when he describes his job while showing Camille the first house he is going to fumigate: 'There are little boys who don't know what they want to do when they grow up. But I, at the age of nine, wanted to be an exterminator and that's what I've become.' Truffaut then did a little parody of Hitchcock, filming the truck's arrival at the house to be fumigated as in *Rebecca*, while the house, which becomes the scene of the attempted murder, is like the set full of stuffed animals in *The Man Who Knew Too Much*. (In the screenplay he planned for the ground floor of the house to be like 'a kind of naturalist's warehouse': 'We see stuffed animals with menacing fangs and brilliant eyes; we also see birds and a serpent on the branch of a fake tree.') Between parody and thriller, real suspense and pure insanity, the film is an odd mélange with which Truffaut had a great deal of fun. One can imagine the childish pleasure he took in dreaming up the fake ads Camille is watching, fascinated, on television (we hear the sound but don't see the image): 'My boss bores [*rase*] me, my wife bores me, my kids bore me, but no one shaves

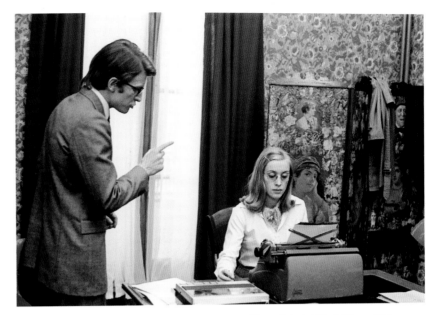

The sociologist (André Dussollier) and his secretary (Anne Kreis).

[*rase*] me like Shave-to-Death, the queen of shaving creams'... Or cutting in under Camille's statement that 'I took him goodies' a shot of Clovis (Philippe Léotard) in the hospital playing with a little doll that you only have to squeeze for it to display its plastic breasts. The scenes in the Bliss garage were filmed in an old brewery where the editing room is also set up in a corner (in the kitchen of the old dining room). The layout of the spaces allowed Truffaut a *mise-en-scène* that was not without a certain theatricality, appropriate to the parodic representation of the relationship between Clovis and his mother. He filmed the family dinners through the window of the kitchen and dollied in long-shot to the garage where Camille is chomping at the bit in the car, or returned from the back of the garage to the window of the kitchen when Camille bursts into the 'casbah' claiming to be pregnant. Sometimes Truffaut developed a joke through the *mise-en-scène* itself: when Clovis flips over and Camille thinks and hopes he's dead ('let the widow through,' she cries to the rubber-neckers), he conceived a grotesque tableau in a single shot. As Clovis flees from the Colt Saloon whose sign he just blew up with rifle blasts, and even as we hear the sounds of the accident, the camera goes ahead of the little crowd that runs after him, pulls back to discover a wrecked car whose driver, overcome, is already leaning on the door, then pulls back further to discover Clovis's body on the ground surrounded by curious bystanders. Truffaut was enjoying himself. As he did each time he wanted to shoot fast and didn't need a very polished image (for *Une belle fille comme moi* he was really looking for the opposite), he got Pierre-William Glenn rather than Nestor Almendros, but expected the same ability to 'play pinball' with the camera without ever being ostentatious from his crew.

Accelerations.

While shooting, while editing, Truffaut speeded his film up more. He cut the rather funny encounter with Camille's old teacher, who describes her to Stanislas as a rebellious monster and a package of nitroglycerine, passing directly from Hélène's attacks to a shot where we see Stanislas buy, as if in the spirit of contradiction, a loud tie. He also eliminated a scene where Stanislas is supposed to visit old Isobel Bliss. (He had nonetheless annotated the first draft with this promising phrase: 'In this scene, we should get the impression that Isobel is drunk and that Stan doesn't realize it. He speaks to her as if she were normal.') Old Isobel takes him for Camille's pimp, then goes down to the cellar and never comes back. Stanislas waits for her in vain and finally leaves, without realizing, as the viewer would have been led to understand, that the trap set up by Camille has just worked and that the old lady has succumbed to it during his visit. Truffaut substituted for this idea, which was perhaps a little complicated, Stanislas's visit to Sam Golden, where the repressed sociologist can't keep up, originally planned in the screenplay for near the end. The scene had been placed during the search for the amateur film-maker, when Stanislas, despairing of ever finding him, wanted to question Sam in the hope of finding another solution. Hélène came looking for him at the Colt Saloon and signalled frantically to him from the door because she had just found a trace of the amateur cameraman. This unexplained loose end remains at the end of the scene (Hélène is theoretically being rather chilly with Stanislas at the moment to which the scene is moved), but we never question it for a second, particularly when Hélène's appearance provokes this excellent comment by Sam Golden to Stanislas: 'That your little cupcake who just showed up?'

Even though he had succeeded in obtaining a very rapid delivery from the actors, in particular Bernadette Lafont, Truffaut accelerated their speech even more while editing. 'This was the big period for quoting Capra,' recalls Martine Barraqué. '"It can be faster," he said. As soon as there was a silence, I had to cut.' Assistant at the time to Yann Dedet, she remembers rough-cut screenings where Truffaut – unusually for him – exclaimed with surprise and burst out laughing. Bernadette's vulgarity and crudeness as Camille made him laugh; he made himself blush and laugh, almost astonished at what he had dared to do. 'I hope to show myself to you as I was before, more joyful,' Truffaut wrote to Dabadie after he finished editing *Les Deux Anglaises*. That is what the filming of *Une belle fille comme moi* helped him to become again, at least while he was working. During the Béziers shoot, renting a big apartment in town allowed him to invite the actors who were arriving on the set to dinners where Claude Brasseur, Charles Denner and Truffaut told one funny story after another. The shoot was not without lots of laughs. Martine Barraqué remembers in particular that during the scene at the Colt Saloon when Sam Golden's wife kicks Camille out of his bed, Guy Marchand, Bernadette Lafont and Danièle Girard, the actress playing florence, the wife, were doubled over with laughter after each take. It was a huge compliment when Truffaut said of Danièle Girard, to whom he had given the small role of the waitress at the bistro in the courtyard who stalks Antoine Doinel ('You, I want, and I'm going to get you'), that she 'managed to squeeze three pages of dialogue into 68 seconds'.

One of the things that no doubt amused Truffaut from the moment he discovered Farrell's novel is the constant play with language, and the possibility of making a film where each character has a singular and often colourful way of talking – where depression, for example, is pronounced 'brekdone'. (Bernadette Lafont, deliciously, said 'brekdoune': 'You're not having a brekdoune on me are you honey?') Hence the film-maker's worries about foreign screenings. To a Danish colleague, whom he was counting on to welcome the film to Copenhagen, Truffaut wrote in 1972: 'Let me draw your attention to the importance of subtitles for this film where the dialogue is quite special: it's almost never informational dialogue, but in reality a form of slang that's both very modern and very poetic, for which it is necessary to find the equivalent in each language, perhaps by getting help from writers who habitually translate American novels like those of Charles Williams. I know that this is the business of the film's distributor, but I still am asking you to use your influence to verify that the subtitling has been done well; without that, the film risks losing two-thirds of its comic impact.' Truffaut had scripted and portrayed this uniqueness of language in the film itself, when Stanislas shows Camille the proofs of his book.

Camille is surprised when she reads it: '"That bastard Clovis, I knew damn well he wanted to sing Ramona to me some more, so I ran and locked myself in the can, but then, bing, he grabbed me in the hall and threw me in the sack" – Oh, that's bad writing, I thought you were a professor… Didn't you correct anything?' Stanislas answers: 'But Camille, it's your language; it's yours. It's as personal to you as your fingerprints.'

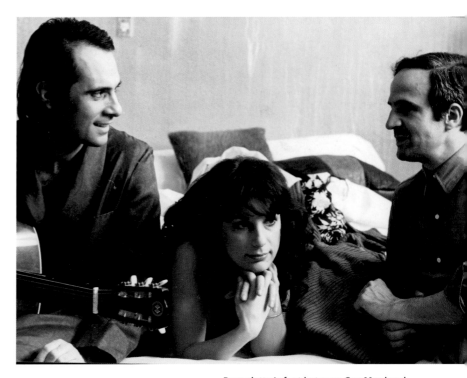

Bernadette Lafont between Guy Marchand (the singer Sam Golden) and François Truffaut.

La Nuit américaine

La Nuit américaine (1973)
Day for Night

LUCIENNE
(19 ans) s'était
enfuie avec son
beau-père
(50 ans)
55 jours après
son mariage

CINQUANTE-CINQ jours après son mariage, Jacques, vingt-deux ans, perdit en même temps Lucienne, sa jeune femme, dix-neuf ans, et son père, cinquante ans. Ce dernier et sa bru n'avaient pas succombé à un accident, mais à un attrait réciproque aussi fougueux que soudain. Ils s'étaient enfuis ensemble...
C'était une nouvelle conséquence de la cohabitation. Le jeune ménage, en effet, s'était installé chez les parents de Jacques. Lucienne et beau-papa s'étaient tout de suite compris...
Malgré leur différence d'âge, 31 ans, ils abandonnèrent tout : sa femme, pour l'un ; son mari, pour l'autre, et, dans l'espoir de ne pas être retrouvés, ils menèrent quelque temps une existence vagabonde qui les conduisit de camping en camping.

Surpris

Mais le hasard était contre eux, en l'occurrence des gens de connaissance qui, campant un jour sur le même terrain, les surprirent dans une attitude qui ne laissait aucun doute sur la nature et l'intimité de leurs relations.
Jacques, aussitôt prévenu, ainsi que sa mère, perdit les quelques illusions auxquelles il se raccrochait encore. Il chargea son avocat de déposer une plainte en adultère.
Les deux amants viennent d'être retrouvés dans un hôtel parisien. Ils ont été inculpés. Cela donnera prochainement, en correctionnelle, un curieux quadrille : le fils contre le père, son rival, Jacques contre Lucienne ; la belle-mère trompée contre son mari volage et la même belle-mère contre la bru qui lui a pris son mari... Le jeune mari a, en outre, intenté une action en désaveu de paternité. Il y a un an, Lucienne a mis un petit garçon au monde.

'Will you do more films about love?' – 'Yes. For example, I'm interested in the story of the young Englishwoman who married a young man her own age and then ran away with her father-in-law, with whom she fell in love at first sight.' That was how Truffaut answered a journalist who was interviewing him for the opening of *La Peau douce* in the provinces. As was his custom whenever a subject interested him, Trufaut cut out and filed the newspaper article about this romantic story and remembered it years later when he started playing with the idea of shooting a film about the shooting of a film. Nor did he consider it a silly story. Apart from the confusion of identities between father and son, the plot is not that different from that of *La Femme d'à côté*, and he could just as well have made it into a tragedy about love at first sight and adultery. The story has the advantage of being simple enough to be easily summarized in a few lines, and that was why Truffaut decided to use it when he began writing *Je vous présente Lucie*, the working title of *La Nuit américaine*.

'I wrote *La Nuit américaine* with Jean-Louis Richard in August 1971, and I started taking notes for this film after shooting *La Sirène* in 1968,' he specified in a letter to his New York critic Annette Insdorf in 1981. 'As you can see, I'm a bit obsessive when it comes to dates.' In July 1971 Truffaut decided to edit *Les Deux Anglaises* at the Victorine Studios near Nîce to be near his daughters, who were on holiday in the area. Walking every morning across a grand abandoned set of a Parisian square, built for a US adaptation of *The Madwoman of Chaillot*, revived his desire to make a film about cinema as soon as possible. He took endless notes while Yann Dedet and Martine Barraqué edited *Les Deux Anglaises*, and in August settled down to writing the screenplay with Jean-Louis Richard in a rented house in Antibes. The subject was not unanimously approved, and the first screenplay was turned down by United Artists, even though Truffaut had already coproduced four films with them, from *La mariée* to *L'Enfant sauvage*. At the beginning of December 1971 he sent the screenplay to Warner Bros, which was looking for French projects and committed to the film, despite the commercial failure of *Les Deux Anglaises*, which had just opened in November. The film-maker was later convinced that if the film had not come after two successive failures – *Une belle fille comme moi* opened ten days before the start of production on *La Nuit américaine* – he would have got two extra weeks of shooting from Warner Bros. 'For me, *La Nuit américaine* was shot too fast,' he would say, suffering from not having been able to perfect the scenes. When the film won the Oscar for Best Foreign Film in 1973, Warners' French subsidiary wanted another project from Truffaut right away but refused *Adèle H*, which was accepted some time later by United Artists, who hadn't wanted *La Nuit américaine*.

'I gathered up all of myself and was reconciled to it in *La Nuit américaine*, which is quite simply about my reason for living,' Truffaut wrote to the critic Jean-Louis Bory. The film-to-be presents itself first as a living mass of random notes. On loose pages, Truffaut collected memories of shoots, elements of his private life, Hollywood anecdotes, sketchy outlines of the main characters. At first he sketched

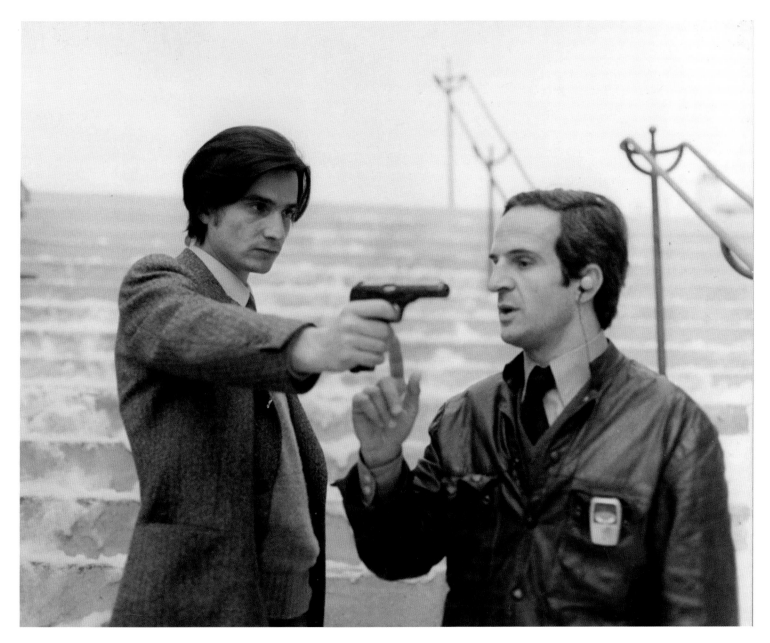

an outline of a director rather removed from himself: 'He started as an actor; he gave it up because he didn't think he was good enough. He has children just about everywhere (we'll say little about his past); in the cinema where rushes are shown we see photos of a film where he was very young.' He also sketched a portrait of the young actor, a part written for Jean-Pierre Léaud from the start, that was rather removed from either Léaud or Antoine Doinel: 'We learn that he started acting by playing a jockey when he was a child, then branched out at one point to become a mime; he has agreed to return to the screen out of admiration for the actor who will play his father, Alexandre.' Truffaut finally gave up the temptation to cover the traces of autobiography, leaving the viewer free to imagine that he could be identified with Ferrand and to bring memories of Jean-Pierre Léaud as Antoine Doinel to the character of Alphonse. Giving Ferrand a hearing-aid that serves as a form of protection for him is also a kind of private joke, since Truffaut himself had an ear damaged by gunfire during training exercises in Germany when he was in the Army.

First notes.

Truffaut jotted down several ingredients for the film right at the beginning. It was clear that the shoot was to involve a series of snags (lots of headaches, lots of problems), but there was already a last line expressing reconciliation ('at the end: we hope the public will take as much pleasure in seeing this film as we have in making it'). He noted how every actor tells the story from an egocentric angle: 'At the beginning each one explains his role: it's the story of a woman who...; of a man who...; of a young man who...' He planned that the actress would refuse to work one day ('lunch hour', a rather enigmatic allusion to a personal memory – could it be from the shooting of *Jules et Jim*?), and that she would spend 'a night with Jean-Pierre helping him, holding his hand'. The scene of the caprice was also indicated under the laconic title of 'slab of butter'. The actress was often named Catherine or Cathe in his first notes, as if Truffaut were thinking of Catherine Deneuve for the role. In fact the character is a synthesis of Catherine Deneuve and Jeanne Moreau (whom he was thinking of for the scene where the director steals lines

Ferrand (François Truffaut) shows Alphonse (Jean-Pierre Léaud) how to handle the revolver which he will later fire at Alexandre's double.

Handwritten notes on characters:

le père :
le "filleul"
la mère :
le fils :
Lucie – Julie
le producteur :
la secrétaire :

19. MAISON DES PARENTS . EXT. JOUR

En fin de tournage, le Docteur Nelson vient chercher Julie
et pendant qu'elle se change, il parle avec Ferrand. Sujet
de conversation : Julie, sa santé, son émotivité.

NELSON

Elle était tellement heureuse quand elle

a reçu cette proposition de tourner en

France. Vous savez que, quand elle était

adolescente elle venait tous les ans pas-

ser ses vacances. Je savais que ce serait

très bon pour son équilibre de se retrouver

ici, sur la Côte d'Azur…

— Ecoute-moi Alphonse, rentre dans la chambre, et regarde un peu ton scénario et couche-toi... c'est le film qui compte, tu comprends, tu es un très bon acteur, le travail marche bien; la vie privée c'est la vie privée, partout elle est boiteuse pour tout le monde;

les films sont plus harmonieux que la vie; le film le plus artificiel donne une meilleure idée du déroulement de la vie que la vie elle même...

Toi et moi, on est fait pour ça, pour être heureux à travers le cinéma... salut... je compte sur toi...

il n'y a pas d'embouteillage dans les films, pas de temps mort... ça ressemble un tissu dans la nuit

avant dernier
1/rire à travers larmes... à propos motte...

Chercher l'attaque:
Elle s'excuse du retard qu'elle crée... 1er professionnel... 1er correct...
il le rassure... on a le temps, on va changer d'ambiance... combien 107 confiance
tissu...

63. LOGE JULIE. INT. JOUR

C'est donc Ferrand qui pénètre dans la loge de Julie qui, en définitive, regarde à peine la motte de beurre; elle a fini de pleurer et elle se confie à Ferrand; elle lui raconte ~~comment elle a voulu aider Alphonse,~~ combien comment celui-ci s'est comporté en téléphonant au Docteur Nelson, et elle ajoute que même si son mari lui pardonne, elle ne pourra pas oublier ce qui s'est passé son mari a été formidable pour elle, deux ans auparavant, lorsqu'elle a "craqué", mais puisqu'il a fait d'elle une femme "responsable", elle se sent assez forte pour vivre seule... Elle ajoute qu'elle abandonne le cinéma... et que de toute façon... la vie est dégoûtante.

Rimmel... il lui coule avec son mouchoir... amusement à propos de la motte.

*Elle lui a fait quitter sa femme et ses enfants, sa vie qui était "faite" depuis 20 ans; il l'a reconstruit... et maintenant il divorce...
(attitude protective)... impression d'un gachi...*

"pour moi, il a quitté..."

Ferrand... il comprendra...
Elle..... même si... mais je ne pourrai pas oublier...

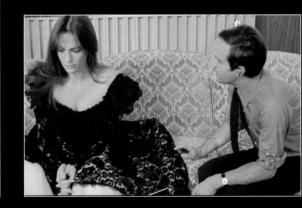

from her to be inserted in the new dialogue for the masquerade scene), and probably Françoise Dorléac as well (in *La Nuit américaine* the scene with the kitten makes another appearance, the original of which is in *La Peau douce*). As the director underlined by casting Jacqueline Bisset in the role, the character is also a synthesis of the English actresses Truffaut had worked with – Kika Markham and Stacey Tendeter, or Julie Christie, whom the completion bond company initially refused to insure for *Fahrenheit 451*. He included a version of that situation when Julie Baker arrives to shoot *Je vous présente Pamela*, the title of the film within the film. The insurance problem was also a memory linked to Charles Denner, who was coming out of a depression at the time of filming *La mariée était en noir*. Truffaut alluded to that in an addition he made to one of the screenplays for a scene where we first see Julie's dressing room: 'It's here that we can bring up Julie's depressive past (worries of Bertrand [the producer] as for Denner: didn't she leave a film that was shooting? etc.).'

The first notes suggested the possibility of an affair between the actress and the director: 'She doesn't want to get involved with the director because reputation, etc. She gives in… She breaks up with her husband… He (the director) hides or sulks at her.' Truffaut abandoned this idea when he decided that the actress would console the unhappy young actor by sleeping with him. (Initially, there was just the idea that she comforts him platonically.) In this respect he also permitted himself to stray from his own experiences, something Jean-Luc Godard would later reproach him for, along with many other violent criticisms. ('One asks oneself why the only one who doesn't screw in *La Nuit américaine* is the director.') When the film opened, Truffaut said in almost every interview that he had definitely not tried to tell the whole truth about making a film, but only true things…

Right from the start, Truffaut planned to introduce the theme of death. 'There has to be a death during the film.' And further on, among other notes, he specified that the older actor 'knows all the tricks: he has died 70 times in films'. Even when muted, suffering was not absent. Truffaut imagined that the actress playing the mother is upset because her son has polio. He also planned a scene where she couldn't remember her lines: 'A single sequence shot with dialogue everywhere + closet.' And he started to outline the problems his young actor has with his girlfriend, who has managed to get hired as assistant script girl on the shoot: 'The script girl intern who leaves with the stunt man and doesn't know what she wants (she says she'd have preferred an editing internship: bad faith').'

There were also some ideas Truffaut preferred to put aside, probably because they sounded too 'inside,' were less immediately entertaining, or were less easy to explain to the audience. For example, the director asks his script supervisor and assistant to only criticize things that can be improved – a trait directly inspired by the role of indispensable facilitator that Suzanne Schiffman performed for Truffaut (as Truffaut had specified while making *Fahrenheit 451*: 'If an actor has an ugly face, don't tell me he has an ugly face; say his right profile is better'). Another trait Truffaut took from his own way of working

was to always have an eye on the next film. 'What are you doing?' asks the older actress. 'I bet you're already thinking about the next film.' Overly subtle allusions to the work of extras: 'You'll tell the production manager that I'm a "speaker" (a gardener?)', or 'I had a close-up: that's as if I had spoken a line.' A few years later, Truffaut would cut a line from *Le Dernier Métro* where Germaine, the dresser, describes the tricks of her husband, who is a theatre extra… Among the technical problems or other difficulties of filming, Truffaut chose the simplest and most amusing to tell (the scene with the cat, the fire that smokes up the set), forgoing those that were too specialized ('The shoot is stopped because the white facade [of the house] is too bright: they have to go looking for green plants'). He also dropped ideas aimed at aficionados rather than a general audience: 'Alexandre points out to Julie and Severine that each shoot reaches a sort of turning point of fatigue toward the sixth week, just when you've got to the last third of the film.' He also skipped a couple of jibes – 'jokes about Braunberger', a story of undated cheques – as well as recollections of overheard lines in the form of corrosive maxims: 'Those who "were promising" when they were young drink to forget that they haven't fulfilled their promise', or 'He takes drugs because it's à la mode. If it was à la mode to eat shit, he'd eat it…'

The actors.

It is clear from these early notes that Truffaut initially expected to have an almost totally French cast: the pages are studded with lists of many of his favourites actors, not including Jean-Pierre Léaud, who was planned from the start. For the father or the director, a part Truffaut was not sure he would play himself: Michel Bouquet, Charles Denner, Michael Lonsdale, Samy Frey, Claude Brasseur, Michel Subor (the voice-over in *Jules et Jim*), Henri Serre, Daniel Boulanger, Jean Servais. Marie Dubois, Monique Mélinand or Claire Maurier in the role of the actress playing the mother, or 'the Italian Sylvana', Serge Rousseau for the star's husband, Danielle Girard (who played Guy Marchand's wife in *Une belle fille comme moi*) for the script girl, Jean-Claude Brialy (in passing), Georges Flamant (René's father in *Les Quatre Cents Coups*) as the owner of a villa for rent, Harry Max… It was only later that Truffaut decided to give his film within the film, and *La Nuit américaine*, an international flavour. Valentina Cortese and Jean-Pierre Aumont would bring an international dimension and the prestige of their Hollywood past. Played by Jean-Pierre Aumont, who had just published a book of memoirs, Alexandre would be the character who passed on cinema's history, a role Truffaut wanted to relieve the character of the director of. Truffaut tried to get all of cinema into his film: Jacqueline Bisset, an English actress and the star of *Bullitt* (by Peter Yates), brought the allure of present-day Hollywood; Jean-Pierre Léaud and Dani represented intimate French-style production; and young actors, then unknown, played some of the technicians: Nathalie Baye (the script girl) and Bernard Menez (the prop man). Other technicians were played by the actual technicians of the film, with some jokes and combinations: Walter Bal, Truffaut's operator, played the cameraman of *Je vous présente Pamela* (with his arm in a sling, the result of a motorcycle accident he

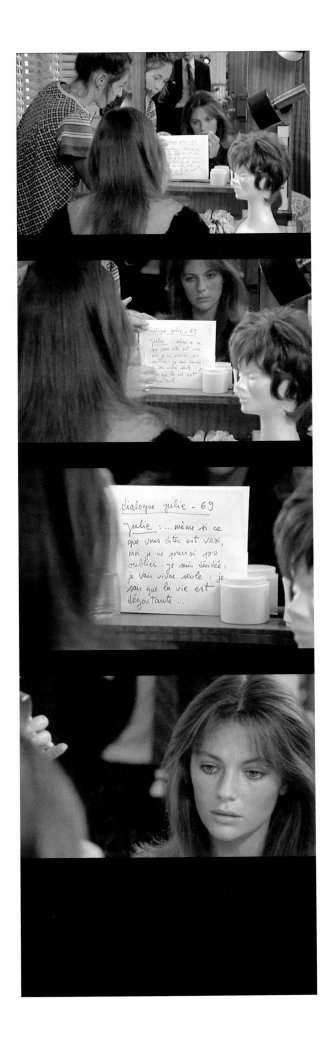

miraculously survived not long before the shoot). The name 'Walter William' appears on the clapperboard of the film within the film, a blend of Bal's name and that of Pierre-William Glenn, who didn't appear on camera. Marcel Berbert didn't play himself but settled for playing the insurance man with Graham Greene at his side (the writer, an admirer of Truffaut's, lived in the area and asked to be in the film, although the film-maker was not told about this in advance). Instead Jean Champion played an exceptionally faithful producer.

Direction of actors.

'No inappropriate sentimentality.' During the credit sequence, we hear Georges Delerue give this direction to his musicians. When Ferrand, the director of the film within the film, directs the scene in the kitchen, a scene where the characters declare their love, he asks the actors to play it in an unsentimental way, to be a bit savage, a bit hard, almost violent. At various points in these first treatments, Truffaut recalled one or two of his 'tricks' for directing actors. The first scene of the shoot is supposed to be a scene between Séverine and Alphonse (one we finally see in the form of rushes). The rehearsal is bad, the tone is wrong and the dialogue sounds false; the director stops the rehearsal and huddles in a corner with the two actors. 'He suggests that they play the scene another way, with no external violence, as if the situation were almost anodyne. They all carry on in whispers and do not seem bothered by the noise and the comings and goings of the crew.' These very pragmatic directions came from a director who detested being asked psychological questions like 'What am I thinking about when I say "Blahblahblah"?' One of the first versions of the screenplay (which would give the film its lovely fast montage sequence) proposed a description of his work with the actors on the precision of gestures, which was a synthesis of several shoots: 'For instance Jérôme [the name of the director] interrupts a take with Julie because she has her head cocked. At another point he shows her how to arrange her fingers on a dark background rather than clenching them. At another point he has her say certain lines while lowering her voice. He indicates different directions for her to look, and at the end of this sequence we return to the present, probably shooting in broad daylight.' Questioned years later about her work with Truffaut (for *Globe-Hebdo*, 1993), Jacqueline Bisset remembered clean, stylized direction that was always a function of the result he sought to achieve in the image: '[He taught me] that it wasn't just about reality. He encouraged me to have certain gestures, certain off-screen looks, that weren't "logical" or "realistic." At first I was troubled, then I realized that on screen these attitudes accentuated my character's mystery.'

The job of construction.

One of Truffaut's preoccupations in writing, then filming, *La Nuit américaine* was to avoid any possible confusion in the audience's mind between the 'real life' of the shoot and the world of the fictional film. Hence his choice of a story that was simple to tell and more dramatic than the real shoot, and his frequent allusions, in order to separate it from the realistic world, to a key scene called the masquerade scene, which also allowed him to show a few

elements involved in shooting a period film (the trick of the candle that illuminates the actress's face thanks to a hidden light bulb and wire, like the candles devised by Nestor Almendros for *L'Enfant sauvage* and *Les Deux Anglaises*). Hence the decision to film on sets at Victorine, which allowed him to distinguish the real from the false and ensure a clear narration. 'I want us to know in every shot whether or not we are in the fiction, the film within the film,' he specified to Claude de Givray a little before the start of filming. The only big piece of trickery is the first shot of the film, where Truffaut makes the viewers believe they are watching a real scene before revealing the existence of the set and the presence of the camera. Between fiction scenes and scenes of filming, writing the screenplay was an on-going and difficult game of building blocks. Truffaut made lists, and Jean-Pierre Richard has described how they ended up laying out a big roll of paper on the table to write in scenes: 'When we had an idea, our problem was incorporating it in this or that moment of the film, and then we'd write it into the place we chose on the big roll of paper. We had an almost graphic vision of the film, a scheme from which we could escape, but which enabled us to maintain the rhythm.' Before building a trajectory, Truffaut outlined an attempt at construction broken into days, which he tried to punctuate with strong elements: the idea of delaying the arrival of the star, who is the only one who can't be there the first day; 'the father at the airport' for the end of the second day of filming, with the mystery of the character; 'airport: arrival star' (after the slip-up at the lab that means they have to retake the scene of the slap) to close the third day. And for the fourth, this note: 'something intriguing to be found', which Truffaut completed with a 'presentation of Sandra [Alexandra Stewart]: problem, refusal to film in a bathing suit, pregnant, discussion'. The fifth day would end with the arrival of the 'beautiful boy': 'Airport. The beautiful Christian.' Truffaut wanted to give the character of Alexandre, who 'we learn indirectly has started the process for adopting his protégé', an element taken from Cocteau. As he would do more pointedly in *Le Dernier Métro*, Truffaut was careful to develop each character's thread by giving each one a secret, more or less serious or frivolous.

Scenes were passed from one character to another. Initially it was Séverine who has the idea of bringing Julie's husband, Dr Nelson, back to her when the actress, wounded by Alphonse's betrayal, takes her into her confidence; then it was the pregnant actress, Stacey, who has the same name as one of the actresses in *Les Deux Anglaises* (the one who played Muriel, who so wanted to have Claude's child). The scene where Joelle, the script supervisor, was supposed to see Liliane (Alphonse's girlfriend) leaving with the stunt man was given to Julie Baker, the star, thereby laying the groundwork for Julie's concern for Alphonse, which leads her to spend the night with him. The idea of having Alphonse discover that Liliane has run off at the moment when everyone is gathered for the traditional cast and crew photo appeared in a later version of the script – originally Alphonse was supposed to find out while filming a scene with Julie. He would have fled at that moment, forcing the director to

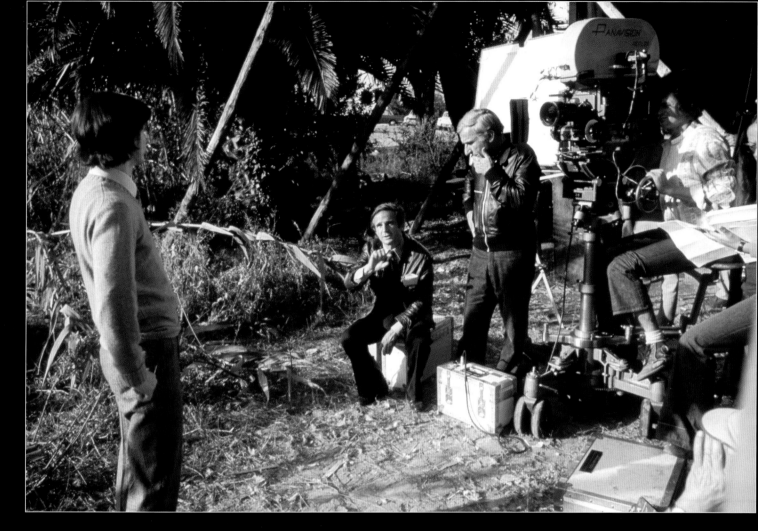

Above: Filming, not of the-film-within-the-film, but of *La Nuit américaine*…

Right: A list of actors drawn up at the start of the writing process.

Left: Notes taken during filming. A list of all the characters who kiss during the film, and a line spoken near the end by the production manager's jealous wife: 'What is this profession where everyone kisses everyone?'

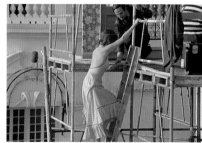
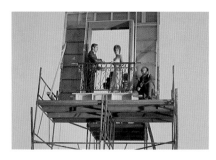
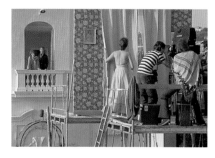
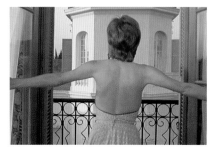
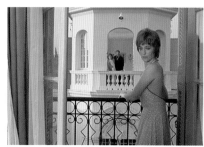

The set and what it conceals.

modify his plans in order to 'save the shot', an idea that Truffaut transferred to another scene: the one using the façade of the apartment next door constructed on a scaffold, where he would get around the fact that Alphonse is missing by having Julie say that her young husband is sleeping. By delaying Alphonse's painful discovery until the moment of the cast and crew photo, Truffaut strengthened the drama and slipped in an old theme: starting with the image of the pin-up that so unfortunately lands in the hands of Antoine Doinel in *Les Quatre Cents Coups*, photographs, when they aren't downright ominous, rarely bring Truffaut's characters good luck.

Through the accelerator.

Having rapidly filmed a great amount between the end of September and mid-November 1972, Truffaut found himself with a rough-cut that was too long, much longer than two hours, and lacking in unity. Because he could be a little shy about talking about cinema, Truffaut had a tendency, as his editor Yann Dedet recalls, to 'put everything through the accelerator' and made numerous cuts. Dedet remembers an agonizing editing period after a shoot that had been experienced as very relaxed by the crew, if not by the film-maker himself. Truffaut had doubts, wondered about the interest of the film within the film, was afraid of being boring, of it being too repetitive or narcissistic, too shut up in the world of cinema. His passionate need to tighten the film up led Jean-Francois Stévenin to say that *La Nuit américaine* resembles an animated cartoon, as fast as a Tex Avery. Truffaut resolved to remove several big scenes, like one told in several stages that features a technician, which he had wanted to include from the very beginning of the writing process. A technician starts telling a story on the set that gets everyone's attention but stops when the director arrives. ('Jérôme is fooling around; when I arrive he stops talking.') Jérôme describes how once, when he was trying his luck in the city, he met a woman alone on a bench who readily agreed to chat with him before admitting that she had just swallowed a bottle of barbiturates. 'Jérôme tells the story with good humour and no sense of its cruelty; moreover he's rather proud because he called an ambulance, so that it's thanks to him the woman's life was saved. We see that this incident made a big impression on Jérôme.' Truffaut had planned to show the director finding a way to incorporate the story in the screenplay of the film he is shooting, giving Séverine the role of the woman on the bench, and then would have filmed a scene of rushes where we re-see the scene while the technician reacts by indicating that it didn't really happen like that. Truffaut decided to get rid of the whole thing, just as he finally decided to cut a scene that was actually very good and very funny (according to Yann Dedet, who regretted this cut, the last one made before mixing) where Alphonse/Jean-Pierre Léaud and the prop man played by Bernard Menez compare jobs. They have opposite points of view. 'It's thanks to me each morning that the world exists,' brags the prop man, while Alphonse responds that for him, real life comes between 'Rolling' and 'Cut'. Truffaut feared losing the audience by spreading things too thin in the seventh or eighth reel, in the zone he often designated as the dangerous reels, just before the lead-up to the denouement.

Before the film was screened out of competition at the
Cannes film festival, Truffaut warned the actors who
appeared in the cut scenes, knowing that they would all
be disappointed. He wrote to Jean-Pierre Aumont at the
beginning of May 1973: 'I understand your regret over
the scene where Alexandre's car leaves, but you will not be
surprised if I tell you that Jean Champion is inconsolable
over the disappearance of the scene he improvised with
the journalist Henri Chapier during the cocktail party
sequence, while Bernard Ménez misses his scene in the
prop department with Jean-Pierre Léaud, and our dear
Valentina will perhaps be saddened not to see her interview,
etc. etc. I had to deliver a normal-sized film to Warner Bros,
and that took sacrifices. To come back to the shot of the
car, it had the misfortune of taking place outside in the
sun, and of therefore contrasting with the homogeneity
of all the episodes of the film taken in corridors, offices,
dressing rooms and on the soundstage. From a dramatic
point of view, it interrupted the suspense: Will Julie agree
to return to work? Will Alphonse be found? Will Dr Nelson
resolve the situation? This shot of the car would have
become significant retrospectively, so it would have been
interesting to viewers who watch films again. The fact is
that many things in *La Nuit américaine* reveal their real
meaning only when re-seen, and that's a bit of a danger
for all my films, because most people only see them once.'

Filming *La Nuit américaine*.

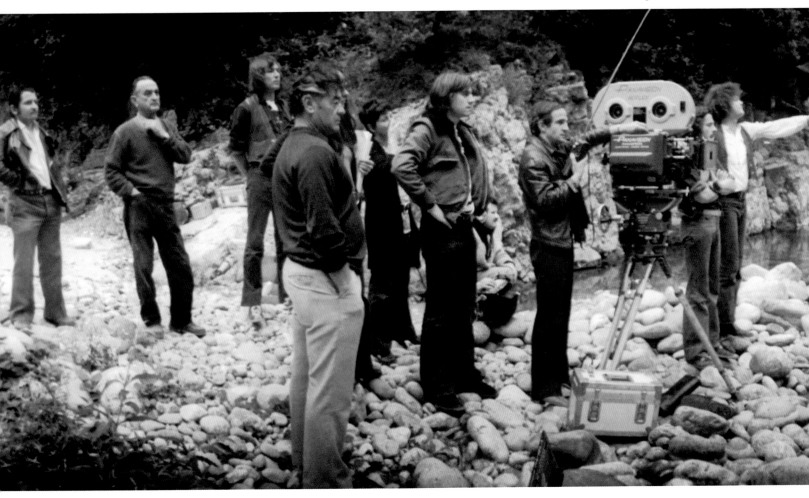

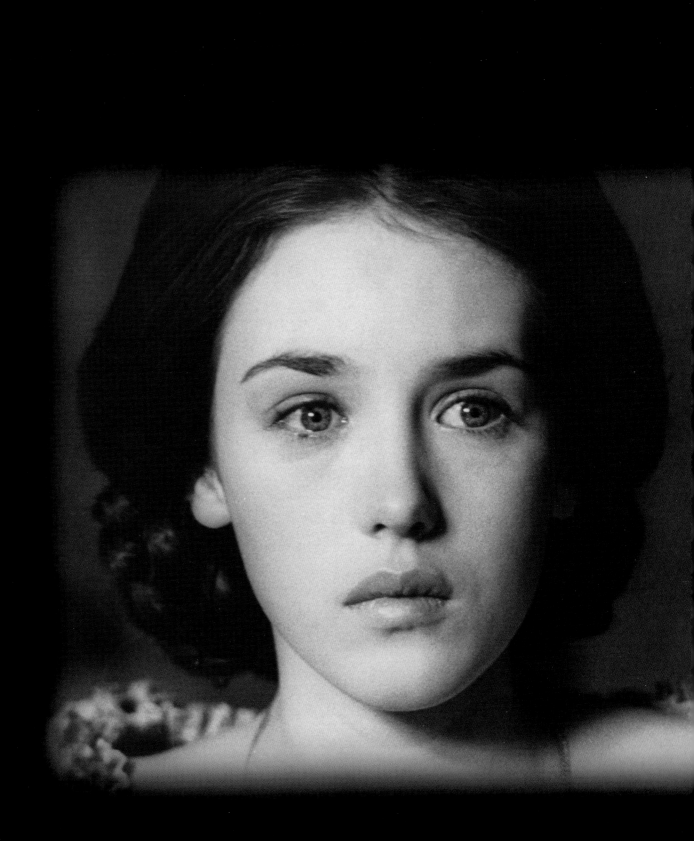

L'Histoire d'Adèle H (1975)
The Story of Adèle H

Previous pages: Isabelle Adjani.

Portrait of Adèle Hugo done by her mother, Adèle: 'She had no first name of her own, and her father's name crushed her.'

'In interviews and in the publicity material, we should avoid references to Victor Hugo, because they put the film in a scholarly, didactic niche and could drive the public away. For the same reasons, we should avoid references to madness: *L'Histoire d'Adèle H* is not a clinical case study. The best angle for presenting the film is that of passion, a story about absolute love.'

Always very careful about how each of his films was going to be sold to the public, Truffaut sent this 'note about the publicity for *Adèle*' to his press officer, Christine Brierre, and to Jean Nachbaur, his contact at United Artists, in September 1975, a month before the film was set to open in Paris (8 October 1975). His refusal to exploit his character's notoriety – indeed, his fear that it might be harmful, giving the audience the impression that this was a boring, scholarly film – coincided with one of the questions he had frequently asked himself during the writing process: when to reveal to the viewers that the young woman they are watching suffer for love is none other than Victor Hugo's youngest daughter, the sister of Léopoldine? Even though he knew the idea to be unrealistic, Truffaut preferred to address the film to a viewer who did not know when entering the cinema that the story was about Adèle Hugo and could enjoy the surprise of discovering it. Having gradually reduced the story of Adèle to the story of a face, Truffaut was aware that he was presenting a rather special item to the public, in which he had tried to 'combine the emotional mood of *Deux Anglaises* and the rigour of *L'Enfant sauvage*.'

Six years earlier, in 1969, Truffaut discovered the existence of the Journal of Adèle Hugo thanks to an article in *Le Nouvel Observateur*. An American academic, Miss Frances Vernor Guille, had found and decoded this journal (with the passing of the years and the progression of her madness, Adèle had started writing in her own language more and more, inverting the word order as well). When *L'Enfant sauvage* opened in February 1970, the film's unexpected success encouraged Truffaut to 'undertake a project of the same kind on Adèle'. He asked Jean Gruault to write a trial script based on the elements furnished by Frances Vernor Guille's book. At the end of September 1970 he wrote to Miss Guille about his desire to make a film about Victor Hugo's youngest daughter. In mid-November, before Truffaut had the idea of throwing himself into *Les Deux Anglaises*, Jean Gruault sent him a first draft. The writing of *L'Histoire d'Adèle H* was launched. It would take much longer than expected, spread out over almost five years. Even though he sensed he was starting a long- or medium-term project, Truffaut nonetheless thought he would shoot the film in two or three years. Regularly updating Frances Vernor Guille on the project – as well as the painter Jean Hugo, the great-grandson of Victor Hugo, whose agreement in principle Truffaut obtained after Hugo overcame his reservations (the idea of making public a rather sad family secret that had been kept for a long time initially horrified Adèle's great-nephew) – he firmly insisted that the American academic keep the project secret: 'The film, which requires meticulous preparation, may not be made until 1973.' As an incentive, and not without a touch of bad faith, he implied at first to Jean Gruault

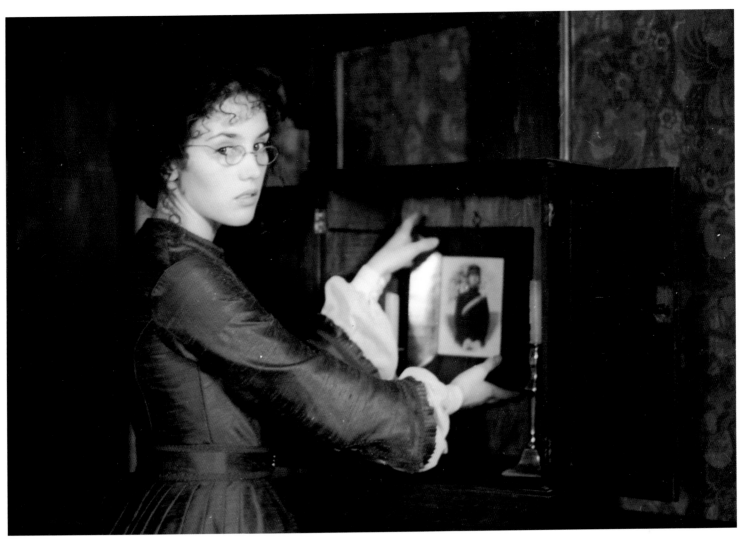

(for whom a more immediate shoot would have been financially helpful) that they would make the film soon. It was only when they visited Jean Hugo at his farmhouse in Fouques, near Lunel, during the filming of *Une belle fille comme moi* in Béziers at the beginning of 1972 that Truffaut said to Hugo, in front of Gruault, that it would be at least a year or two before they shot the film. This news encouraged his co-writer to drink far too much of the wine, local muscat and other liqueurs liberally dispensed by Hugo that evening in front of a still-sober, beaming Truffaut.

This particularly long gestation (slightly more than the other difficult subjects shared with Jean Gruault: four years for *L'Enfant sauvage*, three for *Jules et Jim*, *Les Deux Anglaises* and *La Chambre verte*) allowed for very polished writing (five versions at different intervals), but was also due to an external incident that almost stopped the project. Because she had read a draft of the script and offered a few small biographical or historical suggestions, Frances Vernor Guille wished to be legally considered the co-author of the screenplay and began making exorbitant demands (200,000 francs and a credit as co-writer). Part of her research had been done by her students, so she also objected to the fact that one of them, responsible for the description of Adèle's flight to Halifax, was named on the title page of the script, and Truffaut had to apologize for this 'mistake'. In spring 1973 he thought he would have to

abandon the film, or at least feign being prepared to do so to destabilize the opposing party. The dispute was finally settled in meetings between lawyers, with Frances Vernor Guille receiving around 50,000 francs in return for supposed 'historical supervision' of the screenplay. 'And all this work – yours above all – for nothing,' Truffaut wrote to Jean Gruault. 'Six months after this bitch dies, the cameras will roll on *L'Histoire d'Adèle H.*' (By an irony of fate, Miss Guille died of a heart attack a week after seeing the film.)

Gone with Adèle.

'The first version of *L'Histoire d'Adèle H* was written by Jean Gruault before *Les Deux Anglaises*, and after that film, which was too picturesque and not rigorous enough, I said to myself that I didn't want to see a period film with the obligatory café scene, the carriage that arrives at the end of the street and 30 extras in disguise. I therefore reworked *L'Histoire d'Adèle H* by eliminating everything that was external to Adèle. I no longer wanted to hear about the sun in a period film, or the sky. *Adèle* became more and more enclosed, claustrophobic: the story of a face.' However, Truffaut and Gruault had initially, by mutual agreement and not without a certain optimism, taken a lavish, wordy, quasi-Hollywood approach. During the period from November 1970 to April 1972 (and therefore for some time after the completion of *Les Deux Anglaises*, whatever Truffaut said), they worked from the first through to the

Isabelle Adjani as Adèle Hugo, creating an altar to her lieutenant as Antoine Doinel did for Balzac in *Les Quatre Cents Coups*.

third draft of the screenplay, 373 pages long, which was duly entitled the 'long version'. Initially, Truffaut even encouraged his co-writer to develop, enrich and lengthen scenes, returning to the first treatments in search of ideas and details they might have overlooked. In his large spiral notebooks Gruault did a great deal of preparatory work before writing the first treatment, including a summary of Adèle's biography, a chronology of her life after her arrival in Halifax, Nova Scotia (with respect to which only partial information could be recovered from the occasional witness and her correspondence with her brother) and several 'thematic résumés': 'Adèle spied on by her landlords in Halifax', 'Adèle and exile', 'What Adèle did in Halifax as revealed in her correspondence with François-Victor'... It was Gruault who convinced Truffaut that the film should start with Adèle's arrival in Halifax; the director would have liked to have seen life in Guernsey first, showing her relationships with her family, with Victor Hugo, and the sessions with the Ouija board. Starting in Halifax allowed them to begin with a tried and tested convention of the Western: the arrival of a new character in town. At Truffaut's urging, Gruault then indulged his taste for historical scenes and tactical conversations in period costume, starting with Adèle's arrival at the grand Hotel Halifax, overflowing with guests preoccupied with the American Civil War, which was raging in 1863. Southern officers, planters, slave traffickers and black domestics people the early pages of the script... Truffaut even demanded dialogue for a scene where the participants in a conversation get worked up over the war. He also wanted Gruault to write out completely the scene where a journalist questions Adèle about her trip because she is the only woman arriving on the steamship. (The scene would be kept and only cut in the editing.) Or another scene where a Southern planter staying at the hotel bets with his friends that he can have this girl. ('The dialogue should be discreetly written,' noted Truffaut, 'to keep the public from thinking that this is going to be an important story point.') The planter tries to seduce Adèle by having her serenaded at her window and then climbing up to her balcony; she pushes him down and throws water over him, then starts to cry. The scene was approved by Truffaut with a laconic 'OK', and would be developed in the 'long version', where we also find a big scene featuring a military review where Adèle goes looking for her lieutenant: a crowd of soldiers and horsemen, a big picnic, spits for cooking whole pigs, groups dressed in their Sunday best. Adèle talks to an officer who knows Pinson, because the lieutenant owes him money; she pretends that she is Pinson's cousin and that she can fix things. 'We wanted to make *Autant en emporte Adèle* (Gone with Adèle),' recalls Jean Gruault.

Moves.

Truffaut and his collaborator also had the idea of emphasizing Adèle's descent by her successive moves. After leaving the Hotel Halifax she would land next at the Saunders' (as in the film). Spotted by her landlords, who ended up discovering her identity, she then moves in with another, more modest family, the Mottons, where she would become friends with the young lady of the house, an amateur pianist, with whom she would have exchanged confidences (which would in the third draft

have led to several flashbacks to her past, before and during the Hugo family's exile in Guernsey after the *coup d'état* of 1851). Fleeing again, Adèle would have stayed for a while with an old couple (who in the third draft become O'Brien the coachman's mother, living in a run-down neighbourhood) and then would find herself, after a fire, in a doss-house with other victims of the disaster. At the same time the two collaborators amused themselves by linking each episode in Adèle's life to a long or short film by Chaplin: the arrival at the Hotel Halifax, with a bellboy to carry the trunks, brings to mind *The Cure* (the reference was stated explicitly in the third draft) – the idea of only filming the revolving door of the grand hotel as in *A Woman of Paris* would come later. *A Night in the Show* was their point of reference for the scenes with the hypnotist (for which Gruault recently realized that he was also obsessed by an unconscious memory of Fellini's *Nights of Cabiria*). Then *The Kid* for the arrival in the poor area, and a fragment of an Essanay feature that became a one-reeler, *A Sleepless Night*, for the doss-house scenes (or, as the third draft says, 'a vast dormitory, as in *The Kid* or *Police*'). This game gave them a starting point by establishing between Adèle and Charlie a kind of fraternity of the destitute: two characters ill-adapted to the social order.

The final film eliminated all these moves from place to place and only kept the brutal fall that brings Adèle to the doss-house. Disappointed when he first saw the finished film, Jean Gruault missed not seeing Adèle's decline as he had imagined it. ('A change of lodgings means something in someone's life.') And he objected to the lack of realism in the settings, because the Saunders' granite house had nothing to do with the wooden houses in Halifax in the 1860s which he had documented in his research. For production reasons Truffaut filmed in Guernsey, the location of Hauteville House, the home in exile of the Hugo family. For one thing, the island supplied an Anglo-Saxon ambience and settings for the whole film that could appear to be of the period, and it would be easier to film an English version there at the same time as the French version, by having bilingual actors playing the smaller parts. Truffaut did not care about historical accuracy as long as he could send the viewer on his journey and make him believe in the world being represented.

Even though during the period between 1971 and 1972 Truffaut was clearly tempted, like Gruault, to make *L'Histoire d'Adèle H* a big film, rich and romantic, in a very different style from the film he would end up making a few years later, he did not abandon his habitual strictness when annotating the early drafts. The familiar expressions appear: 'murky', 'let's be logical', 'we can do better', 'it's a somewhat blurry outline, a bit vague', 'my dear Jean, watch out for bric-à-brac' (when Adèle confides in Ellen Motton and her past is shown using photos). So did the need to test, to try out a scene at full length to see if it worked: 'write out completely', 'this scene has to be scrupulously written'. The insistence on clarity: 'This scene is not satisfying because it's confusing [referring to the scene at the office of the notary, Monsieur Lenoir, from whom Adèle tries to learn how to find Pinson, the lieutenant she loves]. We have to understand that she's asking for

...Il est donc très simple de dire que mon mariage s'est fait en Angleterre. Puisque vous êtes tous loin de la maison, la chose sera plausible. Tu diras que je suis partie avec mon mari en Amérique où ses affaires l'appellent et de cette manière, tout sera expliqué. Tu m'adresseras mes lettres à :

Madame Penson
18, Grandville street
Halifax Novia Scotia America.

Mon nom s'écrit également par un i ou un e. J'écris mon nom par un e, préférant l'e au i. Tu mettras Madame en toutes lettres, pour que ta réponse ne s'égare pas et que le mot de Madame soit lisiblement écrit sur ton enveloppe.
Je n'habite ni n'habiterai les casernes ni les camps où ces messieurs sont, cela ne se fait pas, j'ai et j'aurai mon logement en ville comme toutes ces dames, et nos maris viennent et viendront nous voir.

Authentic letter from Adèle Hugo to her family where she announces her marriage and demands to be called Madame Penson: 'It will therefore be very simple to say that my marriage took place in England. Since you are all far from home, the idea will be plausible. You will say that I have gone away with my husband to America, where his business requires him to be, and that way everything will be explained. [...] My name can be written either with an i or an e. Preferring the e to the i, I write my name with an e.'

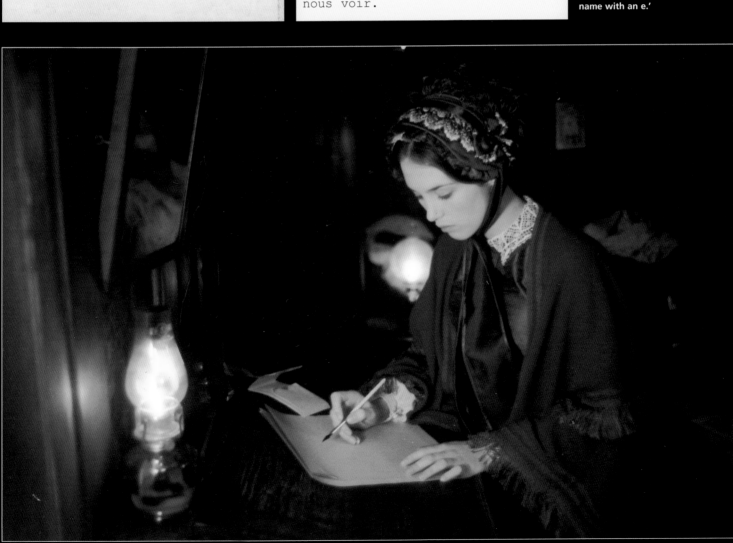

à Halifax, Victor Hugo avait d'ailleurs envoyé le 16 septembre 190 francs, le 10 octobre 200 francs et il nota dans son carnet que Mᵐᵉ Hugo avait elle aussi envoyé 200 francs. Avant la fin décembre 1863, elle aurait donc reçu, selon le carnet, un total de 1 390 francs.

Mais Adèle ne se servit pas de l'argent pour revenir.

C'est au début de l'année 1864, que les Hugo furent mis en relation avec la famille Saunders, chez qui Adèle habita pendant un certain temps sous le nom de Miss Lewly. François-Victor annonça cette nouvelle à sa mère :

Chère mère, mon père a dû te dire que j'avais reçu une lettre des propriétaires de la maison où est logée Miss Lewly. Ces braves gens, ayant vu mon nom sur une lettre écrite par elle, ont eu l'idée de s'adresser à moi, sans savoir quel lien me rattache à leur locataire. Ils me disent que la pauvre enfant néglige entièrement les soins nécessaires à sa santé, à peine se nourrit-elle : quand elle sort, par le froid glacé de ce pays-là, elle est à peine vêtue. Ses vêtements d'une belle qualité, me disent-ils, sont beaucoup trop légers pour ce rude climat. En vain ont-ils insisté jusqu'ici pour qu'elle retournât en Europe. Elle s'obstine à rester là-bas dans les plus tristes conditions d'abandon et de délaissement. L'officier qui devait l'épouser est venu la voir deux ou trois fois seulement depuis qu'elle loge chez eux. Il y a plusieurs semaines qu'il n'est revenu. Et il semble qu'il ait tout à fait abandonnée. Depuis lors, Miss Lewly paraît beaucoup plus triste ; et si ses amis d'Europe savaient son déplorable état, ils se hâteraient de la faire revenir au milieu d'eux. Voilà en substance la lettre de ces braves gens qui paraissent vivement s'intéresser à la pauvre enfant. D'après le conseil de mon père, je leur ai répondu immédiatement qu'ils eussent à acheter à Miss Lewly les vêtements chauds nécessaires dans ce climat, et que chaque jour ils lui fournissent une nourriture substantielle. Je leur expédierais par retour du courrier une lettre de change pour

88

Left: Truffaut read about Adèle's constant requests for money in Frances Vernor Guille's book, where the texts of numerous letters Adèle wrote to her family from Halifax were reproduced. Truffaut noted at the bottom of the page: 'Suppose she gives this money to Pinson. That would be direct, simple, moving and effective.'

Right: Letter from François Truffaut to Isabelle Adjani.

Below: Truffaut's detailed comments on the first version of the screenplay sent to him by Jean Gruault in November 1970.

FRANÇOIS TRUFFAUT

8. CABINET DE MAITRE LENOIR . INT. JOUR

L'avocat dit à Miss Lewly, quelques jours plus tard, qu'il a bien réussi à retrouver le Lieutenant Pinson, mais que celui-ci ne peut la voir actuellement, étant gravement malade. Il mentionne l'adresse du casernement mais il a obtenu celle d'une maison privée où Pinson se rend souvent. Il ne peut ajouter aucune précision et laisse sans réponse les questions inquiètes de sa cliente.

Celle-ci lui règle ses honoraires et sort.

9. CAMPAGNE

10. RUES D'HALIFAX . EXT. JOUR

Miss Lewly erre dans les rues, désemparée.

Soudain elle est dépassée par une voiture découverte où se trouvent Pinson et la femme aux chiens qui s'arrête un peu en avant d'elle, devant une librairie militaire "la maison Gossip". Une ordonnance se précipite pour ouvrir la portière à un officier très dan-

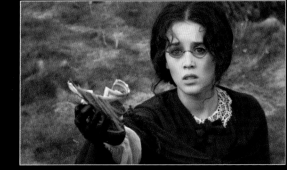

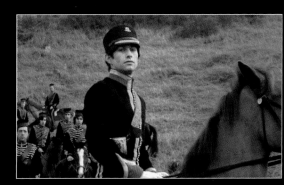

Left: Rewrite of the scene where Adèle hides a cushion under her dress. From the start, Truffaut had been looking for a way to make use of the idea that Adèle pretends to be pregnant by Lieutenant Pinson (Bruce Robinson).

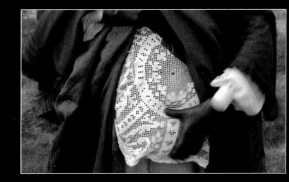

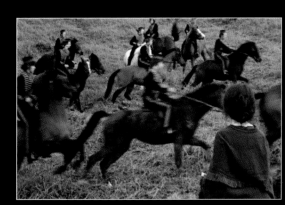

138

regarde fixement.
Il s'approche d'elle, le visage en colère.
PINSON: Disparaissez, je ne veux plus vous voir
Il la regarde un peu plus attentivement sa
silhouette et ajoutez
PINSON: Vous êtes ridicule
Puis il se détourne, lève le bras, lance un ordre
et entraîne sur le côté sa troupe au galop.
Adèle reste un moment immobile dans le nuage
de poussière puis d'un geste violent, elle
arrache le coussin dissimulé sous sa robe.
(c'est cette ruse dérisoire qui la faisait paraître enceinte.)

Adèle tend son bras vers le lieutenant
Pinson, une poignée de billets de banque dans la main.
elle a
Pinson la regarde, regarde l'argent puis la
silhouette alourdie de la jeune femme et ajoute

information about Pinson, but asking Lenoir not to talk about it. That's what has to come out of the dialogue.' The hesitations: 'The false departure of the regiment is a little wasted; that is, we haven't used it as well as we could. I think we have to go so far as to have Adèle get on the little departure boat and then have her get out at the last minute, even if it means pushing back the episode of the false pregnancy.'

As so often, Truffaut was looking for the best place to put certain scenes or certain elements in the dramatic development. For a scene where the Saunders worry about Adèle, which Gruault placed after the ball and the encounter between Adèle and Pinson in the cemetery: 'This scene and this dialogue are interesting, but they come too late. The principal elements have to be placed before Pinson's first visit in the scene on page 26, Scene 19.' Concerning the information that Adèle ran away from Guernsey without her parents' knowledge, told by Adèle to her confidante Ellen Motton near the end: 'Very important to place this earlier, in Scene 39 between Pinson and his commanding officer.' When a character recites fragments of poems by Victor Hugo in front of Adèle: 'This idea has to be kept for somewhere; I don't know where, near the end of the film: it's interesting.' A flashback, again during the confidences shared with Ellen Motton, shows Adèle writing her journal in Guernsey: 'This incredible thing, that a young girl should walk on the water and pass from the Old World to the New to be with her lover…' Truffaut noted: 'To be kept, but I don't know where. Did she forget these pages at the bookshop, at the Saunders'? Not to be forgotten *en route* [he underlined twice]', the outcome being that he would make this great declaration of emancipation, quite astonishing for a young woman of 1860, the leitmotif and symbolic conclusion of his film.

A question of identity.
Seeking to get the most out of the raw materials and to play with the viewer as much as possible, Truffaut began by revolving in a confused way around what would interest him most: the faltering of Adèle's identity, her lies, her determination to liberate herself from a name that is crushing her. If the girl for whom he later invented the declaration 'I denounce the fraud of identity and the deception of the civil state' insists on marrying Lieutenant Pinson no matter what, is it not in order to escape from her own name? In the margins of the first draft of 1970 Truffaut wrote out a detailed, confident outline of Adèle's lies and contradictory stories:
'We have to take a bit of trouble organizing this. Each time Miss Lewly talks about her cousin she says something different, a bit contradictory, a bit incompatible, and that allows the audience to understand that she's lying:
For example
1) At one point she says they grew up together.
2) Another time she says: he's my cousin, but I've never seen him. I've come to get to know him because my parents are dead.
3) Another time she says: he's my cousin, but I avoid him because he's in love with me, and I don't want to encourage him. (She could say that at the bookshop.)
4) He's my cousin, but we've fallen out; I just have to

see him to have him sign some papers concerning an inheritance…
That way it will be much more interesting.'

Truffaut later refined and complicated this plan a bit. In the film she tells the notary that she is looking for her niece's fiancée ('The only thing I care about is my niece's happiness'); at the bookshop, she says that the lieutenant is her sister's brother-in-law ('But I rarely see him. I've fallen out with my sister'); to her landlords she says that he is her cousin, or rather a kind of foster brother ('To tell you the truth, he's been in love with me since we were children'). Truffaut and Gruault adopted the premise of false stories, and Truffaut pursued his idea in a note about a scene in the first draft: 'This scene is modified to contain several things: Adèle, dressed as a man, speaks with Madame Saunders, who had forgotten to give her a letter that came from England. Concerning Pinson Adèle says: "My fiancé." Mme Saunders: "You mean your cousin." Adèle: "In fact we were going to get married, we are only cousins by marriage, etc" (it's the first time we get the impression that Adèle is mad).' The film-maker would subtly signal this vacillation of Adèle's identity from the very start of his film, about which he wrote to Gruault, in the margin of the first draft, that 'something intriguing about Adèle's disembarkation is missing' without being able to define it. Finally, after several tries, he imagined that Adèle changes lines going through customs because she is behind a spy with fake papers. A silent kinship links the girl who no longer has a name (even a first name, since she bears her mother's, as Truffaut noted) and no identity she can admit to, running after an impossible marriage as if in absurd compensation, to the spy who has been detained – a link that is brought out by the direction and her insistent looks.

On the facing pages of his script Truffaut wondered about when and how to reveal to the viewer the true identity of Adèle, who presents herself to others under assumed names. After a scene where she writes to her mother to ask for her parents' consent to her marriage, Gruault proposed bringing about the revelation of Adèle's identity 20 pages later through the character of a hotel manager, a friend of the landlord's, who recognizes the name of Victor Hugo on a misplaced envelope. Later another friend of the Saunders family voices the theory that their lodger could be the second daughter of Victor Hugo. Truffaut asked for the two scenes to be merged and suggested that after writing to her parents (brushing aside historical fact, he insisted on having her write to her father, not to her mother), Adèle would be visited by a doctor: 'He's the one to whom the name Hugo means something.' In his eyes, it was impossible to wait too long for this: 'Attention! From now on we're in the second act. The audience has heard that this is Victor Hugo's daughter. We can't put off the revelation any longer.' Truffaut was in fact torn between the knowledge that his film would have few innocent viewers and the desire to play out a real effect of surprise anyway – an effect he knew he could only achieve before the film had been promoted. Writing in October 1971 to Frances Vernor Guille to update her on how the project was going (the film-maker and the writer were not yet in

disagreement at this point), Truffaut explained that he had avoided including the name Adèle Hugo or the title of his work on the cover of the script because 'when we give this story either to actors or to producers to read, I very much want to preserve the emotional shock they will feel, probably in the middle of the story, when Adèle's identity is revealed'. This is a rather lovely expression of Truffaut's fantasy of the virgin viewer who has no preconceived ideas about the film before entering the cinema.

Rebounds.

As was his habit, Truffaut began to imagine his film by reaction, rebuilding it on the facing pages of the screenplay. 'I want to add somewhere a scene showing Pinson's orderly bringing him his parade uniform after having it cleaned,' he indicated in the margin of the second treatment. 'In the pockets of the jacket and trousers Pinson finds little notes from Adèle, each consisting of a single sentence: "Let me love you, etc." The scene would considerably reinforce the notion of Adèle's omnipresence.' This is in fact the equivalent of the scene in *Domicile conjugal*, filmed a few months earlier, where the little notes escape from the bouquet of tulips sent to Antoine by his Japanese mistress. Truffaut also wanted to make Lieutenant Pinson a cavalry officer, even if it meant filming men on horseback, something he had a horror of. 'From a von Stroheim standpoint, Pinson should be cavalry rather than infantry... What do you think?' the film-maker asked Gruault in the margins of the first screenplay. In the game of influences, their initial idea, considerably diluted by the end, was to make the lieutenant a character inspired by Erich von Stroheim in *Blind Husbands*. Truffaut gave Gruault an 8 mm print of the film he had brought back from New York, and Gruault planned in the early drafts of the screenplay to show Pinson putting on a corset and gluing on his moustaches. Sometimes Truffaut bounced off a simple phrase, one detail among others, to propose a whole development. In the first screenplay Gruault inserted the idea that Pinson reminds Adèle during the ball that she 'didn't hesitate, not that long ago in England, to pretend she was pregnant'. Truffaut was enthusiastic:
'We keep this carefully so that we can film it straight:
first she will announce that she's pregnant
we will see her with a big belly
one day we'll see that she put a cushion under her dress.'

In the account of Adèle's life included in her published journal, we learn in fact that while she was still in Guernsey, in 1861, she began pursuing Lieutenant Pinson, whom she had met during a Ouija-board seance, and pretended to be expecting his child. ('She pretends to have had a child by him and imposes on him the moral obligation to give his son a legitimate name' – a sentence Truffaut underlined in his copy of the book and annotated with this comment: 'Study the idea of the cushion under the dress.') More casual about historical accuracy than Gruault was, Truffaut did not hesitate to transfer the idea to Halifax and take full advantage of the possibilities it presented.

Money.

When he received Gruault's second treatment for *L'Histoire d'Adèle H*, in spring 1971, Truffaut first let the screenplay rest a while (he was shooting *Les Deux Anglaises* until the beginning of July), and when he looked into *Adèle* again, he picked up Miss Guille's book to make sure that they had not overlooked any interesting facts or details. In September 1971 he sent Gruault a series of typed notes, which he entitled 'Improvements to be made to *L'Histoire d'Adèle*', based essentially on the book, where he had checked off ideas that interested him and ingredients to be recovered. Several strong ideas in the film came from this re-reading, such as the requests for money Adèle sends to her family, reinforced by the fact that the young woman believes herself to have been touched in her own way by the vein of creativity that inspired all the Hugos. He circled a footnote where we learn that Adèle asked her family to publish an album of her musical compositions, and he noted: 'This desire justifies Adèle's demands for money. Interesting.' (A few years after Adèle's flight, a certain Robert Louis Stevenson asked in vain that his friends in London have some of his first travel stories published so that he could receive the payments, while he crossed America without resources in pursuit of the woman he loved...) Truffaut then explained himself in more detail:
'The postscript of the letter is very interesting because it makes the questions of money more precise. Not detailed enough in the film. I think for example we're missing a scene where we see Adèle get money at the bank. Since we see her give money directly to Pinson several times, I would like to have on-screen, at a certain moment, this very simple illustration:
a) Adèle writes to her parents, making them believe that she is ready to return to Europe and asking them for money for the trip;
b) We see her get the money at the bank;
c) We see her give the money to Pinson.'

Truffaut later developed the scenes at the bank, imagining that it was also there that Adèle collected poste restante letters from her father, thus concentrating in one space her demands for money and her vain demands for love. Starting from an image that he rediscovered when he re-read the story of Adèle's life, he launched into a long note that developed explicitly (and this explicitness is rather exceptional for him) the psychological arguments he would put into action in his film:
'It is mentioned (p. 127) that sometimes Adèle, dressed as a man, hid behind the trees to watch Pinson and the women who were with him. This shows us that we have neglected the element of jealousy. It shouldn't be an elementary jealousy, but – much more effective – an unhealthy, masochistic jealousy that Adèle takes pleasure in. Her jealousy is double: posthumous *vis à vis* her sister Léopoldine, the favourite, who has been idealized by her death, and somewhat sexual *vis à vis* Pinson, to the point of voyeurism: it's not just to glean information that she observes Pinson from afar when he is with a woman, but to feed her neurosis.'

When Truffaut took up the screenplay again after the rather long interruption caused by the dispute with Miss Guille, his note about jealousy resulted in the scene of voyeurism where Adèle, at night, hides and watches Pinson's every move with the widow with the little dogs. When he

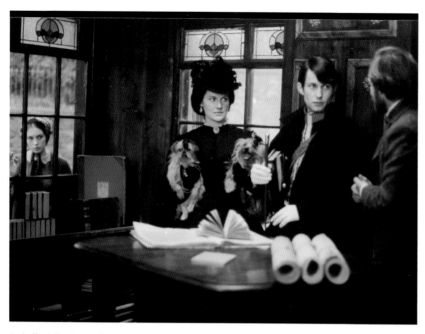

Isabelle Adjani, Aurelia Mansion,
Bruce Robinson and Joseph Blatchley.

showed her writing feverishly in her journal in the next
scene, the film-maker followed up her final little half-smile
of satisfaction with a sentence stolen from the novel *Les
Deux Anglaises*: 'Not being able to have love's smile,
I condemn myself to its grimace.' Just before the scene
of nocturnal voyeurism, Adèle uses a Ouija board to try to
communicate with Léopoldine...

Truffaut took the idea that Adèle's mother has tired eyes
and difficulty reading from Adèle's journal and
her correspondence with her brother François-Victor.
He underlined the relevant allusions in his copy of the
book ('This dear child has written you a letter in enormous
characters so that you can read it,' François-Victor writes
to their mother), which the film-maker annotated, not
without some amusement: 'Everyone will think that this
comes from *Jules et Jim* and *Les Deux Anglaises*, but that's
no reason not to do it.' Everyone did indeed think that this
was the case, all the more so because Truffaut had
shamelessly drawn on *Les Deux Anglaises* for the text of
Victor Hugo's letters: '...because her eyes could only
read large handwriting.'

Marriage under hypnosis.

Truffaut's re-reading of the book also compelled him to
return to the scene with the hypnotist that he had started
writing with Gruault in reference to Chaplin's *A Night in
the Show*. The idea came from letters about Adèle
exchanged by François-Victor and their mother, obviously
after the young woman had confided in her brother:
'Now she wants to put this man to sleep by magnetism
and marry him while he is asleep.' Truffaut wrote a precise
description of the scene: 'Concerning the hypnotist, I think
that the scene in our script is inferior to what we can
achieve. The scene should be much longer, with more
insidious questions being posed by the hypnotist. We have
to give the impression that he's on the verge of accepting.
He needs to say more about how the fake ceremony would
have to be arranged, how to recruit the witnesses and the
Minister. It's a big scene that should shock us right to the
end. We have to find a good conclusion.'

The conclusion would be the idea that Adèle, her back
to the wall in her determination to obtain the hypnotist's
agreement for the idea of a marriage under hypnosis,
finally reveals her father's name, briefly writing it with her
gloved finger on a dusty mirror, immediately before the
accomplice she has seen on stage appears in his dressing
room, revealing that it was all a trick. Even though Truffaut
got the long scene he wanted (in the film the two parts,
on stage and in the dressing room, last almost nine
minutes), he was still not completely satisfied, as if he had
expected too much from this scene. Ivry Gitlis, a musician
he asked to play the hypnotist, seemed to him to be
unbearably slow, hammy and over-expressive during his
show, which Truffaut was tempted to make up for by editing
the maximum number of cutaways to Adèle so as to expand
the scene and show it through her eyes, even at the risk of
losing credibility. (What can she be writing in her notebook
when the volunteer from the Mounted Police, who turns
out to be an accomplice, gets up on stage?) But the scene
achieves its aim in the second part: the mad hope of a little

girl all alone, ready to give whatever she has to get what she wants, to the point of revealing her name as an enticement and letting herself be swindled before our eyes.

The condensed version.

However, there was a long interval of almost three years between these notes on the autumn 1971 version, where Truffaut seemed completely involved in his character and his film, and the moment he decided to risk undertaking the project. In autumn 1972 he filmed one after another *Une belle fille comme moi* and *La Nuit américaine*, then took the break he had not had for two years (since throwing himself into *Les Deux Anglaises*) in order to rest and advance his editorial projects. (*Les Films de ma vie*, his collection of articles, appeared in April 1975.) The long version of the screenplay of *L'Histoire d'Adèle H*, where Gruault embroidered as much as he liked in response to the director's demands, was delivered to Le Carrosse in April 1972 and remained in a drawer for some time. After threats that the project would be abandoned and then his new films, Truffaut did not begin reworking the script with Suzanne Schiffman until almost two years later. Recovering his spirits as if facing a new project, he rapidly put together a screenplay that could be filmed by cutting up, re-assembling and completing the previous version. Le Carrosse was beginning to have problems after two years without producing a film, and it was vital to restart the machine. The cleaned-up version of this draft (reduced to 163 pages) was dated May 1974. It was much more realistic in terms of settings, size and possibilities for production, and at the same time sharper, more incisive. Clearly, Truffaut had decided to make the film this time. Turned down by Warner Bros (despite their having coproduced *La Nuit américaine*) because of its literary background, the film was accepted by United Artists, but only on the condition that the budget be reduced. This fourth version of *L'Histoire d'Adèle H* was the one where the real slimming down occurred. Deletion of all the scenes at the Hotel Halifax, and of all references to the Civil War, since the coachman takes Adèle directly to a bed and breakfast and the story is focused around Adèle's emotional journey to the exclusion of anything else; total deletion of the big scene of the military review and picnic where Adèle tries to approach the military men. Deletion of the successive moves: when Adèle leaves her lodgings because she thinks her lover's regiment is leaving Halifax, then discovers that she has made a mistake, the coachman takes her straight to the doss-house. Numerous scenes are combined. (In the long version, in a scene worthy of the joyful erudition of Jean Gruault, the bookseller wants to give Adèle, who is leaving, a first edition with a dedication by Lafayette and one of the best American books of the eighteenth Century: *Letters from an American Farmer* (1782) by Saint John de Trevecœur, 'with some very amusing pages on Arcadie… and its mosquitoes.' Later Adèle's landlord puts a copy of *Notre Dame de Paris* in her room where she can see it. Simplifying and sharpening the outlines of the film, Truffaut finally chose *Les Misérables*, which Adèle opens to the first chapter, on Fantine.) Elements and dialogue fragments of the deleted scenes were sometimes transferred to the remaining characters: dialogue exchanged with the chambermaid

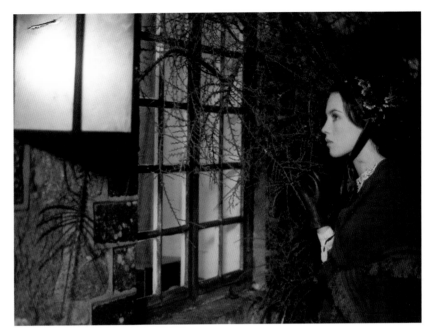

The *mise-en-scène* develops the theme of voyeurism.

at the hotel (the portraits of Léopoldine) or with Ellen Motton, who disappeared from the script when the changes of lodging were removed, was transferred to Mrs Saunders, the landlady.

'It's a process of growing rigour, very exhilarating, which had already pleased me in *L'Enfant sauvage*,' Truffaut said when the film opened. 'Like an electrician, I strip the wires, I reduce the number of elements.' By removing the picturesque period detail, he concentrated on the character of Adèle and the straight line of her obsession. There is no scene that does not concern her *idée fixe*, no diversions. He also affirmed his subject, for in parallel with the process of contraction he added new scenes that reinforced Adèle's solitary passion and problems of identity. In this fourth draft Truffaut also included several scenes at the bank as he had thought to do in his 1971 notes, scenes that allowed him to show Adèle's development. A scene at the beginning when the money the young woman is waiting for has not arrived. A second when she receives and reads at the bank (and not in her room) the letter consenting to her marriage that she has extorted from her parents. Still another when she receives a letter from her father, who is certain that Lieutenant Pinson will never marry her. By having the mail from her family come to the bank, the film-maker affirmed the relationship he wanted to establish between the last emotional ties that remain for Adèle in the depth of her solitude (ties at a distance, marked by misunderstandings), and the money she needs that continually arrives late, which is itself a sign of the fragility of her father's support. At the end of the screenplay, in place of the move to a poor neighbourhood planned in the long version, Truffaut wrote a last scene at the bank where Adèle comes in a pitiful state to beg for her money. During shooting, at the moment when he pushed scenes to their extremes, the additional idea that the employees of the bank have changed and don't recognize her appeared. (We can read this rapid notation on his shooting script: '1) It's not the same employee. 2) à la "wrong man" ["wrong man" is in English]: suspicion etc.').

The violence of the idée fixe.

In rewriting, Truffaut went in the direction of greater violence of feelings and actions, greater crudeness. While rewriting this fourth version of the screenplay he invented the episode of the mistaken identity (Adèle runs up behind an officer, then realizes she has made a mistake, it isn't Pinson), which he decided during production to play himself. Absent from all previous versions, this episode became a kind of symbol of Adèle's desperate, deluded quest. It was here too that he would later incorporate the voyeurism scene (the handwritten pages were slipped into the screenplay): Adèle's carriage follows the lieutenant, she spies on his arrival at the widow's home, climbs on a toolshed to see them flirting through a window, but is disturbed by a servant who lets the little dogs loose and flees. A scene that Truffaut, again, took further in shooting, since he decided to do away with this conventional conclusion (Adèle is disturbed and flees) to end on the young girl's ambiguous half-smile. During editing he asked his editor to extend the scene as far as possible, after Yann Dedet had edited it to be much shorter.

Even as he stripped the wires, Truffaut collected elements that would create greater intensity. In the previous versions of the screenplay, a short scene showed Pinson being approached in the street by a prostitute whom he pushes away. Truffaut transferred the idea to Adèle: now it is she who sends a prostitute to Pinson as a 'gift' and proof of her love. He contracted two series of scenes to sharpen them: a scene that had been moving around from one end of the screenplay to the other where Adèle tries to follow Pinson, who is leading his cavalry troop; and all the scenes where she pretends to be pregnant and walks around Halifax with a cushion under her dress. Everything now went much faster, because he melded all these elements into just two scenes. Adèle, having learned that Pinson is marrying a young girl from local high society, visits the fiancée's father and plays her last card by proclaiming that she is expecting the lieutenant's child. In the next scene she follows the horsemen through the country and seems to be pregnant ('her belly seems to have become rounder since her visit to Judge Johnstone'). Pinson finally stops. She offers him a handful of notes, he insults her and turns away, and she pulls out the cushion that was under her dress. Through this shortcut the film-maker concentrated the business of the false pregnancy and the motif of money that permeated the story in a few pathetic moments: the money Adèle extorts from her father to offer to Pinson, but which will not enable her to buy the love she doesn't have from either of them – a ridiculous double gesture that is all the more pathetic because neither the money nor the pretended pregnancy have any effect on her indifferent lover. Adèle's misery and solitude are materialized in one clean stroke. When he filmed the scene, Truffaut added to its cruelty – without even waiting for Pinson to leave, Adèle removes the cushion hidden beneath her dress under his mocking gaze: a last act of defiance by which she renounces all dignity in front of him, even that of her useless lie.

As he removed the picturesque from his film, Truffaut tightened the trap in which Adèle is caught. He erased the scene in the doss-house as it was previously written: a rather joyful early morning scene where Adèle participates in the refugees' *toilette* with the women and children and washes the face of a little boy like Charlie Chaplin's *Kid*, before writing in large characters a letter to her mother. He proposed a night scene that allowed him to reduce the extras to the mass of sleepers, but above all enabled him to carry further the cruelty of the representation of his heroine's fall: Adèle's neighbour is a toothless old woman who goes through her suitcase and tries to steal her manuscripts. Adèle wakes up in time to slam the lid down on the old woman's fingers and proclaims: 'Don't touch that! It's my book, and one day it will shock the world!' On his shooting script Truffaut added this simple note: 'She sleeps on the ground', thereby making Adèle, who sleeps under the iron bed clutching her suitcase, hanging on to what remains of her identity, a sister of the wild child of Aveyron, brought like him to the temptation of the earth and of burial. Truffaut later said that he saw Adèle as the other side of the coin from the wild child, with the same absence of identity, even if she was the daughter of the most famous man in the world.

In a scene reminiscent of Griffith or Chaplin, Adèle goes to sleep clutching the only thing she has left.

The vehemence of the *idée fixe*.
Adèle's nightmares.

Asked to give his opinion of this slimmed-down version, Jean Gruault sent Truffaut a long letter where he made certain suggestions, some of which related to a sense of economy being necessary. Even though he regretted the reduction of the film's opening ('I agree with getting rid of the Hotel Halifax, even though this takes away from the impression of Adèle's downfall that we originally wanted to give, but the decision not to stay there has to come from Adèle herself'), he was the one who suggested that she examines the front of the hotel without getting out of the coach, then asks, frightened by all the going and coming, to be driven elsewhere, an idea Truffaut reworked and radicalized. 'We remove the planned shot of the Hotel Halifax and replace it by lighting effects on Adèle's face and the sound of voices (plan to have lines in different languages from travellers, porters, etc.),' he specified in a series of notes to be given to the film crew before the shoot. He conclusively deleted all remaining extras. ('A Southern uniform here wouldn't displease me at all,' said Gruault, expressing what remained of his fondness for the historical references in previous versions.) It was also Gruault who prompted his director to represent only as a silhouette the colonel who warns the lieutenant that Adèle is passing herself off as his wife ('We can get away with filming Suzanne from behind, dressed as a colonel, sitting at the desk…'), which the film-maker would do with an extra we barely see through a door that is ajar. Confronted with the only scene where Truffaut, who had long hesitated on this point, had planned to represent Victor Hugo (we would have seen him taking the announcement of his daughter's engagement to the newspaper office in Guernsey), Gruault unhesitatingly suggested getting rid of 'the pseudo-V.H.'s walk, which I find both dumb and unnecessarily costly'. Rather astonishingly, Truffaut at first resisted (he crossed out Gruault's suggestion with a 'no'), then ended up coming round (he replaced the fake Hugo with a servant who delivers the announcement of the engagement to the local newspaper) and, when promoting the film, finally embraced as his own idea the refusal to incarnate the celebrated writer by any bearded extra whatsoever, as if he had always thought of it…

On the other hand, other suggestions from his collaborator fell on deaf ears: both Gruault's recommendations about the architecture and look of the settings, made with a concern for accuracy (and that would be one of the reasons for his disappointment when he saw the finished film), and the idea that a prayer Adèle makes at the altar she has dedicated to her lover turns into a scene of masturbation. Nor did Truffaut accept the suggestion that Adèle watches a very daring, almost pornographic scene between Pinson and the widow (the widow masturbating Pinson or sucking him off, a sight shocking for a woman of the period with Adèle's education), even though Gruault went so far in his efforts to convince his director as to evoke 'the scene in *La Recherche* where the narrator spies through an open window on Mademoiselle Vinteuil and her female friend making love in front of Vinteuil's portrait (Pléïade I p 159 to 165)'. It is easy to imagine Truffaut refusing this scene, not out of prudery, but because it implied another vision of the film and the character than what he had in mind. He did not want *L'Histoire d'Adèle H* to be his *Cries and Whispers*, or

to repeat the attempt at a 'physical film about love' that he made in *Les Deux Anglaises*; instead he was seeking to portray an entirely mental, cerebral passion, the mental power of an *idée fixe*.

No sky.

When he was making his film (from January to March 1975), Truffaut pursued this process of stylization and distillation. In a series of notes that he addressed, untypically, to the whole crew the night before shooting began, he stated precisely certain choices of *mise-en-scène* and indicated a few last restraints. Bare images: 'I plan to begin this scene on Adèle's feet (boots or shoes?) to avoid the usual shot of a street full of folkloric extras (plan on using a dolly). The shot stops when she enters the artisan's shop, and the rest will be seen through the window.' (He was speaking of a scene, finally cut during editing, where Adèle buys a box in which to keep her letters from a cabinet-maker.) No filming of the sky, in order to avoid any dispersal of concentration on the subject and any false poetic effects: 'Every scene will be filmed so as to avoid having the sky in the image. [Adèle pursues the horsemen in the countryside.] The shots of Adèle will be filmed from a high angle as if she were being seen by the men on horseback. Pinson will be filmed from a low angle as if being seen by Adèle, but we'll situate the horses so they have the mountain behind them, or the rocks of the cliff.' The search for unity of emotion: many scenes would be filmed in single sequence shots or shots that last as long as possible, so that the film-maker could spare himself detailing the few remaining crowd scenes, but also so that he could accompany the emotional movement of his heroine in one flowing sweep. The scene of the Bellevue Ball where Adèle goes to pester Pinson was filmed in a single moving shot that follows the hesitant intruder through little groups hidden by shadow; then the camera remains outside the windows behind which the guests move about, while the lieutenant's orderly goes to inform him of Adèle's unwanted presence. Truffaut spelled out for his crew the use of sequence-length shots, filming through the window, for the scenes in the bookshop:
'No. 11. The beginning of the scene will be presented differently. The camera will be in the bookshop, and we will see Adèle arriving in the street. She will pass in front of the shop window, will return furtively as if she has seen something, and then we see her go and hide inside a porch. We hear off-screen the lieutenant and his companion leaving the bookshop and we see them passing in front of the shop window, then we see Adèle come out of hiding and enter the shop. From the moment the dialogue begins I want to film this scene in a single shot.'

Last details.

Contrary to what has often been said about Truffaut's *mise-en-scène*, these were not devices thought up at the last minute as a kind of last-ditch adaptation to circumstances, to the sets and the movements of the actors (which was, in part, the style of the early films), but rather the result of long meditated planning, prepared and reflected on, including all the practical details for executing them. (The film-maker noted further for the benefit of his production designer that he should leave enough space

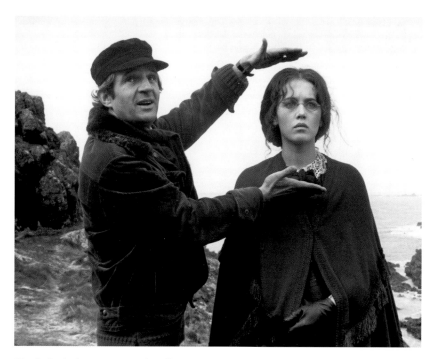

'No sky in the image,' repeated Truffaut, who thought that too much sky caused the shot to lose its emotional force. For him, *L'Histoire d'Adèle H* was the story of a face.

between the bookshelves for the camera to pass on tracks or on a sheet of linoleum so that the scenes in the bookshop could be filmed in a single shot.) In these notes we hear Truffaut speaking to his crew as a director, concerned about what will be in the image and according scrupulous attention to each detail. Concerning the snow scenes, invented to make real Nova Scotia and the passage of time, and also to reinforce Adèle's destitution: 'Pick the window through which the snow will be seen falling before we film so as to determine the placement of the snowdrifts in the street in front of it.' (Roland Thénot tells how, when he went to Guernsey to find locations for another film months later, people were still discovering the little balls of plastic that had been used to imitate snow in their streets, in their courtyards and on their pavements.) Concerning the widow's underwear: 'Since Pinson will be rummaging under the widow's skirts, we have to plan on a crinoline that isn't too comical.' Or the sign on the bank, which Truffaut planned to use in his *mise-en-scène*: 'The plaque on the Bank of Halifax should be well cared-for (careful to make the inscription one hundred per cent English). The plaque should look like it has been forged from steel or brass, and not from wood. It will be placed somewhere in the street, at the same height as Adèle's face, because when she passes in front of the bank her face will go out of frame, we'll stay a second or two on the plaque, and then we'll pick up Adèle again inside the bank.' He was also very preoccupied with the appearance of the paper used by Adèle to write her journal, with the idea of big rolls in keeping with the period, and with how they would appear in the image: 'The public will be surprised by the idea of Adèle buying her paper in rolls. We therefore have to plan to have a moment where we'll see her cutting the paper with a kitchen knife.' A bit later: 'For each time we see Adèle write, we need to have paper that is as non-white as possible, probably rather dark beige. I want to see this paper and also the period writing materials, ink, pen-holder, etc., before the shoot (same quality and colour paper that Adèle buys in rolls at the bookshop).'

Distillations.

Parallel to this, once he was shooting, Truffaut invented new scenes, crystallizations where he radicalized the representation of his heroine. It was during shooting that Truffaut finished a scene at the bank by inventing an encounter between Adèle and a little boy whom she tells that her name is Léopoldine. Then, when she discovers in her mail the consent of her parents to her marriage, she goes back to the child: 'I lied to you. My real name is Adèle.' [These sentences are in English.] The whole psychic history of the girl is summed up in this apparently very simple scene: the rivalry with the dead, idealized sister, the wavering identity and the access to her own identity that marriage seems to permit, the deep reasons for Adèle's fixation on the dull Lieutenant Pinson. A quick sketch in a few lines by Truffaut in the margin of his shooting script: 'The business with the little boy
Adèle: What's your name?
The boy: Michael
Adèle: That's a pretty name. My name is Léopoldine.'
And further on, jotted on another corner of the page:
'I lied to you. My name isn't Léopoldine.'

Truffaut also wrote the scene of the Ouija board during shooting, from a few words noted down on the facing page of his script. In this scene, Adèle, half-mad, frighteningly pale, hair undone, invokes her dead sister: 'Ouija board… It's you, Léopoldine… Léopoldine, I know it's you… If you're there, help me.' He also imagined that at night fall she prowls, ragged, around the barracks where the lieutenant is billeted: 'Like Lily Marlène, Adèle prowls around the barracks as the day ends.' That is when he planned a scene near the end of Adèle's stay in Halifax where the bookseller, shut in behind his window, helplessly watches her decline: '51b: Whistler bookshop: through the window, W. sees Adèle walking past (pregnant), talking to herself, very agitated… End on reaction W. We see her walking: words and hand movements (no purse), then pan to Whistler window and continue to see Adèle reflected.' During the days of filming, Truffaut rewrote and sometimes, at the last moment, slipped under his actress's door the texts of the letters Adèle writes to her parents, reusing material from her correspondence with her brother ('And don't forget to give me news of my album of music: did you take it to the publisher?'), or taking liberally from the text of the novel of *Deux Anglaises*, generally from the journal or letters of Muriel, the more violent and unhappy of the two sisters: 'If a woman like me gives herself to a man, she is his woman'; 'At present I think of my sisters who suffer in the whorehouse, of my sisters who suffer in marriage'; 'I don't give my body without my soul, or my soul without my body'; 'I can now inform myself about everything on my own, but for love I have only you'… Finally, it was also during filming, closing the circle, that he gave Isabelle Adjani the fieriest words about Adèle's relationship to her father, which were not in the script: 'Born of an unknown father… I was born of an unknown father' and the famous 'I denounce the dishonesty of the civil state, the fraud of identity.' A moment of total openness, of empathy with his subject, when the film-maker didn't hesitate in taking his character to the limits of her aberration.

'I do not know Isabelle Adjani.'

For the part of Adèle, Truffaut looked for an older actress at first, closer to the real age of his heroine (just over 30, whereas Isabelle Adjani's age of 20 was criticized when the film came out), not too modern, someone who could be plausible in the nineteenth century, possibly not someone well-known. At one time he considered Jeanne Moreau for the part, as well as Catherine Deneuve and even Stacey Tendeter, with whom he filmed screen tests, without ever feeling that he had before him his Adèle. According to Jean Gruault it was Gérard Lebovici who spoke to him about Isabelle Adjani. Truffaut, thrilled to have a chance to film 'a face in transformation', extracted an agreement from her, since it meant she would have to leave the Comédie française whose director, Pierre Dux, refused to give her the fourteen weeks' leave necessary for her participation in the film. While the film-maker's enthusiasm was total (in October 1974 he wrote to her that since Jeanne Moreau he had never felt 'such a pressing desire to capture a face on film, with no delay', and that he wanted to 'film her every day, even on Sunday'), the encounter did not come off as successfully as planned. The actress recalled, in an interview with the magazine *Cinématographe* in 1984 after

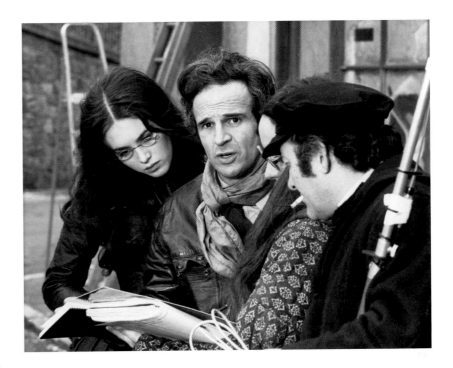

Patient direction of Isabelle Adjani, who expected more from Truffaut than he liked to give. He preferred giving concrete instructions – the same scene repeated in a lower voice, for example.

Truffaut's death, her 'guilty resistances' with respect to the man and the film-maker. 'He didn't need what I could do; he just needed me to be there so I could sit down in front of him to answer to this *idée fixe* he had of me, this steadiness that he demanded of my body.' And: 'He had manias he held on to: with my right hand, I was supposed to squeeze my left arm obsessively. He did that in life and he repeated it each time he played a role, in *L'Enfant sauvage*, *La Nuit américaine* and in the Spielberg film, *Close Encounters of the Third Kind*! In several of his films I see the same gestures in his female characters, gestures that are his. At the time his directions seemed to me strange, intrusive, exterior to me; today I'd be capable of incorporating them.' ('In the hall, while waiting, she rubs her left arm', the film-maker did in fact note on his shooting script, in the margin of the scene in the home of Judge Johnstone, father of Pinson's official fiancée.) After the shoot, Truffaut gave an article he had been asked to write for *L'Express* in 1975 a very telling title: 'I Do Not Know Isabelle Adjani' (he said that he knew her best from seeing her repeated again and again on the editing table). Truffaut went on to describe the scene of mistaken identity he chose to play himself (where Adèle, realizing her mistake, turns her gaze away from the man she mistook for her lover at a distance) as being 'a rather sad joke'. This misunderstanding was no doubt provoked by the unreciprocated passion the filmmaker felt for Isabelle Adjani in addition to their fundamental difference of opinion about how to portray the emotional violence in the film: Truffaut, who hated giving explicit psychological explanations to his actors, preferred to make jokes and take a more light-hearted approach to filming material he was very familiar with, tough material he had worked on intensely. His actress however felt that she now needed to immerse herself in the intensity of Adèle's pain and obsession. 'He invented codes; it was always very simple, almost childish, but he took a great deal of pleasure in it. For example, so that I wouldn't seem too much like a little girl he wanted me to lower my voice, and when I was acting I forgot to keep my voice low. I had talked to him about the last play I'd seen at the Comédie française – *The Lower Depths* by Gorky – so he'd say "Gorky" just before the take… Children's games! And I continued to drown him with questions. One day when we were shooting a scene in a bank, he said to me: "You know why you're asking for the money here?" – "No, I don't know…" I expected him to talk to me about Adèle's relationship with her father, about all the letters between Halifax and Guernsey that neither of them received… And he said, "Because she needs cash!" That made him laugh, and me too!' Suzanne Schiffman confirmed that one of the only things Truffaut asked Adjani to do before the start of production was to try to speak in as low a voice as possible. 'The result was that Isabelle screamed in her shower two hours every night to wreck her voice. There were lines to be heard off-screen that she needed to record, and she'd wake up the recording engineer and the boom man at three in the morning saying: "My voice is wrecked. Come on, let's do a line." To support the actress, the film-maker did a few more takes than was his habit. To help her play the scenes of solitude and enclosure, he played Maurice Jaubert's music on the set, the main titles of which he noted in the margins of his shooting script: 'French Suite No 4 (rondo) 1'30' (final, Adèle on the rocks), 'War of 3 No 7, band 11, Easter Island No 9, band 19, 30' (sea)… 'We had recorded the music before the film, and often I'd use it on the set, either in silent scenes to help Isabelle act or in rehearsal to help her refine her performance. An actor who acts to music adopts a style that is close to dance. Carried by the music, he won't be afraid of stylized gestures, of daring to do things he'd refuse if he were asked brutally, like slowly lifting an arm or backing out of a room.'

The Carrosse Ciné-Club.

'I don't know why I'm making a film like this. So sad. But an *idée fixe* has something vertiginous about it, and I think I have been caught up in the vertigo.' Truffaut was afraid that the seriousness of the subject matter might end up affecting everyone, and as the shoot – which was long and especially arduous because the takes for the English version had to be filmed after those for the French – took place on an island, he was especially concerned that the crew should be distracted. Throughout the shoot he organized screenings of 16 mm films, the 'Carrosse Ciné-Club', whose programme was announced on the call sheets. Sunday 12 January at 5 p.m., a screening for the crew of *The Last Laugh* by Murnau. Tuesday 14 January, *The Magnificent Ambersons*. Sunday 19 January, *The Gold Rush*. Sunday 26 January, *Fahrenheit 451*. Then a public screening of *L'Enfant sauvage* and *La Nuit américaine* at the Cinema Gaumont. Thursday 30 January at 9 p.m., *The Vikings* by Richard Fleischer. The next Sunday at 2 p.m. it was *The Iron Horse*, the film by Pierre-William Glenn dedicated to the motorcycle of Walter Bal (the camera operator on *La Nuit américaine*). On 14 February, back to Hitchcock with *Psycho*. The call sheets were decorated more than usual with private jokes and other gags designed to keep up the crew's morale: 'secret thoughts of Thi Loan' (Thi Loan N'Guyen, the make-up artist); 'Message: to pronounce "Rolling", you have to make your mouth round like an egg, but sometimes the egg is hard and all goes badly. Stop. Cut' (call sheet for 25 January), 'Since 18 January, the world is divided into: 1) what's good for the film; 2) what's not good for the film' (27 January); or on the same day, a childishly misogynistic gag a few years ahead of *L'Homme qui aimait les femmes*: 'The male chauvinists (we have a few) are happy at the noticeable improvement of the female trousers of the crew…' Le Carrosse had created a kind of mini-studio: the company had rented an area near a park that contained several buildings, where the set for the bank was constructed as well as an editing room where work began a few weeks after the start of shooting. This was the moment when Truffaut forced himself not to pull back. 'I thought we were nuts to use the shot where Adèle writes to her parents and we see her reflected in the mirror, with grimaces and mad, wandering looks,' recalls Yann Dedet, who edited the film. 'But when you see it within the movement of the film, the shot works, it's impeccable. François had a very real sixth sense. Certainly he was always more afraid of ridicule than of anything; he never stopped asking himself "are we going a little too far…" "it's not just a little…" But for him nothing was more important than the fact that he had to convey the emotion, even at the price of exaggeration.'

L'Argent de poche (1976)
Small Change

'I practice alternation. Films are exhausting. Keeping to a discipline, keeping to a *parti pris* for a whole film is a strain. What reinvigorates you is doing the opposite, changing your activity. When you have spent six weeks staring at Isabelle Adjani's face for *Adèle H*, you rest up with the 60 kids of *L'Argent de poche*. You have to go from one discipline to the opposite to recover your enthusiasm.'

When Truffaut filmed *L'Argent de poche* in Thiers during the summer of 1975, four months after shooting *Adèle H*, he was realizing an old project. He first had the idea of a film collecting several stories about childhood, of which *Les Mistons* was one of the episodes already developed, in 1957. In 1972 he decided to make concrete this project he had so often spoken about, and took out notes written in 1957 and 1958 and then through the years. These first random notes include the story about the child who falls out of a window several storeys up and is miraculously unharmed (and who says when he gets up: 'Mimile went boom'); the one about the friends who cut each other's hair

The start of the school year and
the bubbling energy of the children.

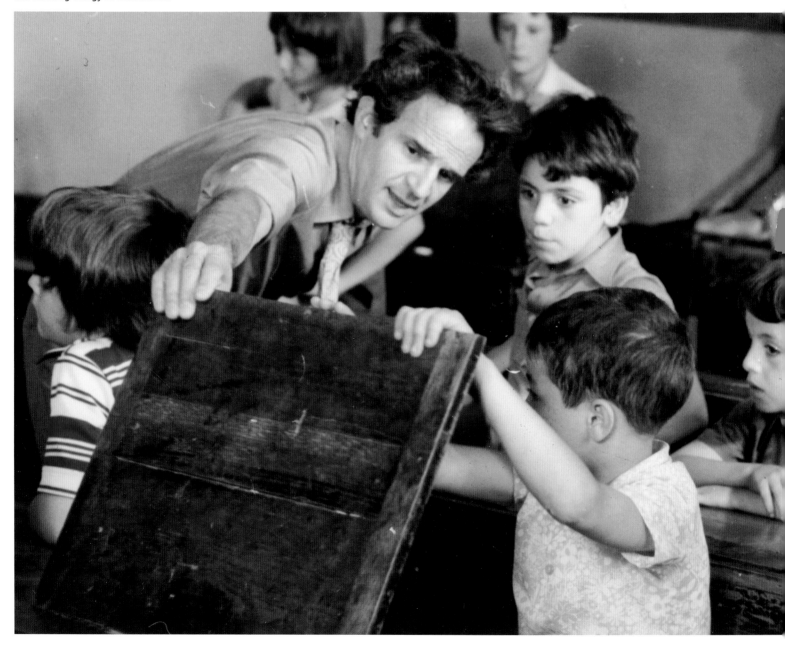

to save money they have been given for the barber's, which Truffaut tried to slip into *Les Quatre Cents Coups*; the first kiss at summer camp… Or the story that impressed him but he never found a way to develop, about the Jewish father who is hard on his little daughter because he knows he is going to be deported and wants her to detach herself from him. A mélange of stories Truffaut had read or heard told, short stories he remembered or autobiographical facts. In his notes from 1957 to 1958 Truffaut also had the intention of making a story out of his discovery of his own illegitimacy ('the family record book'), or of his mother's 'list of lovers', which he would finally film as Bertrand Morane's memory in *L'Homme qui aimait les femmes*.

In 1972, while he was re-launching several film projects, Truffaut attempted a first synthesis under the title 'Project for a Film about Children': 'For the moment this is a film of sketches illustrating different aspects of childhood. For the moment I don't see any possible formula other than a series of sketches, because it seems impossible to stick to one child, one period, one place. We can reconsider all that later. For the moment the only common trait I can find in all these different stories is children's powers of resistance, so much so that the film could be called "Tough Skin".' He envisaged collecting eight stories, disparate and unlinked, before he realized that some of them were not very usable, and that he was going to have to interweave them much more to achieve a normal running time. Several stories were about the link with the mother or the parents, survival, compensation, apprenticeship. The first, which he did not develop, was about a bubble-baby, inspired by the story of an American baby susceptible to every microbe, whose mother can only touch him through the bubble. The second is the fable of the little whistler: having an American father and a French mother, people wonder if his first words will be French or American. He avoids the problem by whistling. 'If we were going to situate this story at the time of the Liberation of France, we would have a flashback-story whose punchline would be the boy's profession: a whistling Pierrot in a music hall.' To incorporate this story, Truffaut finally had the idea of a fake newsreel projected at the cinema where the whole town is in attendance. The third story is the child who falls from the sixth floor. The fourth is the child who with a friend spends all the money his father gave him for the barber's and has no other solution than to have the friend cut his hair in the basement of his building. 'The result is so strange that the father, coming home that night after work, has only one thought: to go punch out the barber.' 'I don't have an ending,' remarked the film-maker, who found one by reversing the order of the story: he began with the anger of the father barging in on the barber, who doesn't know what he's talking about; this leads to the solution of the mystery shown in flashback: the children improvising a barber shop in the basement. The fifth story was to be one of the first scenes of the film: a boy who does a bad job of reciting Harpagon's monologue in front of the teacher but turns out to be a magnificent actor in front of his buddies when the teacher is called away by the headteacher. ('This story doesn't completely belong to me, because I believe I read it in some teacher's story, but I have to do some research on that.') Before abandoning the idea because he had decided to concentrate his account on the two or three months before the summer holiday, Truffaut looked for a story taking place at Christmas and remembered two short stories – one by Saki, the other by Leacock – with which he imagined he could easily identify. They are 'built on the same principle: a child's disappointment when he opens his presents', because in both cases the presents are strictly practical.

The seventh story was to be the one about the family record book. Summing it up, Truffaut described how he discovered that Roland Truffaut was not his father: 'A little boy of 13 alone at home discovers, while going through some things, his father's old diaries. His curiosity leads him to look in the diary for the year of his birth to see what his father might have written on that day. He discovers that his birth isn't mentioned then or later, and so learns that he is not his father's son. He finds definitive confirmation in the family record book. (The ending,

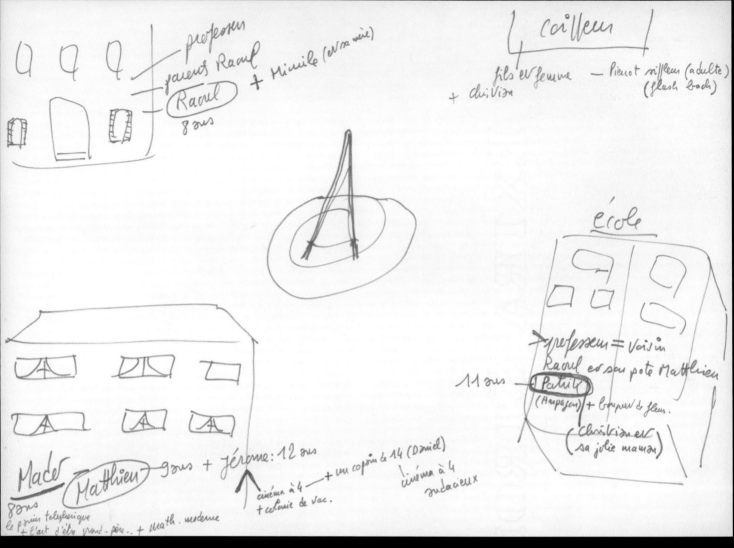

Opposite, top left: The geographical distribution of the main characters. Little Sylvie is still named Mado, like Madeleine Morgenstern, who had told Truffaut the story of the stuffed dog years before.

Opposite, bottom: Jean-François Stévenin as a school teacher.

Right: Patrick (Grégory Desmouceaux) and his father (René Barnerias).

Below: Preliminary notes, including the idea of the family registry book. Truffaut had at one time thought to have Dabadie help him write the screenplay – hence the note 'To be gone over with Dabadie'.

In a rewrite just before filming, the distribution of anecdotes among the characters and the young actors playing them was shuffled. Mathieu, for instance, is described (with a question mark) as the child who 'acts up in class... wants to sell books with Franck... cuts Raoul's hair... saves Sylvie from starvation... offers revolvers to his friends', but the story where he 'sneaks into the cinema without paying' is crossed out and turns up in the list of anecdotes assigned to Julien, the abused boy, instead.

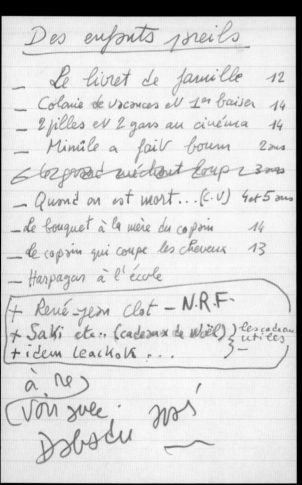

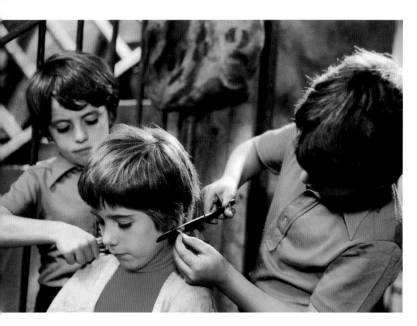

How to save a little dough by keeping the money for the hairdresser, based on a story Truffaut was told by Claude de Givray.

Calins, but no one liked that title but my daughter…') and finally *L'Argent de poche*. Truffaut incorporated some scenes he couldn't keep in *Les Quatre Cents Coups*: the goldfish 'Plic' and 'Ploc' who are impossible to tell apart; the story of little Mado, who became Sylvie, making a scene with her parents to go to the restaurant with her old handbag shaped like a toy dog; or the idea of a child who has broken a dish, throwing the pieces in the gutter to avoid getting yelled at. Just before filming Truffaut found a place in the film for a scene at a fair that he had thought of filming at the time of *Les Quatre Cents Coups* – a child who goes around at dawn and picks up lost objects: comb, nail file, coins… As he built the screenplay, Truffaut tried to stitch the stories together, to make them overlap and establish a dramatic curve, and to make the characters emerge. The *salon de coiffure* where the father of the boy with the bad haircut goes to kick up a fuss would turn out to belong to Monsieur and Madame Riffle, a beautiful young mother, with whom the young Patrick (Georges Desmouceaux, the son of Claude and Lucette de Givray) would be in love. Until the very last moment Truffaut tested the balance, looking for where to place certain supplementary sketches, and attributed to some characters he wanted to make more visible character traits or anecdotes originally intended for others. During filming he would give more to those who distinguished themselves and in whom he sensed a real enthusiasm for filming: the young Luca brothers, for example (the Sunday breakfast) with their eternal green polo shirts (the film-maker insisted that the children always be dressed the same, to make it easier for the viewer to recognize them), to whom he gave more scenes 'because they wanted to be there every day, and I managed to always find something for them'. Steven Spielberg has said that he learned how to direct children from Truffaut: by squatting down and putting yourself at their level. On the set, three or four days before shooting the scene, Truffaut gave the long final speech made to the children before the holidays, after the discovery that one of them has been mistreated, to Jean-François Stévenin, playing the teacher. He made Stévenin his spokesman in the film, asking him to read it 'to see if it works' and to try to say it as fast as possible: 'The only problem is to say all this in four minutes and thirty seconds.'

which is really the development of the situation, remains to be found.)' Truffaut wrote a long letter of explanation to his father in May 1959, during the family schism provoked by the triumph of *Les Quatre Cents Coups* at Cannes because the film-maker's parents felt betrayed: 'It happens that this revelation was a big shock for me, and I think I've already told you that I made the discovery while going through the wardrobes and finding the diary for 1932, then the family record book.' No doubt it was to avoid re-opening the breach with the man who raised him that Truffaut avoided finalizing this story in the film, preferring to show a boy whose father is unknown in *L'Homme qui aimait les femmes*.

The eighth and last story is more light-hearted, and Truffaut appreciated its dramatic and sentimental irony: 'I think that the last story of our film should be of a boy's first love. For the moment I'm thinking of a story Sacha Guitry tells in "I Have a Good Memory": A boy falls in love with the mother of a friend. He breaks his piggy-bank to buy a big bouquet of flowers, and when he offers it to the lovely lady, she kisses him on both cheeks and says: "Please thank your mama and papa."' Truffaut made it one of the film's main threads, attributed to one of the main characters and spread over several scenes. In July 1974 he wrote to Lana Marconi, Guitry's widow, for permission to use this story: 'Because the film portrays the characters of imaginary contemporary children, the name of Sacha Guitry won't be spoken, but it's easy to have a thank-you in the credits if you want.' But he ended up using a second story for the ending: 'If we decide we'd rather have an original story, I think that we should look for something on the theme of the first kiss, for example in the setting of a summer camp.' Patrick and Martine, the two lovebirds, go to a race of bikes following motorcycles but don't watch it. Truffaut later said that he insisted on finding a team of sports enthusiasts who still did that because, even for a few shots, he was attached to this personal ingredient despite its anachronism. From 1972 to 1975, the screenplay, put together with Suzanne Schiffman, was called *Les Enfants*, then under Victor Hugo's influence at the time of preparing *Adèle H*, it was called *Abel et Calins* ('I wanted to call it *Abel et*

In the screenplay of *Abel et Calins*, dated October 1974, Truffaut first developed the idea that one of the children has a crippled father he takes care of. We discover the secret on a Sunday, while we hear the song 'Children are Bored on Sunday' and the camera visits the various apartments. However, it was not yet Patrick's father, but Jérôme's, a school friend who is more bold, who doesn't hesitate to kiss girls at the cinema. Truffaut later decided to give this distinguishing quality to one of the characters he wanted to make prominent in order to fight against the succession of sketches, but this draft already includes a detail typical of a film-maker fascinated by all the devices that people have to compensate for disability: 'He has in front of him a sort of tilted tray on which he places a book, and a little stick makes the pages turn automatically.' The disability of Patrick's father is a painful secret that Truffaut treated fairly lightly as a simple fact. *L'Argent de poche* is a film of reconciliation: a lost shopping list that

could have provoked a drama in *Les Quatre Cents Coups* barely affects the guilty party, who remembers what to buy anyway. At the heart of this gentle and tender film (Truffaut himself said that he would not refuse the word *tendresse*), there is nonetheless a dark core: a mistreated child – not just 'un-treated', as Truffaut could have written of himself – perhaps even more 'at the dawn of revolt' than the Doinel of *Les Quatre Cents Coups*. In his first screenplay with partial dialogue (*Les Enfants*, June 1974) Truffaut introduced the character of Julien (Philippe Goldmann), the stranger, the new student who is not like the others. The concierge brings him into the class while Patrick is struggling to recite *The Miser*: 'Julien is more poorly dressed than the other boys in the class, and his satchel does not do honour to "consumer society".' The exchange between the new kid and his neighbour is already outlined: 'You live where? / Julien: Towards the Mureaux. The old student: There aren't any houses there, just factories. / Julien: Sure there are, because I live there.' Julien survives by ingenuity. Truffaut gave the character a personal memory that he had first given to another child: to hide his shame at not having a television, Julien has an older friend tell him about last night's broadcast so that he can talk about it himself the next day. From the beginning Truffaut planned to reveal during a visit to the school doctor that Julien has been beaten without showing the marks on his body: 'When, after his last resistances, he agrees to get undressed, we see the shock appear on the faces of the doctor and the nurse. We don't see what they've seen, but we see: Little Julien is a mistreated child.' He planned to increase the mystery by not showing the parents: 'We don't see the parents until the end of the film, but we often hear their voices.' He outlined the scene where they are arrested: 'A group of neighbours surround Julien's house, from which we see exit, surrounded by gendarmes, his mother and his grandmother followed by an odd man that we assume is the father.' From this, the surprising idea emerges that the child has been abused by the women, an idea that Truffaut reinforced by removing the character of the father and making terrible by their sudden appearance the figures of the mother and grandmother when they are hauled out by the police. These shots of the big, decrepit shack separated from the city, this scene of the arrest of a hard mother, ravaged, pressing against a ragged old woman with long unkempt white hair, a filthy, scary witch who looks as if she has never been out of her hole and is disoriented by daylight, vindicating the morality of a populace finally awakened, are striking images of almost incongruous brutality in this optimistic film. Truffaut cast Jeanne Lobre, one of his favourite actresses for this sort of little role, as this savage grandmother, and gave her a very different look from that she had in *Les Deux Anglaises* (where she played Claude Roc's concierge) or later in *La Chambre verte* (where she would be Davenne's governess). A singular violence born from the female, this is a resurgence of the concentrated savagery that runs beneath the surface of Truffaut's work, even at its most apparently reassuring.

L'Homme qui aimait les femmes

L'Homme qui aimait les femmes (1977)
The Man Who Loved Women

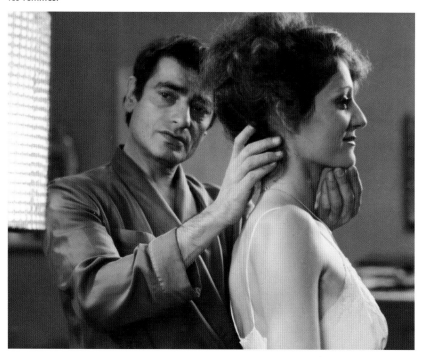

'I proceeded in the spirit of contradiction, as I often do: doing the opposite of what a Villalonga would do, a guy who's vain or sure of himself. I didn't ask myself the sympathy question. The risk, of course, is that people reject the character.' In his foreword for the film's press kit, Truffaut quoted this sentence from Bruno Bettelheim's *The Empty Fortress* as the common denominator of Bertrand's loves: 'It appears Joey didn't have much luck with his mother.' Elsewhere he recognized that the relationships a man develops with women depend on his relationship with his mother. The spirit of contradiction, the risk freely taken of not pleasing, of going all the way with his own vision, the mother's ghost – these are some of the keys to *L'Homme qui aimait les femmes*.

'Here are some of my notes on your notes; in other words: the ball is in your court, because our collaboration is like a game of tennis,' Truffaut wrote in the autumn of 1975 to the playwright Michel Fermaud, whom he had asked to participate in the writing of his next film. Because he knew that Fermaud, an acquaintance since his *Cahiers du cinéma* days (Fermaud was initially a friend of Jacques Doniol-Valcroze), was a skirt-chaser, Truffaut hoped that he would be able to provide 'verification from life', the anecdotes and the strong, somewhat incredible stories that he did not dare completely fabricate. This would also allow Truffaut to distance himself from the dangers of autobiography. He only wanted to use his personal life partially and indirectly, even if the character played by Charles Denner – anxious, haunted, intense, the 'pick-up artist with the uneasy air' who approaches women 'as if his life depended on it' – was rather close to one facet of the film-maker, of whom Bertrand Morane could be a kind of double carried to excess. Truffaut told how he had the idea for the film while shooting the episode of the girl-chasing painter played by Charles Denner in *La mariée était en noir* in 1967: 'I loved his voice, his way of speaking a text which, without him, would have sounded cynical. I therefore thought he could embody better than anyone else a man haunted by women.' In fact, the character often bears the actor's name in the first lists of stories. Truffaut would also recommend that Michel Fermaud base his work on the passage in *La mariée*, which he described 'as a trailer for *Cavaleur* [The Skirt-Chaser]', the temporary title for the project.

Only a few years later, at the end of 1974, Truffaut began putting his plans into effect. On 11 December 1974, he raised the idea of telling 'the story of a man, probably played by Charles Denner, who devotes too much time to women' in a letter to Jean-Louis Bory. This long letter was a response to an attack by the critic, who accused Truffaut, Chabrol, Demy and Rohmer of being 'co-opted by the system'; Truffaut, who defended himself by affirming that he had always chosen the subjects of his films freely, drew up a list of films to come, all strictly personal. On 13 December, as if this reaction had given him the necessary momentum, Truffaut wrote to Michel Fermaud to invite him to lunch, and wrote to him again on 16 January 1975, when he had just begun filming *Adèle*, to ask him to keep their project a secret. Suggestions for stories and notes replying to them passed back and forth between the two men from October through to December

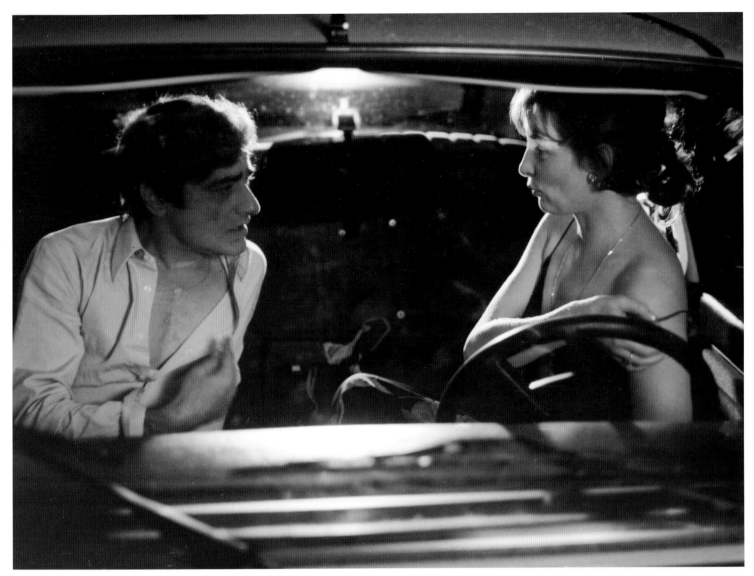

1975. In March 1976 Steven Spielberg offered Truffaut the role of the scientist Lacombe in his film *Close Encounters of the Third Kind*. Truffaut hesitated because it could have upset his rigorously programmed schedule, then finally accepted. In May 1976, before leaving for the United States, he sent Charles Denner a synopsis of the project, now called *Un Homme à femmes*. He continued developing the screenplay with Suzanne Schiffman, at first by correspondence. She then joined him on Spielberg's sets in Mobile, Alabama, where they took advantage of long waiting periods between takes to put the script in order. On 14 December 1976, Truffaut sent Jean Aurel the screenplay of what had by now become *L'Homme qui aimait les femmes*, asking him to make notes even though he was already a month into shooting. Truffaut filmed in Montpellier (then in Paris, near Les Films du Carrosse, for a number of cutaways to women in the streets) from mid-October 1976 to January 1977, when he had to go to Los Angeles to shoot retakes for Spielberg's film.

A skirt-chaser.

Michel Fermaud sent Truffaut a first list of stories, sometimes sketchy, sometimes detailed: the adventures and conquests of a Parisian skirt-chaser told with a touch of misogyny. Working as usual through the processes of

rejection and opposition, Truffaut moulded the material that has been brought to him: enthused, crossed out, transformed it and occasionally criticized it rather vigorously. 'Given all the trouble he goes to, the current ending would be a disappointment; we have to aim higher,' he wrote in the margin about the ending of the story – a woman seen in a car for whom the hero has only noted her number plate. And while Truffaut needed this varied basis of anecdotes and propositions, he would only take what interested him, what he could appropriate for his own purposes.

To begin with, Truffaut rejected a number of stories: an adventure with a taxi driver where the skirt-chaser arranges to take a particular taxi because it is the only one driven by a woman; a German camper who carries her suitcase with no visible effort right under the nose of the hero, who wanted to help her; a married woman whose child is always present; a story in a provincial town with a press officer and a splendid fashion model, the former hatching a scheme to throw the latter in the hero's arms; or a petrol station attendant in overalls who comes on to him ('Esso girl… weak'). Truffaut rejected conventional settings and situations: 'Museums. Unless a remarkable, original scene obliges us, I prefer to talk about pick-ups in museums

Charles Denner and Nelly Borgeaud, the girl who only likes to make love in dangerous places.

27 nov. 75.

Mon cher Michel,

j'espère que tu as conservé un double de tes premières notes, sinon nous t'en ferons une photocopie.

Voici à présent mes notes à propos de tes notes, autrement dit : à toi de jouer, notre colla-boration fonctionnant comme une partie de tennis.

Tu peux appeler Marcel Berbert quand tu veux afin de prendre rendez-vous avec lui. Donne-moi tes impressions sur "la Mariée" et surtout l'épisode Denner que je vois comme une bande annonce au "Cavaleur".

Amicalement,

François

la "Mariée" (coup de fondu trop vaseux)

Départ dans un sous-sol ... jambes surtout de la voiture.] - 8 -

il faut souligner

Charles les contemple, attendri, indifférent, lorsque soudain son regard se fige. Là, dans la rue à deux pas, au volant d'une voiture, une blonde adorable le dévisage. Elle a l'air de dire : Oh Monsieur, comment peut-on laisser une faible femme conduire dans de tels embouteillages ?

> CHARLES pense -
> Mais qui est-ce bon dieu ? Je la connais, je ne connais qu'elle... On dirait Kim Novak.

La fille vient d'être stoppée au feu rouge. Charles se dirige vers la porte sans la quitter des yeux renversant quelques tasses de café au passage.

> - Ah celle-là ! Quelle beauté - seize - dix sept... plus même. Dans le guide Michelin on ne dirait pas "Mérite un détour" on dirait "Vaut le voyage".

Au moment où Charles arrive, le feu est passé au vert; la file s'ébranle. Charles se précipite. Trop tard. Avec un sourire "elle" a détourné la tête et s'est éloignée. Charles relève le numéro en traversant la rue 860 AGK 75. Il s'assure que la voiture ne s'est pas arrêtée un peu plus loin et en revenant commence à fouiller ses poches à la recherche d'un stylo et d'un bout de papier. Il n'en trouve pas. A

OK. oui pour le no sur le papier de gitanes

l'intérieur du café, il sort un paquet de gitanes *presque vide et essaye de s'approcher du comptoir pour emprunter un crayon à la caissière.* Mais près de lui une fille "qu'il a déjà eue" *et qui a assisté à la scène lui tend son stylo avec un sourire complice.* Charles note le numéro et lui offre un café.

excellent

Nous retrouvons Charles dans un couloir regagnant son bureau. Il allume une cigarette et jette le paquet de gitanes dans une corbeille en métal.

Pour Michel Fermaud

A) Notes sur les histoires proposées par Michel Fermaud.

1/ L'histoire de l'enquêteuse du recensement ne me plaît pas telle qu'elle est mais il m'est difficile d'expliquer pourquoi. Ne la rejetons pas absolument. On pourra ultérieurement conserver peut-être un des éléments de cette histoire par exemple l'escalier

2/ L'histoire de la fille sur l'écran de télévision est intéressante mais je voudrais avoir le choix entre plusieurs variantes. on en

3/ L'histoire de la carrosserie rayée est presque parfaite. J'aimerais en avoir une narration détaillée et éventuellement dialoguée. Je voulais ajouter ici : au cours de sa recherche, Michel est "intéressé" par une fille de chez Hertz et prend ses coordonnées. On retrouvera cette fille plus tard dans sa vie. Ce genre de "crochets" évitera le côté film à sketches.

J'insiste sur le fait que cette histoire par sa complication et sa logique est la meilleure de toutes. Trouver une chute plus concluante, peut-être avec la sœur...

B) Le Cavaleur (titre provisoire)

(notes par Michel Fermaud.)

* le cavaleur établit des listes de femmes (qu'il a eues - qu'il espère avoir ?)

* le cavaleur fait peut-être collection de photos (restons dans le domaine de photos d'amateurs - évitons les idées liés aux photos porno)

* proposer quelques histoires de drague au cinéma. La plus compliquée (mais logique et plausible dans sa complication sera la meilleure)

* le cavaleur peut également donner un rendez-vous dans un cinéma ou avoir une histoire avec une ouvreuse.

* les musées. Sauf si une scène remarquable et originale s'impose, je préfère parler de la drague au musée à l'intérieur d'un monologue (illustré de flashes ou non)

* une femme lui paraît "facile" : il échoue

* une autre lui semble une citadelle imprenable, il ne tente rien : elle lui saute dessus

« Écoutez Bertrand, j'ai été obligée de faire ce que j'ai fait. C'était ça ou devenir folle, vous savez que je n'exagère pas. Je ne regrette rien mais vous m'aviez fait mal, très mal. Moi aussi, je me suis retrouvée cassée en petits morceaux, il fallait que je m'en sorte, absolument. Évidemment, je ne pensais pas que vous alliez souffrir autant, vous aviez tellement bien caché vos sentiments, mais, même quand j'ai su que vous étiez là-bas, je n'ai pas regretté ma décision. Je savais que, malgré tout, vous aimez la vie et que vous alliez lutter pour faire surface. »

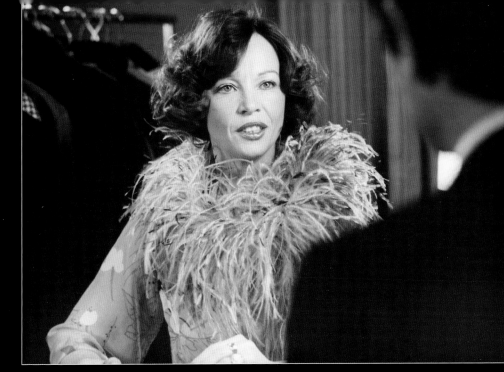

Meeting the old flame (Leslie Caron) in a key scene, the dialogue for which prefigures *La Femme d'à côté*.

Opposite page: The 'tennis game' or the process of reaction, starting from material provided by Michel Fermaud, chosen by Truffaut for his experiences as a womaniser. In one set of notes, Truffaut begins to paint a portrait of his 'skirt-chaser', who makes lists of women and collects photos ('Let's avoid all ideas associated with pornographic photos'). At the end, a sketch of an idea: 'A woman seems "easy" to him: he fails. Another seems to him a citadel that can't be stormed, so he doesn't try: she jumps on him.'

Right: An indecent idea – the comparison of the whore who walks past in the street and the mother – is communicated through quick cutting.

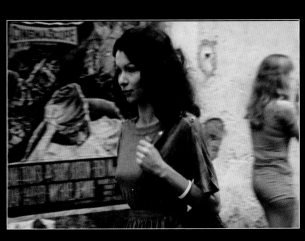

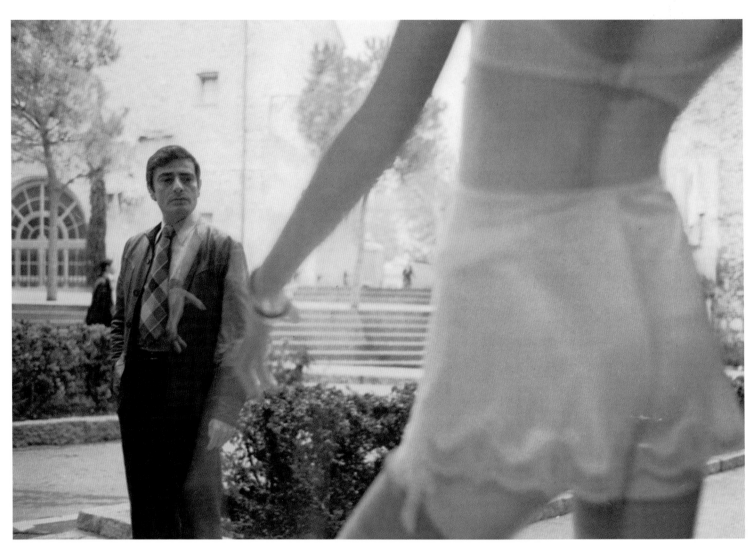

Charles Denner standing in front
of the lingerie shop.

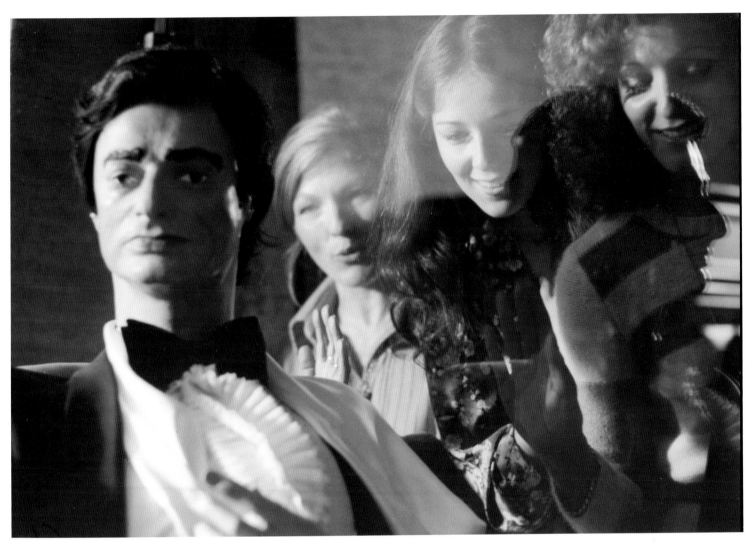

The nightmare of Bertrand Morane (Charles Denner). Among the young women reflected in the window is the film's editor, Martine Barraqué.

in a monologue (illustrated with flashes or not).' He also did away with deprecating remarks that are likely to turn against the characters. Truffaut therefore did not keep the idea that the skirt-chaser grades the women he meets, using the criteria of appearance, intelligence and performance in bed, and eliminated this definition of a female executive, 'three, seventeen, eight, only to be taken out after nightfall', but remembered it when a woman at work looks at Bernard without ever being noticed by him. He could reject a story he disliked but retain one of its ingredients: 'The story about the people who don't answer their phones disappoints me, because the Antillaise gives it a "big comedy" aspect. But the idea of a vocal pick-up followed by a meeting is seductive and should be preserved.' This resulted in the great scenes where the hero seduces the wake-up girl, 'Seven O'Clock Aurore', by telephone, at a distance. But Truffaut happily accepted the conclusion to this story as Michel Fermaud proposed it a second time: the idea of a phonecall in the middle of the night from Aurore, who just wants to talk to him ('excellent'), of a rendezvous at a café that she pulls out of, and the final twist where a woman in her forties flanked by three children says 'Adieu, Charles' at a bus-stop with the voice of Aurore ('interesting to shoot, OK').

Truffaut went browsing through the proposed anecdotes. We sense that he wanted to be seduced, attracted, provoked by something that would set his imagination going. He might grab in passing a bit of an idea that interested him from a story he removed or transformed, a detail that pleased him and could be incorporated into his conception. He jumped on the idea of the hero writing a car number plate on a pack of Gitanes ('OK... yes to the number on the pack of Gitanes'). He wrote in the margin of a story that he crossed out about a pick-up in an office canteen, in which Fermaud positioned the skirt-chaser next to the counter from where he can see the waitresses' legs: 'To be kept: a place where one can just observe legs.' However, instead of the modern setting of a canteen or a cafeteria, it became an old-fashioned laundry, where Charles Denner watches the departing legs of the unknown beauty in the fringed skirt, or a coffin being lowered into a grave at a cemetery ('Where he is now, Bernard is well placed to look at what he loved most about us: our legs.') On the rebound, an idea he liked easily suggested another, and these were often visual itches, film-maker's desires. Fermaud proposed among others the character of a married woman whose face continues to be flushed for at least an hour after making love, which gave Truffaut the idea of filming her with her hair blowing in the window of a car: 'When he takes her home, she puts her head out of the window to lose her pink cheeks.' He would film and edit for his own pleasure this shot where Nelly Borgeaud offers her face to the wind caused by the speed of Denner's car. Truffaut was, for a while, enthusiastic about a story that he finally did not keep. He was interested in the idea that Charles has an adventure with a well-known television presenter who uses the small screen to make dates with him, using appropriate signs to communicate in advance. He asked for variations on the story, and Fermaud proposed a version whose plot was a bit like *An Affair to Remember* by Leo McCarey. The hero recognizes in the television announcer a young woman he loved when she was eighteen, and who then disappeared abruptly. He writes to her, and she pretends that it is a mistake. He ends up learning that she has only one leg. We sense that Truffaut was momentarily hooked ('He looks through old photos and finds her when she was younger... then he writes to her,' he notes in the margin), then rejected the idea ('no,' he wrote in the margin of her suicide attempt and disability), but perhaps he would remember it more or less unconsciously when he introduced the character of Madame Jouve in *La Femme d'à côté*. Several anecdotes proposed by Fermaud supplied the starting points for some of the most memorable passages in the film, and the metamorphoses that Truffaut brought about in them are fascinating because they are always characteristic of his world and his style.

Agreeing with the film-maker that they needed to find a linking thread for the skirt-chaser's adventures, Fermaud imagined making Charles a writer who does not write much because women make him waste his time. Harassed by his publisher, he goes on a retreat to write, cutting off his telephone and forbidding himself to visit the places he usually frequents. But while Truffaut put this idea of a book-in-progress at the centre of his story as a pretext for the multiplicity of stories that are told, giving them an appearance of unity, he rid the idea of any posturing and avoided the cliché: Bertrand would be a man who writes, but certainly not a professional writer with a block; instead he would be an amateur who throws himself into writing for the first time, driven by a kind of internal necessity. In this way Truffaut inserted some of his co-writer's ideas that composed a more conventional portrait of a skirt-chaser. 'We're going to discover that Charles's weakness is his fear of solitude,' noted Michel Fermaud; Bertrand Morane says, more or less sincerely, that he does not dislike solitude.

As he did while working on *Baisers volés*, Truffaut invented in opposition or on the rebound. In Fermaud's notes, the aeroplane full of businessmen was a simple setting for an adventure with a stewardess, one that is quickly aborted because she is not available. But for Truffaut this suggestion also inspired an image, the idea of the hallucination and, dropping the anecdote of the stewardess, he conceived a real scene where Denner suddenly imagines each man replaced by a woman. Truffaut gave up the idea of filming the scene in a plane for budgetary reasons and moved it, to Marcel Berbert's great relief, to the waiting room at an airport rather than sacrifice it. Initially he felt the need to supply a pretext for the character's hallucination and imagined that he has asked for a tranquillizer to help him endure the flight. When he had reworked the scene in his shooting script to move it to an airport waiting room, Truffaut dispensed with this alibi, giving greater force to the hallucination, which becomes a pure projection of his hero's fantasies.

Complication and logic.

Truffaut was looking for a way to begin his film so as to give it its full fantasy value from the start. The whole extraordinary episode that opens the film and imprints it radically with the obsessive, singular nature of the skirt-

chaser as he conceived him – the story about the stranger briefly glimpsed, for whom the hero only has a car registration number, and his incredible efforts to find her – came out of Fermaud's propositions but was completely reworked. 'The hero of *L'Homme qui aimait les femmes* is the opposite of the guy who sees a girl walking in the street and invites her to have a drink,' the film-maker noted when the film was released. 'He goes to mad lengths to get them, but he never tackles them head-on. It's the complication that interests me, the detour.' Michel Fermaud proposed a precious moment of yuppie-style humour where the hero sees, in a car stopped at a red light, an 'adorable blonde who seems to be saying: "Oh Monsieur, how can you let a weak little woman drive in this traffic jam?"' Charles doesn't manage to catch up with her, but notes the number of her car on a package of Gitanes. Truffaut immediately re-appropriated the idea, adapting it to his imagination, reacting first of all by *mise-en-scène*: 'The car. Love at first sight too murky. Start in an undergound car-park... legs getting out of a car'. In other words, a first sketch of what would become the idea of the laundry. When he gets to his office Charles automatically throws away the package, then has to go through all the wastepaper baskets in the hall, and then the basement of the building, to retrieve it. (Truffaut tried to keep this idea, which amused him, until production, then gave it up for the sake of speed and clean lines.) The hero learns in a scene at the police station that nothing can be done to help him and then scratches his own car's bumper. He finds out that the other car was rented and traces it all the way back to the possible driver, or one of several possible drivers, because in Fermaud's version she could be any of several sisters. He ends up talking to the mother, who is no longer sure how many daughters she has and talks to him about one who has a photo gallery on rue de Seine, another who is a stewardess. Believing he has reached his goal, Charles ends up spending the night with the photo gallery owner, only to discover that she is the twin of the one he is looking for. 'Meeting again, weak', and 'It's something out of Boisrond-Wademant', Truffaut noted as he rejected this Parisian comedy, deleting from his film anything that could resemble the *Nouvelle Vague* reworked for the 1970s, but he still saw the part of this story that he could use if he adapted it by combining it with another: 'The story of the scratched bumper is perfect. I'd like to have a narration, eventually with dialogue, of that. And I'd like to add this to it: in the course of his quest, Charles is "interested" in a Hertz girl and takes her number. We'll see this girl later in his life. This kind of "knitting" will avoid the sketch aspect. Find a better conclusion, maybe with the sister... meeting at a bistro... cab teleph...'

While constructing his story, Truffaut was constantly preoccupied with stopping his film from appearing like a succession of sketches by establishing a narration that looked extremely tight and interwoven. Above all, by rejecting frivolous comedy, he radically transformed the character and tone of the story. If he liked the idea of the scratched bumper, he did not hesitate to take even further the paradoxical situation of a man who is happy not only to scratch his car, but to drive it into a column in a car-park in the crazy hope of finding a woman he has barely seen. A man whose every action is concentrated on a single goal, and who often, if not always, gets what he wants because he 'has a special way of asking'. 'It's as if your life depended on it,' the young girl from the car rental office tells him, an expression Truffaut used in certain texts to speak of Chaplin, of his way of escaping from misery and alienation, arguing that Charlie runs faster and further than his colleagues in the music hall 'because, while he is not the only film-maker who has described hunger, he is the only one who has experienced it'. The metamorphosis effected by Truffaut was to radicalize and push to the limit the little adventures of a banal skirt-chaser in order to describe a character for whom pursuing women is nothing less than a vital necessity: 'I realized that the company of women was a necessity for me, or if not their company, at least the sight of them.'

The basement window.

We are moving from the story of a likeable skirt-chaser in the French style to that of a man possessed by an *idée fixe*, the tension of which gradually fills up all the space of ordinary settings. Truffaut underlined this projection of the fantasy by focusing the *mise-en-scène* around his character's *idée fixe*. The idea of the street-level window in the laundry through which Bertrand sees the beautiful stranger's departure, as if through a screen, appeared in the second treatment: 'He is attracted by the silhouette of a woman he only sees from behind. When she leaves the store, he continues observing her legs, first going up the stairs and then in the street through the basement window.' And when he developed his character's spirit during his journey from Montpellier to Béziers, Truffaut began by imagining a shot that would project on to the road ahead, as if on a giant screen, his character's obsession: 'He re-sees in his mind the legs of the beautiful stranger going up the steps at the laundry. This image encourages him to accelerate.'

The punchline of the story nonetheless would remain rather complicated for some time. When he reworked the first treatment Truffaut imagined having his hero discover that the person who really rented the car had lent it to a friend who lives in Béziers, where Bertrand has to wait until the weekend to go. (The effect of speed that supports the steadfastness of the obsession would be achieved later.) And it would have been after spending only a few hours in a hotel room with the young woman from Béziers that Bertrand would have discovered that he was really pursuing the sister who has left for Canada. Reviewing this, Truffaut did away with the sexual finish – 'Don't end in hotel room, but eventual possibility' – and transferred it: 'When we find him in bed, it's with the Hertz girl.' Finally the young woman who comes to the strange rendezvous proposed by Bertrand would be made more sympathetic and spirited when she is confronted with a situation that is at once amusing and a bit thorny. In the next draft, Truffaut had the idea of the dramatic irony of the trousers (in a manuscript correction completing a thought of Bertrand while he waits at the café: 'and if she came in trousers...'), which would have the power to shatter the fantasy. 'It wasn't me you wanted to see again – it was my dress,' says the young woman played by Nathalie Baye, who already knows she is not who the man thinks she is. Truffaut had clearly asked himself when to reveal the mix-

up to the audience. On the second treatment he planned to add an intermediate scene where the young woman discusses the situation with her parents. 'When Bertrand hangs up, Martine questions her father and we learn that the car, which he rented, was lent the previous week to Marianne, Martine's cousin. Martine leaves the apartment to settle the matter.' For safety's sake, the revelation of the misunderstanding would be told twice, once to the viewer, then to Bertrand Morane. But when it came time to shoot it, Truffaut decided to give up this idea, preferring to play the impact of our surprise and the character's disappointment 'live'.

Vertigo of failure.

In the first version of his screenplay, when Truffaut started the film with the scene at the cemetery where his character is being buried, making the whole story one long flashback, the episode of the pursuit of the unknown woman was not placed first. The first version attempted a story more in the manner of a chronicle: wake-up call, watching women in the next building through binoculars, Bertrand at work, walking in the streets at the hour when offices let out, the supermarket where he observes his favourite cashier: a beginning with no connecting thread, where possibilities are explored. The idea of cutting between images of women's legs was already present. (We go from legs seen from the coffin to legs descending a spiral staircase, but for the moment there was just the first draft of the meeting at the restaurant.) Starting with the next treatment, Truffaut made the laundry episode and its consequences the opening of his film: a surer way of grabbing the viewer with the most entertaining episode possible, launched at top speed during the first 15 minutes of the film (twists, surprises and mix-ups), and the one that set the tone better than any other in the film: the power of the fantasy, the uniqueness of a character caught up in his *idée fixe* and ready to do anything to reach the object of his desire. It was also daring for the film-maker to start his film with a story combining frantic élan and failure, or at least disappointment, since his character, pursuing a fantasy that keeps disappearing, will after all turn out to have expended intense efforts for nothing. The failure is of course compensated by the substitute consummation with the girl from the car rental agency, but this is the prelude to other failures that will, more or less openly, punctuate the tale: the vindictive letter from a disappointed woman in love that Bertrand finds under his door when he goes home, and the failure with the woman who sells lingerie and prefers young boys – it is this last that triggers Betrand's need to write and the whole end of the story. (The device was already there in the first draft of the screenplay.) Not to mention the story of his break-up with his first mistress in Montpellier, which did not go all that well ('You're an imbecile, and I'll caress myself while thinking of you'), and above all the chance encounter in Paris with his great former love: a long sequence of almost six minutes, a kind of closed parenthesis whose dialogue is filled with autobiographical reminiscences, where the painful roots of the character's forward flight are exposed. This was an important scene for Truffaut who cast and directed Leslie Caron with astonishing precision, an actress who was both French and a former Hollywood star, and one who was close, as Truffaut was, to Jean Renoir. In a not entirely fortuitous echo, he had her wear a scarf with feathers like the eccentric coat Yves St Laurent designed for Catherine Déneuve in *La Sirène du Mississippi*. 'I thought of ostrich plumes,' he wrote to her before the shoot, 'because it's rarer than boa and gives the appearance of lightness that I want.'

Truffaut refused to portray as victorious this man who needs women, neither in his conquests nor the writing of his book. This is why he inserted a mishap into his film that happened to him when he was having excerpts from the notebooks of Henri-Pierre Roché typed up: the typist's rejection of the manuscript, because she is losing sleep over all these stories about interchangeable women, a condemnation by the first reader. More profoundly, parallel to the vital élan that carries his hero forwards and the obsession with movement that runs through the whole film ('the movement of your walk and the movement of your dress were very beautiful to see'), Truffaut enclosed a depressive kernel in the heart of the film, a dark mass, the 'black hole' that the 'ghost' from the past represents for Bertrand. In a nightmare, Morane finds himself metamorphosed into a mannequin in the window of the lingerie shop he often visits, immobilized and caught in an opposite situation, with avidly curious women crowding around him.

Interlacing.

This vertigo of failure at the heart of the film is concealed by the perpetual movement of the story. When he responded to Michel Fermaud's first suggestions, Truffaut also asked him to 'propose a few stories about pick-ups in cinemas' before supplying the story of the deaf-mute usherette himself. And he added: 'The more complicated (but logical and plausible in its complication) the better.' 'Logic' and 'complication' are clearly the mottoes the film-maker had given himself for his whole film. The 'stitch' with the Hertz girl defines his method. Truffaut sought to interweave threads, advancing as much as possible using the consequences or associations of ideas in a battle against multiplicity and incoherence. He developed an illusion of continuity, even if it was punctuated with gaps. The story, mixing flashbacks and evocations of different periods in the hero's life with his writing, which returns us to the present, is nonetheless riddled with gaps. Successive drafts of the screenplay are like big fluid puzzles where Truffaut is looking for the way to exploit the materials he has gathered. In the first treatment the effects are a little brief. Scenes or their consequences often happen too fast. The story of the typist returning the manuscript and refusing to type it happens very early in the story; so does the *soirée à trois* that Bertrand spends with his old flame just out of prison and a pretty cashier from his supermarket. In the next stage Truffaut had the idea of doubling certain scenes. He would have two scenes at the lingerie shop instead of one. He'd split the story of the baby-sitter, originally told in a single block, in two parts: a first scene placed in the first part of the film shows the young woman putting up her ad on the board at the supermarket; a second scene, much later, allows us to learn what happened then, while Bertrand's future editor is defending his manuscript in the editorial committee. The payoff is the famous punchline that

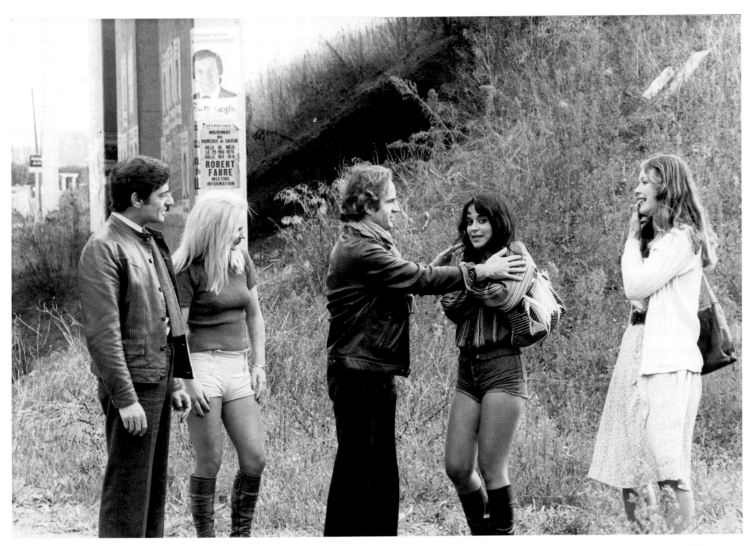

Preparing the shot where Bertrand, back from Béziers after his breathless quest for the stranger with the beautiful legs, has an almost dreamlike vision of three prostitutes who wave to trucks from the side of the road, recalling the prostitutes in the police station of *Les Quatre Cents Coups*.

supplies the scene with an ending and suggests the most searching characterization of the hero – a line Truffaut thought of when bounding off an image proposed by Fermaud. The hero gets his apartment ready for the baby-sitter by putting a baby doll in his bedroom; considerably simplifying the convoluted story developed by Fermaud, Truffaut accelerated the whole encounter with the baby-sitter: 'Bertrand rushes to open the door. Imagine the baby-sitter's surprise, after asking where the baby is, when he answers: "The baby is me!"'

Transfers.

Truffaut was trying to weave a story while the contours of certain characters were still vague and also in flux. In the first version of the screenplay, the character of the dangerous old flame who a cop warns Bertrand has been released from prison is also the beautiful usherette he meets at the cinema. The usherette (named Josiane, like the production secretary at Les Films du Carrosse) has several character traits of the future Delphine who would be played by Nelly Borgeaud (spotted by Truffaut at the time of *La Sirène du Mississippi*), who only enjoys making love in dangerous situations. It is Josiane who can't stand it when Bertrand reads in front of her and throws his book out of the window; she is also the one who sleeps on Bertrand's doorstep to make sure that he doesn't see other women; and finally, she is the one who shoots her husband when Bertrand has been weak enough to say, 'Ah, if only you were free…' Later in this first draft a certain Danielle appears, a pretty woman with long, beautiful legs whom Bertrand notices in a restaurant where she is dining with eight people. Very direct, she follows Bertrand to the lower floor of the restaurant where he is faking a phone conversation and leaves him an unequivocal note: 'Leave. I'll join you.' It is she who worries about Bertrand's star sign, who panics in the car and demands to be driven home, then throws herself on him in the car-park. It is she who says at each parting, 'The things you make me do!', and can only take pleasure in dangerous situations. This character emerged from Michel Fermaud's suggestions, where a certain Danielle pursues the hero and, more banally, harasses him on the phone, tries to make him jealous by sleeping with a younger man, pretends that he beat her and tells her husband she is at the dentist when she is with Charles – a character Truffaut called 'the threat', showing in a marginal note his intention of merging her with 'the old flame, freed from prison for good conduct'. In the next phase he would fuse Josiane and Danielle's traits to create Delphine, to whom he would add at the same time some elements that were first assigned to the character of a young girl accompanied by aged parents whom Bertrand meets in another restaurant scene: legs descending a spiral staircase (Delphine would go up some stairs to show Bertrand her legs), the idea that Bertrand follows her by car to her place, the caduceus or medical insignia he spots in the rear-view mirror, the phone-call from a café and the date made on the phone. A fusion of elements that would permit him to show Delphine with the husband she is going to try to murder, and to slip this phrase into the commentary: 'The restaurant is a marvellous place for lovers starting out, but dangerous for official couples.' Above all, achieving a richer character would help

Truffaut throw off isolated fragments and initiate a sequence with a longer, more complex story, where each gag and each reaction is part of a continuity. Dense and fast-paced, the story of Bertrand's adventures with Delphine take up considerable space in the story three-quarters of the way into the film, and even if it is composed of brief scenes built around distinctive traits, the segment is, at a running time of 15 minutes, the longest one devoted to a single character and a single adventure since the episode at the beginning. A character who, probably not by accident, is not only the most diverting, but who is also a 'deranged' character, at the limits of the condition of marginality she flirts with by way of provocation (even though her husband is a doctor and she is visibly part of the town's solid middle class). Like Marion in *La Sirène du Mississippi*, like Camille in *Une Belle Fille comme moi* – thieves, provocateurs, antisocial, each one free in her own way when it comes to love – Delphine will say that there are those who have known prison and then all the others. And it is after the time he spends with her, after this continuous ensemble placed at the centre of the film, that Truffaut can start his story over in a more disparate style, actually profiting from the brutal rupture provoked by Delphine's arrest. The idea that Delphine could not be replaced by any single woman permitted the film-maker to assemble several stories with multiple women in the same story segment and to carry his hero's logic, his rejection of any single love, to its conclusion through a series of loves without a future: the one who wants to have her nose fixed, the one who plays the living skeleton in a sideshow, the one who reads at her window, the one who pays Bertrand a visit wearing a dress with three hundred buttons…

In a short piece for *Paris-Match* in June 1973, Truffaut evoked 'the usherette's legs, which she shows off with her torch instead of lighting the steps'. (In the same article, which seems like an advance quotation from Bertrand's monologues, he said that he had 'one point in common with Hitler and Stalin: I can't stand male company after six o'clock at night'.) In parallel with the construction of Delphine, Truffaut invented the deaf-mute usherette, an idea he anticipated in a note at the bottom of his first treatment: 'Mixed in with these episodes, we'll have another that gives Bertrand a rest after the extravagances of Danielle, perhaps a ravishing deaf-mute for whom he learns the rudiments of sign language'. She is a character he developed in successive versions with the idea of the furtive sound made by her stockings rubbing together (a fantasy already evoked in *La Peau douce* and *La mariée était en noir*). In an article that appeared in *Cahiers du cinéma* in the 1950s, signed, like most of his texts in an erotic vein, with the name Robert Lachenay, the young critic had already marvelled at the rubbing of suspender-belts. Truffaut added the idea that the deaf-mute has a son whom she has punished in order to be able to spend a Sunday afternoon with Bertramd: 'This cruel news bothered me. Was it possible to feel pleasure without causing someone pain?' This memory or anecdote seems to have rolled around in Truffaut's head for some time, because he alluded to the idea of a child punished to facilitate his mother's love-life in a note in the margin of the treatment for *Baisers volés*.

The first drafts of the screenplay were strewn with an number of elements, essential or anecdotal, that were still seeking their place. While Josiane the usherette is still the character of 'the threat' who is going to be released from prison, Truffaut planned to put in Bertrand's mouth this idea for a commentary: 'He remembers: when she went to prison, mini-skirts were in fashion and Josiane's couldn't have been longer than 25 centimetres. This fashion that should have made him happy had worried him instead: he knew that afterwards they could only get longer.' When writing out dialogue during filming, Truffaut transferred this little remark to the conversation with the woman who sells lingerie.

An uninterrupted flux.

The story of the usherette's daughter allowed Truffaut to initiate a memory of his character's childhood, his relationship with his mother. (His mother kept an account of her love affairs – and he, with his book, is he doing anything different?) It is one of the bridges that the film-maker worked on building the whole length of the film, using the commentary, which he had Denner speak with a rapid delivery, to try to create an almost uninterrupted narrative flux. A certain number of these links would be created after the fact, in the editing, when Truffaut would not hesitate to rewrite the commentary at times, eventually even modifying the meaning of the images he has filmed. The film's construction never stopped changing until the final cut.

The shooting script (where all or almost all of the scenes with 'Seven O'Clock Aurore' have complete dialogue, with the dialogue generally summarized in indirect style) is rather different from the final construction. Curiously, the script does anticipate passing from the legs at the graveside to the stranger's legs at the laundry, since the cut is made on the idea, expressed by the commentary, that Bertrand was always a child. We therefore go from a model plane in the air to a wind tunnel that lets us see Bertrand doing his job, and then learn that he does not tolerate men's company after six o'clock. These everyday scenes would be moved to later in order to allow the effect of speed and the concentration of the focus around his hero's fixation that Truffaut wanted for the beginning of his film. Between the screenplay and the final film, many scenes were moved. Truffaut was visibly trying to get away from explanatory links and at the same time creating a narrative flow that could not be questioned. The scenes with the deaf-mute usherette were placed much earlier in the film, after the break-up with Fabienne, the first mistress in Montpellier (and are a comment on the resulting solitude that leads Bertrand to the cinema), while the screenplay planned having them after Delphine's arrest, the crisis from which Bertrand was supposed to emerge with the slogan 'one woman, one time.' Curiously, the series of encounters Bertrand has at the end of his adventure with Delphine was not written in the screenplay. Instead, the screenplay called for Bertrand to have a kind of moral and depressive crisis in reaction to Delphine's arrest and the ensuing emptiness, which Truffaut would modify and move to after the rejection of the manuscript by the typist: 'Still, I asked myself if it wasn't more restful to live the intrigues of

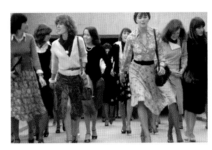
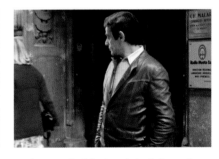

The appeal of the female body in motion: 'I realized the company of women was indispensable to me – if not their company, at least the sight of them.'

imaginary characters rather than to exhaust myself with my own, so I undertook to read all the great love stories of the nineteenth century, those that men had written after living them' (this is the text of the shooting script). Truffaut used the images shot for this (Denner in front of the fireplace with books in his hands) and rewrote the commentary so that his character asks himself, after the veto of his first reader, about how the great diarists wrote: 'How does one write when writing about oneself?' To give his character and his film their élan again, Truffaut also added some scenes that were not planned in the script which show Bertrand finishing his book – the idea that Bertrand locks himself in the bathroom for a week, cut off from daylight, and types away with two fingers without stopping until he reaches the words The End.

Truffaut also decided to move the dream sequence where the character sees himself turned into a mannequin, prisoner of the hungry looks of the women who press against the lingerie shop window. The screenplay had this taking place after Delphine's arrest and the connection made by Bertrand between his own and his mother's collections of lovers, almost as a kind of punishment. By moving it to after the visit to the doctor who informs Bertrand that he has gonorrhea and at the same time gives him advice about getting published, Truffaut disconnected it from the explanatory series and made it more unexpected. The sequence at the doctor's is itself displaced, since initially it came after the *soirée à trois*, of which it could appear to be a consequence; moving it nipped in the bud any old-fashioned moral judgement.

On the shooting script, Truffaut foresaw some possible variants. 'The dialogue with the informal "*tu*" can only work if the scene is played with low voices, as if avoiding being heard by the neighbours. Sober, uneven lighting', he noted under the scene that takes place after making love with the Midi-Car hostess. 'We can shoot a variant of the scene with the formal "*vous*".' (He went with the formal option in the end.) While he shot and edited, Truffaut accelerated his film. The film-maker decided to cut intermediary scenes in existing episodes, in particular doing without preliminaries (preliminary scenes with the Midi-Car hostess and the saleslady in the lingerie shop were cut), deliberately emphasizing the dryness, the immediacy of the compulsion of a character for whom the sexual encounter has to happen immediately, right now ('Why not tonight?'), even if he prefers to take his time at other moments ('Something will happen between me and this woman someday. I'm in no hurry'). The editing therefore made use of straight cuts: with the Midi-Car hostess we go straight from the invitation to dinner to a big map in her apartment showing an island where there are only women; Bertrand is already getting dressed and only pauses to show her what shape glasses would suit her face. Added to Truffaut's uneasiness about filming certain love scenes (the scene of three-way was the only one he ever had storyboarded in his life, so as not to be caught short) was Denner's modesty – the actor refused to be filmed in bed with a woman or even to take off his shirt. The resulting gaps only reinforce the compulsive nature of the protagonist.

Bertrand's childhood.

Truffaut also removed a few complete stories during editing: he cut a fairly complicated series of little scenes placed at the beginning of the screenplay where Bertrand, perched on a toilet seat, watches the office opposite, full of girls, with a pair of binoculars, then tries to get one of them on the phone (using the phone-book arranged by street names), only to discover his mistake: the one he thought he was talking to keeps talking after he hangs up. Also cut was a scene in the military barracks where Bertrand recalls the soldiers' enthusiasm when the magazine *Nous Deux* arrived, which was to lead to a comment that was fundamental for the character: 'It was probably at that moment of my life, continually surrounded by men from morning to night, that I realized that women's company was indispensable for me... if not their company, at least the sight of them.' A comment Truffaut would attach instead, in the finished film, to Bertrand's childhood games with Ginette, his first love games. Truffaut developed other scenes during filming, notably the flashbacks to his hero's childhood, having found an adolescent who resembled Denner and taught him the same mannerisms: a certain way of moving his head, of presenting his profile, a certain seeming awkwardness. The games of hide and seek with Ginette were not in the screenplay, just as the scene where Bertrand recalls how his mother used to walk around half-naked in front of him – 'less to provoke me, obviously, than to prove to herself that I didn't exist' – was absolutely not written or planned. Truffaut ironically ended this scene on the manhole in which young Bertrand threw his mother's love letters ('the mysteries of the mail are unfathomable'). He had written a first version of this scene in 1958 in his preparatory notes for *Les Quatre Cents Coups*: 'Antoine exists so little for his mother that she will casually walk around the apartment in panties and bra in his presence; it's the outfit she's wearing when she gives him money for shopping.' What he omitted in his first film he dared show behind the screen offered by the character of Bertrand Morane and the virtuosity of his story, but without planning to do so in advance: it is as if the crystallization of the shoot permitted Truffaut to free this memory and finally make it into a scene in a film.

Mother and whore.

In the first version of the screenplay, the writing of the book begins with a flashback to childhood: 'He remembers his mother, a very pretty woman, who walked in the street with a furious expression to discourage men.' No mention is made as yet of any resemblance between the mother and a fast-walking prostitute. It was in his shooting script that Truffaut made this stunning connection, the indecency of which he would put across via the combined speed of the image and the text: women who walk in the street and prostitutes who walk rapidly up and down the boulevards create doubt in men's minds, as does his mother, who also walks very fast in the street. In the text of his screenplay Truffaut went so far as to write this terribly explicit sentence, even if it took the form of a negation: 'My mother, who was not a whore, at least not a professional, walked very fast in the street with a furious expression on her face, probably intended to discourage men.' He no longer

needed that explanation when he had the idea – a particularly impudent one – of having the mother and the prostitute played by the same actress, whom he merely gave different hairstyles and outfits. He did not film them in the same way either: whereas he filmed the prostitute in a single, continuous backward dolly as she saunters down the street, he fragmented the mother's body, first filming her bust, then her legs exposed by a very short pleated skirt. This surgical precision of the *mise-en-scène* makes the mother – whose first appearance this is – responsible for her son's fetishism without a word being said. (Several cutaways follow showing women's legs in motion throughout the city.) The unprecedented violence of this abridgement, which Truffaut hid with speed, by passing on to something else without delay, diverts the viewer, who is no longer quite sure what he has seen.

With its outbursts and with the sudden telescoping (like at the beginning of the film when prostitutes Bertrand sees by the roadside returning from Béziers dissolve to the face of the Midi-Car hostess calling after him, 'If you have a problem, come and see me'), *L'Homme qui aimait les femmes* is one of Truffaut's least orderly films, one of the ones where he let himself go furthest in representing the indecency of desire and its antisocial character. He risked portraying a profoundly, violently antisocial character and accompanied this with a radical *mise-en-scéne* that refused any embellishment, capturing the movement of bodies and the intensity of faces against deliberately neutral backgrounds, to the point of being visually unappealing. The world outside the fantasy is reduced to the minimum; non-female secondary characters are also reduced to a minimum whenever possible (like the insurance man Bertrand gets on the phone, to whom Truffaut lends his own voice). The settings are everyday, the shots are often tight, as if the character only sees of the world what might serve his desire. The fragmentation and movement of the female body demand fragmented editing; this is a film where there are relatively few long takes, the film of desire's urgency, of the naked impulse, as in *La Peau douce*. The *mise-en-scène*, less aesthetic, less elegant than the period films of love and obsession (*Les Deux Anglaises et le continent* and *L'Histoire d'Adèle H*), has devolved into the driving power of the fantasy.

'I am not there. I watch everyone[…] The government doesn't like us, we disturb the organization of the world. Sometimes I feel like a thief who profits from society but refuses to take part in it.' If Truffaut finally removed these diatribes he had planned to include in the commentary, it was because the film had rendered them superfluous. But he was still careful to confront the indecency of his subject from behind the mask of a lively, constantly diverting story. He also misdirects us by seeming to settle down, after two thirds of the film are over, to a third act that is more conventional than what proceeds it (the publication of the book, the promise of a love affair with the editor). Even here the feigned reconciliation is subverted by the melancholy encounter with the 'ghost' and the character's final gesture, reaching out to seize his obsession one last time. (Truffaut explicitly compared this to Father Grandet wanting to seize a gold cross on his death bed.) The failure of *La Peau douce* 12 years earlier no doubt discouraged the film-maker from pursuing dry subjects, as the failure of *Tirez sur le pianiste* had discouraged pure fantasy. Caution born of these experiences made it impossible for Truffaut to expose his subversive side without some concessions (if we take the editor's amiableness to be one), and above all without a seductive story, this apparent seduction being what enables him to smuggle in, with an innocent air, every indecency.

La Chambre verte

La Chambre verte (1978)
The Green Room

Julien Davenne (François Truffaut)

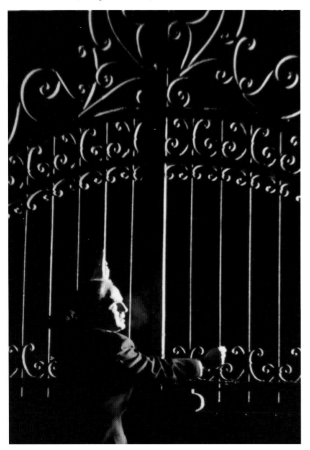

'There are far, far too many dead whom I loved around me, and I made the decision after the death of Françoise Dorléac not to attend any more funerals, which, as you can imagine, does not keep sadness from being there, darkening everything for a while and never being completely obliterated, even after years have passed, for we don't just live with the living, but with all those who have counted in our lives.'

Truffaut wrote these words of condolence in February 1970 to Tanya Lopert on the death of her father, Ilya Lopert, the head of United Artists in Europe, who had been one of the production partners of Les Films du Carrosse. A little more than seven years later Truffaut made a film in which he himself played the main role, like someone writing 'a letter by hand rather than by machine', where he told the story of a man haunted by the obsession of refusing to forget and impelled by the desire to offer his dead a forest of flames, a great celebration. It is one of his most directly personal films, even if it hides behind the adaptation of themes taken from Henry James. It is also one of the strangest and untidiest ones, which he made as cheaply as possible because, while he was prepared to take the risk involved, he knew that the film had little chance of being very successful.

In the years 1972–3 Truffaut received from Diane de Margerie a copy of *The Altar of the Dead*, the James story of which she had just produced a new translation. She inscribed the book to him with this dedication: 'For François Truffaut, this copy of *The Altar of the Dead*. My favourite James novel. The one of which James wrote that he no longer remembered a time when he hadn't "carried" it within him.' When he was young James had lost a beloved cousin, Minnie Temple, barely 20 years old, and this loss stayed with him all his life. *La Fiancée disparue* (The Vanished Fiancée) was an an early title given to *La Chambre verte* and remained attached to it for a long time. At the beginning of 1974 Truffaut read a lot of James and actively looked for books by and about the Anglo-American writer. In February he brought the five-volume biography of James by Léon Edel back from the United States, as well as James's autobiography, which had not been translated into French, and submitted it to the publisher floriana Lebovici, who was the wife of his agent. In the first days of July 1974 he asked his friend the Japanese film critic Koichi Yamada (who had translated the 'Hitchbook' and *Les Films de ma vie* into Japanese) if he could find information about the cult of the dead in the culture and literature of his country for him: 'I have started making notes with the idea of making a film on the story of a man who has a cult of the dead and spends much of his time celebrating people he has known or loved who are dead. I thought I should be able to find many details on this theme in Japanese literature.' On 21 July he sent Jean Gruault a contract to write *The Altar of the Dead*, a contract which he acknowledged was 'not fabulous' because this was a trial project that he was not yet certain he would be able to realize. He indicated that this arrangement would be reviewed if the film ended up being made under normal conditions. According to Jean Gruault the contract for *La Chambre verte* was, in the end, relatively fabulous compared

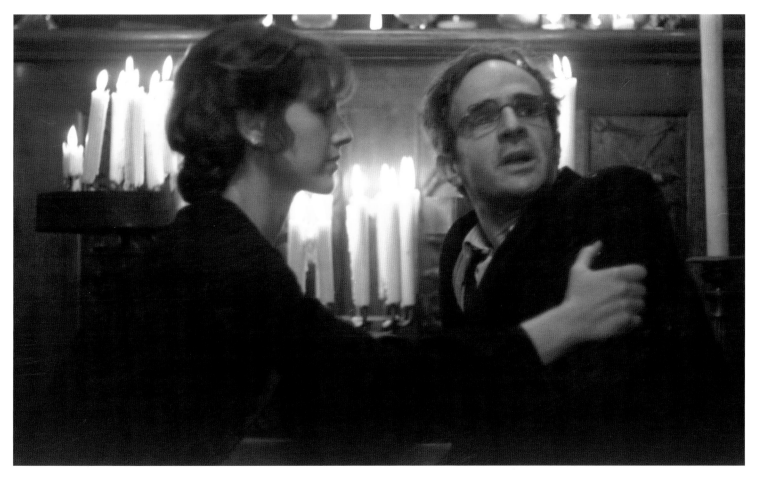

'A forest of candles… A great celebration.'
Cécilia (Nathalie Baye) and Julien Davenne
(François Truffaut).

Previous pages: Truffaut in his film.

7.

Voilà la grande scène

Il comprit alors deux choses : d'abord, qu'au cours de tant d'années, elle n'avait jamais entendu parler de sa grande amitié ni de sa grande querelle ; ensuite que, malgré cette ignorance, bizarrement, elle donnait aussitôt une raison à sa stupéfaction.

— C'est extraordinaire, dit-il enfin, que nous n'ayons jamais su !

Elle eut un faible sourire, qui parut plus étrange à Stransom que le fait lui-même :

— Je n'ai jamais, jamais parlé de lui.

Il parcourut la chambre du regard.

— Pourquoi donc, si votre vie était pleine de lui ?

— Je pourrais vous en demander autant : votre vie aussi n'était-elle pas pleine de lui ?

— La vie de tous, de tous ceux qui ont eu le merveilleux privilège de le connaître.

Après un instant Stransom ajouta :

— Moi non plus, je n'ai jamais parlé de lui, car il m'avait fait du tort — il y a quelques années — un tort inoubliable... Je vois vu le bien...

— Je vois Non, je sais que les choses se pris il était coupable....

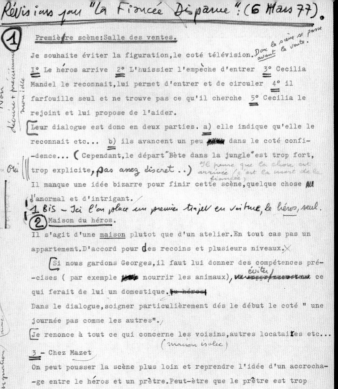

① Première scène : Salle des ventes.

Je souhaite éviter la figuration, le coté télévision. Donc la scène se passe avant la vente.

1° Le héros arrive 2° L'huissier l'empêche d'entrer 3° Cecilia Mandel le reconnait, lui permet d'entrer et de circuler 4° il farfouille seul et ne trouve pas ce qu'il cherche 5° Cecilia le rejoint et lui propose de l'aider.

Leur dialogue est donc en deux parties. a) elle indique qu'elle le reconnait etc... b) ils avancent un peu dans le coté confidence... (Cependant, le départ "Bête dans la jungle" est trop fort, trop explicite, pas assez discret..) Je pense que la chose est arrivée (c'est la mort de la fiancée)

Il manque une idée bizarre pour finir cette scène, quelque chose d'anormal et d'intrigant.

1 BIS - Ici l'on place un premier trajet en voiture, le héros, seul.

② Maison du héros.

Il s'agit d'une maison plutot que d'un atelier. En tout cas pas un appartement. D'accord pour des recoins et plusieurs niveaux.

Si nous gardons Georges, il faut lui donner des compétences précises (par exemple nourrir les animaux), éviter ce qui ferait de lui un domestique.

Dans le dialogue, soigner particulièrement dés le début le coté " une journée pas comme les autres".

Je renonce à tout ce qui concerne les voisins, autres locataires etc... (maison isolée)

3 - Chez Mazet

On peut pousser la scène plus loin et reprendre l'idée d'un accrochage entre le héros et un prêtre. Peut-être que le prêtre est trop "moderne", trop humain et que le héros, lui, réagit comme un partisan de Monseigneur Lefèvre...L'interet de cela c'est de créer du conflit sur l'écran, de donner à penser qu'il y a hostilité de la part du héros à l'égard de la religion (cela nous aidera plus tard à faire

(*) parmi ceux à : l'un qu'il avait oublié et dont il s'en souvient en rencontrant un type qui leur ressemblait...

(*) Autiberti : sois déférent avec les chefs... obéissance... fais son devoir...

(*) Cocteau : ce que les autres te reprochent cultive-le, c'est toi-même...

(*) Mal jeune, très en retard, sans précocité...

(*) Un qui aimait sa maladie... pas triste de mourir... il a suivi en l'évolution de son mal en curieux...

(*) Il n'offrait jamais un livre sans en couper les pages...

 " Je vous les ferai connaître, tous,
 progressivement ... "

(*) Je voudrais pouvoir vous communiquer le timbre de leur voix rompre le silence dans lequel ils sont enfermés.

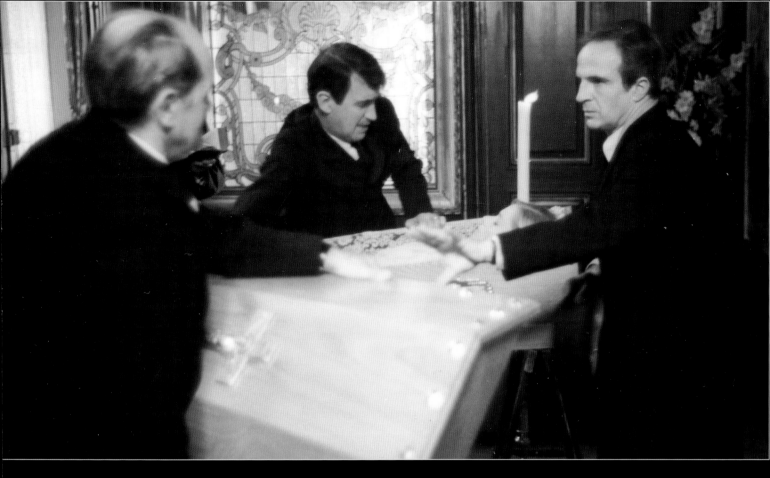

Opposite page: Truffaut's annotated copy of Henry James's *Altar of the Dead*. 'Here is the big scene', Truffaut wrote on a page where the hero learns that the woman he loves mourns a man who, once his friend, became his enemy. On the right, a list of suggestions for Jean Gruault that Truffaut drew up after the fourth version of the screenplay.

Opposite page bottom: On a facing page of the shooting script, Truffaut sketched the big scene, written at the last minute, in which the dead who are honoured in the chapel are presented. The capsule descriptions of his dead that Davenne gives Cécilia appear for the first time.

Right: a page of the shooting script, marked 'Attention: Here the snow begins to fall ... '. After *Tirez sur le pianiste* and *Fahrenheit 451*, Truffaut liked to end his films in the snow.

ATTENTION:
A partir d'ici toute la neige...

— 100 —

58. APPARTEMENT CECILIA. INTERIEUR. SOIR 58.

Cécilia est en train d'écrire une lettre à Davenne :
"Vous refusez de me parler, accepterez-vous de me lire ?"
Elle ajoute qu'elle craint ses réactions, qu'il est imprévisible et qu'il lui fait peur...
"Comme vous, je sais qu'il n'est pas facile de vivre avec les vivants... c'est plus simple avec les morts car ils sont enfermés dans les murs transparents de notre imagination... Les morts sont silencieux, patients, irréprochables. ~~mais vous et moi nous n'avons pas la même façon de les aimer; vous, vous aimez les morts contre les vivants "~~
~~Cécilia ajoute qu'il lui est arrivé, parfois, de se demander si Julien n'en venait pas à~~ souhaiter la mort de ses amis afin d'établir avec eux des relations "totalement harmonieuses".

Cécilia termine sa lettre en disant à Julien qu'elle l'aimait, qu'elle n'a pas osé lui montrer ses sentiments et qu'elle l'avoue aujourd'hui car, de toutes manières, c'est trop tard *et qu'elle a compris que Julien...*

'éventuellement avant.. mais quand ?

(Variante : ... vous n'avez rien compris... je vous aimais... j'aurais je voudrais être morte pour être aimée de vous comme je veux l'être ...)

possédée ...

assurer écriture sur visage
Cécilia

to the screenplays he had written for Truffaut before, all the more because he had in the meantime – starting in 1975 – begun working with Resnais for higher fees.

With its bold, difficult subject, *La Chambre verte* is one of the Truffaut films that was written with the most experimentation, with new starts and back-tracking. It would take three-and-a-half years and seven or eight drafts (as many as a dozen if you count intermediate steps) before the film eventually assumed its final form. To the end, Truffaut went through alternating periods of enthusiasm and discouragement about the text and the subject. From Bombay, where he was back in the role of Dr Lacombe to allow Spielberg to make a few more shots for *Close Encounters*, he wrote to Gruault in February 1977: 'The screenplay is superb and I'm very happy. I only need to work with you for three days in March before letting you write the final version.' Which would be far from final, because a few months later, in June, he told his American critic Annette Insdorf that he had put his next shoot, planned for September, off for a month: 'I'm having a lot of trouble with the screenplay (drawn, confidentially, from *The Altar of the Dead*).' For more than a year, from mid-1975 to the beginning of 1977, he even put the project aside. Whereas he had thought for a time that he would film *La Fiancée disparue* before *L'Homme qui aimait les femmes*, he decided to hurry up and film the latter project first, in 1976, and then in 1977 *L'Agence Magic*, a screenplay he was developing at the same time with Claude de Givray and Bernard Revon about the world of the music hall. (He would put off *L'Agence Magic*, which was set in Africa, until much later and finally did not have time to make it.) After finishing *Adèle*, his relations with Jean Gruault, who did not like the film, cooled for a few months. 'I don't absolutely detest misunderstandings, but I believe our friendship should not permit itself to be breached by silences, of which I am originally responsible,' he wrote to him in November of 1975. 'First there was my disappointment with *The Altar of the Dead* [a third version his co-writer had given him in March 1975], and then your disappointment with *Adèle* on screen. As far as *The Altar of the Dead* is concerned, I gave you a framework that was too rigid to permit you to invent and you did your best. I liked your text better re-reading it, and I'm ready to rework it with Suzanne before sending you the fourth version.' It was not until the start of 1977 that they would work together again in a continuous fashion, doing back-to-back revisions, until the shoot in Honfleur during October and November 1977.

Three stories by James.

At the beginning Truffaut asked Suzanne Schiffman to write a résumé of what the film could be if it were just a version of the story *The Altar of the Dead*. The main ingredients of the story that would appear in the finished film are the idea of a character who devotes himself to worshipping his dead in the chapel of an abandoned church, in a cult made up of a forest of candles on an altar; his encounter in the church with a woman he does not know who at first discreetly shares in the hero's celebration; the idea that the figure of a dead person rises up between them, a former friend of the hero with whom he had a serious disagreement and whom he refused to admit to

the circle of his dead, whereas this man is the only one to whom the woman devotes her thoughts. During the course of the story the hero is confronted by a friend who has come to visit him with his second wife, then crosses the street when they meet a second time in order to avoid saying hello, a situation Truffaut decided to dramatize by opening his film with the laying out of this character's first wife. The hero's attachment to his dead fiancée was still hardly exploited, and for now his encounter with the woman in the church occurred late in the story. After this first résumé Truffaut planned to incorporate situations taken from another James story, preferring to glean his ideas from the same world and planning to apply 'a James solution to a James problem', in the same way that he once said he was looking for 'Irish solutions to Irish problems' when he was adapting the work of William Irish. He wrote to Gruault with this idea, recommending that he read *The Friends of Friends*, the protagonists of which, before knowing one another, each lost a loved one whose death they felt at a distance at the moment it happened (an idea that would be used in the dialogue for the scene where Davenne drives Cécilia in his car and she brings up this phenomenon that links them). He also suggested that Gruault use *The Beast in the Jungle*, one of James's most complex and beautiful stories. 'I see the relationship between the hero and heroine as being a bit like that in *The Beast in the Jungle*; that is, she is in love with him from the beginning (and she is conscious of it) whereas he is in love but without knowing it, probably because he doesn't know it is possible to love twice in one lifetime. Here we find a theme we are familiar with: the definitive and the provisional.' James's hero, possessed by an *idée fixe* that troubles and haunts him, waits all his life for an event, perhaps a terrible one, which he believes he is destined to experience and which will overturn his whole existence. He passes by this event without knowing it and passes by the young woman who secretly loves him. Because she shares his presentiment of the mysterious 'thing' that is tracking him and could pounce on him at any moment, like a beast hidden in the jungle, she watches over him for years until she dies, at which point he discovers at her grave that the 'thing' he feared so much was their common vigil and realizes the extent of his blindness. The incorporation in the story of these rather indirect Jamesian themes was at first awkward and quite artificial, as the film-maker had foreseen: 'The problem with James is that things are never said directly, and we can't permit ourselves to be that vague in a film.' All the first drafts of the script are studded with abstract and fairly obscure conversations where the characters evoke the 'thing' the hero is expecting, which he spoke of to the heroine when they first met in Italy years earlier. She knows something about him that he will never guess: she thinks the 'thing' has already happened, she tells him the first time he visits her at home, just before he discovers the portraits of the former friend for whom he now feels great loathing. The hero cries out at that point: 'This is the thing that had to happen; you have shattered my life, everything is indifferent to me, you have destroyed my only happiness'; and she replies: 'No, you're wrong, it isn't this. And nevertheless, it has already happened' (fourth version). Truffaut ended up removing this aspect of the story, replacing all the cryptic conversations about

the 'thing' that is coming with conversations about the dead, the attention we pay to them and the attention we neglect to pay, their solitude in the cold earth of the cemetery. Concentrating on the subject, he constructed this film carefully bit by bit so that everything related to the theme.

In his first attempts at a script, Gruault tried to mirror James's story. In the first very long résumé the hero, still named Stransom as he is in James's *The Altar of the Dead*, goes on a trip and overhears a conversation between two women on a train. One tells the other about a book she has just read, *The Beast in the Jungle*, and 'the similarity between this story and his own troubles Stransom'. Truffaut rejected that idea with a categorical 'no' before proposing an equivalent that Gruault developed in the next draft, which turned out not to be any better: Ferrand (the character is now temporarily named after the director in *La Nuit américaine*) hears of the story of *The Beast in the Jungle* while watching a programme about literature on television. This reflection of the film-maker's dedication to the programme 'Apostrophes', which he watched every Friday night ('The TV commentator: This is a very welcome new edition. This book is the story of a man etc.'), is a mediocre idea, a bit heavy-handed, and does not appear in any following drafts.

What Truffaut kept of James's story is the idea of an encounter that has already taken place between his two characters. This is a constant theme in his films, where meeting again is always preferable to a first encounter, with an added subtlety borrowed from James: the hero doesn't remember where they met, and it is the woman who recalls their first meeting during a storm in Italy. This is when Truffaut began to disengage himself from the source (the story is no longer mentioned) and instead to incorporate a situation in his story and fuse it with the rest. ('The "Beast in the Jungle" beginning is too strong, too explicit, not discreet enough,' he noted on this version.) It is in this same treatment (the fourth, written following his instructions and delivered to Carrosse by Jean Gruault at the beginning of 1977) that we first find, as a way of staging the encounter, the idea of a scene in an auction house where the hero is looking for a ring that belonged to his dead fiancée, and where he meets the young Mademoiselle Mandel, who deals with objects from the past that belonged to the dead.

A marriage proposal.

For this film, Truffaut was also interested in the theme of a love story that never happened, the hero's blindness. He knew he would never 'put across' his theme of attachment to the dead unless he did it under the cover of a promised love story, even one that never comes to pass. In the first versions the character of the young woman appears fairly late, in the second part of the story; he meets her by chance at the cemetery and sees her again at the chapel after she discovers it. In the version from the beginning of 1977 their meeting is moved to the beginning of the film, and the character's presence begins to permeate the story from beginning to end. This is the version where Truffaut and Gruault begin to give Cécilia a faint Proustian air. The text indicates that she lives at 18 rue Bergotte

(the writer admired by the narrator of *La Recherche*), and during her second conversation with the hero she tells him something she read in a book that has just been published (at this point the action is set in the 1920s): 'Our memory and our heart are not big enough to be faithful. We don't have enough room in our present thought for both the living and the dead.' It is also in explicit reference to Proust that the idea appears that the hero 'never telephones anyone personally'. His housekeeper 'consults a blackboard where phone numbers and other information are written (the kind of *aide-memoire* used by Céleste Albaret, cf. *Monsieur Proust*, p. 384).' As happened during work on *Les Deux Anglaises*, these direct borrowings from Proust later became more hidden, even if we can see great similarities between Proust's writing about the death of loved ones and the death of the narrator's grandmother, and the impossible obsession with fidelity that is the basis for the character of Julien Davenne. As an epigraph to the seventh draft of the screenplay, which Truffaut assembled using scissors and paste at the end of summer 1977, incorporating new scenes and new versions of scenes on sheets of onionskin paper covered with his handwriting, he used a quotation from Proust that he would use again in the publicity material for the film and in numerous interviews: 'It isn't because others die that our affection for them grows weak, but because we ourselves die.'

As he made the screenplay his own, Truffaut began building up Cécilia's presence and her relations of familiarity and disagreement with Davenne, which still had to do exclusively with the question of fidelity to the dead, and always would. Reworking a scene of witty conversation from the fourth treatment, where Gruault suggested that the hero give the heroine a ring for her birthday (although it is not her birthday) as they come out of a concert to which he has taken her, Truffaut, who wanted every scene to be about the theme of paying homage to the dead, even if his character came off as crazy, radicalized the situation: Davenne shows Cécilia the altar he has built in the chapel and asks her to become the guardian of the temple with him. He no longer gives her a ring, but the key to the temple, offered as if it were a ring (sixth draft). 'Now I have something to ask you,' he says to Cécilia after receiving her at the chapel. 'What follows should be like a marriage proposal,' Truffaut noted on the last revision of the screenplay before preparation of the shooting script. During filming, following through this idea, he specified in the margin of the scene: 'Important: for the first time Julien calls Cécilia by her first name.' Fairly early on he asked Jean Gruault to think about a letter the heroine writes to the hero when she despairs of catching his attention, a letter whose essence he mapped out in the margins of a fourth version of the script: 'In the letter, she explains to him that it is not easy to tell him certain things, so she's going to write them. The letter is composed of elements from *The Beast in the Jungle*, humanized and related to our main theme[…] You shouldn't love the dead against the living. The letter ends with a barely veiled declaration of love.' And he added next to this: 'Motivation: you are unpredictable, you frighten me. I like writing to you better than speaking to you.' On his shooting script Truffaut jotted down more lines to complete the violence of this

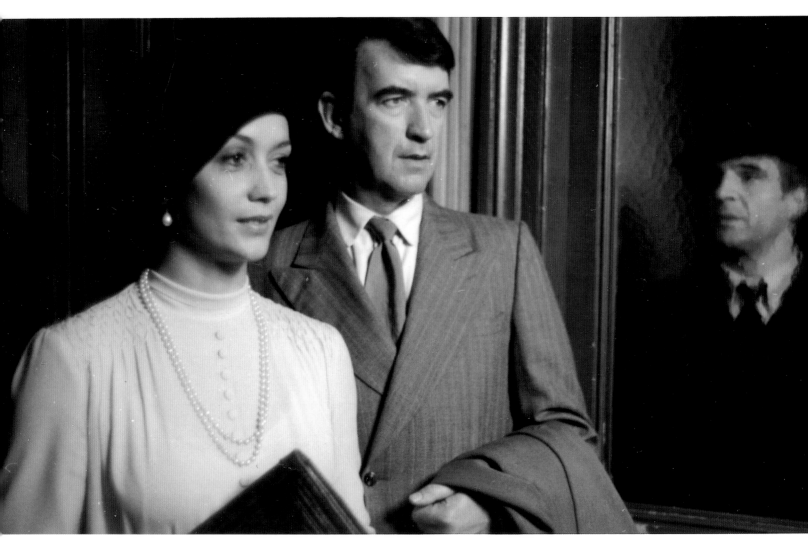

Davenne refuses to accept his friend's
re-marriage: 'Geneviève was blonde,
the new Madame Mazet's hair is dark
as ebony. I imagine that for him only
the colour of the hair has changed.'
Marie Jaoul, Jean-Pierre Moulin and
François Truffaut.

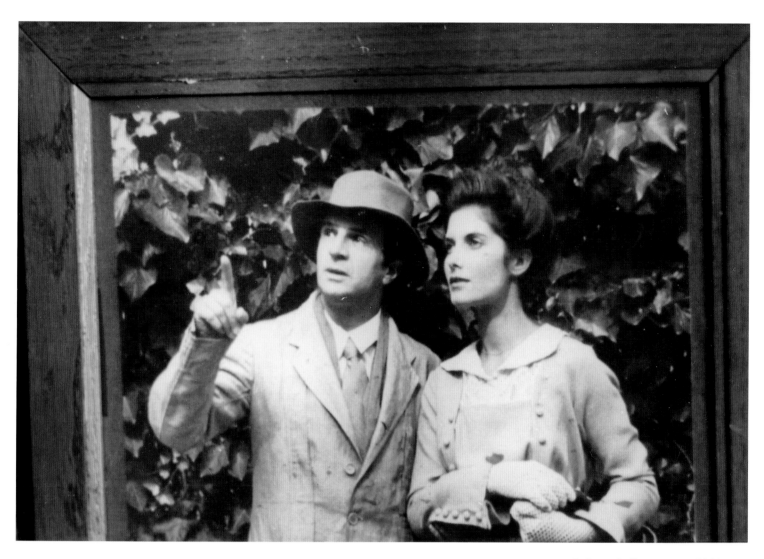

A photo of Julien Davenne with his wife (Laurence Ragon) on the wall of the green room.

letter that his hero – who is dying already and has been for some time – receives too late: 'You don't understand... I love you... Sometimes I wish I were dead so I could be loved by you as I want to be... Possessed...' ('I want to write to you today about things I never dared speak to you about, because you are unpredictable and your reactions frighten me,' would be the definitive text. 'I know that to be loved by you I would have to be dead.') 'Please note: now the snow starts falling,' he also wrote in the margin of this scene in his shooting script, as if the final movement could only be accompanied by snow, as at the end of *Tirez sur le pianiste*, of *Fahrenheit 451* or of *La Sirène du Mississippi*.

Truffaut advanced to the heart of his subject by successive levels. During a visit by the young woman to the chapel he added, in the seventh draft, a scene where Cécilia confronts the dead woman, looking in the eyes of her portrait. He heightened the conflict: for example, when Cécilia tells Davenne that they have in common the appearance of dear ones at the moment of their death (the idea taken from *The Friends of Friends*), he added a conclusion that sets them at odds with one another. 'We're the same,' says Davenne, but Cécilia rejects this idea: 'No, because you love the dead against the living.' Conversely, further on he rewrote the beginning of a scene during a chance encounter at the cemetery, a kind of amorous reconciliation: 'You don't want to see me. / I thought it was you who didn't wish to see me.' In the film Cécilia, amused, points out to Davenne when he visits her home that he does not even know what colour her eyes are. ('Claims on me, you want to have claims on me?') This is one of the rare moments when Truffaut the actor allowed Davenne to smile, just before his cataclysmic discovery of the ties between Cécilia and Massigny, the friend he has renounced. This memory of friendship betrayed is the great underlying issue of the story, because their irreconcilable difference over this dead man opens an abyss between Davenne and Cécilia, doing as much to render their love impossible as his attachment to his dead wife. While filming, Truffaut, still trying to balance the severity of his subject matter with romantic suspense, decided to let the viewer know before his hero. Creating a mystery, he planned to show Cécilia secretly attending Massigny's funeral: 'Burial Massigny. [...] Distinguished people... A beautiful funeral monument built on a plinth... An insignificant speech... Then a slow pan reveals off to the side of the group, hidden behind a tree, Cécilia alone, in tears.' He also added two small scenes emphasizing the chance that Davenne and Cécilia have missed: Davenne tries to phone Cécilia after the shock of the visit to the artisan and his rejection of the mannequin that he had ordered. Lying face downwards, Cécilia lets the telephone ring without answering it, and we see not far from her a portrait of Massigny like the photos we have seen of him in the newspaper where Davenne got carried away writing his obituary. This refinement by small touches done while filming is customary for Truffaut: brief silent scenes that carry on the theme of love thwarted and the discordance of time and feelings. Dramatic irony would have it that the only time in the film Davenne phones Cécilia is the time she does not answer, anticipating another telephone scene the director would film a few years later: Bernard and Mathilde trying to reach one another at the

same time in *La Femme d'à côté*, where the engaged tone of their two telephones represents one of the few moments where the lovers' spirit coincides. In *La Chambre verte* the telephone connection between the two characters is impossible because a dead man separates them, a dead man who causes the hero's strange obsession to develop dramatically. When Jean Gruault gave Truffaut a scene he had asked him to write where Davenne starts furiously writing an obituary for Massigny that will be rejected (because it is like killing him all over again), he recalled how Jean Marais described Cocteau contorting his mouth and whole body while writing: 'When you're writing, I wouldn't like to run into you somewhere in the woods.' Initially the hero was supposed to refuse to write an article glorifying his former friend. Always looking for ways to push scenes further, Truffaut then came up with the idea that he writes an unpublishable text: 'Another interesting solution would be that he writes a rather demented obituary and is called in by his editor, to whom he explains that a personal problem prevented him from writing this obituary with serenity. The hero is very troubled, almost sick, so much so that the editor suggests he should go home.'

Obituaries.

From the beginning, Truffaut was preoccupied with how he would convince the audience to accept the bizarre qualities of a particularly excessive character without toning down any of them, even choosing to accentuate them instead. He first suggested to Jean Gruault that they have other characters talk about the hero. 'Don't forget that our main character should be mysterious and glamorous, and that to achieve this effect, nothing works better than a couple of scenes where people talk about him in his absence. If the hero says, "I have a secret," people say: "Who does this guy think he is?" But if two other characters talking about him say, "That man has a secret," we're intrigued and captivated' (letter of July 1974, before Gruault started work). At the same time Truffaut urged his co-writer not to skimp on the character's madness. 'When the hero does bizarre things, work on extending them and making them visually strong; these are elements that should be treated as if this were a thriller, by reinforcing the secret, somewhat mad aspects of the character.' He always made these eccentricities manifest themselves in relationship to death and dead people, like the copies that are returned to the newspaper marked 'Subscriber Deceased' (but the hero wants to keep the paper alive 'for them'), or the idea of the multiple obituaries that Truffaut told Gruault about when he was making a few suggestions after the first delivery of materials for the screenplay: 'We understand that, at the paper, the hero has become the specialist in obituaries, and someone mentions that last year he succeeded in talking about 45 people who were dead without ever using the same expression twice. A virtuoso in his own way and a strange fellow; no one knows anything about his private life.' This is also a sign that the film-maker was approaching his character and his subject with a certain humour, or rather with a mixture of seriousness and affectionate mockery.

During this phase Truffaut seemed to approach his subject by alternating proximity and distance, audacity and timidity, or at least reserve. He gave Jean Gruault very

precise instructions and never stopped pushing him, but put most of the work on his shoulders, letting him cope on his own with material that was very difficult to work with (as he had also done during the early years of work on *Les Deux Anglaises* and *Adèle H*) and not seriously re-appropriating his screenplay until very late, in 1977. In this game of hide-and-seek, of progress and dead ends, certain scenes that at first seemed to be important to the film-maker were curiously forgotten in some versions, only to reappear in others, as if Truffaut had recoiled at first from exhibiting his own violence, from the vulnerability implied by his profound intimacy with the subject. Then he threw himself into the front line by playing a character himself that he could only imagine being played by Charles Denner, to whom he could not give this type of role so soon after *L'Homme qui aimait les femmes*. Truffaut only decided shortly before the start of filming to decorate the walls of the chapel with his personal gallery, portraits of men or women who had mattered to him, putting together writers, friends and beloved artists whose portraits usually surrounded him in his office. This allowed him to play private jokes that are sometimes amusing (Oscar Lewenstein, the coproducer of *La mariée*, who played the arbiter of Claude and Muriel's marriage plans in *Les Deux Anglaises*, is described as a champion at arbitrating conflicts), sometimes rather sad (Oskar Werner, whom Truffaut hadn't seen since their disagreement during the making of *Fahrenheit 451*, becomes one of Davenne's dead – he shows his photograph to Cécilia as that of a German soldier killed in the war, of whom he was probably one of the killers). On his shooting script, before writing out the big scene where Davenne presents his dead to Cécilia, Truffaut jotted down a few random words that would be used to characterize them: 'Died young, always late out of generosity…,' 'Someone who loved his illness… not sad to die… He had followed the development of his decline with curiosity', 'He never gave anyone a book without cutting the pages'. 'I would like to be able to communicate the timbre of his voice to you,' noted Truffaut, who said how much he loved listening to records of Cocteau's voice after his death. He looked for the right description of Cocteau, crossing out the first quotation he thinks of ('What others reproach you for, cultivate: it is yourself'), and finally showed his portrait without comment, not far from Proust's. Apropos of Audiberti, he evoked 'the timbre of his voice, which was extraordinary', after recalling and then crossing out on his shooting script the quotation from Audiberti that he had the old detective say to Antoine in *Baisers volés*: 'Be respectful to your bosses.' James is there of course, and Davenne says, in an almost invisible joke, that although he did not know him well, it was this man who taught him respect for the dead. Another secret gag in a scene at Cécilia's home is having Serge Rousseau, the 'Definitive Man' from the ending of *Baisers volés* and a close friend of the film-maker, pose for the portraits of Massigny, Davenne's enemy.

The priest thown out of the door.

Truffaut found the beginning for his film through a process of trial and error. He rejected the beginning at the cemetery proposed in the very first résumé modelled on the James story (the burial of a friend's spouse): 'For Mme Creston, no cemetery scene (we have to save that for the hero and

heroine). In 4b we simply show the "laying out of the body" in the Creston apartment and M Creston fainting. He has to be revived; people worry that he might attempt suicide.' Even if Truffaut was involved from the beginning in making a scene that was still pretty well-behaved more active and violent (the hero, offering his condolences to a friend from the office, bizarrely tells him that he is more to be envied than pitied), he still did not imagine making it the beginning of his film. Depending on the draft, the film begins with little mysteries in the hero's house, where we see him lock himself in a room the morning of the anniversary of his fiancée's death, then in the auction house where he goes looking for the dead woman's ring and meets Cécilia. But Truffaut was already planning to have a run-in with a priest: 'If a priest arrives at the end of the scene to bring comfort, the hero can surprise us again with one or two stinging comments about Catholic routine.' But the idea was not pursued. Gruault incorporated the widower's suicide attempt in the next draft but neglected the dispute with the priest. In the next draft, astonishingly, the character of the priest disappears: the hero limits himself to explaining the need for remembering to the widower, who is in a daze and looks at him with incomprehension. But when Truffaut made a few notes on the fourth treatment (a series of notes titled 'Revisions for *La Fiancée disparue*, 6 March 1977'), he did not settle for this shortened scene and returned obstinately to the idea of the confrontation with a priest, an immediate and disconcerting way of characterizing his hero: 'We can take the scene further by using the idea of a dispute between the hero and a priest after all.' But the priest would not be a caricature; in keeping with his habitual paradoxical spirit, the film-maker even suggested swapping the roles: 'Perhaps the priest is too modern, too human, and the hero reacts like a supporter of Cardinal Lefèvre… The point of this is to create conflict on the screen, to let the audience think that the hero is hostile to religion; this will help them understand later that the renovation of the chapel and the cult of the dead have nothing to do with traditional religiosity. (For this whole aspect of the film you should perhaps consult Father Mambrino, poet, Jesuit, theatre critic and film buff.') Truffaut consulted Father Mambrino himself before filming, asking for his help in writing the dialogue for some scenes before ultimately deciding not to follow his suggestions, because they had different visions of the subject. 'I see the "idée fixe" aspect (as for *Adèle*) and you see the "luminous" aspect,' he wrote to him in September 1977. In the meantime the film-maker wanted to surprise the audience and present his hero forcefully: 'This scene, then, should be the first that goes very far in a dramatic sense. The hero defeats the priest, maybe even shoves him out the door… The ending should be rather shocking. Mazet [the friend who has just lost his wife] has become a submissive object in the hands of the hero, who has taken charge of the situation: in short, it is now or never that we make them understand that whenever death is present, our character is in top form.' It was a key decision, since Truffaut would make this scene, taken to extremes, the opening of his film. We find again, besides the insistence on intensifying the story and the situation, that mixture of energy, precision and casual humour – even and above all with a subject that does not seem to lend itself to these qualities very

much – that characterizes his manner: at one and the same time provocative, iconoclastic violence and the masking of it, the refusal to focus longer than necessary on intentions, intensity and the art of concealment. If Catholic routine is attacked, this implies neither on Truffaut's part nor on that of his character a facile, sneering anti-clericalism like that he decried in the French cinema of quality when he was a critic (the spitting-in-church variety), but rather an essential refusal of social as well as religious hypocrisy and of resignation as a hypocritical consolation. 'All we want from you is that you say "Rise and walk" and the dead rise and walk,' Davenne throws in the face of the priest, whose words for the occasion have done nothing but revive the widower's grief. One mysticism is replaced by another, fervent and strange, as he confides to the despairing husband: 'Believe me, Gérard, our dead can continue to live'. Truffaut saved this paradoxical line, which for a long time was drowned in the flow of dialogue, for the climax and close of the scene. When he reworked the seventh draft of the screenplay and made it his own, it was natural that he would move this scene to the beginning of his film, after the credits and the images of the trenches: an opening that sets forth, concentrated into an instant, all the character's uniqueness, a sort of displaced résumé. This laying out of a body looks back to another one, avoided by the story: that of Davenne's own spouse. This secret flashback ('Your story is just like mine, Mazet,' he says explicitly) launches the film with a strange, explosive attack of violence aimed at immediately staggering the viewer. The aim of the film-maker, who wanted us to watch his film 'open-mouthed, going from one surprise to another', was always to move towards something unexpected, a sudden eruption, a strong moment – all the more so because he knew he had an eccentric character and a forbidding subject. Essentially, Truffaut needed the spectacle to go to the limits of the strangeness and the silent subversion within him.

The wax figure.

When he asked for the confrontation with the priest in his 'Revisions for *La Fiancée disparue*', Truffaut added this remark in the margin: 'The hero can give us the impression of being within a hair of becoming like the hero of *Psycho*, a guy who would be capable of stuffing a dead woman he loved to keep with him at home.' This idea was put into effect in the film with the scene of the mannequin Davenne orders by way of compensation after the room consecrated to his dead wife has burned down. Presented to him as if on a stage, the mannequin is then violently rejected by the hero who panics and cries out with visceral disgust: 'No, it isn't possible. It isn't her. Destroy this thing immediately, in front of me.' The episode borders on a horror film, where the wax figure that the hero has had made rises up like a monster he has created by accident. Truffaut in fact said that when he was preparing the film he thought of Universal films from the early days of the talkies (*Dracula*, *Frankenstein*, *The Mummy*): 'I obviously didn't think of using an actor like Bela Lugosi, but before starting work with Jean Gruault, I told myself two screenplays that could have been developments of James's themes in the style of Universal. In the first there is a man who only loves the dead and slowly kills the woman he likes in order to be

able to love her. In the other, conversely, a woman meets a man who only loves the dead and lets herself die to please him.' It was while reading the second treatment that Truffaut imagined the scene with the mannequin. After a storm ravages his secret room, the hero announces to his housekeeper that he is going to have to find another way to protect the dead woman. (A scene was supposed to follow where an unknown mourner meditates at a nearby grave.) Truffaut annotated the screenplay in pencil: 'Here he plans to have a doll made resembling his beloved, and when he sees the result at the atelier, he pays but cancels everything and moves on to something else (the chapel).' Then he added on the facing page: 'Note, this is not an inflatable doll, but a real mannequin copied from photos (see the film *Paris-Secret*). When the mannequin that looks like his dead fiancée has been constructed, the hero goes to the studio, is horrified because he feels it is a blasphemy and refuses to take delivery. "Destroy it," he says and pays cash on the nail, despite his refusal.' Since a wax mannequin was too expensive, Marcel Berbert suggested to Truffaut that special make-up would probably achieve the effect he wanted. So the actress who posed for the photos of Julie Davenne, Laurence Ragon, stood in for the wax mannequin, with open eyes painted on her eyelids as in Cocteau's films. This scene was precisely described by the film-maker in a form close to the version he filmed: the hero enters a glass-roofed atelier where we can make out a number of unfinished mannequins, 'realistic wax heads'. 'I think you'll be satisfied,' says the old man who greets him while his wife and an apprentice smile at the customer. The artisan abruptly pulls back a curtain ('like a conjuror') and reveals a mannequin that looks like the dead fiancée. Horrified rejection by the hero: 'Hide that. Destroy it,' forcing the craftsman to take a cheque and flee, backing into one or two mannequins. Then rather astonishingly the scene was left out of the two following screenplays, disappearing without a trace from the fifth and sixth versions. A more or less deliberate omission? A slip? Truffaut pulling back from an excessive scene? Fear of going too far? The scene was reinstated in the sixth treatment, where the scene from the third version was cut out and completed. Truffaut added the idea that we see the mannequin being destroyed from a distance: 'We stay on Davenne for a moment without seeing very well (but hearing) the destruction of the mannequin.' He considered having Davenne speak before the tomb of his wife – 'Perhaps he will talk to her about the monstrosity he almost committed, the "waxen image", less real than that which lives inside him' – before crossing out this explanation. If Truffaut hesitated, it was perhaps because, fundamentally, he was not at all like the film-makers he admired to whom this scene is a kind of allusion, the Buñuel of *The Criminal Life of Archibaldo de la Cruz* and the Hitchcock of *Vertigo*. In *Archibaldo de la Cruz* the young hero dreams of killing without ever actually doing it, but his imagined victims play a trick on him: they die, curiously, by accident. He has a wax figure made of a young woman he just met and invites the flesh-and-blood woman to his home to see it. After she leaves he throws the mannequin in the fire, where we see the flames destroy it, committing a kind of murder by proxy. In an article from 1971 about this film, Truffaut stressed that the fact that he could not remember if

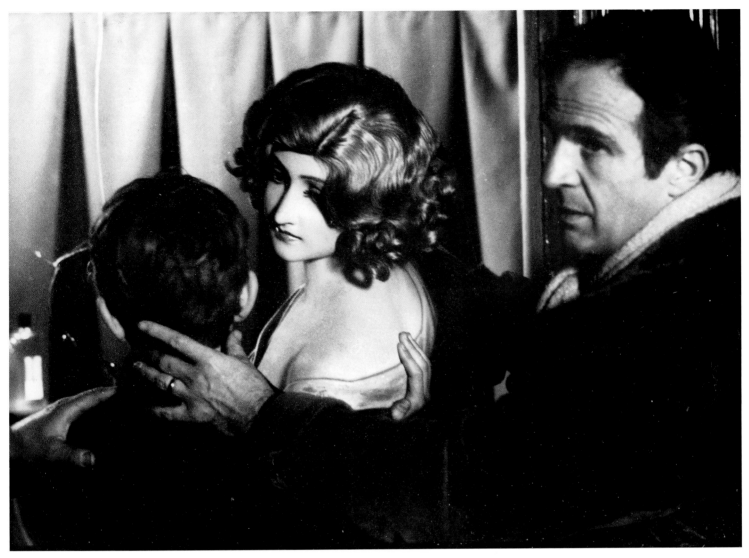

Rehearsing the scene where the wax
head is stolen: 'An act of vandalism
and delinquency.'

Archibaldo's mission is 'sexual or criminal in nature shows that they are the same thing'. And if Davenne's constant effort to fight against forgetting and to revive the memory of his dead wife recalls Scottie's desperate attempts to recreate the image of a dead woman in *Vertigo* (or as Truffaut summarized it, 'James Stewart's painful efforts to make Kim Novak resemble Grace Kelly'), Truffaut's hero stops where (to put it simply) those of Buñuel and Hitchcock begin. More precisely, Truffaut stays with ambivalence, as he wrote in his notes for the screenplay: Davenne is 'within a hair's breadth of becoming a guy who would be capable of stuffing a dead woman he loved'. His hero, who feels the same feelings for the dead that we habitually feel for the living, recoils from necrophilia, but his horror when he sees the mannequin also reveals the part of himself that could come close to that aberration. 'To be loved by you I would have to be dead,' Cécilia writes to Davenne defiantly. The mocking, unbearable immobility of the mannequin is also a kind of irony: at the end of the *idée fixe*, of the taut line of the obsession, there is this frozen form, deathly and ridiculous. What Davenne believes he wants has once again escaped him more than ever. The mannequin is the stopping point, the tragicomic caricature of a trap towards which the temptation of the definitive, the inability to accept the provisional, controls numerous Truffaut characters. Catherine throws herself into the Seine with Jim, Mathilde leads Bernard to his death, Bertrand Morane dies while trying to grab the nurse's legs, Davenne collapses after lighting the last candle that completes the figure, Adèle escapes into madness… The stupid stiffness of the wax is the deceitful, grotesque result of the obsession, the caricature-like bringing to life, at once ironic and prosaically monstrous, of the tragedy of love in Truffaut's films, of the lack his characters try in vain to fill. The mannequin therefore must be destroyed in order to allow movement to return, even if it is illusory. 'We can have the idea that the hero is hostile to the cemetery,' noted Truffaut in the margin of the final version of the screenplay. 'He is against the icy earth and for the candles and the movement of the flames, because movement is life continuing.'

The deaf-mute boy.
The episode of the mannequin crosses another thread of the story with which Truffaut established a rather curious coincidence – that of the young deaf-mute taken in by Davenne. When this boy, a distant cousin of Antoine Doinel of *Les Quatre Cent Coups* and the Wild Child (in the third draft Gruault, temporarily and as a private joke, names the housekeeper Madame Guérin and the boy Victor), runs away after being reprimanded and commits a theft, he is caught throwing a rock through a hairdresser's window where he wants to steal the curly head of a mannequin on display. The scene remains enigmatic, but Truffaut specifically linked it with the wax figure rejected by Davenne. When he reinstated the scene of the mannequin, Truffaut modified his plans for the theft the boy commits (cakes spotted in the window of a bakery) and instead had him being arrested while he 'prepares to make off with a wax head (wig falls off)'. He also intended that Davenne would go down this same street to get to the shop of the craftsman who has made his order, passing

in front of the hairdresser's window. And if any confirmation were needed of this direct connection, the bareness of the sets makes the link between the wax-work atelier and the hairdresser clear ('Seq 21: On his way to the artisan's place, Davenne passes in front of the coiffeur's window', 'Seq 41: Georges breaks the coiffeur's window and is caught'). Truffaut finally decided to dispense with this explanatory hook, which disappeared from the film, but the impression of some sort of contamination still remains. It is as if the child, even though he could not have witnessed the scene where the mannequin is destroyed, were trying to offer a compensation by stealing the wax head – no longer a whole body, but a fragment (the fragment referring as much to the destruction of the mannequin, smashed into pieces, as it does to Davenne's fetishistic relationship with his dead wife) – or as if he were himself caught up in turn by the malevolent seductions of wax. A strange internal contamination that dispenses with any explanation in the film, any cause-and-effect link, and any imaginable realistic basis. (Nothing indicates that the child has been told about the mannequin.) This nocturnal adventure also seems to have no effect on subsequent events, because once Georges has been found by Cécilia and Davenne he is never questioned about it, as if it never happened. And it is precisely this absence of rational justification that gives the film its suggestive power, as if the film, oscillating between nightmare and dream, has begun moving forward on its own, permitting the return of the repressed, freeing up unconscious links and exuding its own nocturnal logic. As Anne Gillain analyses it in *Le Cinéma selon François Truffaut*, the film-maker's shaping of narrative (which we may doubt, in fact, that he did consciously) 'consists of throwing off the conscious mind and forcing the viewer to move into an unconscious mode of perception', and this would be one of the reasons for the hold his oeuvre exerts on many viewers. The return of the mannequin in the form of a fragment occurs at a key moment in the story. The boy's attempted theft happens a little after the big scene where Davenne has set up his chapel, with all the candles burning, and invites Cécilia to discover his dead. It is as if this immediate relapse into delinquency and the immobility of wax were inflicting a kind of reproach on the hero's exaltation and the movement of the flames, causing the film to change course. A few scenes later comes the discovery of the young woman's relationship with Massigny, their insurmountable difference of opinion, and depression and illness, before the paradoxical happy ending that for the film-maker constituted the furthest development of the obsession and the completion of the figure: Cécilia lighting the last candle after Davenne's death.

In the film, there is no explanation for the presence of the child in Davenne's household, while the early drafts of the screenplay presented several. In fact, little Georges is borne from the fusion of two characters: a deaf-mute adolescent (an interest of Truffaut's since filming the scenes of *L'Enfant sauvage* at the Institut des sourds et muets), who is a servant and the housekeeper's assistant, and a younger child, related to the housekeeper, whom Davenne is obliged to take in when his parents separate. In the first draft Gruault planned the arrival of the housekeeper's young nephew, whose parents are divorcing, in Davenne's home.

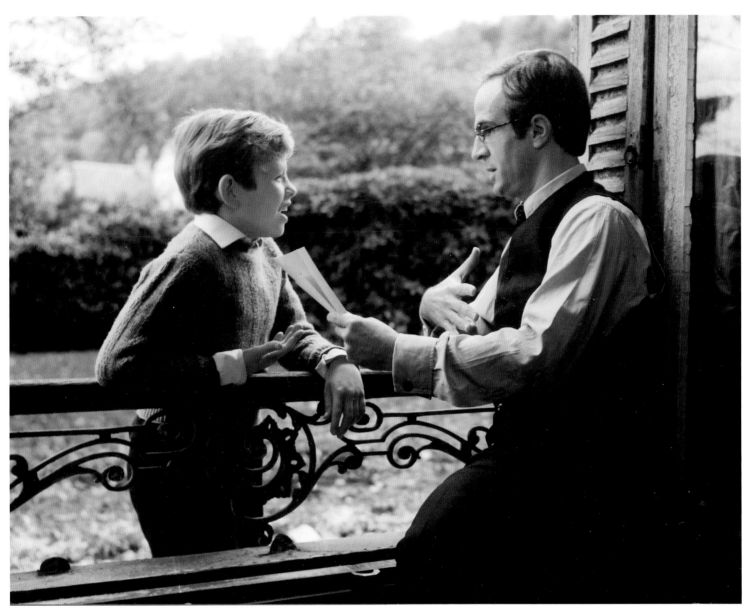

Davenne has received permission
from the diocese to celebrate his dead.
Patrick Maléon, François Truffaut.

Initially the story is rather fantastical: the hero comes home and finds his housekeeper in tears because her daughter has just left her aged husband. But they have an eight-year-old boy, and she should have waited for her husband to die… The hero tells her to take the boy in while her daughter reorganizes her life; it is better she free herself from her husband while he is still alive, because while we owe only the truth to the living, we owe fidelity to the dead… The hero then takes the boy to the chapel, makes him part of the cult and has him help him because, he says, this is the age when children have to be taught to love the dead. In the third draft it is no longer an old pair of servants who take care of the hero, but a new couple consisting of the housekeeper, Madame Guérin, and her nephew Georges, 16 years old, who is mute and 'does the work of a servant'. However, the housekeeper still takes in a boy, who will henceforth be her grandchild, whom the hero teaches about the stars, light years, Saturn… These two characters reappear in the next version: the housekeeper's assistant and her grandchild, for whom the hero – who Truffaut and Gruault thought about making a kind of scientist inspired by Jean-Claude Roché, the son of Henri-Pierre Roché – shows a film (or slides). This shows the 'engagement' ceremony of an insect, the empis, where the male offers his 'fiancée' a 'gift' (a fly enveloped in a kind of cocoon). Truffaut only kept one character in the end, whom he made younger (the boy is 14 in the sixth version, 12 in the seventh). He also decided not to show films, so as to prevent excessive interpretation: 'For the study of animals, I prefer photos on glass slides projected on the wall (by the deaf-mute who knows a little about it) rather than actual films (which will make interpreters of the film say that the hero is a film-maker).' It was while he was revising the fourth draft (when he asked for the scene with the priest to be added back in and built up) that Truffaut rebounded from Gruault's suggestion that the housekeeper be absent at a certain point and developed the scenes portraying the young deaf-mute's flight and delinquency: 'New episode to be constructed: during the housekeeper's absence, Georges commits an act that is between vandalism and delinquency. He is arrested by the police; Davenne manages to get him out with the help of Mademoiselle Mandel. A scene between Cécilia and Georges, without the hero; then Cécilia tells the hero that he isn't taking care of the mute boy properly.' This is a re-appropriation of the young character, because we know the autobiographical resonances of the interconnected themes of childhood, secrecy, transgression, flight, delinquency, punishment and, if not mistreatment, the absence of care. Truffaut continued to make the material his own in rewriting the prison scene in the seventh draft, where the imagery recalls several scenes and figures of *L'Enfant sauvage*, including the image of a character hidden under the straw and curled up on the ground in his distress that runs from film to film, from *Adèle* to *La Femme d'à côté*: 'The place is more like a cellar than a prison. Cécilia arrives with a gendarme. He leads her to an area with straw that is furnished with a wooden bed. The gendarme and Cécilia appear astonished at not finding Georges. The reason is, he has gone to bed, not on the wooden pallet, but under it. He's sleeping there; they haul him out. He leaves with Cécilia.' One of a hundred examples of a moment when Truffaut substituted the force

of elementary, recurrent imagination for a realistic representation, without calling attention to it and as if by magic (who watching the film would stop for one second to think that this cave-prison doesn't exist?).

A silent witness, but curious and distracted, the child, despite his apparent withdrawal, finds himself at the heart of the film's lines of force: a disconnected character, witness to secrets and strangeness as well as to moments of exaltation, a strange confidant who doubles the impact of a scene by the mixture of mime and sign language when he repeats the dialogue. (See the scene where Davenne explains to him that he has received the Archbishop's permission to renovate the chapel and install his cult.) When Gruault responded to Truffaut's request and the child begins misbehaving, he imagined having him run away after two successive mishaps: the child (who at this stage is still a sixteen-year-old deaf-mute assistant) tries to conceal from Davenne an encyclopaedia from which he has cut out some engravings. Davenne gives him a couple of slaps that he immediately regrets, then projects photographic slides for him showing a ceremonial parade among insects. Georges goes to sleep and falls over leaning on the projector table; the slides are broken and Davenne loses his temper. Georges runs away and breaks the window of a bakery. Gruault suggested filming his arrest in reference to the *The Kid* (a big hand settles on his shoulder). Truffaut combined these two crimes in one, keeping the idea of the broken slides (the child knocks them down trying to reach them one night, for a reason that is never clear), thereby linking this image of childish awkwardness leading to punishment, the flight and the theft of the wax head, with another major thread of the story that he put in place just before the start of filming: the omnipresence of the consequences of World War I, very violent images of which Davenne projects for the boy in an astonishing scene at the beginning of the film. Moreover, on his shooting script Truffaut planned to add the reprimand of the housekeeper, who reproaches Davenne for showing the child such images, introducing a little ironic distance from the hero: 'your criticism for Madame Jeanne to make to Davenne' (from the first name of the actress, Jeanne Lobre, whom he had already cast in *Les Deux Anglaises*), and 'interruption Madame J. dinner is ready, such horrors'.

The Great War.
It was not until quite late that Truffaut had the idea of setting his story a few years after World War I in order to better support and justify his main character's morbid obsession. The very first drafts seemed to place the story in a period contemporary with that of Henry James. Later ones moved it to the 1970s (hence the episode with the television programme, where a new edition of *The Beast in the Jungle* is discussed). In the fourth treatment, finished at the beginning of 1977, Truffaut and Gruault decided to push back the period of the story, which would take place 'around 1920. In autumn or winter… Always very early morning, or evening at nightfall, or night'. A crepuscular ambience, a bit old-fashioned, that goes with the character's maniacal rigidity and taste for ritual. But it was only after several quick, successive reworkings, when he reassembled a seventh version with Suzanne Schiffman at the end of the

summer, that Truffaut followed through the consequences of this change in period, indicating on the title page that the story was now set in 1930, a period when 'the disasters of the Great War are still felt'. This is the moment when he conceived the first draft of the opening credits, which he planned to roll over images of war and death: 'We see (fixed) images of the 1914–18 War suggesting not the war itself and its battles, but the idea of death: soldiers being struck, wounded men being transported, men falling, others in hospital beds, etc. Perhaps also, superimposed over these, the reproduction of some documents (newspapers or books) with figures concerning the number of deaths during this or that battle of 1914–18 and at the end of the war.' These images placing the film under the influence of the slaughter of the trenches were also the large-scale outcome of the film-maker's long-standing interest in this period, shared with many of his generation, who were born at the beginning of the 1930s when the effects of the war were still being felt. In *Jules et Jim* Truffaut had already given the interruption of World War I and its effects on the characters an importance that is absent from Roché's novel, inserting a long montage of archival footage where scenes of combat are followed by sequences showing soldiers away from the front, their recreational activities, the shows for the armies: images showing life in spite of war that he would not use again in the credits of *La Chambre verte*, which is like the funereal version of the montage in *Jules et Jim*. Truffaut slipped Davenne's cry to Cécilia in the cemetery into the screenplay: 'Last year I went back to the Vieil Armand where I spent two years during the war. And the soil was so full of shells that the soil, the soil itself, had become impossible to cultivate.' An almost word-for-word repetition of a line in the narration to *Jules et Jim*, when Jim, en route to Germany and his reunion with Jules, stops to visit some of the large cemeteries where the soldiers have been laid to rest: 'In some places the terrain had been so bombarded that there was nothing but iron in the soil and whole fields had become impossible to cultivate.' The same memory, equally absent from Henri-Pierre Roché's second novel, darkened the last minutes of *Les Deux Anglaises*; then, in a major key, in the prologue to *La Chambre verte*, Truffaut inscribed in the flesh of his film the traces of a futile slaughter, of an irreparable break, that undermines the soil and is always ready to come up to the surface.

During the summer of 1977 Truffaut still had not had the idea of having the helmeted, melancholy face of his hero appear superimposed on the images of war – the face of the film-maker, who chose to film himself and show himself, from the first moments of his film, struck by pain, features fixed by fatigue and horror, his look incredulous, over images of a world falling apart (explosions, soldiers running through smoke and exploding shells, earth raining down, battlefields covered with corpses). During the editing process, after the first screenings, Truffaut had the idea of filming this close-up and fusing it with the archival images of trench bombardments, thereby launching his character's obsession in a few images. The sequence was supported by the music of Maurice Jaubert, a composer and musician killed in 1940 (19 June 1940, a few hours before the armistice), whose portrait Davenne would illuminate in

his chapel. This way Truffaut could be sure of avoiding the danger of his character's moods and eccentricities appearing artificial. In the seventh draft Truffaut was still thinking of a more argumentative, scholarly illustration, which he finally abandoned: 'Progressively the figures are replaced by popular engravings illustrating death with traditional symbols: skulls, graveyards, the great scythe, etc.' He began to develop a new idea during the course of writing this text, in keeping with the principle he had stated years before of having two characters speculating about the hero: when Humbert, the editor of the paper, talks to his secretary Monique (played by costume designer Monique Drury who, in *L'Homme qui aimait les femmes*, also portrayed the typist who can't go on typing those stories of interchangeable women), he gives a few details of Davenne's situation at the front during the war. Many of his friends and companions were killed around him, while he lived on. When the desperate widower seen at the beginning of the film wants to introduce his second wife to Davenne, she expresses her happiness at the paradoxical good fortune of their meeting: 'This horrible war killed so many young men that it has condemned many women my age to remain unmarried.' Truffaut indicated then that 'the camera reveals in the shadows on the staircase Davenne, livid, who has heard everything and visibly does not share in the general euphoria'. When he filmed the scene, the film-maker enclosed himself in a side room, radicalizing his hero's difference from ordinary living persons by this particular shot that surrounds and immerses his face in frosted glass.

While revising this treatment, the title of which became not *La Disparue* but *La Chambre verte* for the first time at the end of autumn 1977, Truffaut completed the figure, making his film a closed object, circular and repetitive, where the vestiges of the war seem to rise up under his hero's feet every time he takes a step. This eighth version was clearly made complete by the idea of inserting as systematically as possible the tangible traces of those battles. In the auction house, where the hero, looking for a ring that belonged to his dead wife, walks around among the objects, 'certain ones evoke the recent memory of World War I'. During the sale where 'at the beginning of the scene we see the pricing of two enormous shells transformed into flower vases'. At the house when the hero returns home: 'When the scene begins, Georges is looking at images of World War I in a special issue of *Illustration*.' At the newspaper *Le Globe*, where a line was added to the editor's dialogue: 'In our region, there are not many men of Davenne's generation who walk on their own two legs.' In the atelier where the mannequin is made, Davenne, fleeing, is supposed to run into a bust dressed in 'a sky-blue uniform'. The chapel has been 'damaged by the war', and at the cemetery the hero passes a nurse pushing a war invalid in a wheelchair and walks past the graves of soldiers.

These repeated tracking shots on the helmets of soldiers perched on the crosses over their graves, these wounded men in wheelchairs who keep crossing our path, and finally the big commemorative plaque that Truffaut filmed behind his hero on the stairway leading to *Le Globe*, this omnipresence of the consequences of war makes *La Chambre*

verte a film pulled apart by infirmity (even the only child in the film is disabled) and death. It is as if the power of the *idée fixe* had affected and finally overcome the outside world, a re-created, cloistered world where nothing is visible except the signs perceived by the hero's obsession.

During the shoot Truffaut closed the circle by having the idea that the slides Davenne shows the boy would be not only photographs of insects, but images of the war. 'Here's something that may interest you more,' says Davenne to the child, before revealing the photos of mutilated bodies, like a collector showing his best piece. 'You'll see, they're very beautiful.' This almost obscene passion, accompanied by the jubilation of the young deaf-mute, who doubles the impact of these projected images by mimicking them, adds a great deal to the strange and subtly disturbing violence of the scene. When Davenne, in a flat voice, describes one of the photographs ('this one had his head cut off, probably by an exploding shell'), the boy mimics decapitation by passing a hand over his throat, with the casual fascination of childhood, devoid of sentiment. Rarely would the film-maker go this far in crudeness, a radically singular cruelty with none of the accepted trappings of audacity. The only way you could possibly keep up the myth of the tender, modest Truffaut, which still persists, is by forgetting to look at his films.

Uncontrollable laughter.

Confronted by the power death has over the hero, the young woman with whom Davenne wants to share his cult finds herself up against a formidable opponent. Although Truffaut briefly thought of Stacey Tendeter, the Muriel of *Les Deux Anglaises*, to play Cécilia, he chose the more cheerful Nathalie Baye instead, to whom he had entrusted the role of Suzanne Schiffman in *La Nuit américaine* five years before (and whom he had just given a small role in *L'Homme qui aimait les femmes* that was not easy to pull off – the young woman who comes to the rendezvous wearing trousers in place of the beautiful stranger in the fringed dress the hero saw in the laundry, who has already gone overseas). Even though the discreet but very elaborate sequence-length shots often took several hours to set up, the film – really a small film, focused on a few characters in a few settings – was filmed in a light-hearted, lively way. The ambience on the set was upbeat, and uncontrollable laughter was frequent despite the morbid atmosphere of the story. This no doubt greatly pleased the film-maker, who detested letting his work be contaminated by the violence that he could only gradually set free in his films – he managed to avoid it better in this film haunted by death than when he filmed *Adèle H* three years earlier. Even if it sometimes meant having to stop a scene early, like the one when Cécilia finds the ring at the auction house, where his and Nathalie Baye's uncontrollable laughter caused the film-maker to give up the single sequence shot for once. Truffaut then filmed the rest of the scene in shot-reverse with Suzanne Schiffman reading the lines of first one, then the other character. For reasons of economy, it was a rapid six-week shoot, in a house in Honfleur where all the interior sets were constructed, as if in a kind of mini-studio. Every corner was used to film the Davenne house (on the ground floor) as well as the prison (in the cellar),

the archbishop's office, the dead woman's room on the second floor, Cécilia's apartment and, in the attic, the *Globe* offices. Like Davenne who wants to do more for his lost fiancée, Truffaut became obsessive about details. Communicating, as he did when he was writing, more by refusal and reaction than by ready-made directions, he had the Davenne house's floors repainted at the last minute and the wallpaper in the dead woman's room changed after seeing it for the first time and rejecting it one or two days before planned filming. (The production manager, Roland Thénot, fed the crew coffee and champagne while they changed the wallpaper overnight.) Truffaut worked carefully with Nestor Almendros on the lighting in the scenes in this room, which was illuminated by diffused sunlight coming through the closed blinds. At the Caen cemetery he built a fake wall to allow for long camera moves filming entrances and exits from the cemetery. When this fake wall turned out to be too short, the missing portion was filled in with fake trees so that Nathalie Baye's walk to the gate of the cemetery could be filmed in a single take. And Truffaut, knowing that his film could only work on a very modest level, chose to play Davenne not only because he shared some of his character's views, but also for financial reasons. By the same token and because he liked to, he had members of the crew serve as extras. In the auction house, editor Martine Barraqué pushes Jean-Pierre Kohut-Sveklo, the production designer, in a wheelchair. At the cemetery, passing Davenne, alias Truffaut, Josiane Couëdel, the production secretary at Carrosse, pushes in Roland Thénot, the production manager (who played small roles in several films) in another wheelchair.

The *mise-en-scène* counteracts the dispersal and scattering that animates Julien Davenne, often employing complex, discreet sequence-length shots, long mobile shots moving from one person to another at the auction house ('I want to avoid extras, the television aspect,' Truffaut had noted in one of the intermediate drafts of the script), at *Le Globe* and at the cemetery. Where death disperses and separates, the *mise-en-scène* links and unifies. At *Le Globe* and in the Davenne house, Truffaut deliberately used mirrors to discreetly combine the characters' different actions in one shot. (Thanks to a mirror placed on the stairway, the flight of the young deaf-mute is filmed in one shot as he tiptoes down the steps behind Davenne's back; Davenne is working in his office and does not see him go.) This stylization, this process of linking and movement, often rather slow, that completes the liturgy, is part of the film's hold on us. The movements are often governed by the rhythm of Maurice Jaubert's music, which led the film-maker to say that he had filmed a musical comedy without songs or dances. To pass from the dead woman's room to the cemetery where her portrait decorates her tombstone, Truffaut realized one of the most careful and troubling dissolves of any of his films: a slow dolly-forward on the photographed profile of the dead wife until her face fills the whole screen, followed by a dissolve on this face, which seems to disappear and then reappear, and a dolly-back that reveals the same photograph in a medallion set in the stone of the tomb. The shot does not stop there: after a slow pan to an old cross leaning over an ancient tomb, it completes its movement at the same time as the music,

whose chords began to mount in the room, crying abandonment and threatening ruin.

The empty room.

'As far as the distributors are concerned, the title should be "The Empty Room!"' Truffaut wrote in May 1978, a month after the film opened, to François Porcile, his musical advisor, who helped him choose pieces of music by Maurice Jaubert. In effect, the public, frightened off by the idea of a film about death, came little or not at all. (Some exhibitors even occasionally tried to discourage audience members from entering the auditorium, pointing them towards other, more attractive films, so as to be able to get rid of this one quickly.) The film-maker, well aware of the difficulties posed by his subject, nonetheless travelled around promoting his film, which he felt he succeeded in making according to his intentions. At the last moment, worried that the press would exaggerate the theme of fidelity to the dead, Truffaut changed his mind about how to present it. Very anxious, he wrote to Michel Drucker on 3 April 1978, two days before the film opened, asking him to modify the angle from which they would be discussing the film during his broadcast. He hoped in particular that the clips that he originally planned to show (the scene at *Le Globe* where Davenne reveals to the editor his hatred of Massigny, who has just died; the scene where he becomes indignant with Cécilia about his widowed friend's remarriage) could be replaced by two others that he had had printed up, which had 'the advantage of not mentioning death or dead people'. Even if it meant cheating a bit, Truffaut was ready to put the emphasis on the child at Davenne's side (he suggested the scene where Davenne tells the deaf-mute how happy he is to be able to renovate the chapel) or the promise of an amorous intrigue: the second clip was the one where Cécilia comes to question the editor of the *Globe* about Davenne and is forced to admit that she loves him. 'You make the films that torment you,' he confided during an interview a few days after the opening, when he was asked if the Young Turks of the *Nouvelle Vague* had become the mandarins of French cinema, 'the films that haunt you, and then if they're understood, all the better.'

L'Amour en fuite (1979)
Love On The Run

'In one of the first stages of the screenplay, Marie-France Pisier was a psychoanalyst. Jean-Pierre Léaud is having a nervous breakdown and goes to see Marie-France, who explains to him that you can't treat someone you already know. Because they once had a relationship, she can only listen to him two or three times, face to face, before referring him to someone else. We rejected this idea because analysis is something too complicated to be simplified in a comedy, and it was Marie-France who suggested that her character be a lawyer. So we started off on another track, but that was my first idea: Jean-Pierre Léaud on an analyst's couch recounting scenes from his life.'

L'Amour en fuite is in a sense the only assignment Truffaut ever gave himself. After finishing *La Chambre verte*, the commercial failure of which he saw coming, he needed to shoot something fast to balance the books of Les Films

Antoine Doinel's veterans, Christine (Claude Jade) and Liliane (Dani).

du Carrosse. But he did not feel the screenplays he had in development were ready, particularly *L'Agence Magic*, about the wanderings of a little music-hall troupe on tour in an African country where nothing happens the way it is supposed to because all their contracts have been cancelled after a change of government. Several ingredients from this project would migrate in other forms to other films. The characters were supposed to be carried away by the violence of their feelings: a young actress in the company, who has a limp due to polio, falls in love with an actor who plays a living statue and kills him at the end of their romance. Her mother confesses to the crime in her place. The victim was to have received letters from France that aroused the young woman's jealousy, which we finally realize were part of a correspondence course in religion. But Truffaut wasn't very eager to film in Africa and put off the project, proposing to Claude de Givray and Bernard Revon that they rewrite it, setting it in the Free Zone during the Occupation instead.

Most importantly, Truffaut, who had originally planned for *Domicile conjugal* to be the last Antoine Doinel film, wanted to close the circle with this character and liberate Jean Pierre Léaud. With the four previous films, from *Les Quatre Cents Coups* to *Domicile conjugal*, he knew he had the perhaps unique opportunity of capturing an actor and a character at different phases of his life and development. 'It's not possible to have the luck to film an actor from 14 to 30 years old, to have all this material, and not do anything with it,' he told Suzanne Schiffman. Asking Schiffman as well as Marie-France Pisier, the girl from the young people's concerts in *Antoine et Colette*, to help him out, he spent some months developing a structure that would allow him to make maximum use of flashbacks. But he would soon be ill at ease, conscious that he was building a very artificial story, and also conscious of his inability to make a character mature and advance when he couldn't see himself giving him the emotional stability or social status that comes from having a real career. Truffaut felt trapped and demoralized. 'I'm not very happy with the screenplay for *L'Amour en fuite*,' he wrote to his American critic Annette Insdorf in May 1978. 'What's original is the flashbacks, but to incorporate them smoothly we've come up with a weak script, one that is going to be hard to make better. Obviously I'll do my best, but I also have to give good scenes to Marie-France Pisier, Claude Jade and above all Jean-Pierre; it's very difficult. I've filmed too much these last five years (beginning with *La Nuit américaine*), too much and too fast. Les Films du Carrosse gives me a certain freedom, but it is very expensive and, above all, keeps me from stopping and reflecting.'

Working backwards, Truffaut filmed the present-day scenes in June 1978, as he could not break his commitments to the cast and crew and was under pressure because of Marie-France Pisier's schedule: she had to leave soon for André Téchiné's *Les Soeurs Brontë*, and waiting for her return would have forced Truffaut to postpone his film. Though he tried to lighten the atmosphere by joking with Nestor Almendros and the crew, Truffaut was tense and anxious during the shoot, all the more because saying goodbye to Antoine Doinel was sometimes difficult.

During editing he told Martine Barraqué that he felt the film was 'a swindle', and – not without a touch of bad faith – he was mad at Suzanne Schiffman for having pushed him to make it. 'He never really wanted to get rid of Doinel. We had ghastly arguments about that project. I said: "Either you want to do other films with Jean-Pierre as Doinel, and we end on a Chaplin shot – he hits the road and we'll see him again somewhere – or you kill him and we're rid of him." "You're out of your mind. I can't kill Doinel, I haven't the right!"'

To 'detach Léaud from Doinel,' Suzanne also suggested to Truffaut that he end the film by going backstage, showing at the end of the last scene that it is a film shoot and having the film-maker and the actor walk off deep in conversation. The ending would have shown Antoine and Colette finally falling into each other's arms; then Truffaut would have entered the shot to explain that he wasn't sure about this ending, on which his lead actors insisted, and that he would perhaps film another one tomorrow. Truffaut rejected this ending, which was too close to *La Nuit américaine*, and preferred, without really believing in it, his 'desperately happy' ending, where it seems as if Antoine may stick with his relationship with his new girlfriend Sabine, played by Dorothée, whom Truffaut chose because she seemed to him to represent the young contemporary woman, combining naivety and a frank, fearless nature.

L'Amour en fuite, however, is not without a certain virtuosity, and one can sense that Truffaut, despite his doubts, took some pleasure in manipulating the flashbacks, in going back and forth between past and present. 'The problem for Martine Barraqué and me was to make disparate material homogeneous, not to lose the thread and not to disappoint the audience when we returned to the present after a flashback. In the screenplay we had obviously planned the placement and duration of the flashbacks. But the editing, which lasted 16 weeks, imposed its own laws, very curious ones. Let's just say that when you change the image, you can't change the sound, or you have to change it as little as possible. The more disparate the visual material, the more you have to preserve the unity of the sound.' While writing the screenplay Marie-France Pisier proposed the idea of the train. (She remembered that at the end of a day of shooting *Antoine et Colette*, Jean-Pierre Léaud suddenly jumped on a train she was taking to rejoin her family in Nîce, and proposed to the film-maker that they transfer the idea to the Antoine Doinel of 1979.) Truffaut was delighted because he saw that the journey could be a reservoir of flashbacks, and also because he liked the idea of associating the movement of the train with that of the film. 'The flashbacks that start on the train are particularly dynamic because, when we return to the present, we're on a moving train, therefore part of something that's going forwards. This is the special pleasure we get from what I call "films of unfolding".' He decided to get rid of the flashbacks to the divorce decree pronounced with the mutual consent of Antoine and Christine. (To give the comedy scenes a contrary spin, as in *Domicile conjugal*, he opened the divorce scene with an amused Christine reproaching Antoine for forgetting the day of his divorce.) Others come from the

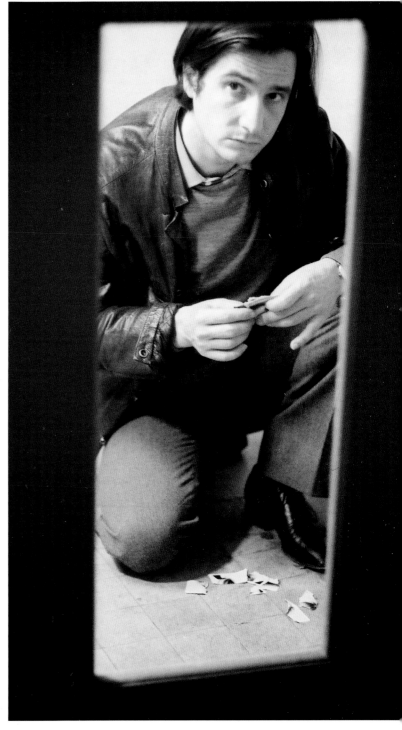

Antoine Doinel (Jean-Pierre Léaud).

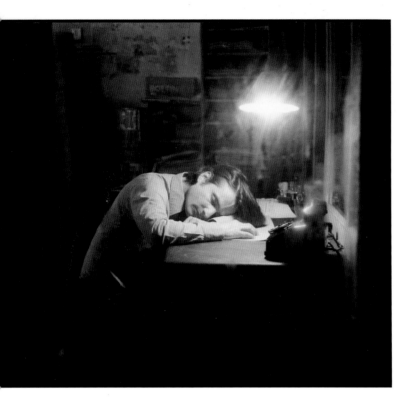

Antoine Doinel
(Jean-Pierre Léaud),
always in a hurry
and out of breath.

pages of *Salades de l'amour*, the novel written by Antoine when he was having marriage problems, or from stories told by various protagonists. Truffaut, who loved Welles's *F for Fake*, took this opportunity to mix up truth and lies, to play with Antoine's little fibs, such as embellishing his adventure with Colette by saying that her parents moved in across from him by chance and not the reverse (but the images of the old film contradict the inaccuracies of his novel just in time), or making his affair with Dani end the way he would have liked it to (Truffaut filmed a scene where Claude Jaude told her side of the story). It's a game of counterpoint between the word and the image, or between one word and another, that he had already practised in *Une belle fille comme moi*. He also had fun mixing real and fake flashbacks while criss-crossing the women in Antoine Doinel's life: some are fakes, shot in 1978 and treated as if they belonged to the old films; others were taken from *La Nuit américaine* (the scenes where Léaud and Dani, alias Antoine and Liliane, quarrel) or from *L'Homme qui aimait les femmes* (the lists of his mother's lovers that fall at the boy's feet, women seen in the street); and some shots were even from *Lolos de Lola*, a film Bernard Dubois and Yann Dedet made with Léaud in 1974. But nothing was taken from *Les Deux Anglaises*, where Léaud's look as Claude Roc is too different.

Despite some very funny effects, the film never breaks free of the melancholy and bitterness from which Truffaut hoped to escape – by perpetual motion, by filming a character on the run, a man like Pierre Lachenay in *La Peau douce*, a character permanently out-of-breath who always arrives late or leaves before trains pull out, who chases about the streets and the halls of a building carrying the 18 volumes of Léautaud's journals. Truffaut kept with the scripts of *L'Amour en fuite* the transcript of an interview between Léautaud and Robert Mallet that he thought about incorporating in the first version. The interview is devoted

to the episode of the 'journey to Calais', which is told by Léautaud in *Le Petit Ami*' and elsewhere: how Léautaud, abandoned by his mother just after he was born, met her and was dazzled by her during three days they spent at the bedside of a dying aunt, resulting in a rather murky and quasi-incestuous relationship. 'When we'd go out in Calais to get some air, she'd say: "Look at us; you'd think we were lovers," – things, very ambiguous things, all the while very amiable with hugs and kisses'... Or: 'A mother, you'd say, of extremely ambiguous behaviour, extremely engaging, and besides that...' (He tells then how she arranged to be informed of his grandmother's promises of an inheritance and managed to sabotage them.) Truffaut planned to adapt *Le Petit Ami* with Jean Gruault at the beginning of the 1980s. He gave it up when he found out that Pascal Thomas intended to make a film on the same subject, Léautaud's youth, drawing inspiration in particular from his *Lettres à ma mère*. In fact, Truffaut fought to hold on to this project for a while, by trying to acquire the rights to Léautaud's works about this episode from two publishers, Gallimard and Mercure de France. But he was discouraged by new demands for the right to distribute the film on video that irritated him and seemed to him to limit his freedom and the prerogatives of Les Films du Carrosse with respect to the film's release. Perhaps he simply seized an excuse for rejecting a subject that might be too hot to handle and an adaptation that would have been difficult to pull off.

Still, *L'Amour en fuite* contains a long, essential central sequence where Antoine Doinel meets his mother's lover, the man he saw her with in Place Clichy in *Les Quatre Cents Coups*. It is a scene of a posthumous reconciliation both with Doinel's mother, whose grave the lover, telling him she is at peace, leads him to in Montmartre Cemetery, and with the film-maker's mother, who died in 1968. 'Your mother was an anarchist. Your mother was a little bird,' the lover, played by Julien Bertheau, tells Antoine. Truffaut transferred to Gilberte Doinel, whose old age the lover describes, the theme of the sick eyes that can no longer read, which also belongs to Catherine in *Jules et Jim* and Muriel in *Les Deux Anglaises*, or to Adèle's mother. By saying that Antoine could not attend his mother's funeral because he was being held by the Army, Truffaut was playing tricks with his own biography, mixing two different and quite distinct periods of his life. When he gave Alain Souchon, from whom he commissioned a song for the film, some indications for writing the lyrics, Truffaut slipped in: 'Are women magic? Antoine should stop... stop fleeing... take advantage of the present moment... no longer settle scores with his mother through each girl he meets...' While he was editing, Truffaut cut part of the letter Antoine writes to Sabine, written during filming, which had become too explicit: 'My memory may be playing tricks on me when it allows me to recall only sinister images of my mother. Mean or not, in any event she taught me one thing: that only love counts.' And when he rewrote the final dialogue between Antoine and Sabine during filming, Truffaut wrote by hand at the bottom of the typed page this answer to the young woman who asks Antoine why he didn't tell her sooner about the intensity of his feelings for her: 'Because... because all my life I've been accustomed to hiding my emotions, and to not saying things directly.'

Quand je suis sorti de l'armée j'ai commencé à collectionner les aventures comme si je voulais imiter ma mère et la dépasser... et puis j'avais tellement besoin de me rassurer : est-ce que la marchande de chaussures voudrait de moi ? Et celle-ci..? Et celle-là..

Mais je t'ai rencontrée, Sabine, et je ne regarde plus les autres femmes. As-tu oublié notre première soirée au cinéma ?

A un certain moment les images violentes t'ont amené à chercher refuge contre mon poitrine. épaule

(plus fermement)

* il faut établir que Sabine le veut...

* le côté copain-copain doit être castrement démenti "tiens, reprends tes lettres..."

* il a "oublié" son divorce

* les scènes au présent doivent être plus fortes : dévoilage de tension..

* ne pas amener le passé mollement caméra cut (pas nostalgie) ne pas évoquer le passé mollement

* rien de normal dans aucune scène au présent...

* fausse piste sur Colette...

* AVANT LES "VACANCES"

- I ère partie -

1) <u>Imprimerie du Croissant</u> : Antoine doit quitter son travail plus tôt que d'habitude

2) <u>Magasin SABINE</u> - Il vient demander à Sabine de le rejoindre dans un café

3) <u>Palais de Justice</u> :
Christine attend Antoine et revoit ------------ la scène du téléphone (Domicile conjugal)
le matelas dans la salle à manger
le manteau dans l'escalier
Antoine quittant le domicile conjugal

Le divorce est prononcé
Sortie du tribunal et croisement avec
Colette qui reconnait Antoine

4) <u>Librairie</u> : Colette voit passer Antoine
et décide d'acheter "Les salade de l'amour"---- ● (Quatre cents coups) : En classe, Antoine
est giflé par son père

5) <u>Café</u> : Antoine parle par téléphone avec
Sabine - dispute, elle raccroche.

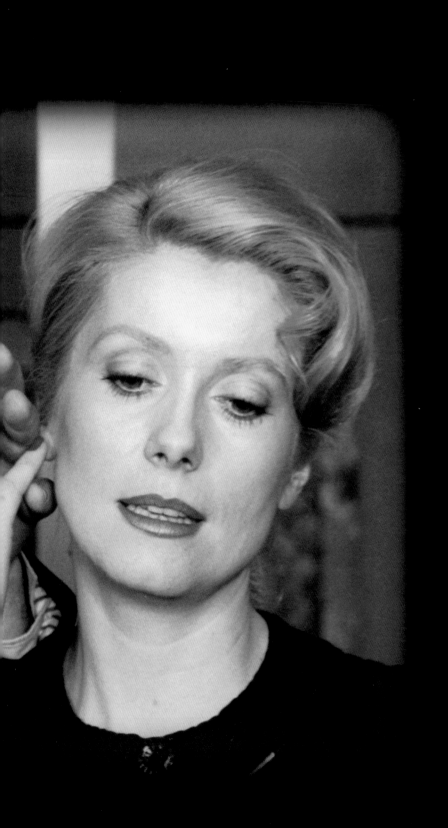

Le Dernier Métro (1980)
The Last Metro

'In any event, we must all have received a very oppressive
education to be constantly plagued with doubts about our
ability in one of the rare *métiers* that is also a calling, one of
those in which the element of pleasure is allowed to occupy
the place of honour,' Truffaut remarked in a letter he wrote
to his actors just before the filming of *Le Dernier Métro*.

September 1980: at the preview in a theatre on the
Champs-Élysées a few days before the film opened, in the
presence of numerous actors, Truffaut was 'green'
(according to Suzanne Schiffman, and Catherine Deneuve,
who were both at his side). Even as the applause rang out,
he was overcome by anxiety, convinced that his film was
a complete failure and that its first audience did not like
it. His anxiety was commensurate with what the film
represented for him after the painful failure of *La Chambre
verte* at the box office and the feeling of dissatisfaction that
L'Amour en fuite had left him with. *Le Dernier Métro* was an
ambitious project, with the largest budget of any film he
had made, and its financing was very difficult. ('If the
film doesn't work, Carrosse will go under,' Marcel Berbert
told Claude de Givray.) Truffaut later recalled in a 1983
interview that the film's success was totally unpredictable,
inasmuch as the Occupation setting was not considered a
draw for an audience: 'Today people think *Le Dernier Métro*
was a hit even before it started: that isn't true. If it were,
it wouldn't have been turned down by UGC or AMLF or
the German coproducers.' (Looking for a distributor,
Marcel Berbert and Gérard Lebovici got a last-minute
agreement with Gaumont, reinforced by a contribution
from the SFP and a pre-buy by TF1, which at the time
was a public broadcasting station.) Paradoxically, Marcel
Dassault, owner of the Paris Theatre on the Champs-
Elysées, one of the theatres where the film first opened,
was embarrassed by the film and reproached the film-maker
for talking too much about Jews. He wanted to cancel
the booking and finally let himself be talked into showing
the film, but – against his own best interests – only for the
period he had contracted, despite its growing success.

Moreover, when Truffaut began shooting in January 1980,
he had a script that, as often happened, did not satisfy
him completely and even made him uneasy. 'I should rework
the script and shoot in six months,' he confided to Claude
de Givray. The fact that this time he had constructed a story
with multiple storylines and no *idée fixe* to support the
through-line disoriented him, and he doubted his own
characters, whom he could only half bring to life, since he
could not push any single character to the point where
he would be revealed in depth. He did not see that he had
built his story and his *mise-en-scène* around something
just as powerful: the secret that eats away at each character
and underlies the whole film.

Theatre and occupation.

The project was borne out of the combination of several
old ones. The idea of making a film set in the Occupation,
and particularly of telling the story of a child during the
Occupation – that is to say, Truffaut's own story – dated
back to *Les Quatre Cents Coups*, which he preferred to
separate from his own childhood both for financial reasons
(the impossibility of making one's first feature a period

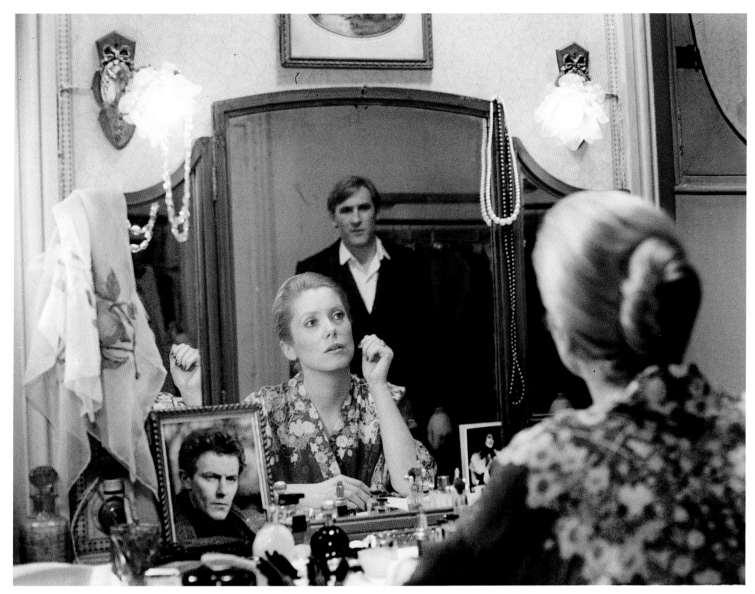

Mirror shot. Marion Steiner caught between the photo of her husband (Heinz Bennent) and the reflection of Bernard Granger (Gérard Depardieu).

film) and to distance himself from his own life story. In 1969 he was impressed by Marcel Ophuls's documentary *Le Chagrin et la Pitié*, the first film, he felt, to treat the Occupation without any fake mythology, one that seemed to him as rich as a fiction film and gave him the impression that he had nothing to add that could be more fair and accurate. In another dossier, Truffaut collected for years elements destined for a film about the theatre, which he put off for a long time, all the more because in a way he left the prerogative of the subject to his friend Jacques Rivette. (Rivette had, notably, had a project in the 1970s called *Phénix*, in which Jeanne Moreau was to have played a reclusive star who lives in her theatre.)

In the years 1970–1, Truffaut placed several large orders for books about the theatre (among others, the lives of Talma, Frédérick Lemaître, Mademoiselle Clairon, Adrienne Lecouvreur, Sarah Bernhardt, the memoirs of Dumas, the lives and loves of great actresses, the history of the Grand Guignol…), certain elements of which he ended up using for the project that became *La Nuit américaine*. In spring 1979, when he was looking for the theme of his next film, he had the idea of combining these two subjects in which he had never lost interest, preferring as usual to wait for the

right moment, when an idea was not too much 'in the air' and could appear new again. 'In the meantime I had let subjects I was passionate about go by, like *Un enfant sous l'Occupation*, a subject I had been thinking about for some time, but which had become too fashionable,' he declared in a 1975 interview. 'I waited for it to become unfashionable again. What I filmed then was probably different from what I would have filmed yesterday or would film tomorrow. These are the risks of the *métier*.'

In October 1976, just before starting production on *L'Homme qui aimait les femmes*, Truffaut wrote to Jean-Loupe Dabadie to talk to him about a book (*Night Falls on the City* by Sarah Gainham) that he did not think was very good but had an interesting premise: during the war, in Vienna, an actress continues to perform while her husband, a Jew who is supposed to be dead or in exile, is hiding in the cellar of the theatre. 'Here is the premise of a story that could be a cross between *The Diary of Anne Frank* and Lubitsch's *To Be Or Not To Be*.' Dabadie said he was more interested in the pre-war years and didn't think that the story could be transposed to Paris. He did not encourage pursuing the idea – another indication if one were needed that the subject was not considered

Right: Nadine (Sabine Haudepin), the ambitious young actress, is dropped off in front of the theatre by a German car.

Below: Modifications to the screenplay and a sketch of the *mise-en-scène* in the shooting script, showing the importance of the beginnings and ends of scenes. Martine, the black marketeer, has brought Raymond a ham he ordered for Marion, an action that gets caught up in a series of entrances and exits. A note specifies: 'We begin and end on Martine alone with her ham.'

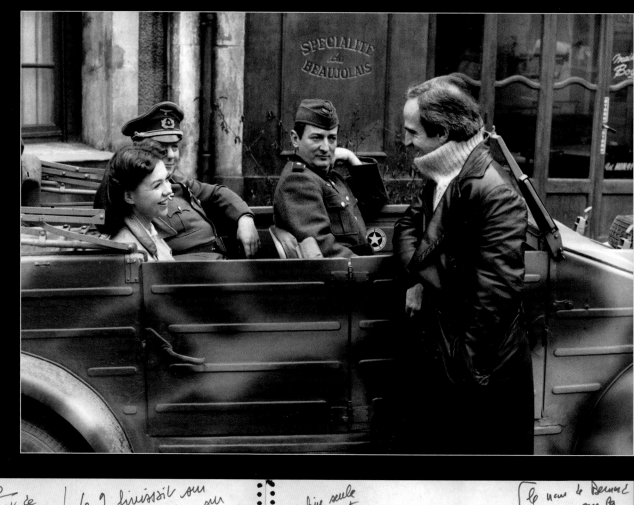

10. COULOIRS THEATRE. INT. JOUR 10.

Dans le couloir des loges, Raymond est aux prises
avec Martine : il lui avait interdit de venir le
déranger dans son travail, alors qu'est-ce qu'elle
fait là, dans le Théâtre ? Martine lui montre ce
qu'elle dissimule sous sa cape : un jambon de neuf
kilos et, si elle l'a retenu, c'est que Raymond lui
a dit qu'il en cherchait un. Elle a promis de le
payer ce soir et elle n'a pas assez d'argent pour
avancer la somme (neuf kilos à six cents francs le
kilo, c'est pas cher au prix où sont les choses,
mais ça fait quand même du fric.) Entendant des pas,
Raymond pousse Martine dans la réserve qui lui sert
d'atelier. Qu'elle attende là, il va s'occuper de
son jambon. A peine la porte refermée, Raymond voit
venir Marion. Mystérieux, il lui demande, à voix
basse, si elle est toujours cliente pour un jambon.
Marion accepte. Que Raymond le lui apporte dans son
bureau, elle pourra le lui payer immédiatement.
Passage de Nadine qui salue tout le monde, puis de
Bernard que Marion retient un moment.

MARION
Dites-moi, Bernard, je n'ai pas bien
compris ce que m'a dit Raymond.
Vous jouez encore au Grand-Guignol ou
vous avez arrêté ?

BERNARD
Non, non. On joue encore deux semaines,
le temps que le spectacle suivant soit
prêt. Là-bas, c'est l'usine. Mais enfin,
il est temps qu'on s'arrête, on n'a plus
beaucoup de spectateurs. grand monde

- 26 -

Desire and taboo: a display of legs points
to the newspaper announcing the invasion
of the Free Zone by the Germans. Truffaut
found his inspiration in a book about

'commercial'. Yet Truffaut, still trying to convince him, added: 'The French public's disinterest in the period of the Occupation doesn't concern me, because we can always hope we'll be the exception, and let's not forget that France is only one of 56 countries where the film can distributed...' Also in 1976, in a short article published in *Parispoche* in defence of André Halimi's film *Chantons sous l'Occupation*, Truffaut mentioned the song that years later would become his film's leitmotif: 'André Halimi's film reminds us that we have never sung more than we did under the Occupation. I can still see Parisians gathered in the streets around street singers, who also peddled the sheet music: "Mon Amant de Saint-Jean", "Au bar de l'escadrille", "Le gardian de Camargue", "Chérie, les jardins nous attendent", etc.' Responding to the accusation that André Halimi had presented a negative image of artists under the Occupation, Truffaut expounded a notion of compromise – or rather of being compromised – that was very close to what he would later put in his film: 'Things aren't that simple, and *Chantons sous l' Occupation* shows this too. Today, in 1976, when we finance our films through foreign banks linked to the manufacture of napalm and when we agree to show them in countries where political prisoners are hanged, are we not being "collaborators" in turn?'

A sign that the subject continued to obsess him, even though he said repeatedly at the end of 1978 and the beginning of 1979 that he did not have a specific film project in mind, was the letter Truffaut wrote in October 1978 to Father Guy Léger (a friend of André Bazin) to ask him if the canticle 'My God, My God, Save France' (which he would use in the scene when Christian is arrested in church) was actually composed during the Occupation. Truffaut started writing the screenplay in March 1979 with Suzanne Schiffman, whose not very happy childhood memories would enrich the film (in particular the character of little Rosette, the daughter of a Jewish tailor forced to practise his profession clandestinely, who plans to come and see the play by hiding her yellow star under her scarf). They worked hard on it that spring and all summer: a first 'complete summary' is dated May 1979; a long 'synopsis', July 1979; and a first treatment with dialogue – written during the summer near Vaison La Romaine, where Truffaut was theoretically on holiday – August 1979. The script was practically finished by the end of September; with a few exceptions, it was just as it would be when the film went into production, and the following months were spent looking for financing. Lopping off a few months, Truffaut would say when the film was released: 'We wrote the script last year in two months, working from our own memories, questioning friends and reading every conceivable book about theatrical life during the Occupation and about the collaborationist press.'

A helping hand.

Approximately ten days before the start of shooting (28 January 1980, at the Théâtre Saint Georges in Paris), Truffaut asked Jean-Claude Grumberg to write additional scenes and dialogue. He was unhappy with the scenes between Marion, who runs the theatre in her husband's absence, and Lucas, her Jewish husband, who is hiding in the cellar – because he felt that he had not quite found

Lucas's way of talking. He had just seen Grumberg's play *L'Atelier* at the Théâtre du Gymnase, and he liked the characters and the tone. He wrote to the playwright, sending him his script, on 15 January: 'Your Leon is sublime. He has everything my Lucas lacks. Would you agree to collaborate? Lucas Steiner will be played by Heinz Bennent, a very good German actor who speaks French quite well, without a thick accent. The problem is that I haven't found how he should speak; I didn't know how to bring him to life. As far as I'm concerned there is no question about it: the solution is at the tip of your pen, which is far more talented than mine.' A few days later Truffaut was reassured, and even if he planned to rewrite the proposed dialogue again in his own style (he warned Grumberg that he might keep only 30 or 50 per cent of his lines, which he would adapt to fit how he or his characters expressed themselves), the helping hand had given him the impetus he needed. He also asked Grumberg to give him one or two new scenes to beef up the character of Daxiat, the critic for *Je suis partout*, who dreams of becoming the director of a theatre. ('To reinforce the character of Daxiat and show that he is really dangerous, I'd like to have a scene with him at a radio station broadcasting his daily informal chat on the theme of Paris theatre, which is too effeminate and too Jewish. When the image of this scene ends, the sound will continue for 30 seconds on the radio in Marion's dressing room.') He wrote to Grumberg three days before the start of production, on 25 January: 'Whenever I write a letter before starting a new film, I more or less imagine that I'm dictating my will. You are hereby named executor of my last desires (which are less dictatorial than last wishes).'

The current is on.

From the beginning, Truffaut planned to construct his screenplay around the process of putting on a play from the first rehearsals to performance and to make this artificially coincide with several years of the Occupation: from the period before the invasion of the Free Zone to the Liberation of Paris and a few months after. On a page of preliminary notes he traced a very crude outline of the overall structure, mixing the time the production was being mounted with a condensed version of history: 'free zone/occupied zone-opening night/performance… Gestapo/ending.' He also planned to begin the story with the arrival at the theatre of a new actor about to be hired for a part in the play, a refugee from the Grand Guignol. From his various sources Truffaut took little facts, ideas, ingredients that he hoped to use and began jotting down lists of scattered notes. He opened one page containing various notes by briefly evoking Alain Laubreaux, the feared critic of *Je suis partout*, whom he first called Tobereaux – a name closer to the original, which he wanted for a play on words with the phrase 'tombereau d'ordures' (dung cart). (Daxiat, the name he finally chose, comes from the pseudonym used by Alain Laubreaux to sign a play, *The Pirates of Paris*.) Truffaut also mentioned an incident that he would use for the critic's appearance on opening night: 'For the opening of *La Reine morte* at the Français he arrived 15 minutes late, with a cigar in his mouth.' He listed fragments of ideas and stories that he set down without knowing what he would do with them and where he would

put them. Sometimes they were just visual flashes, or bits of dialogue, which later became parts of a scene: 'In the cellar he has heard "Mon Amant de Saint-Jean", he wants the sheet music'; 'Dieu de Clémence… church… who? Why? Preferably children…' (In the scene, a chorus of children sings *Dieu de Clémence* while the Gestapo arrests Christian as Bernard looks on helplessly); 'Why do you say that? Because it's in the play'; 'Tobacco growing in a corner…' Or again, in reaction to a story that he probably found in a theatre memoir: 'Episode of electrical sockets too difficult but the idea of installing sockets is interesting (and if the concierge realizes that the electricity has been left on? Allusion *Gaslight* play seen in London).' The business with the electricity being left on was rather extensively developed in the first treatments: Raymond, the stage manager, is worried to find the electric meter on when he had turned off the electricity the night before; he questions Marion. At the beginning of a scene in the shooting script that was not filmed, Marion tells Lucas about Raymond's fear that someone has tapped into the theatre's electricity. Then, washing his hands of the subject, Truffaut kept only a few points that become mysterious because they are not explained: at the end of a scene, Raymond turning off the electricity ('Madame Steiner, can I throw the master switch?'), plunging the theatre and the shot into darkness; an allusion by Lucas to *Gaslight*, a play he was tempted to put on, where we realize that the suspicious husband, after pretending to leave the house, has come back and is hiding in the attic because the gaslights dim; the idea that Marion uses a lantern to go to Lucas in the cellar because she doesn't want to use electricity. Thus Truffaut could also set up the approaching revelation of the central secret – what is Marion doing returning to the theatre? – by using an elementary visual idea with great suggestive force, creating an atmosphere that reinforced the mystery: Marion moves through the dark corridors, and we don't know where she is going, holding before her at eye-level the lantern that is the only light source in the darkness of the shot. In the finished film Lucas does not ask Marion, as he had in the script, why she has not turned on the lights, that part of the scene having been cut, so the rational justification no longer exists. This way of moving the story forward by leaps that are never explained, this constantly mysterious nocturnal ambience, this sense of a thriller being held in check are what is unique about *Le Dernier Métro*, whose story is less straight-forward than it appears. The removal of explanatory scenes about the electrical leak is typical of the movement of a screenplay that progressively frees itself from justifications.

First ingredients.

To develop *Le Dernier Métro* Truffaut broke away from the way of working he had used for his other films: having a first draft of the screenplay with dialogue, whether by Jean Gruault, Claude de Givray or Jean-Loup Dabadie, delivered to him, against which he could react before re-appropriating it. He and Suzanne Schiffman started with scattered notes, ideas for characters, a first unfinished outline, then more detailed résumés before writing a draft with dialogue. Most of the characters were defined from the start, and some ideas were already in place, as in this description of the future Lucas, initially named Oskar (in

memory of Oskar Werner, despite their fall out?), where the idea of anti-Semitic crosswords first appears: 'He takes care of his appearance and his mind, does crossword puzzles (even finds an anti-Semitic solution at one point).' Other ingredients, not yet fixed, moved from one character to another: the idea that Jean-Loup, the replacement director, 'has neither male nor female friends', which would later be used to define the critic for *Je suis partout* ('He doesn't like women, he doesn't like men, he only likes food; he's a gourmet' is a line in the shooting script that was cut during editing); the idea that Germaine, the dresser, wanted to be a singer when she was young and listens to the radio with the sound turned down low to learn songs, which she is then heard humming. Instead it would be Lucas, a more central character, who listens to Radio TSF and is interested in the songs that Truffaut wanted to punctuate his film, for which he clearly needed a thread to string them on. The future Martine, a black market dealer who everyone thinks is Bernard's girlfriend, is initially Bernard's sometime girlfriend and is named Lucette, Lulu for short. In the film she is the one Germaine speaks to about getting a copy of *Gone with the Wind* for Marion, which can be obtained on the black market for a fabulous price. This is the outcome of an idea that was not well defined in the first résumés: 'Perhaps it is Raymond who knows how to get a book Marion wants at the Galeries Lafayette.' Conversely, certain initial characterizations disappeared, such as the idea that Jean-Loup (first named Philippe), like Truffaut himself, collects Eiffel Towers which assistants have to set up for him in his dressing room, or the rather cruel idea that at the end of the story he would try to use his connections to free a poet, but too late, because the man is dead. That idea remained as: freed because of his connections, Jean-Loup is re-arrested the next morning because of his connections. Another episode, at first conceived as important, finally dwindled to nothing: even in the shooting script several short scenes turn on the idea that Jean-Loup wants to give up his part to devote himself solely to directing; Lucas has to whisper to Marion, who is on the telephone, the answers that will make him change his mind. Truffaut cut these scenes in the editing, keeping one and modifying it by looping dialogue of Jean-Loup answering an enigmatic phone call from Daxiat over it, thereby introducing the menace represented by Daxiat sooner, and along with him the shadow he casts over the Théâtre Montmartre. These first outlines also give Bernard's crush on Arlette, the wardrobe mistress (whom he meets for the first time at the theatre and not in the street), an importance that it would partially lose as the screenplay developed the relationship between Bernard and Marion. 'It's after Christian's death and the discovery that Arlette is a lesbian that Bernard decides to quit the theatre,' indicated the first description of the characters. As the writing of the screenplay progressed, the characters' motives, described explicitly at first, became increasingly ambiguous and less determined by a single goal: for example the idea, expressed in the first description of the characters, that if the ambitious young actress (initially named Betty) has an affair with Arlette, it is because the wardrobe mistress can help her get a film role. In the film, which ended up more secret and less rational, the affair is allowed to keep its mystery.

A PARIS, ON RÉPÈTE AUX BOUGIES... Les restrictions d'électricité ont imposé aux théâtres parisiens des contingences extrêmement dures. Aucune répétition n'était possible, aussi c'est aux chandelles (comme aux temps héroïques) que la troupe du Vieux-Colombier a préparé « Les Autres », la dernière pièce de Sartre, qui veut renouer la tradition de Copeau, a engagé, pour son premier spectacle, trois des meilleures vedettes de Paris : Gaby Sylvia, Tania Balachova et Vitold, que l'on voit sur notre photo.

Above left and right: Documentation and borrowings. Truffaut drew inspiration from the theatre periodicals of the time, in which actors were shown rehearsing by candlelight (Catherine Deneuve, Jean Poiret and Gérard Depardieu).

Right and below: In a copy of Jean Marais' memoirs, Truffaut sketched out the scene of the fight between Bernard (Gérard Depardieu) and Daxiat (Jean-Louis Richard), a character inspired by the critic of *Je suis partout*, Alain Laubreaux.

> → Scène Daxiat - Granger.

rents dehors — des éclairs, le tonnerre, une nuit shakespearienne. D'abord, je ne vois rien. A la lueur des éclairs, je reconnais le crâne chauve d'Hébertot. Je lui tends la main. Puis j'aperçois un autre convive, un familier, je le salue. Puis un troisième, je me présente. Il ne se nomme pas. Hébertot me dit : « C'est ~~Alain Laubreaux.~~ *Daxiat:*

Je dis :

« Ce n'est pas vrai !

— C'est ~~Alain Laubreaux !~~ *Daxiat:*

— Si c'est vrai, je lui crache à la figure. Monsieur, êtes-vous ~~Alain Laubreaux ?~~ *Daxiat ?*

Il ne répond pas. Je répète :

« Monsieur, êtes-vous ~~Alain Laubreaux ?~~ *Daxiat!*

Il dit oui. Je crache. Il se lève. Je crois qu'il veut se battre. Je frappe.

Le petit restaurateur, qui m'avait suivi, nous sépare.

« Pas dans mon restaurant ! Pas dans mon restaurant ! Je vais encore avoir des ennuis.

— Bien. Je lui casserai la figure dehors. »

Je descends. C'est aux convives du rez-de-chaussée de me supplier de prendre garde.

« ~~Laubreaux est de la Gestapo. Nous serons fusillés, me dit Jean.~~

— Tu es en dehors de cette affaire, lui dis-je. Je ne crois pas qu'il soit de la Gestapo, mais j'ai dit que je lui casserai la figure et je le ferai. Tu vois, je suis calme, je n'ai plus de colère. »

J'attends plus d'une demi-heure. Il ne descend pas. Enfin, je le vois, suivi d'Hébertot et de l'autre. Ils sortent. Je les suis. Il pleut toujours à torrents.

Laubreaux a une grosse canne carrée. Je la lui arrache. Si je me sers de cette canne, je risque de le

"Allez, maintenant faits de excuses à mr Steiner et à Vauts la troupe de la Disparue.." 225

le Dernier Métro

dialogues additionnels

Fin Scène 38 - INTERIEUR CAVE - NUIT

(la caméra suit
Lucas caresse les jambes de Marion.) ~~Nous suivons~~
un moment la main de lucas et nous
remontons vers ~~leurs~~ leurs visages. Ils
s'embrassent. (On devine que la caresse continue)
au dessous du cadre.

LUCAS : Tu te rappelle .. dans le grand
ascenseur des galeries Barbès ..?

MARION : oh oui! j'étais persuadée que ~~la~~
tout le monde se rendait compte .. (ou:
« j'étais morte de peur.... que tout le monde
nous voyait..)

LUCAS : ~~Seulement~~ Tu avais seulement
de la peur ?

MARION : Non, pas seulement, mais
j'avais peur ~~fraîche~~ ~~même~~ aussi .. Et
le ~~lendemain~~ soir de la couturière de
"Maison de Poupée" ... (Ils s'embrassent
à nouveau)

LES FILMS DU CARROSSE 21 janvier 1980

Mes chers amis,

nous allons tourner un film ensemble.

[Avant de commencer,nous avons tous le trac,c'est à dire que notre imagina-
-tion galope et brode sur une inquiétude abstraite:il nous semble que tout
ce que nous avons fait avant ne va pas nous aider cette fois et que le
trajet du Dernier Métro recèle telle ou telle difficulté pernicieuse jamais
affrontée auparavant.

[Je crois au contraire que Le Dernier Métro sera un film facile et agréa-
-ble à tourner,comme chaque fois que les personnages sont plus importants
que les situations.Bref,selon moi ,seule la pellicule devrait être
impressionnée.

[Tout de même,faut-il que nous ayons reçu une éducation bien oppressante
pour douter aussi systématiquement de notre aptitude dans un des rares
métiers de vocation,un de ceux qui autorisent l'élément de plaisir à
occuper la première place.

[A présent oublions le stage fright,imaginons que nous ~~sommes~~ ~~enfermés~~
évoluons tous dans Le Dernier Métro comme des poissons dans l'eau.

[Nous allons travailler dans le but de raconter une histoire intéressante
et intrigante.Je propose que nous gardions cette histoire secrète et que
nous évitions de la raconter aux journalistes.Evitons même de décrire
les personnages.Ce qui se passe dans le Théâtre Montmartre,de la cave
au grenier ne regarde que nous et ~~aussi~~...le public avec lequel nous
avons rendez-vous mais seulement dans neuf # mois (forcément).

[L'équipe caméra,sous la direction de Nestor Almendros,s'efforcera de
faire une belle image, évoquant avec plausibilité l'époque de l'occupa-
-tion.Ne laissons pas les caméras hasardeuses de reportage télévisé
donner une impression brouillonne de notre travail.

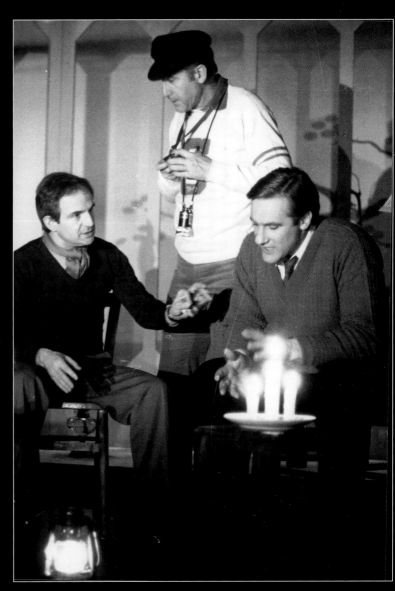

Truffaut wrote several additional scenes
during filming.

Above: Behind Truffaut and Gérard
Depardieu is Nestor Almendros, whose
lighting for the film was particularly
elaborate.

A few days before shooting, Truffaut
wrote to his actors urging them to keep
the film's plot twists secret. He also assured
them that he believed it would be 'an
easy, pleasant film to shoot' and that
'only the film stock should feel exposed'.

If Truffaut was thinking of *To Be Or Not To Be* in constructing this film with multiple characters, mixing stage and backstage, glamorous characters and technicians in the shadows, he was also thinking of *La Règle du Jeu*. He was happy to have one of Renoir's actresses, Paulette Dubost, Christine's maid in *La Règle du Jeu*, play Marion's dresser, always ready to grumble and remind that you can only have things 'by paying for them, of course'. In the first summary the future Jean-Loup, the replacement director, is conceived in explicit reference to Dalio in *La Règle du Jeu*: 'If Marion reproaches him for always understanding everyone's reasons, he will respond that it's true, but he plans to remain superficial because he neither wants to suffer nor to cause suffering…' The guy Marion spends the night with is also designated as her 'Saint Aubain', the lover Christine takes out of spite in the Renoir film.

Displacements.

A first unfinished summary of the film was conceived in three parts:
From Bernard's arrival at the theatre to the invasion of the Free Zone.
Rehearsals until the revelation of the presence of Oskar (the future Lucas) in the cellar and the aftermath of Bernard's punching out the virulent critic.
The play is performed, the dangers to the theatre grow until the hundredth performance, when Marion sleeps with a stranger.
Marion must indeed go see an influential German to protect the theatre, and the first summary ends as follows: 'and if the German is invited to the 100th performance and the party afterwards, where Marion, who feels judged by Bernard, ends up sleeping with a guy… whom she refuses the next day…'

We can see that while most of the elements of the film are already present, they do not necessarily occupy the place the film-maker would finally assign them in a tighter dramatic structure. In the finished film it is during rehearsals, when Lucas has advised her to take the troupe out to encourage them, that Marion lets herself be picked up by a guy whom she shuns on the opening night, asking Bernard to help her get rid of him. Strong scenes eventually find their place. Truffaut would put the discovery of Lucas Steiner in the cellar nearer to the beginning of the film, placing it before the invasion of the Free Zone (and even earlier in the editing than in the writing, removing several intermediate scenes in order to let the audience discover Marion's secret just before the end of the film's first half hour). The screenplay was first conceived as a chronicle, an accumulation of more or less light-hearted episodes. Many elements that were eventually moved to the first part, during rehearsals, were for the moment in the second half (during and after the première): the evening when Bernard talks about the time he escaped from a roundup in a cinema; the anger of pudgy Raymond, who leaves to pick up the second-act dress that had been left at the cleaners and arrives at the last minute, during the interval, because he refused to take a bicycle-taxi; thefts committed in the dressing-room by Lucette, Bernard's friend (the future Martine). In the next résumé, Truffaut moved these thefts to the opening night, where they would be just one mishap among others. In the script with dialogue, he then inserted them at the end of the first part of the film, just before the première, where they were more alarming and contributed to the overall direction the film-maker was giving his film: a muffled menace that weighs on the whole first movement and grows little by little, before dispersing and exploding in the last part. Everyone has something stolen, Nadine no longer has her pass to go out at night or her food card, but Marion refuses to let the police search the theatre, and we know what her refusal and her violence are hiding

Certain developments that would become strong moments in the film were still handled in a rather flat and conventional manner. The announcement that the Free Zone has been invaded, for instance: Germaine, the dresser, hears about it on the radio and announces it. At this point Truffaut and Suzanne Schiffman simply planned to mark the event with 'Marion's violent reaction, stopping the rehearsal and sending everyone home' (first résumé). In the next stage, the complete summary, the scene was lengthened: 'Marion overhears a conversation which informs her that the Germans have invaded the Free Zone. Diverse reactions of the actors.' Elsewhere in this résumé we hear about stockings you can buy on the black market: in the wings, Betty (the future Nadine) buys silk stockings from Lucette (the future Martine), and Marion buys cigarettes from her even though she doesn't smoke, surprising Germaine. In the next treatment, in the midst of a series of little actions that are planned to happen before the première, the black-market stockings reappear, too expensive: Marion is waiting to go on stage and 'in the hallway Martine shows Betty a pair of stockings she just received'. They are not yet the painted-on kind, with imitation seams running down the backs of the legs, where you need the help of someone else, 'preferably a man'. When Truffaut and Suzanne Schiffman wrote a first continuity with dialogue (the Vaison La Romaine version, dated August 1979), he had the idea of combining all these elements: a frivolous conversation among three women (Martine, Nadine and Marion) about black market merchandise, the painted legs that Martine and Nadine display on the table to compare them, right on a newspaper, whose headline we read at the same time as Marion: 'German troops have invaded the Free Zone.' An association between a strong moment, a climax (where the story and history coincide, because the invasion of the Free Zone alters plans for Lucas's escape, forcing him to remain in the cellar), with that image of women's legs boldly displayed: an indirect representation of the undercurrents of sex, desire and fantasy that run through the whole film, and the focus of a feminine rivalry around the character of Bernard. (Doesn't Marion, always a little withdrawn as she is in this scene where the two other women show off their legs, say at the end of the film: 'I had the impression that you tried something with all the women except me'?) Besides constructing a dramatic climax, the whole art of Truffaut is in the way he concentrated at this one point, quite casually, the more or less conscious lines of force of his film, bringing together a good-natured surface (a lively story, charming and falsely classic, the quasi-documentary use of little historical facts, the frivolity of the scene until the bomb contained in the newspaper headline

Bernard Granger (Gérard Depardieu) and
Daxiat (Jean-Louis Richard) in the rain.

explodes) and the repressed forces that animate the film and appear in flashes: desire, taboos, secrets. The power of a hovering threat and of forbidden things weighs on the film. The image of one of the sexual fantasies most frequently displayed in Truffaut's films (the trick of painting on stockings to arouse desire), and the pleasures of lying and seduction attached to it, lead to the impossible, the forbidden, crossing the line of demarcation. Now Marion only has to announce this new obstacle to her husband at the beginning of the next scene. This is how the film functions: the appearance of logical progression covers the movement of less conscious forces; Marion's still unspoken desire encounters an obstacle. She has no choice but to keep her husband in the cellar and stop his attempt to flee.

Naturally, the first résumés didn't carry the situation to its conclusion: at first the husband hidden in the cellar accepts philosophically the fact that he is trapped there after the invasion of the Free Zone. It is only in the first treatment with dialogue, at the same time as the scene of the painted stocking posed on the newspaper headline, that he cracks when he learns the news, brandishing the crossword puzzles he has been doing to keep his brain from softening ('symbol of baseness: *kike*, 'stinking greed: *yid*'), and tries to escape no matter what the cost, obliging Marion to knock him out.

'And here is the cello.'

Movement from a banal scene to a good one, from conventional exposition to a *coup de théâtre*. The work on the screenplay for *Le Dernier Métro* also wove all the levels of the story ever more tightly – history, secrecy, desire, sex, the rehearsal process, theatre life, the life of the troupe – as well as the different genres it combines: a period film with precise documentary facts, a thriller permeated by an omnipresent threat and at certain moments, US-style comedy with repetitions and gags à la Lubitsch. 'No, I didn't sleep at home last night,' Bernard and Marion successively say one morning, one because he barely escaped a roundup by the Service du Travail Obligatoire (STO) for compulsory labour in Germany, the other because she spent the whole night in the cellar sharing 'the conjugal hovel'. Bit by bit, Truffaut refined and complicated his material. In the first incomplete outline Marion goes to a bistro near the theatre to buy a package of food from the country, a simple documentary detail. In the next outline the idea of the ham appears in isolation: 'Raymond brings her the ham he promised and tells her he's shutting her in the theatre.' When Truffaut was writing the version with dialogue, he made the ham an object that circulates between different spaces and different characters: Martine, hidden in the darkened auditorium, brings it to Raymond one night; then Raymond brings it to Marion, who's busy discussing box office receipts at the Grand Guignol with Bernard: a scene in the corridor where Truffaut accumulated levels of secrecy and layers of story. Jean-Loup, Arlette, Germaine, ready to leave, pass between Marion and Bernard talking in the corridor; Raymond comes and says a discreet word to Marion about the ham; Nadine comes looking for Bernard, with whom she clearly has a date, and takes him away from Marion; Marion, who would have liked Bernard to say goodbye using her first name, observes their departure through the window

of the theatre; then Raymond brings her the *corpus delicti* hidden in a cello case – a gag whose purpose is to let her carry it to her hotel without being noticed. No sooner does Raymond leave than Marion surprises us by hiding the cello case and the ham it contains behind the dresses and coats in her closet. Later, when we first see Lucas in the cellar, we recognize the ham hanging on the wall. This process of complication and indirection, this weaving together of multiple micro-actions where ordinary activities and a surface vivacity cover hidden intentions and desires (mixing comedy and thriller, the gag with the ham hidden in the cello case becomes a synecdoche of the whole film) exemplifies the process of writing the film, at the heart of which multiple secrets interlace and interact: Marion hiding Lucas in the cellar and hiding her desire for Bernard, Lucas hiding the fact that he knows, Arlette hiding her attraction to Marion, Bernard taking the theatre's record-player to help his friend Christian in his acts of resistance, Nadine and her all-consuming ambition, Raymond who would like people to think he has a girlfriend, etc. The power of the film and of the account no doubt came from Truffaut's way of telling his story first on the apparent level – complication and intricacy of the material, gags, playing games with the viewer – and a more hidden level: the power of the secret and the telescoping provoked by images and scenes being brought together, not necessarily perceived on a conscious level.

Fear.

If Truffaut developed his story so as to keep the viewer occupied by constantly entertaining him, at the same time he was inscribing fear at the heart of his film. The most visible element is the critic from *Je suis partout*, who initially was not very developed. We hear a lot about him, but Tobereaux (the future Daxiat) only appears in person at the première, where he arrives late. Then we see him again in a restaurant where Raymond brings the first reviews; Tobereaux's is racist. Bernard wants to punch him out, a scene inspired by a fight between Jean Marais and the critic Laubreaux, who had written something insulting about Cocteau and his play *La Machine infernale*. In the next version Truffaut planned that 'Daxiat will be one of the key characters in our story, the one who embodies Collaboration', and summed up his traits in a note: ex-Communist, Doriotist of the right-wing French Popular Party, fascist, obscure pre-war journalist. Then Truffaut accumulated from one version to the next scenes that would enable him to gradually build up the menace embodied by Daxiat, the only character who really represents the outside world, the pressures of war and the ideas of National Socialism. In the first long version with dialogue it was added that he is outside the theatre at the end of the first night; Jean-Loup is supposed to see him, but Marion refuses to have dinner with them. It was also planned that Daxiat would visit a rehearsal, with the idea that Nadine, not at all disgusted, is interested in him, and that Germaine tries to speak to him about her son who is in a German prison. In the first version with dialogue, the long scene where Daxiat comes looking for Marion at her hotel also appears. He brandishes Lucas Steiner's fake identity card, a card found on a refugee trafficker taken in for questioning; there's an alert, the

Lucas and Marion Steiner (Heinz Bennent and Catherine Deneuve). Truffaut has Lucas make fun of himself, reading *Décombres*, an anti-Semitic pamphlet by Lucien Rebattet: 'The Jews take our most beautiful women from us.'

The secret behind the door (Andréa Ferréol and Sabine Haudepin).

descent to the underground shelter, barely veiled threats… When writing this scene, Truffaut at first had the idea of dividing it into two parts in order to play up the danger by ending on a strong moment. ('Lucas Steiner has not left France,' proclaims Daxiat when the sirens sound an alert that makes them go down to the basement of the hotel, where the second part of the scene would be played in whispers and half in shadow.) He also gave up the idea of filming an ending for the scene that would start over on a funnier, more light-hearted note: while Daxiat plays cat-and-mouse with Marion, the script planned to end the scene on an old chef with an accent from the Berrry region who declares that he is too old and tired to go up and down every time there's an alert: 'I've found a good seat – I'm not budging.' A personal memory of one of the writers? It was sacrificed so that the scene could end on a direct, chilling threat: 'The name Steiner is no good for you. You should get a divorce.' In the first version with dialogue Daxiat was nicer, even if it was feigned: 'I'll give you a message for him: he can return to Paris. I swear to you that he will have permission to work.' In the end Truffaut prefers not to beat about the bush.

While editing, the film-maker reinforced the tension of the threat Daxiat embodies. As we have seen, at the beginning of the film he replaced one of the cut scenes with a telephone call from Daxiat to Jean-Loup. He also used alternating montage: after a scene between Lucas and Marion that ends on a rather happy note (Marion, tenderly ironic: 'My mother warned me I'd never be happy with a Jew'), he placed the rehearsal scene where Daxiat suddenly appears. Conversely, after Daxiat's threats to Marion at the hotel, he placed an intimate scene between Lucas and Marion that he wrote during shooting: the recollection of their lovemaking in the big lift of the Galeries Barbès (perhaps a reminiscence of a scene cut from *L'Homme qui aimait les femmes* where Bernard's great love who is turned on by precarious situations gets him to make love to her in a department-store lift). Truffaut hastily jotted down the scene on his copy of the shooting script ('Lucas adds a sexy little private phrase: the big lift at the Galerie Barbès') before giving his actors the dialogue, adding a moment of relaxation and calm intimacy before the menacing climax and the storm. In a prior version of the script, Marion told Lucas about Daxiat's attempt at intimidating her, a redundant scene that Truffaut did not hesitate to cut, preferring to progress by little leaps.

This dramatic irony is carried forward in the next scene, which Truffaut asked Claude Grumberg to write just before the start of shooting: Daxiat spewing the anti-Semitic bile of *Je suis partout* over the radio. For this scene, which he placed just after Daxiat's visit to the rehearsal, Truffaut had sent Grumberg some pages of *Décombres* by Lucien Rebatet and 'a very precise note by Darquier de Pellepoix', Vichy's commissioner for Jewish questions. Daxiat pretends to defend Lucas when he talks to Marion – 'He was wrong to leave France' – only to proclaim seconds later on the radio that 'French theatre must be purged of Jews from the rafters to the prompter's box'. This reinforcement of the permanent menace weighing on the characters and the theatre was basically what Truffaut was

asking Grumberg for when he asked him to bring Lucas to life. It is to Grumberg that we owe the misunderstanding about the bad news that opens the first scene where we see Lucas in the cellar, immediately characterizing the character: 'Marion: I have some bad news for you, Lucas. / Lucas: Has the Propagandastaffel banned the play?' Grumberg also supplied the dialogue about the 'so-called smugglers' who take money and then bring their clients to the Kommandantur, as well as the ingredients for the dialogue about anonymous denunciations that enriches the ending of this first scene where we see the couple: 'Do you know how many denunciations of Jews the police get every day? [...] My boss is Jewish, my neighbour is Jewish, my brother-in-law is Jewish.' Above all, it was Grumberg who suggested to Truffaut the scene where Marion cuts Lucas's hair while he tries on a false nose from a box of props, and asks the famous question: 'What does it mean to look Jewish?' In the script the scene was very short (a shared joke, ending with a blast from the radio as TSF is broadcasting 'Mon Amant de Saint-Jean'). These chilling questions under the cover of comedy dialogue ('I try to feel Jewish. Jewish roles are very delicate. If you underplay, they say: he's exaggerating. If you overplay, they say: he doesn't seem Jewish') unobtrusively reintroduce the threat of the external world in the very scene where, a few moments later, through the double-edged words of the song, the thread of Marion's evolving feelings about Lucas is taken up again ('He no longer loves me. It's over, let's not talk about it any more'). Here we see one of the film-maker's old rules: not writing one scene per idea, but using several ideas to nourish the same scene.

Some of Grumberg's contributions were cut during editing, such as the idea that Goebbels had been a theatre director from 1925 to 1926 and started a troupe to 'cleanse the theatres of the Jewish filth'. At the time his statements made Lucas and his friends laugh, but less so his brother, who recommended that they all leave. (The idea that Lucas has a brother exiled to the United States also suddenly disappeared from the film.) Or these lovely lines in a short, intimate scene with the couple, which Truffaut liked very much but cut to speed up the scene: 'It's an old Jewish trick. We always manage to act pitiful. That way women fall into our arms.'

The ending invented during filming.

The shoot began on 28 January 1980, first at the Théâtre Saint-Georges (a setting found only two weeks before the start of filming), then at the old Moreuil chocolate factory in Clichy, which was turned into a studio for the scenes in the corridor, offices and wings, as well as the exteriors in the street and the courtyard, which were reconstructed there. As was his habit, Truffaut re-read the dialogue and invented some new scenes besides those that had been enlivened by Grumberg. Constantly injecting life into scenes, he added in the final love scene between Bernard and Marion, when Bernard leaves the theatre, Marion's bad faith reply ('I kissed you on the mouth?') and worked in Bernard's big pick-up line ('Aren't you going to say that there are two women in me?'). 'You think I'm telling you to go before me out of politeness? Not at all: It's because I want to look at your legs,' Truffaut added at the end of

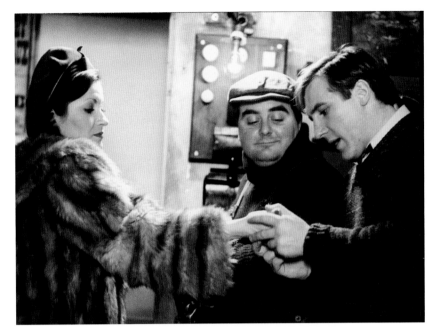

'There are two women in you.' 'Yes, but neither of them wants to sleep with you.' (Andréa Feréol, Maurice Risch and Gérard Depardieu).

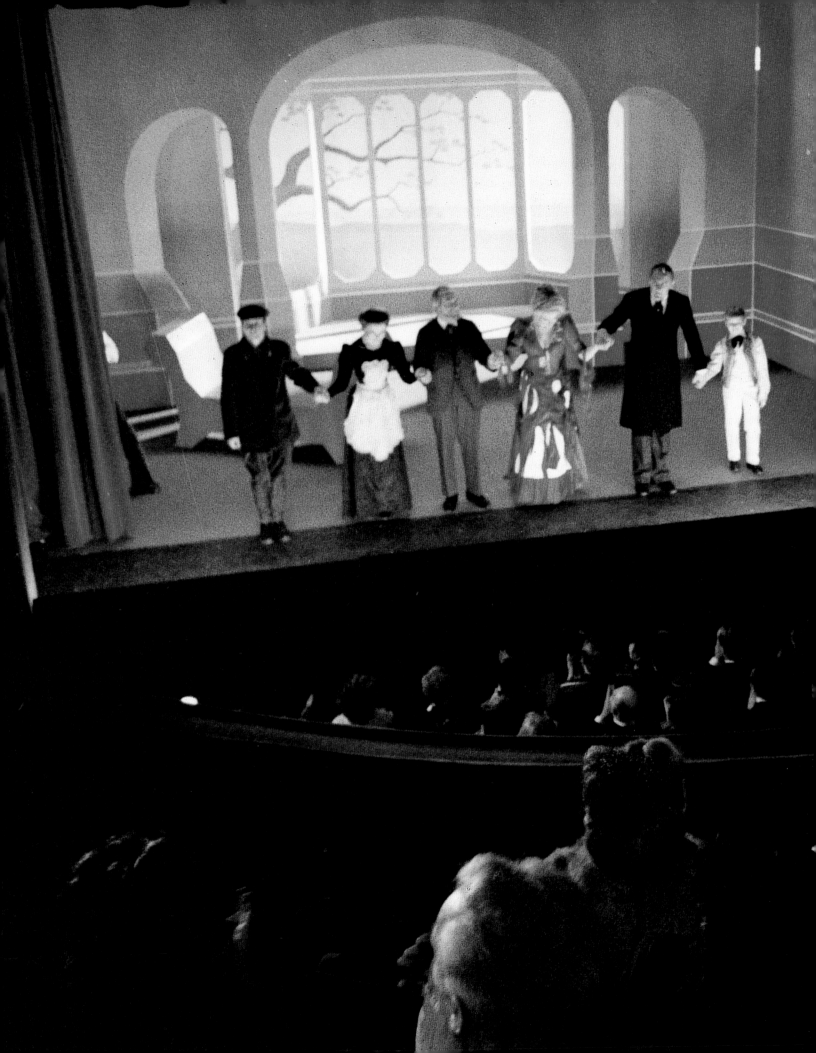

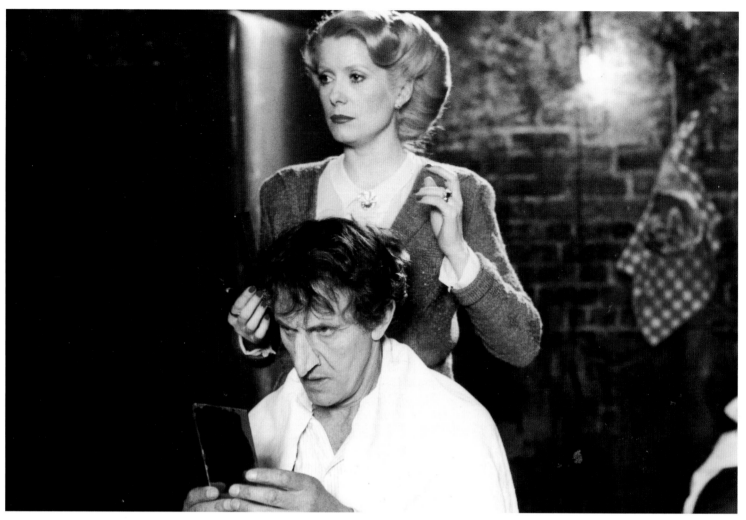

'What does it mean to look Jewish?'

the first scene between Lucas and Marion in the cellar. Later, he cunningly inverted the meaning of a line of dialogue: when Lucas talks to Marion about the love scene (in the play) between her and Bernard, in the dialogue of the script he compliments her ('Congratulations. Sincerity could not be carried further'); before shooting, Truffaut reversed the phrase and Lucas's intentions: 'It's the only love scene in the play – try to be more sincere…'

The filming was none the less difficult, filled with problems (Suzanne Schiffman got sick and had to be hospitalized, remaining away for some weeks; Catherine Deneuve twisted an ankle at the start of filming), but these incidents did not interfere with Truffaut's creativity, all the more so because the collaboration with Gérard Depardieu was a success, almost love at first sight for the film-maker as well as the actor, who was at first hesitant about working with Truffaut and was happy to find the director more of a 'hoodlum' than he had expected. When casting, Truffaut had a game with the viewer in mind: 'Bringing together for the first time the couple Deneuve/Depardieu, when everyone expects a love story between them, it amused me to throw people off by delaying the love story as long as possible.' To convince Jean Poiret to play Jean-Loup Cottins, he told him that he was the only actor he could imagine being arrested in a dressing gown, a nod to Sacha Guitry with whom Poiret made *Assassins et voleurs*, about which the young Truffaut had written an article in 1957. He chose Andréa Ferréol, a very feminine actress, to play Arlette, reversing the cliché, and asked little Sabine from *Jules et Jim* and *La Peau douce*, now an adult, to give the character of Nadine her tenacity. Since he preferred not to have Daxiat played by a star, but by someone whose face the public did not know, Truffaut persuaded his collaborator Jean-Louis Richard to become the film's 'heavy', which the latter accepted on the condition that he could make the character classy. On Wednesday 13 February, the thirteenth day of filming, Truffaut took advantage of their last days in the Théâtre Saint-Georges and completely reinvented the last scene. The new ending did not exist in the screenplay, where all that was planned, after a parallel montage accompanied by a commentary telling the viewer what became of the different characters (there was supposed to be a shot of Bernard, now a soldier, entering Paris in a tank), was a shot of Raymond and little Jacquot putting up a poster for the new production: *The Magic Mountain*, directed by Lucas Steiner. Dissatisfied, sure that he could not finish his film with such a disappointing ending and still having access to the sets for a scene in the play, Truffaut came up with a device that enabled him to trick the viewer by making him believe in a scene in a hospital where Marion finds Bernard again, wounded and indifferent to everything. Suddenly it is revealed that this is the last scene of a play performed by Marion Steiner and Bernard Granger and directed by Lucas Steiner, whom the audience in the theatre call up onto the stage to take a bow with the actors. Truffaut jotted down the introduction for the new ending – 'But at the end of 1944, the war is not over and our story is waiting for its epilogue' – then wrote it quickly on some typed pages, planning the set-up with Nestor Almendros: 'The four last exchanges have been filmed in extreme close-ups in 75 mm, so that the set in the

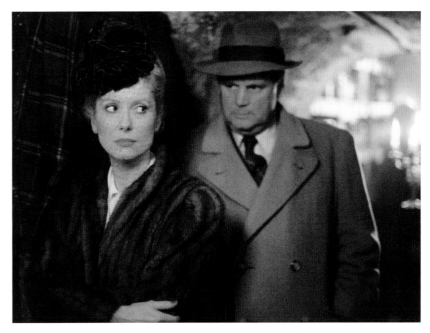

The threats of Daxiat (Jean-Louis Richard): 'I have proof that your husband never left France.'

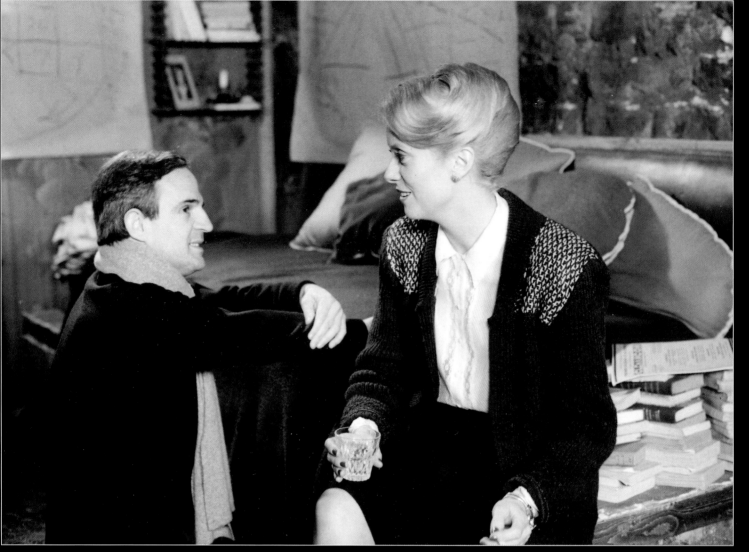

Filming *Le Dernier Métro* in the old Moreuil chocolate factory in Clichy.

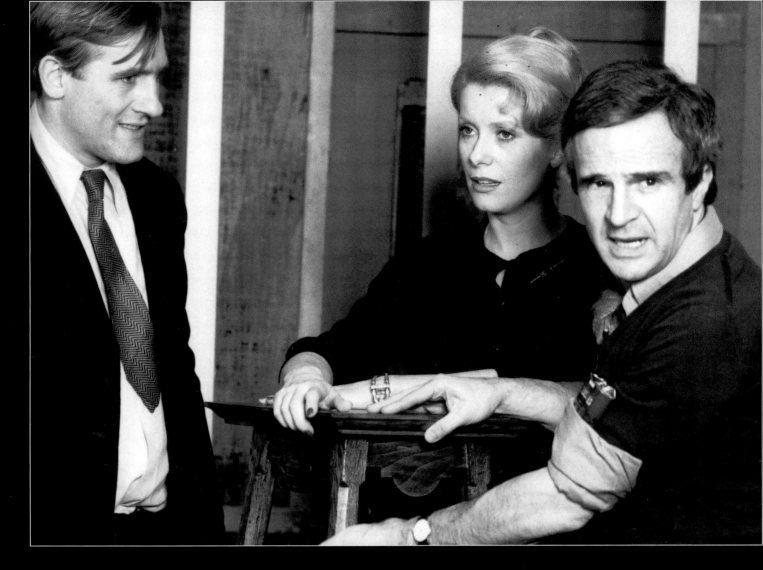

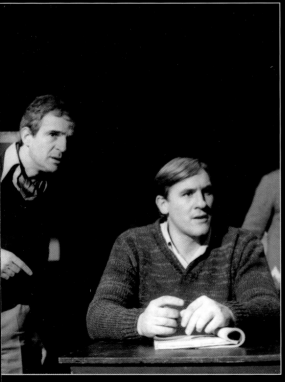

background is out of focus behind the faces. At a certain moment, a shot of the audience sounds the alarm.' And if the screenplay seemed to indicate that Marion chooses Bernard (whose return she sadly awaits), Truffaut decided to bring the ambiguity of feelings to the fore when he filmed the scene, ending his film with the ideal alliance of theatrical work and *l'amour à trois* by Lucas's return to the spotlight and by Marion's taking each of her two men by the hand for the final bow.

Dispositions.

Worried, Truffaut wrote abundant notes on his shooting script indicating the *mise-en-scène*, planning as precisely as possible the beginnings and ends of scenes, the foregrounds and backgrounds and in what directions the characters look: while Marion onstage – as Arlette is showing them drawings for the sets – watches Bernard reading Arlette's palm in the wings, 'here heads of JL and Arlette from back Catherine look ['look' is in English] between the two'. The film-maker wanted all his characters to encounter and interact with one another, to use all the different spaces he had at his disposal both in the theatre and in the old chocolate factory. Accordingly, several scenes planned for Marion or Jean-Loup's office were filmed in the corridors or backstage, where anyone could pass through, encouraging the characters to circulate and their different secrets to criss-cross. A constant concern was not to leave anyone out, as in this scene between Marion and Jean-Loup, alias Helena and Dr Sanders:

'cover: Jacquot in the wings
 Raymond on the lights
 The Public
 The Jewish fireman
2 last lines on Lucas (double meaning).'
The last two lines of the scene are:
'It's that I don't want to lose you.'

Truffaut jotted down some short notes for Nestor Almendros, with whom he was in agreement about how to create the night-time atmosphere, the silhouettes and the intermittent pools of light from old-fashioned lamps in the dark. In order to recreate the period style of the Occupation, he asked the production designer, Jean-Pierre Kohut Svelko, for monochromatic sets verging on brown, with touches of colour that stood out here and there, like the torn red dress Marion wears onstage. Almendros shot more tests than usual for *Le Dernier Métro* and selected with the film-maker's agreement a Fuji stock, less bright than Eastman Kodak. They were even briefly tempted by a Russian stock that produced more subdued colours, but gave up the idea when they heard that Eastern-bloc film-makers had stopped using it because it was too inconsistent from one reel to another. Almendros developed a contrast between realistic lighting for the scenes in the wings and artificial lighting for the scenes of rehearsals and performances, using the directional lights he had criticized in his youth, which allowed him to paint more pronounced shadows. In the lighting Truffaut continued to seek the mystery and fear that runs below the surface of the film, the blackness that surrounds the characters and sometimes affects the story (as it does in the scene where the electric

current is cut). He wrote the following for his cameraman in the margin of the scene where Nadine, during a performance, enters the set holding a lamp that is the only source of light (then, as the lights come up, we discover Marion in her torn dress):
'If Nestor wishes C.S. electrician dimmer. Eventually better if we pan off Nadine… pan into the darkness and into the void.'
Often, always in the same shorthand style, he hastily described the whole disposition of a scene on the left-hand page. When Daxiat, at the beginning of the film, waits for Marion and Jean-Loup outside the theatre:
'1) Marion-Jean-L. arrival corridor
2) Marion-Jean Loup-Marc – discovery Daxiat… new dialogue
3) Arrival Raymond bike
Reframe to catch Daxiat
End on Raymond or Marion going away…?'
Then he added at the bottom of the page: 'End on bistro whose blue curtains are pulled shut', his usual insistence on marking the end of a scene combined with documentary concerns.

The great scene of the rehearsal when Daxiat bursts in while costume fittings are going on was also detailed on the left-hand page of the script, where Truffaut crossed out one after the other the numbers of shots he had to make and carefully planned in what directions the characters look:
'1) Cut to Andrea along the wall during speech ['speech' is in English] JLoup
2) Cut to Marc installing table and trying lamp
3) Intervention JeanLoup towards Nadine… very nice…
4) JL and Marion turn toward Daxiat
little dialogue… rejoining… glad-handing…
5) reverse shot: Nadine, Raymond, Bernard…
(Raymond from behind) looks towards back
6) dialogue sh-reverse shot Marion-Daxiat
7) cutaway to M. Berluti-furtively
8) Germaine look quiquly [sic in English]
9) Raymond… Folies-Bergeres-Bernard
10) return germaine introducing by [sic in English] marion
11) Germaine-Daxiat = (we take opportunity to reverse the angle towards stage)
12) Jean-Loup-Marion additional text
13) Jean-Loup rejoins Daxiat and makes him come up on stage…
14) complicity Marion-Germaine (2 sizes)
15) CS on Bernard.'
Beyond planning the multiplicity of shots and cut-aways (some of which, less connected to the action, would not be used or would be used later), the film-maker was putting in place a *mise-en-scène* shaped by the constant tension of people watching. Warning looks, uneasy looks, ironic looks – there is not a gesture, when the danger erupts in the person of Daxiat in the confined atmosphere of the rehearsal, that is not seen and commented on by others. The whole film, a film about 'the secret behind the door', is subjected to this scrutiny. There is always a blind spot: what must not be seen (Lucas in the cellar), what should not have been seen (Marion sending away the Jewish actor who doesn't have his Aryanization certificate, glimpsed by Bernard through two open doors at the beginning of the

film), the kiss exchanged by Arlette and Nadine ('What happened, after all?' says Jean-Loup, trying to play it down: 'Someone opened a door that should have been locked'), what is heard without being seen (Lucas listening to rehearsals or performances in the cellar), what happens in front of a witness who knows more than he is saying (Bernard's frantic efforts to pick up Arlette as Raymond looks on), what is seen, giving birth to jealousy or desire (Marion looking at Bernard as he reads Nadine's palm and tells her there are two women in her)… There are few scenes that do not acquire their meaning or their ambiguity from the passion of someone's look, someone who is also a surrogate for the spectator. Behind the surface image, apparently innocuous or insignificant, there is always something else to see. The film is always double or triple.

An enigmatic thriller.

Le Dernier Métro is constructed like a thriller. While he filmed and then while he edited, Truffaut developed the fear that planted itself in the film from the start. In place of a conventional beginning for a scene (Raymond in conversation with Martine), he added during production, for example, the idea that Germaine, emerging from the darkness of the corridor, calls to Raymond: she is afraid; there are noises in the theatre. Raymond discovers Martine, who has succeed in slipping into the darkened auditorium to watch the rehearsal without being seen – the first intrusion into the closed, womb-like universe of the theatre by a character from outside, bearing riches and dangers (the ham, the silk stockings, but also the news that the Free Zone has been invaded, the thefts). Taking Lucas's advice, Marion invites her company out for an evening at a cabaret to comfort them, but everything goes wrong: Nadine can't stay because she has an audition, Bernard leaves, Marion escapes on a whim with a 'Saint Aubain' she just happened to meet. Truffaut added to the long scene of the ruined evening the idea that it was the pile of German officers' caps in the cloakroom that made Bernard flee. This additional scene, typed in capital letters, replaced a simple scene in the script showing Marion's jealousy while Bernard flirts with a girl he brought with him, who is a bit of a nitwit and passionate about astrology. Instead we get a visual idea that produces an immediate reaction without any dialogue, displacing the story on to history, crossing the theme of intimacies and misunderstandings with the theme of the German threat, which Truffaut, uneasy about the script he had set out to film, was trying to reintroduce. (It was Claude de Givray who, after reading the script, advised Truffaut to have the German threat arrive earlier.) During the editing, Truffaut added to the film an extract from Henri Amouroux's broadcast about the French under the Occupation (which he listened to daily with Suzanne Schiffman during the summer): 'If Jews had blue skin…' The thread of danger was always being spun, even in ordinary scenes: when Marion goes back to her hotel the receptionist asks her with a great deal of mystery what he should do with the mail that has been arriving for Lucas Steiner. This starts developing the secret, which Truffaut reinforced by the characters' attitudes and by visual and auditory cues, playing on the discrepancy between the normal sounds of a hotel and the way the receptionist feels obliged to lower his voice.

At the same time the film-maker was moving towards a story that was becoming more and more enigmatic. Because the first montage was much too long, way over two hours, he had to make numerous cuts. Truffaut told how, on Jean Aurel's advice, he moved the scene where Gérard Depardieu meets Andréa Ferréol, which happens in the script after Bernard arrives at the theatre and signs the contract, to the beginning of the film – a way to open fast and with a surprise, and to immediately establish the characters. (The scene was inspired by the way Frédérick Lemaître starts talking to Garance at the beginning of *Les Enfants du Paradis*, and by the way he is promptly brushed off.) Other scenes were moved to enhance the overall dramatic direction. Several scenes between the first rehearsals and the discovery of Lucas in the cellar were moved to later so as not to delay the revelation (the scene where Germaine talks about her oldest boy in the German prison, and the scene where Bernard comes on to Arlette and is rejected: '*You* get a handshake'). To make the film proceed faster and focus on a danger that is gradually increasing, Truffaut decided to cut a very funny scene where Germaine, offering advice to the newcomer, recounts one of her husband's exploits as an extra: in order to get hired a second time, he managed to never be seen. The arrival of the German car that brings Nadine is dramatized (the scene is a visual distillation of an earlier idea that had been abandoned: Nadine being invited to Berlin for a short visit), and we pass directly from the scene where she breaks down in front of everyone to the café where Bernard and his friend discuss Marion in a scene out of a thriller (two characters talking about a third whom they present and describe), while we see through the window – an angle often associated with the *idée fixe*, to secrets and their sudden revelation (cf. *La Femme d'à côté*) – Marion returning secretly to the theatre. Cutting the beginning of a scene that started too slowly, Truffaut managed Lucas's entrance with a rhyming cut: from the blackness surrounding Marion with her lantern to the candle Lucas uses to light his cigarette, which light up his face, the liturgy of the candle coming after the liturgy of the lamp Marion carries at arm's length in the darkened corridors, leading us to its rhyme in the cellar.

Truffaut cut numerous expository or preparatory scenes while filming, then while editing, thereby making the emotional back-and-forth between the characters much less explicit and avoiding redundancies that could be revealed only indirectly by the *mise-en-scène*. During shooting he removed a scene where Bernard questioned Raymond about Arlette's private life: Raymond refuses to get involved; Arlette wants to give Marion a scarf that she complimented her on, but Marion refuses the gift while listening to Bernard's questions. In the editing room Truffaut cut a scene between Arlette and Nadine that prepared the audience for the kiss Marion walks in on, giving it an unequivocal meaning. (Nadine admits to Arlette that she has read the script the sick screenwriter brought Marion and dreams of playing the role. Arlette tells her confidentially that she will be making the costumes for the film.) He also cut an explanation for what happens when the neighbourhood experiences a blackout: Marion says she is going back to her dressing room and will call

Nadine on her way. But the film, more enigmatically, is punctuated by little gaps whose effect is reinforced by the nocturnal ambience and the feeling of suspension set up by the cutting off of the electricity: we rejoin Marion, lamp in her hand, walking in the corridors, she opens a door, and behind it Nadine and Arlette are kissing, a sight nothing has prepared us for. After another little gap we find Arlette crying in Jean-Loup's arms. Similarly, earlier in the story Truffaut removed a scene where Raymond tells off Martine for hanging around backstage, a scene destined to prepare us for the episode of the thefts, which ends up being played for mystery and surprise. Advancing by fragments, by little flashes that deliver jolts, a more allusive story unfolds where the discoveries are more abrupt, less tele-graphed, but where in reality everything is secretly prepared by undercurrents: indirection in action. Truffaut dropped a scene later on where Marion, returning to her hotel, asks her chambermaid, who is questioning her about Bernard, for advice: 'What do you do when a man you like doesn't even notice you, pays you no attention?' ('I look elsewhere,' says the chambermaid.) On the same principle he removed, after the fight between Bernard and Daxiat, a scene showing Jean-Loup and Germaine laughing at Daxiat's discomfort while Jean-Loup takes congratulatory phone-calls meant for Bernard, a scene that leads to a discussion of Bernard and Marion's relationship: 'In my opinion those two are in love with each other, but he thinks she detests him and she thinks he detests her' – an explicit justification that Truffaut decided to do completely without, also eliminating a moment in the script that commented in advance on the scene of the slap: Jean-Loup was going to recite a list of scenes in dramas where love is expressed with a slap or an insult. But Truffaut added a little scene after the fight that he noted in his copy of the script: 'Refusal by Marion to take Bernard's hand, she puts Nadine between them.' A movement from the explicit to the implicit, from the said to the shown. As the *mise-en-scène* imposed itself, it replaced the temptation to underline everything with dialogue; then during editing the film-maker happily ditched scenes that had become redundant.

The course of the secret.

This enigmatic and fragmentary progression of the story, reinforced by visual stylization and by a system of rhymes and repetitions (the songs, the text of the play where the same scenes are continually being repeated, the lines that are like refrains: 'There are two women in you', 'I didn't sleep at home last night', 'Wait, wait') no doubt accounts for a large measure of the film's fascination. This doing away with the explicit, which intensifies the impact of a film governed by secrecy, is particularly clear in the tightening of rising tension during the last third, after the fight with Daxiat and the threat that the theatre will be commandeered. The scene in the church ('Dieu de Clémence' and the arrest of Christian) was shortened during filming and placed after Marion's visit to the Propagandastaffel (the script had it earlier, between the scene where Lucas decides to adapt *The Magic Mountain* for his next production and 'Zumba, zumba', the song the troupe chants to celebrate its success at the restaurant). Thus the dramatic curve is made complete as the danger becomes concrete and accelerates. And the preparatory scenes again disappear. A long scene was cut where Marion justifies her reluctance to go ask Dr Dietrich – their contact at the Propagandastaffel – for help and allows herself to be lectured by Lucas in terms often used by Truffaut when a film started production ('There is only one way to see things: what is good for the théâtre Montmartre and what is bad for the théâtre Montmartre'). The scene would have ended on a more sentimental note: 'What did I want when all this started? I wanted to keep my theatre and I wanted to keep my wife: now I'm losing both.' In the finished film, the power of what is not said carries the day. Accompanied by the alternately menacing and captivating music composed by Georges Delerue, Marion goes from a short scene with Lucas to the hall of the Propagandastaffel, where Truffaut filmed the very enigmatic scene where a German officer who has taken Marion aside to inform her of Dr Dietrich's suicide grabs her hand and squeezes it spasmodically, refusing to let go. A sudden shift that remains unexplained, which Truffaut – as if this moment of vertigo had opened the floodgates of disorder – followed with more direct dangers: the arrest of Christian at the church and the Gestapo's descent into the theatre's cellar. That scene may be the equivalent of a rape, as the critic Anne Gillain emphasizes when she notes how throughout the film 'the realistic story is subjected to ellipses, short-circuits, lacunae that the viewer scarcely notices, so powerful is the coherence of the other, fantastic story'. Revisiting Truffaut's oeuvre in the light of psychoanalysis and raising the question of the power of repression that underlies the story, she proposes the hypothesis that the taboo that persists through the film is the taboo of incest: 'The repressed material in *Le Dernier Métro* is the mother's body, which can't be touched or looked at or explored or known. *Le Dernier Métro* tells at one and the same time the story of a theatre under the Occupation and of the exploration of the mother's body by the child's imagination.' Perhaps. In any event, beneath its deceitful classic appearance, *Le Dernier Métro* is a film obsessed and permeated by the secret that inhabits it.

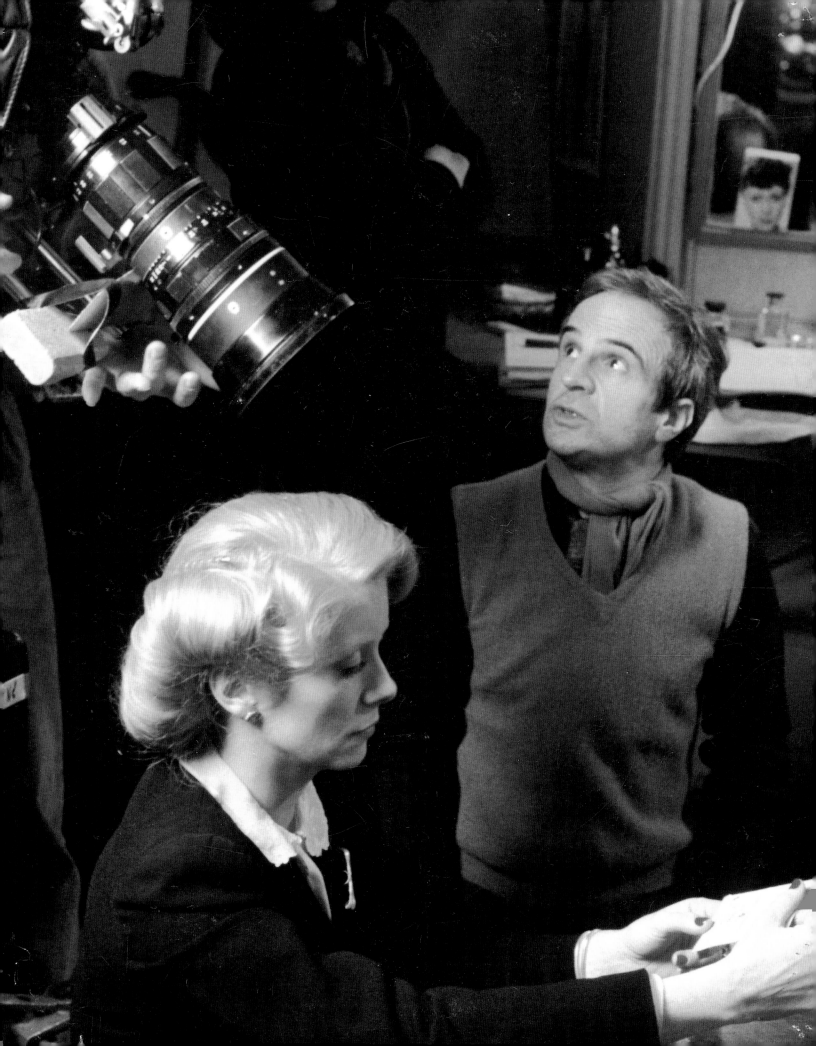

La Femme d'à côté

La Femme d'à côté (1981)
The Woman Next Door

'Let's say that putting a man and a woman who already loved each other in the past face to face is a theme I have had in mind for several years and on which I have been taking notes. At the time my outline was called "Sur les Rails" – that really wasn't a very good title! I just had to find the ideal couple…'

'I thought of Fanny Ardant when I saw her in the television series *Les Dames de la côte*. I immediately wanted very much to work with her. That happened just before filming *Le Dernier Métro*, in which I subsequently felt that I hadn't been able to do the maximum with Gérard Depardieu because he was only one of the seven characters in the film, and not the most important one. So I wanted all the more to work with Gérard again, because I got on marvellously with him. The night of the Césars I introduced Gérard to Fanny Ardant. After that I went back to my story, which at that time was a story about a nervous breakdown after a break-up.' A film like a lightning bolt, a film of maturity conceived by a film-maker in full possession of his craft and his desires, *La Femme d'à côté* was written feverishly in little more than a few weeks, from the beginning of December 1980, when Truffaut roughed out a first résumé with Suzanne Schiffman and Jean Aurel, to mid-February. (The shooting script, without all the dialogue, is dated 11 February 1981, and the film was shot around Grenoble from 1 April.) Truffaut only started after the opening of *Le Dernier Métro* (in September 1980), when, for the first time in years, he did not have a definite schedule of forthcoming films. No doubt more confident, surer of being able to bounce back now that the success of *Le Dernier Métro* was growing, he did not hesitate in taking the risk. He set out to make a small film, shot in six weeks, in which he introduced an actress who was making her first film appearance opposite Depardieu – a film that would be, very simply, a story of passion.

On track.

There are signs that the project had been on Truffaut's mind since before *Le Dernier Métro* and the famous night of the Césars when he introduced Depardieu to Fanny Ardant. (In film footage of the event Depardieu can be seen sitting just in front of Fanny Ardant, who is on Truffaut's right.) He brought up a similar idea in a letter written on 22 November 1979 to Pierre Kast when he was finishing the script of *Le Dernier Métro*: 'Perhaps we'll have an opportunity to work together one day. Do you think it would be possible to maintain through a whole film the tone of the scene in *Vacances portuguaises*: the man and the woman, old lovers who've been long separated, meeting again at night while the house is asleep?' Above all, Truffaut took the old *Sur les Rails* project out of its box, an outline of a few pages augmented by a series of preparatory notes, fragments of ideas and dialogue hastily jotted down on a few pieces of paper, which he had conceived during the 1970s, probably just after *Les Deux Anglaises*, for Jeanne Moreau and Charles Denner (theirs were the temporary first names he used for the characters). The story is about a man coming out of a depression after a relationship that has left him shattered. Because of his need to destroy, he has killed a man and is getting out of prison when the story begins. By chance he meets the woman he loved in a hotel,

Previous pages: Gérard Depardieu and Fanny Ardant.

Gérard Depardieu

and she, while telling him that they can never get back together, tries to help him get back on track. Truffaut probably chose not to develop this story, whose ingredients are in large part autobiographical, because it was too personal ('Charles is in terrible shape, needing to be gathered up with a little spoon'). He used certain elements of it in 1976 for *L'Homme qui aimait les femmes* before returning to it for *La Femme d'à côté*. *Sur les Rails* features a female character who prefers young boys ('and then I love boys younger than me because…') and the basis of the scene between Bertrand and Vera, the 'ghost', the only woman Bertrand has ever loved. (When Charles runs into Jeanne by chance in a hotel hall, he tries to get away, but she sees him and convinces him to have a conversation: 'At first he refuses to talk; she insists; he gives in', and later this piece of dialogue: 'For two years I couldn't walk past your apartment…'). Apart from an optimistic ending where the woman succeeds in giving the broken man a 'spine,' all the ideas that reappear in *La Femme d'à côté* are already in place: the intense, destructive love, the sleeping pills, depression and the difficulty of getting out of the black hole (the expression is also used by Vera in *L'Homme qui aimait les femmes*), the love songs. 'You know that song,

Without love you're nothing at all… The little pills for sleeping… I swear to you, Jeanne, I absolutely want to come out of this, I don't want to stay like this, I really want to get out of the black hole (cf. *Les Deux Anglaises*)', and further on: 'The important idea that emotional torments can be cured by biochemistry… That's right, there are little things in our brains, channels that create (or secrete) euphoria or depression.'

On a bundle of pages sprinkled with random notes, now headed 'The second chance' or 'Jeanne and Charles' (notes Truffaut must also have read while working on *La Chambre verte*, as this annotation indicates: 'To be used in part for *Altar of the Dead*'), we recognize ideas (the broken wrist) and fragments of dialogue: 'Our story is complete, it has a beginning, middle and end,' a line from *Les Deux Anglaises* that would be said by Fanny Ardant; 'You were tender with me' (which Vera in *L'Homme qui aimait les femmes* and Mathilde in *La Femme d'à côté* both say); 'Jeanne: Still, you love women, don't you?'; 'I'm not drunk. The proof: the rigour of my reasoning.' Truffaut crossed out the names from his old project and replaced them with Bernard, Philippe and Mathilde. On one sheet the film-maker had

Everyday married life is perverted by a look and the disruption of order is beginning. Fanny Ardant spies on Gérard Depardieu and Michèle Baumgartner.

The Beverly Hills Hotel

Si il y a quelqu'une
avec qui on ne devrait
jamais coucher c'est
bien sa voisine de
palier

un jour ou golf.

Arlette ¶, épouse de Bernard) I

[Elle a rencontré Gerard Depardieu il y a cinq ans.
Elle a eu le coup de foudre,c'est l'homme de sa vie.
Ils se sont mariés,ils ont un enfant de trois ans.
Elle n'est pas jalouse du passé de Gérard mais elle sait que
parmi ces histoires, une (a été) plus grave que les autres.
[Elle est une femme amoureuse,passionnée,elle n'admet pas le
compromis et elle est le contraire d'une femme résignée.
Elle est moderne et équilibrée.
Lorsque deux nouveaux voisins s'installent dans la maison d'
à coté,elle sympathise avec eux (dés leur retour de voyage de noces)
 [Des rencontres à quatre auront lieu autour de l'apéritif,
de la piscine et des tennis.
[Progressivement,Dominique Sanda sent un malaise et pense que(Fanny Mathilde)
Ardant)malgré son coté bon chic bon genre a une attirance pour
Gerard Depardieu.Elle lui en parle avec légereté et s'apercoit
que son mari lui,est plutot critique à l'égard de la femme de
son voisin.
[Un jour, elle s'apercevra que son mari lui ment,depuis le début, par
omission et que Fanny Ardant n'est autre que la femme qui l'
fait souffrir sept ans plus tot.(Elle peut apprendre ceci en
deux temps:(a) une confidence anodine de Trintignant qui sait par qu'elle
Fanny mm a vaguement connu Depardieu autrefois " Ma cousine était
folle de lui"..(b)Dominique Sanda comparera l'écriture de Fanny,
sur une liste de commissions et une vieille lettre d'amour....¶
 [Dominique va placer Gerard en face de son mensonge et
guettera sa réaction.Dans un premier temps il s'en tire en blaguant
et colmate la brèche.

(à relire)

 SUR LES RAILS
(projet pour un film Jeanne Moreau-Charles Denner.)

Il est sorti de prison
Il sort d'une dépression nerveuse
Il a connu Jeanne,ils se sont aimés,xxxxx elle l'a largué;
il a craqué.Quelque chose en lui l'a poussé à détruire,il
a joué le justicier en tuant un type de grenoble (le
docteur machin qui tuait clandestinement des chamois.)
 x Le film commence en province (sur Charles paumé ou
sur Jeanne qui vient là faire je ne sais quoi.)
[Au début de l'histoire,dans l'hotel où se trouve Charles.
Lorsqu'il aperçoit Jeanne qui vient d'arriver dans cet
hotel,il tente de se tirer mais elle le voit;dans un
premier temps,il refuse de lui parler;elle insiste,il
cède.
On apprend ainsi l'histoire des chamois et de la prison
(interdit de séjour).Charles est dans un état épouvan-
-table,à ramasser à la petite cuiller.Jeanne va s'occu-
-per de lui et le remettre sur ses rails.
D'abord,elle doit lui faire comprendre qu'il est exclu
qu'ils se remettent ensemble :" Notre histoire a eté
complète,elle a eu un début,un milieu,une fin et puis
j'aime les garçons plus jeunes que moi parceque......"
Malgré ça,malgré le jeune garçon (qu'on entr'aperçoit
peut-être) Jeanne prend en main Charles,elle lui esquisse
une colonne vertébrale,elle lui montre son amertume,la
démonte,elle lui redonne le gout de vivre.

l'adultère conjugal
Marié trop jeunes ils se sont
ratés . . .
Ils ot devenir amants
a un diner ils partent séparément
et se retrouvent
ete . . .
" La fille inconnue " Titre.
 femme

La Femme d'à côtè was a film written at top
speed and filmed immediately, but Truffaut had
long had a 'a love story composed of regrets and
bitterness' in mind. He brought out notes he took
at the time of *Sur les Rails*, conceived in the early
1970s for Jeanne Moreau and Charles Denner.
At the same time as the first résumé, Truffaut
and Suzanne Schiffman wrote out descriptions
of the characters. Reading the description of
Arlette, Bernard's wife, we discover that Truffaut
briefly thought of assembling a quartet of actors
– Fanny Ardant, Gérard Depardieu, Dominique
Sanda and Jean-Louis Trintignant. It would have
been a different film.

MATHILDE: Laisse ce polaroïd,viens plutot m'aider à rafistoler la
 robe..

Départ des deux jeune femmes vers la maison.On les voit franchir
la porte.

14 - Maison premier étage.Elles arrivent sur le palier et entrent dans
 la chambre dont elles ferment la porte.

15 - Rez de chaussée maison.On précède Bernard qui erre dans la
 maison,regarde des bagages *posés, ouverts,* au pied de l'escalier et monte.

16 - Arrivée de Bernard sur le palier.Il voit d'autres bagages.Il
 passe prés du téléphone et du tableau-gifle.On le sent trés enervé.
 Il décroche le téléphone sans raison et pose le combiné sur
 le rebord de la fenètre.Il ouvre une porte qui est celle des
 toilettes,la referme et pousse à présent celle de la chambre ou
 se trouvent les deux femmes.Il attire Mathilde prés de lui.
 BERNARD: Mathilde,on vous demande au téléphone.
 Mathilde va vers la fenètre,prend le téléphone.
 MATHILDE: Je ne comprends pas,il n'y a personne.
 BERNARD: Si,il y a MOI ! Je veux te voir seule..Retrouvons-nous
 à l'Hotel..tout à l'heure..
 MATHILDE: Mais c'est impossible..
 BERNARD: Ou alors dans ma voiture,là,maintenant..J'ai besoin de
 te parler..
 MATHILDE: Tu dis toujours ça et,quand on se voit,on n'a rien à se
 dire..
 BERNARD: Je ne te demande pas grand chose.On n'a jamais le temps
 de se parler..
 MATHILDE: Je t'en prie,ne parle pas si fort
 BERNARD: Je parlerai aussi fort que je veux.Ce que je te demande
 c'est de ne pas partir ce soir avec
 Philippe ou alors de retarder ton voyage de quelques
 jours.J'ai quelque chose à te dire..

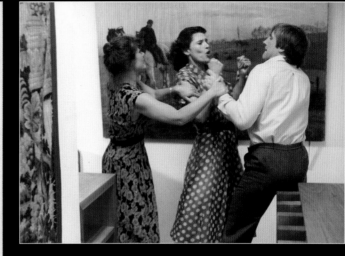

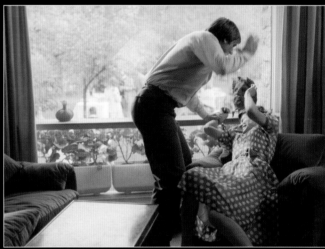

MATHILDE: Laisse-moi,tu es fou,tu es complètement fou

Bernard commence à la secouer en haut de l'escalier.L'amie sort
de la chambre et s'inquiète.

BERNARD: Ah,vous ! Foutez-nous la paix !

Mathilde tente d'échapper par l'escalier.

17 - On reprend en bas de l'escalier.Bernard continue son harcèlement.
 Mathilde tombe prés de la baie vitrée,Bernard la relève mais
 elle s'échappe vers la porte.Encombrement à la porte.Tout
 le monde considère la scène avec effarement.Deux personnages
 nous ramènent vers la baie vitrée à travers laquelle nous
 voyons la suite.Bernard,comme s'il était inconscient
 de l'entourage,poursuit Mathilde jusqu'au parasol au pied
 duquel elle se laisse glisser.Des hommes maitrisent
 Bernard.Au passage,on passe sur Philippe sidéré et l'on
 termine sur Madame Jouve.

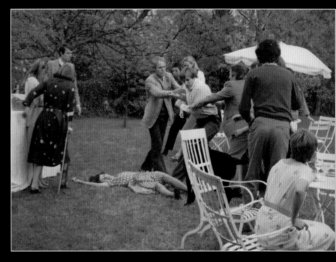

Passing through appearances. During filming
Truffaut took advantage of the setting to rewrite
the garden party scene, where the lovers' passion
explodes before everyone's eyes, in front of the
picture window and then outside.

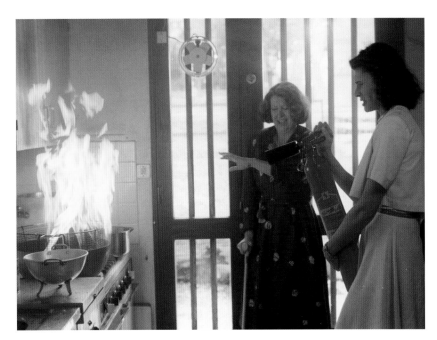

Fire in the kitchen: The accumulation of apparently insignificant events leads to collapse. (Fanny Ardant with Veronique Silver as Madame Jouve).

jotted down an idea for a film that he would not take any further: 'Married too young, they missed each other... They will become lovers. At a dinner party, they leave separately and join each other. Etc... Title: The Unknown Woman.' Thinking of the character he was going to create for Charles Denner, Truffaut also made some self-critical recommendations: 'Try not to create a man who's too weak. Jim, Desailly, Montag, Mahé, Dussollier, Doinel, Claude Roc. Think of Sterling Hayden instead, wounded, violent men.' Answering a questionnaire in 1974 about certain US actors and actresses, Truffaut defined the actor George C Scott as follows: 'He is a vulnerable colossus, the tough guy with a tender heart, the successor of Sterling Hayden, the ideal actor for a love story built around regrets and bitterness.' Truffaut would eventually find the embodiment of this vulnerable colossus, this wounded, violent man in Gérard Depardieu, whereas he saw his heroine as being more like Vienna in Nicholas Ray's film *Johnny Guitar*.

First outline.

The exceptional speed of execution that characterizes *La Femme d'à côté* was a result of the film-maker's profound intimacy with his subject. The first résumé of the story, dated 4 December 1980, presents an outline that was already constructed, the four main characters with their first names and the general movement of the plot. Only the character of Madame Jouve had not yet been invented, so when Bernard, wanting to avoid the dinner with the neighbours, calls from a bistro to excuse his absence, he just eats a sandwich and goes to a movie. The main turning points of the film were already in place: the arrival of the new neighbours, the encounter between Bernard and Mathilde in the supermarket, the scene of the slap Bernard gives Mathilde during a cocktail party in Philipe and Mathilde's garden, even the idea that Mathilde returns to the house when it is for sale and a light inside attracts Bernard. As if Truffaut did not dare risk it yet, the ending was still uncertain: 'Do they make love? Does she kill herself?' Jean Aurel has said how Truffaut first timidly expressed his idea for the ending he desired: and if they should die making love? The point where the first outline diverges from the film is the idea that Mathilde takes another lover. Bernard, who is watching, realizes this, and his fury is the reason for the slap he gives her at the cocktail party in his neighbours' garden. This light comedy and its banality would be abandoned in later versions in order to describe an inevitable passion. In a very different development of subsequent story choices, the public slap Bernard gives to Mathilde leads to a 'messy situation'. Arlette leaves Bernard and takes the child with her; Bernard, who is left alone, takes a mistress; Mathilde cracks up 'despite her husband's supportiveness'. Then Truffaut again increased the singularity and intensity of the drama by turning away from light comedy to develop the out-of-sync feelings of Bernard and Mathilde further. It is less a matter of external obstacles standing in their way than their own contradictions: when one is at the height of passion, the other pulls back. But Mathilde's depression is already sketched in this first outline: anorexia, the sleep-cure clinic, and a rough sketch of the idea that Philippe, the husband, asks Bernard to go and see her at the clinic.

Two couples.

What Truffaut originally had in mind was to write a film where the characters – husbands, wives or lovers – were treated on an equal footing, which was also what he wanted to achieve in *La Peau douce*. He even began by planning for a quartet before tipping the film towards a passion that excluded others, because a description of the characters attached to the first résumé shows that he first thought of Dominique Sanda and Jean-Louis Trintignant to play Arlette and Philippe. 'When two new neighbours move into the house next door, they get to like them (after they return from their honeymoon). The four get together for cocktails, swimming and tennis. Progressively, Dominique Sanda becomes uneasy and thinks that Fanny Ardant, despite her hoity-toity airs, is attracted to Gérard Depardieu. She mentions it to him, making light of it, and discovers that her husband is rather critical of his neighbour's wife.' A different film is outlined here, and even though one actress is blonde and the other brunette, Truffaut perhaps chose to give up his first idea in order to avoid competition on the subject of feelings and passion between two actresses who were too much alike, especially since Fanny Ardant was essentially known to the public through Nina Companeez's television series. On the advice of Serge Rousseau (the 'Definitive Man' in *Baisers volés*, Truffaut's friend, his agent and an occasional actor or voice actor in some of his films), he decided to hire an unknown actress, Michèle Baumgartner, a natural brunette, whose hair Truffaut had dyed light blonde and cut short so that she would be clearly distinguishable from Fanny Ardant and seem more anchored in contemporary reality, more everyday. Initially Bernard's wife was a more active character, cleverer and more vindictive, but also undoubtedly more banal. Because she suspects something after an 'anodyne revelation by Trintignant', she compares Mathilde's handwriting on a shopping list and an old love letter, and she never thinks twice about leaving her husband after the 'day of the scandal' because she refuses to be 'a substitute woman'. The scene where Arlette says she does not want to be a substitute woman was in fact filmed (it was a scene with Madame Jouve that was supposed to follow the garden party), and then cut during editing, perhaps because it was not very good, but also no doubt because Truffaut preferred not to encourage too much compassion on the part of the viewer for the deceived wife, when he considered it crucial to remain centered on the sufferings of Bernard and Mathilde. In this cut scene, Arlette talks about how she experienced unreciprocated love at first sight with Bernard. She wore him down; he wasn't someone her parents considered suitable. Madame Jouve explains to her that she is one of those women who love dangerous men. A trace of this scene remains in the trailer for the film, where we hear Madame Jouve's voice say, 'There are women who only love suitable men, and others who only love dangerous men'. On the other hand, without giving him quite the prestige Trintignant would have conferred on the character, Truffaut did leave some beautiful scenes for the character of Philippe, played superbly by Henri Garcin. For example, the scene of the names Mathilde says in her sleep and the scene where Philippe confesses that he lives with a liar and loves a liar, the dialogue for which Truffaut sketched

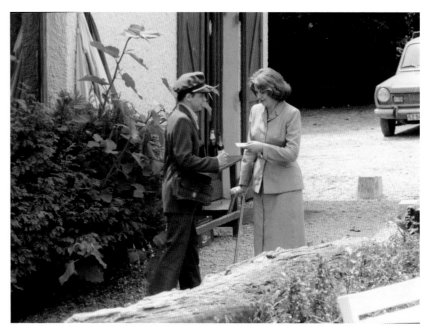

The little messenger: The appearance of everyday life and the return of the past.

in the margin of his shooting script: 'He: Well I hadn't anything either… Men know nothing about love, they're amateurs… I loved you the way you are… I've never lied in my whole life… liar.' And finally the scene where Philipe asks Bernard to visit Mathilde at the clinic, although the film-maker ended up deciding to shoot this from a distance, from outside an office, letting the dialogue between the two men remain a secret.

Love in a car park.

Truffaut added a little note to Jean Aurel when he sent him the first outline they had decided on at the start of December 1980: 'Here is a photocopy of our oral skeleton (that expression demands an illustration!). It's a bit/very theoretical, but I'm not worried about that. If we get a satisfactory outline, the rest will follow – that is, flesh, life, humour and authority. Take notes, think about it while you're driving, I'll call you when I get back on the 15th. Then I plan to work some with you, some with Suzanne (and eventually all three of us) until we're happy with our story.' One of the problems with the first résumé was that everything happened too fast, the effects were rushed. Truffaut's efforts were therefore focused on relaxing the story, as well as on exploiting his material by reinforcing the peaks and by dramatizing. In the two first résumés of the story, Mathilde and Bernard meet in the supermarket and talk in the car park, in his car or hers, where they proceed directly to making love: 'The scene evolves until the moment they conclude a kind of non-aggression pact and a good neighbour policy. They exchange a kiss of reconciliation that turns into a lovers' kiss because Mathilde wants it to, and with no further formalities, they make love in the car.' While he was reworking a more filled-out treatment at the beginning of February, Truffaut decided to delay the love scene between Bernard and Mathilde, to make the audience wait (as per the recommendation he had made to himself on his copy of *Les Deux Anglaises* in the margin of the sequences where Anne asks Claude to educate her sexually: 'We have to make the viewer wait'), and invented the idea of Mathilde fainting in the car park: 'When Bernard lets go of her, Mathilde falls to the ground almost in a faint. Bernard picks her up, holds her and takes her back to her car. She gets behind the wheel. Bernard: Can you drive? Without answering, Mathilde drives off.' Better than an immediate love scene, the physical collapse says how much Mathilde remains tied to Bernard by all her senses. It is much less an old-fashioned romantic symbol than it is a symptom of the violence and permanence of the attraction between the two characters, which makes *La Femme d'à côté*, like *Les Deux Anglaises*, 'not a film about physical love, but a physical film about love'. On his shooting script Truffaut wickedly added apropos of Bernard as he watches Mathilde's car drive off: 'He's not out of the woods.'

Without hearth or home.

Since the two characters have already made love again in the car park, the December outline does not include the scenes in the hotel room. Bernard waits in the rented room, but Mathilde calls and says she can't come, an idea Truffaut would use and intensify later in the story: Bernard calls Mathilde from the hotel where they did not have

their rendezvous and begs her to come, but she refuses. The second résumé, finished at the end of December (on Christmas day), incorporates a scene in a hotel room: 'love and conversation', the sketched-in dialogue for which would in reality be delayed and displaced to the dining room of the hotel, where Bernard and Mathilde recall the unhappy, irreparable misunderstandings of their past together. From each phase to the next, Truffaut expanded and fleshed out his screenplay. In the filled-in February treatment the conversation comes after love-making: 'When we find them after love, we learn more about their past.' Above all, Truffaut began to add the little touches concerning the truth of sensations and feelings that would give the film its acuity, by materializing through successive details the frenzy of the impossible that his characters keep running up against. He outlined the following dialogue for the end of the scene: 'Before leaving he says: I'd like to rent this room by the month. Mathilde: Why? So we can come here when we want? Bernard: Yes, and it bothers me that other people can make love in our bed.' Houses side by side, a clandestine hotel, cars: *La Femme d'à côté* tells the story of two lovers who have no place except this temporary room, which in the next version the film-maker imagined would be taken from them, since the hotel is being converted into apartments. Martine Barraqué, his editor, tells how Truffaut later worried about not having had his lovers meet often enough and regretted not filming a second scene in the hotel room. (After the first scene, the subsequent rendezvous are all abandoned.) Truffaut asked her to put together the illusion of a second encounter at the hotel using out-takes and shots of the hall, but it didn't work, and they were obliged instead to make the first scene last as long as possible in order to establish the amorous and sensual link between Bernard and Mathilde in the viewer's mind.

Two houses.

The second résumé dating from Christmas 1980 is the one where the flesh Truffaut promised Aurel began to appear. Some details are specified: the place could be the South of France, a modern village for executives from a high-tech company, 'two houses separated by a bit of yard and a double garage'. And new scenes were added that enable the story to grow at its centre (Suzanne Schiffman talked about how Truffaut first liked to define the through-line, then rework and develop the 'belly' of the story): a scene of marital love between Bernard and Arlette, a scene where Arlette invites Mathilde to visit her home, and the beautiful idea that Bernard and Mathilde try to call each other at the same time, getting engaged tones, the only moment in the film where they have the same impulse at the same time. The dinner scene also appears where we learn that Philippe has bought Mathilde a daring dress that she tries on for their guests. A scene was added where Bernard is insulted when Philippe tells him how Mathilde previously had an affair with 'a violent manic-depressive guy'… And a scene was planned and not used where Mathilde finds her new dress cut up with scissors; Bernard's violence would finally come out in another way, more exciting and less expected. This second résumé also includes the scene where Philippe reproaches Mathilde for the name she says in her sleep,

a scene that was isolated at first, placed after Bernard and Arlette go on an outing in town and before the garden party; Truffaut would then move it to after the scandal, to the time when Mathilde is slowly coming apart, in his search for the best place for each scene and its appropriate level of intensity in a series of small events. Similarly, Truffaut decided not to put a scene where Mathilde visits the house next door at the beginning of the film because the situation was too commonplace. But he would re-use it in a more memorable fashion later when Mathilde is on the point of going under and he imagined that she asks the child to show her the house when his parents are not there – a house she discovers by entering like a thief, letting her eyes linger on the unmade marital bed.

In the second December résumé Truffaut began to outline with astonishing precision the long garden party scene, accumulating every possible reason for Bernard to explode. It is no longer a simple cocktail party, but the announcement that Mathilde and Philippe are leaving on their honeymoon. Arlette takes a Polaroid of Mathilde and Bernard, who is making a face (photos in Truffaut's films often have bad consequences). Philippe says that he once practised nudism, Mathilde behaves coquettishly, sits on her publisher's lap, her robe splits open when she gets up, and playing to the laughing crowd, she strikes a pose like a stripper. Bernard pretends she has a phone call in order to talk to her ('everyone saw you behaving like a whore'), and the slap makes their quarrel public until Mathilde collapses. Because this is a crucial scene in the film, its turning point, the care Truffaut brought to writing it is not unimportant: no scene is so detailed, none so long and composed – up to its climax – of a succession of electric shocks. 'Another slap. She escapes. She arrives outside among the guests. Bernard, completely beside himself and unaware of the others, is unable to stop himself from hitting her again. The guests grab Bernard. Mathilde loses consciousness and falls on the grass. Philippe hurries over to her, and while Bernard is being got under control, the camera pans to the person who has been most shocked by this spectacle: Arlette.' All that is missing is the directorial device that Truffaut invented on set: a picture window that the camera can look through during the last part of the scene. And in the next phase he would add Madame Jouve watching: 'While Bernard is being got under control, the camera pivots to the person who understands everything, Madame Jouve, then to the person who has been most staggered by this spectacle: Arlette.'

Madame Jouve.

The filled-out treatment from the beginning of February 1981 marked the appearance of Odile Jouve, whom Truffaut gave the same name the Bernadette Lafont character in *Mistons* had in Maurice Pons's story. ('Jouve's sister was too beautiful. We couldn't stand it.' *Odile* is the title of a Raymond Queneau novel that Truffaut especially liked.) Sensing that a character was missing, the authors decided to introduce and develop the owner of the bar at the tennis club where the inhabitants of the area gather. A character who is an observer, at once complicit and calm, of the contradictions that are the cause of the two protagonists' struggles; a witness, but a witness who has been marked by

an adventure like the one that torments them. Was Truffaut thinking of Ginette Leclerc in Henri-Georges Clouzot's *Le Corbeau*, a film and a character he admired? In any case, he also gave Madame Jouve an injury, a monstrosity, that sets her apart from the amiable, well-arranged world of tennis players that she lives in, a mirror of the story taking place before our eyes. No doubt Truffaut also remembered Ophuls' *Le Plaisir*, where Jean Servais tells the story of Simone Simon, who is in a wheelchair because she threw herself out of a window for love and whose fall was broken by a glass roof. Truffaut arranged Odile Jouve's first appearance via Bernard, who takes refuge in her bar when he is escaping from dinner with the neighbours: 'We feel that there's a good complicity between Bernard and the bar owner. Madame Jouve is a beautiful woman of around 50, her left leg is in a metal brace, and even though she uses a cane, she gets around rapidly. Bernard already knows that Madame Jouve's disability is the result of an accident that happened 20 years ago: she fell from the seventh floor, and if a glass roof hadn't broken her fall, she wouldn't be here today. The evening being propitious for confidences, the woman tells Bernard that it wasn't an accident but a suicide attempt: 25 years ago Odile Jouve was left by a man she loved madly; he left her to get married in New Caledonia. Thinking she would never get over her pain, she threw herself from the window of a building, in the old quarter of Nîce.'

When Madame Jouve looks back on that past love and its dramatic end, she says: 'The end of our story was tragic, but not fatal' and takes pleasure in quoting Edith Piaf: 'No, nothing at all, I regret nothing.' After introducing Madame Jouve, Truffaut and Suzanne Schiffman immediately extended the mirror effect by having her old story come back into the present. They introduced the idea that she receives a telegram (already described as being delivered by a young postman who circulates among the tables asking for her, whose movement Bernard follows) because a visitor is asking for her and she has been gone for several days: her former lover has come to visit her, but she refuses to let him see her because he does not know she tried to kill herself because of him. Truffaut and Schiffman also planned an extra scene at the clinic where Mathilde tells the psychiatrist Madame Jouve's story. The introduction of Madame Jouve enabled Truffaut to avoid having a quartet. He said he always followed the advice of Henry James to choose an odd number of characters so as to escape from the conformity of symmetry: 'The unforeseen, the bizarre, always insinuate themselves thanks to the odd number.'

Nonetheless, it was only after seeing a rough cut that Truffaut had the idea of opening and closing the film with Madame Jouve telling the story from her point of view. The first cut left him disappointed and dissatisfied, as frequently happened. Martine Barraqué reports that after the rough cut, Truffaut generally needed 24 hours to digest his film. 'Why this film? Who is going to be interested in a story like this?' he would ask, and then, preoccupied, he would usually disappear into his office in the company of Suzanne Schiffman. This time Truffaut felt that he did not yet have his film, that he had missed something essential. The helicopter shots of the ambulance driving past the

Rehearsing with Fanny Ardant and
Gérard Depardieu.

houses at the beginning should had set off the flashback, but something was not working. 'Who can tell this story?' he asked, and Suzanne Schiffman suggested the idea of filming an introduction with Madame Jouve, played by Véronique Silver. Editing was interrupted for 15 days, and new shots were filmed in front of the tennis courts where the actress pretended to be talking to some hypothetical camera, then revealed her cane and brace, which were at first hidden by the close-up. It is a way into the film through the promise of a story and an image of disjunction, of disorder masked by the polished glaze of appearances, while behind her the tennis players are knocking balls back and forth. ('And if you take me for a tennis player, you are completely wrong.') A patched-together opening which, while not seeming to be much at all, nevertheless becomes one of the most engaging in Truffaut's cinema, as Georges Delerue's haunting music, at once sweet and disquieting, supports the images of the ambulance flying down the road at dawn, before the face of Véronique Silver slowly dissolves in: 'This business began six months ago. You could say that it began ten years ago, but no, it began six months ago.'

Under cover of the anodyne.

From one version to another of his text, after the overall movement and the key scenes were set, Truffaut worked by little successive touches. When it is Bernard and Arlette's turn to have dinner with the neighbours, he reinforced the idea of the daring dress Mathilde tries out in front of everyone by planning to have Mathilde say that she saw it in a shop window and decided not to buy it because 'I thought it was almost impossible to wear in public'. A detail that will have on Bernard, the impotent spectator of Mathilde's married life, the effect of a provocation, which Truffaut pushed in that direction by having Martine Barraqué edit it with as much Gérard Depardieu as possible, showing Bernard withdrawn from the superficial amusement that is going on around him. When he returned to the treatment at the beginning of February 1981, Truffaut added to the scene the idea of people running in the street that interrupts the discussion and draws the two men to the door. (It is a handwritten addition: 'The two men's conversation is interrupted by people running outside. Hurried footsteps, shouts. Philippe opens the door and explains that it's probably the getaway of a thief caught in the act.') The eruption of external disorder stands in for the disorder that remains hidden behind the walls of the house, creating a point where the scene tips over, opening the way for confidences (this is when Philippe brings up Mathilde's unhappy past). This allowed Truffaut to avoid cliché, because he knew that he benefitted at each instant from the information he was giving the viewer (who knows that the manic-depressive guy who stole Mathilde's smile is none other than Bernard).

These additions, often enriched by personal memories or things that Truffaut was told and which he did not hesitate to use to introduce touches of the truth, brought an element of crudeness with them. When Mathilde meets Bernard at the hotel and asks to go downstairs to talk, Truffaut imagined a *mise-en-scène* that allowed him to have his characters speak in low voices (because they are

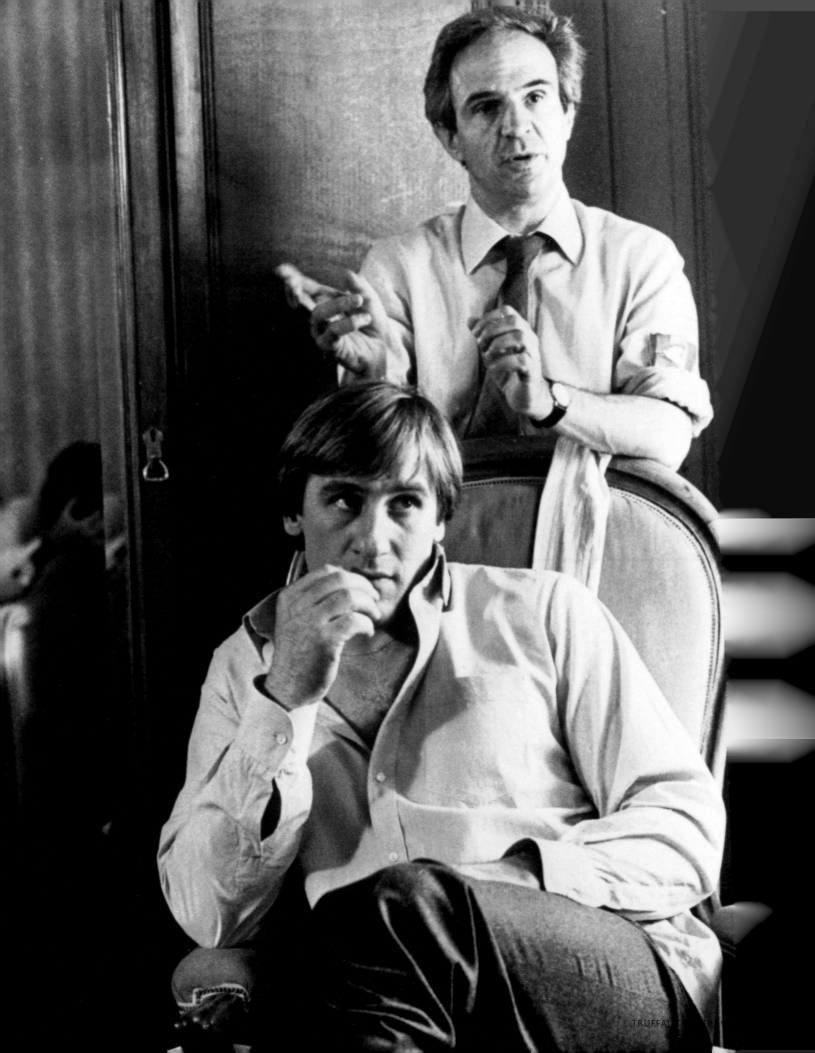
TRUFFAI

not alone in the bistro) and slipped in the story of the precipitous marriage: 'It was almost like those stories where the guy says: I'll marry the first woman who walks in that door.' In a few sentences handwritten in pencil Truffaut then added the story of the abortion that became one of the main reasons for Bernard and Mathilde's break-up: 'The conversation becomes more heated as Mathilde reproaches Bernard for having forced her to have an abortion when she was expecting his child.' On his shooting script Truffaut added this brief line that he gave to Mathilde: 'You had that child with someone else.'

Truffaut was always searching for the right detail, the one that hurt. When Bernard locks his keys in the car, Truffaut planned to add to his humiliation the fact that the neighbours were watching from their window, then imagined this detail: Arlette says hello to Mathilde, who has just opened her window across the way and is 'soon joined by Philippe in pyjamas who puts his arm around his wife's neck'. To bring on Bernard's outburst in the garden party sequence, Truffaut added his reaction to the bags packed ready for the honeymoon trip: 'Looking haggard, Bernard walks around the house, no doubt looking for Mathilde. The sight of several suitcases and bags set out makes him beside himself.' When he filmed the scene Truffaut showed Bernard caressing a slip similar to the one he pressed to his lips during their afternoon at the hotel. And instead of simply showing her crying Truffaut also wrote, to materialize Mathilde's collapse, an added scene, following a plan like that of the garden party, which it recalls: 'Country club. Publication of book. Boxes of books. Everyone flips pages. Journalist from Nice-Matin. Brief anodyne + information book
Two dogs, Madame Jouve's dogs. Conversation. Brief fire. Daring dress with straps. She helps Jouve. Dirty hands. Coat room... neighbour on same floor... lift... Anodyne later... collapse.
Mathilde becomes laconic, then openly mute. After she has not answered two or three questions put to her, she breaks down sobbing. Conversation ceases and everyone looks at Mathilde who is shaking, face covered with tears she can no longer control.'

The scene is characteristic of what Truffaut was attempting throughout *La Femme d'à côté*. The underlying emotional disorder that little by little invades the characters and the film upsets the equilibrium of appearances, manifesting itself in a series of more or less innocuous external happenings (dog-fight, domestic fire, macho jokes about women next door), the accumulation of which finally provokes an outburst or a collapse. This accumulation of signs, a more or less visible, more or less muffled, series of brief disturbances of the social order or surface, allowed the film-maker to dispense with portraying any psychological logic. Mathilde puts on a dress that cannot be worn, whistles are blown in the street, a fire starts in the kitchen: nothing but seemingly everyday events beneath which, sign after sign, incident after incident, the forces of disorder and destruction smoulder and grow stronger. As often happened, Truffaut took the scene of the book signing further when he was filming, making Mathilde flee the gathering into the woods where she collapses like a wounded animal, face

and belly against the earth, like a sister to Adèle or the wild child, reduced in front of her husband, who has run to help her, to a body out of control, shaken by uncontrollable sobs.

A carapace.

On his shooting script, and when he was completing the dialogue he wrote on weekends or sometimes from day to day during the six weeks of shooting, Truffaut continued to introduce more life elements. He set up the kiss against the door of the car in the car park with a line from Mathilde, asking Bernard to speak her name every now and then. (Truffaut had originally written the line 'You could at least say my first name' for Bernard during their first phone conversation, before putting it here where it would have the most effect.) After the love scene at the hotel he introduced, from a brief exchange sketched out by hand on the facing page, the detail of the hair in the eyes: 'She: You have hair hanging in front of your eyes. He makes as if to brush it back with his hand. She: It wasn't true, I just wanted to see you make that gesture... When we first knew each other I thought: If he asked me to make love to him, I'd say yes.' When he wrote out the whole exchange to shoot it, Truffaut incorporated an idea Depardieu gave him: the discovery of Mathilde, the first time he sees her, framed by a window while she makes a snack for the children (a vision recalling the way the young Werther fell in love with Charlotte in Goethe's novel). This is also when Truffaut introduced fragments of dialogue recovered from the *Sur les Rails* project, as if he had re-read those pages during the shoot: a scar on Mathilde's wrist that Bernard notices, the idea of the spine ('My lover thought he had a spine; in reality it was a carapace, and after his carapace cracked, he detested Mathilde'). Or the dialogue 'You said to me, "I'm not drunk. The proof: the rigour of my reasoning"', which gets this response from Mathilde: 'And you reasoned and reasoned, and I thought: What is he waiting for to kiss me?' This accuracy is no doubt the reason why after the film was released Truffaut received numerous letter from strangers, each of whom said: 'You have told my story.'

The umbrella and the garden party.

Truffaut also jotted down in the margin brief indications for the *mise-en-scène*: details of the set ('stairs, upper floor, room' for a conjugal scene between Bernard and Arlette), or the beginning of a scene ('we see Mathilde's hand leafing through the phonebook', with the annotation 'painting-slap' underlining the effect Truffaut wanted when he placed this painting of a man slapping a woman where we can see it whenever Fanny Ardant telephones or watches the house next door through the window), or a precise sketch of a set-up. 'Bernard's arrival at Mathilde's. She sees him approaching through the window of the kitchen, where she is found using an electrical gadget. The intermittent noise of the mixer creates the rhythm of their dialogue. At first they speak at a distance, Bernard being in the garden; then Mathilde invites him in.' Or it might be a gesture, a seemingly secondary detail: 'Walking in front of the picture window, he picks up a umbrella', Truffaut noted, when Bernard, furious, arrives at Mathilde's from the back of the garden. In the film we see Depardieu, who bolts like a madman toward his lover's windows,

stopping for a moment to straighten up the umbrella, gently and precisely. (He did it in every take, according to Martine Barraqué.) This ridiculous attempt at restoring order, even when he is carried away by passion, is a prelude to the scene of temporary reconciliation between the two lovers ('friends like we were before,' 'friends like we were before what?'), before disorder overwhelms them again. Moreover, the umbrella that Bernard picks up is lying in the exactly the same spot where a few scenes later he will knock Mathilde down in front of everyone. It was not at all a chance detail for Truffaut. 'Bernard pursues Mathilde to the foot of the umbrella, where she lets herself slide down', he specified when he rewrote a description of the garden party adapted to the setting before he filmed it.

Thanks to the possibilities offered by the décor and its large picture window, Truffaut worked out the final disposition of the garden party sequence on set: an astonishing mobile sequence-length shot that he took the time to write out, along with the complete dialogue, on pages distributed to the whole crew before shooting. It was a very detailed plan, including the idea of following two guys who station themselves there as voyeurs in order to return to the picture window, through which Truffaut would film the conclusion of the scene as if through a screen: 'We pick it up at the bottom of the stairs. Bernard continues his harassment. Mathilde falls down near the picture window. Bernard picks her up, but she escapes toward the door. Traffic jam at the door. Everyone watches the scene in horror. Two characters return us to the picture window through which we see what happens next. Bernard, as if he were unconscious of his surroundings, pursues Mathilde to the umbrella, at the base of which she lets herself slide down. Some men subdue Bernard. In passing, we pan over Philippe, stunned, and we end on Madame Jouve.'

By filming the overflowing of mingled love and hate that overwhelms his characters first in front of and then through and from the other side of a screen (which the large picture window resembles), Truffaut literally represented the journey to the other side of the mirror that Bernard's public outburst represented for the lovers. What has been hidden suddenly becomes visible, visible to all, to everyone at once, and we see unmistakably that Truffaut was never interested in light comedy or for that matter psychology, but in the overflowing of feelings and the way this overflowing and this violence of passion pervert the calm hypocrisy of the social order. By filming through the picture window, he no longer privileged individual emotions (which the first versions of the screenplay described); he placed the struggle of bodies at a distance, no longer seeking to represent any way but abstractly, generally, the moment when the disorder of passion escapes all control and shows itself to everyone. This is the only moment in the film when Truffaut represented the scandal in a single condensed shot (it will never come up again; other people, the external world, are virtually hidden), by showing us a spectacle, like those voyeurs placed in the foreground on the left of the shot. It is what he spoke to Hitchcock about during their conversation about *Rear Window* in 1962: 'We're all voyeurs, if only when we watch an intimate film.' The most astonishing thing is that at the moment he reached the point where his film tipped over (for nothing from now on would be as it was before), where he filmed an act of physical violence without precedence in his cinema, Truffaut did not seek identification, but placed the viewer at a distance, creating emotion not by closeness, but by abstraction, by the astonishment the overflow provokes – projecting through a screen the instant where the violence of passions that is the burning core of his falsely smooth cinema breaks out to create a symbolic shot that is its culmination.

The call of the void.

Re-seeing *La Femme d'à côté*, we constantly rediscover how much, in this film of maturity, the *mise-en-scène* is adapted to the subject. Not only by the deliberate neutrality of the settings (modern houses, kitchens, car parks, tennis courts), where Truffaut constantly plays on the disjunction between the ordinary and the resurgence of desire, but even by the camera moves. At the beginning of the film the camera easily links the two houses, with big pans accompanying Bernard, for example, coming home and then crossing the road to speak to the new neighbour, whom he takes over to his house so that he can use the telephone, or the child who slips into the neighbours' house to play their piano. When the taboo comes undone, this link becomes impossible: after Bernard leaves Mathilde, whom he has gone to see illicitly to have it out with her (and she tells him that if he has been seen he should explain that he was helping her fix some kitchen appliance), the camera no longer escorts him. Truffaut cuts instead and does not show the path he took returning from his lover's kitchen to his wife's. When it is Bernard and Arlette's turn to have dinner with their neighbours, Truffaut begins the sequence with an empty shot of the kitchen, while we hear snatches of conversation, and Bernard and Mathilde enter to get the coffee. Bernard leads Mathilde into a corner where he begs her in a low voice to grant him a rendezvous, she refuses, and when they return to the living room we see in the same shot, which still stays with them, that only a thin half-partition actually separates the two spaces. The film-maker makes the precariousness that is the lot of the lovers who are without hearth or home throughout the film tangible in this single precise, deliberate shot that seems perfectly insignificant, at the beginning of a scene where disturbing signs accumulate (the unwearable dress, Mathilde's laughter, the recollection of the past, the sudden noises in the street). Moreover, this is when we cut to Mathilde discovering the package containing the unwearable dress. In a rather beautiful inversion of form and content, Truffaut ends the scene with another long take and a contrary movement from the living room to the kitchen when Mathilde comes downstairs in the daring dress, takes the cups into the kitchen and leads Bernard under the stairs in order to grant him the rendezvous that she began by refusing: as if, beyond any rational explanation and any psychology, the micro-incidents that have studded the scene have set up this reversal.

La Femme d'à côté is a film trapped by the void, into which the characters never stop falling: Mathilde faints, sliding down on the floor of the car park, she falls near the umbrella, pursued by Bernard in front of everyone during

the garden party, collapses on the ground near the tennis courts, makes love with Bernard in the empty house before putting bullets in his head and hers… Madame Jouve slips on the tiles when she is feeding her dog. And even in Mathilde's drawings, the little boy has fallen down and a pool of blood spreads out under him. Mathilde may be 'the aviator's wife', in a nod to Rohmer, because her husband is an air traffic controller, but she remains flattened on the ground by this page she cannot turn, which seems to her to weigh a hundred pounds. The pull of weight is shown almost invisibly by the *mise-en-scène* and the editing. When Mathilde faints and falls down in the car park, the camera accompanies Bernard's movement as he bends over her and goes out of the shot, then gets up with her and puts her in her car. The shot continues until the end of the scene on Bernard's face, left alone after Mathilde's brutal departure. Actually, the shot is interrupted by a jump-cut in on Bernard as he bends. Martine Barraqué says that they decided on it for simple technical reasons, in order to show Depardieu's expression at that moment. But this very beautiful and barely perceptible jump deepens the shot and reinforces the sensation of vertigo. When Bernard takes refuge in Madame Jouve's café instead of dining with the neighbours, she, before telling him her past, takes a snack to her dog and slips on the floor with her cane. Bernard runs to her. This passage was explicitly designed by Truffaut to set up the shift to exchanging confidences. In the margin of his shooting script he had written these notes: 'The big dog to frame the leg… She gives him something to eat… She gets up and he helps her…' In the middle of the scene, filmed in two long moving shots, the cut comes at the precise moment Madame Jouve falls, at the point where the scene tips over. Odile Jouve then tells how when she was 20 she threw herself into the void like a bunch of dirty laundry…

La Femme d'à côté is constructed like a tragedy that nothing can prevent and neither knowledge nor foreknowledge can help, a tragedy of feelings out of sync that recalls this line in *Jules et Jim*: 'Impossible for us both to suffer at the same time. When you stop, I'll begin.' First act: it is Mathilde, a menacing presence behind the window, who loves and suffers the most, until the first explosion when she faints in the car park. Second act: the most rapid, since it is the only one where time and feeling coincide, superbly materialized in the scene where Mathilde and Bernard can't reach each other because their telephones are engaged at the same time. They meet at the hotel, and by a lovely effect of speed, the dialogue where they set up the rendezvous accompanies their two cars already en route as a sound overlay.
Third act: Bernard suffers and waits more than Mathilde, until the sudden, violent explosion of his contained jealousy at the garden party. Fourth act: the movement reverses, Bernard is cured, but Mathilde goes under, and premonitory incidents accumulate (her visit to the house next door with the child, stopping before the drawing where she asks herself about the whale's pain, the fire at the tennis club, collapse). The fifth act is a false status quo, where everything is put back to rights: Bernard's visit to the hospital ('Mission accomplished: you can go and see them and tell them, the madwoman is becoming normal again'), moving out, the door that slams in the night, love and the putting to death.

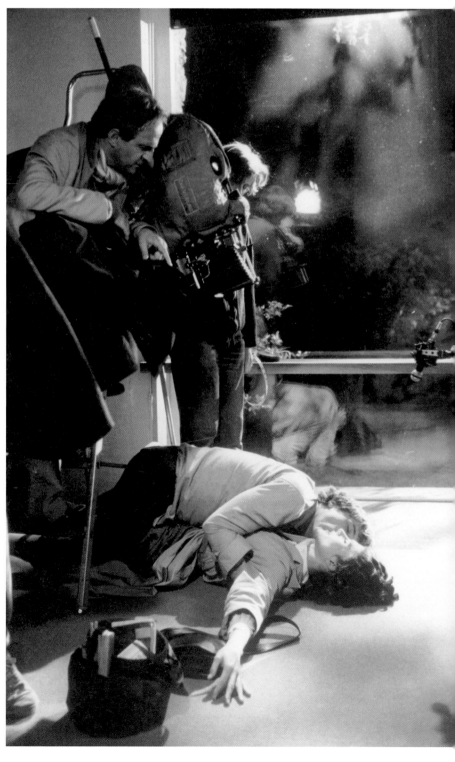

Vivement dimanche! (1983)
Finally Sunday, also known as *Confidentially Yours*

'To "de-fatigue" myself after *La Femme d'à côté*, I decided to make a film with Fanny Ardant where she would be used as a *série noir* heroine.'

Truffaut said that the idea of finding a mystery novel he could adapt for Fanny Ardant came to him when a viewer of the rushes for *La Femme d'à côté* exclaimed on seeing the actress, who was wearing a long raincoat, walk through the alley separating the two gardens before catching the attention of her lover in the house next door: 'She looks like the heroine of a *série noire*!' He asked Suzanne Schiffman to do some research, and she recommended Charles Williams's novel *The Long Saturday Night*, which Truffaut, a big fan of the humour and imagination of the author of the film *Fantasia chez les ploucs* (based on his novel *The Diamond Bikini*), had already spotted in the 1970s and briefly thought of adapting for Jeanne Moreau. The film-maker had the rights bought without re-reading the book. Afterwards, having discovered that the novel as such was mostly unusable, he held a grudge against Suzanne Schiffman to the point of still being bitter with her during the shoot. Everything had to be reinvented, particularly if the leading role was to be the secretary of the estate agent suspected of murder, because she was only a sidekick in Williams's book – active and intelligent, but still a sidekick. In the novel it is the estate agent who conducts the investigation, going to the city where his murdered wife had spent some time, trying to retrace her steps, hiring private

detectives to look into her past, etc. Reversing the situation, in Truffaut's vesion Julien Vercel (Jean-Louis Trintignant) dozes by the fire, bored by his secretary's chatter, while she takes the initiative. The adaptation still seemed laborious to the film-maker, and he remained very dissatisfied with it, conscious of the thinness of the subject and the slapdash nature of the screenplay. 'Lots of things happened via telegram, telex, telephone… We (Suzanne Schiffman, Jean Aurel and I) therefore kept the beginning and the ending of the book, but were obliged to invent the whole middle to have something visual on the screen. That's when I realized that inventing *série noire* plotting is difficult: it's a job for specialists. To write *série noire*, you have to be in training. The plot of *Vivement dimanche!*, even if it's childishly simple, was longer and harder to develop than *La Femme d'à côté*. It was a lot of work for something that gives the impression of lightness, of great facility.'

Vivement dimanche! was clearly an excuse for filming the many faces of Fanny Ardant, walking around the city, wearing a short page's costume under the raincoat borrowed from her boss or dressed as a whore. (With heavy make-up, hair up, blouse knotted beneath her breasts, she asks her boss: 'Do I look convincing?' 'As what, for God's sake?' he asks, raising his eyes to the sky.) Each situation was an opportunity to film the beloved actress from every angle, in long-shot and close-up, laughing, preoccupied, scandalized, provocative, always superb, even when she was being soaked by a broken tap in the middle of the police station, derailing the interrogation. Truffaut said that he wrote the scene about the tap that comes off in the commissioner's hand when he goes to get a glass of water in order to introduce a diversion and a touch of the unexpected into the conventional murder mystery genre: it was also a chance – one of a hundred – for yet another close-up emphasizing the heroine's beauty.

In one of the scripts of *La Sirène du Mississippi*, Truffaut had expressed the fantasy of a woman half-undressed under her raincoat. Found by her husband in the South of France, the heroine is wearing a 'gabardine raincoat'. After entering her hotel room, she takes off 'her raincoat under which she finds herself dressed in her girly costume as in the photo'. In order to film Fanny Ardant in a page's costume, he developed one or two sentences in the novel to create the scenes of amateur dramatics: an allusion to the theatre classes the estate agent's wife pretended to be attending the previous year. In the first long synopsis of *Vivement dimanche!*, Julien is not at all bothered to tear Barbara away from her mother's birthday dinner, and under her overcoat she hides, more banally, an evening gown. But the theatre, the stage shown twice (first the amateur actors rehearse in street clothes, and then, because Barbara's husband is late, they try on their costumes), became the ideal excuse.

The pleasure of filming a woman in motion, as he had filmed Bernadette Lafont flying through the streets of Nîmes on her bicycle at the time of *Les Mistons*: Truffaut announced his theme in the first images of his film, which show a woman striding through the streets, joyful and alert ('a woman who has set out to conquer the city' was the instruction the film-maker gave Georges Delerue for

Seeing without being seen: From the fanlight to the cellar window.

the music); a woman soon to be accosted by a young man who regrets that their paths will diverge so quickly. Moments of pure cinema: Truffaut skipped the overly explanatory prologue in the script, a voice-over by Barbara that was going to accompany her walk and introduce her job as a secretary. ('The word "secretary" came from the word "secret", and I expect to experience much criticism, since I've decided to unveil all the secrets I know.') In the script the short pick-up scene with the stranger was planned for much later, when Barbara goes to buy the newspapers following the night when she and her boss had to knock out someone they thought was the murderer. (If we look closely, we see that Barbara is wearing a different jacket when we come back to her walking in the street after the opening scene of a hunter being murdered, the black-and-white checked jacket that she wears in the newspaper scene.) Truffaut let this brief encounter set the mood for the film: joyfulness and seduction, the vivacity and everydayness of relationships between men and women, letting Barbara's clever bravery set the pace. He did it without slowing down the action, having cut another longer pick-up scene, written for a few pages after the opening: Barbara rebuffs a guy who pretends she reminds him of a dead woman he adored. ('The resemblance with the dear departed is a trick that has been tried on me at least 20 times'), an irreverent reference to *La Chambre verte* that Truffaut decided to do without.

Not totally at ease with the mechanics of the murder mystery that he knew would in any case just be a pretext, Truffaut preferred to use broad strokes and be openly playful. He broke up the seriousness of the police interrogations with diversions – such as the Albanian refugee who bursts in demanding political asylum, or the phone call the commissioner makes to his fake wife (alias Barbara) to worry the guilty party by means of a bit of business about casseroles. (Barbara is given a recipe for potato salad taken by Truffaut from *La Règle du Jeu*.) Reminders of *Baisers volés* (the Lablache Agency, sister of the Blady Agency) or *La Peau douce* (an ironic remake of the scene in the lift: this time Barbara is accompanied on her way up to room 813, which Marie-Christine Vercel had occupied before her death, by a reveller played by Jean-Pierre Kohut-Svelko, Truffaut's production designer on many films, from whose pocket tumbles out a bra). In the script, while Barbara explores the room occupied previously by Marie-Christine, she immediately finds a racing form in the rubbish bin with the names of horses circled: 'Beautiful April in the third.' During filming Truffaut preferred to defer the revelation and use both conventional mystery and a romantic red herring. When Barbara finds in the bin two scraps of paper on which we read 'My Love' and 'The Captain', she sends the detective on this trail of adultery. And it is only later, passing by the racetrack (a huge coincidence assumed by

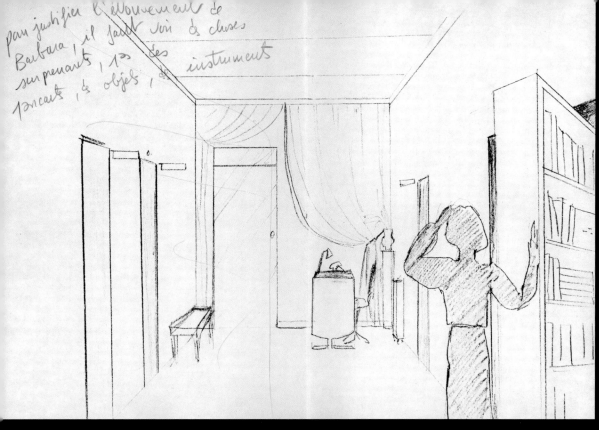

par justifier l'étonnement de
Barbara, il faut voir des choses
surprenants, 1^{as} des instruments
précants, des objets, 1

Annotated drawing
of Marie-Christine's
beauty salon,
whose proximity
to the lawyer's
office is discovered
by Barbara
(Fanny Ardant):
'To justify Barbara's
astonishment,
we have to see
surprising
things, not just
posters, objects,
implements.'

Opposite: Additions
during filming.
Barbara gives her
boss a look at
her legs. And
a cut scene, where
she would have
playfully blocked
his view.

HOTEL GEORGE V
PARIS

Vivement dimanche

elle dit "et bla et bla"

il s'énerve : finissez vos phrases

à la fin il dit et bibi et
bla.

elle dit : il faut être une pute
pour porter ça
à la fin elle le porte

Lubitsch touch : "je vous ennuie en
ce moment ..."

A page of preparatory notes: 'She says:
You'd have to be a whore to wear that.
In the end she wears it. Lubitsch touch:
"Right now I'm boring you".'

Right: Sketch for Ange Rouge cabaret.

L'Ange Rouge

the screenplay), that Barbara happens to hear the key to the mystery – the same trumpet sounds that she heard the day before on Marie-Christine's telephone call to the agency, and the announcer's voice that resolves the misunderstanding: 'The Captain takes the lead, followed My Mascot and My Love.' So Barbara can now call the detective and tell him: 'It's not a lover. The Captain isn't a man – it's a horse.'

While filming and then while editing, Truffaut also moved to later the discovery that the lawyer's office adjoins Marie-Christine's hair salon. As soon as this information is given, 'the net closes in on the murderer', as the slightly parodic newspaper article in the film says. In the screenplay the revelation arrives less than halfway into the story, at the end of Barbara's first visit to the lawyer. As she is leaving, before being picked up by the police who take her to the police station, Barbara was supposed to see the beauty salon sign through a dormer window. While filming Truffaut decided to move the scene to the moment when Barbara returns to see the lawyer, after she disguises herself as a whore in order to penetrate the 'mysterious' world of Louison (who turns out to be a man, played by Jean-Louis Richard). The lawyer is out, and that is when Barbara sees the sign for the beauty salon through the window. She asks to be left alone in the office, where she discovers the existence of a secret passage. Truffaut only shows us what is hidden behind the secret passage at the moment of the final climax, in flashback. He thus defers the most important plot revelation for over an hour and twenty minutes into the film, while keeping Fanny Ardant in her skimpy disguise longer for his own pleasure, which he played with by having the lawyer's secretaries react to her vulgar appearance.

Truffaut was interested in the mix of genres, not so much in the mystery plot itself as in the possibility of mixing it with 'marital comedy where the couple bicker constantly', allowing him to show Fanny Ardant both as a *série noire* heroine and a comedy heroine à la Katharine Hepburn. It was a gift the film-maker wanted to give her so that she would not remain typecast in romantic roles after *La Femme d'à côté*. During filming, Truffaut pushed the scenes of bad faith. He amused himself by substituting a new scene for one where a woman client came to retrieve the file putting her house on sale because she was worried about the suspicion weighing on Julien Vercel: a caricature blonde turns up to apply for the secretary's job, says she doesn't read newspapers because the ink makes her hands dirty and shows how she types at top speed with one finger. It is a chance to confront the comparative merits of brunettes and blondes, provoked by Barbara who knows that Julien, hidden nearby, is hearing everything. During filming, Truffaut also invented the famous scenes with the cellar window, through which Julien Vercel watches, from the hole where he is confined, the legs of female passers-by. Quoting himself from both *L'Homme qui aimait les femmes* and *Le Dernier Métro*, Truffaut came up with moments of distraction where Julien glances away from the conversation to concentrate on the window and its almost non-stop cinema. Truffaut also invented Barbara's slightly provocative response, both naughty and tender:

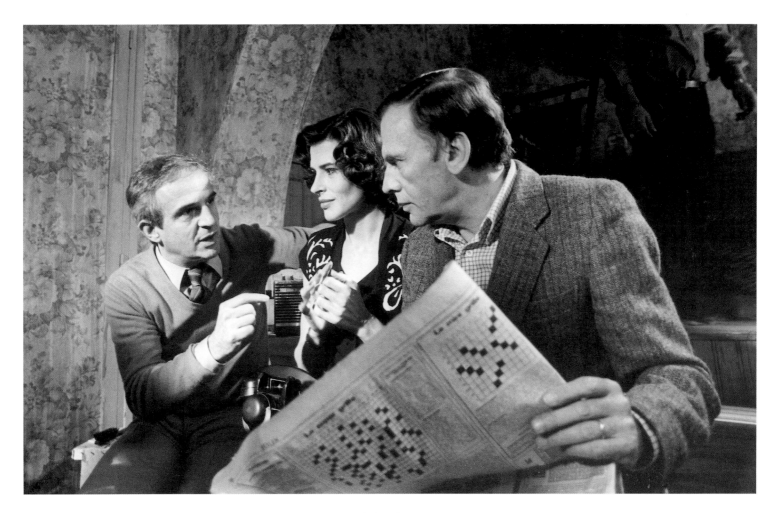

Truffaut directs Fanny Ardant and Jean-Louis Trintignant.

Fanny Ardant passes back and forth in front of the window to offer her boss the best spectacle of all, her own legs. He even considered taking it further, conceiving a scene (which was filmed) where Barbara nails two planks over the window to block Julien's view and recapture his attention. But he preferred to retain the glorious, joyful and insolent image of a triumphant young woman offering the man she secretly loves the object of his desire.

Mischief, impertinence carried to the limits of casualness and enthuiasm: if Truffaut felt that his screenplay was often tangential to his real interests, he knew that speed would give him a chance of pulling it off. He had his actors talk at the speed of US comedies: 'Here, contrary to what she did in *La Femme d'à côté*, Fanny Ardant should speak fast, like in a dubbed film. It's the instruction I gave all the actors: I told them: "Imagine you're dubbing a US film and there's not enough time or space for all the words."' He wanted a quick seven week shoot during November and December 1982, with a sustained rhythm and not many takes, so that Nestor Almendros was at first disconcerted by the haste the film-maker considered necessary to the style of his film. 'His only concern on *Vivement dimanche!*,' recalls Martine Barraqué, 'was "go faster, go faster".' Truffaut wanted to end his film on this note of speed and impertinence. During filming, he invented the ending in place of the narration planned in the script, which would have included Barbara's explanations about the marriage, building a house and waiting for a child with a series of shots showing these developments, several of which had already been filmed

(Julien Vercel entering the estate agents pushing a pram, for example, while a swelling stomach distances Barbara from her typewriter). The priest would return so that we could recognize in him the cleric Barbara knocked out earlier, and a choir of children was also planned. ('A group of children sing a wedding march that blends with the music over the end credits.') But while filming Truffaut had an idea for subtly diverting the wedding scene: at the last minute the photographer drops a lens cap and it is passed around like a football between the feet of the children. Speed, movement, the unruliness of childhood: this casual, playful diversion was, at the end of a film whose advantages and limits he knew, a kind of pirouette, an amused recapitulation, a prelude to what would have been a new direction for other films.

For Truffaut, *Vivement dimanche!* was also a chance to reaffirm his aesthetic principles and artistic independence. The film-maker insisted on shooting in black and white, even if it made financing harder to find. The project was rejected several times by the television networks, which had become an important source of financing for films at the beginning of the 1980s. 'Behind this choice there is the conviction that between two scenes filmed in colour and in black and white, the scene in black and white has more credibility, it's more mysterious. The same way that between a film shot in daylight and one shot at night, the night scene is more interesting. Either people don't know these laws or have forgotten them, or they think it's a whim of the director.' Truffaut decided not to give up, and he told

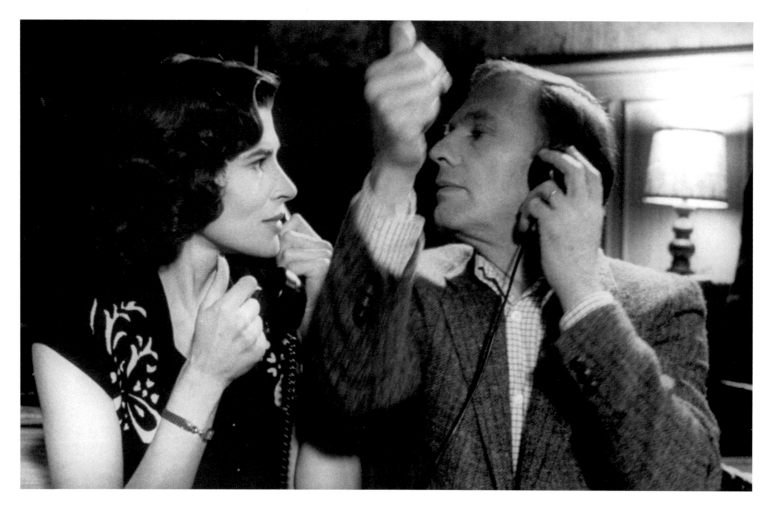

A mixture of *série noir* and American comedy (Fanny Ardant and Jean-Louis Trintignant).

Gérard Lebovici, his agent, to hang tight, writing to him on 9 September 1982: '*Vivement dimanche!* will attempt to restore the night-time ambience, mysterious and brilliant, of US mystery comedies that once enchanted us. I think that using black and white will help us to find that lost charm, and no one in the world will succeed in convincing me that black and white is less cultural than colour.' When the battle had been won (Antenne 2 finally agreed to coproduce the film), he took care with the costumes, notably those of Fanny Ardant, meticulously chosen for their contrasts of black and white, and the sets constructed almost entirely in an immense abandoned hospital near Hyères allowed him to recreate studio conditions as he did during the shoot in the old chocolate factory for *Le Dernier Métro*. To work alongside Nestor Almendros, Truffaut hired an American production designer, Hilton McConnico, who had the sets painted black and white and created graphic compositions. Almendros used very direct lighting with pronounced shadows in homage to the photography of 1940s films and some Fullers of the 1950s. He also gave prominence to Fanny Ardant's forehead to make her look 'more Rita Hayworth'.

A film where set-ups and compositions are more important than the story, *Vivement dimanche!* became a demonstration of the mastery of *mise-en-scène* whose precision had been constantly affirmed in all the film-maker's last films. If Truffaut began his career more or less basing his camera moves on the way the actors' movements develop in the space available, this film was the culmination of the reversal of that approach by a director who now filmed highly choreographed mobile single sequence shots where the camera moved without the viewer noticing it, and knew to the millimeter what he wanted to obtain from the image and how to get it. 'Truffaut no longer asked them what they wanted to do,' recalls Suzanne Schiffman. 'Instead he would explain to them: "At this point Fanny gets up, or Jean-Louis will go to the window, he will join her, then Fanny will move over there, she goes toward the mirror and then turns around", indicating the movements and gestures they were to make and how they would be filmed with a much greater precision, much more direction than what he had given in the 1960s and 70s.'

Finally this anecdote: the slap given to Barbara by her boss, furious at having to rot for hours on end in the back room of the estate agent's office while she is out investigating, was administered by François Truffaut himself. He discovered that Trintignant was unwilling to use enough force, so he said to him: 'I'll show you.' Truffaut waited for Fanny Ardant's entrance, winked at Nestor Almendros to start the camera and gave her an enormous slap (it is impossible to tell who was giving it from the close-up, once the shot was cut in so the hand was barely seen), certain to have in the can the flash of stupefaction and the look of anger he wanted.

Biographical Notes (1932–84)

1932: François Truffaut is born on 6 February in Paris. His father, Roland Truffaut, is an architectural draughtsman, and his mother, Janine de Montferrand, is a secretary at *L'Illustration*. Grows up in Pigalle, living under the German Occupation between the ages of eight and twelve. He takes refuge in reading and films and often goes to the cinema secretly, associating seeing films with a sense of illicit pleasure. After the war he regularly visits ciné-clubs and sees very many films.

1946: Drops out of school and works as a stock market errand boy, a sales clerk and a welder.

1948: Truffaut and his boyhood friend, Robert Lachenay, set up the 'Cercle Cinémane' and meet André Bazin. Overwhelmed by debts, Truffaut is locked up in the *Centre d'Observation pour Mineurs Délinquants* at Villejuif at his father's request. On his release, Bazin invites him to work on the film section of the magazine *Travail et Culture*. Truffaut writes his first real articles, and contributes to the *Gazette du cinéma*, edited by Eric Rohmer.

1950: Becomes a freelance journalist at *Elle*. After an unhappy love affair, he enlists for a three-year stint in the Army without being called up.

1951: Before he is scheduled to leave for Indo-China, he deserts while on a leave of absence and spends months imprisoned in the Dupleix barracks and a military hospital. Thanks to Bazin, he is discharged and freed in February 1952.

1953: Living with André and Janine Bazin at Bry sur Marne, Truffaut enters the film department of the Ministry of Agriculture and becomes a film critic at *Cahiers du Cinéma*, and at *Arts*. His article 'Une certaine tendance du cinéma français' appears in *Cahiers*, no. 31, in January 1954.

1954: Makes his first short film, *Une visite*.

1956: Truffaut becomes Roberto Rossellini's assistant (for two years); he collaborates on two projects for films that are not made.

1957: Truffaut founds his production company, Les Films du Carrosse (named in homage to Jean Renoir's *Le Carrosse d'or*), before shooting *Les Mistons* during the summer. On 29 October he marries Madeleine Morgenstern, with Bazin and Rossellini as the witnesses.

1958: Truffaut writes and shoots *Les Quatre Cents Coups*. On 11 November 1958, on the evening of the first day of filming, Bazin dies.

1959: Laura Truffaut born in January. In May, wins prize for Best Director at Cannes for *Les Quatre Cents Coups*. Thanks to the film's success, Truffaut helps Jacques Rivette finish *Paris nous appartient* and co-finances Jean Cocteau's *Le Testament d'Orphée*. Gives Jean-Luc Godard the script for *À Bout de souffle*. Filming of *Tirez sur le pianiste*.

1960: Meets Helen Scott at the French Film Office.

1961: Truffaut produces and supervises Claude de Givray's *Tire au flanc*, in which he appears as a soldier reading *Werther*. Filming of *Jules et Jim*. Eva Truffaut born the day after filming is completed.

1962: Films *L'Amour à vingt ans*. In August, he begins recording interviews with Alfred Hitchcock.

1963–5: Truffaut receives the script for *Bonnie and Clyde*, but he decides against making it in 1965. Unable to set up *Fahrenheit 451*, he films a 'little replacement film', *La Peau douce*, in autumn 1964. Filming of Jean-Louis Richard's *Mata-Hari*, which he and Truffaut wrote for Jeanne Moreau. Truffaut decides to launch several projects at once.

1966: Filming of *Fahrenheit 451*. Robert Laffont publishes *Le Cinéma selon Hitchcock*. Helen Scott supervises the publication of the book in English. Les Films du Carrosse co-produces Godard's *Deux ou trois choses que je sais d'elle*.

1967: Filming *La Mariée était en noir*. In June, Françoise Dorléac dies.

1968: Henri Langlois is dismissed as head of the Cinémathèque française. A Committee for the Defence of the Cinémathèque is set up; the honorary president is Jean Renoir, the treasurers are Jacques Doniol-Valcroze and Truffaut. Filming *Baisers volés*. Truffaut hires the detective Albert Duchêne to find out more about his real father.

1969: Filming *La Sirène du Mississippi*. Les Films du Carrosse co-produces Maurice Pialat's *L'Enfance nue* and Rohmer's *Ma nuit chez Maud*. Filming *L'Enfant sauvage*.

1970: Filming *Domicile conjugale*. Publication in September of *Les Aventures d'Antoine Doinel*. Les Films du Carrosse co-produces Georges Franju's *La Faute de l'Abbé Mouret*.

1971: Filming of *Les Deux Anglaises* in the spring. Truffaut writes the preface to André Bazin's posthumously published book on Jean Renoir.

1972: Filming *Une belle fille comme moi*. Works on the scripts for *Adèle H* and *La Nuit américaine*, which he begins filming at the end of September.

1973: Les Films du Carrosse produces Pierre-William Glenn's *Le Cheval de fer*.

1974: The script for *La Nuit américaine* is published, followed by *Journal de tournage de Fahrenheit 451*.

1975: Filming *L'Histoire de Adèle H*. Publication of *Cinéma de cruauté*, a book of Bazin's essays with a preface by Truffaut, then Bazin's *Cinéma de l'Occupation et de la Résistance*, with a preface by Truffaut and *Films de ma vie*, a collection of Truffaut's articles. Filming of *L'Argent de Poche*. De Givray and Bernard Revon start the script for *L'Agence Magic*. Production of Bernard Dubois' *Les Lolos de Lola* and Renaud Victor's *Ce Gamin-là*.

1976: From May to August, Truffaut is in the US for *Close Encounters of the Third Kind*, and writes notes for a book (unfinished): *L'attente de l'acteur*. Works on his script for *L'homme qui aimait les femmes*, which he films at the end of the year.

1977: Filming *La Chambre verte*.

1978: Filming the contemporary scenes for *L'Amour en fuite*.

1979: Truffaut works with Suzanne Schiffman on the script for *Le Dernier Métro*, which is difficult to set up financially.

1980: Filming *Le Dernier Métro*.

1981: Quickly writes and films *La Femme d'à côté* in the spring. Les Films du Carrosse co-produces Rohmer's *Le Beau mariage*.

1982: Filming *Vivement dimanche!*, Truffaut abandons his plans to adapt Paul Léautaud's *Le Petit ami*, and starts writing a story of the Belle Epoque, *00–14*, with Jean Gruault.

1983: Truffaut gives his 'cinema lesson' as part of a series recorded by the Institut National de l'Audiovisuel. (The two programmes were broadcast on TF1 on May 5 and 12.) Dudley Andrew's book *André Bazin*, with a preface by Truffaut, is published. Truffaut works with Gruault on *00–14*, in which they plan to mix fictional characters with real people (Proust, Calmette, the editor of *Le Figaro*, the minister Caillaux, the nightclub singer Fragson). He works with Claude de Givray on the script for *La Petite Voleuse*, an old project that he plans to make one of his next films. Other projects are planned: an adaption of La Varende's *Nez de Cuir* for Gérard Depardieu, and a story for Guy Marchand about a man who loves women to the point of killing them. In August, a few days before *Vivement dimanche!* opens, Truffaut feels unwell on holiday in Honfleur, and has 'the impression that a firecracker had gone off in his head'. In September, he is operated on for a brain tumour.

1984: Second edition of *Hitchcock-Truffaut* (extended by one chapter) published. Truffaut reconstructs the complete version of *Les Deux Anglaises* with Martine Barraqué, which is released in 1985. He dreams of writing an autobiography and records several interviews with de Givray. Truffaut dies on 21 October 1984.

The work plan compiled by François Truffaut after *La Mariée était en noir*.

Filmography

Filmography by Josiane Couëdel.
Synopses by Marc Chevrie.

Une visite (1954, short)
A Visit

Screenplay: François Truffaut. *Operator:* Jacques Rivette. *Assistant director and producer:* Robert Lachenay. *Editing:* Alain Resnais. *Filming:* 1954. *Filmed at:* Paris. *Format:* 16 mm black and white film. *Running time:* 19 minutes. *Visa de contrôle:* n° 55649 of 12 March 1982. *Cast:* Laura Mauri, Jean-José Richer, Francis Cognany, Florence Doniol-Valcroze.

A young man looking for a room to rent answers an ad. He telephones, goes to an apartment that is occupied by a young woman and moves in. She is visited by her brother-in-law, who brings her his little girl to take care of for the weekend, clowns and flirts with her with no success. The new tenant also tries his luck and is brushed off. He packs and leaves the apartment with the brother-in-law. Night has fallen on Place Blanche. The girl puts her little niece to bed and draws the curtains.

Les Mistons (1957, short)
The Brats

Screenplay, adaptation and dialogue: François Truffaut, based on the story by Maurice Pons, published in the collection *Virginales*. *Music:* Maurice Le Roux. *Narrated by:* Michel François. *Director of photography:* Jean Malige. *Assistant cameraman:* Jean-Louis Malige. *Assistant directors:* Claude de Givray and Alain Jeannel. *Editing:* Cécile Decugis, assisted by Michèle De Possel. *Production manager:* Robert Lachenay. *Production:* Les Films du Carrosse. *Filming:* 1957. *Filmed in:* Nîmes and vicinity. *Laboratory:* GTC. *Aspect ratio:* 1,33. *Format:* 16 mm black and white film. *Running time:* 23 minutes. *Visa de contrôle:* n° 20423 of 31 December 1964. *Release date:* 1958. *Distributor:* Les Films de la Pléiade. *Awards:* Prix de la mise-en-scène at the Festival de Bruxelles, Prix des Jeunes Spectateurs (Belgium), Médaille d'Or in Mannheim (Germany), Blue Ribbon Award (United States). *Cast:* Bernadette Lafont, Gérard Blain.

Five boys ('the brats') spy on a couple, Gérard and Bernadette, pursuing them with their curiosity and their teasing in the arenas and the streets, at the 'flicks' and in the countryside. They send a 'suggestive' postcard to Bernadette, who has remained alone without Gérard, whose tragic death in a mountain-climbing accident is then reported in the newspaper.

Histoire d'eau (1958, short)
A Story of Water

Direction: François Truffaut and Jean-Luc Godard. *Director of photography:* Michel Latouche. *Editing:* Jean-Luc Godard. *Production manager:* Roger Fleytoux. *Production:* Pierre Braunberger. *Filming:* 1958. *Running time:* 18 minutes. *Format:* 16 mm black and white film. *Release date:* 1961. *Distributor:* Les Films de la Pléiade. *Cast:* Jean-Claude Brialy, Caroline Dim.

'Water, water everywhere!' cry the inhabitants of Villeneuve-Saint-Georges, from where the heroine leaves each morning to take the bus to Paris. But the buses aren't running. Her cousin Bébert helps her get on a boat. Hitchhiking, she meets a guy she thinks is 'not bad'. Instead of coming on to her, he sings the praises of his Ford. They start for Paris, but the car gets stuck in the mud and, heading out in any direction, they find themselves back where they started, surrounded by water. Bogged down again, they try to get the car out but are forced to continue on foot. They lie down underneath a tree and make a deal: if he tells her a funny story, he can kiss her. But how will they get to Paris? Impossible to continue on foot. They find a boat that takes them back to the car and start off. 'The faster the Fordist drove, the less I loved him.' Finally, from the banks of the Seine they see the Eiffel Tower. Tonight she will probably sleep at his place because France being flooded makes her happy. 'And that, Ladies and Gentlemen, is the end!'

Les Quatre Cents Coups (1959)
The 400 Blows

Original screenplay: François Truffaut. *Adaptation and dialogue:* François Truffaut and Marcel Moussy. *Music:* Jean Constantin. *Director of photography:* Henri Decae. *Cameraman:* Jean Rabier. *Assistant cameraman:* Alain Levent. *First assistant director:* Philippe de Broca, assisted by Alain Jeannel, Francis Cognany, Robert Bober. *Script supervisor:* Jacqueline Parey. *Sound engineer:* Jean-Claude Marchetti. *Boom man:* Jean Labussière. *Production design:* Bernard Evein. *Props:* Raymond Lemoigne. *Still photographer:* André Dino. *Editing:* Marie-Josèphe Yoyotte, assisted by Michèle de Possel, Cécile Decugis. *Production manager:* Georges Charlot. *General production manager:* Jean Lavie, assisted by Robert Lachenay. *Production administrator:* Roland Nonin. *Production secretary:* Luce Deuss. *Production:* Les Films du Carrosse, SEDIF. *First version of screenplay:* 1957. *First title:* La Fugue d'Antoine. *Filmed:* 10 November 1958 to 3 January 1959. *Filmed in:* Paris, Normandy. *Thanks to:* Jean-Claude Brialy, Jeanne Moreau, Claude Vermorel, Claire Mafféi, Suzanne Lipinska, Alex Joffé, Fernand Deligny, Claude Véga, Jacques Josse, Annette Wademant, l'École Technique de Photographie et de Cinématographie. *Laboratory:* GTC. *Auditorium:* SIMO. *Format:* Dyaliscope. 35 mm black and white film. *Running time:* 93 minutes. *Visa de contrôle:* n° 21414 of 18 May 1966. *Release date:* 3 June 1959 (as well as the first screening at the Cannes Festival). *Distributor:* Cocinor. This film is dedicated to André Bazin. *Awards:* Grand Prix de la-mise-en-scène at Cannes, Grand Prix de l'OCIC at Cannes, Prix Fémina belge du Cinéma (Olivier d'Or), Award of the International Festival of Acapulco, Joseph Burstyn Award for Best Foreign Film (United States), Award for Best Foreign Film from the New York Film Critics Circle, Prix Méliès, Grand Prix des Valeurs Humaines de Valladolid (Épi d'Or), Award of the Austrian Press (Plume d'Or), Silver Laurel of David O. Selznick. Nominated for an Oscar for Best Screenplay Written Directly for the Screen. Screened at the Festival of Cork. *Cast:* Jean-Pierre Léaud (Antoine Doinel), Albert Rémy (the stepfather), Claire Maurier (the mother), Patrick Auffay (René Bigey), Georges Flamant (M Bigey), Yvonne Claudie (Mme Bigey), Robert Beauvais (director of the school), Pierre Repp (the English teacher), Guy Decomble (the teacher), Claude Mansard (the examining magistrate), Henri Virlojeux (the watchman), Richard Kanayan (Abbou), Jeanne Moreau (the young woman with the dog), Jean Douchet (the lover), Jean-Claude Brialy, Christian Brocard, Bouchon, Marius Laurey, Luc Andrieux, Jacques Monod, and the children: Daniel Couturier, François Nocher, Renaud Fontanarosa, Michel Girard, Serge Moati, Bernard Abbou, Jean-François Bergouignan, Michel Lesignor.

Paris at the end of the 1950s. Antoine Doinel is fourteen. He has problems with his teacher, who punishes him for writing on the walls. Things aren't much better at home: his mother, tough and strict, and his stepfather, carefree, don't get along and can't decide what to do with him during the holidays. Having not completed his punishment, he plays truant with his pal René. On the street he catches his mother in the arms of her lover. He can go home, but the next day, without a written excuse to explain his absence, he tells the teacher that his mother has died. The lie is discovered and there's an uproar. He runs away from home and spends the night in a printing plant. Feeling sorry for him, his mother goes to pick him up the next day from school. There is a temporary reconciliation, which is supposed to be sealed by a good grade. Sure of himself, Antoine copies the ending of Balzac's *La Recherche de l'Absolu*, which he admires greatly, for his French composition. As as result, he is expelled from school. Antoine runs away again, hides out at René's place and steals a typewriter from his father's office. But he can't sell it and is caught returning it. He is sent to the Centre for Delinquent Children. He escapes and runs towards the sea.

Tirez sur le pianiste (1960)
Shoot the Pianist

Screenplay and adaptation: François Truffaut and Marcel Moussy. *Dialogue:* François Truffaut, based on the novel *Down There* by David Goodis. *Music:* Georges Delerue. *Songs:* 'Framboise' by Boby Lapointe, performed by the author, 'Dialogue d'amoureux' by Félix Leclerc, sung by the author and Lucienne Vernay. *Director of photography:* Raoul Coutard. *Assistant Cameramen:* Claude Beausoleil, Raymond Cauchetier, Jean-Louis Malige. *Assistant directors:* Francis Cognany, Robert Bober. *Script supervisor:* Suzanne Schiffman. *Sound engineer:* Jacques Gallois. *Boom man:* Jean Philippe. *Production design:* Jacques Mély. *Still photographer:* Robert Lachenay. *Make-up:* Jacqueline Pipart. *Editing:* Cécile Decugis, then Claudine Bouché, assisted by Michèle de Possel. *Producer:* Pierre Braunberger. *Production manager:* Roger Fleytoux. *General production manager:* Serge Kormor. *Production secretary:* Luce Deuss. *Production:* Les

Films de la Pléiade. *First version of screenplay:* July 1959. *Filming dates:* 30 November 1959 to 22 January 1960. *Filmed in:* Paris, Levallois, around Grenoble. *Format:* Dyaliscope. 35 mm black and white film. *Running time:* 85 minutes. *Visa de contrôle:* n° 22836 of 27 January 1967. *Release date:* 25 November 1960. *Distributor:* Cocinor. *Awards:* Prix de la Nouvelle Critique, German Award for Best Photography. *Cast:* Charles Aznavour (Charlie Kohler), Marie Dubois (Léna), Nicole Berger (Thérésa), Michèle Mercier (Clarisse), Catherine Lutz (Mammy), Albert Rémy (Chico), Claude Mansard (Momo), Daniel Boulanger (Ernest), Serge Davri (Plyne), Jean-Jacques Aslanian (Richard), Alex Joffé (the passer-by), Boby Lapointe (the singer), Claude Heymann (the impresario), Richard Kanayan (little Fido), Alice Sapritch (the concierge).

Charlie Kohler is a pianist in a bistro. Some gangsters have a bone to pick with his brothers, one of whom, Chico, takes refuge at the bistro one night when he is being chased. Léna the waitress is in love with Charlie. She knows that his real name is Édouard Saroyan, that he is a famous virtuoso pianist and that he was once married. His wife was also a waitress in a bar where he met her. One day she told him that she paid for his success by having an affair with his manager, then she committed suicide by jumping out of a window. Édouard, washed up, became Charlie the little piano player. Léna wants to help him become what he was once again. They go to tell Plyne, the owner of the bistro, that they're quitting. But things go badly: Léna insults Plyne, he provokes Charlie, who kills him in self-defence. Charlie's little brother Fido, whom he lives with, has been kidnapped by the gangsters. Charlie and Léna flee along snowbound roads to the mountains and the little chalet where the other brothers are lying in wait for the gangsters. The gangsters arrive. Gunshots. Léna is mortally wounded. Her body slides through the snow. Charlie takes his place at the bistro once again.

Jules et Jim (1962)
Jules and Jim

Screenplay, adaptation and dialogue: François Truffaut and Jean Gruault, based on the novel *Jules et Jim* by Henri-Pierre Roché. *Narrated by:* Michel Subor. *Music:* Georges Delerue. *Song:* 'Le Tourbillon' by Bassiak (Serge Rezvani), performed by Jeanne Moreau. *Director of photography:* Raoul Coutard. *Assistants/operators:* Claude Beausoleil, Jean-Louis Malige. *Assistant directors:* Georges Pellegrin, Robert Bober, Florence Malraux. *Script supervisor:* Suzanne Schiffman. *Production design:* Fred Capel. *Props:* Raymond Lemoigne. *Still photographer:* Raymond Cauchetier. *Costumes:* Fred Capel. *Make-up and hair:* Simone Knapp. *Editing:* Claudine Bouché. *Head grip:* Bernard Largemains. *Head electrician:* Fernand Coquet. *Executive producer:* Marcel Berbert. *General production manager:* Maurice Urbain. *Production administrator/accountant:* Christian Lentretien. *Production secretary:* Lucette Deuss. *Production:* Les Films du Carrosse, SEDIF. *First version of screenplay:* summer 1960. *Filming:* 10 April to 28 June 1961. *Filmed in:* Paris, Côte d'Azur, Alsace. *Thanks to:* Services

Cinématographiques de l'Armée. *Laboratory:* GTC. *Auditorium:* Studios Marignan. *Format:* Franscope. 35 mm black and white film. *Running time:* 100 minutes. *Visa de contrôle:* n° 23636 of 24 November 1961. *Release date:* 24 January 1962. *Distributor:* Cinédis. *Awards:* Award for Best Direction at the Festival of Mar del Plata, Award for Best Direction at the Festival Acapulco, Cantaclaros Award in Caracas, Prix de l'Académie du cinéma (Étoile de Cristal for the Best French Film and Grand Prize for Best Actress for Jeanne Moreau), Critics Prize at the Festival of Carthage, Danish Oscar 'Bodil 1963' for the Best European Film of the Year, Nostro Argento awarded by the Italian press for Best Film of the Year. *Cast:* Jeanne Moreau (Catherine), Oskar Werner (Jules), Henri Serre (Jim), Marie Dubois (Thérèse), Boris Bassiak (Albert), Danielle Bassiak (Albert's friend), Sabine Haudepin (Sabine), Vanna Urbino (Gilberte), Anny Nelsen (Lucie), Bernard Largemains (Merlin), Dominique Lacarrière (one of the women), Jean-Louis Richard (a customer in the café), Elen Bober (Mathilde), Christiane Wagner.

In Paris in the 1900s, friendship at first sight joins Jules, who is German, and Jim, who is French. They are captivated by a photo of a statue of a woman with a mysterious smile and go to Greece to find it. Back in Paris they meet Catherine, who has the same smile. She loves Jules. With Jim's blessing, she marries him. The war separates them. Jules and Catherine have a little girl, Sabine. Jim visits them in Germany. Catherine is bored with Jules and passes back and forth between Jules and Jim. She begins to love Jim. She wants to have his child, but does not get pregnant, and stays with Jules. Jim has returned to Paris. He is going to marry Gilberte, his old mistress, with whom he can have children. One day Catherine sees him again and invites him to get in a car with her. She drives off the end of a demolished bridge. Their plunge into the river is fatal. Jules, alone, has their bodies cremated.

Antoine et Colette (1962, short)
Antoine and Colette

First episode of *L'Amour à vingt ans*, made up of five episodes by François Truffaut (France), Renzo Rossellini (Italy), Marcel Ophuls (Germany), Andrzej Wajda (Poland), Shintaro Ishihara (Japan). *Original screenplay:* François Truffaut. *Music:* Georges Delerue. *Narrated by:* Henri Serre. *Director of photography:* Raoul Coutard. *Assistant cameraman:* Claude Beausoleil. *Photographic links between episodes:* Henri Cartier-Bresson, filmed by Jean Aurel. *Assistant director:* Georges Pellegrin. *Script supervisor:* Suzanne Schiffman. *Editing:* Claudine Bouché. *Associate producer:* Pierre Roustang. *Production manager:* Philippe Dussart. *Artistic consultant:* Jean de Baroncelli. *Production (French episode):* Ulysse Production, taken over by Les Films du Carrosse. *Filmed in:* Paris. *Laboratory:* CTM and Studios de Marignan. *Format:* CinémaScope. 35 mm black and white film. *Running time of French episode:* 29 minutes (total running time: 120 minutes). *Visa de contrôle:* n° 25237 of 2 March 1971. *Release date:* 22 June 1962. *Distributor:* Twentieth Century Fox. *Cast:* Jean-Pierre Léaud (Antoine Doinel),

Marie-France Pisier (Colette), Patrick Auffay (René Bigey), Rosy Varte (Colette's mother), François Darbon (Colette's stepfather), Jean-François Adam (Albert Tazzi).

Antoine Doinel is now seventeen and works in a record factory. He continues to see René, his buddy in *Les Quatre Cents Coups*. At a concert for young music lovers he notices a girl, Colette, with whom he falls madly in love. He sees her, telephones her, goes to her home and goes so far as to move into an apartment across the street from her building. But she only thinks of him as a friend. One night he has dinner with Colette and her parents. The meal is interrupted by the arrival of the young man who is taking her out. Antoine remains alone with her parents, watching the concert he planned to take Colette to on television…

La Peau douce (1964)
Soft Skin

Original screenplay: François Truffaut and Jean-Louis Richard. *Dialogue:* François Truffaut. *Music:* Georges Delerue, Haydn 'Toy Symphony'. *Director of photography:* Raoul Coutard. *Cameraman:* Claude Beausoleil. *Assistant cameramen:* Georges Liron, Denis Mornet. *Assistant directors:* Jean-François Adam, Claude Othnin-Girard. *Directing intern:* Jean-Pierre Léaud. *Script supervisor:* Suzanne Schiffman. *Props:* Jean-Claude Dolbert. *Still photographer:* Raymond Cauchetier. *Dresser:* René Rouzot. *Make-up:* Nicole Félix. *Editing:* Claudine Bouché, assisted by Lila Biro. *Head grip:* Bernard Largemains. *Chief electrician:* Fernand Coquet. *Executive producer:* Marcel Berbert. *Production manager:* Georges Charlot. *General Production manager:* Gérard Poirot. *Administrator and production accountant:* Christian Lentretien. *Production secretaries:* Lucette Desmouceaux, Yvonne Goldstein. *Production:* Les Films du Carrosse, SEDIF. *First version of screenplay:* summer 1963. *Filming dates:* 21 October to 30 December 1963. *Filmed in:* Paris, Orly, Lisbon. *Laboratory:* LTC. *Auditorium:* Studios Marignan. *Aspect ratio:* 1,66. *Format:* 35 mm black and white film. *Running time:* 116 minutes. *Visa de contrôle:* n° 28067 of 15 May 1964. *Release date:* 20 May 1964. *Distributor:* Athos Films. *Awards:* Danish Oscar 'Bodil 1964' for the Best European Film of the Year. *Cast:* Françoise Dorléac (Nicole), Jean Desailly (Pierre Lachenay), Nelly Benedetti (Franca), Daniel Ceccaldi (Clément), Jean Lanier (Michel), Paule Emanuèle (Odile), Sabine Haudepin (Sabine), Laurence Badie (Ingrid), Gérard Poirot (Franck), Dominique Lacarrière (Dominique the secretary), Carnéro (the organizer in Lisbon), Georges de Givray (Nicole's father), Charles Lavialle (clerk at the Hôtel Michelet), Mme Harlaut (Mme Leloix), Olivia Poli (Mme Bontemps), Catherine Duport (young girl in Reims), Philippe Dumat (manager of the theatre in Reims), Thérésa Renouard (cashier), Maurice Garrel (bookshop), Brigitte Zhendre-Laforest (delivers laundry), Pierre Risch (canon).

Pierre Lachenay, married and father of a little girl, is the editor of a literary magazine. On a trip to Lisbon where he is giving a lecture on Balzac and

money, he has an affair with a stewardess, Nicole. He sees her again in Paris. His relations with his wife, Franca, deteriorate. He takes Nicole to Reims, where he is presenting Marc Allegret's film on André Gide, then, after a busy evening, to an inn in the countryside. His wife suspects him of having an affair; he refuses to admit it. They separate. Pierre asks Nicole to marry him, but she turns him down. They break up at the moment when Franca accidentally finds the photos Pierre took of his mistress, proof that there was someone else in his life after all. In the restaurant where Pierre is having lunch, he tries to telephone his wife to patch things up. She has just left, he is too late. She suddenly appears in the restaurant, takes out a shotgun and fires. Pierre pitches over. A strange smile lights up Franca's face.

Fahrenheit 451 (1966)
Fahrenheit 451

Screenplay: François Truffaut, Jean-Louis Richard. *Additional dialogue:* David Rudkin, Helen Scott, based on the novel *Fahrenheit 451* by Ray Bradbury. *Music:* Bernard Herrmann. *Director of photography:* Nicholas Roeg. *Assistant cameraman:* Alex Thompson. *Personal assistant to François Truffaut:* Suzanne Schiffman. *Assistant director:* Brian Coats. *Script supervisor:* Kay Manders. *Sound engineer:* Bob McPhee. *Boom man:* Gordon McCallum. *Make-up:* Basil Newall, assisted by Paul Rabieger. *Hairdresser:* Joyce James. *Editing:* Thom Noble. *Sound editing:* Norman Wanstall. *Special effects:* Bowie Films Ltd, Rank Films Processing Division and Charles Staffel. *Casting:* Miriam Brickman. *Associate producer:* Michael Delamar. *Associate executive producer:* Jane C Nusbaum. *Production manager:* Ian Lewis. *Production:* Lewis M Allen, Vineyard Films Ltd. *First version of screenplay:* Summer 1962. *Filming:* 12 January to 22 April 1966. *Filmed in:* Pinewood Studios and locations near London. *Format:* Technicolor. 35 mm colour film. *Running time:* 113 minutes. *Visa de contrôle:* n° 32282. *Release date:* 16 September 1966. *Distributor:* Universal. *Awards:* Best Foreign Film Award, Italy. *Cast:* Julie Christie (Linda Montag and Clarisse), Oskar Werner (Montag), Cyril Cusack (the Captain), Anton Driffing (Fabian), Jeremy Spencer (the man with the apple), Anne Bell (Doris), Caroline Hunt (Helen), Gillian Lewis (the television announcer), Anna Ralk (Jackie), Roma Milne (neighbour), Arthur Cox (the first nurse), Éric Mason (the second nurse), Noël Davis (the first TV speaker), Donald Pickering (the second TV speaker), Michael Mindell (student Stoneman), Chris William (student Black), Gilliam Adam (the TV judo teacher), Édouard Kaye (the TV judo teacher), Mark Lester (the first little boy), Kevin Elder (the second little boy), Joan Francis (the woman on the phone in the bar), Tom Watson (sergeant instructor), Bee Duffel (the book woman) and the book people: Alex Scott (The Life of Henri Brulard), Dennis Gilmore (The Martian Chronicles), Fred Cox (Pride), Frank Cox (Prejudice), Michael Balfour (Machiavelli's The Prince), Judith Drinan (Plato's Dialogues), Yvonne Blake (The Jewish Question), John Rae (The Weir of Hermiston), Earl Younger (the nephew of The Weir of Hermiston).

In this country, firemen don't put out fires – they burn books. Reading is banned, and all who engage in it are hunted down. Montag is a fireman. One day he meets a girl, Clarisse, on the Aerotrain. If not for her short hair, she would bear a strange resemblance to his wife, Linda, who spends her time in front of her TV. Clarisse asks him: 'Are you happy?' and makes him doubt himself and his job. With the other firemen he finds the secret library of an old woman. She refuses to leave her home and is burned with her books. Traumatized by the sight, Montag begins reading in secret. The firemen come to arrest Clarisse and her uncle, but she escapes. Montag doesn't know, and the Captain catches him looking for their arrest papers. Linda, who has found his books, denounces him. He is forced to burn down his own house. But he turns the flame-thrower on the Captain, flees and hides in a forest where the book people live, each of whom has learned a book by heart to preserve its memory. He finds Clarisse there and begins learning a book as snow starts to fall, and a dying old man transmits 'his' text to a little boy.

La mariée était en noir (1967)
The Bride Wore Black

Screenplay, adaptation and dialogue: François Truffaut and Jean-Louis Richard, based on the novel *The Bride Wore Black* by William Irish. *Music:* Bernard Herrmann. *Musical direction:* André Girard. *Director of photography:* Raoul Coutard. *Assistants/operators:* Georges Liron, Jean Garcenot. *Assistant directors:* Jean Chayrou, Roland Thénot. *Script supervisor:* Suzanne Schiffman. *Script supervision intern:* Christine Pellé. *Sound engineer:* René Levert. *Boom man:* Robert Cambourakis. *Production design:* Pierre Guffroy. *Props:* Jean-Claude Dolbert. *Still photographer:* Marilu Parolini. *Dressers:* Nanda Bellomi, Anna Pradella. *Make-up:* Louise Bonnemaison. *Hairdresser:* Simone Knapp. *Editing:* Claudine Bouché, assisted by Yann Dedet. *Head grip:* Louis Balthazard. *Head electrician:* Fernand Coquet. *Executive producer:* Marcel Berbert. *Production manager:* Georges Charlot. *General production manager:* Pierre Cottance, assisted by Yvonne Eblagon. *Production administrator:* Christian Lentretien. *Production secretary:* Lucette de Givray. *Location manager:* Jean Nocereau. *Production:* Les Films du Carrosse – Les Productions Artistes Associés (Paris) – Dino de Laurentiis Cinematografica (Rome). *First version of screenplay:* Summer 1965. *Filming dates:* 16 May to 10 November 1967. *Filmed in:* Cannes, Paris and vicinity, Grenoble. *Laboratory:* LTC., Cinétitres. *Aspect ratio:* 1,66. *Format:* Eastmancolor. 35 mm colour film. *Running time:* 107 minutes. *Credits:* F L Fouchet. *Visa de contrôle:* n° 33254 of 5 January 1968. *Release date:* 17 April 1968. *Distributor:* Les Artistes Associés. *Awards:* Award of the Hollywood Foreign Press Association. *Cast:* Jeanne Moreau (Julie Kohler), Claude Rich (Bliss), Jean-Claude Brialy (Corey), Michel Bouquet (Coral), Michel Lonsdale (Morane), Charles Denner (Fergus), Daniel Boulanger (Delvaux), Serge Rousseau (David), Christophe Bruno (Cookie), Alexandra Stewart (Mlle Becker), Jacques Robiolles (Charlie), Luce Fabiole (Julie's mother), Sylvie Delannoy (Mme Morane), Jacqueline Raillard (chambermaid), Van Doude (inspector), Paul Pavel (mechanic), Gilles Quéant (the examining magistrate), Frédérique and Renaud Fontanarosa (musicians), Élisabeth Rey (Julie as a child), Jean-Pierre Rey (David as a child), Dominique Robier (Sabine, Julie's niece), Michèle Viborel (Gilberte, Bliss's fiancée), Michèle Monfort (one of Fergus's models), Daniel Pommereulle (a friend of Fergus).

After a suicide attempt, Julie Kohler enters several mens' lives: Bliss, a seducer whom she pushes off his balcony on the day of his engagement party; Coral, a bachelor she poisons after seducing him; Morane, a politician she shuts in a closet, where he dies of suffocation. These men and two others were part of a group of friends who shared a passion for hunting and firearms. On the day of a wedding, as the wedding party was leaving the church, one of them aimed a rifle at the groom for fun and accidentally killed him. The man had just married Julie and was the love of her life. These are the men she encounters one by one. Delvaux is a crook, whom the police arrest, putting him out of the reach of Julie's vengeance. Lastly there is Fergus, a painter who falls in love with her. She poses for him as Diana the huntress, shoots an arrow and kills him. Attending his funeral she lets herself be caught in order to get at Delvaux in prison. She gets herself a job in the kitchen, following the cart that brings the prisoners their food. She hides a knife under a towel, and stabs him in his cell.

Baisers volés (1968)
Stolen Kisses

Original screenplay: François Truffaut, Claude de Givray, Bernard Revon. *Music:* Antoine Duhamel. *Song:* 'Que reste-t-il of nos amours?' by Charles Trenet performed by the author. *Director of photography:* Denys Clerval. *Operator:* Jean Chiabaut. *Assistants/ operators:* Jacques Assuérus, Jacques Labesse. *First assistant director:* Jean-José Richer. *Second assistant:* Alain Deschamps. *Script supervisor:* Suzanne Schiffman. *Script supervision intern:* Christine Pellé. *Sound engineer:* René Levert. *Boom man:* Robert Cambourakis. *Production design:* Claude Pignot. *Props:* Jean-Claude Dolbert. *Still photographer:* Raymond Cauchetier. *Make-up:* Nicole Félix. *Editing:* Agnès Guillemot, assisted by Yann Dedet. *Head grip:* Louis Balthazard. *Head electrician:* Claude Rouxel. *Executive producer:* Marcel Berbert. *General production manager:* Roland Thénot, assisted by Daniel Messère. *Production administrator:* Christian Lentretien. *Location manager:* Boussaroques. *Production:* Les Films du Carrosse – Les Productions Artistes Associés. *First version of screenplay:* 1966. *Filming dates:* 5 February to 28 March 1968. *Filmed in:* Paris. *Thanks to:* Dubly Private Detective Agency, Paris. *Laboratory:* LTC. *Format:* Eastmancolor. 35 mm colour film. *Running time:* 90 minutes. *Visa de contrôle:* n° 33 531 of 11 September 1968. *Release date:* 6 September 1968. *Distributor:* Les Artistes Associés. This film is dedicated to the Cinémathèque of Henri Langlois. *Awards:* Grand Prix du cinéma français, Prix Méliès, Prix Fémina Belgium, Prix Louis Delluc, Best French Actor Award for Jean-Pierre Léaud, British Film Institute Award, Award of Hollywood Foreign Association, chosen to

represent France at the Oscars. *Cast:* Jean-Pierre Léaud (Antoine Doinel), Claude Jade (Christine), Daniel Ceccaldi (M Darbon), Claire Duhamel (Mme Darbon), Delphine Seyrig (Fabienne Tàbard), Michael Lonsdale (M Tàbard), André Falcon (M Blady), Harry Max (M Henri), Catherine Lutz (Mme Catherine), Christine Pellé (secretary), Marie-France Pisier (Colette Tazzi), Jacques Robiolles (the unemployed man on television), Serge Rousseau (the stranger), François Darbon (the chef-adjutant), Paul Pavel (Julien), Simono (M Albani), Jacques Delord (the prestidigitator), Jacques Rispal (M Colin), Martine Brochard (M Colin's wife), Robert Cambourakis (Mme Colin's lover) and at the Darbon Garage: Marcel Mercier and Joseph Mériau.

Antoine Doinel is 24 and in a military prison, but is soon discharged because of mental instability. He dines with the parents of Christine Darbon, the young girl he's in love with. They get him a job as a night watchman in a hotel, but he is fired for letting a private detective enter the room of an adulterous couple. This leads to him getting a job at a detective agency. He continues to see Christine, who is being followed by a disturbing stranger. When Antoine is hired to work in a shoe shop whose owner wants to know why no one likes him, he falls in love with the boss's wife, a vision of a woman to whom he sends a romantic message. She spends a moment with him on the condition that he does not see her again. His adventure discovered, Antoine is fired by the agency and becomes a TV repairman. Taking advantage of her parents' absence, Christine breaks the family TV and calls for Antoine's services. They are reunited and walk off together, after the stranger who has been following Christine has declared his 'definitive' feelings for her.

La Sirène du Mississippi (1969)
Mississippi Mermaid

Screenplay, adaptation and dialogue: François Truffaut, based on the novel *Waltz into Darkness* by William Irish. *Music:* Antoine Duhamel. *Director of photography:* Denys Clerval. *Operator:* Jean Chiabaut. *Assistants/operators:* Jacques Assuérus, Jacques Labesse. *First assistant director:* Jean-José Richer. *Second assistant:* Jean-François Détré. *Directing intern:* Jean-François Stévenin. *Script supervisor:* Suzanne Schiffman. *Sound engineer:* René Levert. *Boom man:* Robert Cambourakis. *Production design:* Claude Pignot, assisted by Jean-Pierre Kohut-Svelko. *Props:* Jean-Claude Dolbert. *Still photographer:* Léonard de Raemy. *Dressers:* Jacqueline Pauvel, Christiane Fageol, Paulette Breil. *Make-up:* Michel Deruelle, assisted by Jean-Pierre Eychenne and Jacqueline Anatole. *Editing:* Agnès Guillemot, assisted by Yann Dedet. *Mixing:* Guy Chichignoud. *Head grip:* Louis Balthazard. *Head electrician:* Claude Rouxel. *Executive producer:* Marcel Berbert. *Production manager:* Claude Miller. *General production manager:* Roland Thénot, assisted by François Menny. *Production administrator:* Christian Lentretien. *Production secretary:* Christine Pellé. *Production:* Les Films du Carrosse – Les Productions Artistes Associés (Paris) – Produzioni Associate Delphos (Rome). *First version of screenplay:* May end of 1966. *Filming:*

2 February to 7 May 1961. *Filmed in:* Réunion, Nîce, Aix-en-Provence, Grenoble, Lyon and Paris. *Laboratory:* LTC. *Format:* Eastmancolor Dyaliscope. 35 mm colour film. *Running time:* 120 minutes. *Credits:* CTR. *Visa de contrôle:* n° 34499 of 18 June 1969. *Release date:* 18 September 1969. *Distributor:* Les Artistes Associés. This film is dedicated to Jean Renoir. *Cast:* Catherine Deneuve (Marion), Jean-Paul Belmondo (Louis Mahé), Michel Bouquet (Comolli) Nelly Borgeaud (Berthe Roussel, and in the photo, Julie Roussel), Marcel Berbert (Jardine), Roland Thénot (Richard).

Louis Mahé owns a cigarette factory on Réunion. He finds a wife through the personal ads, but doesn't yet know his bride-to-be, Julie Roussel, when she gets off the boat. He doesn't recognize her: she scarcely resembles the photo he received. She pretends that she didn't want him to marry her for her beauty, so sent him a portrait of someone else. They get married, but Julie soon disappears with Louis's fortune. She is not the real Julie, but assumed her identy after killing her on the boat. Her real name is Marion. Louis hires a detective to find her and returns to France. One day he sees her on television: she's a hostess in a nightclub. He finds her, intending to kill her, but her confession touches him, and they leave together and hide out in a villa in Provence. He becomes her accomplice and kills Comolli, who threatened their happiness. They flee to Lyon, and he returns to Réunion to sell his factory and returns with the money. Hunted by the police, they have to flee again, and hide out in a little chalet in the mountains. She tries to poison him. Louis realizes what she's doing, and Marion, overcome by remorse, feels love growing in her. They flee together in the snow.

L'Enfant sauvage (1970)
The Wild Child

Screenplay, adaptation and dialogue: François Truffaut and Jean Gruault, based on *Mémoire and Rapport sur Victor de l'Aveyron* by Jean Itard (1806). *Music:* Antonio Vivaldi. *Musical direction:* Antoine Duhamel. *Flautino:* Michel Sanvoisin. *Mandolin:* André Saint-Clivier. *Director of photography:* Nestor Almendros. *Operator:* Philippe Théaudière. *Assistant cameraman:* Jean-Claude Rivière. *First assistant director:* Suzanne Schiffman. *Second assistant:* Jean-François Stévenin. *Script supervisor:* Christine Pellé. *Sound engineer:* René Levert. *Boom man:* Robert Cambourakis. *Production design:* Jean Mandaroux, assisted by Jean-Pierre Kohut-Svelko. *Props:* Jean-Claude Dolbert. *Still photographer:* Pierre Zucca. *Costumes:* Gitt Magrini. *Make-up:* Nicole Félix. *Editing:* Agnès Guillemot, assisted by Yann Dedet. *Mixing:* Alex Pront. *Head grip:* Louis Balthazard. *Head electrician:* Jean-Claude Gasché. *Executive producer:* Marcel Berbert. *Production manager:* Claude Miller. *General production manager:* Roland Thénot, assisted by Armand Barbault. *Production:* Les Films du Carrosse – Les Productions Artistes Associés. *First version of screenplay:* spring 1965. *Filming dates:* July to September 1969. *Filmed in:* Auvergne, Paris. *Laboratory:* LTC. *Auditorium:* SIS. *Aspect ratio:* 1,33. *Format:* 35 mm black and white film. *Running time:* 83 minutes. *Visa de contrôle:* n° 30081 of 13 February 1970. *Release date:* 26

February 1970. *Distributor:* Les Artistes Associés. This film is dedicated to Jean-Pierre Léaud. *Awards:* Palme d'Or at the Festival of Valladolid. Christopher Award (USA). Prix Fémina Belge, National Catholic Award (USA). *Cast:* Jean-Pierre Cargol (Victor of Aveyron), François Truffaut (Dr Jean Itard), Françoise Seigner (Mme Guérin), Jean Dasté (Philippe Pinel), Paul Villié (old Rémy), Pierre Fabre (nurse), Claude Miller (M Lémeri), Annie Miller (Mme Lémeri), Nathan Miller (the Lémeri baby), Mathieu Schiffman (Mathieu), René Levert (the commissioner), Jean Mandaroux (Jean Itard's doctor), Jean Gruault (one of the visitors to the Institute), Robert Cambourakis, Gitt Magrini, Jean-François Stévenin (peasants in the chicken-stealing scene) and the children on the farm: Laura and Eva Truffaut, Guillaume Schiffman, Frédérique and Éric Dolbert, Tounet Cargol, Dominique Levert, Melle Théaudière.

In 1798, peasants capture a child in the forest of Aveyron who has been living in a savage state for several years. He can't walk, speak, read or write. He is transferred to the police station at Rodez, then to the Institute for the Deaf and Dumb in Paris, where Dr Jean Itard becomes interested in him. Against the advice of his colleague Pinel, who thinks the savage is incurable, Itard takes charge of him with his housekeeper Madame Guérin. Itard undertakes to educate him, inventing procedures to teach him gestures and customs, language and speech. The child, who is particularly sensitive to the sound 'O', is named Victor. He runs away, but returns to Itard, with whom he has formed a quasi-filial bond. His education will continue.

Domicile conjugal (1970)
Bed and Board

Screenplay: François Truffaut, Claude de Givray, Bernard Revon. *Music:* Antoine Duhamel. *Director of photography:* Nestor Almendros. *Operator:* Emmanuel Machuel. *Assistant cameraman:* Jean-Claude Rivière. *First assistant director:* Suzanne Schiffman. *Second assistant:* Jean-François Stévenin. *Directing intern:* Jérôme Richard. *Script supervisor:* Christine Pellé. *Sound engineer:* René Levert. *Boom man:* Robert Cambourakis. *Production design:* Jean Mandaroux, assisted by Jean-Pierre Kohut-Svelko. *Props:* Jean-Claude Dolbert. *Still photographer:* Pierre Zucca. *Costumes:* Françoise Tournafond. *Make-up:* Nicole Félix. *Editing:* Agnès Guillemot, assisted by Yann Dedet. *Editing intern:* Martine Kalfon. *Head grip:* Louis Balthazard. *Head electrician:* Jean-Claude Gasché. *Executive producer:* Marcel Berbert. *Production manager:* Claude Miller. *General production manager:* Roland Thénot. *Production administrator:* Christian Lentretien. *Production secretary:* Lucette Desmouceaux. *Production:* Les Films du Carrosse, Valoria Films (Paris), Fida Cinematografica (Rome). *First version of screenplay:* end of 1968. *Filming:* 21 January to 18 March 1970. *Filmed in:* Paris. *Laboratory:* LTC. *Format:* Eastmancolor. 35 mm colour film. *Running time:* 100 minutes. *Visa de contrôle:* n° 35872 of 30 July 1970. *Release date:* 9 September 1970. *Distributor:* Valoria Films. *Publicist:* Christine Brierre. *Cast:* Jean-Pierre Léaud (Antoine Doinel), Claude Jade (Christine Doinel),

Daniel Ceccaldi (Lucien Darbon), Claire Duhamel (Mme Darbon), Hiroko Berghauer (Kyoko), Barbara Laage (Monique), Sylvana Blasi (tenor's wife), Daniel Boulanger (the tenor), Claude Véga (the strangler), Bill Kearns (the American boss), Yvon Lec (the meter maid), Jacques Jouanneau (Césarin), Pierre Maguelon (a client of the bistrot), Danièle Girard (the waitress at the bistrot), Marie Irakane (the concierge), Ernest Menzer (the little man), Jacques Rispal (the recluse), Guy Piérauld (the pal at SOS), Marcel Mercier and Joseph Mériau (people in the courtyard), Pierre Fabre (the sniggerer), Christian de Tilière (the guy with influence), Marcel Berbert, Nicole Félix and Jérôme Richard (employees of the US company), Marianne Piketti (the little violinist), Annick Asty (the little violinist's mother), Jacques Robiolles (the cadger), Ada Lonati (Mme Claude), Nobuko Maki (Kyoko's friend), Iska Khan (Kyoko's father), Ryu Nakamura (the Japanese secretary), Jacques Cottin (Monsieur Hulot), Marie Dedieu (Marie), little Christophe Vesque, Melle Irakane, Frédérique Dolbert and Mlle Barbault (the newborn Alphonse Doinel).

Antoine Doinel is 26, and married to Christine Darbon. He dyes flowers in the courtyard of their building while she gives violin lessons. Their neighbours include an opera singer and his wife, a voluntary recluse, a waitress in love and a mysterious man known as 'the strangler'. A peculiar fellow periodically accosts Antoine in the street to borrow a few francs. Antoine's floral experiments are not very successful, so he has to change jobs. Mistaken for someone else, he is hired by a US hydraulics business where he pilots model ships. One day he guesses that Christine is expecting a child. Wild with joy, Antoine Doinel becomes the father of a little boy, Alphonse. At his new job he meets a Japanese girl, Kyoko, with whom he has an affair. She sends him little love notes in a bouquet of flowers, which Christine discovers. Sparks fly, and after a dinner with Christine's parents where they feign harmony, it's all over. Antoine leaves, slamming the door behind him. He is preoccupied by the autobiographical novel he's writing. His liaison with Kyoko founders, and, from the restaurant where they're having dinner, he telephones Christine three times in the same evening and gets back together with her.

Les Deux Anglaises et le continent (1971) *Two English Girls*
Screenplay, adaptation and dialogue: François Truffaut, Jean Gruault, based on *Les deux Anglaises et le Continent* by Henri-Pierre Roché. *Music:* Georges Delerue. *Narrated by:* François Truffaut. *Director of photography:* Nestor Almendros. *Operator:* Jean-Claude Rivière. *Assistant cameraman:* Yves Lafaye. *First assistant director:* Suzanne Schiffman. *Second assistant:* Olivier Mergault. *Script supervisor:* Christine Pellé. *Sound engineer:* René Levert. *Boom man:* Robert Cambourakis. *Production design:* Michel de Broin, assisted by Jean-Pierre Kohut-Svelko. *Props:* Jean-Claude Dolbert. *Still photographer:* Pierre Zucca. *Costumes:* Gitt Magrini, assisted by Pierangelo Cicoletti (Tirelli, Rome). *Dresser:* Paulette Dolbert. *Make-up:* Marie-Louise Gillet. *Hairdresser:* Simone Knapp. *Editing:* Yann

Dedet, assisted by Martine Barraqué. *Head grip:* Louis Balthazard, assisted by Marcel Mercier, Joseph Mériau. *Head electrician:* Jean-Claude Gasché, assisted by Georges and Serge Boirond. *Executive producer:* Marcel Berbert. *Production manager:* Claude Miller. *General production manager:* Roland Thénot, assisted by Philippe Lièvre. *Production administrator:* Christian Lentretien. *Production secretary:* Dominique Birolini. *Production:* Les Films du Carrosse, Cinétel. *First version of screenplay:* spring 1968. *Filming:* 20 April to 9 July 1971. *Filmed in:* Contentin peninsula, Paris, Vivarais, Jura. *Laboratory:* LTC. *Auditorium:* SIS. *Aspect ratio:* 1,66. *Format:* Eastmancolor. 35 mm colour film. *Running time:* 132 minutes. *Visa de contrôle:* n° 38400 of 18 November 1971. *Release date:* 26 November 1971. *Distributor:* Valoria Films. *Publicist:* Christine Brierre. The film was cut by 20 minutes when it was first released under the title *Les Deux Anglaises et le continent*. An uncut version now exists, the final edit of which was prepared by Martine Barraqué in collaboration with François Truffaut in 1984. *Awards:* Épi d'Or at the Festival of Valladolid, Award of the Circle of Spanish Screenwriters. *Cast:* Jean-Pierre Léaud (Claude Roc), Kika Markham (Anne), Stacey Tendeter (Muriel), Sylvia Marriott (Mrs Brown), Marie Mansart (Claire Roc), Philippe Léotard (Diurka), Irène Tunc (Ruta, painter and photographer), Annie Miller (Monique of Montferrand), Jane Lobre (the concierge), Marie Irakane (the maid of Claire and Claude Roc), Georges Delerue (businessman), Marcel Berbert (owner of the art gallery), David Markham (the palmist), Jean-Claude Dolbert (the policeman), Christine Pellé (the secretary), Anne Levaslot (Muriel as a child), Sophie Jeanne (her friend Clarisse), René Gaillard (the taxi driver), Sophie Baker (the friend at the café), Laura and Eva Truffaut, Mathieu and Guillaume Schiffman (the children around the swing), Mark Peterson (Mr Flint).

In Paris at the turn of the century Claude Roc meets Anne Brown, a young Englishwoman who, playing matchmaker, invites him to Wales to meet her sister Muriel. The planned love at first sight doesn't happen, but little by little Claude grows to love Muriel, and asks her to marry him. She says no, but leaves him hope. But her mother and Claude's impose a separation of one year. Claude returns to Paris, busies himself with paintings and art criticism, meets other women and finally sends Muriel a letter breaking it off that plunges her into depression. Anne comes to Paris to study sculpture and becomes the mistress of Claude, then of a Slav, Diurka, who publishes art books. Muriel, never expecting to see him again, sends Claude part of her journal where she confesses to her experience of masturbation. Claude's mother dies. Anne reappears and tells Claude that Muriel is in Paris. They have one long kiss. Anne tells her sister that Claude has been her lover, Muriel collapses. Now Claude sinks into despair, then recovers by writing his first novel, which is autobiographical. The book is published by Diurka, who goes to Wales to see Anne again and ask her to marry him, but she is dying. Diurka returns to Paris and tells Claude about Anne's death. A few years later Claude meets Muriel getting off the boat in Calais. They spend the

night together. She believes she is expecting his child, but is disappointed. Epilogue: Madame Brown is dead, Muriel is married and has a child. Perhaps she is one of the English schoolgirls visiting the Rodin Museum at the same time as Claude, who feels he has grown old.

Une belle fille comme moi (1972) *Such a Gorgeous Kid like Me*
Screenplay, adaptation and dialogue: François Truffaut, Jean-Loup Dabadie, based on the novel *Such a Gorgeous Kid Like Me* by Henry Farrell. *Music:* Georges Delerue. *Director of photography:* Pierre-William Glenn. *Operator:* Walter Bal. *Assistant cameraman:* Anne Khripounoff. *First assistant director:* Suzanne Schiffman. *Second assistant:* Bernard Cohn. *Script supervisor:* Christine Pellé. *Sound engineer:* René Levert. *Production design:* Jean-Pierre Kohut-Svelko, assisted by Jean-François Stévenin. *Props and special effects:* Jean-Claude Dolbert. *Still photographer:* Pierre Zucca. *Costumes:* Monique Dury. *Make-up:* Thi Loan N'Guyen. *Editing:* Yann Dedet, assisted by Martine Barraqué. *Mixing:* Studios de Billancourt. *Head grip:* Louis Balthazard. *Head electrician:* Jean-Claude Gasché. *Associate producer:* Claude Ganz. *Executive producer:* Marcel Berbert. *Production manager:* Claude Miller. *General production manager:* Roland Thénot. *Production administrator:* Christian Lentretien. *Production:* Les Films du Carrosse, Columbia Film SA. *First version of screenplay:* spring 1971. *Filming:* 14 February to 12 April 1972. *Filmed in:* Béziers and Lunel. *Laboratory:* LTC. *Aspect ratio:* 1,33. *Format:* Eastmancolor Panavision. 35 mm colour film. *Running time:* 98 minutes. *Credits:* CTR. Michel François. *Visa de contrôle:* n° 39309 of 30 August 1972. *Release date:* 13 September 1972. *Distributor:* Columbia Films. *Publicist:* Christine Brierre. *Songs:* 'Sam's Song', music by Guy Marchand, words by Jean-Loup Dabadie. 'Une belle fille comme moi', music by Jacques Datin, words by Jean-Loup Dabadie. 'J'attendrai' by Dino Olivieri and Nino Rastelli. *Cast:* Bernadette Lafont (Camille Bliss), Claude Brasseur (Maître Murène, the lawyer), Charles Denner (Arthur, the exterminator), Guy Marchand (Sam Golden, the singer), André Dussollier (Stanislas Prévine, the sociologist), Philippe Léotard (Clovis Bliss, the husband), Anne Kreis (Hélène, the secretary), Gilberte Géniat (Isobel Bliss, the mother-in-law), Danièle Girard (Florence Golden, the wife), Martine Ferrière (the prison secretary), Michel Delahaye (Maître Marchal, the loyal friend), Annick Fougerie (the teacher), Gaston Ouvrard (the old prison guard), Jacob Weizbluth (Alphonse, the mute).

Stanislas Prévine, a young sociologist, is writing a thesis on criminal women. In prison he meets Camille Bliss, a young woman fallen into dissolute ways, and records the story of her life on tape. As a child she provokes the death of her father, a drunk. She is sent to a Centre for the Observation of Delinquent Minors, but escapes and is picked up hitch-hiking by Clovis, a yokel whose wife she becomes. Clovis's mother has hidden a treasure in the cellar that they only find part of, and Camille seeks refuge in the arms of Sam Golden, a singer.

Crazed with jealousy, Clovis tries to take her back, but is run over by a car and ends up in a wheelchair. Camille meets Arthur, a pest control officer, Catholic and a virgin, as well as a crooked lawyer who takes advantage of her by making her sign compromising papers, a record of adultery that Sam Golden's wife can use against him. Her back to the wall, Camille tries to get rid of Clovis and the lawyer. But Arthur saves them and, horrified at her cold-bloodedness, decides to commit suicide with her by jumping off a bell-tower. Instead, he jumps alone and Camille is accused of murdering him, which is why she is in prison. Stanislas, an amateur detective, seeks and finds a home movie taken by an amateur film-maker of the event, proving that Arthur committed suicide, that Camille didn't push him. She is freed and begins a singing career, while Stanislas, who Camille has managed to get accused of Clovis's murder in her place, rots in turn behind bars.

La Nuit américaine (1973)
Day for Night

Original screenplay, dialogue: François Truffaut, Jean-Louis Richard, Suzanne Schiffman. *Music:* Georges Delerue. *Director of photography:* Pierre-William Glenn. *Operator:* Walter Bal. *Assistants/operators:* Dominique Chapuis, Jean-Francis Gondre. *First assistant director:* Suzanne Schiffman. *Second assistant:* Jean-François Stévenin. *Script supervisor:* Christine Pellé. *Sound engineer:* René Levert. *Boom man:* Harrik Maury. *Production design:* Damien Lanfranchi. *Still photographer:* Pierre Zucca. *Costumes:* Monique Dury. *Make-up:* Fernande Hugi, assisted by Thi Loan N'Guyen. *Hairdresser:* Malou Rossignol. *Editing:* Yann Dedet, assisted by Martine Barraqué. *Mixing:* Antoine Bonfanti. *Head electrician:* Jean-Claude Gasché. *Executive producer:* Marcel Berbert. *Production manager:* Claude Miller. *General production manager:* Roland Thénot, assisted by Alex Maineri. *Production administrator:* Christian Lentretien. *Production:* Les Films du Carrosse, PECF. (Paris), PIC. (Rome). *First version of screenplay:* spring 1971. *Filming:* 25 September to 15 November 1972. *Filmed in:* Studios de la Victorine, Nîce. *Laboratory:* GTC. *Auditorium:* Paris Studios Cinéma. *Aspect ratio:* 1,66. *Format:* Eastmancolor, Spheric Panavision. 35 mm colour film. *Running time:* 115 minutes. *Optical effects and credits:* CTR. Michel François. *Visa de contrôle:* n° 39253 of 3 May 1973. *Release date:* 24 May 1973. *Distributor:* Warner Bros. *Publicist:* Christine Brierre. This film is dedicated to Dorothy and Lillian Gish. *Awards:* Oscar for Best Foreign Film. Shown out of competition at the Festival of Cannes on 14 May 1973. *Cast:* François Truffaut (Ferrand, the director), Jacqueline Bisset (Julie Baker/Nelson – Paméla), Valentina Cortese (Séverine), Alexandra Stewart (Stacey), Jean-Pierre Aumont (Alexandre), Jean-Pierre Léaud (Alphonse), Jean Champion (Bertrand, the producer), Nathalie Baye (Joëlle, the script supervisor), Dani (Liliane, the script supervision intern), Bernard Menez (Bernard, props), Nike Arrighi (Odile, make-up), Gaston Joly (Gaston Lajoie, production manager), Maurice Séveno (TV reporter), David Markham (Dr Nelson, Julie's husband), Zénaïde Rossi (wife of the production

manager), Christophe Vesque (little boy with the cane), Henry Graham/Graham Greene and Marcel Berbert (English insurance men), Marc Bayle and Xavier Saint-Macary. Certain technicians, grips and electricians play themselves: Jean-François Stévenin, Pierre Zucca, Yann Dedet, etc.

At the Victorine Studios in Nîce, Ferrand is filming a Hollywood-style film, *Je vous présente Pamela*. He's waiting for the star, Julie Baker, who is due to arrive at the airport with her husband, Dr Nelson, who is older than she. Alphonse, the young actor who will be her on-screen partner, has a tumultuous relationship with Liliane, whom he has hired as script supervising intern. Alexandre, who will play his father, is reunited with Séverine, a former Hollywood star with whom he once had an affair. But things are going badly between Alphonse and Liliane. She leaves with an English stuntman. Alphonse, depressed, locks himself in his room and threatens to quit the production. Julie talks to him and ends up spending the night with him. The next day Alphonse phones Dr Nelson to inform him that he's going to marry Julie. Sick with remorse, Julie plunges into despair, but her husband calms her and gives her back her confidence, so work begins again. Not for long: Alexandre is dead. He was killed in a car accident on the way to the airport. The film has to be finished with a double replacing him for the last five days. It's the end of an era. But right until the end, cinema reigns.

L'Histoire d'Adèle H (1975)
The Story of Adèle H

Original screenplay, dialogue: François Truffaut, Jean Gruault, Suzanne Schiffman, with the collaboration of Frances Vernor Guille, who published *Le Journal d'Adèle Hugo*. *English adaptation:* Jan Dowson. *Music:* Maurice Jaubert (1900–40). *Musical direction:* Patrice Mestral. *Music consultant:* François Porcile. *Saxophone solo:* Jacques Noureddine. *Director of photography:* Nestor Almendros. *Operator:* Jean-Claude Rivière. *Assistants/operators:* Dominique Le Rigoleur, Florent Bazin. *First assistant director:* Suzanne Schiffman. *Second assistant:* Carl Hathwell. *Script supervisor:* Christine Pellé. *Sound engineer:* Jean-Pierre Ruh. *Boom man:* Michel Laurent. *Production design:* Jean-Pierre Kohut-Svelko, assisted by Pierre Gompertz, Geoffroy Larcher. *Props:* Daniel Braunschweig. *Still photographer:* Bernard Prim. *Costumes:* Jacqueline Guyot. *Dresser:* Clémence Lapouyade. *Make-up:* Thi Loan N'Guyen. *Hairdresser:* Chantal Durpoix. *Editing:* Yann Dedet, assisted by Martine Barraqué, Jean Gargonne, Michèle Nény. *Editorial intern:* Muriel Zélény. *Mixing:* Jacques Maumont. *Head grip:* Charles Freess. *Head electrician:* Jean-Claude Gasché. *Executive producer:* Marcel Berbert. *Production manager:* Claude Miller. *General production manager:* Patrick Millet, assisted by Roland Thénot. *Production administrator:* Christian Lentretien. *Production:* Les Films du Carrosse, Les Productions Artistes Associés. *First version of screenplay:* August 1970. *Filming:* 8 January to 21 March 1975. *Filmed in:* Guernsey, Gorée (Senegal). *Thanks to:* Carol McDaid Seib, Air France, British Island Airways. *Laboratory:* LTC. *Auditorium:*

SIMO. *Aspect ratio:* 1,66. *Format:* Eastmancolor spherical Panavision. 35 mm colour film. *Running time:* 96 minutes. *Visa de contrôle:* n° 37630 of 28 July 1975. *Release date:* 8 October 1975. *Distributor:* Les Artistes Associés. *Publicist:* Christine Brierre. *Awards:* Grand Prix du Cinéma Français, Best Original Screenplay (New York Film Critics Society), Best Actress, Isabelle Adjani (New York Film Critics Society). *Cast:* Isabelle Adjani (Adèle Hugo), Bruce Robinson (Lieutenant Pinson), Sylvia Marriott (Mrs Saunders), Reubin Dorey (Mr Saunders), Joseph Blatchley (the bookseller Whistler), Mr White★ (the Colonel), Carl Hathwell★ (Pinson's orderly), Ivry Gitlis★ (the hypnotist), Sir Cecil of Sausmarez★ (Maître Lenoir, notary), Sir Raymond Falla★ (Judge Johnstone), Roger Martin★ (Dr Murdock), Madame Louise★ (Madame Baa), Jean-Pierre Leursse★ (black scribe), Louise Bourdet (Victor Hugo's servant), Clive Gillingham (Keaton, bank employee), François Truffaut (an officer), Ralph Williams (the Canadian), Thi Loan N'Guyen (the Chinese woman), Edward J Jackson (O'Brien), Aurelia Mansion (widow with dogs), David Foote (David, the young boy), Jacques Fréjabue (the cabinet-maker), Chantal Durpoix (young prostitute), Geoffroy Crook (George, Johnstone's valet).
★ making their film debut.

Halifax, 1863: A young woman disembarks and takes lodgings under the name Miss Lewly. She is looking for a young English soldier, Lieutenant Pinson, with whom she is hopelessly in love. But her love is not reciprocated. After sending him a letter he doesn't answer, she finally sees him: he tells her that any hope she has is vain and illusory. She discovers he has a mistress. Thanks to a letter she writes to her parents, we learn that she is Adèle Hugo, the second daughter of the author Victor Hugo. She gets them to give her permission to marry, makes them believe she is married to Pinson and devises numerous stratagems: she sends him a 'girl', tries to enlist the powers of a hypnotist, tries to prevent his marriage by telling his fiancée's father that she's expecting his child. At the same time that she learns of her mother's death, she learns that Lieutenant Pinson's regiment is being sent to Barbados. She follows him, fallen, haggard, mocked by street urchins. A Barbadian woman, Madame Baa, takes her in. Adèle passes Lieutenant Pinson silently in the street one more time. Her eyes pass over him. Madame Baa writes to Victor Hugo suggesting that he take Adèle home to France, where she will die in an asylum in 1915.

L'Argent de poche (1976)
Small Change

First title: Abel et Câlins. *Original screenplay:* François Truffaut, Suzanne Schiffman. *Music:* Maurice Jaubert (1900–40). *Musical direction:* Patrice Mestral. *Music consultant:* François Porcile. *Song:* 'Les enfants s'ennuient le dimanche' by Charles Trenet performed by the author. *Director of photography:* Pierre-William Glenn. *Operator:* Jean-Francis Gondre. *Assistants/operators:* Jean-Claude Vicquery, Florent Bazin. *First assistant director:* Suzanne Schiffman. *Second assistant:* Alain Maline. *Script supervisor:* Christine Pellé. *Sound engineer:*

Michel Laurent. *Boom man:* Michel Brethez. *Production design:* Jean-Pierre Kohut-Svelko, assisted by Pierre Gompertz. *Props:* Michel Grimaud. *Still photographer:* Hélène Jeanbrau. *Costumes:* Monique Dury. *Make-up:* Thi Loan N'Guyen. *Editing:* Yann Dedet, assisted by Martine Barraqué, Jean Gargonne, Stéphanie Granel. *Editorial intern:* Muriel Zéleny. *Mixing:* Jacques Maumont. *Executive producer:* Marcel Berbert. *Production manager:* Roland Thénot. *General production manager:* Daniel Messère. *Production administrator:* Christian Lentretien. *Production:* Les Films du Carrosse, Les Productions Artistes Associés. *First version of screenplay:* 1972 (based on notes from 1957 and 1958). *Filming:* 17 July to 9 September 1975. *Filmed in:* Thiers and vicinity, Clermont-Ferrand, Vichy. *Laboratory:* LTC. *Auditorium:* SIMO. *Aspect ratio:* 1,66. *Format:* Eastmancolor Spherical Panavision. 35 mm colour film. *Running time:* 104 minutes. *Credits:* Jean-Noël Delamare. *Visa de contrôle:* n° 43719 of 3 March 1976. *Release date:* 17 March 1976. *Distributor:* Les Artistes Associés. *Publicist:* Christine Brierre. *Cast:* The children: Grégory Desmouceaux (Patrick Desmouceaux), Philippe Goldmann (Julien Leclou), Claudio and Franck Deluca (Mathieu and Franck Deluca), Richard Golfier (Richard Golfier), Laurent Devlaeminck (Laurent Riffle), Bruno Staab (Bruno Rouillard), Sébastien Marc (Oscar), Sylvie Grézel (Sylvie), Pascale Bruchon (Martine), Corinne Boucart (Corinne), Eva Truffaut (Patricia) and little Grégory. The adults: Francis Devlaeminck (M Riffle, the barber, Laurent's father), Tania Torrens (Nadine Riffle, the hairdresser), Jean-Marie Carayon (the commissioner, Sylvie's father), Kathy Carayon (the commissioner's wife), Paul Heyraud (M Deluca), Christine Pellé (Mme Lèclou, Julien's mother), Jane Lobre (Julien's grandmother), Nicole Félix (Grégory's mother), Virginie Thévenet (Lydie Richet), Jean-François Stévenin (Jean-François Richet, the teacher), René Barnérias (M Desmouceaux, Patrick's father), Christian Lentretien (M Golfer, Richard's father), Laura Truffaut (Madeleine Doinel, Oscar's mother), Jean-Françis Gondre (Oscar's father), Chantal Mercier (Chantal Petit, teacher), Marcel Berbert (director of the school), Vincent Touly (concierge), Yvon Boutina (adult Oscar), Annie Chevaldonné (nurse), Michel Dissart (M Lomar, gendarme).

In Thiers, it's the end of the school year, overseen by the two teachers, Mademoiselle Petit and Jean-François Richet, whose wife is expecting a child. Small and large events happen: Bruno refuses to recite *L'Avare* with feeling, Richard lends his haircut money to two friends, a tiny child with tough skin falls several floors without hurting himself, Sylvie who has missed a meal because of a whim gets lunch from her neighbours, who send it over to her on the end of a rope. Patrick, a boy who lives with his disabled father, is in love with a friend's mother. At the movies we see Oscar, a boy who refuses to speak and communicates by whistling. We learn that Julien is being mistreated and beaten by his family. His mother and grandmother are arrested. 'Monsieur Richet' becomes a father. Soon it's time for the holidays and summer camp, where Patrick and Martine share a first kiss.

L'Homme qui aimait les femmes (1977) *The Man Who Loved Women*

Original screenplay, dialogue: François Truffaut, Michel Fermaud, Suzanne Schiffman. *Music:* Maurice Jaubert (1900–40). *Musical direction:* Patrice Mestral. *Music consultant:* François Porcile. *Director of photography:* Nestor Almendros. *Operator:* Anne Trigaux. *Assistant cameraman:* Florent Bazin. *First assistant director:* Suzanne Schiffman. *Second assistant:* Alain Maline. *Script supervisor:* Christine Pellé. *Sound engineer:* Michel Laurent. *Boom man:* Jean Fontaine. *Production design:* Jean-Pierre Kohut-Svelko, assisted by Pierre Gompertz, Jean-Louis Povéda. *Props:* Michel Grimaud. *Still photographer:* Dominique Le Rigoleur. *Costumes:* Monique Dury. *Dresser:* Nicole Bancel. *Make-up:* Thi Loan N'Guyen. *Editing:* Martine Barraqué, assisted by Michèle Nény, Marie-Aimée Debril. *Editorial intern:* Michel Klochendler. *Mixing:* Jacques Maumont. *Head grip:* Charles Freess, assisted by Jacques Fréjabue, Gérard Bougeant. *Head electrician:* Jean-Claude Gasché, assisted by Serge Valéry, Jean Lopez. *Groupman:* Michel Leclercq. *Executive producer:* Marcel Berbert. *Production manager:* Roland Thénot. *General production manager:* Philippe Lièvre, assisted by Lydie Mahias. *Production administrator:* Christian Lentretien. *Production secretary:* Josiane Couëdel. *Production:* Les Films du Carrosse, Les Productions Artistes Associés. *First version of screenplay:* 1975. *Original title:* Le Cavaleur. *Filming:* 19 October 1976 to 5 January 1977. *Filmed in:* Montpellier and vicinity, Lille. *Laboratory:* LTC. *Auditorium:* SIMO. *Aspect ratio:* 1,66. *Format:* Eastmancolor. 35 mm colour film. *Running time:* 118 minutes. *Credits:* Euro-Titres. *Visa de contrôle:* n° 45350 of 28 March 1977. *Release date:* 27 April 1977. *Distributor:* Les Artistes Associés. *Cast:* Charles Denner (Bertrand Morane), Brigitte Fossey (Geneviève Bigey, editor), Nelly Borgeaud (Delphine Grezel), Geneviève Fontanel (Hélène, lingerie saleslady), Nathalie Baye (Martine Desdoits), Sabine Glaser (Bernadette, employee of Midi Car), Valérie Bonnier (Fabienne, wife at the window), Martine Chassaing (Denise, engineer at the Institute of Fluid Mechanics), Roselyne Puyo (Nicole, cinema usherette), Anna Perrier (Uta, the baby-sitter), Monique Dury (Mme Duteil, typist), Nella Barbier (Liliane, waitress at the karatéka restaurant), Frédérique Jamet (Juliette), Marie-Jeanne Montfajon (Christine Morane, mother of Bertrand), Leslie Caron (Véra, the old flame), Roger Leenhardt (M Bétany, publisher), Henri Agel and Henry-Jean Servat (readers), little Michel Marti (Bertrand as an adolescent), Christian Lentretien (the inspector), Rico Lopez (the clown at the restaurant), Carmen Sardà-Canovas (the laundress), Philippe Lièvre (Bertrand's colleague), Marcel Berbert (surgeon, husband of Delphine), Michel Laurent, Pierre Gomperti, Roland Thénot (Marine officers), Josiane Couëdel (switchboard operator), Valérie Pêcheur (young woman at cemetery in tennis clothes), Anne Bataille (the young woman with the fringed dress), Ghylaine Dumas (second employee of Midi Car), Jean-Louis Povéda (printer), Thi Loan N'Guyen (the Chinese woman), Suzanne Schiffman (woman with baby on Mme Duteil's stairs).

Montpellier, Christmas 1976. A multitude of women attend the funeral of Bertrand Morane. Neither a pick-up artist nor a Don Juan, he had a passion for women and could bear no one else's company after 6 o'clock. In a laundry he notices a woman and pursues her. He only has time to take down her car number plate and finds her after a breathless chase. But he has the wrong woman, and he goes back to the car rental girl, who helped him. He gets to know a woman of around 40, Hélène, owner of a lingerie shop, but she tells him she prefers young boys. After this failure, meditating on his amorous memories, he decides to write a book about them. He is reunited with Delphine, just out of prison, with whom he had a troubled liaison during which she killed her husband. He sees Vera again, the only woman he loved, who hurt him profoundly. But she won't be in the book. He has already sent it to a publisher where Geneviève Bigey, a young literary consultant, has ardently defended his manuscript. Several times, she comes to see him in Montpellier. One night – Christmas is coming – after taking Geneviève to the airport, he sees a woman in the street, tries to cross over to join her, throws himself in the middle of the traffic. A car suddenly appears, there is an accident. At the hospital, he reaches out to touch the legs of his nurse, disconnecting his drip, and dies. The funeral takes place. His book will be published.

La Chambre verte (1978) *The Green Room*

First title: La Disparue. *Screenplay, dialogue:* François Truffaut, Jean Gruault, based on themes by Henry James (three stories: *The Altar of the Dead, The Friends of Friends, The Beast in the Jungle*). *Music:* Maurice Jaubert (1900–40). *Musical direction:* Patrice Mestral. *Music consultant:* François Porcile. *Director of photography:* Nestor Almendros. *Operator:* Anne Trigaux. *Assistant cameraman:* Florent Bazin. *First assistant director:* Suzanne Schiffman. *Second assistant:* Emmanuel Clot. *Script supervisor:* Christine Pellé. *Sound engineer:* Michel Laurent. *Boom man:* Jean-Louis Ughetto. *Production design:* Jean-Pierre Kohut-Svelko, assisted by Pierre Gompertz, Jean-Louis Povéda. *Still photographer:* Dominique Le Rigoleur. *Preliminary photos (Massigny and Davenne's wife):* Guy Gallice. *Costumes:* Monique Dury and Christian Gasc. *Make-up:* Thi Loan N'Guyen. *Editing:* Martine Barraqué, assisted by Jean Gargonne, Michel Klochendler. *Mixing:* Jacques Maumont. *Head grip:* Charles Freess, assisted by Jacques Fréjabue, Gérard Bougeant. *Head electrician:* Jean-Claude Gasché, assisted by Serge Valézy. *Executive producer:* Marcel Berbert. *Production manager:* Roland Thénot, assisted by Geneviève Lefebvre. *Production administrator:* Christian Lentretien. *Production secretary:* Josiane Couëdel. *Production:* Les Films du Carrosse, Les Productions Artistes Associés. *Filming:* 11 October to 25 November 1977. *Filmed in:* Honfleur, Caen Cemetery, Fiquefleur-Équainville. *Thanks to:* Laboratoire d'Entomologie du Muséum d'Histoire Naturelle de Paris. *Laboratory:* LTC. *Auditorium:* SIMO. *Aspect ratio:* 1,66. *Format:* Eastmancolor. 35 mm colour film. *Running time:* 94 minutes. *Opticals and credits:* Euro-Titres. *Visa de contrôle:* n° 43535 of 15 March

1978. *Release date:* 5 April 1978. *Distributor:* Les Artistes Associés. *Publicists:* Simon Mizrahi and Martine Marignac. *Note:* Suzanne Schiffman initially worked on the development of the screenplay. *Cast:* François Truffaut (Julien Davenne), Nathalie Baye (Cécilia Mandel), Jean Dasté (Bernard Humbert, editor-in-chief of the 'Globe'), Jean-Pierre Moulin (Gérard Mazet), Antoine Vitez (Bishop's secretary), Jane Lobre (Mme Rambaud, the housekeeper), Patrick Maléon (little Georges), Jean-Pierre Ducos (the priest in the home of the deceased), Annie Miller (Geneviève Mazet), Nathan Miller (his son), Marie Jaoul (Yvonne Mazet), Monique Dury (Monique, secretary of the 'Globe'), Laurence Ragon (Julie Davenne in photos and as the mannequin), Marcel Berbert (Dr Jardine), Guy d'Ablon (the maker of mannequins), Thi Loan N'Guyen (his apprentice), Christian Lentretien (orator at the cemetery), Henri Bienvenu (Gustave, the usher), Alphonse Simon (one-legged usher of the 'Globe'), Anna Paniez (Anna, the little pianist), Serge Rousseau (Paul Massigny in photos), Carmen Sardà-Canovas (the woman with the rosary), Jean-Claude Gasché (police agent), Martine Barraqué (nurse, auction house), Jean-Pierre Kohut-Svelko (her patient, auction house), Josiane Couëdel (nurse, cemetery), Roland Thénot (her patient, cemetery), Gérard Bougeant (cemetery guard).

Ten years after World War I, in a small town in eastern France, Julien Davenne, contributor to the newspaper *Le Globe*, lives alone with Madame Rambaud, his housekeeper, and Georges, a young deaf-mute boy. Davenne's wife Julie died 11 years ago, a few months after they were married. Deciding that for him, she will always be alive, he consecrates a room in his house, the green room, to her memory. He meets Cécilia, secretary of the auction house where he wants to buy back a ring that belonged to Julie. One day he learns that Paul Massigny, a politician who was his best friend before betraying him, and whom he has despised ever since, is dead. After a storm, a fire ravages the green room and Julien has to find another way to keep Julie close. He has a wax figure of her made, but seeing it shocks him and he demands that it be destroyed. He discovers a ruined chapel that he renovates and consecrates to a cult of the dead and above all, his wife, with a forest of flames where each one has his candle. He chooses Cécilia to be the guardian of the temple and to 'complete the figure'. But he discovers she was Massigny's mistress and refuses to give him his flame on the altar of the dead. They break off all relations; Davenne begins to fade. Shut up at home, sick, he refuses to see a doctor. Cecilia writes to him and declares her love at last. He meets her at the chapel; he has forgiven Massigny. With no strength left, he collapses and dies. Cecilia, completing the figure, lights the candle for Julien Davenne.

L'Amour en fuite (1979)
Love on the Run

Original screenplay, dialogue: François Truffaut, Marie-France Pisier, Jean Aurel, Suzanne Schiffman. *Music:* Georges Delerue. *Song:* 'L'Amour en fuite', words by Alain Souchon,

music by Laurent Voulzy, sung by Alain Souchon. *Director of photography:* Nestor Almendros. *Operator:* Florent Bazin. *Assistant cameraman:* Emilio Pacull-Latorre. *First assistant director:* Suzanne Schiffman. *Second Assistant:* Emmanuel Clot. *Directing intern:* Nathalie Seaver. *Script supervisor:* Christine Pellé. *Sound engineer:* Michel Laurent. *Boom man:* Michel Mellier. *Production design:* Jean-Pierre Kohut-Svelko, assisted by Pierre Gompertz, Jean-Louis Povéda. *Props:* Michel Grimaud. *Still photographer:* Dominique Le Rigoleur. *Costumes:* Monique Dury. *Make-up:* Thi Loan N'Guyen. *Editing:* Martine Barraqué, assisted by Jean Gargonne. *Editorial intern:* Corinne Lapassade. *Mixing:* Jacques Maumont. *Head grip:* Charles Freess, assisted by Jacques Fréjabue, Gérard Bougeant. *Head electrician:* Jean-Claude Gasché, assisted by Serge Valézy. *Groupman:* Michel Leclercq. *Executive producer:* Marcel Berbert. *Production manager:* Roland Thénot. *General production manager:* Geneviève Lefebvre. *Production administrator:* Christian Lentretien. *Production secretary:* Josiane Couëdel. *Production:* Les Films du Carrosse. *First version of screenplay:* end of 1976. *Filming:* 29 May to 5 July 1978. *Filmed at:* Paris. *Laboratory:* LTC. *Auditorium:* SIMO. *Aspect ratio:* 1,66. *Format:* Eastmancolor, Pyral. 35 mm black and white and colour film. *Running time:* 94 minutes. *Opticals and credits:* Euro-Titres. *Visa de contrôle:* n° 48607 of 15 January 1979. *Release date:* 24 January 1979. *Distributor:* AMLF. *Publicists:* Simon Mizrahi and Martine Marignac. *Cast:* Jean-Pierre Léaud (Antoine Doinel), Colette (Marie-France Pisier), Claude Jade (Christine), Dani (Liliane), Dorothée (Sabine), Rosy Varte (Colette's mother), Marie Henriau (divorce judge), Daniel Mesguich (Xavier, the bookseller), Julien Bertheau (M Lucien), Jean-Pierre Ducos (Christine's lawyer), Pierre Dios (Maître Renard), Alain Ollivier (judge in Aix), Monique Dury (Mme Ida), Emmanuel Clot (Emmanuel, friend at the printer), Christian Lentretien (the pick-up artist on the train), Roland Thénot (angry man on telephone), Julien Dubois (Alphonse Doinel), Alexandre Janssen (child in restaurant car).

Antoine Doinel is over 30 and working as a proofreader at a printing works. After five years of marriage, Christine and Antoine get divorced. He is in love with Sabine, a salesgirl in a record store. Colette, the girl from the Young People's Concerts in *L'Amour à vingt ans*, is a lawyer. She is in love with Xavier, a bookseller from whom she buys *Les Salades d'amour*, Antoine's autobiographical novel. Memories return. They meet by chance at the Gare de Lyon, where he has come to see off his son and jumps on her train at the last moment. They remember the past, he tells her about his next novel, which she finds disappointing. He tries to start up with her again; she reprimands him. He pulls the alarm cord and jumps off the train. Sabine is angry that he has run away. He meets his mother's lover, who tells him she was 'a little bird', and they visit her grave. Colette, whose little girl was run over by a car, is nevertheless going to defend a child murderer. She has picked up a photo of a woman that fell out of Antoine's pocket and suspects that she's Xavier's wife, whom he has kept secret. But she is his sister. She seeks out Christine, and the

'veterans of Antoine Doinel' exchange memories. To prove his love to Sabine and be forgiven, Antoine tells how he fell in love with her when he picked up the pieces of a photo an angry man had torn up and how he found her after a long search. She is won over, and they embark on life together, making believe it's for a long time.

Le Dernier Métro (1980)
The Last Metro

Screenplay: François Truffaut, Suzanne Schiffman. *Dialogue:* François Truffaut, Suzanne Schiffman, Jean-Claude Grumberg. *Music:* Georges Delerue. *Director of photography:* Nestor Almendros. *Operator:* Florent Bazin. *Assistants/operators:* Emilio Pacull-Latorre, Tessa Racine. *First assistant director:* Suzanne Schiffman. *Assistant directors:* Emmanuel Clot, Alain Tasma. *Script supervisor:* Christine Pellé. *Sound engineer:* Michel Laurent. *Boom man:* Michel Mellier. *Production design:* Jean-Pierre Kohut-Svelko, assisted by Pierre Gompertz, Jacques Léguillon, Roland Jacob. *Props:* Jacques Preisach. *Still photographer:* Jean-Pierre Fizet. *Costumes:* Lisèle Roos. *Dressers:* Christiane Aumard-Fageol, Edwige Chérel, Françoise Poillot. *Make-up:* Didier Lavergne, Thi Loan N'Guyen, Françoise Ben Soussan. *Hairdresser:* Jean-Pierre Berroyer, Nadine Leroy. *Editing:* Martine Barraqué, assisted by Marie-Aimée Debril. *Editorial intern:* Jean-François Giré. *Mixing:* Jacques Maumont. *Head grip:* Charles Freess, assisted by Jacques Fréjabue, Gérard Bougeant. *Head electrician:* Jean-Claude Gasché, assisted by André Seybald, Serge Valézy. *Production manager:* Jean-José Richer. *General production manager:* Roland Thénot, assisted by Jean-Louis Godfroy. *Production administrator:* Henry Dutrannoy. *Production secretary:* Gervaise Blattmann. *Production:* Les Films du Carrosse, SEDIF, TF1, SFP. *First version of screenplay:* spring 1979. *Filming:* 28 January to 16 April 1980. *Filmed in:* Paris and vicinity. *Laboratory:* LTC. *Auditorium:* Paris Studios Cinéma. *Aspect ratio:* 1,66. *Format:* Fujicolor, Pyral. 35 mm colour film. *Running time:* 128 minutes. *Opticals and credits:* Euro-Titres. *Visa de contrôle:* n° 51161 of 10 September 1980. *Release date:* 17 September 1980. *Distributor:* Gaumont. *Publicists:* Simon Mizrahi and Martine Marignac. *Songs:* 'Bei Mir Bist du Schön' music by Sholom Secunda, words by Cahn-Chaplin, Jacob Jacobs, Jacques Larue; 'Prière à Zumba' by A Lara, Jacques Larue; 'Mon Amant de Saint-Jean' by E Carrara, L Agel; 'Sombreros et Mantilles' by J Vaissade-Chanty; 'Pitié mon Dieu' canticle by A Kunc. *Awards:* 10 Césars, Archange du Cinéma, Foreign Press Awards, Prix Jean Le Duc, one Oscar nomination. The video version is six minutes longer (AAA 1982). *Cast:* Catherine Deneuve (Marion Steiner), Gérard Depardieu (Bernard Granger), Jean Poiret (Jean-Loup Cottins), Heinz Bennent (Lucas Steiner), Andréa Ferréol (Arlette Guillaume), Paulette Dubost (Germaine Fabre), Sabine Haudepin (Nadine Marsac), Jean-Louis Richard (Daxiat), Maurice Risch (Raymond, the production manager), Marcel Berbert (Merlin), Richard Bohringer (Gestapo agent), Jean-Pierre Klein (Christian Léglise), Martine Simonet (Martine the thief) and little Franck Pasquier, Rénata, Jean-José Richer, Laszlo

Zsabo, Hénia Ziv, Jessica Zucman, Alain Tasma, René Dupré, Pierre Belot, Christian Baltauss, Alexandre Aumond, Marie-Dominique Henry, Jacob Weizbluth, Rose Thierry, Philippe Vesque and les Petits Chanteurs de l'Abbaye.

Paris, September 1942. At the théâtre Montmartre a play is in rehearsal. The theatre's director, Lucas Steiner, is Jewish and had to leave France. His wife Marion has taken over. She hires Bernard Granger, a refugee from the Grand Guignol, who courts Arlette, the wardrobe mistress, in vain; she prefers Nadine, a young actress. Jean-Loup Cottins, the director, has to gain the favour of Daxiat, the critic from *Je suis partout*, a threat to the theatre. We learn that Steiner is hidden in the theatre's cellar, waiting to escape to the Free Zone. But the Germans cross the line of demarcation, and he is forced to remain in the cellar, where he listens to rehearsals through a heating vent. The play is a hit. But Daxiat, who has proof that Lucas hasn't left France, attacks the production in his paper. Bernard threatens him, which has no effect but to get Marion angry: she only cares about saving the theatre. She only speaks to Bernard on stage. Daxiat tells Jean-Loup that the theatre no longer legally belongs to anyone and the Germans could requisition it, unless the direction is taken over by someone acceptable to them: him. Marion goes to the Propaganda-Staffel to plead her case. But Dr Dietrich, whom she was to meet, has committed suicide. Bernard watches helplessly as the Gestapo arrests a friend of his. He decides to give up the theatre for the Resistance. The Gestapo comes to inspect the cellar of the theatre, and Bernard helps Marion hide Lucas, whom he finally meets. Marion at last confesses her love for Bernard and he becomes her lover. Another actor assumes his role. At the Liberation, Daxiat flees to Germany, Lucas can come out of hiding, and Bernard returns to the théâtre Montmartre.

La Femme d'à côté (1981)
The Woman Next Door
Original screenplay: François Truffaut, Suzanne Schiffman, Jean Aurel. *Music:* Georges Delerue. *Director of photography:* William Lubtchansky. *Operator:* Caroline Champetier. *Assistant cameraman:* Barcha Bauer. *First assistant director:* Suzanne Schiffman. *Second assistant:* Alain Tasma. *Directing intern:* Gilles Loutfi. *Script supervisor:* Christine Pellé. *Sound engineer:* Michel Laurent. *Boom man:* Michel Mellier. *Production design:* Jean-Pierre Kohut-Svelko, assisted by Pierre Gompertz. *Props:* Jacques Preisach. *Still photographer:* Alain Venisse. *Costumes:* Michèle Cerf. *Dresser:* Malika Brahim. *Make-up:* Thi Loan N'Guyen. *Hairdresser:* Catherine Crassac. *Editing:* Martine Barraqué, assisted by Marie-Aimée Debril. *Editorial intern:* Catherine Drzymalkowski. *Mixing:* Jacques Maumont. *Head grip:* André Atellian, assisted by Michel Gentils. *Head electrician:* Robert Beulens, assisted by Emmanuel Demorgon. *Groupman:* Patrick LeMaire. *Production manager:* Armand Barbault. *General production manager:* Roland Thénot, assisted by Jacques Vidal. *Production manager intern:* Françoise Héberlé. *Production administrator:* Jean-François Lentretien. *Production secretaries:* Josiane Couëdel, Anny Bartanowski.

Production: Les Films du Carrosse, TF1 Films Production. *First version of screenplay:* December 1980. *Filming:* 1 April to 15 May 1981. *Filmed in:* Grenoble and vicinity. *Thanks to:* SOGREAH (Production design place of work, Bernard Coudray). *Laboratory:* LTC. *Auditorium:* Paris Studios Cinéma. *Aspect ratio:* 1,66. *Format:* Fujicolor, Pyral. 35 mm colour film. *Running time:* 106 minutes. *Opticals and credits:* Euro-Titres. *Visa de contrôle:* n° 53588 for 18 September 1981. *Release date:* 30 September 1981. *Distributor:* Gaumont. *Publicists:* Simon Mizrahi and Martine Marignac. *Video distribution:* AAA (1982). *Cast:* Gérard Depardieu (Bernard Coudray), Fanny Ardant (Mathilde Bauchard), Henri Garcin (Philippe Bauchard), Michèle Baumgartner (Arlette Coudray), Véronique Silver (Madame Jouve), Roger Van Hool (Roland Duguet), Philippe Morier-Genoud (the psychoanalyst), Roland Thénot (the estate agent), Jacques Preisach and Catherine Crassac (the couple on the hotel stairs) and little Olivier Becquaert.

Ten years ago, Bernard and Mathilde were in love but separated violently. One day Mathilde, who has since married Philippe Bauchard, comes to live next door to Bernard and his wife, Arlette, and their son. Everyone meets at the tennis club run by Madame Jouve, who once threw herself out a window for love, only to have her fall broken by a glass roof. She serves as the witness to the story and the characters' confidante. The two couples become good neighbours, but Bernard avoids the first dinner and refuses to meet Mathilde. They run into each other at the supermarket, make peace, kiss, Mathilde faints. Their passionate liaison begins again. At a garden party, Philippe says that he's taking Mathilde on the honeymoon they never had, Mathilde's dress gets caught on a chair and she finds herself half-naked in front of the guests. Bernard slaps her in front of everyone, revealing his feelings to his wife and Philippe. After Philippe and Mathilde return from their trip, Bernard has recovered, but Mathilde is hospitalized for depression. Philippe decides to move away. But one night Mathilde returns to the empty house, where Bernard finds her. They make love. She takes out a gun and kills him, then herself.

Vivement dimanche! (1983)
Finally Sunday, also known as Confidentially Yours
Screenplay, adaptation, dialogue: François Truffaut, Suzanne Schiffman, Jean Aurel, based on *The Long Saturday Night* by Charles Williams. *Music:* Georges Delerue. *Director of photography:* Nestor Almendros. *Operator:* Florent Bazin. *Assistant cameraman:* Tessa Racine. *First assistant director:* Suzanne Schiffman. *Assistant directors:* Rosine Robiolle, Pascal Deux. *Script supervisor:* Christine Pellé. *Sound engineer:* Pierre Gamet. *Boom man:* Bernard Chaumeil. *Production design:* Hilton McConnico, assisted by Jean-Michel Hugon, Franckie Diago, Alain Gambin, Jacques Gaillard. *Props:* Jacques Preisach. *Still photographer:* Alain Venisse. *Costumes:* Michèle Cerf. *Dresser:* Christiane Marmande. *Make-up:* Thi Loan N'Guyen. *Hairdresser:* Chantal Durpoix. *Editing:* Martine Barraqué, assisted by Marie-Aimée

Debril. *Editorial intern:* Colette Achouche. *Mixing:* Jacques Maumont. *Head grip:* Charles Freess, assisted by Gérard Bougeant, Jean-Yves Freess. *Head electrician:* Jean-Claude Gasché, assisted by Patrick Gasché, Philippe Darmon. *Groupman:* Patrick LeMaire. *Production manager:* Armand Barbault. *General production manager:* Roland Thénot, assisted by Jacques Vidal. *Production administrators:* Jean-François Lentretien, Jacqueline Oblin. *Production secretaries:* Josiane Couëdel, Donatienne Desmarestz. *Production:* Les Films du Carrosse, Films A2, Soprofilms. *First version of screenplay:* end of 1981. *Filming:* 4 November to 12 December 1982. *Filmed in:* Hyères and vicinity. *Laboratory:* LTC. *Auditorium:* SIMO. *Format:* Kodak, Agfa, Pyral. 35 mm black and white film. *Running time:* 111 minutes. *Opticals and credits:* Euro-Titres. *Visa de contrôle:* n° 55509 for 20 June 1983. *Release date:* 10 August 1983. *Distributor:* AAA. *Publicist:* Marie-Christine Malbert. Video distributed by AAA (1984). *Awards:* Two César nominations. *Cast:* Fanny Ardant (Barbara Becker), Jean-Louis Trintignant (Julien Vercel), Philippe Laudenbach (Maître Clément), Caroline Sihol (Marie-Christine Vercel), Philippe Morier-Genoud (Commissioner Santelli), Xavier Saint-Macary (Bertrand Fabre, photographer), Jean-Pierre Kalfon (Jacques Massoulier), Anik Belaubre (cashier at the Eden), Jean-Louis Richard (Louison), Yann Dedet (Angel Face), Nicole Félix (the scar), Georges Koulouris (the detective Lablache), Roland Thénot (the policeman Jambrau), Pierre Gare (Inspector Poivert), Jean-Pierre Kohut-Svelko (Slavic reveller), Pascale Pellegrin (the secretarial candidate), Jacques Vidal (the King), Alain Gambin (the theatre director), Pascal Deux (Santelli's assistant), Franckie Diago (employee, detective agency), Isabelle Binet and Josiane Couëdel (secretaries of Maître Clément), Hilton Mac Connico (client of prostitutes), Marie-Aimée Debril and Christiane Marmande (the pet-grooming women), Golaud the dog, Thi Loan N'Guyen (the Chinese girl at the commissariat), Jacques Gaillard (man on bike), Martine Barraqué (passer-by with newspaper), Rosine Robiolle (secretary commissariat), Armand Barbault (passer-by with prostitute) and Michel Aubossu, Paulina Aubret, Dany Castaing, Michel Grisoni, Pierrette Monticelli.

Julien Vercel, an estate agent, is suspected of murdering his wife and her lover, Massoulier. Things look bad for him, a third murder makes his situation worse. He hides in the basement of his agency, and watches the legs of women passing by. Barbara, his young secretary, with whom he constantly argues, sets out to discover the truth. She meets an upset cinema cashier, a suspicious client who turns out to be Massoulier's brother, an old detective, a Slavic merrymaker, a blonde typist who could be competition for her, a tenacious police commissioner, the terrible owner of a 'club' she can only enter by pretending to be a street-walker. She also meets a lawyer who seems devoted to their cause, but finally betrays them: he is the murderer. Barbara has solved the mystery, Julien is cleared, and he marries her.

Bibliography

Books by François Truffaut

Le Cinéma selon Hitchcock, Robert Laffont, Paris, 1967. Later French editions have the same title as the American one: *Hitchcock-Truffaut*, Ramsay, Paris, 1984.

Les Aventures d'Antoine Doinel (screenplays for *Les Quatre Cents Coups*, *Baisers volés*, *Domicile conjugal*, with notes and working outlines), Mercure de France, Paris, 1970. A later edition contained an outline of *L'Amour en fuite* prepared for the press book of the film, Ramsay Poche Cinéma, Paris, 1987.

La Nuit américaine, screenplay, with the *Journal de tournage de Fahrenheit 451*, Seghers, Paris, 1974; new edition, Cahiers du cinéma, Paris 2000.

Les Films de ma vie, Flammarion, Paris, 1975; new edition, Flammarion, coll. Champs Contre-Champs, Paris, 1987.

Le Plaisir des yeux, Cahiers du cinéma, Paris, 1987.

Correspondance, Hatier Cinq Continents, Paris, 1988; new edition, Le Livre de Poche, Paris, 1993.

Complete shot-and-dialogue transcriptions of *Les Mistons*, *Histoire d'eau*, *Tirez sur le pianiste*, *Jules et Jim*, *La Peau douce*, *L'Enfant sauvage*, *L'Amour en fuite*, *La Chambre verte*, *Le Dernier Métro*, *La Femme d'à côté* and *Vivement dimanche!* were published by L'Avant-Scène Cinéma.

Studies of François Truffaut

Graham Petrie, *The Cinema of François Truffaut*, International Film Guide Series, AS Barnes, New York, 1970.

Dominique Fanne, *L'Univers de François Truffaut*, Cerf, Paris, 1972.

Jean Collet, *Le Cinéma de François Truffaut*, Lherminier, Paris, 1977.

Jean Collet, *François Truffaut*, Lherminier, Paris, 1985.

Annette Insdorf, *François Truffaut*, Twayne Publishers, Boston, 1978.

Elizabeth Bonnafons, *François Truffaut*, L'Age d'Homme, Lausanne, 1981.

Mario Simondi (ed.), *François Truffaut*, La Casa Usher, Florence, 1982 (essays by Vincent Amiel, Claude Beylie, Elizabeth Bonnafons, Eduardo Bruno, Jean Collet, Serge Daney, Vittorio Gacci, Annette Insdorf, Franco La Polla, Jean Narboni, Serge Toubiana).

Dominique Rabourdin, *Truffaut par Truffaut*, Éditions du Chêne, Paris, 1985.

Hervé Dalmais, *Truffaut*, Rivages/Cinéma, Paris, 1987.

Dominique Auzel, *Truffaut, les milles et une nuits américaines*, Henri Veyrier, Paris, 1990 (album of posters for his films).

Anne Gillain, *François Truffaut, Le secret perdu*, Hatier, Paris, 1991.

Carole Le Berre, *François Truffaut*, Cahiers du cinéma, Paris, 1994.

Carole Le Berre, *Jules et Jim*, Nathan/Synopsis, Paris, 1996.

Antoine de Baecque, Serge Toubiana, *François Truffaut*, Gallimard, Paris, 1996.

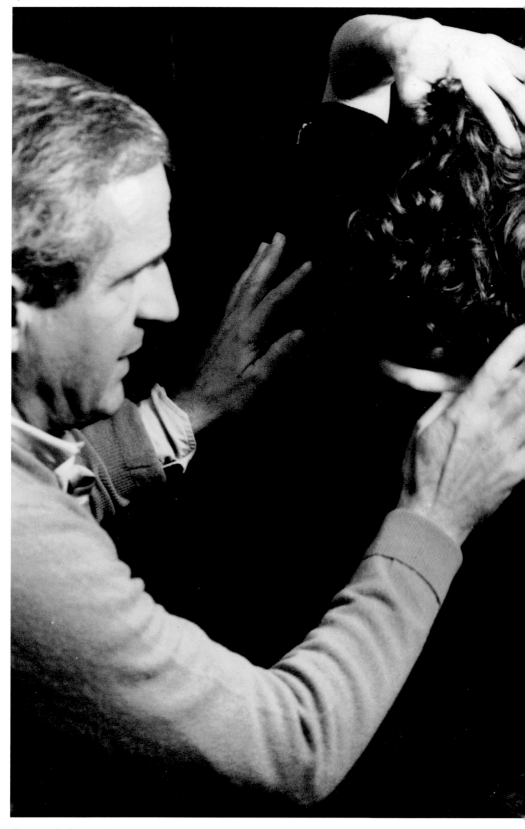

Personal Accounts

'François Truffaut', *Cinématographe*, no. 105, Paris, December 1984.

'Le Roman de François Truffaut', *Cahiers du cinéma*, special issue, December 1984; new expanded edition, Paris, 1985.

Arbeiten mit François Truffaut, Cicim, Institut français de Munich, May 1987; new edition 1992.

François Truffaut, Les Mistons, compiled by Bernard Bastide, Ciné-Sud, Nîmes, 1987.

Jean Gruault, *Ce que dit l'autre*, Julliard, Paris, 1992.

Claude Jade, *Baisers envolés*, Éditions Milan, Toulouse, 2003.

Quotations from François Truffaut about his work are mostly taken from *Correspondance*, his own documents and press books, his archives at Les Films du Carrosse and the BIFI, the transcript of a broadcast on Radio-Canada in 1971 (*Aline*

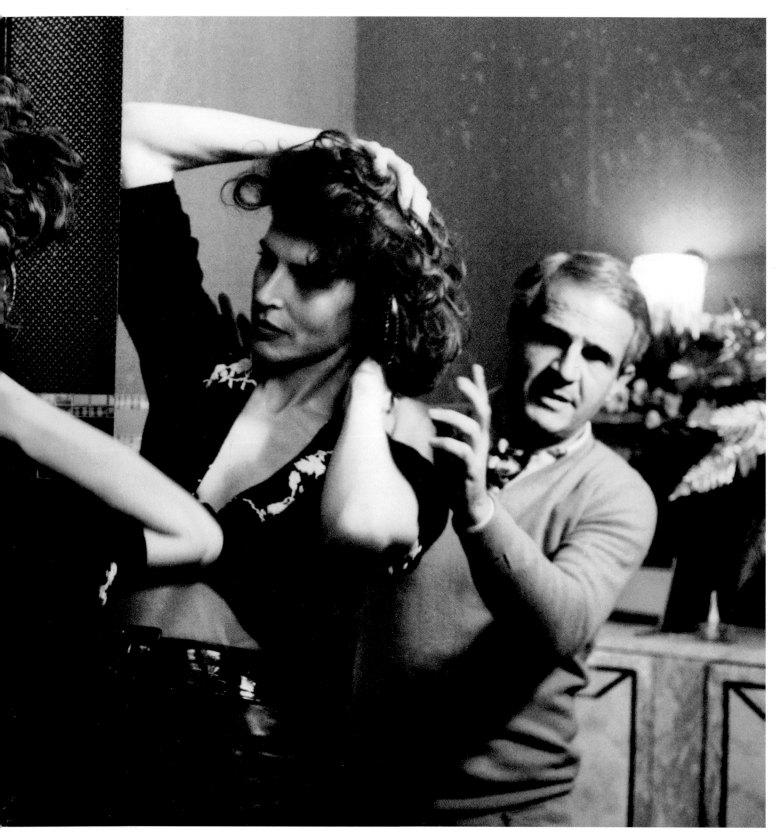

Desjardins s'entretient avec François Truffaut, transcript of a Radio-Canada broadcast), Éd Léméac, Ottawa, 1973; new edition, Ramsay Poche Cinéma, Paris, 1987), the collection of interviews edited by Anne Gillain (*Le Cinéma selon François Truffaut*, Flammarion, Paris, 1988) and the following interviews which the film-maker gave during the course of his career: Louis Marcorelles, *France-Observateur*, no. 598, 19 October 1961; Pierre Delot, *Clarté*, March 1962; Jean-Louis Comolli and Jean Narboni, *Cahiers du cinéma*, no. 190, May 1967; Pierre Bénichou, *Le Nouvel Observateur*, March 1970; Serge Toubiana, *Cahiers du cinéma*, no. 315 and 316, September and October 1980; Dominique Maillet, *Première*, October 1981; Anne de Gasperi, *Le Quotidien de Paris*, 24 February, 1982; Jean Collet and Jérôme Prieur, *Leçon de Cinéma* (edited by José-Maria Bersoza), INA, 1983.

Filming *Vivement dimanche!* François Truffaut and Fanny Ardant.

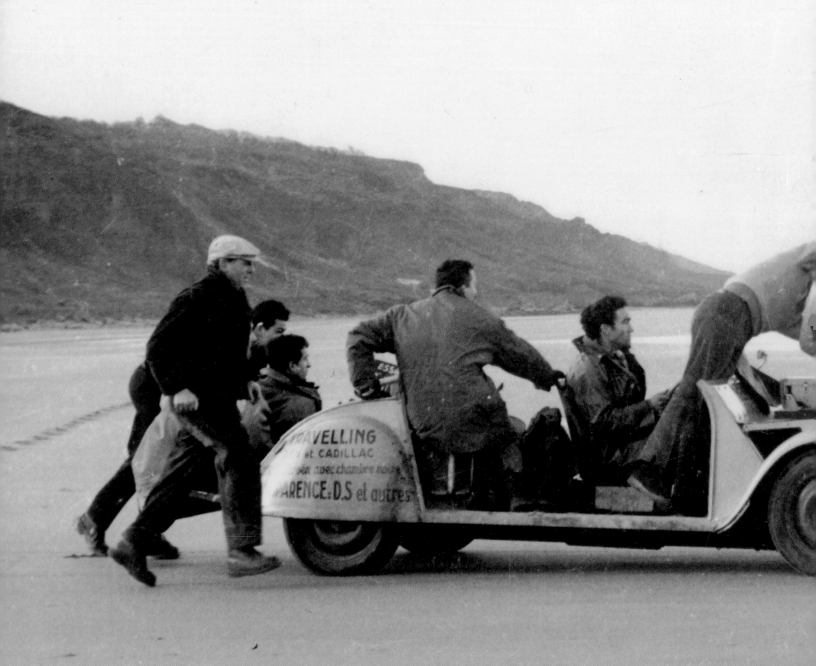